WOMEN'S REALITIES, WOMEN'S CHOICES

E. Dorsey Smith · Sarah B. Pomeroy · Dorothy O. Helly · Florence Denmark · Sue Rosenberg Zalk · Virginia Held · Susan Lees · Ülkü Bates

WOMEN'S STUDIES COLLECTIVE

HUNTER COLLEGE

Women's Realities, Women's Choices

AN INTRODUCTION TO WOMEN'S STUDIES

HUNTER COLLEGE
WOMEN'S STUDIES
COLLECTIVE

New York Oxford
OXFORD UNIVERSITY PRESS
1983

Library of Congress Cataloging in Publication Data
Main entry under title:
Women's realities, women's choices.
Bibliography: p. Includes index.
1. Women's studies—United States.
I. Hunter College. Women's Studies Collective.
HQ1181.U5W653 1983 305.4'0973 82-8059
ISBN 0-19-503227-6 AACR2
ISBN 0-19-503228-4 (pbk.)

Printing (last digit): 9 8 7

Printed in the United States of America

The Authors

ÜLKÜ Ü. BATES was born in Rumania and grew up in Turkey. She studied at the Universities of Istanbul and Freiburg (West Germany) and received her Ph.D. in Islamic Art History from the University of Michigan. She has traveled widely and done research on Islamic archaeology and architecture in Middle Eastern countries, most recently on the architecture of Ottoman Cairo, on which she is completing a major work. She is an Associate Professor of Art History. She has one son.

FLORENCE L. DENMARK is a past president of the American Psychological Association, a Professor of Psychology, and a former executive officer of the doctoral program in psychology at the City University of New York Graduate School. She is also a past president of the Division of Psychology of Women of the American Psychological Association and the editor and author of many works on the psychology of women. She is the mother of three children and the stepmother of three others.

VIRGINIA HELD is a Professor of Philosophy, teaches at the Graduate School of the City University of New York, and is the author of *The Public Interest and Individual Interests* (1970), the co-editor of *Philosophy and Political Action* (1972) and *Philosophy, Morality, and International Affairs* (1974), and editor of *Property, Profits, and Economic Justice* (1980). She is on the editorial boards of *Ethics, Hypatia, Political Theory,* and *Social Theory and Practice.* She was for a time a reporter and has written many articles on feminism, social philosophy, and public policy. She has a daughter and a son.

DOROTHY O. HELLY has degrees from Smith College, Radcliff College, and Harvard University. She is an Associate Professor of History and an Associate Dean. Her field of specialization is Victorian England and she is on the editorial board of *Women & History*. She is a member of the Board of Directors of the Institute for Research in History. She was a participant in the first national Women's Studies Institute sponsored by the Great Lakes Col-

leges Association (1981) and served on the program committee of the Fifth Berkshire Conference on Women's History (1982). She has received a Fellowship in Academic Administration from the Council on American Education for 1983–84. She has a daughter.

SUSAN H. LEES is a Professor of Anthropology and teaches in the Graduate School of the City University of New York. Her primary professional interests are in the anthropology of rural development in the Third World and the human impact of new technology in developing countries. Her degrees are from the Universities of Chicago and Michigan and her research has been conducted primarily in Latin America. She is the editor of *Human Ecology, An Interdisciplinary Journal*. She is the mother of two sons and the stepmother of a daughter.

SARAH B. POMEROY is the author of *Goddesses, Whores, Wives & Slaves: Women in Classical Antiquity* (1975). She was trained as a papyrologist at Columbia University, was the first chair of the Women's Classical Caucus, and is the coordinator of the women's studies program at Hunter College. She is a Professor of Classics and teaches at the Graduate School of the City University of New York. She is currently at work on a social history of women in Ptolemaic Egypt and is a director of a 1983 Summer Institute on Women in Classical Antiquity at Hunter College, sponsored by the National Endowment for the Humanities. She has two daughters and a son.

E. DORSEY SMITH studied at Duke University and has a doctorate from Columbia University. She is an assistant director of nursing for the Division of Maternal Child Health at Mount Sinai Medical Center in New York City and has taught nursing at the undergraduate and graduate levels at Hunter College, Cornell University, and San Jose State College in California. She is a Fellow of the American Academy of Nursing and a member of Sigma Theta Tau National Honorary Society. She has specialized in the nursing care of women and children, has been active in the field of abortion rights, and has written and edited several works in the field of women's health. She is the mother of teenage twins, a girl and a boy.

SUE ROSENBERG ZALK studied at New York University and received her Ph.D. in psychology from Yeshiva University. She is a Professor in the department of educational foundations and is on the faculty of the Graduate School of the City University of New York. She is a member of the editorial board of *Sex Roles: A Journal of Research,* and has done research and published in the fields of racial attitudes, psychology of women, sex roles, and sex role attitudes and family roles. She has run workshops on the topic of female sexuality and is the co-author of *Expectant Fathers* (1978). She goes scuba-diving for relaxation.

The authors dedicate this book to
all the significant others in their lives,
and to all those scholars and activists
whose achievements have inspired this book
and made it possible.

Preface

This book is the first basic textbook written for introductory women's studies courses. Unlike other comprehensive women's studies textbooks which are described as multidisciplinary but are actually either collections of individual chapters, each written from the perspective of a single discipline, or collections of readings with an editor's prefatory remarks, this book is thoroughly interdisciplinary. We hope that its use will encourage and regularize the teaching of women's studies introductory courses.

Our book can be visualized as organized in a series of concentric rings. In Part I, "Defining Women," we start with the innermost ring, the woman as an individual person. We ask: What are the cultural "givens" which seemed to define women in the past, and how do women, looking out from the center, see ourselves, our own body images, our minds, our social place? Then, in Part II, "The Family Circle," we look at women in terms of our closest human relationships. How have these relationships (woman as daughter, sister, wife, and mother) been defined and imposed on us? How do women see them, and how might we reshape the relationships to take account of our own interests? How have women shaped our own place in lesbian households and in nonkinship structures (e.g., communal groups and religious communities)? In Part III, "Women in Society," we look at the widest sphere of human interactions, the society at large. Here we look at the place of women in social institutions related to religion, health, education, work, and political power, and at how women's roles have changed and are changing through time. Although there is a final chapter titled "Changing the Present: A Look to the Future," within each chapter questions and suggestions point the way toward social change.

We recognize that to place the "self" in the center of the circle is to focus on the individual—individual awareness, individual growth, and individual fulfillment—in contrast to stressing the collective movement, collective goals, and broader social change. We are aware that many feminists believe that

there can be no real individual liberation without radical social change and that the appropriate emphasis must be on collective efforts to effect that change. The authors of this book differ on the degree to which we adhere to one or the other position, but we question whether one excludes the other. Certainly in many places in this book the "self" appears to be stressed; the need for basic social change, however, is never ignored.

It should be pointed out that this book itself was a collective effort. We did not merely divide up the chapters among the authors; instead, each of us has contributed to each chapter. No aspect of women's lives is isolated from any other, whether it be personal, familial, or societal. Divisions are arbitrary, and the chapter titles and book organization are merely designed to provide a conceptual framework. We believe that the concept of concentric circles presents a visual image which meshes with the experiences and perspectives of most readers.

Thus, our book attempts to go from the center, the self, outward, to examine the implications of the ways women have existed and how we may wish to reshape our own existence in society. At each level we observe the contradiction between the social or cultural "givens" that generally have been structured by men, in their own interests, and what we perceive to be women's own realities. We consider what women's reality ought to be, and how we can work to bring it about. The title we have selected acknowledges the gap between women's realities and women's choices. Our book is an effort to help bridge that gap.

We expect our courses in women's studies to be cooperative ventures between students and teachers, for we are all breaking new ground, trying to bring together disparate insights and experiences to share our progress with one another.

This textbook has had a gestation period of over four years. In 1978–79, the authors participated in an interdisciplinary seminar directed toward designing a curriculum for "Introduction to Women's Studies" and training faculty in interdisciplinary techniques. Meetings open to interested members of the Hunter community were held weekly as the core group proceeded in a year-long discussion. The seminar meetings were recorded on tape and transcribed. In addition, minutes were taken. For each topic, participants would offer remarks from the perspective of our disciplines; one or two would present extended comments; and all would contribute bibliographical sources from our own fields. The outline of this textbook is based on the material developed for the course.

Throughout this book, we its authors use the pronoun "we" to refer to women everywhere, in any period of history. The choice requires an explanation and some personal history.

We, the authors, originally decided to try to take the point of view of women, to speak for women as subjects (we) rather than as objects (them), to

speak, that is, for all of "us." The device of the pronoun, using "women . . . we" rather than "women . . . they" appealed to us, so we tried using it.

We immediately ran into difficulties. The device struck some readers as awkward and artificial: "we the authors" did not take part in the French Revolution or suffer the indignities of slavery; how could we presume to speak for all women? Was it not either disrespectful or silly to pretend to do so?

We decided that the manuscript should be rewritten, using "they" to refer to women collectively and in the contexts we were describing, and "we" to refer only to us the authors.

It was at this stage that the chapters were put together and that many of us authors saw the book as a whole for the first time. As we read it over, we realized what had been lost in relegating women, again, to the voiceless "they," the "other," where patriarchy has always tried to put all of us.

After much re-thinking and lengthy discussion of fresh criticism and reactions from new readers, we the authors revised the perspective of the book yet again, again trying to speak, however haltingly, for all women. We the authors do not presume for a minute to be able to do so. We are only a small number of women with restricted backgrounds and limited experiences. We are of course not pretending to be able to give adequate voice to the experiences of all women. But the authors of this book together with all those who read it and teach with it may be quite a large number of women with more varied backgrounds. We hope that women can be encouraged to see the world from the point of view of *women*, from the point of view of all of *us*, from *our* perspective. We hope the device of identifying with whatever women are being discussed in this book will help in this shift of perspective.

History, literature, philosophy, the arts, the sciences, have been made by men from the point of view of men. Men have seen themselves as the subjects, the "we" of mankind. We the authors of this book want to make clear that women are the "we" of womankind, and must be part of the "we" of humankind. We the authors of this book on women want to try to open the eyes of readers to the extent to which it feels new and different to begin to see human experience from *our* point of view, the point of view of *women*. As women, we hope that all women can come to experience the world as *we* see it.

The National Endowment for the Humanities awarded us a grant to write the textbook for the basic course. We would like to express our gratitude to Dr. Cynthia Wolloch of the Endowment for her support and constructive criticism. This grant permitted us free time in which to write and discuss our work and enabled us to carry out an extensive evaluation of these curriculum materials. An early draft of the manuscript was read by three outside evaluators: Nancy Hartsock, Joyce Ladner, and Catharine Stimpson. Other specialists who graciously read and commented on individual chapters were Jane Flax, Audrey Haschemeyer, Laura Randall, and Mary Ella Zippel. We would

also like to thank the members of the Columbia University seminar on Women in Society for their comments on an earlier version of chapter 9, Choosing Alternatives.

Three of us described our project at the 1980 convention of the National Women's Studies Association. The textbook was also announced in articles in *Women's Studies Newsletter* and *MS;* and a flyer was mailed out to women's studies programs across the country. This publicity brought a wonderful response from women's studies faculty who recognized the need for the textbook and volunteered to participate in the evaluation process. In 1980–81, chapters were used experimentally in classrooms at Hunter College and elsewhere. Students and faculty filled out evaluation questionnaires. For their help in this process, we would like to thank, in particular, Mary Harak-Sand, Virginia Cyrus, Margaret Simmons, and Helen Trobian.

Thus, this book has been written collectively, and not only by the authors whose names appear on the title page. Nancy Dean and JoAnn MacNamara participated in the early stages of the writing, and we thank them. It is a pleasure also to thank Janice Richter, Gita Sen, Cynthia Lloyd, and Virginia Joyner for their help. The authors were drawn from four divisions of Hunter College—Humanities and the Arts, Social Sciences, and the professional schools of Nursing and Education. Hunter College was the first free municipal college for women and has maintained its tradition of providing a quality education for women. We are pleased to have an opportunity to express our gratitude to the administration, in particular to former Provost Jerome Schneewind, former Dean Gerald Freund, Dean Walter Weiss, and President Donna Shalala for their support of this project.

New York City H.C.W.S.C.
May 1983

Foreword

The publication of any book is reason enough for a celebration. This particular volume deserves fireworks. It symbolizes the coming of age of the women's studies movement. Indeed, the substance of this book represents years of struggle by courageous scholar-teachers, to be taken seriously by their more traditional colleagues.

That a woman's studies program has produced a textbook is also a tribute to progressive elements in higher education in the United States. Women's studies programs and courses, more specifically scholarship on women, are now so widely accepted that there is scarcely a college or university without some offerings.

Hunter College's long commitment to the education of women makes it a particularly fitting place for launching this text. No institution has sent more women on for doctoral studies. Our graduates include a Nobel Prize winner, and leaders in education, the arts, and business.

This effort by a collective of our most distinguished faculty fills us with pride. It also allows us to recommit ourselves to the elimination of sexism in higher education.

April 1983

DONNA E. SHALALA
President, Hunter College
of the City University
of New York

Contents

Introduction to Women's Studies, 3

WOMEN'S STUDIES AND FEMINISM, 4

History of Women's Studies. How Does Women's Studies Study Women?

THE NEED FOR WOMEN'S STUDIES, 7

Missing Information About Humans. Misconceptions About Humans. Old and New Processes of Inquiry. Knowledge of Men.

WOMEN'S STUDIES: ISSUES AND GOALS, 11

Ethnicity, Racism, Social Class, and Feminism. Women's Studies as an Academic Discipline. Women's Studies as a Source of Strength.

HOW THIS BOOK PRESENTS WOMEN'S STUDIES, 15

Summary, 16

References, 17

1 DEFINING WOMEN

INTRODUCTION, 19

1. Imagery and Symbolism in the Definition of Women, 22

THE MEANING OF IMAGERY AND SYMBOLISM, 23

Experience, Perception, and the Symbolic Construction of Reality. The Function of Images and Symbols. The Social Context of Image Construction. The Use of Symbols and Their Influence.

SOME PREDOMINANT IMAGERY, 28

Frightening Females. Venerated Madonnas. Sex Objects. Earth Mothers. Woman as "Misbegotten Man."

THE EFFECT OF THE IMAGES ON WOMEN, 36

CHANGING REALITY BY CHANGING IMAGES, 37

Changes in Appearance and Conduct. Participating in Imagery Construction: An Example.

WOMEN DEFINE OURSELVES, 41

Women's Search for Self through Art. Women's Search for Self through Literature. The Propagation of Feminist Imagery.

CONCLUSIONS: BEING WHOLE, 53

Summary, 54

Discussion Questions, 55

Recommended Readings, 55

References, 56

2. Ideas About Women's "Nature," 59

DEFINITIONS AND THEORIES, 60
Woman as "Other." Philosophical Definitions of Women. Religious Reflections.

IDEAS OF EQUALITY, 67
Liberalism and Feminism. Wollstonecraft. Mill and Taylor. Liberal Feminism. Relevant Characteristics.

THE CONCEPT OF FREEDOM, 78

CONSERVATIVE SENTIMENTS AND FEMINISM, 79

SOCIALISM AND FEMINISM, 80
Socialist Feminism.

RADICAL FEMINISM, 83

SOME PRINCIPLES OF FEMINISM, 84
Dangers and Hopes.

Summary, 88

Discussion Questions, 89

Recommended Readings, 89

References, 90

3. Women's Bodies, 93

WHY TWO SEXES? 94

SOME BIOLOGICAL DILEMMAS IN DEFINING WOMEN, 96
The Problem with "Averages." Variations Within a Sex and Between the Sexes.

HOW IS A WOMAN DEFINED BIOLOGICALLY? 98
Chromosomes and Gender. Intrauterine Events. Genital and Reproductive Anatomy.

PHYSIOLOGY OF THE FEMALE REPRODUCTIVE SYSTEM, 103
Female Reproductive Cycle. Negative Attitudes About Menstruation. Menstruation and Moods. Female Sexual Response. The Physiology of Pregnancy. The Biology of Birth. Postpartum or "Lying-In" Period. Breast-Feeding. Menopause.

BIOLOGY AND BEHAVIOR, 121
Hormones and the Brain. Evolutionary Theory.

Summary, 126

Discussion Questions, 127

Recommended Readings, 127

References, 128

4. Women's Personalities, 132

STEREOTYPES OF FEMININITY, 133

What Are Women Like? "Femininity": Descriptions and "Observations." Dimensions of Variability Among Women. Explanations of Female-Male Differences.

THE DEVELOPMENT OF A "FEMALE" PERSONALITY, 143

Historical and Cultural Variation. Infancy. Early Childhood and the Development of Gender Roles. Later Childhood and Adolescence.

THE ADULT WOMAN AND SEXUAL MATURITY, 160

The Classical Psychoanalytic Theory of Helene Deutsch. Psychoanalytic Dissidents: Karen Horney and Clara Thompson. Older Women.

CHANGING THERAPIES, 164

Summary, 166

Discussion Questions, 167

Recommended Readings, 168

References, 169

5. Social Roles, 173

SEX AND GENDER, 174

Social Definitions. The Social Construction of Gender. The Historical Dimensions. Social Science and the Conceptualization of Gender Roles.

THEORIES OF SOCIETY, 180

Social Charter Myths. The Search for Social Origins. Evolutionary Theories: Patriarchal and Matriarchal Origins.

ASPECTS OF SOCIALIZATION, 187

The Division of Labor by Gender. The Heterosexual Prescription. Marriage as a Legal and Social Institution.

THE SOCIAL CONTROL OF WOMEN, 197

Physical Control: Clothing and Gender. Vulnerability as Social Control. Language as Social Control.

SOCIALLY CONSTRUCTED INVISIBILITY, 203

The Theory of Muted Groups. The Need for New Interpretive Frameworks. The Social Construction of Human Beings.

Summary, 207

Discussion Questions, 208

Recommended Readings, 209

References, 210

II THE FAMILY CIRCLE

INTRODUCTION, 213

6. Daughters and Sisters, 216

DAUGHTER IN THE FAMILY, 217

Female Infanticide. The Value of Daughters. Naming the Daughter.

FAMILY RELATIONSHIPS: PARENTS, 223
Daughters and Mothers. Daughters and Fathers.

SISTERS: SIBLING RELATIONSHIPS, 233
Sisters as Opposites and Companions. Sister-Brother Relations.

INHERITANCE, 238

THE SISTERHOOD OF WOMEN, 239

Summary, 241

Discussion Questions, 242

Recommended Readings, 242

References, 243

7. Wives, 246

WHY MARRIAGE? 247
Reproduction. Minimizing Male Rivalry and Cementing Male Alliances. Reducing Competition Between Women and Men. Personal Reasons.

SELECTING A MATE, 251
Society Chooses. Families Choose. Women Choose.

MARRYING, 258
Types of Marriage. The Coming of Marriageable Age. The Rite of Passage. The Wedding Night.

THE MARITAL HOUSEHOLD, 265
Family Politics. Extramarital Affairs.

DIVORCE, 271

WIDOWHOOD, 274

FEMINIST OPTIONS, 275

Summary, 276

Discussion Questions, 278

Recommended Readings, 278

References, 279

8. Motherhood, 281

PARENTHOOD VERSUS MOTHERHOOD, 282
Parental Behavior: Instinct and Culture. Motherhood: Ideology and Reality. The Assignment of Mothering to Women: Whose Interest Does It Serve?

THE CULTURAL SHAPING OF BIOLOGICAL EVENTS, 290
Attitudes Toward Pregnancy. Childbirth: A Cultural or a Natural Event? Breast-Feeding: Attitudes and Choices.

MOTHERS AND OTHERS: SUPPORT SYSTEMS, 298
Fathers. Women's Networks. Community Support.

CHOICE AND CONTROL, 301
Whether, When, and How Often to Become a Mother. Control Over Children. Working for Wages.

IMAGES OF MOTHERHOOD, 306
Perspectives: Who Creates the Image? "The Happy Mother": Painting as Propaganda? "Ethnic" Mothers and Social Mobility. Motherhood and the Media. Mothers Speak Out.

Summary, 315

Discussion Questions, 316

Recommended Readings, 317

References, 318

9. Choosing Alternatives, 320

COMMUNITIES OF WOMEN, 322
Religious Communities. Educative Communities. Laboring Communities. Support Networks.

UTOPIAN AND EXPERIMENTAL COMMUNITIES, 330
Utopian Literature. Experimental Communities. Criticisms of Experimental Alternatives.

ALTERNATIVE FAMILY AND HOUSEHOLD FORMS, 339
Role Reversals. Egalitarian Households. Families of Women. Single Parent Households. Choosing Not To Mother.

WOMEN ON OUR OWN, 345
Sexual Freedom. Notes of Caution.

Summary, 349

Discussion Questions, 350

Recommended Readings, 350

References, 351

III WOMEN IN SOCIETY

INTRODUCTION, 353

10. Women and Religion, 355

RELIGIOUS BELIEFS, 356
The Organization of Religion. The Religious Experience of Women. Origin Myths. Females in the Supernatural World. The Gender of God.

RELIGION AND SOCIAL CONTROLS, 367
Family Cults and Controls, Protection of Women, Public Cults and Controls.

WOMEN AS RELIGIOUS LEADERS, 373
Shamans. Missionaries and Martyrs. Religious Rebels.

RELIGION AND INDIVIDUAL FULFILLMENT, 380
Mysticism. Possession.

AMERICAN WOMEN AND RELIGION, 383
Leadership by Women.

FEMINIST CONTRIBUTIONS TO RELIGIOUS CHANGE, 389

Summary, 391

Discussion Questions, 393

Recommended Readings, 393

References, 394

11. Women and Education, 397

WOMEN'S KNOWLEDGE, WOMEN'S LITERACY, WOMEN'S PLACE, 398
The Present State of Women's Literacy and Education.

FORMAL EDUCATION IN THE PAST, 401
The Ancient World. The Middle Ages. Renaissance Humanism and Early Modern Europe.

THE TRADITIONAL GOALS OF WOMEN'S EDUCATION DEBATED, 406

THE MODERN EDUCATIONAL REVOLUTION, 409
The Achievement of Elementary and Secondary Education. The Education of Black Women in America. The Struggle for Higher Education.

EDUCATION AND CAREER CHOICES, 421
Women's Education and Women's Realities. Professional Advancement. The Limitation of Women's Choices. Exceptions: Women Who Achieved. Reentry Women. New Beginnings for Women.

Summary, 431

Discussion Questions, 432

Recommended Readings, 433

References, 433

12. Women and Health, 438

HISTORICAL BACKGROUND, 439
Views on Women's Health. Interaction between Women and the Medical Profession.

BODY IMAGE—EXTERNAL PERCEPTIONS, 444
Breasts. Body Size and Nutrition. Aging.

BODY IMAGE—INTERNAL PERCEPTIONS, 450
Common Menstrual Abnormalities. Menopause. The DES Dilemma. Infertility. Hysterectomy.

PREGNANCY, CHILDBIRTH, AND CONTRACEPTION, 454
Pregnancy and Childbirth. The Medicalization of Childbirth. Teenage Pregnancies. Contraception. Sterilization. Abortion.

SEXUALLY RELATED HEALTH PROBLEMS, 461
Female Sexuality. Sexually Transmitted Diseases.

MENTAL HEALTH AND WOMEN, 463
Women in the Mental Health System. Women and Substance Dependence. Women and Assault and Battery. Rape.

WOMEN AS PROVIDERS IN THE HEALTH CARE SYSTEM, 468
Nurses. Midwives. Women Physicians.

APPROACHES TO HEALTH CARE OF WOMEN, 472

Summary, 472

Discussion Questions, 475

Recommended Readings, 475

References, 476

13. Women and Work, 479

THE LABOR OF WOMEN, 481
Production and Reproduction. Maintenance of the Domestic Unit. Women's Work in the Marketplace. The Contribution of Women to Wartime Economy. The Contribution of Women to Economic Development.

THE DOMESTIC MODE OF PRODUCTION: AN INTEGRATED SYSTEM, 485
Food Production. Maintenance. Exchange and Marketing.

THE CAPITALIST MODE OF PRODUCTION: AN ALIENATED SYSTEM, 489
Urbanization and Class Distinctions. Working for Wages: Its Organizational Prerequisites. Division of Labor by Gender: Women's Work. Minority Women and Work in the United States. The Multinational Corporation. Self-Employment. Women in Corporations. Unemployment.

THE POLITICS OF WORK: BARRIERS AND STRATEGIES, 510
Conflict and Competition Between Women and Men. Nuclear Families, Labor, and Capitalism. Sexual Harassment and Other Problems. The Dual-Career Family. Social Support for Working Women. Government and Law. Protective Legislation. Laws Against Sexist Job Discrimination. Equal Pay—Comparable Work. Socialist and Communist Impact on Gender Division of Labor.

NEW DIRECTIONS, 523
Impact of the Women's Movement. The Double Burden.

Summary, 526

Discussion Questions, 527

Recommended Readings, 528

References, 529

14. Women and Political Power, 531

FEMINISM AND POLITICS, 532
Stereotyped Views of Political Behavior. "The Personal is Political."

POLITICAL POWER, 537
What is Power? Power and Authority. Types of Government. Women's Political Power in the Past. Patterns of Male Dominance.

WOMEN AS POLITICAL LEADERS, 542
Women in the United States. Women in Communist Countries.

WOMEN AS CITIZENS, 548
Women and War. Women and Peace Movements. Women and the Law.

EQUAL RIGHTS, 554

The Struggle for the Vote. The Modern Women's Liberation Movement. Feminism and Internal Conflicts.

THE POLITICAL CLIMATE OF THE 1980S, 568

Summary, 569

Discussion Questions, 570

Recommended Readings, 571

References, 571

15. Changing the Present: A Look to the Future, 574

WOMEN AND SOCIAL CHANGE, 575

The Early Years. Women's Organizations. Early Radical Feminists. After the Vote. Patterns of the Past.

TAKING STOCK OF THE PRESENT: THE EARLY 1980S, 582

An Optimistic Picture? The Other Side of the Picture.

THE WORLD OF THE FUTURE: WHAT SHOULD IT BE? 589

Women (and Men) of the Future. Vehicles for Change. Women's Studies and the Feminist Movement.

Summary, 605

Discussion Questions, 607

Recommended Readings, 607

References, 607

Index, 611

Boxes

1.1. Woman as Fiction—Woman as Reality, 29
1.2. The Masculine Mystique, 34
1.3. Louise Nevelson: "My Whole Life is Feminine," 47
1.4. Song of Solomon, 48
1.5. Aphra Behn: To Alexis in Answer to His Poem Against Fruition, 49

2.1. For Him, 64
2.2. What is "Natural" for Women? 67
2.3. Hindu Conceptions, 68
2.4. Woman as Servant, 74
2.5. Capitalist Oppression, 83
2.6. Emma Goldman: Woman's Emancipation, 85
2.7. Gloria Steinem: Feminist Labels, 86

3.1. Adam-out-of-Eve, 102
3.2. Female Internal and External Genital Structure, 104

4.1. Sex and Temperament, 136
4.2. The Wisdom of Confucius, 156
4.3. Too Much to Require, 157
4.4. The Bridge Poem, 158
4.5. The Socialization of Las Chicanas, 160
4.6. Nonsexist Guidelines for Therapy with Women, 165

5.1. "Ain't I a Woman?" 175
5.2. The Social Construction of Gender, 177
5.3. Western Patriarchal Culture and Native American Women
5.4. "Cassandra": A Victorian Daughter's Complaint, 191
5.5. Heterosexuality as a Political Institution, 192
5.6. Welfare Motherhood, 198

6.1. Buying Daughters in Traditional China, 221
6.2. Mothers and Daughters, 225
6.3. My Grandmother Who Painted, 227
6.4. "I Know Why the Caged Bird Sings," 228
6.5. Male Parenting, 232

7.1. The Christian View of Monogamy, 249
7.2. Monogamous Marriage as Economic Exploitation, 250
7.3. Marriage in the English Common Law, 252
7.4A. The Marriage of Catherine of Aragon: I, 258
7.4B. The Marriage of Catherine of Aragon: II, 259
7.4C. The Marriage of Catherine of Aragon: III, 260
7.4D. The Marriage of Catherine of Aragon: IV, 261
7.4E. The Marriage of Catherine of Aragon: V, 263
7.4F. The Marriage of Catherine of Aragon: VI, 264
7.4G. The Marriage of Catherine of Aragon: VII, 265
7.4H. The Marriage of Catherine of Aragon: VIII, 267
7.4I. The Marriage of Elizabeth I, 268
7.5. John Stuart Mill on Marriage as Friendship, 276

8.1. The "Profession" of Motherhood, 287
8.2. Women's Mothering, 289
8.3. Separation and Autonomy, 308
8.4. Carriages and Strollers, 315

9.1. Sappho, fragment 94, 327
9.2. Feminist Family Circles, 331

10.1. "Without a husband I shall live happily," 377
10.2. The Trial of Joan of Arc, 379
10.3. A Moroccan Story, 381
10.4. Jewish Prayers, 388
10.5. Invocation to the Goddess, 392

11.1. Shakespeare's Sister, 405
11.2. Seventeenth-Century English Feminism, 408
11.3. Equal Pay for Women Teachers, 1853, 413
11.4. Anna Cooper on the Higher Education of Women, 416
11.5. Women's Education at Hunter College, 429

12.1. Women and Madness, 441
12.2. Guidelines for the Woman Who Is Going to See Her Health Care Practitioner, 446
12.3. Has Feminism Aided Mental Health? 465
12.4. The Legal Bias against Rape Victims, 468

13.1 Women's Work Outside the Home: A Debate by the Mills, 484

13.2. Comparison of Time Allocation to Rural Activities, 486

13.3. Mother Jones and the March of the Mill Children, 496

13.4. Excerpts from EEOC Harassment Rules, 513

13.5. Ladies' Day in the House, 519

14.1. Women Do Not Belong in the Public Sphere, 534

14.2. Shirley Chisholm: "I'm a Politician," 544

14.3. Does Gender Make a Difference? 546

14.4. Carrie Chapman Catt Remembers, 559

14.5. NOW Statement of Purpose: 1966, 560

14.6. Consciousness-Raising and Political Change, 562

14.7. The Equal Rights Amendment, 564

14.8. What We Believe: A Black Feminist Statement, 568

15.1. The Declaration of the Rights of Woman and the Female Citizen (France 1791), 577

15.2. Women Radicals Suppressed (France 1793), 579

15.3. Charlotte Perkins Gilman on Women and Work, 586

15.4. Poll Finds New View of Women, 587

15.5. Women and Revolution, 595

15.6. Stages of Women's Awareness: The Process of Consciousness-Raising, 598

15.7. Are Women Sexist? 600

WOMEN'S REALITIES, WOMEN'S CHOICES

Introduction to Women's Studies

WOMEN'S STUDIES AND FEMINISM
History of Women's Studies
How Does Women's Studies Study Women?

THE NEED FOR WOMEN'S STUDIES
Missing Information About Humans
Misconceptions About Humans
Old and New Processes of Inquiry
Knowledge of Men

WOMEN'S STUDIES: ISSUES AND GOALS
Ethnicity, Racism, Social Class, and Feminism
Women's Studies as an Academic Discipline
Women's Studies as a Source of Strength

HOW THIS BOOK PRESENTS WOMEN'S STUDIES

Women's studies is not simply the study of women. It is the study of women which places women's own experiences in the center of the process. It examines the world and the human beings who inhabit it with questions, analyses, and theories built directly on women's experiences.

In the past, both women and men have studied women from a male perspective only. That is because until recently, all theories about human beings, our nature and our behavior, have been "man"-made. Knowledge about ourselves and our world has usually been divided—for the purpose of study—into distinct "fields" or "disciplines." Such fields may have a long past, as in the case of history or philosophy. Other fields or disciplines such as sociology, economics, or psychology have developed as distinct approaches to knowledge only in the past century or two. Still other ways of studying the world or parts of the world, such as communications, computer sciences, or black studies have even more recent origins.

However long these areas of study have been in existence, each involves a relatively distinctive approach to knowledge. Each also involves an explicit set of observations of what is perceived to be true and rests on an implicit set of assumptions and ethical views. These observations and assumptions provide us with guidelines for human action. Yet, if these observations and assumptions reflect a predominantly male perspective of reality, the interpre-

tations they give rise to are not as true for women as for men. They do not correspond with women's experiences of reality, and may be poor guides for women's behavior. They represent, in fact, men's studies. Thus, women's studies focuses on women's experiences to provide observations and to be informed by assumptions that can help establish women's reality.

Women's studies is both a complement and correction to established disciplines and a new academic discipline of its own. In both respects, it requires other disciplines to reexamine and revise the basic assumptions and theories on which they rest. As a new discipline, women's studies not only challenges basic methods and presuppositons in established disciplines but also crosses the boundaries between them giving fresh views of their subject matter and creating a coherent new way of seeing the world.

Women's studies is an attempt to bring about change of a fundamental kind as a result of its search for knowledge. Its role in the academic community and in the feminist movement is still under discussion. Its distinct perspectives, issues, and goals are continually being formulated, debated, revised, and reformulated. This is an exciting process and a challenging one for all of us in women's studies.

Women's Studies and Feminism

Feminism has been defined in various ways, but it is agreed that it encompasses a set of beliefs, values, and attitudes centered on the high valuation of women as human beings. Women are not valued for attributes imposed on us by others, but for those that exist in and are chosen by women ourselves. As feminists, we reject negative cultural images of women and affirm our strength, capability, and intelligence. We value autonomy, and we work for conditions that favor our independent control of our destinies.

As feminists, we reject the assignment of social roles with their corresponding qualities according to whether a person is female or male. We reject evaluations which esteem presumably "masculine" qualities, such as aggression, and denigrate presumably "feminine" qualities, such as compassion. Any quality may appear in any human being and must be evaluated on its own merits, not in terms of the gender of the person in whom it appears. Understanding that most cultural attitudes and beliefs about women have been based on false premises, feminists are working to replace ignorance and fantasy with knowledge and reality. We realize that discriminatory laws and customs have oppressed women for centuries, that this oppression is disgraceful and harmful to all human beings, and that we can, through our persistent and collective efforts, bring about change for the better.

Feminists may differ in their immediate goals and the directions in which they choose to focus their energies for change. For some, the focus of feminism is on individual change and self-fulfillment; for others, the core of femi-

nism lies in collective efforts and shared goals. Feminists also disagree about whether equality and freedom for women can occur in society as it is currently structured or whether a radical transformation of the social structure is required. Whichever position we take, feminists still gain our strength through mutual support and collective efforts.

Feminists recognize that it is not only women who have been oppressed. We therefore support liberation from oppression of every kind, such as racism, class privilege, and discrimination against homosexuals.

Feminism, then, represents an intellectual, ethical, and political position that can be espoused by women or men. It provides a major justification for the development of women's studies and makes explicit its most fundamental assumptions. *Women's studies can be understood as the academic manifestation of feminism.* It is the outgrowth of a realization that we know little about women, and its purpose is to provide a means of replacing ignorance with knowledge. As the scholarly discipline of feminism, women's studies receives support from feminist commitment outside the academic community and provides knowledge and activities to help women's efforts, both inside and outside the academy.

History of Women's Studies

The development of an academic manifestation of feminism has been a recent addition to the history of feminism. Although there were scattered courses in areas such as women's history or women in literature, women's studies was not taught under that name on American college campuses until 1970. In the late 1960s, however, concurrent with the civil rights, students' rights, and antiwar movements and the creation of black studies, courses sprang up across the country exploring the status of women, discrimination experienced in public roles and private lives, and gender bias in general in society, literature, and learning. Dozens of courses, some official, some unofficial, were launched in a variety of contexts by instructors with many different academic backgrounds but most often in the liberal arts: the humanities, sociology, psychology, and history. During the next six years, such courses proliferated on American campuses. Instructors in high schools as well as in colleges exchanged syllabi and ideas about how to teach in the feminist mode. While many of the courses were incorporated into the curriculum of existing disciplines such as psychology or history, special programs for a major or minor in women's studies were also developed at several colleges and universities.

From 1970 to 1976, women's studies began to be articulated as a distinctive, increasingly integrated field. Journals in women's studies were established, including, in the United States alone, *Feminist Studies, Women's Studies, Signs, Quest, Sex Roles,* and the *Women's Studies Newsletter.* Anthologies of writings and full-length books in women's studies were published. These began to establish the field as a discipline. The National

Women's Studies Association was founded in 1977 to facilitate the sharing of information among individuals involved in women's studies and other feminist pursuits.

The roots of the discipline are found in the development of feminist critiques of existing scholarship and higher education. One such critique, which predates the modern feminist movement by twenty years but greatly influenced it, is Simone de Beauvoir's *The Second Sex,* first published in French in 1949. Since that time, there has been a virtual explosion of books and articles on feminism in general as well as on feminism in specific fields as varied as poetry and literature, health and medicine, economic development in the Third World, management and commerce, law, history, and philosophy. Increasing numbers of volumes of annotated bibliographies in these specialized fields are becoming available. This explosion of scholarship has not only raised fundamental questions about the perspectives in all academic disciplines; it has also generated profound questions about the place of women in society.

How Does Women's Studies Study Women?

Every discipline uses concepts and theories about how our universe functions and uses methods devised to pursue inquiry. Women's studies incorporates concepts and methods other disciplines have developed to the extent that they are gender-neutral, that is, so long as they do not make assumptions that reflect a focus on men's reality only. It marshals the new scholarship on women, whatever the source, and builds on it to understand the nature of women's experiences in the past as well as to analyze women's situations today. As feminist scholars continue to pursue studies from disciplinary perspectives, we increase the body of knowledge women's studies can use. As women's studies develops a new discipline, it can use this diverse research to formulate more questions that may yield new concepts, new theories, and even new methods of research which will, in turn, aid those pursuing other disciplines.

For example, biological studies of women have been affected by discoveries in the field of psychology. A topic such as hormonal cycles may require knowledge of the effects of emotional events on biological functions as well as a command of environmental and genetic sciences. Similarly, women's studies, in trying to solve particular problems, may simultaneously draw from a number of different disciplines what it finds useful and appropriate. In order to understand changes in child-rearing practices in a particular situation, for example, we may wish to draw from the field of biology to understand how lactation works, from economics to see the conditions under which women make decisions about how to rear infants, from psychology to see why women perceive conditions as we do, from anthropology to understand the cultural context of child-rearing practices, from nutrition to see the

effects of different practices on mothers and children, from politics and law to understand the formal support systems (or lack of them) for particular decisions, and so forth. The questions asked may be different from those of established disciplines, but the means by which they are answered may rely heavily on developed fields of knowledge.

Certain questions in women's studies call for information that other disciplines have not been concerned with. These questions also involve other groups of people who have traditionally been neglected by the established disciplines. We know little about women in antiquity because we rely on documentary material written by men about men's experiences. How can we find out about women in these periods? Again, we have learned that certain psychological tests, such as personality or I.Q. tests, have been culturally biased and may not tell us anything about the reasoning ability or emotional makeup of ethnic groups which are not members of the dominant class. Is the way that a person performs the effect of biological or cultural causes or both? How can we devise tests which are bias-free and which tell us what we want to know? Because women's studies is so new, it is just beginning to identify its own needs for special methods and to diverge, where necessary, from traditional approaches.

A very distinctive characteristic of women's studies, inherited from its earliest days during the 1960s, has been the development of collective modes of production. Although women who are scholars, health professionals, artists, and the like work alone, we also frequently pool our resources (knowledge, skills, and energy) for collective work whose product does not emphasize the individual but the sum of group effort.

The strengths gained from this kind of action are twofold. First, collective action provides mutual support in a difficult endeavor. Establishing a new discipline, like breaking into a field from which one has been excluded, is hard work and can be psychologically alienating; the collective mode helps individuals by reconfirming values in the context of a group. Second, many problems require the expertise of more than one individual. Women's studies develops as a new discipline by drawing from various fields of knowledge both to challenge established ideas and to work out new ones. Women need one another's knowledge to find out how the pieces fit. The excitement already generated by this process has been enormous. It has spurred new collaborative modes of study and work to bring together all that we know to define and redefine the study of women—and to reassess what we know about men as well.

The Need For Women's Studies

Some academicians argue that the other established disciplines study women as well as men. When we look closer, however, we see large gaps in our knowledge about women. As new work emerges, we uncover many miscon-

ceptions about women and question whether established approaches of inquiry can correct them.

Missing Information About Humans
We are just beginning to find out how little we know about half the human species—women. For example, for many years prehistoric archaeologists had been refining theories about human origins based upon increasing knowledge about tools and behavior associated with what is generally a man's activity: hunting. But when feminist anthropologist Sally Slocum (1975) asked what *women* were doing, it was realized that little or nothing was known of women's activities in preagricultural communities. Historians may have imagined that they knew a great deal about the Renaissance until feminist historian Joan Kelly (1977) asked: Did *women* have a Renaissance? What were women doing during that period in Europe? One focus of problems in women's studies is the search for "missing information" about women: as providers of food, as writers, thinkers, and artists, as traders and producers of crafts, in the past and at present.

One reason women have been "invisible" has to do with our own "silence" about ourselves. Women have generally tended to be excluded from public discourse and confined to the "domestic sphere" of home and family and to "woman's work." Because women were only rarely taught to write, there is relatively little direct documentary material about most of our foremothers' lives. Compared to the numbers of male artists, few women were engaged in creating the painting, sculpture, and architecture that historians traditionally study. Many women who did express themselves creatively tended to use such modes as music, dance, weaving, tapestry-making, quilting—forms that are fragile, ephemeral, and anonymous. Women still are poorly represented in the world of the arts establishment, among those who decide which paintings will be hung in museums and which books published. There have been few women participants in the scholarly world in the past, and even today women are few in numbers in many academic disciplines. Women have rarely played a decisive role in politics or industry or established religion, and we remain largely excluded from such leadership today.

Not only have women had few opportunities to express ourselves to others, but scholars and critics have not selected as interesting the things that women did. Why should this be so? One obvious answer is that these scholars and critics (generally men) felt that the restricted set of activities open to women was simply not very important: what was important was what men did—governing, fighting, producing "great" works of art. While it is true that the course of social events has largely been directed by men's activities, it is also true that much of what men have done has been directed toward *controlling* what women do, or are thought to do.

The lack of interest in women can also be traced to a more general

devaluation of women. Our works have often been ignored simply because they were produced by women. That is why some women in the past chose to write under male pen names, such as George Eliot (Marian Evans) and George Sand (Amantine-Lucile-Aurore Dudevant).

It is a distortion of history to think that the course of social events has been directed by men's activities alone. Wars could not have been fought and industrialization could not have taken place without the complementary support of women's work and activities. Women maintained the homes and entered the labor force in times of war. Economic and social changes in men's lives are paralleled by changes in women's lives, but these have been largely ignored.

Today economic planners are beginning to ask what the impact of technological development is on women in the Third World. Educators are looking at the effects of particular pedagogical methods on girls' learning of mathematical concepts. In this manner, we are beginning to get a new view of phenomena we once thought we understood, from the explanation of the origins of culture, to the events of a historical period, to the process of economic development, to the impact of primary school teaching. This raising of our consciousness is teaching us new things about women, about men, and about society in general.

Women are becoming more visible. Our collective efforts to participate in the determination of our lives, for instance, by demanding the right to vote, to control our own bodies, to make laws, or to control property, have raised basic questions about what women are, what we do, how we feel, and what we are entitled to as members of society. These questions have had repercussions on scholarship and on the arts as well as on the social and legal world. To the extent that such questions help us to become aware of our own potential, they encourage more active participation of women in these areas. They make it more difficult for women and men to ignore women. They force a reevaluation of widespread assumptions. They counteract the general devaluation of women as human beings and increase the chances for women to shape the world that shapes our lives.

Misconceptions About Humans

The discovery that a great deal of information is missing about humans has contributed to a second discovery: some very serious misconceptions about humans, particularly about women, are widely believed. In some cases, these misconceptions are the result of too narrow a focus of study. When historians assumed that the Renaissance meant the same things in the lives of women and of men, they failed to ask the questions that would prove otherwise. Although they noted that upper-class men became more dependent politically on their princes, they failed to see how upper-class women lost not only the possibility for political power but also the power to achieve sexual or any

other kind of independence from their domestic roles. Anthropologists, writing about "Man the hunter" in the Paleolithic period, concluded that hunted animals provided the entire food supply for these ancient populations. Questions about what preagricultural women were doing led to the discovery that among some contemporary "hunting" societies, up to 80 percent of the diet consisted of vegetable foods gathered by women (Tanner, 1981).

Feminist research has uncovered a large number of misconceptions about women's bodies, mental capacities, activities, and achievements. This book will address many of these misconceptions and their implications for a better and broader understanding of human nature and society.

Old and New Processes of Inquiry

The discipline of women's studies searches to understand how these misconceptions in other disciplines came about, how they affect these disciplines today, and how we might improve processes of inquiry to approach the truth more accurately. The historian who wishes to understand why we know so little about women's activities during a particular period might observe that only a limited set of written documents were used to study that time and place, primarily those relating to "public" events or leaders. This historian might then look for other kinds of sources—such as those dealing with local and family records. These records add new kinds of information and also yield new insights into the previously used materials. The economist who asks how women contributed to development in an emerging African nation might observe that calculations of the Gross National Product were based on men's wage labor and ignored unpaid agricultural production largely done by women. To find out what that production was, the economist might have to develop new means of collecting data and new types of analysis. She or he might decide that it is necessary to reexamine certain basic concepts such as "work" (should it be defined in terms of wages?) and "production" (should it be defined in terms of markets?), as well as to reexamine the whole notion of how an economy functions, thus challenging established assumptions.

Women's studies may begin with questions about women, but it leads to many other questions about men and societies and about the methods we use to find out about them. In some cases, it is discovered that old research tools can serve new purposes; in other cases, it is found that new methods may be required. While the processes of inquiry are extremely diverse, women's studies provides a common basis for evaluating methodology. Do the results of inquiry conform with a realistic and justifiable view of what women are and what we do? Do they adequately take into account the possible differences between women and men and the ways these differences come into being? Are they based on accurate observations or on assumptions? If the latter, do the assumptions themselves have adequate grounds in reality, or do they reflect a self-serving ideological bias?

Knowledge of Men

Women's studies raises questions about all that we have been taught and all that we have learned. It has become increasingly clear that if women are not well understood, neither are men. Because female and male roles are intricately interwoven, a distorted perspective of one sex must of necessity involve a misunderstanding of the other. Just as social systems, based on beliefs about gender roles, perpetuate stereotypic female roles, so do they perpetuate stereotypic male roles. Just as these systems pressure women to conform to the "feminine" ideal, so do they pressure men to conform to the "masculine" ideal. This is not only detrimental to women but is a handicap to men. Women's studies will inevitably contribute to our knowledge about men. Women's liberation will, we believe, also stimulate the liberation of men.

Women's Studies: Issues And Goals

Like any academic discipline, women's studies has multiple goals and confronts many issues, although it may be more explicit than most disciplines about what it hopes to accomplish.

Ethnicity, Racism, Social Class, and Feminism

Individuals come to women's studies and feminism from a variety of cultural and social backgrounds. As members of different races, ethnic groups, economic classes, and age groups, we bring with us different interests and preoccupations which sometimes make it difficult to arrive at a consensus.

Those of us who were brought up as members of oppressed racial and ethnic groups and social classes may find it particularly difficult to see what we have in common with those whom we have learned to classify as members of privileged, dominant groups. Women and men alike may be viewed as undifferentiated "enemies," to be feared, hated, resisted. In order to attain some measure of self-esteem, we have learned to emphasize and positively express our differences and to value features which distinguish us as a group. We do not want to be "assimilated" according to the values of others, but rather insist on being accepted on our own terms.

Our identity as black, Jew, Chicana, Puerto Rican, Native American, Asian American, or member of a less privileged economic class depends on our consciousness of the history of our oppression by others. Freedom from racist, ethnic, or class oppression may rank highest among our priorities, and to focus attention on a division *within* our groups, between women and men, may seem to us a betrayal of our common cause. How can we concern ourselves with the problems of the women among our oppressors or even with our own experiences of sexism in our particular group when the men in our group daily suffer oppression from more privileged groups and classes? We may feel that our very survival depends upon unity within our group and

that our men cannot be blamed for conditions not of their own making. Perhaps when *these* conditions change, we argue, we can worry about the relations between the sexes. Right now, the quality of those relations is determined by the social position of our group as a whole.

Thus, black women may rightfully argue that relations with black men are shaped by racist job discrimination which denies black men full and equal employment opportunities. What can these relations have in common with relations between white women and men? Jewish women in Israel may argue that given a state of perpetual military siege, concern about women's equality must be deferred. While Native American women may have suffered oppression by a sexist society, sexism in and of itself seems a much lesser evil than genocide. The oppression of an entire economic class by those born into a privileged class may seem to some to be a greater injustice than sexism.

Those of us, then, who deal with day-to-day problems of enormous dimensions arising from racial, ethnic, and class oppression, may find it hard to focus on a form of oppression shared by others who do not suffer directly from these same problems. Nevertheless, we must understand that the various kinds of discrimination we experience in whatever group we belong to arise from some similar sources. Racism, sexism, and class oppression all assign people roles based on stereotypes, on supposed attributes perceived as inevitable and used to provide a rationalizaton for exploitation. Essentially, to fight against the one kind of discrimination is to aid the fight against the other kinds. Just as feminism in the nineteenth century arose along with the struggle against slavery and with an awareness of other exploited groups in society, so the twentieth-century women's movement has been part of the civil rights movement and is increasingly allied with more inclusive movements for social justice.

Women are divided not only by race and class but also by age and sexual orientation. Groups such as the Gray Panthers and gay activists have recently emerged to confront ageism and homophobia, respectively. They ask: To what extent does feminism direct itself to *our* concerns? The answer is that discriminatory stereotyping on the basis of perceived biological attributes or sexual preference is a major target of the feminist movement. Women who fight against any form of ageism, homophobia, racism, and class oppression also join to fight sexism as well.

Women who have been privileged in every respect except with regard to gender discrimination may need to work hard to become conscious of the double and triple burdens of those of our gender who have suffered other types of discrimination. And those of us who have been part of groups oppressed for reasons other than sexual discrimination may have to face the fact that sexism also exists in our own group. We should weigh whether we do not have a great deal to gain by making a common cause with all other women to fight sexism. We do not make light of these intellectual and practi-

cal hurdles; they are as much a matter of concern as our concern over sex/gender roles themselves. The reasons for making a common cause lie in practical as well as ideological concerns. Fighting discrimination against women in general—in the job market, in gaining education, in becoming trained professionals, and in leading dignified personal lives with a heightened self-esteem—cannot but help every woman, regardless of group or class affiliation. The more we identify the barriers women face in general, the clearer our different perspectives will become. We should then be able to understand better how to formulate feminist goals that address the concerns of all our sisters.

Like members of any other oppressed group taking a first step toward change, women begin by recognizing the characteristics that distinguish us as a group, in the view of outsiders and in our own view. We emphasize those distinctive characteristics of our group that we value and that we believe ought to be a source of pride. This emphasis on group distinctiveness and unity gives us the political and psychological strength we need to demand the right to be accepted on our own terms. While as women we may welcome the help of men who recognize the oppression we have suffered, we do not wish to depend on it or to compromise our own views of the truth to obtain it. In a context of practical politics, compromise may be appropriate. In a context of women's studies, it is not.

Women's Studies as an Academic Discipline

People in women's studies differ as to whether the new scholarship about women should be developed as a separate academic discipline or whether it should be integrated entirely within the established disciplines. The study of women as a specific focus emerged within the established academic disciplines. Individuals who received their training in a particular field such as literature, history, psychology, or philosophy became discontented with the existing knowledge, perspectives, and research methodologies regarding women and began to pursue the study of women within their disciplines. In this way, such specialties as the psychology of women, women's history, and women's literature emerged. Courses about women were first offered within these traditional disciplines, and most women's studies programs that have since emerged are staffed by people trained in these other disciplines. All this new scholarship provides a powerful impetus to create new theories and concepts that include women from a nonsexist perspective. For this reason, many people believe that the field of women's studies should be its *own* discipline, and not simply a focus on women integrated into the already existing disciplines.

For women's studies to grow as a discipline, more individuals will have to consider training in it directly, rather than in other disciplines with a special focus on the study of women. This will require universities to offer advanced

training in women's studies, a rare but slowly growing phenomenon. As in other disciplines, individuals in women's studies would also very likely specialize in some particular area of the study of women, as the field is too broad for anyone to be an "expert" in all its aspects.

Women's studies as a discipline allows scholars to draw information about women from all the other academic disciplines and to select from that scholarship whatever perspectives, information, and approaches are most useful to a particular question. There is no need to take into account the specific conceptual requirements of different disciplines. Women's studies can develop its own conceptual framework and build upon it new theories while engaging in research projects that will test, revise, and expand those theories. Actually, the study of women need not be confined to one approach. It can be part of established disciplines as well as a discipline on its own.

The study of women provides a basis for critical examination both of existing disciplines and of the existing social practices they study. Women's studies sharpens our awareness of the connections between ideas and behavior. Knowing the effects of ideas, institutions, and patterns of behavior on the place of women in society provides us with a basis for criticism in both moral and practical terms. It helps us to understand our past as well as to plan our future.

Women's Studies as a Source of Strength

One of the most important functions of women's studies as an academic discipline is to recover achievements by women in the past and to sustain the work women are now doing. Many isolated women in the past succeeded at extraordinary accomplishments that have been buried through lack of interest by those controlling intellectual life. Previous feminist ferment produced outstanding academic and cultural efforts that were then submerged by waves of reaction. Three examples of these losses recently recovered are Mary Beard's *Woman as a Force in History* (1946,1973), Elizabeth Cady Stanton's *Woman's Bible* (1895–1898, 1972), and Christine de Pizan's *Book of the City of Ladies* (1405,1982). We must ensure that the women's movement today remains strong and is not submerged again; the history of feminist gains followed by losses should serve as a warning of what can happen.

An institutional base for women's studies at as many universities and colleges as possible will help keep alive the work women have done and are now doing, even when such work is unwelcome in the wider society. But women's studies must have a broader base and a greater sphere of influence than the university. Independent centers for research on women, community-based women's organizations, lobbying in government circles, creation of a cadre of political backers, and similar activities are needed if women's studies is to survive. Similarly, women's studies needs to support these activities.

Women's studies also provides a basis for action in specific and practical

ways for the individual, both in college and later in life. While you are in college, women's studies courses expand your perspectives on what you are taught in other courses, providing you with a basis for evaluating what you are taught and for relating such knowledge in a meaningful way to your lives.

Whatever our major fields of interest in school, most of us will use our education in the nonacademic world. What you learn from women's studies may help you to make better decisions about how to live and work and vote and express yourself. Women's studies gives us an increased awareness of ourselves (women and men) which may help us to understand our personal pasts and futures. These personal issues—such as choosing a career, making decisions about human relationships, and planning our futures—touch us all in one way or another. Women's studies is not a "how-to" course, but it does bring the issues and implications of our personal decisions into sharper focus.

How This Book Presents Women's Studies

The field of women's studies is so new it has no traditional subgroupings, no standard way of presenting materials, not even a general agreement about its definition. In this book, we have tried to present the discipline as we see it, in the process of defining itself. As far as possible, we have avoided disciplinary boundaries in order to focus on our subject, women, as human beings.

We begin with a focus on women as individuals, on the "self," and explore ways in which women have been defined and have defined ourselves. We then move to women in the family and, lastly, to women in society. The order could be reversed; indeed, many may prefer to view it that way. We have visualized the subject matter as three concentric circles. Moving from the self outward, we have sought to suggest that what occurs in each circle has inevitable reverberations through the others.

While we feel we have been largely successful in marshaling and integrating information from a range of diverse fields, we are concerned that we have achieved less than we sought in another goal—providing a sense of the real diversity of women. Women are not one group of people with common backgrounds, experiences, and perspectives. Even those of us who live in cities and those who live in rural areas will have very different things to say about our heritages, experiences, and thoughts. However, there is much more information on white, middle-class women and on women in the majority classes of the more industrialized countries than on minority women and women from Third World nations. As women's studies has grown, literature by and about the latter women has begun to appear, and we anticipate that we will witness a striking increase in such work.

One last word about the approach of this book. It must be apparent by now that when we authors write about women, we use the pronouns *we* and *our*. We discuss the decision in detail in the preface and refer the reader to it,

but some attention to this technique seems appropriate here. In using *we* when referring to women, we the authors do not intend to imply that we speak for all women; indeed, we are very much aware of the diversity among women. We know that we may be accused of a cultural ego/ethnocentricity, just as we have accused men who, using the generic *he,* claim to speak for women as well as men. There is a considered point of view behind our use of *we,* and our commitment to that point of view has made us willing to take the risks inherent in employing this technique.

First, our use of *we* is an attempt to make a statement about previous writing about women. Historically, women have been written *about;* they have been presented as passive objects in all forms of communication. The use of *we* and *our* is an attempt to place women before the reader as the subjects, the actors. Our second goal is to try, through this technique, to instill in the reader a sense of camaraderie with all women and identification with women's realities and women's choices in every setting and every age. Such identification, across our differences—real as they are—is the meaning to us of sisterhood. Doris Lessing refers to such a concept in her novel *Shikasta.* "This supply of finer air had a name. It was called SOWF—the substance-of-we-feeling. . . . The little trickle of SOWF that reached this place was the most precious thing they had" (Lessing, 1979:73).

We authors are aware that the reader may find this usage jarring. We hope that the reader's sense of differentness that results will provoke thought about this matter. We are aware of the danger that many readers may even feel excluded when they first read *we* in reference to a group of women—for example, older women or women of the past or another culture—with whom they do not identify. Our purpose is that the reader then think about the factors which account for such differences of experience and consider what all women have in common. By the end of this book, the reader may find it possible to come closer to identifying with all women and may perhaps have breathed a "little trickle of SOWF."

Summary

Women's studies examines the world and those who inhabit it in the light of women's own experiences of that world. It complements and corrects established disciplines as well as constituting a discipline of its own.

Feminism is based on the high valuation of women as human beings and rejects the assignment of roles based on gender. Women's studies is the academic manifestation of feminism. It receives support from feminists and arms us with knowledge. Women's studies has grown on American college campuses since the late 1960s. It marshals new feminist scholarship from various disciplines and builds on it to create new concepts and theories. Much of this work is done as a collective effort.

Women's studies programs are necessary because they fill in missing information about women in history and correct misconceptions about women's bodies, mental capacities, activities, and achievements. In the process of doing so, women's studies is developing new lines of inquiry that focus on women and our views. Women's studies is also adding to our knowledge of men.

Women's studies serves as an academic discipline that can keep alive the past and present work of women. It is a source of strength for the women's movement and a basis for action to bring about social change and individual development.

Women come from all kinds of cultural and social backgrounds. Many women in oppressed groups tend to find more in common with other members of their group (including men) than with women in general. But the women's movement is concerned with oppression from all sources. To understand and fight for the liberation of women is to aid the fight against all oppression.

References

Beard, Mary R. *Women as Force in History: A Study in Traditions and Realities.* 1946. Reprint. New York: Collier, 1973.

Beauvoir, Simone de. *The Second Sex.* 1949. Translated by H.M. Parshley. New York: Knopf, 1953.

Kelly [Kelly-Godol], Joan. "Did Women Have a Renaissance?" In *Becoming Visible: Women in European History,* edited by Renate Bridenthal and Claudia Koonz. Boston: Houghton Mifflin, 1977.

Lessing, Doris. *Shikasta.* New York: Knopf, 1979.

Pizan, Christine de. *The Book of the City of Ladies.* 1405. Translated by Earl Jeffrey Richards. New York: Persea, 1982.

Slocum, Sally. "Woman the Gatherer: Male Bias in Anthropology." In *Toward an Anthropology of Women,* edited by Rayna R. Reiter. New York: Monthly Review Press, 1975.

Stanton, Elizabeth Cady. *The Woman's Bible.* 1895–1898. Reprint. New York: Arno Press, 1972.

Tanner, Nancy M. *On Becoming Human.* New York: Cambridge University Press, 1981.

1
Defining Women

Introduction

What is a woman? What makes her what she is? Think about these questions. They are not simple. An appropriate response would be "Which woman?" We are all different. Yet if we are to study women, we must have some definition of the group of people we are studying. What is it about women that allows us to group ourselves together and refer to women's studies as a discipline?

The most common definition of "woman," one that is generally viewed as incontestable, comes from the biological sciences: women are that group of the human species whose members are able to conceive, carry a fetus, give birth, and lactate. Is that an acceptable definition of woman? Certainly women are much more than two ovaries, a couple of tubes, a uterus, a vagina, and two breasts. We are whole and complex persons, not merely "walking wombs."

Attempts to define "woman" are not new, and recorded history reveals a range of opinions on this theme. People trained in a variety of areas of knowledge have ventured forth with definitions of what women are and how we came to be that. A review of the professional literature on women conjures up a picture of a woman encircled by disciplines, each one of which reaches into the center of the circle and slices out a different part of the woman—mind, soul, body, emotion, behavior. We are left without a sense of "woman" as a whole.

Many of the different disciplines do, however, have basic similarities. Psychology, for example, has roots in philosophy as well as physiology. Anthropologists frequently employ psychological theories to explain their findings. Researchers often study the effects of biology on behavior and emotions as well as the way in which psychological processes act on the body. The symbols and images that appear in literature and the arts reappear in diverse fields. In addition, conclusions from one discipline affect the thinking and approaches to study of another. In this way, we see many overlapping premises and perspectives. The problem with this is that much information is gathered and many theories are built on common misconceptions and biases. This is especially true in the case of women.

Where do these underlying assumptions come from? They come from the beliefs, teachings, and experiences of the people who contribute to the disciplines. These individuals generally come from similar educational backgrounds infused with a history of attitudes and beliefs about women. Their conclusions are frequently generalized to women who never have themselves been studied. What is more, all these disciplines are dominated by men. In all cultures, men's

experiences differ from women's, yet it is nearly always men who define women. As a result, women learn to see ourselves through men's definitions.

The definition of women as "baby makers" is almost universal. That women have the babies is hardly debatable. What are questionable are the conclusions drawn from this biological fact, such as that what women are and do must be shaped by our reproductive roles. Women have the babies and lactate; therefore, it has been thought, it is natural for us to be the caretakers, and for our entire lives to be determined by this. Gender roles, the roles which society prescribes for women and men, are based on definitions. Definitions are used as explanations. In just such a way, a cycle of faulty reasoning evolves.

Women need not read the professional literature to know how we have been defined. Definitions are communicated in direct as well as subtle ways in all cultures. They are communicated in social roles; in myths, rituals, and folklore; in the symbols of a culture; and in the language used to express ideas. Inevitably, those described are pressured to fit the symbols and definitions used to describe them, thereby lending support to the original definitions.

The attitude, however subtle, that permeates definitions of women is the view of woman as "the other." Thus, women have been defined as "not men." This is evident in the emphasis in research on the differences between women and men. In this way, women have been defined by comparison: *more* frivolous, *less* rational, *closer* to nature, or *more* nurturing, for example. Women have been defined by our endocrine and reproductive systems—that which makes us *different* from men. Men have been viewed as the norm, and women as a deviation from that norm. What is identified as "male" has been viewed as "ideal," and thus "male" characteristics have been highly valued. By comparison, women's characteristics have been devalued because we have been viewed as defective or incomplete males, less than "ideal," and even less than human.

The consequences of such definitions of women affect our daily lives. They undergird the legal system we live in and the public policy that affects our control over our bodies in matters of contraception and abortion, and they shape our society's approaches to women's physical and mental health and occupational opportunities. They mold our self-esteem from childhood to old age. What is more, the act of defining what a woman is also tells women what they *should* be. In the process of socialization, these definitions of woman communicate to us what we should aspire to. In this way, definitions also provide a framework within which to censor women who do not, or will not, conform to them.

What are clearly missing are women's self-definitions. As feminists increasingly move into the various disciplines of study, we are questioning underlying assumptions and definitions in our fields, proposing new questions and methods of research, and offering alternative interpretations of findings. We are revealing the faulty logic of previous thought and explanations. Women's studies as a discipline is not constrained by the narrower focus of other disciplines. It can study women as whole people. Utilizing the new insights of feminists in other disciplines, women's studies provides an integrated picture of the lives and experiences of women.

The chapters in Part I look at the ways in which the question "What is a woman?" has been answered. They take a critical look at these definitions and analyze their implications and consequences for women and men. The chapters also address the ways in which women have defined ourselves throughout the years, the changes that have occurred, the rebellious voices raised, and the new directions we are pursuing.

One might ask whether it is helpful to rehearse past definitions of women. It is our belief that these traditional perspectives on women are very much a part of our heritage and are inseparable from the lives women have led. An understanding of what has existed can help women clarify where we want to go.

1
Imagery and Symbolism
in the Definition of Women

THE MEANING OF IMAGERY AND SYMBOLISM
Experience, Perception, and the Symbolic Construction of Reality
 Classification and Perception
 The Shaping of Reality
The Function of Images and Symbols
The Social Context of Image Construction
 Presentation of Self
The Use of Symbols and Their Influence
 Language
 Myths, Fantasies, and Artifice

SOME PREDOMINANT IMAGERY
Frightening Females
Venerated Madonnas
Sex Objects
Earth Mothers
Woman as "Misbegotten Man"

THE EFFECT OF THE IMAGES ON WOMEN

CHANGING REALITY BY CHANGING IMAGES
Changes in Appearance and Conduct
 Clothing
 Etiquette
Participating in Imagery Construction: An Example

WOMEN DEFINE OURSELVES
Women's Search for Self through Art
 A Historical Perspective
 Contemporary Feminist Imagery
Women's Search for Self through Literature
 Discovering Models in Women's Culture
 The Heroine
 Women's Words
 Women's Identity in Utopia
The Propagation of Feminist Imagery

CONCLUSIONS: BEING WHOLE

No man would consent to be a woman, but every man wants women to exist. "Thank God for having created woman." "Nature is good since she has given women to men."

<div align="right">SIMONE DE BEAUVOIR</div>

The Meaning of Imagery and Symbolism

Experience, Perception, and the Symbolic Construction of Reality
Classification and Perception. If we were suddenly transported to another world, where none of the objects, smells, sounds, colors, or any sensations were anything like what they are on earth, we would feel greatly confused. Our senses might be open to everything, but we would have difficulty knowing what we were experiencing. Until we had learned to classify what we sensed, we would have no clear perception of this strange world. What we perceive is dependent on the way we order our experience. We select certain characteristics and say that they typify an object; other characteristics are dismissed as unimportant and erased from our consciousness. The ordering that we do in our minds structures our experience for us and renders it intelligible. Without some order, there is no meaning.

We are all born with a capacity to organize our perceptions, but we must learn the categories we will use to classify them. In our first years of life, we learn from people around us distinctions that have meaning within our own cultural settings. We learn to distinguish colors such as green from yellow, objects which are food from those which are "not to eat," and things which are for girls from things which are for boys. Soon we take the meanings of our classificatory system so much for granted that we cease to question. We believe that we are perceiving "reality" even though, to a large extent, we are seeing only our culture's interpretation of it.

When we need to teach a child or a stranger the distinctions meaningful to us, we see how arbitrary they are. A little boy needs to be taught that he cannot wear silk panties or ruffled dresses. These are arbitrarily classified as "feminine," although there is nothing intrinsically feminine about fine material or personal adornment. Through distinctions such as these, children quickly learn to identify gender by clothing. An American child might easily be confused by the dress of a Scottish bagpiper or a traditional Arab chieftain.

23

In organizing our experience, we make use of *symbols* to give meaning to our perceptions. A symbol, such as a word, a color, or an object, is used arbitrarily to represent something else. Paper money is a cultural or public symbol, a representation widely understood and agreed upon by members of our society. There can be private symbols as well, representations that individuals make to themselves in their own dreams and fantasies.

Our perceptions of women and men are shaped by our symbolic constructs of "femininity" and "masculinity." We select very particular features of personality and physical shape to focus on and to emphasize while we ignore others. We reinterpret what we see according to these preconceptions about what is important. The symbols we allow to represent "feminine" and "masculine" are quite arbitrary. For example, we may designate long hair as a feminine characteristic, but both sexes can (and do) wear long hair. In any culture, the social construct of "femininity," dependent as it is on symbols, is artificial.

An *image* is an idea or picture formed in the mind. It may be composed of symbols, or it may serve as a symbol itself. The Statue of Liberty is an image formed out of symbols representing womanhood, light, and strength; as a symbol itself it represents liberty, welcome, security—and also the United States, particularly New York City. Imagery is a medium of expression which depends on the symbolic association of the perceiver.

The Shaping of Reality. Not only do we interpret and construct the reality of the external world through the application of names and symbols, but the same names and symbols gradually construct us. Consider the way we look. In places where most people have an image of women as persons who wear makeup, jewelry, and skirts, women who are eager to be perceived as "feminine" do indeed wear makeup, jewelry, and skirts. Social constructs also influence more profound matters of conduct, personality, and intellect. To conform to a cultural representation of femininity, we may think of ourselves as being—and act as though we were—physically weak, incapable of understanding mathematics, and preoccupied with getting married and having babies. Furthermore, such constructs govern the behavior of others toward the individual in such a way as to reinforce the actuality of the image. If women are assumed to be incapable of learning mathematics, we will not be taught mathematics; hence we will indeed be incapable of doing mathematics.

As children, we learn to view ourselves and to behave according to others' perceptions and expectations of us. Cultures vary widely in their attribution of characteristics to childhood and adulthood, femininity and masculinity. In some cultures, women are thought to be naturally strong and hardy while in others, we are thought to be delicate and weak. Little girls in the former will probably come to see themselves as strong. Little girls in the latter will probably come to see themselves as weak.

Thus, we live in a world doubly shaped by mental constructions. We perceive "reality" in terms of the categories we have learned to impose on it, and we actively shape ourselves and others to conform to the images we have created. We learn to classify objects and to combine symbols into imagery in subtle, inexplicit ways, so that we are not even aware of how we learned what we learned. Understandings about the meanings of symbols are conveyed through language, through art and literature, through popular media and folklore. This chapter is about these symbolic media, the images they convey about women, and the significance of their representations for women's behavior and ideas about ourselves.

It is important to remember that to the extent that symbolic expression, through whatever medium, is dominated by one segment of society, the imagery conveyed is that group's imagery. If men, not women, are the artists, then the image of women depicted in painting and sculpture will be men's images; women's images of ourselves will not be conveyed either to men or to ourselves. If women have access to the products of this creativity as "consumers"—if, for example, we read but we do not write—then the perceptions of women who read this literature will be shaped by this one-sided view of reality. In the history of the world's best-documented civilizations, men have indeed predominated as creators of symbolic expressions. This results in an imbalance, a lack of reciprocity: men have been the providers of images and women and men have been the recipients.

The Function of Images and Symbols

The images built out of our symbol-controlled perceptions are usually grouped into categories and classified in different ways depending on our immediate purposes. Different sorts of purposes will result in classification of the same objects in different ways. We may have three articles of clothing: a pink sweater with a ruffle, a bikini, and swimming trunks. We may classify the two bathing suits together if we are interested in function, but we may classify the sweater and the bikini together if we are interested in the gender of the wearer.

How does this apply to classification of people? For some purposes, Aristotle (384–322 B.C.) classified women and children together. Since he believed that neither had fully developed rationality, he concluded that the male should rule both females and children and be responsible for them. This attitude, pervasive in Aristotle's time and culture, was reflected in a social system where women and children were excluded from public life. In modern America, we often find similar attitudes.

How is this type of classification represented symbolically? A "feminine" woman may affect childish mannerisms such as baby talk. Womanhood may be idealized as essentially childlike and associated with innocence, unworldliness, and vulnerability; the "ideal" woman portrayed in a novel or play may be vested with these characteristics. Thus, the cultural classifica-

tion of women and children together, in opposition to men, is represented in a variety of symbolic images, some contributed by men, but some contributed by women as we create ourselves to fit the classificatory system that exists.

The Social Context of Image Construction

We do not construct our images in a vacuum. Our social context has a great deal to do with the perspectives from which we observe the world. Every society differentiates at least some subgroups according to age and sex, and the more complex societies provide a variety of other groupings by class, ethnicity, and other factors. Our positions in these groupings help determine the way we see ourselves and others.

Of particular importance for social image construction are age, social class, ethnicity, sex, and sexual preference. A woman who is a mother may be seen by her son one way, her daughter another way, and her husband a third way, and she may see herself in yet a fourth way. The view of each of her perceivers will depend on her interactions with them, their own experiences, and their own needs. A little child might see her mother as powerful, important, and beautiful; but when she becomes a teenager, she may view her mother as overbearing, incompetent, ignorant, and frumpy. A wealthy woman might see a woman on welfare as lazy, weak, and pathetic; another woman on welfare might see her as strong, patient, and responsible. The wealthy woman's image of the poor woman meets her need to rationalize a social order which is favorable to her but not favorable to those without wealth. This kind of rationalization may be used in any situation of social inequality. Since women and men are unequal in social power, men's images of women are constructed so as to rationalize men's dominant position.

Presentation of Self. In order to get the desired response from others, we may feel obliged to shape ourselves according to their expectations. For example, one conveys a competent and businesslike image to a supervisor at work by wearing a suit rather than a party dress or overalls. We all offer certain gestures to others to get a response from them.

Humans are not unique in this kind of behavior. All social animals have a repertoire of gestures that they use to evoke desired responses. In a confrontation between two animals, the weaker of the two may assume a particular behavior that announces its willingness to concede. These disarming devices can be understood as useful defensive adaptations to inferior strength; they enable the weak to survive in an unequal world. Similarly, humans employ a variety of physical signals which say: I am weak, I am harmless, don't attack me, protect me instead. Lowering the eyes, smiling, and offering one's self as a subordinate sex object are all examples of these signals. People often convey such messages unconsciously and automatically. When we examine

and think about these gestures, however, we may find that they are habits which we do not need, or which do not really serve us well.

The Use of Symbols and Their Influence

A woman does not need to be told explicitly that women are separate from and considered unequal to men. We learn this in many different ways, through various symbolic media including language, myths, fantasies, and artifice.

Language. The language that women use to think and talk with contains the message of inequality in many forms. We learn that *man* means people and that *he* is the standard singular pronoun. One "masters" material; one does not "mistress" it. "Patrons" support artists; "matrons" serve as custodians in prisons. *Patronage* describes the condescending help the wealthy or important person offers the poor or less influential one. *Matronage* has not been a word at all until recently, when some feminists have begun to use it in support of women's causes.

These verbal matters are not frivolous and insignificant. This use of language teaches the young girl that men are the doers and women are valued mainly for our looks and our amenability. When there are only postmen and firemen and spokesmen, the young girl may assume that only men "man" these posts. (In the new language that feminists are forming, the word *staff* will serve for *man* in this context.) *Effeminate* is always a "bad" word meaning weak, flaccid, irresolute. *Feminine* is a "nice" word as applied to women, but applied to anything else it is likely to be uncomplimentary. Language has always expressed a people's cultural biases, whatever they are; sexism is only one of them. In other ways, for example, our language is phallocentric. Consider how metaphors reflect a male-centered view of the world in the way that they reflect the close linkage implied between the male sex and machines. Wanting to provide "input," a male "plugs into" a conversation to get its "thrust" and to "penetrate" the problem. Or consider how ideas are referred to as "seminal," not "germinal."

Myths, Fantasies, and Artifice. More insidious perhaps than the spoken word, because their messages are subliminal, are myths and fantasies. The story of Adam and Eve, an origin myth for Jews, Muslims, and Christians, begins with the creation of man by God "in his own image." Here we learn that man came first and that God is like man (because man is like God.) Eve was made as a companion to Adam and constructed from his rib. This tells us that women are subordinate to men in that we are made from them (but not the reverse), and that we exist to serve men's needs. The next event in the creation myth is that Eve, succumbing to temptation, leads Adam into sin. From this we learn that women are morally weak and that our weakness

leads men into trouble. In this case, the trouble is great; Adam and Eve are expelled from paradise and are cursed. The curse itself is interesting: Adam's curse is that he shall have to work for a living, and Eve's is that she shall bear children in pain. This suggests that it is men, not women, who engage in productive labor, and further that it is right and proper that childbirth be painful (see chapter 10).

Cultural imagery, largely originating in men's minds, expresses ideas about women and our roles. The messages conveyed are complex; there may be contradictions and multiple aspects and many levels of communication. The symbolic devices themselves constitute the creative content of culture: literature (spoken and written), sculpture and painting, ritual, dance, drama, clothing, and other ways that humans use their imagination to express their ideas.

Some Predominant Imagery

Various art forms in different cultures and different historical periods have expressed certain basic ideas of women in similar ways. We will now take a look at some of the ways that women have been represented through symbolic constructs by examining five themes which commonly appear in many cultures around the world—frightening females, venerated madonnas, sex objects, earth mothers, and "misbegotten men." These themes may not be universal, but they are also not confined to any type of culture or geographical region. And although the messages conveyed are not necessarily consistent, contradiction itself makes a statement, as we shall see later in this chapter.

Frightening Females

Men's fear of women is expressed in a vast number of different symbolic modes. Rituals and beliefs suggesting that women's anatomical parts or physiological processes are polluting have been found to be extremely widespread. Women in many cultures are secluded during and after childbirth and during menstruation, after which we must undergo a purification ritual lest we contaminate men. In some cultures, men are prohibited from sexual intercourse with women prior to engaging in religious rituals or warfare. Many religions prohibit the participation of women in the most sacred ceremonies and even forbid our witnessing these rituals; we are not to touch or see the most sacred ritual objects, or we will pollute them. Such practices may all be interpreted as expressing fear of women.

Folk tales present a more direct image of women as fearsome objects. Witches, sorceresses, and other semisupernatural figures able to transform men by spells are frequently females. Sometimes these threatening figures are deceptively beautiful, but often they are old and ugly. In the Western heritage of fairy tales, the wicked stepmother has no male counterpart; she is the

Woman as Fiction—Woman as Reality Box 1.1

Have you any notion how many books are written about women in the course of one year? Have you any notion how many are written by men? Are you aware that you are, perhaps, the most discussed animal in the universe? . . . Indeed, if woman had no existence save in the fiction written by men, one would imagine her a person of the utmost importance; very various; heroic and mean; splendid and sordid; infinitely beautiful and hideous in the extreme; as great as man, some think even greater. But this is woman in fiction. . . .

A very queer, composite being thus emerges. Imaginatively she is of the highest importance; practically she is completely insignificant. She pervades poetry from cover to cover; she is all but absent from history. . . . Some of the most inspired words, some of the most profound thoughts in literature fall from her lips; in real life she could hardly read, could scarcely spell, and was the property of her husband.

It was certainly an odd monster that one made up by reading the historians first and the poets afterwards—a worm winged like an eagle; the spirit of life and beauty in a kitchen chopping up suet. But these monsters, however amusing to the imagination, have no existence in fact.
 (Woolf, 1929, 1957:26, 45–46)

Copyright 1929 by Harcourt Brace Jovanovich, Inc. Renewed 1957 by Leonard Woolf. Reprinted by permission of the publisher.

embodiment of evil—selfish, powerful, and dangerous to men and children alike.

Female deities and mythical women are also often portrayed as evil, dangerous, and powerful. The Hindu goddess Kali is the very powerful, supernatural agent of destruction. In Greek mythology, numerous female monsters threaten men: Scylla squeezes men's bones together and eats them, while Charybdis, the whirlpool, draws men into her watery depths.

These cultural expressions of men's fear of women have inspired numerous explanatory treatises. Psychohistorical arguments rest on Freudian analysis, which begins with early childhood conflicts that become projected in fantasies. Sociologist Philip Slater (1968) argues that the close, stifling relationship of mothers and sons in ancient Greece accounts for the terrifying females of Greek mythology. He claims that mothers, confined to the women's quarters, vented their baffled energies on their small and defenseless sons, whose understandable fears were the basis for the bloodthirsty female figures of myth they grew up to write about.

Some nineteenth-century social thinkers, such as Johann Jacob Bachofen, author of *Mother Right* (1967), as well as a few contemporary feminists, have argued that myths representing female figures as powerful and domi-

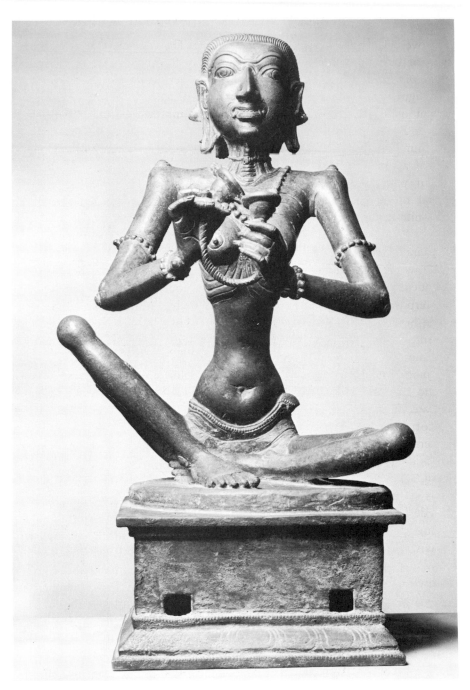

The Hindu Goddess Kali portrays woman as monster. This goddess is assigned the attributes of death and destruction, and is usually depicted with four arms, red palms and eyes, and blood-stained tongue, face, and breasts; her hair is matted with blood, her eyes are crossed, and she has fang teeth. She sometimes wears strings of skulls around her neck, while her earrings resemble corpses. Sometimes her waist is depicted as girdled by snakes. (Nelson Gallery–Atkins Museum, Kansas City, Missouri [Nelson Fund])

nant over men have a historical explanation. They believe that at an earlier stage of human history, women ruled. This form of social organization, called *matriarchy*, was later overthrown by men. Awesome, uncivilized female figures are interpreted, in this argument, as representative of a more ancient order, threatening to patriarchy, the more recent rule of men (see chapter 5).

A number of anthropologists have sought the explanation for men's fear of women in social conditions (Ember, 1978). Some conclude that fear of women is greatest where women are most oppressed. Expression of fear of women may or may not be universal; it is certainly variable in its manifestation.

Venerated Madonnas

While women are perhaps most widely portrayed as objects of fear, we are also idealized as objects of love and veneration. The wicked witch has a counterpart in the fairy godmother; the destructive goddess has a counterpart in the heavenly madonna. Woman in this guise is self-sacrificing, pure, and content. Her job is to make men (and children) feel happy and successful. This message is conveyed in sex manuals and child-rearing manuals alike. The madonna construct is fascinatingly unbiological; she has no blemishes and no body functions. One imagines that she does not menstruate, urinate, defecate, or even perspire.

Incorporated in the image of the Virgin Mary, the madonna has existed in Western culture for centuries: she is the young, beautiful, and pure woman who is at once mother and virgin, source of comfort and support, fulfilled in giving, submerged in the male figures who make use of her (God and Jesus). She is symbolically represented as the new Eve, whose obedience and humility redeemed "mankind" from the curse the first Eve brought upon "him." Through her perpetual virginity, she serves as a symbol of the "good" woman. Through her maternal nature, she nourishes and comforts her offspring in this vale of tears.

How do we account for this image, the converse of the frightening witch? The warm and nurturing relationships small children can enjoy with their mothers may provide the basis for the mythical madonna figures. But madonnalike images do not predominate where women are more equal to men; rather, they sometimes seem to accompany the fearsome images as foil or counterpart in situations of inequality (Cornelison, 1976:27; Wolf, 1968:42, 296, 299). They may be understood not only as idealizations but as wish fulfillments, women defanged and declawed, women now sanctified for our compliance with men's wishes. The "good" woman, stripped of her dangerous elements, desires nothing, demands nothing, and receives worship, not equality.

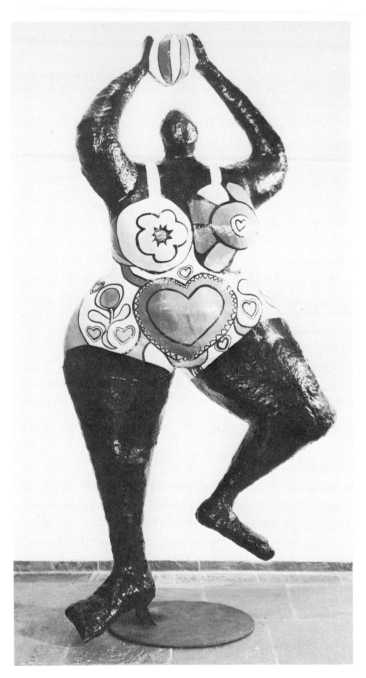

"Black Venus" (1967) by Niki de Saint-Phalle (b. 1930) demonstrates how a woman artist has taken the imagery of a powerful female figure and mixed it with traditional symbols of femininity—hearts and flowers—to create a figure whose litheness, power, and sheer muscularity no longer signify an overpowering monster, but woman independent, woman autonomous, woman joyous, woman at play. (Painted polyester, 110×35×24 inches. Collection of Whitney Museum of American Art. Gift of the Howard and Jean Lipman Foundation, Inc.)

Sex Objects

Images of women as witches or madonnas leave out an inescapable fact. The first image suggests that sexual relations with women are dangerous to men; the second suggests that sexual relations are unnecessary. But sexual relations with women obviously occur, and without them men cannot have children. The idea of woman as sex object focuses on male sexual gratification (box 1.2). Images of women as sex objects are affected, however, by other notions about women. If we are perceived as dangerous, then before we can be sexually attractive, our dangers must be overcome. If "good" women are pure and asexual, then the objects of sexual desire and release must be invented as "bad," impure.

Pornography, which attempts to reduce human beings to sexual objects, manipulates images of women to appeal to male fantasies. While the non-erotic witch-woman may consume men (the vagina is sometimes imagined to have teeth), the erotic sex object offers herself to be "eaten." She is displayed as merchandise and popularly called "sugar," "honey," "dish," "peach," "tomato." She may be reduced to a bodily part and called "cunt" or "pussy." If her bodily parts are perceived as threatening, they may be rendered more harmless by being portrayed as childlike. Juvenile pinups, deprived of threatening adult characteristics, make the sex object appear more accessible, more harmless. She may be referred to by the name of small animals such as "chick" or "bunny." If she is perceived as being too pure to be accessible, her breasts and buttocks may be exaggerated. The adult female may be depicted as bound and thus rendered helpless. Or she may be portrayed as the irresistible seductress. "Hard" pornography does not confine itself to binding women but displays scenes of mutilation; breasts are sliced off, throats bleed, and genitals are penetrated with broken glass. Vulnerable women, debased, in chains, and totally available to male penetration, constitute the fantasy of hard pornography.

Although the imagery of pornography may exist purely for male fantasy, real women are encouraged (or even obliged) to reform our own bodies to conform to male erotic expectations. Bindings that miniaturized the feet, deforming neck rings, and excessively tight corsets have all been endured by women in the name of sexual attractiveness. Women are encouraged to bind or elevate their breasts in response to the dictates of male fantasies. In recent years in the Western world, the emphasis on large breasts has led women to use an array of subterfuges ranging from padded brassieres to silicone injections. Throughout history, various extremes of physical restraint of the female body have not been limited to erotic art or pornography.

Earth Mothers

If the depiction of women as sex objects depends largely on cultural artifice, the counterpart, the earth mother, is seen as embodying what is "natural."

The Masculine Mystique Box 1.2

Instead of yielding to the affective self, as implied by sensuality, the
warrior hero must fight another battle, treating sex as war (between the
sexes), making conquests, gaining victories. Even the contemporary vision
of the sexual expert is more a matter of a "job-well-done" than shared
delight.

. . . The official macho attitude requires that women, in their delicacy,
dependence, timidity, gullibility, and softness, are to be used and enjoyed,
like a peach plucked ripe from a tree and discarded just as easily. A young
man told me that his father advised him to practice the four f's: "Find
'em, feel 'em, fuck 'em, and forget 'em." Contempt blossoms into hatred:
women are stupid, dangerous, wheedling. The only exceptions are those
who cannot be contemplated as sexual partners—mothers and sisters, for
example, or nuns. (Ruth, 1980:47, 49)

Sherry Ortner (1974), an anthropologist, sees the universal devaluation of
women as related directly to the symbolic association of women and "na-
ture." Her argument runs as follows: Every culture controls and transforms
nature by means of symbols and artifacts. "Culture" is equated with human
consciousness and its products (thought and technology), which humans use
to control "nature." Culture is superior to nature, for it can transform nature
according to its needs or wishes. Women have been associated with "nature"
and men with "culture"; hence, women are seen as inferior to men, and able
to be controlled by them.

Women are not entirely identified with nature, but are held to be closer to
it than men. There are three reasons for this position: (1) Because women
also participate in culture, we are considered intermediate between culture
and nature. However, what is distinctive about women's physiology is con-
nected with our reproductive role, and our bodily involvement with repro-
duction is greater than men's. Thus, we are seen as more a part of nature
than are men. (2) Because women nurture infants and children, we are asso-
ciated with children, who have not yet acquired culture (and are therefore
closer to nature). Again, however, women are intermediate between culture
and nature because our role is to socialize children, that is, to transform
"natural" humans into "cultural" ones. Women who care for children are
kept closer to domestic cycles, hence to the "natural" family, than men, who
circulate in the more artificial "cultural" settings of society beyond the
family. (3) Woman's psyche is thought to be closer to nature. Women deal
more with what is concrete, while men deal more with what is abstract. This
results from the difference between the ways females and males are socialized
by their mothers (Ortner, 1974).

Women are thus seen as being closer to nature than men and we are

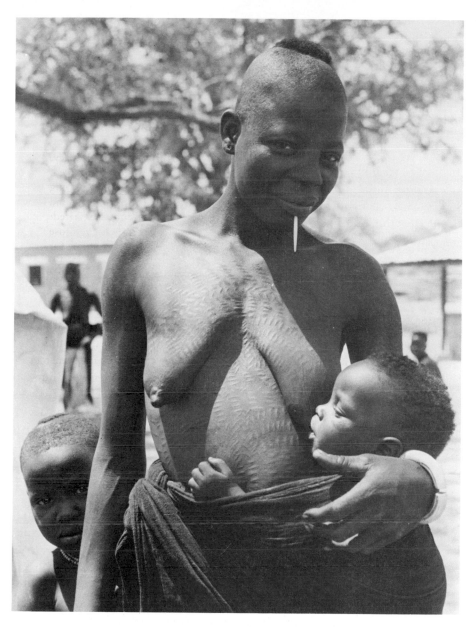

A Kambari woman with her child in northern Nigeria. The scarification across her chest and the ivory pick hanging from her lower lip are examples (like traditional Chinese footbinding) of the ways in which cultures require women to submit to physical discomfort as a badge of gender. (United Nations)

accordingly consigned to lower status. Men have culturally manipulated their ideas about women in order to clarify their own position with regard to controlling nature. The representations of women in cultural imagery—mythology, art forms, ritual, and so forth—are affected by the relations between men, culture, and nature.

Woman as "Misbegotten Man"

In all the foregoing cultural constructs of femininity, women remain a distinctive and formidable presence, but in this construct, we very nearly disappear. In the male-centered conceptual world, man is the toolmaker, the doer of deeds, the thinking being. Women who engage in these activities are "like men." Women of ambition who succeed in training our intellects, despite all the obstacles, are said to "think like men."

The subsuming of women under the category "man" that has taken place in the conceptions prevalent in much theorizing has led to the virtual disappearance of women from conscious thought. When Artistotle proclaimed man a "political" (i.e., civilized) animal, he certainly did not mean to include women. The "brotherhood of man" is not a sisterhood. When anthropologists refer to "Man the hunter" or literary scholars refer to "man the hero," it is hard to believe they mean to include women in those categories. In many respects, this systematic ignoring of women as full human beings expresses the image of woman as part of nature. Yet this final image more emphatically denies women a place in culture. We are no longer threats, saints, sex objects, or earth mothers; we just are not there.

The Effect of the Images on Women

It would be a mistake to assume that any one image of the female is predominant in a society or at a particular time; in fact, the apparently contradictory images are different expressions of the same idea: woman as "other," the anomalous being who is both like and unlike man. As anthropologist Claude Lévi-Strauss (1964) argues, a myth cannot be understood in isolation from the full repertoire of the mythology of a society.

The message that the imagery of women conveys lies not only in its content (woman is dangerous, woman is natural) but also in its form, the oppositions of extreme elements: good *versus* evil, natural *versus* artificial. All these images serve to set us apart as "other," to make us more creatures of the imagination than real people. We are conceptualized only in our parts, not as whole human beings.

This kind of conceptualization, according to sociologist Nancy Chodorow (1978), reflects a male way of thinking, a tendency to deal with categories rather than people, which results from the socialization process applied to boys (see chapter 4). That it predominates in a culture attests to male control

over symbolic construction itself—over language, religion and ritual, literature, and the arts.

Although the imagery we have discussed may well originate in the male mind, women certainly subscribe to it and use it. We socialize our children to live in a male-dominated world. We teach our daughters to be feminine and our sons to be masculine (however those terms may be construed).

Do women conform to male images simply in order to survive, knowing that we must placate men? Do we adopt male fantasies because we have none of our own? No. It appears more likely that women's own imagery has been hidden as a result of male control of symbolic communication. Since women have for the most part been confined to the domestic world, our thoughts rarely emerge in public. Denied a chance to speak or write or paint or engage in public ritual, we cannot communicate our imagery in any lasting way to one another or to men. Men may, in any case, ignore what women produce because they devalue it. If in other cultures or other times, historians or anthropologists had the opportunity to observe women's imagery, they paid little or no attention to it. Most historians and anthropologists have been men, trained by men. They have been communicating with men about what interests men (see chapter 5).

It was suggested above that social imagery provides a rationalization for the real social order. The social distancing established by the notion of women as "other" provides an excuse for the actual devaluation of women, for the treatment of women as less than human, for exploitation and abuse, for the denial of our rights to self-determination. The same ideological devices are used against various ethnic groups and social classes exploited by the elite of a stratified and unequal social order. What is distinctive about this treatment of women is that it is so widespread, so ancient, and so pervasive. This makes the challenge to change it extraordinarily formidable.

Changing Reality by Changing Images

If our sense of ourselves, and of the ways we feel and act, is shaped by predominant social images of gender, then presumably our perceptions, feelings, and behavior can be changed in part by a change in imagery. And if our discomfort with past images is derived in part from the fact that we had little to do with their construction, then the positive directions these changes will take will depend on the extent to which women participate in image formation now and in the future. Women who are actively involved in determining the ways in which we express ourselves (in the way we look, talk, move our bodies, write, paint, sing, think, even dream) will help us inform ourselves in a deeper, more realistic, and more honest way about who and what we are. On the basis of a different self-perception, women may begin to act in more gratifying ways and may more nearly approach the realization of our human

potential. This is not to say that the source of our past oppression is largely in our minds, and that it can be relieved merely through changing images. It is to say that recreating ourselves in our own images is an important part of change.

As long as the images that women and men have of women are largely the product of men's perceptions and endeavors, women will continue to be perceived, and to perceive ourselves, as the "other," to be objectified, simplified, dehumanized. Our own active participation is essential if we are to break out of stereotypes. Our self-expression may take many different forms, verbal, visual, or musical. Some of these forms are the work of "professionals"—such as writers, artists, and scientists—but many others depend on common, everyday forms of spoken and written language, personal appearance, and conduct.

The first step toward change is to become conscious of what we do and of the significance of our behavior. Most women do not stop to think about the meaning of our daily activities, such as wearing high heels, allowing a male companion to pay for dinner in a restaurant, or remaining silent in the classroom. We should ask ourselves: Do these actions express what I feel or want to feel about myself? Once we begin to ask questions about our daily conduct, we can make judgments about what is important to us and how best to achieve it. These judgments may not be the same for everyone; what is important is that we take responsibility for deciding for ourselves.

Changes in Appearance and Conduct

We all express ourselves through the ways we look and act, but we have learned to take these matters so much for granted that we tend to overlook the significance of this form of self-expression. Our clothing is a costume for a role, a "character" we assume when we get dressed, which announces to others the part we expect to be playing. Makeup serves as a mask, part of the costume; hair is arranged to go with the role, and body movements are choreographed for the part we play. Modifications in each of these modes of appearance have an impact on others' perceptions of our roles and make people aware of what conventional styles of clothing, makeup, hairdressing, and so forth have to say.

Clothing. Many feminists consciously modify our clothing styles in order to assume new roles. Our new styles emphasize comfort, ease of movement, and utility for work rather than sexual availability, weakness, or ornamentality. While American feminists have been concerned with changes of dress that shift our presentation of self from "sex object" to "person," some fundamentalist religious sects have been concerned about dress codes and sexuality in a different way. Certain Muslim countries, for example, require that

women cover our faces and bodies in dark cloth when appearing in public. This requirement suggests that female sexuality is unseemly and dangerous. Many feminists have criticized this attitude as well, claiming that it degrades women, hampers our freedom, and reduces us to less than human status. Hiding female sexuality only serves to exaggerate its importance, to emphasize it at the cost of women's other human characteristics. and it places on women an unfair burden of responsibility for men's sexual arousal (see chapter 5).

Etiquette. Rules of etiquette, like those of clothing and makeup, often signal female dependency, subordination, and inferiority. Although such polite practices as men opening doors for women, helping us to take off and put on our coats, and offering us seats are presumably gestures of respect, their "protective" quality emphasizes women's presumed weakness and incompetence. Feminists' efforts to change rules of etiquette are in fact ways of expressing a desire to be accepted on equal terms. For instance, whoever reaches a door first should be the one to open it and hold it open for others. And anyone can help anyone else on with a coat.

Rituals of etiquette are symbolic acts; we must ask ourselves what these acts signify and what we might *prefer* to say by other gestures. It is sometimes only through the discomfort we feel in changing etiquette that we realize how important such gestures are in defining ourselves and our interpersonal relationships.

What has been termed *body language,* the ways we sit, walk, move our hands, and so forth, is also important as a means of self-expression. Body language is a learned code, which, like clothing and social rituals, often carries messages about female subordination. The amount of space we take up seated in a train or on a bus indicates the space we feel we have a "right" to. Women usually sit compactly, with feet together or knees crossed and elbows in. Men frequently adopt very loose positions that take up more space than they "need." Women are often taught not to gesture expansively, not to speak or laugh too loudly.

Finally, we should consider "naming" customs and what they mean. Why are women identified by our legal and sexual relationship to men ("Mrs.," "Miss") and men identified merely by the gender indication "Mr."? Is marital status more important for women than men? To deemphasize marital status where it is irrelevant, American feminists have adopted "Ms." as a female equivalent to "Mr." We may have reached the time that finds all these prefixes vestigial. Perhaps we should be referred to by our names alone or reserve unisex designation for moments of formality.

The more that women examine our daily habits of communicating our identities, the more it seems that in order to express ourselves in a male-

dominated world, we have resorted to using men's perceptions and fantasies about us. Our own means of self-expression, derived from inner perceptions, are underdeveloped as yet. It takes a certain intellectual effort to discover and create imagery of our own.

Participating in Imagery Construction: An Example

An important function of the expressive arts—literature, drama, poetry, painting, and music—is the creation of imagery with which we can see, express, and order the world. Women artists have a very significant role to play in orienting women to our own female identities, as we will see later in this chapter. Here we will look at an effort to change popular imagery which illustrates the challenges and possible achievements of altering consciousness—changing language.

It is no longer news that much of our daily language, spoken and written, tends to be sexist. This language tends to reinforce sexist behavior and organization in our society, to promote stereotyping by gender, and to perpetuate inequality. Feminists have urged those involved in the public media to change their use of language and other imagery in favor of nonsexist usage.

An entirely new language is not necessary to present equal treatment of the sexes. Very conservative changes, using common, traditional language, but with balance, can be quite effective. Many book publishers now have explicit editorial policies about nonsexist usage. One well-known educational publisher has issued guidelines to eliminate sexist assumptions from all its publications to encourage "a greater freedom for all individuals to pursue their interests and realize their potentials" (*Guidelines . . . McGraw-Hill*, n.d.:3).

Guidelines concerning language usage suggest that the terms *man* and *mankind*, when used to denote humanity at large, should be replaced by *human being, person, humanity,* or *people*. The term *man-made* can be replaced by *artificial, synthetic, constructed,* and so forth. Occupations can be denoted by nonsexist terms, as Table 1.1 shows.

In order to avoid repetition of the pronouns *she, he, her,* and *his,* authors can use plural terms. Instead of saying, "The student can buy his or her books at the bookstore," we can write, "Students can buy their books. . . ." When a single student is being discussed, the sex of the individual can be alternated in different cases: "She may graduate with honors if . . ." or "He must fulfill the following requirements. . . ." The inclusion of the phrase *and women* in "men and women" can signal an author's sensitivity to the issue of sexism in language.

There is nothing difficult or jarring about these changes for either the writer or the reader. They are minor, easily achievable reforms of language usage. Some writers have attempted more radical changes, but the extent to which they can affect usage is not yet clear.

Table 1.1 Nonsexist Occupational Terms

Congressman	Representative
Fireman	Fire fighter
Mailman	Mail carrier
Salesman	Sales clerk, sales representative, sales person
Insurance man	Insurance agent
Chairman	Chairperson, chair, presiding person
Cameraman	Camera operator
Policeman	Police officer
Spokesman	Spokesperson

Source: Adopted from *Guidelines . . . McGraw-Hill*, n.d.:13).

Women Define Ourselves

The courageous motto that the nineteenth-century mathematician Sonya Kovalevsky wrote on a prize-winning essay was "Say what you know, do what you must, come what may" (Osen, 1974). This is splendid advice for those who know that they do know something and have a strong sense of what they must do. But self-definition is highly problematical for many women. We have not been taught to use our critical faculties, and we have little self-esteem and few ways to develop it apart from society's narrowly approved means. The deepest problems may revolve around our internalization of society's views, our lack of realization that we have a "self" to fulfill, or even that we have any wishes beyond those of pleasing our families or others around us. In what follows, we will look at how women have searched for a self through art and literature.

Women's Search for Self through Art
A Historical Perspective. A few examples from the history of women as painters illustrate the problem of gaining self-definition. As Ann Sutherland Harris says, "Most women artists before the nineteenth century were the daughters of artists. Those who married often married artists as well. Most women artists before 1800 were trained by their fathers, or by their husbands or some other male relative" (Harris and Nochlin, 1977:41).

Men were more or less free to choose such a field, but women could not think of taking up a pursuit like painting without the approval, chaperonage, support, and teaching of a male relative. As a result, we painted as we were taught to paint. Marietta Robusti (1550–1590), daughter of the great Tintoretto, learned to paint with her brothers in her father's studio and learned, as

they all did, to paint in their father's manner. Her own paintings of her father's friends for the silversmith's guild may never be identified, lost as they are among Tintoretto's works (Greer, 1979:14–15). Many painters taught their daughters to paint in their own style. The daughters would probably have been rejected as associates if they had followed a personal vision.

To be taught to write or to paint by imitating a style is not unusual; but to be an accomplished artist, it is necessary to learn independence of mind and judgment as well, qualities not stressed in the training of women. Writing of another era, Linda Nochlin acknowledges the high price women paid:

> The result of . . . discriminatory attitudes—whether veiled or overt—was often achievement at a level of competent mediocrity by those women artists tenacious enough to pursue professional careers. . . . Simply being persistent enough to devote a lifetime of effort to being a serious artist was a considerable accomplishment for a nineteenth-century woman, when marriage and its concomitant domestic duties so often meant the end of even the most promising careers. (Harris and Nochlin, 1977:57)

But there were women artists who did follow a personal vision. The works of these women are apt to be lost because they are so fine that they are assumed to be those of a male artist. The painting of the Dutch artist Judith Leyster (1609–1660), for example, was drawn into the more famous works of Frans Hals, even though their stylistic differences are obvious.

Leyster, born about thirty years after Hals, was respected in her own time. She was mentioned in Ampzing's description of Haarlem in 1628 and listed as a member of the Haarlem Guild in 1633 (Harris and Nochlin, 1978). Yet some of her works were identified as the works of other artists, men like Hals and her husband Jan Molenaer. It is possible to identify her paintings by her signature, a monogram JL attached to a star (from her father's brewery, the Leyster or Lodestar). One of her works was found to bear her monogram crudely altered to an interlocking "FH"—to suggest an identification with Frans Hals (Greer, 1979:139). In her paintings Leyster shows "mothers combing their children's hair and women sewing by the fireside while their children play beside them. . . . That Leyster was the first to paint such themes cannot be proved but she conveys greater sympathy for the daily lives of women and their social situations than do the men in her circle who on occasion turned to similar subjects" (Harris and Nochlin, 1977:138). It was only subsequently, when Nicolaes Maes, a follower of Rembrandt, and Pieter de Hooch, a Delft artist, began to portray household scences in the 1650s that they became popular in Holland.

The point is clear: How can our accomplishments be known if our works do not remain attached to our names or if our works are dismissed because done by a women? How can subsequent generations of women avoid being discouraged by the assumption that there have been no important women artists? We should not, then, permit the question "Why were there no great

women artists?" since we dispute what it presumes. Notice the careful phrasing of the questions put by Harris and Nochlin in their important book and catalog for the exhibition of *Women Artists: 1550–1950.*

> Why was the Renaissance almost over before any woman artists achieved enough fame for their works to be treasured and thus preserved and for their accomplishments to be noted by contemporary biographers? Why did women artists not reach the historical status of Giotto, so to speak, until almost two hundred fifty years after he had become prominent? What made it possible for a small but growing number of women to have successful careers as painters after 1550 but prevented them from having any significant impact before that date? (Harris and Nochlin, 1977:13)

For us to know of women artists, their potential had to have been valued enough in their own time so that they could be taught the craft and left free to pursue it; and then their work had to be valued enough to be kept under their own names so that biographers could learn of it and preserve these names for us.

To define ourselves, we must value our own vision despite the pressure of male teaching and male dominance and a lingering wish to please our fathers, male teachers and lovers, or an imposing male relative. Research shows that there were many great women artists. Our work has been ignored, misidentified, and subsumed into the work of male artists. Until feminists flood the ranks of scholarship, women's efforts today at self-definition will be flooded by erroneous assumptions about our cultural past.

Contemporary Feminist Imagery. Feminism has created a new context in which women artists may work and feminist critics comment on our work. Feminist artists are beginning to flourish. The multiplicity of our work demonstrates that there is no single form of expression that must be labeled "feminist."

Some contemporary feminists, like women artists of the past, continue to record and interpret women's lives and fantasies about such experiences as birth, motherhood, food preparation, and being in the presence of other women. In 1971 Judy Chicago and Miriam Shapiro, two feminist artists, along with their students created a "Womanhouse." This environment "included a dollhouse room, a menstruation bathroom, a bridal staircase, a nude womannequin emerging from a (linen) closet, a pink kitchen with fried egg-breast decor, and an elaborate bedroom in which a seated woman perpetually made herself up and brushed her hair" (Lippard, 1976:57). Like other feminist artists, Judy Chicago availed herself of the freedom of the twentieth century to express herself through an explicitly female sexual imagery.

Working for six years with hundreds of other women and a few men, Chicago created "The Dinner Party," a work which celebrates women's heritage and employs arts traditionally cultivated by women, including needle-

"The Dinner Party" by Judy Chicago celebrates women of myth and history. A central motif for the decoration of the plates is the vaginal shape, which traditionally has signified women's hidden sex identity, with implications of shame, weakness, and inferiority. The transformation of such an image into a celebration of women's greatness and achievements represents the new work of feminist artists bent on self-definition. (© Judy Chicago, 1979. Photo by Michael Alexander)

work, lacemaking, and china-painting. On an equilateral triangular table, forty-eight feet long on each side, thirty-nine places are set for goddesses and women, from prehistoric earth goddesses to the artist Georgia O'Keefe (b. 1887). The table rests on a floor of triangular tiles on which the names of 999 women are written. The triangular shape is based on the configuration of women's pubic mound. For the plates, Chicago adapted the imagery of flowers and butterflies to represent the female genitalia. This imagery derives from the work of O'Keefe, who developed the painting of flowers into a

serious subject but who herself denies that being a woman has influenced her painting. "The Dinner Party" is controversial even among feminists. Some consider it a celebration: others question its artistic merit (Pois, 1979, 1981; Kuby, 1981).

There are other feminist artists whose work does not explicitly express a feminist identity. Louise Nevelson (b. 1899), one of the most successful woman artists of the twentieth century, is best known for her assemblages of machinery, buiding materials, and welded metal. Nevertheless, Nevelson attributes the special genius of her creativity to being a woman (box 1.3).

Women's Search for Self through Literature

The earliest woman writer in Western literature whose works are extant is Sappho, who lived on the Greek island of Lesbos in the sixth century B.C. She wrote poetry for and about a group of younger women who spent time with her before they departed for marriage. The emotions expressed by Sappho run the gamut from love to jealousy to hate, but they were all inspired by women. Although she lived in a male-dominated culture, she asserts women's values. Sappho would not trade her daughter for limitless treasures; she appreciates the beauty of other women; and she prefers love to war. Despite her preoccupation with women's culture, Sappho was admitted into the mainstream of classical literature because of her technical versatility. Male poets could adopt her erotic imagery for homosexual or hetrosexual purposes.

Sappho's poetry is an artistic rearrangement and interpretation of reality, though it appears to be frank and personal. In fact, most women's literature is personal to such a degree that the confessional style of writing has been labeled "feminine" even when men employ it (Kazin, 1979). Owing to the circumstances of our lives, women writers have often turned inward to explore the private, rather than the public, sphere.

Discovering Models in Women's Culture. Virginia Woolf once said, "Anonymous was a woman." In the past, it was often difficult for us to maintain our respectability if we made our writing public (Bernikow, 1974). As in the case of paintings, many works of literature whose creators are now unknown may have been produced by women. According to historian S. D. Goitein (1978), the poet who composed the Song of Songs (also known as the Song of Solomon) was female (box 1.4). Her dream of bringing her beloved into her mother's house was unlikely to be realized in the society of the Old Testament patriarchs, where brides moved to their husband's place of residence (see chapter 7). Her description of herself is a model for women who feel ambiguity or self-hatred about our appearance: the poem may demonstrate the positive effect of romantic love on a woman's self-esteem.

Instead of working anonymously, or as an amateur, Aphra Behn (1640–

"Moon Garden Wall II." Louise Nevelson has combined everyday objects and discarded scraps of metal to achieve this original, vibrant, and intriguing scultured panel. She creates an extraordinary environment, never seen in such a composition before. One of the foremost artists of the twentieth century, Nevelson considers her art feminine because of its emphasis on creating a new life out of ordinary matter. (1961–75, wood painted black, 96×72×24 inches. The Pace Gallery. Photo by Al Mozell.)

Louise Nevelson: "My Whole Life is Feminine" Box 1.3

I feel that my works are definitely feminine. . . . There is something about the feminine mentality that can rise to heaven. The feminine mind is positive and not the same as a man's. I think there is something feminine about the way I work. . . . The creative concept has no sex or is perhaps feminine in nature. The means one uses to convey these conceptions reveal oneself. A man simply couldn't use the means of say, finger-work to produce my small pieces. They are like needlework.

I have always felt feminine . . . very feminine. . . . Men don't work this way; they become affixed, too involved with the craft or technique. They wouldn't putter, so to speak, as I do with these things. The dips and cracks and detail fascinate me. My work is delicate; it may look strong, but it is delicate. True strength is delicate. My whole life is in it, and my whole life is feminine, and I work from an entirely different point of view. My work is the creation of a feminine mind—there is no doubt. What I wear every day and how I comb my hair all has something to do with it. The way you live a life. And in my particular case, there was never a time that I ever wanted to be anything else. I was interested in being myself. And that is feminine. I am not very modest, I always say I built an empire.

(In Glimcher, 1976:23–24)

1689) became the first woman author in England actually to support herself through writing. Restoration literature is tolerant of talk of sex, but Aphra Behn showed courage and originality in speaking of the game of love from a woman's viewpoint. "The Disappointment" is about premature ejaculation. In "A Thousand Martyrs I Have Made," she writes about sexual pleasures. But in "To Alexis in Answer to His Poem Against Fruition" (Box 1.5), she recounts a common experience that women faced after satisfying a lover's pleas. Aphra Behn was labeled a prostitute for her outspokenness (Bernikow, 1974).

The Heroine. The word *heroine* is ambiguous. It has been applied to both the female protagonists in a literary work and to females whose actions are admirable. By what criteria are we to judge those heroines of greek tragedy who, motivated by personal concerns, threatened the masculine fabric of the state? Queen Clytemnestra slew her husband Agamemnon upon his triumphant return from Troy in order to avenge his sacrifice of their daughter Iphigenia. Antigone dared to disobey the edict of the king, Creon, by giving her brother, a traitor, a proper burial. Clytemnestra was murdered by her son, and Antigone, condemned to death, committed suicide. Are these women heroines or villains? Our answer clearly depends on who we are and the period of history in which we live. Doubtless some members of the Athenian audience in the fifth century B.C. sympathized with Clytemnestra

Song of Solomon **Box 1.4**

I am black, but comely, O ye daughters of Jerusalem, as the tents of Kedar, as the curtains of Solomon. . . .

I am the rose of Sharon, and the lily of the valleys. . . .

I found him whom my soul loveth: I held him, and would not let him go, until I had brought him into my mother's house, and into the chamber of her that conceived me. . . .

How beautiful are thy feet with shoes, O prince's daughter! The joints of thy thighs are like jewels, the work of the hands of a cunning workman.

Thy navel is like a round goblet, which wanteth not liquor: thy belly is like an heap of wheat set about with lilies.

Thy two breasts are like two young roes that are twins.

Thy neck is as a tower of ivory; thine eyes like the fishpools in Heshbon, by the gate of Bathrabbim: thy nose is as the tower of Lebanon which looketh toward Damascus.

Thine head upon thee is like Carmel, and the hair of thine head like purple. . . .

How fair and how pleasant art thou, O love, for delights!

This thy stature is like to a palm tree, and thy breasts to clusters of grapes. . . .

I would lead thee, and bring thee into my mother's house. . . .

(Song of Solomon, 1:5, 2:1, 3:4, 7:1–7, 8:2)

Authorized [King James] Version

and Antigone for the wrongs they suffered but condemned their actions. Women's experimental theater groups nowadays reenact the old myths so as to leave no doubt that in our assertion of female values Clytemnestra and Antigone are heroines in every sense of the word.

In *The Woman Warrior* (1976), Maxine Hong Kingston conjures up a myth derived from stories told by women in her family. A Chinese-American girl living a humdrum life in San Francisco envisions herself as a warrior woman in China fighting barbarians, bandits, and even the emperor. She takes vengeance on behalf of the people of her village whose grievances were inscribed on her back with knives. Heroines are women who do not accept their fate passively. They think, choose, and act.

In the past, heroines of literature and history like Judith, Jael, and Joan of Arc fought for their families and communities. The heroines of current feminist literature are often engaged in a quest for self-knowledge. Doris Lessing's works have always seen the individual woman (and women are her novels' central characters) within a political setting, and all grapple with the questions of what it is to be female. Kate, the heroine in *Summer Before the Dark* (1973), mother of four grown children and married to a fond but unfaithful

Aphra Behn: *To Alexis in Answer to His Poem* Box 1.5
Against Fruition

Man! our great business and our aim,
For whom we spread our fruitless snares,
No sooner kindles the designing flame,
But to the next bright object bears
The Trophies of his conquest and our shame:
Inconstancy's the good supreme
The rest is airy Notion, empty dream!

Then, heedless Nymph, be rul'd by me
If e're your Swain the bliss desire;
Think like Alexis he may be
Whose wisht Possession damps his fire;
The roving youth in every shade
Has left some sighing and abandon'd Maid,
For tis a fatal lesson he has learn'd,
After fruition ne'er to be concern'd. (Bernikow, 1974:71–72)

husband, decides that she must discover who she really is, outside the identities of mother and wife foisted on her by her family roles.

At one point, Kate rents a room from a young woman named Maureen. As Kate is looking into the mirror, Maureen comes in, sticks out her tongue at the reflection of Kate and herself, and walks out:

> Kate felt assaulted. No matter how her mind said that it had been friendly, a sharing—the girl had come to share her moment at the glass—she felt it as aggression, and this was because, quite simply, of the marvelous assurance of the girl's youth. Of her courage in doing what she felt like doing. Yes, that was it, that was what she, Kate, had lost. (Lessing, 1973:169)

There is no guarantee of happiness for Kate. Lessing's title implies that after her lonely summer of adventure, darkness awaits her. Kate earns the status of a heroine for her relentless pursuit of the truth. Her search for self is lonely and painful. Heroines who search for self while enjoying the support of groups of women or friends of both sexes—like those in Marilyn French's *The Women's Room* (1977) and Mary Gordon's *Final Payments* (1978)—are more likely to find happiness simply in the process of searching.

The search for self—even for the duration of a summer—is a luxury that has been enjoyed by few of the world's women (Trilling, 1973). But that does not mean the theme should be rejected as unimportant (Jelinek, 1980). The written text need not reveal—directly or distortedly—the experiences of the majority. We are looking forward to a world where more options will be available to increasing numbers of women. Literature serves as a testing ground for new models.

Women's Words. Language itself shapes social realities, for words are our primary system of communication. Some people claim that changes in language are an important step in developing awareness of reality and essential for changing society. But language is controlled by those in power and enables them to structure women's individual and collective unconscious. If men have labeled, named, and catalogued everything and have thus forged our system of thought, then women must be thought of as thinking and writing in a dialect and mode that is foreign to us (Spender, 1980). Feminist scholars are now attempting to determine whether there is a distinct language, a distinct quality of the imagination, and a separate literary style that are natural to women (Todd, 1980).

According to Robin Lakoff's analysis (1975), women's language has been shaped by socialization. Our vocabulary is expected to be ladylike, and our phraseology and intonation are shaped by our role as language teachers to young children.

> Women's language: Oh dear, you've put the peanut butter in the refrigerator again, haven't you?
>
> Men's language: Shit, you've put the damn peanut butter in the refrigerator again.

Such differences are being dispelled as women enter the work force and the locker room, and as men take on a larger share in child-rearing.

Some women argue that the goal of women authors should be to employ the standard language and to write of the common human experience, rather than to examine the truths particular to female life. According to Helen Vendler, "Our young women poets, however loyal their interest in the work of their female predecessors and contemporaries, are still finding the best poetry available to them in the pages of Shakespeare, Milton, Keats, and Wordsworth" (Vendler, 1981:33). She is not convinced that this array of male predecessors must be inhibiting, though she admits that "no woman can fail to hope for the appearance of a woman poet of Shakespearian or Keatsian power" (ibid.).

On the other hand, it is possible to argue that powerful female poets already exist in the English tradition, though they may not be appreciated by students whose teachers are prejudiced by sexist values. Emily Dickinson, for example, may be viewed as at least as admirable a poet as, say, William Wordsworth (Gilbert and Gubar, 1979).

Women's Identity in Utopia. Science fiction is a kind of laboratory for testing suppositions and presenting new paradigms. Women's utopian science fiction attempts to create better worlds for everyone but pays particular attention to what is beneficial for women. Feminist writers disagree about whether to emphasize the differences between the sexes in such a world and to honor

women's distinctive characteristics, especially the ability to bear children. Should the goal, instead, be *androgyny* (blending of female and male), with the separate identities of the sexes reduced to a minimum? Some feminists prefer a separate women's culture, and others prefer freedom from gender (Ketchum, 1980).

In a complicated work called *The Female Man*, Joanna Russ (1975) tells the stories of Jeanine, Janet, Joanna, and I, who turn out to be all aspects of Woman—women of the past, present, and future, all conflicting, and all carried within each woman, shaped as she is by her temporal, cultural, and personal environment. Russ uses science fiction to explore women's multifaceted nature, freed of the restrictions of society. Ursula LeGuin's *The Left Hand of Darkness* (1976) considers a world in which people are androgynous and anyone may go into "kemmer," the female sexual cycle, and give birth. Critics have objected that her central character is still male, referred to by the male pronoun throughout, so that the old error of men being the norm and women the deviates, the other, is perpetuated even in this inventive book.

Marge Piercy's *Woman on the Edge of Time* (1976) also uses the science fiction mode to suggest two opposing possible futures. To include all women, Piercy takes pains to make her work multiethnic and multiracial. Her visions of two different possible futures, one sexist and one nonsexist, are conveyed in part through terms which underscore social inequality and equality. In the nightmarish sexist future, women are designated *fems*. If we are not "richies" (members of the upper class), we try to survive as "contracties" (women who arrange to get a contract for sexual service to men). The contracts range for periods of a night or a month to several years; only a "bulgie" (a shapely woman) can get a long-term contract. Reproduction is limited mainly to women who are professional babymakers, "moms." Women are generally considered useful only for sexual entertainment. If we fail to get a "prospect" (client), we might end up in a "knock-shop" (house of prostitution); by forty, we are useless, hence likely to be "ashed" (cremated). If we misbehave, we might be sent to an "organbank" so that our organs can be used for someone else.

The nonsexist utopian future has sex and sexuality, but not gender. The pronouns *him* and *her* are replaced by *per*, for "person." People select their own names at adolescence. These names have no particular gender reference but reflect the personalities and preferences of their owners: Luciente, Jackrabbit, Bee, Red Star. Distinctions are not made by sex in coupling; there are "handfriends" and "pillowfriends" among women and men and between them. The term *mother* applies to all parents, regardless of sex; there are no fathers. All babies are created in laboratories (breeders), not born from women; and through hormonal control, both females and males can (and do) breast-feed. The people who are closest friends form a "core," but there are no marriages or nuclear families. Each child has three "co-mothers" who are

usually not lovers ("sweet friends"). Although every person might have various kinds of friends, including lovers, co-mothers, and handfriends, everyone has a room of "per" own, a private living space within the community. Only babies live together.

By her use of *per* and *co-mother* and *core* and a variety of other terms, Piercy challenges us to see the sexism implicit in the institutional arrangements that standard terms for social relationships represent. She suggests that in a society not governed by sexual stereotyping, a whole new set of concepts, and therefore new language, would be necessary.

The Propagation of Feminist Imagery

Is there a female esthetic? If so, what are the artistic principles by which we may evaluate works created by women about women's experience for a female audience?

The problem of self-definition through art extends to criticisms of women's work by a cultural establishment dominated by men. Consider needlepoint, quilt-making, and painting on porcelain. These are termed crafts or arts, as in "arts and crafts"—not art. Such terms demonstrate that political power defines reality. The one who classifies grants needlepoint the status of craft and painting the status of art. The biases of the categorizer, whether male, white, wealthy, industrial or ethnic, poor, or agrarian will help determine whether the world so classified will be lauded or criticized.

Contemporary strategies are developing to aid women's self-definition. One strategy has long been known to women in small communities—that of using the support of other women. Just as the larger society has found that people sharing a common concern gain strength from meeting together, so women have learned to use our common experiences to illuminate and support ourselves, to show that we are not alone in our experience as women.

Another variation of this strategy now developing is one that women have learned from men. It finds its origin in the grapevine, the underground railway, and the "old boys' network" and goes by the term *networking*. Having observed the way jobs are filled by someone calling someone "he" knows, women are trying to develop our own networks. This is the importance of the increasing numbers of women's regional, national, and even international conferences. Women are learning that in helping each other we constitute a force of considerable magnitude in the world.

Groups have formed in which women band together to gain and sustain employment and to enjoy and participate in women's culture. The *Index/ Directory of Women's Media* for 1980 lists 196 women's periodicals (newspapers, journals, magazines, newsletters) in the United States. Collectives are forming in this country and elsewhere to display other media than the written word. There are at least twenty-three women's film groups and seventeen

video and cable groups listed. Music groups are also flourishing, as are theater groups, graphics collectives, and galleries to exhibit women's work.

One illustration of the new interest in networking is the number of women's directories available. Most of them list women in crafts or women-run businesses, such as the *Womanforce Directory* (Washington, D.C.), *Media Report to Women Index/Directory* (Washington, D.C.). *Women's Directory* (Washington State), *Toronto Women's Yellow Pages*, *Guide to the British Columbia Women's Movement, Whole Woman Catalogue: A Guide to Resources for Women in North Carolina,* and *The New Woman's Survival Sourcebook* (New York). They offer fine examples of the range of resources open to new, self-defining women who are increasingly at home in our own world.

Conclusions: Being Whole

The efforts of many feminists in a wide variety of professions—including writing, law, health, and art—have been directed toward establishing an image or idea of woman as a whole human being. Women should not be reduced to the subordinate member of a relationship (wife of x, mother of y, secretary of z) or a body part (breasts, uterus, legs). This complex process implies, to many, a radical rethinking of what human beings are and what our society has made of us.

Most feminists today reject self-definitions which deny any one of our parts as much as we reject a self-definition in terms of one or more of these characteristics. We do not, that is, deny the fact that we have families, children, lovers, friends, or dependents: our obligations to and pleasures with others are emphatically a part of our lives. We seek to incorporate these parts into our perceptions, into our work, and into our activities. This may mean working for certain practical changes, such as accommodations for children in the workplace or in other public places (cinemas, restaurants, and so forth) so that we may take our children with us when we want to.

Being whole also means accepting and taking pride in one's physical self, not feeling shame or awkwardness or limitation because of bodily parts and processes or sexual preferences. This entails adopting different attitudes toward menstruation, childbirth, menopause, and sexuality, as well as toward breasts and vaginas and legs. Women see these things in terms of what they mean for us, not simply in terms of what they may mean for others. From this perspective, older images of women (witch, polluter, saint, savior) make no sense whatsoever.

Should our new view of ourselves actually become established, through art and literature, medicine and law, many women and men would be obliged to reexamine self-identities and self-definitions. Men, in particular, would have

to seek new self-images. If men have defined themselves as "not-woman," characterizing manliness in terms of male superiority toward, conquest of, or disdain for women, the concept of manhood too would have to be rethought. Once "woman" along with "man" means "human," we can begin reconceptualizing everything in which difference and contrast has been an organizing principle.

Nor are there secrets, mysteries, or privileges of sex. Women would give this up in exchange for the ability to express ourselves. Menstruation and childbirth become neither dirty secrets nor sacred mysteries. No longer hidden and no longer threatening, they cannot be used to manipulate others. Having insisted that we are not *simply* nurturers, consolers, and sources of pleasure for men and for children, women must admit to our human shortcomings and admit the competence of others, including men, to be nurturers, consolers, and sources of pleasure.

It should not be surprising that the effort to create an image of oneself, true to one's own experience and knowledge, is difficult. Any difficult endeavor depends considerably on the extent of cooperation and support people receive from one another. Women who have sought change in our images of ourselves have depended mainly on other women. The literature of feminism is filled with references to support groups and networks of women who share ideas and motivations and time and effort. In this, women have cooperated as they have in the past, whether to bring about change or just to survive in the face of pressure, work, and resistance.

Summary

The ideas that women and men have had about who we are, how we relate to one another, and what our potential is are the products of our cultures. An important part of any culture is its system of symbolic representations of reality—the attribution of *meaning* to perceptions. We (or our cultures) shape our perception of what is "out there" on the basis of the ways we have learned to *interpret* reality. These perceptions, or "images," are social creations whose shape and origin need to be explained rather than accepted at face value.

Notions of what women are have been shaped by social imagery. Society conveys imagery through ordinary language, social behavior, and creative works. The images themselves have served to set women aside from humanity by reducing us to one or a few aspects or our personalities, physiologies, or behavior. Thus, the image of women as either witch, madonna, sex object, earth mother, or misbegotten man reduces us to something less than whole human beings. This symbolic reduction of women then becomes a rationale for unequal treatment of women and for our own self-devaluation. Women often shape ourselves according to this demeaning imagery simply in order to survive

in a world dominated by men. This imagery is damaging. Why is it so wide-spread and how can we change it? One important factor in explaining the biased imagery is the predominance of *men* in producing and disseminating it: men have dominated the fields of public discourse and professional activity in the past. Few women have had the opportunity to present our views of our-selves, although feminist scholars are now discovering many self-defining women whom men's history has hidden. Now, many more women are self-consciously producing images of women, drawing from our own life experi-ences and perceptions and guided by a feminist appreciation for women's worth. We have examined some of the past obstacles and current strategies that enhance this development.

Imagery and symbolism are of great importance in shaping not only works of art but all perceptions of reality, including those to be discussed in the next chapters. The ways that scientists and scholars have perceived women have been no less influenced by the subtle constructions of culture than have the perceptions of artists, writers, and poets.

Discussion Questions

1. Describe a woman and a man whom you know. (You may use yourself as one of the characters.) Note the difference in language you have used to describe each.
2. Tell a fairy tale or folk tale or the words of a song that a woman told you when you were young. Which of the stereotypes that we have discussed in this chapter appear in this tale? What message is being conveyed to the listener?
3. Examine a woman's fashion magazine. Discuss the images that fashion imposes upon women. What "feminine" qualities are emphasized? What qualities are ignored? What sorts of women are not shown in the photos? If you were designing clothing, what would you create?
4. Is there a female sensibility or esthetic? Formulate a method by which you might determine whether such an esthetic exists. Discuss the differences and similarities between a female esthetic and a feminist esthetic.

Recommended Readings

Fisher, Dexter, ed. *The Third Woman: Minority Women Writers of the United States*. Boston: Houghton Mifflin, 1980. An extraordinary anthology of con-temporary writing by American Indian, Afro-American, Chicana, and Asian American women, demonstrating the on-going quest for self-definition in its cultural contexts. These poems and excerpts of longer prose works offer the reader some idea of the imagination and creativity and the range of themes that modern minority women in the United States are exploring today.

Gornick, Vivian, and Moran, Barbara K., eds. *Woman in Sexist Society: Studies in Power and Powerlessness*. New York: Basic Books, 1971. See especially "The Image of Woman in Advertising," pp. 207–17; "The Image of Women in Textbooks," pp. 218–25; and "Seduced and Abandoned in the New World: The Image of Women in American Fiction," pp. 329–46. These articles examine modern image-making ranging from images in textbooks for children to advertisements for adults.

Hull, Gloria T., Scott, Patricia Bell, and Smith, Barbara. eds., *But Some of Us Are Brave: Black Women's Studies*. Old Westbury, N.Y.: The Feminist Press, 1982. This anthology includes bibliographic essays which present a wealth of scholarship about Afro-American women poets (pp. 245–60), novelists (pp. 261–79), and composers (pp. 297–306). There is also a series of syllabi used in literature courses on black women writers (pp. 360–78).

Miller, Casey, and Swift, Kate. *The Handbook of Nonsexist Writing*. New York: Lippincott and Crowell, 1980. This witty book offers middle-of-the-road solutions to language problems that may be encountered by those who are beginning to write in a nonsexist style.

Millett, Kate. *Sexual Politics*. Garden City, N.Y.: Doubleday, 1970. An angry survey of the way "great" male novelists such as D. H. Lawrence and Henry Miller have treated—and mistreated—women in their writing. One of the important influences on the reawakened women's movement of the early 1970s.

Sternburg, Janet, ed. *The Writer on Her Work*. New York: Norton, 1980. Essays by women writers about the sources of their creativity; the landscapes of their personal, female, and literary worlds; and the angles of vision that these give rise to. They discuss their efforts to find their way out of "silences" and their daily struggles to find their authentic artistic voices.

References

Bachofen, Johann Jakob. *Myth, Religion and Mother Right*. Selected Writings of J.J. Bachofen. 1861. Reprint. Translated by Ralph Manheim. Princeton: Princeton University Press, 1967.

Beauvoir, Simone de. *The Second Sex*. 1949. Translated by H.M. Parshley. New York: Knopf, 1953.

Bernikow, Louise. *The World Split Open: Four Centuries of Women Poets in England and America, 1552–1950*. New York: Vintage, 1974.

Chodorow, Nancy. *The Reproduction of Mothering: Psychoanalysis and the Sociology of Gender*. Berkeley: University of California Press, 1978.

Cornelisen, Ann. *Women of the Shadows: The Wives and Mothers of Southern Italy.* Boston: Little, Brown, 1976.

Ember, Carol. "Men's Fear of Sex with Women: A Cross-Cultural Study." *Sex Roles* 4 (1978):657–78.

French, Marilyn. *The Women's Room.* New York: Summit, 1977.

Freud, Sigmund. *The Interpretation of Dreams.* New York: Macmillan, 1963.

Gilbert, Sandra M., and Gubar, Susan, eds. *Shakespeare's Sisters: Feminist Essays on Women Poets.* Bloomington: Indiana University Press, 1979.

Glimcher, Arnold B. *Louise Nevelson.* New York: Dutton, 1976.

Goitein, Solomon D. *A Mediterranean Society. The Jewish Communities of the Arab World as Portrayed in the Documents of the Cairo Geniza.* Volume 3. *The Family.* Berkeley: University of California Press, 1978.

Gordon, Mary. *Final Payments.* New York: Random House, 1978.

Greer, Germaine. *The Obstacle Race.* New York: Farrar, Straus, & Giroux, 1979.

Guidelines for Equal Treatment of the Sexes in McGraw-Hill Book Company Publications. New York: McGraw-Hill, n.d.

Harris, Ann Sutherland, and Nochlin, Linda. *Women Artists: 1550–1950.* New York: Knopf, 1977.

Jelinek, Estelle C., ed. *Women's Autobiography: Essays in Criticism.* Bloomington: Indiana University Press, 1980.

Kazin, Alfred. "The Self as History: Reflections on Autobiography." In *Telling Lives, The Biographer's Art,* edited by Mark Pachter. Washington, D.C.: New Republic Books, 1979.

Ketchum, Sara Ann. "Female Culture, Womanculture and Conceptual change: Toward a Philosophy of Women's Studies." *Social Theory and Practice* 6 (1980):151–62.

Kingston, Maxine Hong. *The Woman Warrior.* New York: Knopf, 1976.

Kuby, Lolette. "The Hoodwinking of the Women's Movement: Judy Chicago's *Dinner Party.*" *Frontiers VI* (1981):127–29.

Lakoff, Robin. *Language and Woman's Place.* New York: Harper & Row, 1975.

LeGuin, Urusula. *The Left Hand of Darkness.* New York: Harper & Row, 1976.

Lessing, Doris. *The Summer Before the Dark.* London: Cape, 1973.

Lévi-Strauss, Claude. *The Raw and the Cooked.* 1964. Translated by John and Doreen Weightman. New York: Harper & Row, 1969.

Lippard, Lucy R. *From the Center: Feminist Essays on Women's Art.* New York: Dutton, 1976.

Ortner, Sherry. "Is Female to Male as Nature Is to Culture?" In *Woman, Culture and Society,* edited by Michelle Z. Rosaldo and Louise Lamphere. Stanford: Stanford University Press, 1974.

Osen, Lynn M. *Women in Mathematics.* Cambridge, Mass.: MIT Press, 1974.

Pois, Anne Marie. "*The Dinner Party.*" *Frontiers IV* (1979):72–74.

———. "A Reply to Kuby's Review." *Frontiers VI* (1981):129–30.

Piercy, Marge. *Woman on the Edge of Time.* New York: Knopf, 1976.

Register, Cheri. "Literary Criticism." *Signs* 7 (1980):271–76.

Russ, Joanna. *The Female Man.* New York: Bantam, 1975.

Ruth, Sheila. *Issues in Feminism: A First Course in Women's Studies.* Boston: Houghton Mifflin, 1980.

Slater, Philip. *The Glory of Hera.* Boston: Beacon, 1968.

Spender, Dale. *Man Made Language.* Boston: Routledge & Kegan Paul, 1980.

Todd, Janet, ed. *Gender and Literary Voice.* New York: Holmes & Meier, 1980.

Trilling, Diana. "The Liberated Heroine." *Times Literary Supplement.* October 13, 1978:1163–67.

Vendler, Helen. Review of Margaret Homan's "Women Writers and Poetic Identity." *New York Review of Books.* February 19, 1981:33.

Wittig, Monique. "The Straight Mind." *Feminist Issues* 1 (1980):

Wolf, Eric R. "Society and Symbols in Latin Europe and in the Islamic Near East: Some Comparisons." *Anthropological Quarterly* 42 (1969):287–301.

Woolf, Virginia. *A Room of One's Own.* New York: Harcourt, Brace, 1957.

2

Ideas About Women's "Nature"

DEFINITIONS AND THEORIES
Woman as "Other"
Philosophical Definitions of Women
Religious Reflections

IDEAS OF EQUALITY
Liberalism and Feminism
Wollstonecraft
Mill and Taylor
Liberal Feminism
Relevant Characteristics

THE CONCEPT OF FREEDOM

CONSERVATIVE SENTIMENTS AND FEMINISM

SOCIALISM AND FEMINISM
Socialist Feminism

RADICAL FEMINISM

SOME PRINCIPLES OF FEMINISM
Dangers and Hopes

What is a woman? What should the word 'woman' be understood to mean? What is "equality"? What does "freedom" mean? Philosophers have traditionally dealt with such fundamental question as these. Yet philosophers in the past have dealt only very inadequately with fundamental questions concerning women.

In this chapter, we will look at various philosophical definitions of women and at the concepts of equality and freedom. We will examine feminist viewpoints on these issues and see how feminist philosophers are changing ideas about women and about women's "nature."

Definitions and Theories

When people want to know the meaning of a word, they look in a dictionary. But dictionaries are written by people (nearly always male) and can be rewritten. For the most part, they merely record usage at a given time; usage can change, and the ideas that people have can cause usage to change. It is philosophers (also nearly always male) who suggest what our ideas about fundamental matters *ought* to be. They offer definitions that they hope will be found to be satisfactory in the long run. They propose what the dictionaries *ought* to say.

Definitions are starting points or building blocks. They give us the terms with which we can make assertions about what is in fact the case, or about what is normatively valid. We can consider whether these assertions are true or false, depending on the evidence and arguments. For instance, once we have defined *swan* without requiring whiteness to be part of the definition, we can look for empirical evidence of whether or not there are black swans (there are).

We also need definitions in order to construct theories, both theories about what is and theories about what ought to be. Human beings need theories in order to deal with life and experience—to understand the world and to act in it. For instance, it is a theory about what it is to be a "person" that allows us to think we are the same persons as when we were children. It is a theory that lets us expect that the sun will rise tomorrow because it has risen every previous day. (Of course, we now have a *different* theory to explain this than people had before Copernicus showed that the earth revolves around the sun.)

A definition may reflect an assumed theory. For instance, we are assuming one theory if we define "earth" as "center of the universe" and another if we define it as "planet in the solar system." Definitions of "woman" have often reflected faulty theories which men have had about the "nature" of women. This is partly because thinking and writing on the subject of women have been irrational, erroneous, and unclear. And the very language in which women have been considered and talked about has contained hidden, implicit sexism (Vetterling-Braggin, 1981). Usually definitions of women have been the result of much fear or ignorance and have almost always been affected by the distorted perspective of one part of humanity seeing another part as "other" than itself, and drawing unjustified inferences from this partial perspective.

Woman as "Other"

The philosopher Simone de Beauvoir's extraordinarily rich and perceptive book *The Second Sex* first appeared in 1949, at a time when there was no

women's liberation *movement* to sustain the sorts of views she presented. Better than anyone, she explores the implications of defining women as "other." The dominant view, she writes, is that it is men who are agents in the world: they act, they make history, they are conscious, they think and work and rule. She shows that whenever the concepts of the "self," or of the self as "agent," had been developed, they had *male* exemplars. From the perspective of the male agent, women are "other." Men look upon women as other than themselves. Man, the agent, acts. Woman, the "other," exists. Man is active; woman is passive. According to this view, woman is a part of nature or of the external world on which and with which man, who is human and conscious, acts. Yet she is sufficiently conscious to be able to recognize man's humanity and achievement. By being a conscious "other," woman is able to affirm him in his manhood in a way in which inert matter (or nature) cannot. In possessing this passive yet conscious "other," man both asserts himself and reassures himself about his selfhood and his humanity.

It is possible to question de Beauvoir's assumption that the archetype of the "free agent" is the ideal of human life, but as an existentialist, she saw that ideal as what all human beings should consciously become. De Beauvoir summarizes the way men have seen themselves in relation to nature and to other human beings:

> Once the subject seeks to assert himself, the Other who limits and denies him, is none the less a necessity to him: he attains himself only through that reality which he is not, which is something other than himself. That is why man's life is never abundance and quietude; it is dearth and activity, it is struggle. Before him, man encounters Nature; he has some hold upon her, he endeavors to mold her to his desire. But she cannot fill his needs. Either she appears simply as a purely impersonal opposition, she is an obstacle and remains a stranger; or she submits passively to man's will and permits assimilation, so that he takes possession of her only through consuming her—that is, through destroying her. In both cases he remains alone; he is alone when he touches a stone, alone when he devours a fruit. There can be no presence of an other unless the other is also present in and for himself: which is to say that true alterity—otherness—is that of a consciousness separate from mine and substantially identical with mine (1953:139–40)

Thus, in order to understand *himself* as a human being, man, the subject, needs other human beings rather than merely nature. Other *men* do not serve this purpose, however. They only present him with an interminable conflict. Each man, de Beauvoir writes, "aspires to set himself up alone as sovereign subject. Each tries to fulfill himself by reducing the other to slavery." Since all men are trying to triumph over all other men, conflict is constant.

> And so, quite unable to fulfill himself in solitude, man is incessantly in danger in his relations with his fellows: his life is a difficult enterprise with success never assured.
>
> But he does not like difficulty: he is afraid of danger. He aspires in contradic-

Simone de Beauvoir, photographed here in 1964, fifteen years after the publication of *The Second Sex*, has been all her life an activist in political causes and a member of French intellectual circles. Her essential contribution to modern feminism was to point out that most of what had ever been written and considered important had been written by men, and in consequence women were always portrayed as acted upon, the eternal "other," in relation to the male agent. (Wide World Photos)

tory fashion both to life and to repose, to existence and to merely being; he knows full well that "trouble of spirit" is the price of development, that his distance from the object is the price of his nearness to himself; but he dreams of quiet in disquiet and of an opaque plenitude that nevertheless would be endowed with consciousness. This dream incarnated is precisely woman; she is the wished-for intermediary between nature, the stranger to man, and the fellow being who is too closely identical.

... [T]hrough a unique privilege she is a conscious being and yet it seems possible to possess her in the flesh. Thanks to her, there is a means for escaping that implacable dialectic of master and slave. ... Woman thus seems to be ... the absolute Other. ... This conviction is dear to the male, and every creation myth has expressed it.(1953:140–41)

Woman presents man with neither "the hostile silence of nature" nor the opposing will that leads other men to strive to be master: "woman is defined exclusively in her relation to man." Such definitions, de Beauvoir continues, are truly *man*-made. "Representation of the world, like the world itself, [is]

the work of men; they describe it from their own point of view, which they confuse with absolute truth" (1953:143).

The definition of woman as "other" has led to many unjustifiable theories, false assertions, and distortions of perspective. Men have failed to consider whether these views are confirmed in the experience and reality of women. As we begin to understand ourselves as women, we are not likely to consider the misconceptions that have prevailed throughout history as valid ideas about "woman" and woman's "nature." We will recognize these views as claims, usually false, about what women are like, and recommendations, usually invalid, about how women should behave (box 2.1).

Women can begin with ostensive definitions, definitions which *point to* the entities designated. In this case, the entities are real. *They are us. We are* women. Any definition of "women" that does not refer to women as we know ourselves to be is faulty. Of course there is a catch in "and know ourselves to be" because in the past we have too often only known ourselves through the eyes and languages and theories of men. We have lacked the confidence to know ourselves directly. But as we increasingly see for ourselves our own reality and express it in our own words and ways, we can reject the definitions of women that belie that reality. Let us now look at some of the distorted philosophical definitions that have prevailed in the past.

Philosophical Definitions of Women

In writing about women, male philosophers have by and large shared in the distorted views characteristic of their times and places, however original or antitraditional their views may have been on other issues. There have been a few notable exceptions, such as Plato (c. 427–347 B.C.), Condorcet (1743–1794), and John Stuart Mill (1806–1873), but the list is distressingly short. The implication is not that the philosophical mode of inquiry is suspect, but that feminist philosophers must make sure philosophy is enriched by women's views and women's realities. Contemporary feminist philosophers are striving to do this (English, 1978; Moulton, 1976; Pierce, 1975).

A so-called definition of "woman" which has had an enormous and pervasive influence on vast segments of human thought, however ludicrous we can recognize it to be, is that which holds that "a woman is a defective man." This view was suggested by Aristotle in the fourth century B.C. Aristotle was one of the most influential philosophers of ancient Greece. His work was rediscovered by Christian theologians in medieval Europe; they referred to Aristotle as "the" philosopher and adapted many of his views.

Aristotle's view of women was based partly on a theory that among animal species, females have less vital heat than males. He reasoned that woman, lacking this heat, was unable to impart shape to what flowed away as menstrual blood. Woman's part in conception was merely to supply the container, the "flower pot," one might say, in which the distinctive seed, im-

For Him **Box 2.1**

The definition of woman in terms of man's needs admits of variations. In particular it varies depending on whether it is the adult male or the male child's perspective that is regarded as primary. In the first case it is the role of assistant/wife that is considered as definitive for femininity and for "fulfillment" as a woman, in the second case it is the role of mother that is definitive for femininity and womanhood. In our culture the assistant/wife role is seen in terms of such traits and abilities as the following, not necessarily in this order: attractive appearance; a responsiveness to her man which makes him feel attractive; a willingness to take over routine tasks and accomplish them to perfection; the ability to produce a home/office/children which are a credit to him; a personal style which is supportive to her man which enables her to work around and modulate his moods, quirks and neuroses, disguising them even from herself; a loyalty to her man above all else; and the ability to amuse herself when not needed. Maternal worth is seen in terms of such traits and abilities as the following: physical strength, stamina, a disposition which is placid enough to nurse with ease, but versatile enough to change with each new stage of the child's development so that, for example, she is enthralled with physical functions of the infant and can stimulate the intellectual interest of a twelve-year old. (In short she is able to produce a highly achieving but non-neurotic son.) Furthermore she is devoted to her children above all else, and able to induce their father into taking an interest in them, never sees herself as martyr, and is able to sustain herself as her children outgrow her. I submit that characteristics for the mother role are not only different from but conflict with those of the assistant/wife role. As with all roles there is a negative as well as positive aspect implicit in each, so that a woman *qua woman* is in jeopardy of becoming a *bad* assistant/wife, epitomized in a witch who steals men's potency or even literally steals his penis and the evil mother, epitomized in the witch who kills and even eats children. Success as an assistant/wife runs the danger of making a woman a bad mother, and the perfect mother is at risk for being a bad assistant/wife. (Whitbeck, 1976:61–62)

From "Theories of Sex Difference" by Caroline Whitbeck in *Women and Philosophy*, copyright © 1976 by Carol C. Gould and Marx W. Wartofsky. Reprinted by permission of G.P. Putnam's Sons.

planted by a man, grows (Whitbeck, 1976). "We should look on the female," Aristotle said, "as being as it were a deformity, though one which occurs in the ordinary course of nature" (Aristotle, 1943).

Although we now know this "biological" theory to be mistaken, belief in it has had long-lasting implications that have nothing to do with biology. Lest we discount as archaic and therefore unimportant Aristotle's notion that women are "defective" men, and his view of *why* we are, we need only be aware of how a related outlook is ingrained in the thinking of Sigmund Freud

(1856–1939). Freud's conception of females added up to the view that we are defective males because we lack penises (see chapter 4).

One issue, of course, is that the biological "facts" imagined by Aristotle and others are false. We now understand that both the woman's ovum and the male's sperm contain essential chromosomes to create the genes which form the embryo. We also know that without the Y chromosome, all embryos would be female. And although the female does not have a penis, the implications of this for the female may not be what Freud claimed them to be. We could as well claim that the man lacks a clitoris and has, instead, an elongated and inefficient organ of a similar kind. In this view, a man would be a defective woman. Such "facts" depend, then, on our perspective.

A discussion of facts, however, is not the end of the matter. The more significant question is why anyone would suppose that from any such "facts" about such a biological process or reality, conclusions of an evaluative kind could be drawn. To suppose that a woman is a *defective* man, or less *important* as a human being, or of lesser worth, or that she *ought* to be ruled by men, or ought to be passive, does not follow from *any* facts of biology or psychology.

The contemporary version of such arguments is that women have some biologically based trait, such as being less aggressive, which is properly reflected in society, as in having men dominate women in all major activities. But no such conclusion can follow from any statement of biological fact. Even if it were true that men are innately more aggressive, society might be organized so as to restrain far more than it now does, or even punish, the aggressiveness of men, rather than reinforce and reward it.

Because women give birth to babies, it has often been supposed that this is our primary function, and that it is somehow fitting that we be confined to the role of mothers, nurturers, or homemakers. Again, no such conclusion follows from the biological facts, but innumerable thinkers, from ancient times to the present, have made such gross mistakes of reasoning when the subject was women.

Aristotle, again, gives us a good example. He assumed that we could understand what a thing *is* by understanding what it does, as when we see that a knife is a thing whose function is to cut. The function of woman, he thought, is to bear children, whereas the function of man is rational activity. He did not argue that the function of man was to beget children. He also argued that since the function of woman is not the same as the function of man, virtue for women is different from virtue for men. A woman's virtue could only be found in serving men. A "good woman" is one who produces children and confines herself to this function.

Aristotle had a hierarchical view of human society. He thought it right and proper for free, adult males to rule over women, children, and slaves, for he believed that only some adult males are capable of being fully rational. Aris-

totle held that slaves, both female and male, lack the ability to deliberate, that children have this ability only in an underdeveloped form, and that in all women the ability is only partial or defective. We now recognize such theories of intelligence, or reasoning ability, to be false. There is no evidence of significant differences of intelligence among people differentiated by race or sex. But again, *even if there were* a difference of intelligence, this would not entitle us to conclude that those with greater intelligence *ought* to be in a privileged position in society. Society can be based on equal rights even if persons are biologically unequal in intelligence, strength, or psychological tendencies.

Arguments from biology or psychology to social advantages that are claimed to be justified have many forms. Women need to be on guard against the many current misuses of such arguments (box 2.2).

Religious Reflections
Throughout most of its history, the Christian conception of women has not been very different from that of Aristotle, even though the authority claimed has been "spiritual" rather than "natural." In Simone de Beauvoir's words, "through St. Paul the Jewish tradition, savagely anti-feminist, was affirmed" (de Beauvoir, 1953:97). The church fathers, who largely determined the philosophical conceptions of the West until the sixteenth century, continued and refined the basic views concerning women that were already dominant. Augustine in the fifth century and Thomas Aquinas in the thirteenth continued to maintain that the function of woman was to procreate. Aquinas put it this way: "It was necessary for woman to be made, as the Scripture says, as *a helper* to man; not, indeed, as a helpmate in other works, as some say, since man can be more efficiently helped by another man in other works; but as a helper in the work of generation" (Mahowald, 1978:80).

Many religious thinkers have held that religious "truths" can be discerned by reason, or they have thought that reason enables us to understand what revelation gives us grounds to believe. Accordingly, women, whose powers of reasoning have so often been thought to be inferior, are considered deficient from a religious point of view. But even those thinkers who based religion on faith rather than reason thought that women lacked the intellectual commitment necessary for true faith.

When it has been pointed out that Eve seems to have displayed intellectual curiosity and courage in eating of the fruit in the Garden of Eden, the church has responded with its gravest and most persistent charge: woman is evil. Almost all religions display a remarkably consistent attitude of hostility toward women. Women are not only other and inferior; they are also the source of what is wrong in the world. Pythagoras, one of the earliest Greek philosophers, arranged the ten basic principles of things into two columns: on one side he listed right, male, straight, light, and good, while in the other

What is "Natural" for Women? Box 2.2

What does it mean ... to say that nature intends for us to do certain things? We know what it means to say that "I intend to pack my suitcase," but what sense can it make to say that nature intends for us to do one thing rather than another? [One] use of "natural" reduces to saying "this is what most animals do." To the extent that this is the meaning of the term, it will be hard to get a notion of value out of it. The fact that something happens a lot does not argue for or against it. . . .

Teleological uses of "natural" automatically set up an evaluative context; knowing the function of "X" makes it possible for us to evaluate "X" on grounds of functioning well. But . . . teleological uses have to be morally evaluated: a good bomb is one that destroys, but is a good bomb morally good? (Pierce, 1977:162, 171)

From "Natural Law Language and Women" by Christine Pierce in *Woman in Sexist Society: Studies in Power and Powerlessness*, edited by Vivian Gornick and Barbara Moran. Copyright © 1971 by Basic Books, Inc. By permission of Basic Books, Inc., Publishers, New York.

column he included left, female, crooked, darkness, and evil (Kirk and Raven, 1962).

The religions of the world have elaborated this theme in countless ways, embedding them in the deepest levels of human belief (box 2.3). Feminists are now attempting to clarify and to change the concepts and principles bequeathed to us by our religious heritage. We are appealing beyond the institutions that have so often excluded women to the sources of religion itself in human—but this time female—experience. And we are investigating the causes of religious doctrines that denigrate women in the unconscious fears of the men who have invented them. (These issues will be examined in chapter 10.)

Ideas of Equality

The first major rejection of the hierarchical traditions that characterized much of Western thought from the time of Aristotle occurred in the seventeenth and eighteenth centuries. Enlightenment philosophers deliberately rejected notions of original sin and of the innate inferiority of some men compared with others. They emphasized instead the essential equality of men and the importance of liberty. This liberal tradition formed the background of the new American nation in the late eighteenth century and its ideas have helped to shape the society of the United States to a significant extent ever since. The familiar words of the American Declaration of Independence express the dominant ideas of the liberal tradition: "We hold these truths to be self-evident, that all

Hindu Conceptions **Box 2.3**

By the time of the lawgivers the literate woman had become anathema. Manu decreed that women had no right to study the Vedas. Not only did literacy become a rare quality in women, but it was even regarded as disreputable. . . .

The lawgivers declared women to be inherently impure. . . . In the *Bhagavadgītā* women are lumped together with sinners, slaves and outcastes. Medieval writers like Mitramiśra held that women were quite ineligible not only for the upanayana but for most other religious rites as well. . . . Orthodox Hindus, like the Digambara Jains, hold that women can never attain salvation except by being reborn as men. . . .

The *Taittirīya Samhitā* declares that a good woman is worse than a bad man. *The Maitrāyana Samhitā* describes woman as Untruth. The *Mahābhārata* says, "Woman is an all-devouring curse. In her body the evil cycle of life begins afresh, born out of lust engendered by blood and semen. Man emerges mixed with excrement and water, fouled by the impurities of woman. A wise man will avoid the contaminating society of women as he would the touch of bodies infested with vermin." The Lawbook of Manu states that killing a woman, like the drinking of liquor, is only a minor offense. . . .

Manu declared, "Day and night woman must be kept in subordination to the males of the family: in childhood to the father, in youth to her husband, in old age to her sons." . . . Complete devotion, absolute fidelity and submissiveness to him was the least that any wife owed her husband, and these virtues were greatly extolled in the Hindu scriptures. Manu says, "Even though the husband be destitute of virtue, and seeks pleasure elsewhere, he must be worshipped as a god." (Walker, 1968:603–5)

men are created equal; that they are endowed by their Creator with certain inalienable rights; that among these, are life, liberty, and the pursuit of happiness. That, to secure these rights, governments are instituted among men, deriving their just powers from the consent of the governed."

Many refer to this tradition as the democratic tradition because it led to the development of political democracy. Liberalism requires such aspects of political democracy as periodic free elections, an independent judiciary, laws which respect the rights of citizens to be treated fairly, and a government that is responsive to the will of its citizens as expressed through the political process.

Traditional liberalism in the nineteenth century fostered the acceptance of "laissez faire," the view that government should not interfere with the economic activity of citizens. This political policy allowed the relatively unrestrained growth of capitalist forms of economic production and ownership. Liberalism did not require economic institutions to be democratic, and it

retains this deficiency to a large extent. Though government may enact laws which businesses must obey, the liberal view regards economic activity as belonging to a "private" sphere. The term *private enterprise* specifically indicates that economic activity is considered appropriately *outside* the sphere of democratic political control and decision, that it is to be free to develop (its critics would say free to exploit) without governmental interference. Criticism of exploitative capitalism also developed in the nineteenth century, and there were calls for political restraints on "free enterprise" along with more radical demands for the overthrow of capitalism. Many contemporary social critics point out that the modern corporation is an extraordinarily undemocratic institution and that the vast disparities of wealth and income and inherited position between rich and poor in an economic system such as that of the United States are incompatible with the spirit and principles of democracy.

In the tradition of political liberalism, therefore, democracy applies to the political sphere of activity, not to the economic. This view of democracy continues to dominate opinion in the United States and to a lesser extent in Western Europe. Many socialists also advocate democracy. But democratic socialism argues that economic activity ought to be organized to serve the needs of the whole society rather than allowing individuals to own the means of production and to profit from this private ownership. The liberal tradition and the alternative democratic socialist tradition differ in their views of the sort of economic system we ought to have, but both claim to be democratic.

The liberal tradition has made the concepts of freedom and equality central to our ways of thinking. Most of us characteristically begin our discussions of what society ought to be like with commitments to democracy, to freedom, to equality, and to the rights of individuals. But liberalism has not applied these principles in a satisfactory way to women.

Liberalism and Feminism

Feminists often take for granted various principles which liberalism first espoused, such as that people have rights to be free and to be treated as equals, and that social arrangements ought to be based on consent and not simply imposed by the strong on the weak. These ideas were developed in Europe and America in the seventeenth and eighteenth centuries, but until very recently, had not been applied to women as well as men, even in the political domain. Women were only given the vote, an absolute minimum of political equality, in England in 1918 and 1928, in the United States in 1920, in France in 1945, and in Switzerland in 1971. But liberal ideas are the foundations on which feminists have often built, and many continue to do so. They offer us conceptions of freedom and equality and suggest principles to which we should commit ourselves.

In the early seventeenth century in England, the dominant view was that represented by Robert Filmer (c. 1588–1653), who held that political author-

ity should be based on inherited title, with the rulers of nations standing toward their subjects as a father toward his wife and children. Filmer advocated benevolent patriarchy throughout society. With the rise of democratic liberalism, this view as a view of government was replaced. Thomas Hobbes (1588–1679) and John Locke (1632–1704) saw government as based on a hypothetical contract between free and equal individuals. The purpose of government was to protect the rights of individual citizens and to serve the interests of those who contracted to establish and maintain government. The great documents of political freedom and equality such as the Declaration of Independence and the French Declaration of the Rights of Man reflect these views. Society was to be based on principles of equality and freedom.

The citizens for whom liberal government was thought legitimate, however, turned out to be male heads of households. The interests of women were thought to be covered by taking account of the interests of these men. As James Mill (1773–1836) expressed it as late as 1820 with respect to who should be permitted to vote:

> One thing is pretty clear, that all those individuals whose interests are indisputably included in those of other individuals, may be struck off without inconvenience. In this light may be viewed all children up to a certain age, whose interests are involved in those of their parents. In this light also, women may be regarded, the interest of almost all of whom is involved either in that of their fathers or in that of their husbands. (James Mill, 1821:21)

Most liberal thinkers were not explicit on the subject of women. They took the family as given, and they saw women as confined to the family. They neither included women in the political realm as free and equal citizens nor considered the possibility of relations *within* the family becoming egalitarian and consensual. As Susan Okin writes in her important study *Women in Western Political Thought*, "Whereas the liberal tradition appears to be talking about individuals, as components of political systems, it is in fact talking about male-headed families. . . . Women disappear from the subject of politics" (Okin, 1979:202).

Not all of the fathers of democracy and liberalism were so reticent. Jean Jacques Rousseau (1712–1778), one of the most important figures of the Enlightenment on the European continent, argued that liberal principles could not and must not be applied to women, or government would be impossible. He exemplified the contradiction between an egalitarian view of men in society and an inegalitarian view of women in relation to men. In his book *Émile*, he maintained that women must learn to submit to man's will and to find happiness in doing so. It was according to nature, Rousseau argued, for the woman to obey the man. "The entire education of women must be relative to men. To please them, to be useful to them, to be loved and honored by them, to rear them when they are young, to care for them when they are grown up, to counsel and console, to make their lives pleasant

and charming, these are the duties of women at all times" (in Okin, 1979:136).

Since the essence of being human, for Rousseau, is freedom, women in his conception become less than fully human. Rousseau argued that within the family, there must be a dominant authority (which must be the father). Without the rule of the man within the family, society would fall apart.

It never occurred to Rousseau either to apply the principles of freedom and equality to relations between women and men in the family *or* to apply to the wider society his conception of the necessity for clear lines of authority in the family. If Rousseau was right that not even two persons with ties of affection and common concerns can reach decisions on the basis of mutuality rather than domination and submission, it would suggest that there is little hope for the democratic, consensual organization of any larger society which he so passionately advocated. On the other hand, if the liberal and democratic view of government is correct—that is, if government should be based not on tradition or force but on consent between free and equal individuals—it is remarkable that its adherents have been so unwilling to extend such ideas to that bastion of tradition and coercion, the family.

Along with many others, Rousseau invoked nature to keep women from sharing in the principles of the Enlightenment. The so-called philosopher of freedom declared that

> Nature herself has decreed that woman, both for herself and her children, should be at the mercy of man's judgment. . . . When the Greek women married, they disappeared from public life; within the four walls of their home they devoted themselves to the care of their household and family. This is the mode of life prescribed for women alike by nature and reason. (1966:328–30)

Wollstonecraft

Mary Wollstonecraft (1759–1797) is perhaps the first woman philosopher to make a place for herself in history, although few histories of philosophy mention her. Writing in England in the late eighteenth century, she shared fully in the Enlightenment's reliance on human reason to assure human progress. But she argued forcefully against Rousseau's view that women are inferior in reasoning and that virtue in a woman is thus different from virtue in a man. She wrote in 1792:

> Men, indeed, appear to me to act in a very unphilosophical manner when they try to secure the good conduct of women by attempting to keep them always in a state of childhood. . . . It is a farce to call any being virtuous whose virtues do not result from the exercise of its own reason. This was Rousseau's opinion respecting men: I extend it to women. (1967:50, 52)

Wollstonecraft said that women had been taught to be creatures of emotion rather than of reason. Instead, we should have educations comparable to those which enable at least those men not corrupted by too much wealth to

Mary Wollstonecraft, a courageous opponent of Rousseau's view that women should be subordinate to men, argued in her book *A Vindication of the Rights of Woman* (1792) that the principles of freedom and equality are as valid for women as for men. (Sophia Smith Collection [Women's History Archive] Smith College, Northampton, MA 01063)

become rational and responsible beings. She was not discouraged by the magnitude of the changes needed in human behavior; with so many other Enlightenment thinkers, she celebrated the distance already traveled by men:

> Men have submitted to superior strength to enjoy with impunity the pleasure of the moment—women have only done the same, and therefore till it is proved that the courtier, who servilely resigns the birth-right of a man, is not a moral agent, it cannot be demonstrated that woman is essentially inferior to man because she has always been subjugated.
>
> Brutal force has hitherto governed the world, and that the science of politics is in its infancy, is evident from philosophers scrupling to give the knowledge most useful to man that determinate distinction.
>
> I shall not pursue this argument any further than to establish an obvious inference, that as sound politics diffuse liberty, mankind, including women, will become more wise and virtuous. (1967:73)

To Wollstonecraft, the principles of the Enlightenment were correct principles that ought to apply fully to women as well as to men. Unfortunately, Rousseau's ideas rather than Mary Wollstonecraft's appealed to those who have made history and the history of ideas in their own image. What gains women made in the political turmoil of the eighteenth century were soon lost, even in theory (see chapter 15).

Various rationalist philosophers on the European continent continued to maintain that women are defective in rationality, however admirable in other respects, such as beauty or sensitivity. In Germany, the influential philosopher Immanuel Kant (1724–1804) developed a morality based on reason alone, seeing the fundamental principle of morality as a requirement of rationality. Since women in his view are emotional rather than rational beings, we are not capable of fully moral action. Thus the great moral principles enunciated so forcefully by Kant, which added to the liberal tradition of respect for individual rights the concept of respect for persons *as* persons, are simply not applicable to women.

At the same time, among various critics of Enlightenment optimism about human reason and progress, the denigration of women is often deeper still. The German philosopher Friedrich Nietzsche (1844–1900) looked on women as "property," destined to serve man (box 2.4).

Mill and Taylor

Almost all the giants of the liberal tradition excluded women from the political world in one way or another, but there were a few exceptions. John Stuart Mill, the son of James Mill, argued for an end to the subjection of women. Mill's lifelong companion and eventual wife, Harriet Taylor (1807–1858), helped him develop his feminist positions. Mill argued that the liberal requirements of equal rights and equal opportunities should be extended to women and that women ought to be able to own property, to vote, to receive

Woman as Servant **Box 2.4**

To go wrong on the fundamental problem of "man and woman," to deny
the most abysmal antagonism between them and the necessity of an eter-
nally hostile tension, to dream perhaps of equal rights, equal education,
equal claims and obligations—that is a *typical* sign of shallowness, and a
thinker who has proved shallow in this dangerous place—shallow in his
instinct—may be considered altogether suspicious, even more—betrayed,
exposed: probably he will be too "short" for all fundamental problems of
life, of the life yet to come, too, and incapable of attaining *any* depth. A
man, on the other hand, who has depth, in his spirit as well as in his
desires, including that depth of benevolence which is capable of severity
and hardness and easily mistaken for them, must always think about
women as *Orientals* do: he must conceive of woman as a possession, as
property that can be locked, as something predestined for service and
achieving her perfection in that. Here he must base himself on the tremen-
dous reason of Asia, on Asia's superiority in the instincts, as the Greeks
did formerly, who were Asia's best heirs and students: as is well known,
from Homer's time to the age of Pericles, as their culture *increased* along
with the range of their powers, they also gradually became *more severe*,
in brief, more Oriental, against woman. *How* necessary, *how* logical, *how*
humanely desirable even, this was—is worth pondering.

(Nietzsche, 1966:166–67)

From Friedrich Nietzsche, *Beyond Good and Evil*. 1886. Translated by Walter
Kaufman. Copyright © 1966. Reprinted by permission of Random House, Inc.

education, and to enter into any profession for which we were qualified.
These views were the height of radicalism in mid-nineteenth-century England,
but discussions of Mill through the 1960s usually fail to include his ideas on
women among his important writings.

Mill's arguments ran counter to those of the French philosopher Auguste
Comte (1798–1857), often considered the "father of sociology." Comte as-
serted that women are biologically inferior to men and will always be so.
Biology, he claimed, was already "able to establish the hierarchy of the sexes,
by demonstrating both anatomically and physiologically that, in almost the
entire animal kingdom, and especially in our species, the female sex is formed
for a state of essential childhood" (Okin, 1979:220). Mill rejected the view
that observable deficiencies found among women are due to innate inferior-
ity. He argued that since women have never been given a chance to gain the
same education and intellectual development as men, we cannot know what
our capacities are. It may well be, he thought, that the environment rather
than any innate incapacity has caused women to achieve less than men so far.

Mill believed that society would benefit if women were given all the educa-
tional opportunities given men. But even he thought that although women

Harriet Taylor Mill left us only a small legacy of her writing, but her views about women and the issues of women's emancipation were essential to the analysis made of this subject by the nineteenth-century philosopher John Stuart Mill. (The London School of Economics, The British Library of Political and Economic Science)

should be free to choose a career, marriage itself was a career. Despite Harriet Taylor's objections, he continued to think that while men could have both parenthood and an occupation, women could have only one or the other.

Harriet Taylor's own writings on women were even more forceful than Mill's in demanding equality for women. She derided the faulty arguments through which men tried to support their refusal to accord women equality.

> Apart from maxims of detail, which represent local and national rather than universal ideas: it is an acknowledged dictate of justice to make no degrading distinctions without necessity. . . . When that which is interdicted includes nearly everything which those to whom it is permitted most prize, and to be deprived of which they feel to be most insulting; when not only political liberty but personal freedom of action is the prerogative of a caste; when even in the exercise of industry almost all employments which task the higher faculties in an important field, which lead to distinction, riches, or even pecuniary independence, are fenced round as the exclusive domain of the predominant class . . . the miserable expediencies which are advanced as excuses for so grossly partial a dispensation, would not be sufficient, even if they were real, to render it other than a flagrant injustice. . . .
>
> The world were once persuaded that the supreme virtue of subjects was loyalty to kings, and are still persuaded that the paramount virtue of womanhood is loyalty to men. . . . Self-will and self-assertion form the type of what are designated as manly virtues, while abnegation of self, patience, resignation, and submission to power . . . have been stamped by general consent as preeminently the duties and graces required of women. The meaning being merely, that power makes itself the centre of moral obligation, and that a man likes to have his own will, but does not like that his domestic companion should have a will different from his. (H. Taylor Mill, 1970:97)

Harriet Taylor has been the object of much calumny by a host of antifeminist critics, male and female, who expect women to defer to men, especially great men. The American literary critic Diana Trilling said of her: "This was no woman, no real woman" (Held, 1971). The women's movement of recent years has led to a reevaluation of Taylor and to a new appreciation of her strengths.

Liberal Feminism

Contemporary liberal feminists often continue the task begun by Wollstonecraft and the Mills: to extend liberal principles to women, not only when we enter the so-called public realm but also within the family. Equality, it is argued, can never be realized for most women if we are forced by social convention or law to choose between parenthood and a career while men can have both. The marriage contract can never be a free and voluntary agreement as long as women are forced by economic necessity to marry or stay married, and as long as the terms of the contract are so clearly unfair, within what used to be the standard marriage—the entire responsibility of child

care and household tasks falling on the mother, and the opportunity of developing a career and economic independence open only to the father. And since wives, and especially mothers, perform hard work in the home for very long hours, the economic value of this work should be recognized.

Some feminists favor wages for housework. But pay for housework (as distinct from support payments to provide for children) may do little to change the unjustifiable division of labor within the household that assigns tasks on the basis of gender. A more plausible liberal solution is the equal sharing of housework and child care and of the responsibility to support the family economically (Bem and Bem, 1978).

Liberal feminists also call for the equalization of women and men in the realms of political life and economic activity, where liberals have always professed commitments to equality of opportunity (though not to "economic democracy"). The liberal tradition should be seen to imply that women have an equal right to as much education as men, to develop an occupation that is as fulfilling, to hold public office, to choose to have or not have children, and to be a parent with some leisure for further self-development. To make equal opportunity a reality, special efforts of "affirmative action" to open up opportunities for women will have to be made. As the U.S. Supreme Court declared in a six-to-three decision in the *Fullilove* case (1980), it may be quite legitimate to set aside a certain number of jobs or a percentage of spending for a minority group in order to remedy past discrimination against that group. This case concerned racial minorities, but similar arguments apply to remedying discrimination based on gender, as when a police department may decide to hire qualified women ahead of qualified men because its policies in the past have unfairly kept women off the force.

The resistance of men and of society to the changes that their own traditions indicate should be made tells us something about the extent to which self-interest rather than a commitment to principles of equality motivates the behavior of the fortunate (see chapter 14). As Joan Kelly (1976) pointed out, during many of the great periods of "progressive" change in history, such as classical Athenian civilization, the Renaissance, and the French Revolution, women not only failed to share in the progress, but actually suffered a "relative loss of status." But among the strongest arguments feminists can make is that the traditions of liberalism and democracy inherently require many of the changes we seek (Eisenstein, 1981).

Relevant Characteristics
In making our arguments, feminists can usefully employ some arguments made by one of the greatest philosophers of all, Plato, the teacher of Aristotle in ancient Greece. Unlike Aristotle and nearly all the best-known philosophers since, Plato was, at least to some extent, an early feminist. For centuries hostile critics have ignored and distorted his arguments concerning women

(Pierce, 1973). But these arguments are remarkably relevant to discussions taking place today concerning the role of women in various occupations from which we have been excluded. They illustrate well how philosophy can help us to construct solid arguments for equality and justice and develop the reasons needed to defend them.

Plato was no advocate of democracy because he thought that a just society should be ruled by those best at ruling; he did not think democracy was the best method for bringing this about. But Plato did think rulers should govern in ways that would be best for *everyone* in a community, not just best for the rulers. He advocated a long period of education and very rigorous testing, of both knowledge and character, for those who would, at age fifty, be selected as fit to govern.

Women, he argued in *The Republic,* may well be among these, a highly original view at the time. Plato thought that in choosing rulers, we should consider only *relevant* characteristics, and that whether one "bears or begets" children is *not* relevant to whether one is fit to govern. He believed that in general women are less good at everything than are men, and in this he accepted various highly misogynist opinions of his time (Pomeroy, 1975), but the point that was essential to his argument was that some women are better than some men at given activities and should be judged on the basis of individual capacities for ruling. These capacities included a developed intelligence, courage, and an ability to resist the temptation of selfish gain. Women, then, should be considered as candidates for the ranks of the "guardians" of society along with men. If the same qualifications for selection are applied to women as to men, some women will be chosen.

Plato's arguments concerning relevant characteristics and their relative distribution are reflected in contemporary discussions of the suitability of women for all occupations. Even though women may on the average have less physical strength than men, some women have more physical strength than some men. Thus, we should not be excluded even from occupations requiring considerable physical strength, such as the jobs of "longshoremen." Physical strength is not a relevant consideration for most occupations. Neither is the capacity to bear children, nor the fact of having borne them.

Feminists keep constantly in mind that being a woman is not a relevant basis on which a person should be excluded from an occupation, paid a lower wage, or denied a loan or a promotion. Nor is being a man a relevant basis on which a person should avoid doing a fair share of the job of parenting.

The Concept of Freedom

In addition to concerning ourselves with equality, feminists need to develop principles of freedom for women. In doing so, we may recognize that freedom for women will have to be very different from the freedom advocated by

the liberal tradition, which is essentially a freedom to be left alone without governmental interference. This concept of freedom was developed by such theorists as Hobbes and Locke with the self-sufficient farmer or tradesman in mind. It was assumed that if such a "free man" had no property, he could always acquire some unoccupied territory belonging to no one—of which there was still at that time thought (however erroneously) to be a considerable amount. Left alone by those who might rob or kill him and by a government that ought, according to this view, do no more than protect his life and property from attack, he would be free.

This conception of freedom is sadly out of date for all those in contemporary industrial society who do not already own substantial amounts of property—whether land or capital or a satisfactory, safe income. It is particularly unsatisfactory for women. Poverty-stricken people who are taking care of small children, for example, need to have basic necessities provided, not just to be left alone. People need to have jobs made available if they cannot find employment. The traditional image of the strong individual able to fend for himself and acquire what he needs through his labor with no help from society is a romantic image that simply does not apply to today's society or to most women. There is no empty land there for the taking. A person may try to sell her or his labor but find no one to buy it. In contemporary society, people need to be enabled to be free, not just to be left alone to cope with their deprivations (Held, 1978).

The liberal tradition offers the basis on which our ideas of freedom and equality might be developed so women can enjoy the individual rights to which "all men" have long been thought to be entitled. In recent years, many American feminists have been working within this tradition and expanding on it. We argue for rights to basic necessities such as food, shelter, and medical care, and for rights for a woman to decide for herself whether to have children or an abortion. We argue for rights to employment—that is, to actually *have* a job—as well as to be treated fairly in trying to get a job which happens to become available and in advancing within it. We argue for a meaningful kind of "equality before the law," plainly stated in the Constitution and then substantively interpreted. Women can never be liberated without a more satisfactory idea of what freedom is than the one so far recognized in the law of the United States.

Conservative Sentiments and Feminism

Conservatives have often claimed to be concerned about many aspects of life important to women and valued by us: the family, the voluntary association, the moral standards of society. Traditionally, they have upheld ties of family and friendship against the more calculated and competitive relations advocated by traditional liberalism. They have understood the emo-

tional value of ethnic traditions and the role of habits of discipline or responsibility. A liberal sometimes appears willing to decide everything in the marketplace; to a conservative, there are things which should not be bought and sold, such as a person's honor. Alexis de Tocqueville, a French observer of nineteenth-century America, is often cited by conservatives: "When a class has taken the lead in public affairs for centuries," he wrote, "it develops as a result of this long, unchallenged habit of pre-eminence a certain proper pride and confidence ... It not only has itself the manly virtues; by dint of its example it quickens them in other classes. ... We should be ill advised to belittle our ancestors; and would do better to regain, even if it meant inheriting their prejudices and failings, something of their nobility of mind" (de Tocqueville, 1955:111, 119).

In some respects, the sentiments of feminists parallel those of conservatives. Feminists too understand the importance of family relations although we have different notions of what constitutes a family. We too resist the calculations of liberal self-interest and commercialism. But conservatives have so far shown no inclination to transform their views in a way that would be compatible with feminism. The traditional values conservatives try to uphold include that of the place of woman: in the home, as wife and mother, giving emotional support to a husband who supports her economically. And conservatives nearly always adopt positions which uphold economic as well as social privileges while espousing a commitment to moral principles. Their lack of consistency undermines their credibility. For example, the conservative Republican platform of 1980 refused to support a constitutional amendment providing equal rights to women on the grounds that the federal government should not be involved in this issue; at the same time, it advocated a constitutional amendment banning abortion to assure that the federal government would be involved in this issue.

Conservatives (even more so than traditional liberals) favor less governmental regulation of the activities of business corporations. Yet conservatives (unlike liberals) favor more governmental regulation of the sexual behavior of individuals. The idea that the activities of a large corporation which affect the lives of millions, are "private" while what consenting adults do in bed is "not private" does not stand up well to critical reflection. Nor does the claim that conservatives respect women, if at the same time they expect women to "stay in their place."

Socialism and Feminism

Many feminists look to the socialist tradition as the most satisfactory source of ideas for a women's movement that will improve society. These feminists see conservatism as conserving a sexist status quo and fear that liberalism will merely promote an even more generalized pursuit of self-interest than

already exists. Socialist feminists fear that too many of the few women in a liberal capitalist system who will taste success will learn to scramble for self-advancement in the corporate hierarchy, striving for profits regardless of the good of society, just as men do. And too many other women will simply be left out, especially Third World and minority women.

These feminists claim that liberalism has never paid enough attention to economic issues because of its concern with political issues and its tradition of laissez-faire. Women could gain all sorts of legal rights such as the right to vote, the right to equal admission to professional schools, the right to join certain clubs, and even the right to abortion, and still be left in a condition of economic dependency thoroughly damaging to our self-respect and our efforts to win liberation.

The unfortunate effect of the economic dependence of women was recognized by Karl Marx (1818–1883) and Friedrich Engels (1820–1895). In *The Origin of the Family, Private Property, and the State,* Engels argued that the institutional and cultural manifestations of a given historical period, including the monogamous family, result from economic causes. At that stage of human development at which property began to be accumulated by men (though it is not clear, some feminists note [Flax, 1976], why it was *men* who did the accumulating), men became the first ruling class.

In the middle-class family of Western capitalism, as seen by Marx and Engels, the wife had sold herself sexually for economic support. In the eyes of many other writers as well, the wife and mother in the successful bourgeois family of Victorian times was "elevated" to a position of powerlessness: cared for by hired servants, flattered but sexually imprisoned, denied any chance for self-development or personal freedom.

Women of the lower classes, meanwhile, were economically exploited in factories and needletrades and as domestic servants even more brutally than were men. Economic and social "progress" by late in the century had moved many women from the factory into the home. They aspired to the status and promised security of the middle-class wife, not realizing how few could achieve it or how unsatisfactory this goal could turn out to be. The point was well made by Charlotte Perkins Gilman (1860–1935), the author of "The Yellow Wallpaper" and of *Women and Economics,* published in 1898:

> When the woman, left alone with no man to "support" her, tries to meet her own economic necessities, the difficulties which confront her prove conclusively what the general economic status of women is. . . . We see the human mother worked far harder than a mare, laboring her life long in the service, not of her children only, but of men; husbands, brothers, fathers, whatever male relatives she has. . . . The human female, the world over, works at extra-maternal duties for hours enough to provide her with an independent living, and then is denied independence on the ground that motherhood prevents her working!" (Gilman, 1966:10, 19–20, 21)

The Marxist view held that the working class must gain control of the means of production and thus end the exploitation of workers by capitalists. In this view, if women enter the labor force in large numbers, our problems will be soluble along with the problems of the working class. Marxist feminists, however, recognize that this picture needs revision.

One should not make the mistake of supposing that what happens in Communist countries such as the Soviet Union today is a refutation of Marxist predictions since political rule in such countries is a far cry from anything recommended by Marx. Marx's goal was a "classless society"; he thought that an eventual "withering away of the state" would occur as the conflicts between the bourgeoisie and the working class came to an end and that there would be a greatly decreased need for state coercion. Instead, the Soviet Union, for example, represses its citizens to maintain the control and privileged position of Communist party members and their leaders. Although the Soviet government claims to have achieved the equality of women, and most Soviet women work at paid jobs, Western feminists note that Soviet women still have come nowhere near realizing what feminists would consider equality. Virtually no political leader among the upper ranks of the Soviet Union or Eastern European Communist countries is or has been female. In addition, in Communist countries women still carry a double burden. We are still expected, as rigidly as anywhere, to take almost sole responsibility for all the housework and child care done in the home (see chapter 14).

Democratic socialism in Western Europe and elsewhere has in many ways come closer to representing the ideals of Marxism. But it has not escaped the notice of feminists that social-democratic men, along with capitalist and Communist men, have, at least until recently, still expected "their" women to do the dishes and to bring up the children. Social-democratic men have often had great difficulty taking women seriously and acknowledging us as intellectual equals. They have argued that attention to the concerns of women should not be allowed to deflect attention from the "real" struggle: the struggle of the working class.

Socialist Feminism
The lack of awareness among traditional Marxists of the views and problems of women has resulted in the development of a socialist feminist position. This has been one of the leading positions among Western feminists concerned with the formulation and expression of feminist theory (Jaggar and Struhl, 1978; Kelly, 1976). Socialist feminists such as Sheila Rowbotham and Juliet Mitchell argue that many transformations of the economy called for by socialists are necessary before women—confined primarily to the lowest-paying and least secure jobs—can begin to gain real economic independence.

Socialist feminists hold that many specific demands made by socialists will need to be met before society can begin to provide what women need rather

Capitalist Oppression Box 2.5

Oppression is not an abstract moral condition but a social and historical experience. Its forms and expression change as the mode of production and the relationships between men and women, men and men, women and women, change in society. Thus, while it is true that women were subordinated to men before capitalism and that this has affected the position of women in capitalist society, it is also true that the context of oppression we fight against now is specific to a society in which the capacity of human beings to create is appropriated by privately owned capital and in which the things produced are exchanged as commodities.

(Rowbotham, 1973:xiii)

From Sheila Rowbotham, *Woman's Consciousness, Man's World* (Pelican Books, 1973), p. xiii. Copyright © Sheila Rowbotham.

than what is profitable for corporations. All feminists can enthusiastically join socialists in demanding publicly funded child care and medical care, decent housing for all, and nonexploitative jobs for all who can work. And we can join with socialists in working for the changes in corporate capitalism that will be necessary to make these possible.

But socialist feminists also recognize that traditional socialism has failed to understand the specific ways in which women are oppressed *as women* and not merely as workers (Gould, 1976). Socialist feminists emphasize that the traditional gender division of labor *within* the family as well as outside it will have to disappear, that men will have to learn to have as much regard for women as they have for each other, and that feminist alternatives—such as women-centered communities and lesbian families—will have to be recognized as legitimate.

Radical Feminism

In almost all the countries of Western Europe, strong social-democratic political parties periodically win elections and govern. The United States, in contrast, has no strong socialist tradition, and socialism has never become a very significant political influence in the United States. Radicals in the United States—whether women or men—sometimes think they may do better to develop their own arguments for the socially and ecologically responsible control of economic activity. Some think that to invoke the ideas of Marx and Engels, and certainly Lenin, the architect of the Soviet revolution, may hurt more than help their cause.

Certain anarchist ideas dismissed by Marx as utopian appeal to some feminists, and many think we must develop our own ideas rather than rely on

any previous social or political theories, including those of male radicals in the United States.

For anarchists, personal liberty is the highest ideal, and all authority is suspect. *Any* government or other concentration of power is seen as a threat to individual autonomy. The anarchist tradition would suggest that we should be suspicious of socialist bureaucracies as well as large corporations and national governments. We should strive for a high degree of individual control over our lives even at the expense of "working class solidarity" or economic efficiency (Krimerman and Perry, 1966).

Many radical feminists emphasize that emancipation for both women and men will also require a reorganization of society and work in ways that will allow for warmth and love within the family and between friends and neighbors and colleagues.

One of the most eloquent and spirited forerunners of contemporary feminism was the anarchist Emma Goldman. Born in Russia in 1869, she emigrated to Rochester, New York, as a young woman and became disillusioned with both countries. She deplored the fact that for a woman to succeed in a profession, she virtually had to give up everything else, to refuse to become a wife or mother, to become "empty and dead" as a woman. The lot of the nonprofessional working woman was no better. Goldman argued for a world in which women would be free to develop our minds and talents, but also to feel deeply, to give expression to "the voice of love," and to be sweethearts and mothers as well as workers (in Rossi, 1974:514) (box 2.6).

Gloria Steinem, a highly influential feminist journalist and a founding editor of the magazine *Ms.*, which is both a feminist and a mass magazine, has explained why she prefers to be called, quite simply, "a feminist." But if further distinctions are called for, she would choose to identify herself as a "radical feminist" (box 2.7). Many feminists understand the reasons for such a choice. Feminism will require the dismantling of the deepest misconceptions of all. And although a strong social-democratic movement in the United States would help achieve many of our objectives, feminists may doubt that socialism is a "necessary stage" along the way to a feminist society. Perhaps we can move from capitalism to a feminist society more directly.

Some Principles of Feminism

Just what a feminist philosophy should include is a subject of much discussion among feminists, and there are healthy debates among us. Feminists are engaged in much innovative thinking about the kind of world we should work for and about the sorts of actions that ought to be taken to advance our goals.

All feminists put great emphasis on freedom. The term *women's liberation* expresses this. Women universally have a great deal of experience with what it is like to *be dominated*. Feminists advocate societies which are *not* charac-

Emma Goldman: Woman's Emancipation Box 2.6

As to the great mass of working girls and women, how much independence is gained if the narrowness and lack of freedom of the home is exchanged for the narrowness and lack of freedom of the factory, sweatshop, department store, or office? . . . No wonder that hundreds of girls are so willing to accept the first offer of marriage, sick and tired of their "independence" behind the counter, at the sewing or typewriting machine. . . . Our highly praised independence is, after all, but a slow process of dulling and stifling woman's nature, her love instinct and her mother instinct. . . . Emancipation, as understood by the majority of its adherents and exponents, is of too narrow a scope to permit the boundless love and ecstasy contained in the deep emotion of the woman, sweetheart, mother, in freedom. . . .

The demand for equal rights in every vocation of life is just and fair but after all, the most vital right is the right to love and be loved. Indeed, if partial emancipation is to become a complete and true emancipation of women, it will have to do away with the ridiculous notion that to be loved, to be sweetheart and mother, is synonymous with being a slave or subordinate. It will have to do away with the absurd notion of the dualism of the sexes, or that man and woman represent two antagonistic worlds. (In Rossi, 1974:510–16)

terized by relations of domination and subordination (Held, 1976). We are, in a sense, the true "democrats," advocating for people in every sphere of life a freedom and equality that will enable all to live with dignity and respect.

In regard to economic issues, feminists sometimes start with the workplace. We advocate units of economic activity in which a concern for the environment and for providing satisfying work is more important than either profits or high wages. We seek work arrangements that will encourage cooperative rather than hierarchical and coercive interaction among members (Hartsock, 1980).

Just as in the household, the question must be asked outside the home: What work *needs to be done?* Obviously, much of the work that gets done in both business and bureaucratic societies does *not* need to be done: people are persuaded to buy things they do not need so that corporations can increase their sales and officials multiply the occasions on which they can exercise their authority over citizens, regardless of whether this serves a useful purpose. On the other hand, important work often is not done: children go uncared for and inexpensive housing goes unbuilt because those with the capital to invest do not consider that there is adequate profit to be made in these areas.

Feminists deciding what work needs to get done begin with the meeting of real human needs. The next questions may concern how to divide the work

Gloria Steinem: Feminist Labels **Box 2.7**

In the label department . . . I would prefer to be called simply "a feminist." After all, the belief in the full humanity of women leads to the necessity of totally changing all male-supremacist structures, thus removing the model and continuing support for other systems of birth-determined privilege. That should be radical enough. However, because there are feminists who believe that women can integrate or imitate existing structures (or conversely, that class or race structures must be transformed *first*, as a precondition to eliminating sexual caste), I feel I should identify myself as a "radical feminist." "Radical" means "going to the root," and I think that sexism *is* the root, whether or not it developed as the chronologically first dominance model in prehistory. It's clear right now that women are most restricted in societies that are also devoted to keeping race or class groups "pure" in order to perpetuate the status quo. It's clear, too, that comparatively classless societies, where private property is substantially eliminated, can still keep women as an undercaste. True, in these societies women are less exploited as "workers." But we remain the most basic means of production (that is, our bodies produce workers, soldiers, citizens), and instead of being owned or controlled by one husband, tribe, religion, or class, we are in the not-much-better position of being restricted and controlled by the state. (No wonder reproductive freedom, a fundamental human right demanded by feminists internationally, isn't much more popular in socialist, atheist states than in capitalist or religious-based ones.) If we think about what this injustice does to us personally, it is also clear that the tolerance of a habit as pervasive as male-dominance not only creates an intimate model for oppression as "natural," but builds a callousness to other dominations—whether based on race, age, class, sexuality, or anything else. (Steinem, 1978:92–93)

© Gloria Steinem

so that each person does her or his fair share, and how to structure it so it is done cooperatively, with a minimum of hierarchy. Then attention may be turned to making work as joyful and creative an activity as possible.

Some of us seek the development of small and independent feminist businesses, carrying forward a tradition which is central to the American experience: the tradition of the independent and responsible small-town artisan or merchant. This tradition is more threatened by than reflected in the hierarchical organization and excessive power of the modern giant corporation. Feminist activity may build on and transform this tradition instead of concentrating its attention on a traditional goal of socialism: the nationalization of major industries.

A feminist business which produces a product or performs a service genuinely useful to women, which uses its earnings to train other women and to

help us increase our economic independence, will not be a "business" in the usual sense (Woodul, 1976). It may respond voluntarily to community or regional or even national planning. It should certainly take responsibility for maintaining the health of its workers or neighbors and preserving the environment of future children, and it may be expected to do so without government intervention. Its goal will not be to maximize profits and increase its control over others, but to perform useful work in humanly satisfying ways.

How should the changes needed in society be brought about? Those with power in bureaucracies, and those with power in corporations, whatever the form of the economic system, are nearly always male. Women must work largely from the bottom up. We must organize, persuade, and build our strength gradually and steadily.

Dangers and Hopes

Many feminists warn that corporate capitalism will buy up, market, and put to its own uses its feminist critics and our enterprises, as it has succeeded in buying up so many other critics and independent enterprises over so many decades. It is true that many women seem willing to climb the corporate ladder along with male capitalists and to forget their sisters as they compete for the privileges of winning economic contests. A rash of new slick magazines directed to the aspiring woman executive have been designed to make their publishers money while telling these women how to grasp at success.

Many feminists, however, have not forgotten that women do not want to be liberated in order to be increasingly like men. A basic aspect of feminist thought will continue to resist such absorption into male structures of domination and oppression. Feminists derive some of our best arguments from liberal, socialist, anarchist, and other ideas. But by now feminism has its own foundations. Its further development can be expected.

Some feminists argue that instead of bringing the self-interested aspects of liberal principles of equality and freedom into the family, we should instead extend what is best about characteristically feminine human relations to a wider domain (Chodorow, 1976; Held, 1976; Ketchum and Pierce, 1979). Women within the family, and especially mothers, have traditionally been connected with other persons by relations that have been, at their best, characterized by caring, nurturing, mutual concern, and sharing rather than by self-interested bargaining. Mothers typically reason in certain distinctive and useful ways (Ruddick, 1980).

Feminists often start by attempting to make our immediate communities more humane and satisfying and cooperative places to live and work. We may go on to develop ways of governing ever wider communities that will enhance rather than pollute and destroy our environments. We may change the culture from one which induces greed and egotism to one which fosters mutual concern and respect. We may demand that disputes be settled without

resort to nuclear or even conventional war. And we may refrain from imperialistic ventures.

Women are finally choosing for ourselves the conceptions of women with which we wish to live. And we are striving to imagine and to achieve societies fit for such beings.

Summary

Definitions of women have often reflected faulty theories that men have had about the "nature" of women. Distorted definitions result from men seeing women as something "other" than themselves and drawing unjustified inferences from this perspective. Men tend to view themselves as active subjects and women as passive objects.

Aristotle's early definition of woman as "a defective man" has had enormous influence on human thought. Biological "facts" about women, regardless of their validity, should not be misused to draw evaluative conclusions about women's rights.

Religious conceptions of women have stressed our inferiority, our primary procreative function, and our "evil" influence on the world.

Philosophers of the Enlightenment rejected hierarchical traditions of Western political thought but not for women. The liberal principles of equality and freedom that helped to shape our nation applied to men and to male heads of households. Many liberal thinkers were silent on the subject of women. Jean Jacques Rousseau, however, was outspoken in his opinion that the existence of society required woman's subordination to man. Many philosophers believed that women were deficient in rationality.

The Enlightenment philosopher Mary Wollstonecraft argued that women had not yet been taught to favor reason rather than emotion and that we should have an education comparable to men's. John Stuart Mill also believed women's capacities would increase with more education. His wife, Harriet Taylor, argued even more forcefully for women's equality.

Contemporary liberal feminists favor equality in the home as well as in the public realm, holding that wives and husbands should share equally in child care and household tasks. Affirmative action programs are needed to provide women with equal job opportunities.

Plato's argument that only relevant characteristics should count in deciding who is fit to govern suports feminist arguments today. For example, the fact that women bear children is not relevant to our fitness for an occupation.

Feminists today are concerned with freedom as well as with equality. But the liberal idea of freedom—freedom to be left alone—is clearly inadequate in contemporary industrial society. We must have our basic needs met in order to be free. We need to have various economic and social rights recognized, such as the rights to adequate food and shelter, to pursue education whether

or not we have the money, and to have a job made available to anyone who seeks work.

Some conservative views coincide with feminist concerns for the family and moral values. But conservatives oppose feminism on the place of women, maintaining that woman's place is only in the home.

Some feminists have been influenced by the socialist tradition. Since traditional Marxism did not well understand many of the problems of women, socialist feminism has developed its own positions. It focuses on the oppression of women as women, not merely as workers.

Radical feminism in the United States draws from a variety of traditions but moves beyond the ideas familiar in any existing social theories. It is inventing specifically feminist practices and new feminist ideals.

Although feminists argue about goals, we all emphasize freedom. Many of us seek to restructure the workplace. We are interested in work that meets human needs, with the work fairly divided and cooperatively organized. We believe society should be governed with a minimum of domination and subordination.

Many feminists believe that women should promote in wider arenas the caring, nurturing, mutual concern, and sharing that characterize relations, at their best, in the home and among women. Women no longer have to accept the conceptions that others have had about us and about society. We can choose for ourselves what ideas to accept, and what to work for.

Discussion Questions

1. Do women have a "choice"? Discuss the ways in which women can or cannot choose to (a) "accept" subordinate roles, (b) believe in the "natural" inferiority of women, (c) act as free and responsible persons, and (d) do what we rather than others would like.
2. What would be needed for women to have (a) legal equality, (b) equal opportunities, (c) equality within the family, and (d) full equality?
3. Why is freedom in the sense of freedom from governmental interference so insufficient for the liberation of women?
4. Why have feminists so often looked to socialism for ideas on what a feminist economic program should include?
5. Discuss the importance of feminist theory in your own experience. Has it helped you to understand, to choose, to act? If so, how? What are the major areas in which you think feminist theory needs to be improved?

Recommended Readings

Beauvoir, Simone de. *The Second Sex*. 1949. Translated by H.M. Parshley. New York: Vintage, 1974. The single most important book on how women

have been thought about, and on how we can begin to think for ourselves about ourselves.

Gould, Carol, and Wartofsky, Marx, eds. *Women and Philosophy. Toward a Theory of Liberation.* New York: Putnam, 1976. A collection of essays by contemporary feminist philosophers.

Jaggar, Alison M., and Struhl, Paula Rothenberg, eds. *Feminist Frameworks.* New York: McGraw-Hill, 1978. Readings arranged to show the different views of conservatives, traditional Marxists, liberal feminists, radical feminists, and socialist feminists on a variety of issues of concern to women.

Mahowald, Mary Briody, ed. *Philosophy of Woman, Classical to Current Concepts.* Indianapolis: Hackett, 1978. What the great philosophers, and a few others, have said about women. Food for outrage.

Okin, Susan Moller. *Women in Western Political Thought.* Princeton: Princeton University Press, 1979. A calmly written account of how women have been discounted and abused by Western political thought.

References

Aristotle. *The Generation of Animals.* Volumes 1 and 4. Translated by A.L. Peck. Cambridge, Mass.: Harvard University Press, 1953.

Beauvoir, Simone de. *The Second Sex.* 1949. Translated by H.M. Parshley. New York: Knopf, 1953.

Bem, Sandra, and Bem, Daryl. "Homogenizing the American Woman." In *Feminist Frameworks*, edited by Alison M. Jaggar and Paula Rothenberg Struhl. New York: McGraw-Hill, 1978.

Chodorow, Nancy. *The Reproduction of Mothering: Psychoanalysis and the Sociology of Gender.* Berkeley: University of California Press, 1978.

Eisenstein, Zillah. *The Radical Future of Liberal Feminism.* New York: Longman, 1981.

Engels, Friedrich. *The Origin of the Family, Private Property, and the State.* 1884. Translated by Alec West. Edited by Eleanor Burke Leacock. New York: International Publishers, 1972.

English, Jane. "The New Scholarship: Review Essays. Philosophy." *Signs* 3 (1978):823–31.

Flax, Jane. "Do Feminists Need Marxism?" In *Building Feminist Theory: Essays from Quest, a Feminist Quarterly.* New York: Longman, 1981.

Fullilove v. *Klutznick.* 100 S. Ct. 2758 (1980).

Gilman, Charlotte Perkins. *Women and Economics.* 1898. Reprint, edited by Carl Degler. New York: Harper Torchbooks, 1966.

———. *The Yellow Wallpaper.* 1899. Reprint. Afterword by Elaine R. Hedges. Old Westbury, N.Y.: Feminist Press, 1973.

Gould, Carol. "Philosophy of Liberation and the Liberation of Philosophy." In *Women and Philosophy*, edited by Carol Gould and Marx Wartofsky. New York: Putnam, 1976.

Hartsock, Nancy. "Staying Alive." In *Property, Profits, and Economic Justice*, edited by Virginia Held. Belmont, Calif.: Wadsworth, 1980.

Held, Virginia. "Justice and Harriet Taylor." *The Nation*. October 25, 1971.

———. "Marx, Sex, and the Transformation of Society." In Gould and Wartofsky, eds., *Women and Philosophy*. New York: Putnam, 1976.

———. "Men, Women, and Equal Liberty." In *Equality and Social Policy*, edited by Walter Feinberg, Urbana: University of Illinois Press, 1978.

Jaggar, Alison M., and Struhl, Paula Rothenberg, eds., *Feminist Frameworks*. New York: McGraw-Hill, 1978.

Kelly [Kelly-Gadol], Joan. "The Social Relations of the Sexes: Methodological Implications of Women's History." *Signs* 1 (1976):809–23.

Ketchum, Sara Ann, and Pierce, Christine. "Separatism and Sexual Relationships." In *Philosophy and Women*, edited by Sharon Bishop and Marjorie Weinzweig. Belmont, Calif.: Wadsworth, 1979.

Kirk, Geoffrey Stephen, and Raven, John Earle. *The Presocratic Philosophers*. Cambridge, Eng.: Cambridge University Press, 1962.

Krimerman, Leonard I., and Perry, Lewis, eds. *Patterns of Anarchy: A Collection of Writings on the Anarchist Tradition*. Garden City, N.Y.: Doubleday Anchor, 1966.

Locke, John. *Two Treatises of Government*. 1690. Reprint. Edited by Peter Laslett. New York: Mentor, 1965.

Mahowald, Mary Briody, ed. *Philosophy of Woman, Classical to Current Concepts*. Indianapolis: Hackett, 1978.

Mill, Harriet Taylor. "Enfranchisement of Women." In John Stuart Mill and Harriet Taylor Mill, *Essays on Sex Equality*. Edited by Alice S. Rossi. Chicago: University of Chicago Press, 1970.

Mill, James. "Government." Written for the 1820 supplement to the *Encyclopedia Britannica*. Reprinted as a pamphlet. London, 1821.

Mill, John Stuart. "On the Subjection of Women." In Mill and Mill, *Essays on Sex Equality*. Chicago: University of Chicago Press, 1970.

Mitchell, Juliet. *Woman's Estate*. New York: Vintage, 1973.

Moulton, Janice. "The New Scholarship: Review Essays. Philosophy." *Signs* 2 (1976):422–33.

Nietzsche, Friedrich. *Beyond Good and Evil*. 1886. Translated by Walter Kaufman. New York: Vintage, 1966.

Okin, Susan Moller. *Women in Western Political Thought*. Princeton: Princeton University Press, 1979.

Pierce, Christine. "Equality: *Republic V.* " *The Monist* 57 (1973):1–11.

———. "Natural Law Language and Women." In *Woman in Sexist Society: Studies in Power and Powerlessness*, edited by Vivian Gornick and Barbara Moran. New York: Basic Books, 1971.

———. "The New Scholarship: Review Essays in the Humanities. Philosophy." *Signs* 7 (1975):487–503.

Plato. *The Republic*. Translated by H.D.P. Lee. Baltimore, Md.: Penguin, 1955.

Rossi, Alice S., ed. *The Feminist Papers*. New York: Bantam, 1974.

Rousseau, Jean Jacques. *Émile*. 1762. Translated by Barbara Foxley. New York: Dutton, 1966.

Rowbotham, Sheila. *Woman's Consciousness, Man's World*. Baltimore: Pelican, 1973.

Ruddick, Sara. "Maternal Thinking." *Feminist Studies* 6 (1980):342–67.

Steinem, Gloria. "From the Opposite Shore, or How to Survive Though a Feminist." *Ms.* 7 (1978):65–67, 90–94, 105.

Tocqueville, Alexis de. *The Old Régime and the French Revolution*. 1856. Translated by Stuart Gilbert. Garden City, N.Y.: Doubleday Anchor, 1955.

Vetterling-Braggin, Mary. *Sexist Language*. Totowa, N.J.: Littlefield, Adams, 1981.

Walker, Benjamin. *The Hindu World. An Encyclopedic Survey of Hinduism*. Volume 2. New York: Praeger, 1968.

Whitbeck, Caroline. "Theories of Sex Difference." In *Women and Philosophy*, edited by Gould and Wartofsky. New York: Putnam, 1976.

Wollstonecraft, Mary. *A Vindication of the Rights of Woman*. 1792. Reprint. New York: Norton, 1967.

Woodul, Jennifer. "What's This About Feminist Businesses?" *Off Our Backs* 6 (1976):24–26.

3

Women's Bodies

WHY TWO SEXES?

SOME BIOLOGICAL DILEMMAS IN DEFINING WOMEN
The Problem with "Averages"
Variations Within a Sex and Between the Sexes

HOW IS A WOMAN DEFINED BIOLOGICALLY?
Chromosomes and Gender
Intrauterine Events
Genital and Reproductive Anatomy

PHYSIOLOGY OF THE FEMALE REPRODUCTIVE SYSTEM
Female Reproductive Cycle
Negative Attitudes About Menstruation
Menstruation and Moods
Female Sexual Response
The Physiology of Pregnancy
The Biology of Birth
Postpartum or "Lying-In" Period
Breast-Feeding
Menopause

BIOLOGY AND BEHAVIOR
Hormones and the Brain
Evolutionary Theory

A colleague recently mentioned to a coworker that someone was looking for her, but that she did not get the person's name. When the coworker asked if it had been a woman or a man, her colleague responded, "I do not process *that* kind of information!"

Despite the disclaimer, it is difficult to believe. Whether someone is female or male is probably the first information we do establish. Categorizing people in this way is universal. The question we ask in this chapter is: Do biological characteristics give us a definition of "woman"? The answer is not as simple as we might expect it to be.

93

We turn to biology for definitions because, after all, it is a *science*, and we have been taught to believe that science is both factual and objective. But when we study science to find out how the universe—and everything that inhabits it—works, we discover that we are dealing with theories. These theories are based on the findings of scientists, who until recently have more often than not been white, upper- and middle-class men. Like the rest of us, scientists have been raised as part of a particular culture, class, and gender. These experiences inevitably shape the way they "see" the world. As we saw in chapter 1, perceptions are shaped by expectations, and observations can be interpreted in a range of ways. Biological explanations, therefore, are not necessarily "objective" because they reflect the particular perspectives of those who have proposed them. Even the language used to record observations, which in turn become the basis for explanations, may reflect the perspectives and expectations of the dominant male culture (Hubbard, Henifen, and Fried, 1979).

Labels like *female* and *male* are not just a simple way of explaining what we observe but carry cultural and personal meanings as well. For example, when biologists speak of the "male" hormone androgen as "masculinizing" fetal sex organs, they may appear to be using a simple, descriptive term, but in fact they are bringing their observations within well-worn paths of human expectations and meaning that derive much from the specific culture, society, and identity of the person using the term. The language of sexual dualism carries with it far more than simple biology; when biologists use it to define what the sexes are, an extra, often hidden, explanation of social expectations is always present.

The "facts" of science repeatedly give way to better "facts." What concerns us in this chapter is how the currently accepted "facts" of biology deal with the distinctions between women and men, and how they define "woman." We ask the question "*Can* women be defined in physiological terms?" and we discuss what we currently know about physiology that contributes to our understanding of women. But just let us consider the question of why there should be two sexes.

Why Two Sexes?

Current scientific explanations for the existence of two sexes rely primarily on the theory of evolution. Evolutionary theory—based on the nineteenth-century formulations of Charles Darwin—explains biological traits (such as warm-bloodedness and bipedalism) in terms of how successfully they help organisms to compete for the resources they need in order to reproduce themselves. To reproduce, all but the simplest organisms need such things as food, shelter, and mates. Some of these resources are in limited supply, which is why, according to evolutionary theory, organisms must compete. Those

organisms which have traits that confer on them a competitive advantage will reproduce more than others. In this way, the traits they pass on to their offspring are represented in greater proportions of the next generation. Those organisms which do not have advantageous traits reproduce less, pass on their characteristics to fewer offspring, and are represented in smaller proportions of the next generation, if at all. Any trait which persists over the long run can be accounted for in terms of the advantage it has over other variants of that trait. (It must be understood that advantages are tied to certain environmental situations; what is beneficial in one context may be harmful or neutral in another.)

According to evolutionary theory, the existence of two sexes increases the variety of genetic combinations within a population, since genetic material comes from both partners and recombines to form a new organism. This would enhance the selection of favorable traits and the suppression of defective, or less adaptive, characteristics.

Why do we have only two sexes, and not three or more? According to evolutionary theory, the two-sex system is an efficient way to facilitate genetic reassortment for some species. Nature operates under the principle of parsimony; since two sexes accomplish the reassortment of genes effectively, no more are needed. Since we do not know of other ways of reproducing the mammalian species, this appears to be a satisfying explanation.

Some writers have postulated a sort of "social" relationship between the ovum and the sperm (Lowe, 1978). According to sociobiologist Dawkins (1976), the roots of female-male relationships lie in the arrangement between the larger, immobile food-storing egg and the small, agile, mobile sperm cell. The male, like his sperm, is cheap, expendable, and promiscuous, searching out, competing for, and "attacking" the egg ("woman"). The egg, in contrast, is pictured as costly, valuable, and a "stay-at-home." Eventually accepting only one sperm, the ovum then gets down to the business of nurturing it. By analogy, since men can impregnate numerous women and increase their genetic contribution, it is biologically appropriate for them to "flit" about with as many women as possible. Women, on the other hand, are limited in the number of offspring we can bear, so quality, as opposed to quantity, is our goal (Symons, 1979). The implications drawn for sexual behavior are clear.

Such theories start with a set of value judgments and stereotypes of male-as-active and female-as-passive; those who employ these theories then label all active behavior as *masculine* and passive behavior as *feminine*. In fact, all we have is a demonstrable division *for reproductive purposes* between egg bearers and sperm carriers who combine their genes. The attempts to generalize from the roles of the egg/sperm and the equating of reproduction with sexuality fail to consider the cultural definitions given to sexual behavior, reproduction, and the relations between the sexes, from which biological theories have been developed.

Some Biological Dilemmas in Defining Women

What physiological characteristics do we look for in distinguishing women from men? The most obvious are those that are apparent even to the child, like body shape or height. For example, men on the average are taller than women. But does that make a six-foot-tall woman, who is taller than most men, not a woman? An obvious physiological difference is seen in the genital organs. But what about people with genital "abnormalities"? Do we reassign these people to another gender? Reproductive anatomy seems basic: women have the machinery for gestation (pregnancy), and men do not. But what about the woman who cannot have children? Does that biological fact make her not a woman?

Hormonal differences between the two sexes are often used as explanations for differences in behavior as well as physiology. Hormones are chemical substances transported in the blood which affect various bodily functions. The presence or absence of hormones and the degree of hormones present account for many of the physiological differences referred to above. Women and men have some hormones in approximately equal amounts. There are, in addition, so-called female hormones and male hormones, but such references are misleading. All people have both "female" and "male" hormones in varying amounts, and even within one gender the variation in amount of each set of hormones is great. It also varies for any one person in moments of stress, on different days, and at different times of life.

Chromosomes (which contain the genes, or heredity factors) are an obvious place to turn for a way to define a woman biologically. According to our present state of knowledge, most people at conception get a genetic combination which results in the development of physical characteristics labeled "female" or "male." However, there are other genetic combinations that are neither *simply* "female" or "male." Are these people genderless? There are people whose genetic makeup appears to be that of one sex but who are born with the genitals of the "other" sex. What gender are they? They are usually considered, by themselves and by others, and show the behavior expected of, the gender label they are given, regardless of their chromosomal makeup.

The Problem with "Averages"

In the next section, we will consider in more detail the specific physiological characteristics that biology focuses on when defining "woman." First, however, let us question whether dichotomizing people according to gender is even a reasonable thing to do.

When we talk about sexual dimorphism (different attributes of the sexes), we are referring to a statistical average of the frequency or degree of specific differences. While this may be useful in describing large groups, it tells noth-

ing about individuals. Since "average" is often thought of as being the mid-point of a range, it may be seen that half the people in any group are always above average and half always below. When comparing two groups, we may find that on the "average" one group may be able to do something faster than the other. We may also find that there is tremendous overlap between the groups, and that the variation within any one group may be greater than the difference between the two groups. For example, in the 1979 marathon race in New York City, the first woman to complete the race, Grete Waitz, ran faster than over 99 percent of the men who reached the finish line. There was roughly a sixteen minute difference in running time between her and the first man to finish. There was over a five-hour difference in running time between the first man and the last man to finish.

Variations Within a Sex and Between the Sexes
The differences between the sexes, real and imagined, have served as the basis for prescribing behavior and defining women and men. Pregnancy and/or the potential to be pregnant appear to have ruled the perception people have had of women throughout time. This has persisted even when contraceptive technology can control or eliminate the possibilities of pregnancy. Nevertheless, the fact that human males neither become pregnant nor menstruate does remain a major difference between the sexes.

Often other physical differences between females and males are emphasized, such as men's larger size and greater muscle mass. These can be explained and need to be described in broad-based fashion, rather than assumed. Two primary factors influence these differences—genetic traits and nutritional intake. The Watusi and the Pygmies of Africa are known, respectively, for their great and small height. Women within these tribes are usually smaller than the men, but the Watusi female is taller than the average non-Watusi male, and the average non-Pygmy female is taller than the Pygmy male. Thus, to say *all* women are smaller than men is obviously inappropriate.

Discussions of secondary sex characteristics imply artificial polarities along dimensions of height, weights, musculature, body hair, breast size, and the pitch of the human voice. While the "average" woman differs from the "average" man on these dimensions, *all these characteristics fall on a continuum*. Body shape, for example, may be influenced to a great extent by nutrition.

Some scientists differentiate women and men on the basis of hormonal fluctuation in women. They see hormonal fluctuations as responsible for erratic behavior which would preclude responsible decision-making. They assume that men are steady, stable individuals whose hormones do not fluctuate. But men too have hormonal variations and fluctuations. For example, the steroid hormones which are produced by the adrenal glands fluctuate on a circadian or twenty-four-hour cycle, with the low point being in the early

morning hours (four to five) for the individual who sleeps at night and is awake in the day (Luce, 1970). Steroids affect emotional response.

Cross-cultural research in the area of the biological determinants of decision-making has not been copious. Nonetheless, social attitudes promoting the inferiority of women have permitted ideas grounded in notions of biology to be accepted as "fact" without adequate research. Similarly, they have limited investigation into the existence of hormonal cycles in males and their relationship to decision-making.

It is very likely that the focus on the "instability" of females, both during and after the childbearing years, is dependent on observations of outward signs of cyclic changes—menstruation and the cessation of menstruation—rather than on *actual* cyclic changes which occur in both women and men.

How is a Woman Defined Biologically?

A woman is a member of the species *homo sapiens*, all of whom are mammals. (Notice this term derives from the female's method of feeding her young!) She walks upright, on two feet, has opposing thumbs, a cardiovascular system, a respiratory system, a central nervous system, a musculo-skeketal system, a digestive system, an endocrine system, and so forth. These systems function according to biological principles to sustain the process of life. When people talk about the biology of women, however, the two systems that mediate their perception are the endocrine and reproductive systems—in other words, the systems that make women "not male." In this chapter, we will concentrate on a discussion of the implications of these systems, with the clear understanding that such a presentation is only *a part* of the whole woman. Space does not permit a full discussion of the biology of *homo sapiens*.

Chromosomes and Gender
Current scientific opinion holds that a person's sex is primarily determined by chromosomal makeup. Most human beings have forty-six chromosomes, arranged in twenty-three pairs in each cell. Each chromosome has about twenty thousand genes in it. These genes contain what is called the *genetic code*, the program for the development of those characteristics inherited from the parents. All cells in the body have these forty-six chromosomes with the exception of the sex cells, or *gametes*. The gametes are the ova (eggs) for the female and the sperm for the male. Each of these cells has only twenty-three chromosomes.

At conception, the twenty-three chromosomes from the ovum and the twenty-three from the sperm pair up. The fertilized egg, or zygote, now has forty-six chromosomes, or twenty-three *pairs*. One of these pairs carries the genes which will determine if the fetus is a genetic female or genetic male. In

females this pair of chromosomes is made up of X-chromosomes, making an XX pattern; in males the pattern is XY. All ova, then, having only one set of the twenty-three pairs, will always carry an X chromosome. Male sperm will carry either an X or a Y chromosome. Thus, if the ovum is fertilized by a sperm carrying an X chromosome, there will be an XX pattern and a genetic female. If the egg is fertilized by a sperm carrying a Y chromosome, there will be an XY pattern, and a genetic male. As we will see below, it is the presence of the Y chromosome which initiates a sequence of events which results in the development of male reproductive organs. The illustration on page 100 depicts this chromosomal determination of sex. Women who undergo amniocentesis can be told the genetic sex of the fetus as well as some other chromosomal information because analysis of the cells shows whether there is an XX or XY pattern.[1]

According to what we currently know about the Y chromosome, it carries little other genetic information (except for the gene for hairy ears, which is why females do not inherit this trait). The X chromosome, in contrast, is rich with genetic information. This explains a number of things about sex-linked inherited characteristics and diseases. A number of characteristics (for example, balding in men or certain forms of color blindness) and diseases (for example, hemophilia, or the "bleeding disease") are carried on the X chromosome. If a man gets that X chromosome (which can only come from his mother), he will have the disease or condition. The Y chromosome offers no resistance, no counteraction. The female, in contrast, is much less vulnerable to these diseases or traits. If she receives an X chromosome which is carrying one of these traits, she has another which will offer resistance, and she will most likely not show the trait. She would have to get a chromosome carrying that characteristic from both her mother and her father, a much less frequent occurrence. Thus, women may carry these conditions (have one gene for it while not showing the condition) and pass them on to their children (a son would have a fifty-fifty chance of getting the condition if the mother was a carrier). Men either have it or they do not. They cannot simply be carriers of sex-linked traits.

Some scientists speculate that because males carry only one X chromosome, male fetuses are more vulnerable to intrauterine (in the uterus or womb) distress and more likely to be spontaneously aborted. This explanation has also been offered to explain why baby boys are more vulnerable to illness and developmental problems after birth.

This genetic division into female or male is not as simple as it appears, however. Occasionally, genetic anomalies occur at conception. For example, such genetic combinations as XO, XXY, XXX or XYY have been found. Since the Y chromosome triggers the development of the male reproductive

1. Amniocentesis is a procedure sometimes performed on a pregnant woman which allows analysis of the chromosomal makeup of the fetus. This is done by withdrawing some of the amniotic fluid in which the fetus resides inside the uterus.

MOTHER FATHER

XX XX XY XY
FEMALE CHILD FEMALE CHILD MALE CHILD MALE CHILD

A genetic female has an XX chromosomal pair; a genetic male an XY. Consequently, the ovum contains one X chromosome, while a sperm contains either an X or a Y. When an ovum and a sperm carrying an X combine at conception, a genetic female results.

system, the absence of a Y will result in the development of female organs. Those genetic combinations with a Y chromosome (even XXY) will develop male genitals. Most people with these genetic variations have some developmental problems and are sterile.

It is tempting to define females biologically as those individuals who receive at their conception two X chromosomes. It would be even more accurate to say that females are those individuals who have no Y chromosomes, and males are those who receive at least one Y chromosome. But a clearer understanding of the role of genes shows the difficulty with such a simplistic approach.

A fertilized ovum multiplies again and again, and different parts of the mass of cells become different body systems and organs. Slowly it takes on the form of the human fetus. We do not begin in the womb as miniature beings that just get larger (although this theory, called the *homunculus theory*, was believed for many centuries). The genetic code somehow communicates to the cells how to proceed with our development. But genes are not traits or organs or even genders in and of themselves. They are like a blueprint, indicating the direction something should take. A good analogy is that of a computer program: certain operations will occur if it receives the right kind of information. Genes merely reflect the potential for development; any genetic program requires a particular environment in which to evolve. This is an important fact to remember whenever we think about the contribution of genes in any behavior or trait. The nature of the genetic contribution will vary depending upon the environment in which that trait has to develop. Thus, you may hear people in the field of child development say such things as "creating environments which will allow people to maximize their genetic

potential." This point has relevance when we talk about differences in female and male skills later on in the book. If females and males are not exposed to the same environment, we have no way of knowing whether their differences reflect genetic potentials.

This interaction between the genetic code and the environment also applies to the determination of the fetus's sex organs. The chromosomal blueprint merely starts the process. A range of things can modify or change it.

Intrauterine Events

We have seen that it is not the X chromosome that determines whether the fetus will be female but the absence of the Y that allows this natural development. Several events must occur during the development of the fetus in order for the male to develop organs consistent with his genetic sex. For both sexes, these events in fetal development are critical in determining which sexual organs will develop.

For about the first six weeks of gestation, both genetic females and genetic males have an identical, undifferentiated gonad (sex organ). If the embryo[2] has a Y chromosome, the genes on the chromosome will release a substance which will cause the inner layer of the gonad to develop into testicles. In the absence of this substance, the outer layer of this gonad will develop naturally into an ovary.

Primitive genital duct structures for the female internal reproductive organs (the Müllerian duct) and for the male (the Wolffian duct) exist as two parallel systems in both XX and XY fetuses. The Müllerian duct system has the potential to develop into the uterus and the fallopian tubes. The Wolffian system has the potential to develop into the male internal reproductive system. The newly formed testicles release two hormones, one of which will suppress the development of the Müllerian duct system. The other hormone will stimulate the growth of the Wolffian system, causing the development of the male internal organs. In the absence of these hormones, the Wolffian duct system will spontaneously degenerate and the Müllerian system will develop into the female internal reproductive organs—even in a genetic male. No special hormones are needed for female internal reproductive organs to develop. That will simply occur if the hormones released by the testicles fail to be introduced into the system. These hormones, then, are critical for the development of male internal reproductive structures. If there should be an interference in the production of the hormones, a genetic male may get some female internal organs.

A similar process occurs in the development of the external genitalia at the end of the third fetal month. Prior to that time, one undifferentiated structure exists in both genetic male and genetic female fetuses. After the third month,

2. *Embryo* is the term for the growing fetus from the second week through the second month of the pregnancy.

Adam-out-of-Eve Box 3.1
The primacy of the embryonic female morphology forces us to reverse
longheld concepts on the nature of sexual differentiation. Embryologically
speaking, it is correct to say that the penis is an exaggerated clitoris, the
scrotum is derived from the labia majora, the original libido is feminine,
etc. The reverse is true only for the birds and reptiles. For all mammals,
modern embryology calls for an Adam-out-of-Eve myth!

(Sherfey, 1972:46)

the release of fetal hormones from the testicles will cause this system to
differentiate into a penis. If the release of the hormones, called androgens,
does not occur, the structure will differentiate into a vagina and clitoris, even
in a genetic male fetus. As one can see, many of the sexual organs in females
and males have evolved out of the same embryonic tissues (box 3.1). We say
they are *homologous*. They are also similar in function (analogous). Table
3.1 shows examples of homologues and analogues.

The last intrauterine event which may differentiate females from males is
the effect of the androgens on the hypothalamus. This is the part of the brain
that regulates the release of sex hormones in the mature individual and
controls some types of behavior. Although it is speculated that this event
occurs, it has not been adequately documented in humans.

It is easy to see from the above discussion that an interference in the events
dictated by the genetic blueprint may result in persons born with internal or
external organs different from their genetic sex. This does indeed occur.
Occasionally, the fetal testicles do not produce sufficient androgens or the
genetic male fetus is unable to use these hormones when they are produced
(called *androgen insensitivity*). In these cases, the person will be born with
the external genitals of the female. Such individuals are usually labeled and
raised as females; they identify themselves as women and they assume
gender-appropriate roles (Money and Ehrhardt, 1972).

Similarly, androgens may be introduced into the system of a genetic female
fetus. When born, such persons are referred to as *androgenized* females.
Depending on the extent of the androgenizing influences, these genetic fe-
males may be born with female internal reproductive organs and an enlarged
clitoris or what appears to be a normal penis with an empty scrotum (Money
and Ehrhardt, 1972). This condition may be the result of a hereditary dis-
order or an externally induced disorder. The latter occurred in the 1950s, for
example, when some pregnant women were given progestin, a synthetic hor-
mone, to prevent miscarriages.

Table 3.1 Homologous and Analogous Sexual Organs

Female	Male
Ovaries	Testicles
Shaft of clitoris (connects the head of the clitoris to the pubic bone)	Corpus cavernosum (cylindrical body inside the penis)
Glans of clitoris (head of clitoris)	Glans of penis (head)
Labia majora (outer lips)	Scrotum (houses the testicles)
Labia minora (inner lips)	Bottom side of the penis
Bulb of the vestibule (sensitive tissues around the opening of the vagina)	Bulb of the penis (base of the penis) and corpus spongiosum (cylindrical body in the penis)
Bartholin's glands (glands on each side of the vaginal opening)	Cowper's glands (glands inside the penis)

Source: Adapted from Boston Women's Health Collective, *Our Bodies, Ourselves* (New York: Simon and Schuster, 1976). Copyright © 1971, 1973, 1976 by The Boston Women's Health Book Collective, Inc. Reprinted by permission of Simon and Schuster, a Division of Gulf & Western Corp.

This discussion of the biological events that lead up to being labeled "female" or "male" at birth demonstrates that what appears on the surface to be the clearest biological definition of woman or man—that is, one's genetic and reproductive makeup—is far from being so simple.

Genital and Reproductive Anatomy
Generally, the prenatal period is unproblematic, and people are born with a genital reproductive structure readily identified by society as either "female" or "male." The gender assignment made at birth is then followed by the long socialization process by which children's behavior is encouraged to conform to a society's gender roles. What, then, is that genital and reproductive system we identify with females (box 3.2)?

Physiology of the Female Reproductive System

After puberty there is a marked difference in the production of hormones that regulate the reproductive capacity of females and males. Puberty is marked by menstruation in females and the ability to ejaculate in males. On the average, females reach puberty two years earlier than males.

Exactly what triggers the beginning of puberty is not known. It is thought that at this point in development, the hypothalamus (a gland in the brain) signals other body organs to begin the production of sex hormones—estrogen and progesterone in the female. The girl's nipples and then breasts begin to develop, pubic hair appears, and hair begins to grow in the armpits. The girl's body begins to experience a spurt of growth and to assume the characteristics of the adult woman. These developments continue throughout the

Vulva—the external genital area (clitoris, outer lips, inner lips, and vaginal opening).

Mons—soft fatty tissue lying in front of the pubic bone. It is the area above where the crotch begins. It contains pubic hair.

Labia Majora ("outer lips")—hair-covered, soft, fatty area between the legs.

Labia Minora ("inner lips")—surrounded by the labia majora, hairless folds of skin which frame the vaginal opening. The labia minora meet toward the front of the woman to cover the *clitoris*. The covering is called the *hood*. The labia minora consists of erectile tissues. It is very sensitive and responds to sexual arousal by filling up with blood (vasocongestion).

Clitoris—highly sensitive piece of erectile tissue just covered by the labia minora where they meet in the front of the body (clitoral hood). The head or tip of the clitoris is called the *glans*. During sexual arousal, the clitoris fills with blood and swells, extending out from its hood. Prior to orgasm, it withdraws again. The clitoris is the most sensitive part of the female genital structure. Its sole purpose is to receive and send messages about sexual arousal. There was for some years a debate about whether the clitoris in the "mature" woman loses much of its importance and the vagina becomes the primary organ of sexual arousal. We believe now that this is not the case and that regardless of the source of sexual arousal, the clitoris plays a primary role, even if it is not stimulated directly.

Urinary Opening (urethral orifice)—small hole below the clitoris. This is the opening for the urethra, the small tube that leads to the bladder and from which urine is expelled.

Vaginal Opening—just below the urinary opening, this is a larger opening that leads to the vagina. It may be partially covered by a thin membrane, called the hymen. The hymen is generally stretched or ruptured by sexual or physical activity.

Bartholin's Glands—two glands on either side of the vaginal opening. They secrete a small amount of fluid.

Perineum—area between the labia minora and the *anus* (opening to the rectum).

Vagina—the canal which extends from the uterus to the outside of the body ("vaginal opening"). During sexual arousal, the vagina "sweats" or lubricates. This is caused by the increase in blood flow through the vaginal tissue.

Fornix—end of the vagina.

Cervix—base of the uterus.

Os—opening in the cervix leading to the inside of the uterus.

Uterus ("womb")—a pear-shaped, muscular organ located between the bladder and the rectum. The fetus develops in the uterus. The outer third of the lining (*endometrium*) of the uterus is shed during menstruation.

Fundus—the top of the uterus.

Fallopian tubes—two tubes extending outward from the top of the uterus. The outer end of the fallopian tubes are funnel-shaped and

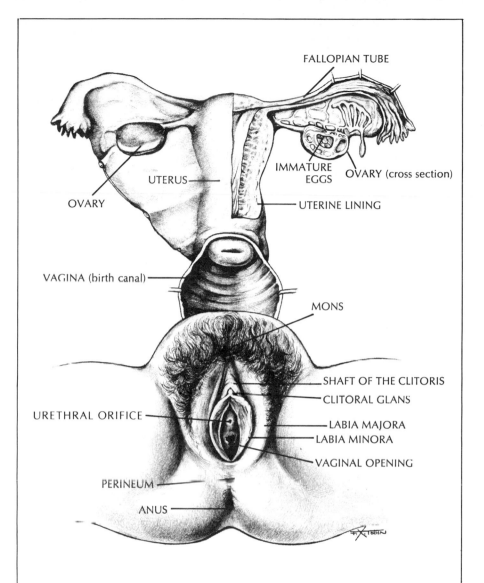

FALLOPIAN TUBE

IMMATURE
EGGS

OVARY (cross section)

UTERUS

OVARY

UTERINE LINING

VAGINA (birth canal)

MONS

SHAFT OF THE CLITORIS

CLITORAL GLANS

URETHRAL ORIFICE

LABIA MAJORA

LABIA MINORA

VAGINAL OPENING

PERINEUM

ANUS

fringed (*fimbria*). They wrap around the ovaries but do not actually touch them. When a woman ovulates, the ovum travels down the fallopian tube to the uterus.

Ovaries—two almond-shaped organs, each located on one side of, and slightly behind, the uterus. These glands produce the hormones (estrogen and progesterone) which are responsible for the development and release of the mature ova.

Illustration from: S. Bittman and S. R. Zalk, *Expectant Fathers*. New York: Hawthorne Books, 1978. Artist: F.X. Tobin.

"The Abandoned Doll" by Suzanne Valadon (1867–1938) captures the moment at which the girl is changing into a young woman. The girl is examining herself in the mirror and looking at the changes; the older woman appears as a mother figure, explaining and supportive. The doll, the symbol of childhood, lies at their feet, no longer claiming the girl's attention but symbolic of a turning point in her life. (1921, Galerie Spiess, Paris)

teenage years, but about one to two years after their onset, menstruation begins, and the female reproductive cycle is set into motion (see pp. 108–9).

Female Reproductive Cycle

Three main glands—the hypothalamus, the pituitary, and the ovaries—govern the reproductive cycle by secreting hormones into the blood. These hormones communicate regulatory messages between the glands. Let us begin looking at the cycle at the point where the body experiences low levels of the ovarian hormones estrogen and progesterone. At this time, the hypothalamus, which is sensitive to fluctuating levels of hormones, produces a hormone called follicle-stimulating-hormone-release factor (FSH-RF). This hormone stimulates the pituitary gland, which in turn produces another hormone called follicle-stimulating hormone (FSH). FSH does just what its name says; it stimulates the follicles in the ovaries to grow. The maturing follicle produces estrogen, which causes the endometrium or uterine lining to grow thick. When the follicle reaches maturity, it releases an ovum which is expelled from the ovary. This event is referred to as *ovulation*.

Just prior to ovulation, the mature follicle will also secrete progesterone. This hormone helps to create a nourishing and retentive environment for the fertilized ovum should conception occur. If the ovum is fertilized, the matured follicle, now called *corpus luteum*, will continue the secretion of progesterone and estrogen. If fertilization does not occur, the follicle will slowly disintegrate, decreasing the amount of these hormones (see p. 110). With this decrease of estrogen and progesterone, the uterus can no longer hold its lining. It sheds a portion of the endometrium, the process of *menstruation*. The remaining endometrium will form the new lining. Now the hypothalamus responds to the fact that there are low levels of estrogen and progesterone in the body and releases FSH-RF, beginning the cycle all over again.

Menstruation is simply one part of an integrated body cycle. Although ovulation and menstruation are tied together, it is possible to menstruate without ovulating and to ovulate without menstruating. Some women may fail to menstruate at all (*amenorrhea*) or do so irregularly (see Chapter 12).

Negative Attitudes About Menstruation

There are a range of attitudes about *menarche*, or beginning of menstruation. In some parts of the world, menarche is accompanied by initiation rituals. The event is welcomed as the girl's passage into womanhood. Many societies treat the menstruating woman as unclean and in need of isolation, especially from men. In these cultures, menstrual blood is viewed as polluting. Some of these customs also dictate that women purify ourselves at the end of the menstrual period in various ritualistic ways (Weideger, 1977).

Euphemisms for menstruation pervade our language. This effort to avoid public embarrassment suggests menstruation carries the taint of an un-

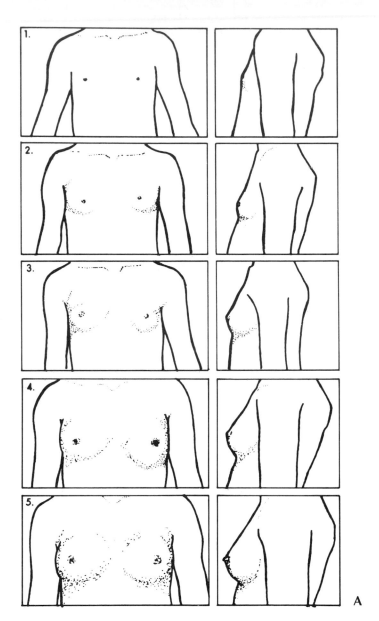

A. Stages of breast development in adolescent girls: (1) prepubertal flat appearance like that of a child; (2) small, raised breast bud; (3) general enlargement and raising of breast and areola; (4) areola and papilla (nipple) form contour separate from that of breast; (5) adult breast—areola is in same contour as breast. (J.M. Tanner, *Growth at Adolescence*, 2d ed. Oxford: Blackwell Scientific Publications, 1962.)

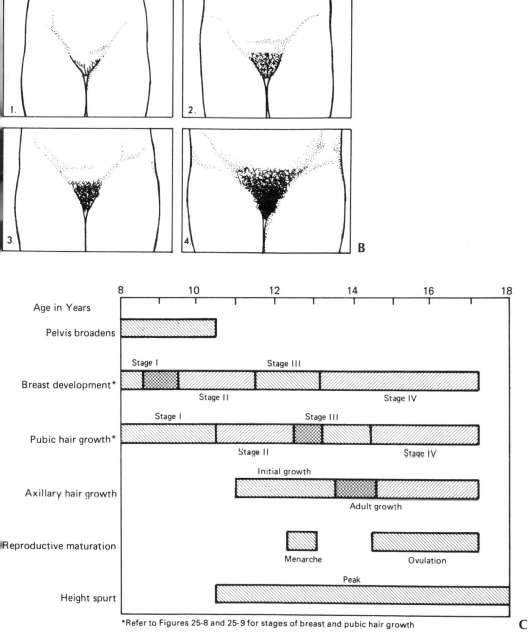

B. Stages of pubic hair development in adolescent girls: (1) sparse growth of down hair mainly at sides of labia; (2) pigmentation, coarsening, and curling, with an increased amount of hair; (3) adult hair, but limited in area; (4) adult hair with horizontal upper border. (J.M. Tanner, *Growth at Adolescence,* 2d ed. Oxford: Blackwell Scientific Publications, 1962.)

C. The average age of bodily changes related to pubescence in the American female. The stages of breast development and pubic hair growth refer to the sketch in figures B and C.

1. DAY OF CYCLE

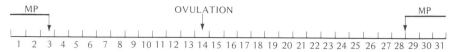

2. BASAL TEMPERATURE

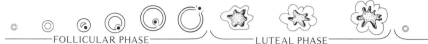

3. OVARIAN CHANGES

4. ENDOMETRIAL CHANGES

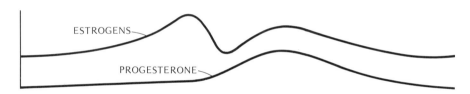

5. OVARIAN HORMONE LEVELS

Phases of the menstrual cycle:

1. Ovulation usually occurs midpoint between menstrual periods (MP).

2. At the time of ovulation, basal temperature (temperature upon waking in the morning) rises slightly.

3. These changes occur in the ovary prior to ovulation, at ovulation (day 14), and after ovulation if conception does not occur.

4. The lining (endometrium) of the uterus sheds during menstruation and then grows thick again.

5. Estrogen and progesterone levels are high around the time of ovulation and then gradually diminish; the diminished levels cause the endometrium lining to shed. (Adapted from D. Jensen, *The Principles of Physiology*, 2d ed. New York: Appleton, 1980.)

clean excretory function. Products related to menstrual hygiene are now advertised widely in magazines, newspapers, and television but rarely make direct references to menstruation. In the United States today, it is common to hear the statements, "I have the curse," "My friend is visiting," or "It's that time."

Also associated with menstruation is the notion that it is an illness. During the Victorian era, upper-class women took to their beds in order to be cared for when they were menstruating. Most women in the world do not have the resources to treat it as a sickness, and most do not "feel sick." Nevertheless, this notion is often met in the workplace and has been used to discriminate against women in the matter of jobs. Menstrual cramps may occur, but in most cases this condition is not debilitating. As is the case with any bodily function, menstruation *may* cause discomfort to a disabling degree in some women. Exercise, biofeedback techniques, and medication can help alleviate discomfort.

Menstruation is a natural bodily function. Women may engage in any activity while menstruating which we engage in at other times, including bathing, swimming, sexual intercourse, or exercise. Nonetheless both society and professional literature have perpetuated myths about menstruation which have helped to keep women in subordinate roles (Parlee, 1978). Since menstruation is an *observable* function, it has been easy to perpetuate such myths.

Menstruation and Moods

Just as menstruation has been used to argue women's physical weakness, so it has been used to make a charge of mental instability in women. Recent research has discovered that there can be a biochemical basis to certain moods and emotional states. But these feelings may be brought about by the hormonal changes that occur during *many* cycles, not just the menstrual cycle. It must be kept in mind that other cycles and changes in other hormones, in both women and men, affect psychological responses (Luce, 1970).

In addition, environmental, emotional, and biological factors interact in complex ways, so that no one factor can be singled out as the primary cause. Women may react differently to the hormonal cycle from one month to another, depending on our personal situations; and our reactions may in turn affect our physical condition. Since menstruation is a continuous reminder of our reproductive capacity, social attitudes and expectations shape our personal experiences of menstruation (Parlee, 1978).

Some women experience what has been loosely termed a *premenstrual syndrome*. Typical symptoms that fall into this category include water retention (which causes body swelling and weight gain), cramps, headaches, irritability, anxiety, and tension. Actually, a total of 150 symptoms have been cited at different times (Moos, 1969). This makes it difficult to come up with a definition that conforms to most women. There is also little agreement as to how many women experience the syndrome. The proportion reported vary

from 15 to 95 percent, depending on the definition used and the researcher using it (Paige, 1973). It is important to note that all these symptoms are reactions *all* people have at different times in their lives in response to stress, regardless of the phase of their hormonal cycle. Any stress experienced by women is frequently attributed to premenstrual (or menstrual, or postmenstrual) reactions. Women who have experienced such reactions have been called hysterical and hypochondriacal. We have been accused, among other things, of rejecting our femininity. Arguments such as these have been used as an excuse to keep women from positions of power and authority.

Although we know that hormones can affect moods, we also know that our expectations, attitudes, and experiences can affect the occurrence of this syndrome. Many women have been taught to respond negatively to menstruation. The stress that we experience can be partly attributed to these negative cultural attitudes (Paige, 1973).

As we noted earlier, *both* women and men have hormonal cycles (Luce, 1970; Ramey, 1972). Men's cycles are more difficult to chart because of the absence of an observable event such as menstruation. When researchers have undertaken projects to determine cyclic functioning in males, they report an interaction between hormone fluctuations and mood and functioning. But little attention has been given to these male cycles.

Female Sexual Response
Discussion of female physiology and its role in defining women would not be complete without addressing the topic of female sexuality. Sexual behavior for *all people* is a complex interaction between physiological responses and emotional state. It is shaped by prevailing social expectations and personal experiences. Any one aspect in isolation gives an incomplete picture of the whole human being.

Only relatively recently has female sexuality been considered a legitimate subject for scientific research. Historically, philosophers, religious teachings, and the moral norms of the culture dictated ideas about female and male sexuality. As today, these were all intricately woven into the sociopolitical climate of the time. The United States, along with many other countries, has "inherited" a legacy of Victorian attitudes about sexuality. These beliefs have tended to dichotomize women into the "good" woman (virgin-like) and the "bad" (whorelike) one. The good woman had no sexual desire but complied to satisfy her husband's need and to have children. The sexual woman was viewed as sick and dangerous. Victorians, we have been told, viewed all sexual behavior as dirty and dangerous but recognized that men had a desire which they should fulfill. "Good" women did (or should) not. The concept of sex as dirty and dangerous gradually changed over time to the belief that sex is good—but only for men. Although this standard has changed to some extent, it has actually followed us into the 1980's.

Although Victorian ideology dictated that women should refrain from sexual expression, some Victorian women were clearly sexually active and enjoyed it (Degler, 1980; Rosenberg, 1982). The contradiction between behavior and social expectations may have created guilt and anxiety for many women. Those who did conform to the Victorian sexual standard felt torn between their sexual desires and fantasies and the Victorian teachings about what was "normal" for women.

It was during this Victorian era that Havelock Ellis and Sigmund Freud, among others, began to write about human sexuality and to legitimize it as a topic of study (Robinson, 1976). Freud, the founder of psychoanalysis, stated that women were indeed beings with sexual needs, and that the repression of sexual expression was a cause of neurosis in women. This was in contrast to prevailing attitudes of the time, which held that sexual expression was a cause of, and evidence of, neurosis. Freud based his ideas primarily on the recollections of women who consulted him for help. His theories evolved out of his interpretation of these women's underlying emotional dynamics and unconscious motives. While he believed women should express our sexuality, he also believed that our fulfillment could only come about in the form of vaginal orgasm (as distinct from clitoral orgasms, which Freud considered "masculine" and childish) and the subsequent bearing and nurturing of children. Although in many ways Freud began a liberation of female sexuality, his theories had components which passed on yet another set of masculine standards against which women were to judge ourselves (see chapter 4).

Psychoanalytic theories dominated beliefs about sexuality for the following decades and represented a new set of assumptions about "normal" sexual behavior. In the 1940's and 1950's, Alfred Kinsey conducted an extensive survey of the sexual behavior of women and men. His findings, based on interviews, astonished his contemporaries. He found many people engaging in a range of sexual behavior considered to be atypical by standards of that time. Masturbation, homosexuality, and oral-genital sex were found to be practiced by a significant proportion of the population.

It was Masters and Johnson (1966), however, who brought human sexual responses into the laboratory. Observing and monitoring sexual responses, they divided the human response cycle into four phases. Not all women experience these phases (we have seen that all people do not fall into any category), and the phases are not discrete but flow into one another. Masters's and Johnson's findings for females are shown in table 3.2.

Masters and Johnson note remarkable similarity in the sexual responses of females and males. One noteworthy exception is the presence of a refractory stage in males but not females. According to Masters and Johnson, after orgasm, males have a refractory period in which they cannot get another erection regardless of the amount of stimulation. For young men, this may

Table 3.2 Phases of the Female Sexual Response

Excitement

1. Vaginal lubrication.
2. Venous dilation of the external genitalia.
3. Clitoral engorgement (filling with blood) causing the clitoris to swell.
4. Vaginal expansion.
5. Erection of the nipples.

Plateau

1. Outer third of the vagina becomes engorged with blood, narrowing the passageway.
2. Inner two-thirds of vagina expands.
3. Uterus rises up.
4. Purple coloration of nipples and areola.
5. Clitoris retracts under its hood but remains extremely sensitive.

Orgasmic

1. Vasocongestion reaches a critical point and the muscles of the lower vagina and uterus contract (the orgasm), which expels the congestion.
2. There are approximately 8–15 contractions, of which the first 5–6 are most intense.

Resolution

1. Genitalia return to the nonaroused state.
2. Clitoris returns to its usual position and size.
3. Vagina returns to a relaxed state (10–15 minutes),
4. Coloration of nipples returns to prearoused state.
5. If the woman does not have an orgasm, the resolution phase takes longer, and she may feel discomfort in her genitals.

last barely a few minutes; for older men it may last for hours. Women, in contrast, do not have such a period, and if effective stimulation is supplied, we can move back and forth between the plateau and orgasmic phase without returning to the nonaroused state. Thus, the term *multiple orgasms*.

Masters's and Johnson's phases are just one scheme of sexual responses; other researchers have outlined different divisions. There is also a great deal of debate over some of their findings. For example, many women find they do not have (or feel a need for) multiple orgasms. Any attempt to make hard-and-fast generalizations for all people merely results in replacing one standard by another. The most important finding of such research is the existence of great diversity among people.

Sexual excitement can be triggered by fantasy, visual images, odors, tactile sensations, and emotional responses. Regardless of the source of stimulation, the physical responses are the same. Similarly, Masters and Johnson argue that all orgasms are physiologically the same, regardless of the source of

stimulation—intercourse, manual or oral stimulation from one's partner, or masturbation—although the orgasms may differ in intensity or be subjectively experienced differently. Research on whether all orgasms are similar still continues, as does the debate on this matter.

Knowledge of the biological responses to sexual stimulation is useful: it explodes myths and offers women greater understanding of our bodies. Yet to view sexual behavior as *only* a biological response is to leave a gap in the understanding of the whole individual. Sexual behavior is mediated by personal and social meaning.

We are socialized for a particular kind of sexual behavior. In spite of the increasing liberalization of sexual attitudes, women in America are taught a male perspective on sexuality. All people are sexual, even little children. Yet our society generally recognizes the sexuality of females only when we reach puberty. At that time, the social pressure on us to play the role of sex object increases. Attention is given to the way we look, and various parts of our bodies are decorated to accentuate the role. The attention of males is supposed to become a mark of our worth.

The female is supposed to be passive, the male active. Sexual inexperience is more likely to be acceptable in the female than in the male, since the male is socialized to be the "teacher." Where young men learn about sex is an interesting question to consider. Frequently, it is from locker-room talk and masturbation, hardly an experience that would inform them about female sexual pleasures. Under such dichotomized roles, it is difficult for a woman to teach a man about her sexual needs.

Traditionally, investigations of sexuality emphasized satisfaction for men and procreation for women, although homosexuality among men was discussed. The fact that many women find sexual satisfaction in each other was given little attention. Today there is a significant increase in literature on this topic (see for example, Faderman, 1981; Hite, 1976; Jay and Young, 1977; Sissley and Harris, 1977; Vida, 1978).

Popular writings have up to now depicted romantic sexual unions in which the innocent female virgin is initiated into sexual pleasure by the worldly, experienced man. The picture generally portrayed is "penis-in-vagina" sex, with orgasm depicted as automatic. Since society has conditioned women to acquiesce to men's preferences, it is only natural that men should project their own sexual preferences onto women. One consequence of this has been noted by Laws and Schwartz (1977) in their discussion of sexual foreplay. The term *foreplay* generally refers to sexual contact that precedes intercourse (note the heterosexual focus of the term). Men generally view foreplay as something they have to do to make the woman more receptive, but of little intrinsic value. Yet, "if we think for a moment about what foreplay involves, we discover that for women it is often the main event. In reporting their own sexual experience, women say that they like

the holding and hugging, physical closeness and murmuring, kissing, touching, and caressing. It is only from a male point of view that such contact is foreplay" (Laws and Schwartz, 56).

For women, sexuality seems to be more diverse, in contrast to the phallic-centered sexuality of men. Laws and Schwartz note how female sexuality may differ from that of men:

> Rather than hurry-up, goal-oriented activity, with overtones of achievement anxiety, sexual encounter has a quality of flow, a continuous high, punctuated by incidents like orgasm. Women do not necessarily conceptualize a sexual episode as "before and after" orgasm. From the female point of view the term "foreplay" is a misnomer. Women like foreplay before, during, and after. As a social construction, foreplay clearly embodies male priorities and practices in the sexual encounter. (ibid.)

The growing recognition of female sexual capacity and the awareness of women's abilities to have multiple orgasms have pushed many women into treating sex like a competitive sport, with the focus on the achievement of the goal of multiple orgasms. Whereas our lack of sexual responsiveness was a measure of our "femininity" in Victorian thinking, today women are asked to judge ourselves according to the number of orgasms we have. Exchanging one sexual dictate for another hardly seems the way to liberation. Unfortunately, in our culture, there is little support for us to turn toward ourselves for a sexual standard that we find gratifying. Women and men alike generally look outside themselves, toward the media and the reports of others, especially "authorities," for such a standard.

Feminists today are working to liberate women from the sexual scripts that have been provided by others. Women are feeling freer to explore our own bodies, to consider sexual options, and to develop a sexual self, independent of men. This is the direction toward sexual liberation.

The Physiology of Pregnancy

The biology of pregnancy is obviously closely tied to the hormonal cycle governing ovulation and menstruation. Women are born with all of our ova, which are stored in the ovaries. At the time of ovulation, one ovum (or more in the case of multiple births) matures. When the ovum leaves the ovary, it is swept into the funnel-like end of one fallopian tube. The ovum then makes the journey down the tube to the uterus, a trip that takes about six days. If the ovum is not fertilized, it either disintegrates or is sloughed off in vaginal secretions. If fertilization by a sperm does take place, this is called *conception*. Since the ovum is only viable for about twenty-four hours, fertilization must occur in the upper third of the fallopian tube. The sperm has to travel up through the vagina, through the uterus, and into the fallopian tubes. Sperm live longer than the ovum, so women can conceive if we have had intercourse shortly before we ovulate.

As the fertilized ovum (zygote) travels down the fallopian tube, the cell multiplies over and over again. When it reaches the uterus, it attaches to the uterine wall, and a placenta begins to develop. The *placenta* is a broad, flat organ which joins the woman by means of the umbilical cord to the fetus. The developing placenta secretes a hormone which signals the corpus luteum (the mature follicle after it has released the egg) to continue its production of hormones that will keep the uterine lining proliferated and secreting. Occasionally, the fertilized ovum implants in the fallopian tube. This is called a tubal or *ectopic* pregnancy. It is not a viable pregnancy and usually requires surgery.

Nutrients are carried by the woman's blood into the placenta and pass through a placental barrier to the fetus. The fetus and woman have separate circulatory systems, and there is no exchange of blood between them. The fetus continues to grow inside the uterus, and the different body parts will develop from the embryonic tissues according to a genetic code. This sequence of developments is dictated by the genetic code and is the same for all fetuses.

The expanding uterus as the fetus grows is what gives women the "pregnant look." This expanding uterus also causes the increased need to urinate (the uterus places pressure on the bladder) and the shortness of breath later in the pregnancy (the uterus takes up more space, decreasing the area in which the lungs can expand when the woman inhales).

In a normal development, the fetus has all of its organs months before birth and only the respiratory system is not functioning. The infant begins breathing independently only after emerging from the mother. That is the significance of the baby's first cry at birth. It is this immature respiratory system that provides the greatest risk to a baby born prematurely.

The biology of pregnancy is just one aspect of this nine-month period. Attitudes and beliefs about pregnant women vary and can help us understand what pregnancy means, and how women react to this event (see chapter 8).

The Biology of Birth

Most human pregnancies last nine months. The birth process is called *labor*. Exactly what triggers labor is not known. Late in the pregnancy, the woman may become aware of some "practice" contractions. These contractions serve to prepare the uterus for the birth by beginning the effacement (thinning) and dilation (opening) of the cervix. There are several indications that labor will begin soon. Some women notice a mucus discharge streaked with blood. The membrane of the amniotic sac (which contains the fetus) may rupture and the amniotic fluid be expelled through the vagina. It may drip out and hardly be noticed, or it may come with a gush. The beginning of labor itself is signaled by a pattern of regular contractions.

Health care professionals tend to divide labor into three stages. The first

stage can take anywhere from two to twenty-four hours or more. As the labor progresses, the contractions are more frequent, last longer, and are stronger. These contractions cause the cervix to efface and dilate so that the fetus can pass out of the uterus and into the woman's vagina. Most fetuses are head-down when labor begins. This position makes it easier for the fetus to fit through the woman's pelvis. The head-down position is least likely to cause complications. Some fetuses do present themselves in other positions, the most common being the breech (buttocks-down) position. The first stage of labor ends when the cervix is completely effaced and dilated.

The second stage of labor is the fetus's movement through the birth canal (the vagina); it ends when the baby is born. This second stage usually lasts from one-half hour to two hours. The woman will be told to push or bear down, thus helping the process along (unless large amounts of anesthesia have been given).

The third stage of labor is the delivery of the placenta. This occurs within minutes or up to one-half hour after the birth. Certain hormones are produced that cause the uterus to contract and expel the placenta. If the mother breast-feeds immediately after birth, the sucking newborn will stimulate the production of these hormones. Breast-feeding will also speed up the return of the uterus to its nonpregnant size. The illustration on page 119 shows the journey of the fetus during the birth process.

Some women are unable to have vaginal deliveries. This may occur, for example, if the pelvis is too small for the fetus to pass through, or if the cervix fails to efface and dilate sufficiently. Sometimes the fetus or the pregnant woman is in physical distress, necessitating a speedy delivery. When these events occur in our society, a *caesarean* procedure is performed. This involves surgical removal of the baby by cutting through the abdominal wall and into the uterus. The placenta is also removed in this way.

Postpartum or "Lying-In" Period

After birth, women's bodies readjust to the nonpregnant state. This occurs very rapidly compared to the slow and continuous adjustment of the body to the pregnant state over nine months. It takes about six weeks for the uterus to return to the nonpregnant state, but the changes in the circulatory system are rapid, occurring within the first twenty-four hours after the birth. A person experiencing these events who had not been pregnant would be in shock.

During the postpartum period, women experience uterine bleeding similar to the menstrual period and lactation, or the production of milk, begins. Often we feel fatigued because of the stress on our bodies and the limited sleep cycle permitted by a newborn infant. Traditions, circumstances, and personal preferences dictate the time a culture allots for a woman to readjust during this period.

Engagement,
Descent,
Flexion

Internal Rotation

External Rotation (Restitution)

Extension Beginning (Rotation Complete)

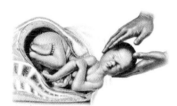

External Rotation (Shoulder Rotation)

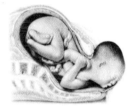

Extension Complete

Expulsion

Stages of labor: (a) engagement, descent, flexion; (b) internal rotation; (c) extension beginning; (d) extension complete; (e) external rotation (restitution). (f) external rotation; (g) expulsion. (From: Ross Clinical Education Aid # 13, Ross Laboratories, Columbus, Ohio.)

Women experience a significant hormonal alteration after birth. This alteration, coupled with sleep deprivation and the need to adjust to a newborn, can affect our emotional response. Many women experience a let-down or transient period of depression. Our social support systems at this time are significant. In many places in the world, this period is a time when women take care of other women. But in the United States, with its high degree of mobility and modern emphasis on technology, women may frequently be isolated from kin or even friends, a situation which may increase the stress of the situation.

Breast-Feeding

Women can not only carry and give birth to babies, but are also born with the biological capacity to feed our young. During pregnancy, the placenta produces hormones which prepare the mammary glands in the breast for secreting milk. These hormones also inhibit the production of milk-forming chemicals until after the birth. The first few days after birth, the mother produces a high-protein secretion called *colostrum*. It is believed that colostrum provides the newborn with immunity to selective diseases the mother had in the past. Two or three days after the birth, the mother starts to produce milk.

Lactation refers to the production of milk after childbirth. Two hormones are involved—one for production and one for secretion. The sucking baby stimulates the production of these hormones; thus, the more women nurse, the more milk we produce. If we stop nursing, milk production will cease.

Often lactation inhibits ovulation, but this is not an adequate means for contraception. Women may begin ovulating again before the first menstrual flow, so we may not get an indication that we are once more fertile.

Menopause

Most women are fertile for about half of our lives. When a woman's body begins the changes that signal the disruption of the reproductive cycle, it is referred to as *climacteric*. Colloquially, it is frequently termed a *change of life*. The cessation of menstruation, the most obvious result, is called *menopause*.

Most women go through menopause sometime between the ages of forty-five and fifty-five. Gradually, menstrual bleeding will become less regular and lighter, eventually stopping altogether. This menopausal period usually lasts for about two years. Biologically, our ovaries are no longer responding to the hormones from the pituitary gland. As a result, we no longer ovulate, and our ovaries stop producing estrogen and progesterone. By the time women have gone through menopause, our estrogen production will have decreased to one-sixth of what it was in our fertile years. The decrease of estrogen in our bodies will cause a thinning of the vaginal walls, a decrease in vaginal lubrication, and a loss of muscle tone. Many women experience hot flashes, that is,

episodes of warmth and flushing accompanied by perspiration. Women frequently report other physical symptoms such as dizziness, headaches, and tingling sensations. These feelings can be explained by the decreased estrogen and resulting hormonal imbalance, as it takes the body some time to adjust to the changes.

As mentioned previously, decreases in estrogen and progesterone are frequently accompanied by emotional stress, and many women experience what is termed *menopausal depression*. Once more, these hormonal changes interact with emotional and cultural pressures. "Going crazy" has been a stereotype associated with menopause and a way of labeling and belittling women's statements about this life-change event. If women are viewed primarily in terms of motherhood, we might well wonder how society will treat us when we can no longer bear children. If we feel we will be discarded both as mothers and as sexual beings, we may experience a sense of depression. Research suggests that in cultures where a multiplicity of roles are available and where women see menopause as a freedom from menstruation and the risk of pregnancy and an indication of increased social status, depression is less likely to ensue (Griffen, 1977; Bart, 1971; Flint, 1975).

Biology and Behavior

What are the behavioral consequences of these biological differences? While men have traditionally referred to women as the "weaker sex," it is clear that starting with conception and lasting a number of years after birth, girls are the "stronger sex." Female fetuses are less likely to abort spontaneously or die at birth and are less vulnerable to physical traumas in the early years. Even in adulthood, women live longer (unless more deprived of nourishment). American parents are likely to report that boy babies are more active than girl babies, but parents may be responding to social stereotypes. Research does not lend much support to this claim. Aside from the fact that males are born, on the average, slightly larger, little difference between newborns can be documented (Maccoby and Jacklin, 1974).

It has also been suggested that preschool and early school boys are more active than their girl schoolmates, but it is unclear whether this is a biological or a social consequence. A similar dilemma faces us when we note that boys are more likely to have learning problems in school, get into more trouble, and are more likely to be placed in special education classes. Girls do mature physically more rapidly than boys, which may explain some of these perceived differences (Denmark, 1977).

Let us look at some of the major characteristics that have been studied. Maccoby and Jacklin (1974) did an extensive review of the research on sex differences. They concluded that there is *no* support for the long-held beliefs that girls: (1) are more social or suggestible than boys; (2) are better at rote

learning and simple repetitive tasks while boys perform better on higher-level tasks requiring higher cognitive processes; (3) are less analytic than boys; (4) are more affected by heredity as opposed to environment; (5) have lower self-esteem; or (6) lack achievement motivation. In other areas that have traditionally been viewed in gender-stereotyped terms—such as fear, activity level, competitiveness, dominance, compliance, dependence, and passivity—Maccoby and Jacklin report that the findings are in fact ambiguous. Different definitions and research measures and contradictory results from different age groups and in different situations make conclusions difficult.

Maccoby and Jacklin (1974) also report four areas in which research findings have supported sex differences. They are verbal ability (girls excel); visual-spatial ability (boys excel); mathematical ability (boys excel); and aggression (boys are more aggressive). In fact, however, the research on these areas is still controversial (see chapter 4). What is thought to account for these differences? Both social and biological explanations have been offered, but we will here consider only the latter.

Hormones and the Brain

Of the four areas where sex differences are consistently found, aggression has received the strongest support as having a biological cause. Most of this support, however, is based on animal studies. For example, it has been found that the administration of testosterone (the "male" hormone) to female rhesus monkeys increased the incidence of aggressive behavior (Goy, 1970). Similar results have been found with rodents (Edwards, 1969). Research has indicated that more aggressive monkeys have higher testosterone levels than less aggressive monkeys (Rose et al., 1971). But the same researchers found that providing a male monkey with an opportunity to dominate increased his testosterone level (1972). The reverse worked in the opposite way. Such research shows that not only is there a relationship between a hormone (in this case testosterone) and aggressive behavior, but that such behavior can affect the production of the hormone as well. Little research on hormones and aggressive behavior was done on humans until the beginning of the 1970s, when study of this subject began to be formulated (Persky et al., 1971).

It makes little sense to talk about direct hormonal effects when we talk about children since girls and boys have remarkably similar hormonal patterns before puberty. Yet research on children has consistently found boys to be more aggressive than girls (Maccoby and Jacklin, 1974). This has led researchers to attempt to explain the difference in aggressive behavior by differential socialization experiences. These attempts have been inconclusive. Research has *not* supported the idea that mothers encourage (or even tolerate) aggressive behavior in their sons and not their daughters (Minton et al., 1971; Newson and Newson, 1968). Other researchers have suggested that girls express their aggression in less direct ways, but their findings are equivo-

cal on this point (Feshback, 1970; Hatfield et al., 1967). One researcher found that when girls were given an incentive to behave aggressively, they were as aggressive as boys (Bandura, 1973). This researcher proposes that girls learn aggressive behavior but choose not to use it because they also learn that it is socially unacceptable for them to do so.

A more recent theory suggests that although mothers do not respond differentially to daughters' and sons' aggression, fathers do. Lamb and his associates (1979) contend that fathers treat children differentially after the age of one: the sons receive far more paternal attention of any kind than do daughters. Accordingly, it may be fathers, and not mothers, who reward girls and boys differentially for aggressive behavior and allow boys to be overtly aggressive while punishing girls for it.

Another sex difference which has been studied is the difference in visual-spatial ability (the ability mentally to manipulate objects in space, or to respond to a visual stimulus without being distracted by background information). Following puberty, males, on the average, develop this ability to a greater degree than do females. Two biological theories have been offered to explain this finding. The first is that visual-spatial ability may be a recessive trait carried on the X chromosome. As we saw earlier in the chapter, females are less likely to show characteristics that are X-linked and recessive, since they have another X chromosome which will dominate over the recessive trait. Females require two recessive X-linked traits to demonstrate the behavior. Males, in contrast, demonstrate the trait if they have one X chromosome which carries it. Thus, we would expect to see the characteristic more frequently in men (Bock and Kolakowski, 1973; Stafford, 1961). The second biological explanation is that the ability is related to right temporal brain lateralization, which may be greater in men than women (McGlone, 1976; Sherman, 1974).[3]

Yet other researchers present evidence that indicates socialization and learning play a significant role in visual-spatial ability (Sherman, 1967, 1974; Witkin, 1964). The toys and games given to boys and the activities and interests considered in our society to be "masculine" are more likely to encourage these skills. Cross-cultural research bears out that in societies where women are most subordinated, their visual-spatial skills are inferior. In contrast, societies that allow both boys and girls early independence—such as the Eskimos—do not show differences in this skill (Berry, 1966; MacArthur, 1967).

Differences in quantitative skills have also been studied. During the high school years, boys, on the average, begin to outperform girls and continue to do so. In their review of this research, Maccoby and Jacklin (1974) conclude

3. Brain lateralization occurs when one hemisphere of the brain becomes more active when the person is performing a task.

that there is no evidence to link this difference to genetic causes, although others have suggested that it is an inherited advantage in males (Benbow, 1980). This is still a controversial issue. A more promising approach may be to focus on the cultural attitude that mathematics is "men's work." Young women are concerned about being considered unfeminine if they excel at math, and they have been conditioned to experience anxiety when performing math related problems (Tobias, 1976).

Young girls outperform boys in verbal ability. Some researchers attribute this sex difference to early parent-child interactions and the enriched verbal environment that mothers provide for daughters, as compared to sons (Cherry and Lewis, 1976). Another theory suggests that the difference in verbal ability may be due to the more rapid maturing of girls, allowing the left hemisphere of the brain, which controls language, to develop earlier (Buffery and Gray, 1972). As we will now see, research to date reveals that this hypothesis is much more complicated than it may seem (Landsell 1976; McGlone, 1976).

Brain differences between females and males have recently been used as an explanation of differences in a range of behavior and skills. The primary focus of this work has been on the differences in verbal skills and visual-spatial performance (Goleman, 1978). One line of speculation is that brain differences emerge as a result of hormonal influence (McGuinness and Pribram, 1979); another theory focuses on electrical activity in the brain (Buchsbaum, 1978). What are these brain differences? First, it is important to note that this research is based on the *performance* of women and men, not on brain dissections. Research with individuals who have received damage to one hemisphere of the brain shows that males are more likely to have impaired verbal skills if the left hemisphere is damaged (the supposed center of this skill). Women, on the other hand, show much less impairment in both verbal and visual-spatial skills, regardless of which hemisphere is damaged (McGlone, 1976). This and similar research seem to indicate that men are more likely to have brain lateralization. Their language skills appear to be centered in the left hemisphere and their spatial skills on the right, while women apparently are more likely to have these skills duplicated on both sides of the brain. Thus, we are less vulnerable to damage to one hemisphere of the brain. (Some left-handed children seem to be an exception to these findings.)

The consequences of these brain differences in the performance of a variety of complex tasks are still quite speculative. They do not clearly explain the difference in performance between females and males in verbal skills and spatial tasks. Witelson (1976) has suggested that spatial tasks may benefit from greater lateralization while verbal skills are hampered by it. It is clear that we are dealing with a high level of speculation that is difficult to relate to "evidence." It is like trying to put together pieces of a puzzle that are too

similar for us to decide with certainty where they fit; there continue to be few clues to help us explain what we find. The research findings on brain lateralization, the conclusions drawn, and the explanations offered are often simply contradictory. It is also possible to view this research as "political" and to point out the sexist premises on which the conclusions are based (Star, 1979).

Evolutionary Theory
The different and unequal roles of females and males in reproduction provide many evolutionary theoreticians with the grounds for "explaining," and sometimes rationalizing, a wide variety of social differences and inequalities between the sexes. For example, the fact that only women can become pregnant, give birth, and breast-feed has been used to explain the fact that in human society, women are generally the primary caretakers of children. However, while these facts are indisputably true, there is no necessary connection between them: there is no *biological* reason why men cannot share equally in child care.

It would be a mistake, however, to argue that evolutionary biology has nothing valid to contribute to our understanding of human beings on the basis of the false and illogical claims that have been made in its name. We *can* ask questions about the evolutionary origins of many of our physical and even behavioral traits without assuming that earlier conditions justify present ones.

People who use "evolutionary" explanations of human behavior frequently overlook three essential elements of biological theory. The first is the role of environment: no behavioral attribute can be evaluated in evolutionary terms out of environmental context. It makes no sense to claim that a specific trait evolved because it was advantageous for reproduction unless we know the circumstances in which the trait was advantageous. The second essential element is the relationship between "potential" and "expression." All organisms begin life with an array of potentials, physiological and behavioral, but the ways in which these potentials will be expressed depends on what happens after conception. The experience which shapes genetic expression begins in the uterus and continues throughout life. The third element is the factor of diversity. No two organisms in a population or species are identical: if this were so, evolution would not work. "Natural selection" depends on the existence of diversity; otherwise, there would be no grounds for "selection." Darwin, the founder of evolutionary theory, began his argument with the observation of diversity.

In trying to understand our biological selves and how we came to be as we are, we must keep in mind that we all exist in specific environments, that our experience shapes the expression of our inherited potential, and that we all differ from one another in many ways. Humans are the most flexible of all the animals on earth. Our ability to adjust ourselves, and to create our own

environments, is surpassed by none. To believe that the genetic potential for possession of a uterus, ovaries, and breasts determines what we are or can be obviously makes no sense.

Summary

Biological and physical attributes are frequently used in defining "woman." Scientists, who are primarily men, reflect the biases of the culture. These biases can be seen in language, the research questions pursued, and the conclusions drawn. In the study of women, biologists generally focus on those aspects of women that make us "not men," such as secondary sex characteristics and reproductive anatomy. Average differences between males and females in physical and behavioral attributes, such as physical strength and height, are frequently cited. An average, however, is a statistical concept. The range of differences within any one sex is greater than is the average difference between the sexes.

All people receive half their genes from their mother and half from their father. Genetic females have an XX chromosomal pair and genetic males have an XY chromosomal pair. The sex genes received at conception, however, are only the beginning of a series of intrauterine events that determine the reproductive and genital structure of the fetus. As a result, events can occur, or fail to occur, which cause genital variations. The environment the fetus develops in is as important an element in the development of genitals and reproductive organs as is the genetic contribution.

Puberty for most women is signaled by the onset of menstruation. Throughout women's reproductive years, our bodies experience a cycle of hormonal events. Menopause marks the cessation of this reproductive cycle. Research suggests that hormonal shifts may affect women's moods, but it also indicates that men may be subject to emotional swings as a result of hormonal events. What are frequently ignored in the discussion of hormones and moods are cultural and social attitudes regarding the physical events that accompany these hormonal changes. Thus, most societies have attitudes and beliefs about menstruation which reflect negative attitudes toward women. Cultural beliefs have also affected societies' reactions to pregnancy, birth, the postpartum period, and menopause. Cultural factors are also blatantly apparent in attitudes toward sexuality and in sexual behavior.

Biologists have looked to genetic and hormonal factors to explain behavioral differences between women and men. But research lends little support to the view that these assumed differences even exist. Differences have been documented in verbal ability, spatial ability, quantitative ability, and aggression. The reasons offered for these differences are highly controversial. That differences in aggressive behavior between females and males have a biological component has received the most support. However, with aggression, as

with other behavior, the environment the child is raised in is a powerful element in shaping the expression of the behavior. This finding is supported by differences between members of one gender within a particular culture as well as by cross-cultural research.

Evolutionary theory has been used to explain the development of gender roles. It has also been misused to justify these roles and the subordination of women. One fallacy in these arguments based on evolution is the failure to appreciate that events evolve within a particular environment. If that environment is changed, the evolutionary course changes. This is an important theme in all discussions of biological definitions of women. All aspects of human development, even those with a strong genetic component, evolve within a given environment. As females and males are not raised in identical environments, it is not possible to determine whether differences between them are a function of biological or environmental factors. Biological answers to the question "What is a woman?" are, at present, inadequate. They look at women as though we are separate body parts rather than integrated beings living within a cultural and personal environment.

Discussion Questions

1. People generally view scientists as objective and scientific findings as factual. As a result, it is frequently assumed that scientific explanations for the definition of "women" and for gender roles are free from sexist biases. Do you think this is accurate? Defend your answer.
2. The "polarity between the sexes" implies that females and males are "opposites." Given what you have learned in this chapter, does this seem a reasonable concept? Explain.
3. If the biological events that accompany such phenomena as menstruation, pregnancy, childbirth, lactation, and menopause are documentable, why is it reasonable to say that these events reflect cultural attitudes? How do these attitudes affect the biological experience? What experiences from your own life relate to this discussion?
4. How have scientific explanations affected sexual behavior and expectations? How have sexual beliefs and behavior affected scientific explanations about human sexuality?
5. Based on the biological information you have learned, construct a theory of the superiority of women.

Recommended Readings

Boston Women's Health Collective. *Our Bodies, Ourselves* Rev. ed. New York: Simon and Schuster, 1976. This informative book, written by a women's health collective, covers women's anatomy, physiology, and health

and also discusses such topics as rape, self-defense, and sexuality. The contents are clearly written and have a personal touch. An excellent reference book for the nonscientist to keep close at hand.

Hite, Shere. *The Hite Report*. New York: Macmillan, 1976. A report on the findings of a nationwide survey of female sexuality. Thousands of women filled out questionnaires about sexual feelings, behavior, and preferences. This report cannot be considered a scientific study and may not be based on a representative sample of American women. Nonetheless, it offers many insights about women and an appreciation of our diversity.

Hubbard, Ruth; Henifen, Mary Sue; and Fried, Barbara, eds. *Women Looking at Biology Looking at Women: A Collection of Feminist Critiques*. Cambridge, Mass.: Schenkman, 1979. An excellent collection of readings in which feminist scientists criticize the way in which the biological sciences have historically viewed women. They uncover the sexist biases underlying past works and interpretations and provide information on the present status of the field.

Sherfey, Mary Jane. *The Nature and Evolution of Female Sexuality*. New York: Random House, 1972. An examination of the evolution of female sexuality. In contrast to traditional beliefs, Dr. Sherfey takes the position that women have an unlimited sexual drive which has been suppressed in order to allow our present civilization to evolve.

References

Bandura, Albert. *Aggression: A Social Learning Analysis*. Englewood Cliffs, N.J.: Prentice-Hall, 1973.

Bart, Pauline B. "Depression in Middle-Aged Women." In *Woman in Sexist Society: Studies in Power and Powerlessness*, edited by Vivian Gornick and Barbara Moran. New York: Basic Books, 1971.

Benbow, Camilla P., and Stanley, J.C. "Sex Differences in Mathematical Ability: Fact or Artifact." *Science 210* (1980):1262–64.

Berry, J. W. "Temme and Eskimo Perceptual Skills." *International Journal of Psychology* 1 (1966):207–29.

Bock, R.D., and Kolakowsky, D. "Further Evidence of Sex-Linked Major-Gene Influence on Human Spatial Visualizing Ability." *American Journal of Human Genetics* 25 (1973):1–14.

Boston Women's Health Collective. *Our Bodies, Ourselves*. New York: Simon and Schuster, 1976.

Buchsbaum, Monte, "The Sensoristat in the Brain." *Psychology Today* 11 (1978):96–104.

Buffery, A., and Gray, J. "Sex Differences in the Development of Spatial and Linguis-

tic Skills." In *Gender Differences: Their Ontogeny and Significance*, edited by C. Outsted and D.C. Taylor. Baltimore: Williams and Wilkins, 1972.

Cherry, L., and Lewis, Michael. "Mothers and Two-Year-Olds: A Study of Sex Differentiated Aspects of Verbal Interaction." *Developmental Psychology* 12 (1976):278–82.

Dawkins, Richard. *The Selfish Gene.* New York: Oxford University Press, 1976.

Degler, Carl N. *At Odds: Women and the Family in America from the Revolution to the Present.* New York and Oxford: Oxford University Press, 1980.

Denmark, Florence. "What Sigmund Freud Didn't Know About Women and Men." Convocation Address as interim Mellon Scholar, St. Olaf's College, 1977.

Edwards, E. A. "Early Androgen Stimulation and Aggressive Behavior in Male and Female Mice." *Physiology and Behavior* 4 (1969):333–38.

Faderman, Lillian. *Surpassing the Love of Men: Romantic Friendship and Love Between Women from the Renaissance to the Present.* New York: Morrow, 1981.

Feshback, Seymour. "Aggression." In *Carmichael's Manual of Child Psychology*, edited by P. H. Mussen. New York: Wiley, 1970.

Flint, Marsha. "The Menopause: Reward or Punishment?" *Psychosomatics* 16(1975): 161–63.

Goleman, Daniel. "Special Abilities of the Sexes: Do They Begin in the Brain? *Psychology Today* 12 (1978):48–59.

Goy, R. W. "Early Hormonal Influences on the Development of Sexual and Sex-Related Behavior." In *The Neurosciences: Second Study Program*, edited by F. O. Schmidtt. New York: Rockefeller Univrsity Press, 1970.

Griffen, Joyce. "A Cross-Cultural Investigation of Behavioral Changes at Menopause." In *Psychology of Women*, edited by Juanita Williams. New York: Norton, 1979.

Hatfield, J. S.; Ferguson, L. R.; and Alpert, R. "Mother-Child Interaction and the Socialization Process." *Child Development* 38 (1967):365–414.

Hite, Shere. *The Hite Report.* New York: Macmillan, 1976.

Hubbard, Ruth; Henifen, Mary Sue; and Fried, Barbara, eds. *Women Looking at Biology Looking at Women: A Collection of Feminist Critiques.* Cambridge, Mass.: Schenkman, 1979

Jay, K., and Young, A. *The Gay Report.* New York: Summit, 1977.

Lamb, Michael; Woen, M.; and Chase-Lansdale, L. "The Father-Daughter Relationship: Past, Present, and Future." In *Becoming Female: Perspectives on Development*, edited by C. Kopp. New York: Plenum, 1979.

Lansdell, H. "The Use of Factor Scores from the Wechsler-Bellevue Scale of Intelligence in Assessing Patients with Temporal Lobe Removals." *Cortex* 4 (1976):257–68.

Laws, J. L., and Schwartz, P. *Sexual Scripts: The Social Construction of Female Sexuality.* Springfield, Ill.: Dryden, 1977.

Lowe, M. "Sociobiology and Sex Differences." *Signs* 4 (1978):118–25.

Luce, G. G. *Biological Rhythms in Psychiatry and Medicine.* Chevy Chase, Md.: U.S. Department of Health, Education and Welfare, 1970.

MacArthur, R. "Sex Differences in Field Dependence for the Eskimo." *International Journal of Psychology* 2 (1967):139–40.

Maccoby, Eleanor E., and Jacklin, Carol N. *The Psychology of Sex Differences.* Stanford: Stanford University Press, 1974.

Masters, William H., and Johnson, Virginia E. *Human Sexual Response*. Boston: Little, Brown, 1966.

McGlone, J. "Sex Differences in Functional Brain Asymmetry." Research Bulletin No. 387. University of Western Ontario, 1976.

McGuinner, Diane, and Pribram, Karl. "The Origins of Sensory Bias in the Development of Gender Differences in Perception and Cognition." In *Cognitive Growth and Development—Essays in Honor of Herbert G. Birch*, edited by Morton Bortner. New York: Brunner/Mazel, 1979.

Minton, G. A.; Kagan, J.; and Levine, J. A. Maternal Control and Obedience in the Two-Year-Old." *Child Development* 42 (1971):1873–94.

Money, John, and Ehrhardt, Anke. *Man and Woman, Boy and Girl*. Baltimore: Johns Hopkins University Press, 1972.

Moos, R. H. "Typology of Menstrual Cycle Symptoms." *American Journal of Obstetrics and Gynecology* 103 (1969):265–68.

Newson, J. and Newson, E. *Four Years Old in an Urban Community*. New York: Pelican, 1968.

Paige, Karen. "Women Learn to Sing the Menstrual Blues." *Psychology Today* 7 (1973):41–46.

Parlee, Mary B. "Psychological Aspects of Menstruation, Childbirth and Menopause: An Overview with Suggestions for Further Research." In *Psychology of Women: Future Directions of Research*, edited by J. Sherman and Florence Denmark. New York: Psychological Dimensions, 1978.

Persky, E.; Smith, E. D.; and Basu, G. K. "Relation of Psychologic Measures of Aggression and Hostility to Testosterone Production in Man." *Psychosomatic Medicine* 33 (1971):265–77.

Ramey, Estelle. "Men's Cycles (They Have Them Too You Know)." *Ms*. Preview Edition (1972):8–14.

Robinson, Paul. *The Modernization of Sex: Havelock Ellis, Alfred Kinsey, William Masters and Virginia Johnson*. New York: Harper & Row, 1976.

Rose, R. M.; Gordon, T. P.; and Berstein, I. S. "Plasma Testosterone Levels in the Male Rhesus: Influences of Sexual and Social Stimuli." *Science* 178 (1972):643–45.

Rose, R. M.; Holaday, J. W.; and Bernstein, I. S. "Plasma Testosterone, Dominance Rank, and Aggressive Behavior in Male Rhesus Monkeys." *Nature* 231 (1971):366–68.

Rosenberg, Rosalind. *Beyond Separate Spheres: Intellectual Roots of Modern Feminism*. New Haven: Yale University Press, 1982.

Sherfey, Mary Jane. *The Nature and Evolution of Female Sexuality*. New York: Random House, 1972.

Sherman, J. A. "Field Articulation, Sex, Spatial Visualization, Dependency, Practice, Laterality of the Brain, and Birth Order." *Perceptual and Motor Skills* 38 (1974):1223–35.

———. "Problem of Sex Differences in Space Perception and Aspects of Intellectual Functioning." *Psychological Review* 74 (1967):290–99.

Sissley, E., and Harris, G. *The Joy of Lesbian Sex*. New York: Simon and Schuster, 1977.

Stafford, R. E. "Sex Differences in Spatial Visualization as Evidence of Sex-Linked Inheritance." *Perceptual and Motor Skills* 13 (1961):428.

Star, S. "The Politics of the Right and Left: Sex Differences in Hemispheric Brain

Asymmetry." In Hubbard et al., eds., *Women Looking at Biology Looking at Women*. Cambridge, Mass.: Schenkman, 1979.

Symons, D. *The Evolution of Human Sexuality*. New York: Oxford University Press, 1979.

Tanner, J. M. *Growth at Adolescence,* Second ed. Springfield, Ill.: Thomas, 1962.

Tobias, Sheila. "Math Anxiety: Why Is a Smart Girl Like You Counting on Your Fingers?" *Ms.* 5 (1976):56–59.

Vida, Ginny, ed. *Our Right to Love*. Englewood Cliffs, N.J.: Prentice-Hall, 1978.

Weideger, Paula. *Menstruation and Menopause: Their Physiology and Psychology, the Myth and the Reality*. New York: Dell, 1977.

Witelson, Sandra F. "Sex and the Single Hemisphere Specialization of the Right Hemisphere for Spatial Processing. *Science* 193 (1976):425–26.

Witkin, H. A. "Origins of Cognitive Style." In *Cognition: Theory, Research, Promise,* edited by C. Sheerer. New York: Harper & Row, 1964.

4

Women's Personalities

STEREOTYPES OF FEMININITY
What Are Women Like?
"Femininity": Descriptions and "Observations"
 Biases in Data Collection
Dimensions of Variability Among Women
Explanations of Female-Male Differences
 Biology
 Subjective Experiences
 Theories of Socialization

THE DEVELOPMENT OF A "FEMALE" PERSONALITY
Historical and Cultural Variation
Infancy
Early Childhood and the Development of Gender Roles
 Freudian Theory
 Criticisms of Freud's Theory
 Alternative Psychodynamic Explanations
 Cognitive-Developmental Theory
 Social Learning Theory
Later Childhood and Adolescence
 Social Environment and Gender Roles
 From Adolescence to Adulthood
 Some Cultural Variations in America

THE ADULT WOMAN AND SEXUAL MATURITY
The Classical Psychoanalytic Theory of Helene Deutsch
Pscyhoanalytic Dissidents: Karen Horney and Clara Thompson
Older Women

CHANGING THERAPIES

At one time it was considered a compliment for a woman to be told "You think like a man" or "You're not like other women." In contrast, for it to be said of a man that "he thinks like a woman" was (and probably still is) an insult. Today we shudder at such statements, for we recognize their implicit sexism, and we no longer believe that thinking or acting "like a man" is necessarily desirable. The statements are, nonetheless, curious. What thinking

processes, verbal comments, or behavior could prompt such a "compliment" or "insult"? What images or associations are stimulated in the mind of the receiver? Such statements as these are evidence of a cultural stereotype of the feminine and masculine and blatantly reflect the values attached. Are these stereotypes valid? How can we understand their existence?

Stereotypes of Femininity

Is there a specifically "feminine" way of thinking? Do women as a group possess certain behavioral characteristics that distinguish us from men as a group? These questions have been explored for generations. Common knowledge provides some "answers," and so does scientific research. In this chapter, we look into the ways in which women's personalities, motivations, and behavior have been characterized and explained. Of course, we must bear in mind here, as elsewhere in this book, that the characterizations and explanations have largely been dominated by male perceptions. Men have been the writers, researchers, and theorists in the past; only recently have feminist writers developed quite different perspectives on the subject of women's psychological makeup.

Human psychology—descriptions of the mental and behavioral characteristics of our whole species—has tended to be shaped by men's conceptions of what *men* are like. When women are considered, there is an emphasis on the differences between the two: what is male is the norm, and what is female is a deviation. Such generally human attributes as toolmaking, opposable thumbs, expressive faces, and certain intellectual capabilities tend to be neglected in discussions of *female* psychology. Rather, the focus tends to be on the ways women differ from men—in their genital apparatus and childbearing capacity in particular—to explain women's mentality and behavior. The evolution of generally human traits is commonly explained in terms of prehistoric *male* behavior, such as the hypothesis that the development of language was the result of male cooperative efforts in hunting rather than a result of female behavior or both.

Thus, women have been placed on the margins of humanity by those interested in accounting for our mental, emotional, intellectual, and other psychological traits. "Femininity" refers to traits characteristic of women, not shared by men or aspired to by them, as we shall see. We have noted previously that in the psychological sense, women have been defined as "other," as not only non-men, but as not quite fully human.

What are Women Like?

Characterizations of women's psychological traits in our society have a specific history, class origin, and cultural context. In *The Feminine Mystique* (1963),

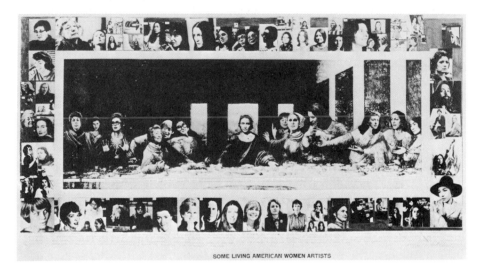

"Some Living American Women Artists/Last Supper" (1972) by Mary Beth Edelson is a celebration of the diverse personalities of women artists. Throughout history, women have had almost no chance for recognition as individual painters, and very limited opportunities for serious and sustained work in any of the arts. The center figure is Georgia O'Keefe. To her left is Louise Nevelson. On her far left is Yoko Ono. Edelson is at the bottom, one square away from the right corner. (Offset poster courtesy of the artist.)

Betty Friedan suggests that current popular notions of what women are like date back to the end of the Second World War, when the return of men from the army forced women out of jobs and back to the home. But some of these ideas have a much longer history (see chapters 1 and 2).

Despite the historical and cultural context within which they evolve, stereotyped notions about women are frequently viewed as universal and are applied to all women as a class. These generalizations are rooted in the popular belief that female behavioral and personality characteristics are a consequence of biological functions (see chapter 3). Yet these ideas about women are indeed class- and culture-bound. Just how much so becomes obvious when we look at female and male personalities as defined by other cultures. For example, Margaret Mead in *Sex and Temperament* (1935) found that in some other societies, characteristics we think of as typically "female" are assigned specifically to men, and others, typically "male," are assigned to women in similarly arbitrary fashion. Thus, among the Tchambuli of New Guinea, women are dominant and impersonal and manage tribal affairs. The men, in contrast, are less responsible and more emotionally dependent (box 4.1).

"Femininity": Descriptions and "Observations"

What are the personality characteristics ascribed to women? In the 1950s, sociologist Talcott Parsons analyzed the American family structure and concluded that in middle-class families,

> the most fundamental difference between the sexes in personality types is that, relative to the total culture as a whole, the masculine personality tends more to the predominance of instrumental interests, needs and functions, presumably in whatever social system both sexes are involved, while the feminine personality tends more to the primacy of expressive interests, needs and functions. We would expect, by and large, that other things being equal, men would assume more technical, executive and "judicial" roles, women more supportive, integrative and "tension-managing" roles, (Parsons and Bales, 1955: 100)

Parson's dichotomy of female-male behavior in the family set the tone for many subsequent social-scientific analyses of gender roles. In addition, Parsons concluded that the "typical" American nuclear family, in which the man is the wage earner and the woman is the housewife and child caretaker, is the most appropriate family structure for achieving the ideals and meeting the demands of American society. "At its best it seems to provide, in the intimate and private sphere, a highly appropriate pattern and environment of life for the enlightened citizens of a free society" (1959: 274). Thus, Parson's analysis also established a framework for the stereotype of the "middle-class suburban family," with members playing traditional roles, as the social ideal. His conclusions devalued other types of family structures.

Research in the 1970s indicated that women and men have been stereotyped in American society according to a broad range of psychological characteristics. A sample of these traits and the values placed on them appear in table 4.1. Most of the "feminine" characteristics are deemed inferior to most of the "masculine" ones, and the desirable "feminine" characteristics are viewed as better for women to have than for men (Broverman et al., 1972).

Biases in Data Collection. The stereotypes are not very useful for characterizing the real women that are studied by researchers. Empirical research, which tries to measure psychological and behavioral characteristics along a scale, is based on direct observation of representative samples of larger populations. However, such research, objective as it may attempt to be, may also contain many biases. Most systematic observations of hypothetical differences between females and males involve white, middle-class people, both as observers and as subjects. The labels the researchers use to classify behavior may reflect their own biases, as when they label nurturing or passivity as "feminine." Furthermore, the context of observation may influence the results. Women might, for example, behave one way at home, another way at

Sex and Temperament Box 4.1

We have now considered in detail the approved personalities of each sex among three primitive peoples. We found the Arapesh—both men and women—displaying a personality that, out of our historically limited preoccupation, we would call maternal in its parental aspects, and feminine in its sexual aspects. We found men, as well as women, trained to be co-operative, unaggressive, responsive to the needs and demands of others. We found no idea that sex was a powerful driving force either for men or for women. In marked contrast to these attitudes, we found among the Mundugumor that both men and women developed as ruthless, aggressive, positively sexed individuals, with the maternal cherishing aspects of personality at a minimum. Both men and women approximated to a personality type that we in our culture would find only in an undisciplined and very violent male. Neither the Arapesh nor the Mundugumor profit by a contrast between the sexes. . . . In the third tribe, the Tchambuli, we found a genuine reversal of the sex-attitudes of our own culture with the woman the dominant, impersonal, managing partner, the man the less responsible and the emotionally dependent person. These three situations suggest, then, a very definite conclusion. If those temperamental attitudes which we have traditionally regarded as feminine—such as passivity, responsiveness, and a willingness to cherish children—can so easily be set up as the masculine pattern in one tribe, and in another be outlawed for the majority of women as well as for the majority of men, we no longer have any basis for regarding such aspects of behavior as sex-linked. And this conclusion becomes even stronger when we consider the actual reversal in Tchambuli of the position of dominance of the two sexes. . . .

. . . Only to the impact of the whole of the integrated culture upon the growing child can we lay the formation of the contrasting types. There is no other explanation. . . . We are forced to conclude that human nature is almost unbelievably malleable, responding accurately and contrastingly to contrasting cultural conditions. The differences between individuals who are members of different cultures, like the differences between individuals within a culture are almost entirely to be laid to differences in conditioning, especially during early childhood, and the form of this conditioning is culturally determined. Standardized personality differences between the sexes are of this order, cultural creations to which each generation, male and female, is trained to conform. (Mead, 1935:279–80)

© Margaret Mead, 1935. Reprinted by permission.

school or work, and still another way in a laboratory situation, and the effects of these environments may differ for women and men. Finally, the observer may influence the subjects' behavior without even being aware of it. If the person administering a psychological test behaves one way toward female

Table 4.1 Stereotypic Traits

Feminine Pole Is More Desirable

Feminine	Masculine
Doesn't use harsh language at all	Uses very harsh language
Very talkative	Not at all talkative
Very tactful	Very blunt
Very gentle	Very rough
Very aware of feelings of others	Not at all aware of feelings of others
Very religious	Not at all religious
Very interested in own appearance	Not at all interested in own appearance
Very neat in habits	Very sloppy in habits
Very quiet	Very loud
Very strong need for security	Very little need for security
Enjoys art and literature	Does not enjoy art and literature at all
Easily expresses tender feelings	Does not express tender feelings at all easily

Masculine Pole Is More Desirable

Feminine	Masculine
Not at all aggressive	Very aggressive
Not at all independent	Very independent
Very emotional	Not at all emotional
Does not hide emotions at all	Almost always hides emotions
Very subjective	Very objective
Very easily influenced	Not at all easily influenced
Very submissive	Very dominant
Dislikes math and science very much	Likes math and science very much
Very excitable in a minor crisis	Not at all excitable in a minor crisis
Very passive	Very active
Not at all competitive	Very competitive
Very illogical	Very logical
Very home oriented	Very worldly
Not at all skilled in business	Very skilled in business
Very sneaky	Very direct
Does not know the way of the world	Knows the way of the world
Feelings easily hurt	Feelings not easily hurt
Not at all adventurous	Very adventurous
Has difficulty making decisions	Can make decisions easily
Cries very easily	Never cries
Almost never acts as a leader	Almost always acts as a leader
Not at all self-confident	Very self-confident
Very uncomfortable about being aggressive	Not at all uncomfortable about being aggressive
Not at all ambitious	Very ambitious
Unable to separate feelings from ideas	Easily able to separate feelings from ideas
Very dependent	Not at all dependent
Very conceited about appearance	Never conceited about appearance
Thinks women are always superior to men	Thinks men are always superior to women
Does not talk freely about sex with men	Talks freely about sex with men

Source: Broverman et al., 1972, 63. The table shows the extreme poles of seven-point rating scales. Average ratings of the typical male fall toward one pole; of the typical female, toward the other pole.

subjects and another way toward males—say, by smiling more often at women, or speaking more abruptly to men—then the results may reflect the differential treatment of the subjects. As a result, there is considerable potential for confusion about the results of empirical research on personality and behavioral differences between women and men. So far, the results of research provide little substantiation for most presumed differences. Table 4.2 presents a summary of the research findings about hypothetical sex differences. Even where differences do exist, the differences refer to group averages, and the overlap between groups is considerable.

Dimensions of Variability Among Women

Characterizations and caricatures of women vary by culture and class. The personality of female aristocrats is not expected to be like that of female servants. Stereotypes also differentiate women of different ethnic origins. Black women have been characterized as strong, dominant, and nurturing; Hispanic women as emotional, nurturing and passionate; Jewish women as aggressive, dominant, and intellectual; and so forth. (Differences between cultures and classes also apply to stereotypes of male behavior.) Because of this variation, different explanations are given for different "types" of women. "Female psychology" also varies by age. The characteristics of little girls are not the same as those of old women. Thus, general characterizations of female personality and emotions must take into account factors associated with life experiences, changing biological states, and social context.

From the feminist viewpoint, one of the most important dimensions of variability is that which occurs among individuals of the same sex and within the same individual at different times. It is this dimension that, for women, has been most neglected, and that most directly challenges previous assumptions about women and explanations grounded in earlier male-dominated theory.

Explanations of Female-Male Differences

The same categories that are used to explain variation among women— biology, subjective experience, and socialization—can be used to explain the real or perceived differences between women and men.

Biology. Strictly biological explanations refer to genetically derived factors, such as hormones, which may influence behavior and emotions. The complex variables that interact in the relationship between physiology and behavior are discussed in chapter 3 and will not be dealt with here.

Subjective Experiences. Explanations for possible differences between women and men based on "subjective experience" are derived from a general psycho-

Table 4.2 Sex Differences and Similarities

Abilities

General intelligence	No difference on most tests.
Verbal ability	Females excel after age ten or eleven.
Quantitative ability	Males excel from the start of adolescence.
Creativity	Females excel on verbal creativity tests; otherwise, no difference.
Cognitive style	No general difference.
Visual-spatial ability	Males excel from adolescence on.
Physical abilities	Males more muscular; males more vulnerable to illness, disease; females excel on manual dexterity tests when speed is important, but findings are ambiguous.

Personality Characteristics

Sociability and love	No overall differences; at some ages, boys play in larger groups; some evidence that young men fall in love more easily, out of love with more difficulty.
Empathy	Conflicting evidence.
Emotionality	Self-reports and observations conflict.
Dependence	Conflicting findings; dependence probably not a unitary concept.
Nurturance	Little evidence available on adult male reactions to infants; issue of maternal vs. paternal behavior remains open; no overall difference in altruism.
Aggressiveness	Males more aggressive from preschool age on.

Source: Tavris and Offir, 1977:33. © 1977 by Harcourt Brace Jovanovich, Inc. Reproduced by permission of the publisher.

analytic framework initially developed by Sigmund Freud (1856–1939). As a means of data collection, it involves the interpretation of subjects' experiences as they are remembered and related to the psychoanalyst. The material is quite subjective in that it reflects the biases and perspectives of both the teller and listener. While there are now a number of competing theories and interpretations within this framework, they share a certain perspective on explaining the characteristics of human personality. The emphasis within this perspective is on unconscious thought processes. Conscious thoughts and perceptions may be rational and in accord with facts, but the unconscious is nonrational and governed by emotions such as fear and desire. Psychoanalysis brings to light such unconscious thought processes and tries to show how they influence our feelings and behavior.

Psychoanalytic theory maintains that although people often suppress and hide such feelings, they affect us anyway, no matter how much our rational minds try to deny them. They emerge, sometimes in disguised form, in our dreams and fantasies, when we remove some of the constraints of reason. Because we become experts at "covering up" our irrational thoughts and feelings in everyday life, we need to interpret our behavior on two levels: in terms of its face value, and then in terms of its deeper meaning, the hidden value. Psychoanalysts are specialists trained to do such interpretation.

What interests the psychoanalyst is not so much the actual, objectively perceived experience of the individual, but the way the individual reacted to personal experience on the unconscious level. Let us consider, for example, a hypothetical applicant interviewing for a job.

A personnel director, who introduces herself as Martha Smith, asks the applicant several questions about her qualifications and tells her that she will hear soon about whether or not she will be hired. The applicant leaves, feeling dejected, certain that she has failed to impress the personnel director. Later she begins to examine her feelings. Why is she so sure that she has made a poor impression? Then she remembers that the personnel director's name, Martha, is the same as her aunt's. Her Aunt Martha always seems disapproving, no matter how hard she tries to please her. The applicant has made an unconscious association between her "disapproving" aunt and the personnel director; this accounts for her own emotional interpretation of her interview and her irrational anticipation of a negative outcome. For the purpose of this analysis, neither the behavior of the personnel director nor Aunt Martha is relevant; only the perception of them by the applicant is what matters. Thus, we can call this an explanation based on "subjective experience."

The psychoanalytic perspective assumes that we are all born with instinctive drives, called the *id*. But we acquire an *ego*, or rational control mechanisms, and a *superego*, or conscience, as we mature, through learning and

experience. We learn what we can and cannot have or do, and how, and when. This learning experience is subjective, like all experience relevant to the psychoanalytic perspective. We interpret on a personal basis the "rewards" and the "punishments" that guide us to behave in certain ways. Because we begin learning at birth, it is our early childhood experience that determines much of the content of our unconscious thought throughout our lives. That is, our attitudes toward the gratification of hunger and sexual and aggressive drives, for example, may be set by what we first learned about their fulfillment and control.

Because much of the subject matter of psychoanalytic theory concerns "unconscious" thought processes, it is not amenable to direct observation. Consequently, unconscious elements are inferred from behavior and memories. Interpretation is something of an art, dependent upon and influenced by the subjective attitudes of the interpreter. In order to evaluate an interpretation, then, we should know something about the attitudes of the interpreter. Most psychoanalytic observations in the past have been made of patients who were troubled in one way or another and sought help from a therapist. Freud believed that neurotic patients manifest problems that we all have, but in a much more pronounced form. Therefore, we can see the universals more clearly in their cases than in better-adjusted people. Critics have subsequently claimed the reverse: they say it distorts the picture to look at neurotic patients and generalize from the abnormal to the normal.

Nevertheless, psychoanalytic theory is intended to arrive at conclusions that apply universally, on the one hand, and very personally, on the other. The operations of the mind, as conceived by the theory, are the universals; the specifics are entirely individual. but the theory has little to offer for an understanding of directly observed statistical "averages." And it tells us nothing about cultural, ethnic, or class variation. Let us turn to theories of socialization, an alternative approach which is designed to address precisely the issues of average behavior in social context.

Theories of Socialization. Margaret Mead (1901–1978) was a pioneer in research on the cultural and social context of personality development. She began with the question: Are there universals of personality development? She felt that one could empirically test propositions about universals by comparing people in different cultural settings. Her first study addressed the question of adolescence. Is adolescence necessarily fraught with tension and conflict, as it seemed to be in her own society? To find out, she went to study adolescent girls in Samoa, a society very different from her own. Mead discovered that adolescence was a very relaxed, comfortable period of life in this society. She concluded that it was the socialization of human development that shaped its form, rather than any biologically determined universals (1928). Later,

Margaret Mead was perhaps the most influential and widely read anthropologist of our time. Her field work among different societies in the South Pacific illustrated the great diversity one can find in the cultural definition and shaping of gender roles and personalities. This very diversity, in her view, indicated that what is thought to be "feminine" and "masculine" is culturally, not biologically, determined. (American Museum of Natural History)

investigating the relationship between gender and personality, she compared several other South Pacific societies with her own and discovered, as we have seen, that what we think of as "feminine" and "masculine" are culturally determined traits, not inherent in sexual difference (1949).

Mead looked at the behavior of real girls and boys as they grew up, and real women and men in ordinary life, not at a reconstruction of childhood and adulthood from dreams and memories, as the Freudian psychoanalysts had done. Had she done her research in Vienna, where Freud practiced, she might have come up with a different picture of childhood and femininity than Freud had. Then again, had Freud gone to Samoa, using his psychoanalytic technique, he might have seen Samoan girlhood differently than Mead. He might have concentrated on a few special cases and examined their dreams and memories to uncover their unconscious world, a world which is invisible

to direct observers like Mead. Thus, the different depictions of personality formation we have from psychoanalysts and social psychologists may be as much a product of their different interests and expectations as of their different theories and methods.

Like psychoanalytic theory, socialization theories consider personality as something acquired and shaped (at least in part) through early childhood experience. Socialization theories, however, focus attention on what is *taught* as well as what is learned. That is, they direct attention to the social context of learning—the messages a child receives from others in the social environment—and how these messages are conveyed. For example, let us say that some psychological test shows that girls, on the average, feel we are less competent with mechanical devices than boys, on the average feel they are. In order to explain this difference, the social psychologist might look at the ways girls and boys are taught to deal with mechanical devices. The psychologist might observe the behavior of girls, boys, and their teachers in a kindergarten class. If girls are systematically discouraged from playing with mechanical toys, and from fixing them ourselves, while boys are encouraged to do so, this might account for the differences observed in the initial psychological test. The observation would provide support for the hypothesis that the lower self-judged competence in mechanical ability of girls results from what we are taught about our abilities (Denmark, 1977).

A number of theories and interpretations compete within the socialization framework, as we will see. Together, they provide a way of looking at the development of "feminine" characteristics that differs from the psychoanalytic way in many respects. They give different answers to questions. In this sense, theories resting on "subjective experience" and on "socialization" are not necessarily mutually exclusive, even though they may seem at times to conflict with one another.

The Development of a "Female" Personality

Historical and Cultural Variation

A variety of theorists have had a great deal to say about the development of feminine personality, stage by stage. We should keep in mind that their statements are based mostly on observations of twentieth-century Western society and limited to the white middle class. They do not take account of the enormous historical and cultural variation that in fact exists.

Childhood itself is a culturally variable phenomenon. In some societies, it is a very distinctive period of life. Its end is marked by special "rites of passage," initiation ceremonies which signal the individual's right and responsibility to assume adult status. In other societies, childhood is not so distinctive. Children may begin to engage in adult activities very early in life, and simply become more adept with time and practice. Certain stages of social

development which are important in Western society, like adolescence, might be eliminated altogether. In a society where a girl is technically married in childhood (at the age of seven or eight), moves to her husband's household at or before puberty (at the age of ten or twelve), and gradually learns to perform all the duties of a wife, there may be no social adolescence at all— just childhood and adulthood.

Western cultures tend to place a rather strong emphasis on individuation (the perception of one's self as a separate and unique entity). In many respects, psychological maturity is defined in terms of individuation, particularly by psychologists. But such an emphasis is not necessarily universal. Others may define maturity in different terms. Thus, many of the observations we will be discussing must be viewed with the understanding that they reflect certain cultural values and perceptions of the nature of childhood.

Infancy

The first words spoken about an infant who has just emerged from the womb usually are: "It's a girl" or "It's a boy." Although the infant cannot yet make sense of these words, parents and everyone else who come into contact with the baby can and do. Almost immediately, the meaning takes effect. That is, our concepts and expectations related to gender affect our behavior toward infants.

From the earliest age, mothers look at and talk to female infants more than male infants. For the first three months of life, but not after, boys receive more physical stimulation (e.g., kissing, holding, rocking, and touching) than girls do. After six months, mothers are more likely to encourage daughters than sons to touch and remain near, and physical contact between child and mother diminishes at a later age for girls than boys. Differences have been observed in the ways in which mothers hold sons and daughters: after six months of age, girls are held facing toward their mothers whereas boys are held facing away (Lewis, 1972). This pattern may be considered one aspect of a general tendency to protect and restrict females more than males.

These very early sex differences in parent-child interactions reflect what might be termed *nonconscious* ideologies (Bem and Bem, 1970); they may function as self-fulfilling prophecies. Once females and males are defined as basically different on a number of dimensions, they are treated differently and thereby develop in ways which confirm and reinforce the initial expectations of their caretakers (Denmark, 1977).

Research by Money and Ehrhardt (1972) on changes in gender assignments of infants born with ambiguous genitals dramatically illustrates the impact of gender-labeling on parental behavior; even small children altered their behavior toward siblings whose gender label was changed. Another study (Seavey, Katz, and Zalk, 1975) shows how one can demonstrate the effects of gender-labeling on the treatment of infants on an experimental basis. Subjects who

were told that a three-month-old baby was a girl were more likely to engage in one sort of treatment (such as playing with a doll) than they were when told that this baby was a boy.

It is unclear why mothers tend to touch sons more frequently than daughters during the first three months of life. Perhaps it is because boys are more irritable or are awake for longer periods of time (Moss, 1967) or because they are valued more (Hammer, 1970). But the reversal which occurs at about six months is consistent with cultural norms and stereotypes. Males are expected to be more independent than females and less fragile, and thus they are restricted less and allowed more freedom to explore the environment (Aberle and Naegle, 1952; Lewis, 1972). Autonomous males and dependent, domesticated females are cultivated in conformity with certain cultural definitions of femininity and masculinity. By the age of thirteen months, American boys spend longer periods of time away from their mothers and explore further distances; girls spend more time talking with and looking at our mothers than do boys (Lewis, 1972). The touching practices of mothers with infants parallel the differences we observe in touching behavior in adult women and men. In our society, men will rarely make physical contact with other men outside of certain prescribed and socially sanctioned situations. Women appear to feel freer than men to touch other persons, and we are touched more often in turn. This is consistent with the nurturant role women are designated to play in our relationships with other women and men as well as with children.

What are the effects of adult behavior on infants? Do differences in treatment of girl and boy infants have any clear impact on the infants' behavior or on their later lives? On these points, we can only speculate. Freudian theory holds that psychosexual differences do not begin to manifest themselves until children reach the age of about three years.[1] Until that time, all children are (subjectively) *both* female and male, since they have not yet noticed either consciously or unconsciously that there are sexual differences. This is not to say that they are not sexual creatures. In fact, Freud's claim that small children have sexual drives was found shocking and objectionable in his time. Rather, it is to say that the differences between female and male are not yet evident to small children, so they do not yet feel themselves to be "male" or "female"; the distinction is not yet subjectively relevant to them.

Despite Freud's contentions, some research indicates that children have formed the basis for their gender identities before the age of three (Money and Ehrhardt, 1972). To the extent that we believe that early social environment has an impact on personality and behavior, we must also believe that even before the age of three, gender differences will be manifest if girl and

1. *Psychosexual* is the term used for Freud's theory of human development. It is based on the belief that the sexual drive along with the unconscious meaning it takes on for the individual is the key factor underlying all personality development.

boy babies have been treated differently. What remains unclear is the extent to which girl babies associate our treatment with our "femaleness" and boy babies associate theirs with their "maleness."

Early Childhood and the Development of Gender Roles
Freudian Theory. According to Freudian theory, the significant turning point in psychosexual development for gender identity occurs at about the age of three. Before this time, sensual pleasure has been centered on oral gratification—sucking for milk at the bottle or at the breast of the mother or wet nurse. The provider of this pleasure, most often mother, is the primary object of the child's love. Conflict for the child at this *oral stage* centers upon need-gratification, the concept of self/not-self in relationship to the mother, and the development of a sense of trust. As the child grows, the anal area and anal functions become a source of sensual pleasure. This *anal stage* is characterized by struggles around issues of retention/elimination, toilet-training, and a sense of autonomy, self-control, and control of the environment.

The three-year-old's shift of focus to the sexual organs as the source of pleasure is labeled the *phallic stage* of psychosexual development. It is at this stage, according to Freud, that girls notice that boys and men have penises, a source of pleasure which is larger (and presumably more pleasurable) than our own clitorises. We also recognize that without this organ, we cannot "possess" the mother (our original love object) the way a man can, especially our fathers. According to Freud, this recognition leads girls to develop a sense of inferiority and the desire for a penis, a wish he labeled *penis envy*. At the same time, boys notice that girls and women do not have penises, and this leads boys to suspect that girls' penises were somehow denied or taken from them. Freud concluded that this produces anxiety in boys that they too will lose their principal source of pleasure, the penis. Freud called this anxiety the *castration complex*. He argued that girls blame our "inferior anatomy" (lack of a penis) on our mothers. We turn our affections toward our fathers, hoping to get the desired object (a penis) or a substitute (a baby) from him. Although we later learn that we cannot possess our fathers either, and must replace them with other men to provide gratification, our sense of denial is never fully resolved: we will never have a penis. Furthermore, in order to gain gratification through a relationship with a man, we must give up active sexual stimulation (clitoral masturbation) and turn to passive gratification (vaginal intercourse).

Boys, by contrast, desire to marry their mothers (their primary love object) and replace their fathers. Freudian theory labels this the *Oedipus complex*.[2] When they learn that they cannot possess their mothers because their rivals

2. Named after the Greek myth about Oedipus, who unwittingly killed his father and married his mother.

(their fathers) are bigger and stronger, they fear that their fathers will retaliate for this desire by castrating them. However, boys normally achieve a resolution of the Oedipal conflict by relinquishing the mother as love object (for a substitution to be acquired later on) and identifying with the father. This identification with the father removes a boy from the realm of competitor and thus reduces the castration fears. During this identification with the father, the boy develops a "male" identity and internalizes the father's moral standards. Girls, by contrast, must identify with our mothers. We do so reluctantly, because this identification does not help us obtain the wished-for penis. Thus, our own internalization of moral standards is weaker and less developed than that of boys. Because internalization of moral standards (resulting in the development of a conscience or superego) is essential to maturity, girls are seen as having more difficulty maturing than boys.

Criticisms of Freud's Theory. We can divide those critical of Freud's postulations about female development into two groups. The first group is inclined to dismiss the basic assumptions that underlie Freudian theory. These critics question whether or not these psychological events do take place. Because the events are largely unconscious developments, they cannot be observed directly. Because there can be no empirical proof or test of presumed unconscious processes, or even of the unconscious, for that matter, some argue that these conjectures do not belong in the realm of scientific discourse. Psychoanalysts counter this argument with another: postualation of these events is based on inferences drawn from observations of children and the behavior of adults, and they help us to understand other events

The second group of critics (including even a number of Freud's students) attack not the psychoanalytic approach but Freud's specific formulation of female development. These theorists believe that in other respects, Freud has contributed to the understanding of psychological processes and behavior. In *Psychoanalysis and Feminism* (1974), Juliet Mitchell attempts to reconcile Freudian theory and feminism. She takes the position that psychoanalytic theory is an analysis of a patriarchal society—not a recommendation for one—and so she views Freudian theory in a cultural context. Dorothy Dinnerstein, a psychologist who has written about the development of gender roles, incorporates much Freudian thought into her work:

> I am disturbed, like other radical critics of our gender arrangements, by the sexual bigotry that is built into the Freudian perspective. But I am disinclined to let the presence of that bigotry deflect my attention from the key to a way out of our gender predicament that Freud, in a sense absent-mindedly, provides. Feminists' preoccupation with Freud's patriarchal bias, with his failure to jump with alacrity right out of his male Victorian skin, seems to me wildly ungrateful. The conceptual tool that he has put into our hands is a revolutionary one. (Dinnerstein, 1976: xi)

The aspect of Freudian theory most criticized by feminists is the emphasis on penis envy and the view that our lives must be determined by our anatomy. Many critics have pointed out that women have anatomical features and capacities that men lack: why should girls be the ones to envy and boys be the ones to fear loss? Boys might observe that only women have breasts; later, they learn that only women can bear children. Why not "breast envy" or "womb envy"? Research on adults suggest that many men do experience such feelings in many societies (Mead, 1949; Zalk, 1980).

Karen Horney (1885–1952), a psychoanalyst and herself a student of Freud, dissented from Freudian theory on female psychology. She believed that Freud's theory of female psychosexual development reflected a male bias and that it was not plausible that woman, physically built for specifically female functions, should be psychically determined by a wish for attributes of the other sex (Horney, 1967). Horney suggests that the wish for a penis may be no more significant than the frequently observed wish for breasts. In addition, she notes that the characteristics ascribed by Freud to the "masculinity complex" (egocentric ambition, envy, the desire for dictatorial power) are exhibited by neurotic men as well as neurotic women and thus are not necessarily related to envy of the penis. These personality characteristics are indicative of feelings of inferiority which may derive from any number of sources. Horney points out that self-confidence in either sex is based on the development of a wide range of human characteristics: talent, initiative, erotic capacity, achievement, courage, independence. In a culture where the development of a woman's potential is sharply restricted, it is not surprising that feelings of inferiority are pervasive among women.

Criticisms of the dynamics of the "phallic" stage of development in girls are not simply based on a distaste for the theory or competing theoretical speculations. Psychoanalyst Zenia Odes Fliegel notes that the findings from both direct-observational studies of children and clinical reports of child analyses lend little support to Freud's formulation of female psychosexual development. She rebukes those analysts who rigidly adhere to this dynamic in the face of contradictory information and notes that it has "almost become a test of doctrinaire loyalty" (1980).

Alternative Psychodynamic Explanations. Attempts to understand female psychological development within a psychoanalytic or psychodynamic framework have led many theorists to explore the mother-daughter relationship. These writers focus not on genitals but on the role of maternal care. Some argue that because women have primary responsibility for child care in most societies today, as in the past, systematic differences between the mother-daughter and mother-son relationships may be critical to the understanding of gender differences in personality and behavior which emerge at later stages of life. It may be that the fact that the female child is

Karen Horney published a major feminist critique of Freudian psychoanalysis and women in her 1926 paper "The Flight from Womanhood." She pointed out that the masculinist mode of thought represented by the psychoanalysts of her day was not surprising given the male domination of all institutions. Thus both social reality and theoretical constructs were based on male views of the inferiority of women. She attributed this male perspective to a deep envy of the primacy of woman in reproduction. (Association for the Advancement of Psychoanalysis of the Karen Horney Psychoanalytic Institute and Center)

cared for and raised primarily by a parent or a parent-surrogate of the same sex engenders feelings and conflicts that differ from those elicited in the mother-son relationship. As a function of our gender, mothers tend to identify more completely with our female offspring. Flax suggests that mothers "do not seem to have as clear a sense of physical boundaries between themselves and their girl children as do mothers of boys" (1978: 174).

If this is true, it is not difficult to imagine what the repercussions might be. Female children are apt to have a more difficult time developing a sense of ourselves as separate, independent entities than do our male counterparts. We may also experience a conflict between maturation and autonomy and preserving our mothers' love. While the mother-daughter relationship may enhance the development of nurturance and impede the development of autonomy in girls, the cross-sex parenting boys receive may have the reverse effect. Boys can escape from infancy by becoming little men, but the girls cannot escape from infancy by becoming what our mothers are *not*—beings of a different gender (Flax, 1978). This is not to say that all mothers attempt to maintain unhealthy bonds with our female children, but rather that there may be a greater propensity to act out symbiotic needs, when they do exist, in relation to a child of the same sex than to one of a different sex. In addition, society offers fewer socially acceptable channels by which the daughter can assert her independence (see chapter 6).

Chodorow (1978) discusses the effect that predominantly female parenting has on the establishment of the boy's gender identity. In order for him to develop his appropriate gender role, the boy must break away from the female-dominated world from which he emerges. The devaluation of femininity and female activities may represent the male's attempt to differentiate himself from that feminine world. Erik Erikson (1964) refers to this as the establishment of a "negative identify," that is, an identity which hinges around what one is *not*. Males who grow up in a world in which gender roles exist but who as youngsters are relatively divorced from adult members of their own sex may need to solidify their sense of themselves as males by explicitly rejecting that which they are not, that is, females. Contemporary psychoanalysts have suggested that fear and envy of women and female sexuality may underlie negative attitudes toward women and may be traced back to these early mother-son relations (Flax, 1978).

Cognitive-Developmental Theory. Other schools of psychological thought offer alternative explanations for the development of female and male gender identities and roles. External pressures to conform to gender-appropriate behavior are augmented by an internal need to actualize one's gender identity. Cognitive psychologists are interested in the ways in which people organize and understand physical and social reality. They have suggested that

at age two, girls and boys begin to learn gender categories, but these are not initially based on an awareness of anatomical distinctions nor are they conceived to be unchangeable characteristics. Children construct gender classifications in the course of social interaction. The child learns to label certain persons female and others male and begins to associate physical as well as psychological attributes with these categories of people, based on experiences with representatives of each gender. Once children have classified themselves as female or male and recognized that their gender does not change, they are motivated to approximate to the best of their ability the social definitions of this identity: the girl strives to be the best female possible, and the boy strives to be the best male. In the case of female children, the motivation to fulfill our gender identity presses us toward the ideal of femininity (as socially defined), independent of externally mediated rewards or punishments for attaining such a goal. This explanation for gender-role acquisition may account for the fact that often girls and boys will conform to stereotypic gender roles even when their parents or other socializing agents do not differentially reinforce feminine and masculine behavior in them (Kohlberg and Zigler, 1967).

Social Learning Theory. Social learning theory associates gender-role acquisition with the external reinforcements (rewards and punishments) that people receive for behaving in particular ways. This theory minimizes the role of stable "personality" traits existing independently of external forces. It holds that we learn both "female" and "male" behavior by observing others. However, the behavior we perform is a function of whether it is rewarded ("you're a good girl") or punished ("nice girls don't do that!"). This theory maintains that females and males act in gender-stereotyped ways because these roles have been rewarded in the past and cross-gender roles have been punished. Social learning theorist and experimental psychologist Albert Bandura (1965) has research evidence to suggest that this is the case. When reinforcements for behavior are changed—for example, when women are rewarded rather than punished for engaging in "masculine" activities—behavior changes accordingly. Bandura suggests that the introduction of rewards for cross-sex behavior will enable girls and boys to expand their behavioral repertoires with little difficulty.

The cognitive theory of gender-role development focuses on the internal motivations of females and males to excel at the roles in which they find they have been classed, while the social-learning theorists emphasize the role of external pressures imposed on the developing girl and boy. Both these theories stress the acquisition of personality traits within a social context, traits that are inherent not in female and male, but in societies. Their emphasis is, then, on the role of social variables, not on universals of "femininity" and "masculinity" derived from anatomical distinctions.

Later Childhood and Adolescence

We still know little about cultural diversity in the experience of girlhood and adolescence (Denmark and Goodfield, 1978). The evidence we do have suggests that the experience of growing up in different cultures has been quite varied. Our society kept girls close to home, supervised our activities closely, and trained us early in the tasks of household work and child care. Samoan girls, in contrast, grew up in a social environment that was very relaxed about sex. Thus Samoan girls did not have the same types of anxieties about sex that American middle-class girls seemed to have. To take another example, Joyce Ladner's study of black girlhood in America (1971) suggests that unlike white middle-class girls, black girls in urban ghetto environments develop emotional stability, strength, and self-reliance early in life in order to cope with harsh conditions. Unfortunately, however, research on American minorities has been limited, and most of the studies that have emerged on minority women are plagued with biases and unfounded assumptions. For example, regarding research on black American women, Bonnie Thornton Dill states:

> Four major problems pervade the literature on Afro-American families. The first of these derives from the use of inadequate historical data and/or the misinterpretation of that data. The second entails erroneous or partially conceived assumptions about the relationship of blacks to white society. The third problem is a direct result of the second and arises because of the differences between the values of the researcher and those of the subject. Fourth is the general confusion of class and culture. (1979: 544)

In the pages ahead we will review some of the research on the socialization experiences of women. Although research findings on minority women will be included where possible, most of the data reported are based on a biased sample. However, by looking at the outcome of socialization in this sample drawn largely from white, middle-class America, we may be able to speculate on the processes which produce "feminine" and "masculine" adults elsewhere.

Social Environment and Gender Roles. Studies of American children indicate that as young as age six, boys hold higher expectations about their future performance on novel intellectual tasks than do girls, even when there is no difference in actual intelligence as measured on standard IQ tests (Crandall, 1969). Lower expectations are also found on the part of females in college and may act to inhibit women's achievement. How can we account for these differences in expectations?

Differences in the treatment of girls and boys may point to an answer. If, for example, achievement and competence are considered appropriate for males, then insecure males are likely to be encouraged to overcome their feelings of inadequacy. Girls who attempt to overcome this negative self-

image by asserting themselves may meet with social disapproval for trans-
gressing gender-role norms. Moreover, the incompetent female receives help
from others as well as social acceptance, both of which reinforce an infantil-
izing personality characteristic.

Pressures to conform to behavior deemed appropriate for gender roles
begin in the family and may be reinforced in the school by both authorities
and peers. Conformity to the male role generally forces a boy to strike out
daringly or else face ridicule and scorn, but conformity to the female roles
does not require such behavior. Boys who are highly concerned with social
approval are more likely to be unpopular with their peers, but the opposite is
found to be the case for girls (Tulkin, Muller, and Conn, 1969).

The early development of peer group relationships has traditionally dif-
fered between the sexes. Boys are generally involved in sports, which join
them with same-sex peers in a common activitiy. Girls are more likely to pair
off with one or more intimate friends than to participate in a group endeavor
(Maccoby and Jacklin, 1974). What matters in these close relationships is not
the activity but interpersonal communication. (Today girls are becoming less
systematically excluded from organized sports activities, a change which
might have a significant effect on the peer relationships we begin to form.)
These divergent experiences extend throughout adolescence and are relevant
to the cultivation of different gender roles in adult life.

From Adolescence to Adulthood. Patterns of interaction in adolescence seem
to train males to be "task specialists" and females to be "socioemotional
facilitators." We saw earlier that sociologists Parsons and Bales analyzed
adult female and male roles within the family in this manner. From this
perspective, what appear as "natural" and "functional" adult social roles
have been learned in adolescence. Thus, adult women are seen as less capable
of accomplishing specific task-oriented goals by group effort and adult men
as less capable of playing the role of nurturer.

The competitive experiences of adolescent males in the academic and
sports arenas provide them with opportunities to test themselves and to
compare their strengths and weaknesses with others. In doing so, they learn
that effort is related to the level of their performance. They also learn how to
adapt psychologically to both success and failure. It may be argued that
female adolescents compete, but in other forms, such as for boyfriends or for
social approval. Although both genders thus have the opportunity to exercise
competence within the limitations of their social roles, girls have the addi-
tional task of learning to please others and to comply with their demands.
Because girls direct our efforts toward modifying and shaping the behavior
and/or attitudes of these others toward ourselves, we have to depend more
than boys on external variables that are ultimately outside of our own con-
trol. In addition, adolescent girls are taught to avoid social discord, even to

the extent of not asserting our own views; as a result, we (and others) are less likely to perceive our views as valid.

The anticipation of a career choice looms large in the adolescent's identity formation (Douvan and Adelson, 1966; Erikson, 1964). Past research indicates that during junior high and high school years, boys' scholastic achievement improves while the academic performance of girls declines (Good, Sikes, and Brophy, 1973; Lynn, 1972). This may reflect the fact that others expect girls to achieve less in the future and, as a result, we expect less of ourselves and perform at a lower level. Or it may be testimony to our anticipation of the traditional female role of wife and mother in which we accommodate ourselves to a lifestyle largely dictated by our husbands' occupation and status.

Research over the past two decades into people's motivation to achieve has demonstrated the difficulty of conceptualizing and measuring aspects of personality. When achievement is defined in exclusively "masculine" terms, it may be incorrectly inferred that women, in a generic sense, are not motivated to achieve (Gilligan, 1979; Sassen, 1980). However, place the same women in a socially defined "female-appropriate" domain, and the motivation to achieve will be hedged by fewer mixed emotions; it will equal or exceed that of our male counterparts. The extent to which women "achieve" within traditionally male arenas also appears to be related to the "achievement" activities of our mothers. This relationship was observed during the 1960s among many black women and among more highly educated women (Ginzberg, 1966).

In her research with college students, psychologist Matina Horner found a recurring theme in women's stories which she labeled "the motive to avoid success," popularly known as "fear of success" (1969, 1972). This theme appeared more frequently among women than men. Horner based her explanation of fear of success in women on the perceived inconsistency between achievement and femininity. It is as if women thought the two categories of "feminine" and "achieving" were mutually exclusive. Horner's research has been seriously challenged (e.g., Sassen, 1980). Other investigators have found that men also show evidence of fear of success (Tresemer, 1973). However, the underlying concerns about success appear to be different for women and men (Hoffman, 1974). The men demonstrating fear of success had doubts about the value of success; the women associate success with social rejection.

Psychoanalyst Mabel Cohen (1973) points out that conformity to the role of the female as an attractive, dependent child limits a woman's capacities to perform in professional areas. Thus, in order to fulfill our gender identities we must often sacrifice the fulfillment of our identities as adult persons. Robert Seidenberg, another psychoanalyst, concurs. He suggests that "no woman will treasure any fame or glory she may achieve at the price of being called unfeminine" (1972: 319). Of course, what is designated as "unfemi-

nine" is not a fixed pool of attributes. The definition may even vary between families as well as between larger cultural groups.

Although it is not discussed as extensively in the psychological literature, there is some evidence that males experience the same sort of discomfort and hesitancy as females when they violate the social standards of their gender roles (Lockheed, 1975). Margaret Mead suggested early on that males are unsexed by failure but females are unsexed by success. It appears that all people who cross over "gender-appropriate" roles suffer from some degree of anxiety.

Some Cultural Variations in America. Research that has focused primarily on American minorities reveals some similarities as well as tremendous variation. Among Asian American women, for example, the split between the "ideal" woman and man has traditionally been quite extreme (Fujitomi and Wong, 1976). Asian women have been taught from birth that we are inferior to men in all valued areas. We must be submissive, passive and demure (boxes 4.2, 4.3). "Since the image of the passive, demure Asian woman is pervasive, the struggle for a positive self-identity is difficult. Within the Asian community, the family supports the development of the male's personality and aspirations, while the sister is discouraged from forming any sense of high self-esteem and individuality" (ibid.: 236). Although attitudes about family roles are much less traditional among Asian American women today, the Asian American male is far more reluctant to make such changes.

The socialization of the black woman is quite different from that of the Asian American or white American women. One study found that black women and men in the United States do not perceive any differences in the way they were socialized to achievement (Turner and Turner, 1971). Consequently, it is not surprising to find that black women are less likely to show evidence of "fear of success" than white women are—although there is evidence that this may be less so with middle-class black women (Weston and Mednick, 1970). The "ideal" woman as described by black women and black men is more independent than is the "ideal" woman described by white women and white men (Crovitz and Steinmann, 1980).

Frances Beal refers to the position of the black woman in a racist and sexist society as one of "double jeopardy" (1970). Psychologist Virginia O'Leary notes that

> according to the commonly held female stereotype, women are (or should be) weak, passive, dependent, and submissive. . . . [S]tereotypically feminine traits are valued less than stereotypically masculine ones. However, these stereotypically feminine traits do not reflect accurately those characteristics that are most highly valued in Black women within the Black community—strength, independence, and resourcefulness.

As a member of a minority group, the Black woman has had to assume a

```
┌─────────────────────────────────────────────────────────────────────┐
│                                                                       │
│   The Wisdom of Confucius                                  Box 4.2   │
│   One hundred women are not worth a single testicle.                 │
│                            *    *    *                                │
│      The five worst infirmities that afflict the female are indocility, discon- │
│   tent, slander, jealousy, and silliness. . . . Such is the stupidity of her char- │
│   acter that it is incumbent upon her, in every particular, to distrust herself │
│   and obey her husband.                                               │
│                     (Confucian marriage manual; in Cox, 1976:238, 239) │
│                                                                       │
└─────────────────────────────────────────────────────────────────────┘
```

> central role in the economic structure of her community. Forced to compete in the economic marketplace, often in the role of sole provider of financial resources for her family, the Black woman adopted behaviors and attitudes characteristically assumed to be "masculine." Submission, passivity, and dependence were for many Black women dysfunctionally related to the reality of their lives and roles. (1977: 136)

In this country, there are fewer economic opportunities for blacks than for whites and, historically, those jobs that have been available have often been thought to be more suited for black women than black men. More black women than white women are heads of households. The socialization of black girls is a preparation for these realities of adult life. Ladner (1971) points out that poor black girls are given a great deal of responsibility and independence at a young age and are likelier to spend more time in peer groups without adult supervision at a younger age than are white counterparts. Ladner contends that these girls are socialized into womanhood by the age of eight.

In a review of the research on the work patterns and gender roles of black women, Janice Porter Gump (1972, 1978) also notes that black girls grow up with the expectation of working; it is an integral and accepted part of black identity. Work and motherhood are not seen as incompatible. Black women express greater feelings of competence and self-confidence than do white women. According to Gump (1978), intelligent, competent black women are more attractive and less threatening to black men than are similar white women to white men. We are considered assets to men. Black women know that it is unrealistic to depend on men for protection and nurturance (although many would like to). While the traditional female role is less available and black women's expectations and career patterns are nontraditional, many black women's attitudes about marriage, children, and gender roles are traditional. Black women, more than white women, expressed the opinion that happiness and identity would come from traditional roles (Gump, 1975). Black women's lives may reflect desires less than necessities.

The role black women have assumed in the family has caused some writers

Too Much to Require Box 4.3

Fathers
required me
to split my tongue

to learn the silent
graces
of womanhood
like sweeping
cobwebs from family relics

 and so i am gentle

to taste
that guilt for not being
 'what you should be'
and working harder/for/everything

 and so i am gentle

to remember the ease
of instant omission
and the necessity for
assimilation

 and so i am gentle

to forget hiroshima
to ignore vietnam
to accept tule lake
to enjoy chinatown

 o yes, daddy,
 very gentle i am

 when i clean my gun.
 (Mirikitani, 1972)

© Janice Mirikitani, 1972. Reprinted by permission.

to claim that black families, even when the family is intact, are based on a matriarchal social structure. Such an analysis not only misinterprets the history of the black family in America (Gutman, 1976) but has also led to the claim that the structure of the black family, insofar as it differs from the assumed norm of the white, male-headed family, is pathological or "sick" (e.g., Moynihan, 1965). In her review of the research on "black matriarchy," O'Leary concludes that it is a myth that cannot be defended on any empirical grounds (1977).

Some writers have claimed that the greater success and power of black

The Bridge Poem Box 4.4

I've had enough
I'm sick of seeing and touching
Both sides of things
Sick of being the damn bridge for everybody

Nobody
Can talk to anybody
Without me
Right?

I explain my mother to my father my father to my little sister
My little sister to my brother my brother to the white feminists
The white feminists to the Black church folks the Black church folks
To the ex-hippies the ex-hippies to the Black separatists the
Black separatists to the artists the artists to the parents of my friends . . .

Then
I've got to explain myself
To everybody

I do more translating
Than the Gawdamn U.N.

Forget it
I'm sick of it

I'm sick of filling in your gaps

Sick of being your insurance against
The isolation of your self-imposed limitations
Sick of being the crazy at your holiday dinners
Sick of being the odd one at your Sunday Brunches
Sick of being the sole Black friend to 34 individual white folks

Find another connection to the rest of the world
Find something else to make you legitimate
Find some other way to be political and hip.

I will not be the bridge to your womanhood
Your manhood
Your human-ness

I'm sick of reminding you not to
Close off too tight for too long

I'm sick of mediating with your worst self
On behalf of your better selves

I am sick
Of having to remind you
To breathe
Before you suffocate
Your own fool self

Forget it
Stretch or drown
Evolve or die

The bridge I must be
Is the bridge to my own power
I must translate
My own fears
Mediate
My own weaknesses

I must be the bridge to nowhere
But my true self
And then
I will be useful

<div align="right">Donna Kate Rushin, 1981:xxi–xxii</div>

This poem originally appeared in a slightly different version in *This Bridge Called My Back: Writings by Radical Women of Color*, edited by Cherríe Moraga and Gloria Anzaldua. © 1981 Donna Kate Rushin. Reprinted by permission.

women has had a psychologically castrating effect on the black man and that black women should support black men even at our own expense (Chappelle, 1970). Frances Beal strongly opposes this position. She states that the black woman has been a "slave of a slave." "Black women are not resentful of the rise to power of black men. We welcome it. [However] . . . it is fallacious reasoning that in order for the black man to be strong, the black woman has to be weak" (1973: 141).

When we speak of women of color in the United States, we often divide the designation into such broad categories as black, Hispanic, or Asian. These categories themselves, however, represent a range of ethnic and cultural backgrounds. Black women in the United States may hear family stories about Africa, slavery, or life on the Carribean islands; Hispanic women may identify as Chicanas or Puerto Ricans; and women with Asian roots may have experienced or been brought up with widely divergent cultural values. Consequently, generalizations about the experiences that shaped the personalities of women of color, as well as the personalities themselves, are apt to be inaccurate for many individuals. What many of us, immigrants as well as the daughters of immigrants, do have in common is the pressure to reconcile family culture and values with those imposed on us by the particular kind of Western culture that predominates where we live. Chicanas, for example, have roots in a Mexican-Indian heritage. Historically, Mexican-Indian women had a responsible role in the social, religious, and economic life of the community (Nieto-Gomez, 1976). With the arrival of a colonizing Spanish culture and the Catholic Church, the opposed concepts of good woman–bad

The Socialization of Las Chicanas Box 4.5
Marianisma is the veneration of the Virgin Mary. . . . Through the Virgin
Mary, the Chicana begins to experience a vicarious martyrdom in order
to accept and prepare herself for her own oppressive reality. . . . To be a
slave, a servant, woman cannot be assertive, independent and self defin-
ing. . . . She is conditioned to believe it is natural to be in a dependent
psychological condition as well as dependent economically. The absolute
role for women is not to do for themselves but to yield to the wishes of
others. . . . Her needs and desires are in the charge of others—the patron,
her family, her father, her boyfriend, her husband, her God. She is told to
act for others and to wait for others to act for her. . . .

The basis for La Mujer Buena, the good, respectable woman in La
Casa Grande, was the upper class Spanish woman whose role was to stay
home. . . . The concept of Marianisma reinforced this Spanish role as a
positive ideal for everyone to follow. . . .

. . . Marianisma convinced the woman to endure the injustices against
her. (Nieto-Gomez 1976:228–33)

woman took over. The Spanish "lady," representing a different set of tradi-
tional roles, became the new ideal, and the place of Mexican-Indian women
was diminished and denigrated within that culture (see box 4.5).

The divergent pulls of personal heritage and the new dominant culture
impose additional stresses and conflicts on women of color in the United
States, who must struggle to maintain roots while establishing an individual
identity. In doing this, women confront not only the inherent sexism of our
cultures but the racism as well. The importance of this struggle can not be
underestimated. As Cherríe Moraga writes in *This Bridge Called My Back*, "I
think: what is my responsibility to my roots—both white and brown, Spanish-
speaking and English? I am a woman with a foot in both worlds; and I refuse
the split" (Moraga, 1981:34).

The Adult Woman and Sexual Maturity

The Classical Psychoanalytic Theory of Helene Deutsch
In her two-volume discussion of the psychology of women (once a standard
reference on the subject), Helene Deutsch, who had been a colleague of
Freud, proposes that the triad of narcissism, passivity, and masochism is a
natural concomitant of female biology (1944, 1945). The term *narcissism* is
derived from the Greek myth of Narcissus, who fell in love with his own
reflection. Masochism refers to the capacity to obtain gratification through
our own pain and suffering. Deutsch suggests that because girls do not pos-
sess an "active" sexual organ, our "active" impulses must be inhibited and

transformed into passive aims. Deutsch defines female passivity as "receptive readiness." As a consequence of our anatomy, women are naturally suited to be "acted upon" rather than to take action, and the reward for passivity is love.

Some degree of masochism, according to Deutsch's formulation, is an adaptive attitude for the female gender, whose biological functions of childbirth and menstruation are infused with both pleasure and pain. While the psychologically healthy woman is not masochistic to the point of self-destruction, in her relationships with men she is willing to renounce her own needs in order to obtain love. Love is the central motivation of the "feminine" woman. Narcissism, for women, serves the necessary psychic function of balancing out what might otherwise be an unhealthy tendency toward masochism.

From Deutsch's perspective, sexual pleasure and orgasm are not ends in themselves for the mentally well-adjusted female; coitus is unconsciously identified with impregnation and childbirth, which are her primary concerns. The woman perceives both clitoral sexuality and intense vaginal pleasure to be inconsistent with "normal" femininity. Deutsch suggests that the sexual experience of the feminine woman is—and what is more important, *should be*—a vicarious reflection of the experience of the man.

Psychoanalytic Dissidents: Karen Horney and Clara Thompson
Psychoanalysts Karen Horney and Clara Thompson both diverged from the classical Freudian theory of female psychology. They elaborated on the cultural constraints which contribute to the formation of the "feminine" personality

Karen Horney differs radically with the interpretation of female masochism propounded by Deutsch. Horney does not see masochism as an inevitable accompaniment to the female biological functions. Masochism represents, in Horney's formulation, an attempt to achieve personal safety and satisfaction by appearing inconspicuous and dependent. Weakness and suffering provide a vehicle for controlling others. She examines the cultural factors that nourish masochistic attitudes in women: women's economic, and hence emotional, dependency on men; society's emphasis on women's inherent weakness and delicacy; the barriers which block women's expansiveness and sexuality; and, finally, the ideology permeating our culture which dictates that a woman's purpose in life centers around the concerns of family, husband, and children. Horney suggests that these factors can explain masochistic tendencies in women without requiring any reference to anatomical determinants.

The "overvaluation of love" which Horney observed in normal as well as neurotic women of her time is a consequence of our economic and social dependency, which limits our direct access to security and prestige. The vicarious aspect of women's status and accomplishments can explain why

women may seem to be more afraid of losing love than are men. It is not necessary to attribute this to the symbolic desire for a penis.

Horney's explanation of "feminine psychology" suggests that social change might be able to remedy traits deemed undesirable. If socialization practices were changed so as to permit the development of women's expansiveness, sexuality, and independence, the female personality would be different. For example, a restructuring of the family to preclude women's economic and social dependence on men would eliminate the pressure on women as a group to take a masochistic attitude toward life. This view is in stark contrast to those who attribute "femininity" to penis envy and biological makeup.

Clara Thompson (1893–1958) also challenged classical Freudian explanations of female personality development. She takes issue with the assumption that the discovery of the penis is invariably a psychic trauma for the girl; yet she agrees that it may function this way if the lack of a penis is associated with lower status and fewer privileges within the family—and, historically, this has generally been the case (Thompson, 1964).

Rather than attributing the adolescent female's renunciation of the "active" role in life to the resolution of penis envy and acceptance of vaginal primacy, Thompson attributes it to external social pressures. Within a society that equates femininity with submissiveness and domesticity, the female's submissive and dependent behavior constitutes an adjustment (however debilitating) to the existing *social* realities. Insofar as the requirements of a culture are unchangeable or unchanging, it may be a more positive adaptation for the female to find pleasure in pain and self-sacrifice than to reject the life of a woman altogether and refuse to marry and bear children.

Freudian theory characterized women as less capable of moral integrity than men. Supposedly our superegos are weaker because we cannot fully resolve our penis envy. This conclusion was based on the observation that women's judgments seem to be based on feelings of hostility and affection and that many women merely repeat the views and opinions of the men who are nearest and most important. If in fact women are more chameleonlike in our opinions than men (and there is no empirical evidence to support such a general conclusion), Thompson suggests that this is a function of the status characteristics of females and males rather than of women's failure to develop strong internal standards of right and wrong. She points out that people in subordinate positions, who are dependent on an authority figure, may try to get along with that person by espousing similar interests and beliefs. Social psychological research on "integration" behavior provides empirical evidence for just such a proposition (Jones, 1964). *Irrespective of gender*, people who are dependent and relatively powerless are more likely to conform in their opinions than those who are immune from the sanctions of others.

The psychological literature on the social bases of power shows that

higher-status individuals are more successful in influencing, and more invulnerable to being influenced themselves, than lower-status individuals. Gender differences in interactional behavior appear to parallel these status differences; that is, males are more successful than females in their attempts to shape the attitudes of others and are less likely to yield or modify their own positions. Clearly, status differences between men—powerful men vs. powerless men—cannot be attributed to penis envy, or to the failure to internalize the standards of the father. Differences between women's and men's status and power appears to be a more convincing explanation for Freud's observations.

Older Women

Why do so many women seem much more concerned with signs of aging than do men? As this chapter and the preceeding chapters have indicated, much of the theorizing about women's personalities and behavior has been based on the assumption of biological determinism. With the loss of our reproductive and active parenting roles, Western cultures devalue our worth, an attitude which is not universal (see below). Along with this social attitude, stereotypes of the older woman abound. We are viewed as asexual, hypochondriac, dependent, intrusive, and generally, in negative terms. Our mood changes are attributed to what has popularly been referred to as "change of life." We may be condemned or tolerated for this change in body chemistry. Undoubtedly, negative social responses have an effect on our emotional state, but interviews with and research on older women reveal the gross distortions of the stereotypes. Aging may be as difficult for individuals as growing to adulthood often is, but personal responses to the process by women are usually the result of a complex set of circumstances: our physical health, our social realities, and our sense of psychological well-being. In each case, the messages we receive from our culture and those with whom we interact can make a significant difference. It is a matter of whether aging comes to mean the shutting down of possibilities or new and different opportunities for self-expression.

Menopausal depression refers to stress and depression women may experience during menopause. The *empty nest syndrome* refers to stress and depression experienced by a mother (or father, for that matter) when children grow up and leave the home, no longer requiring care. Both menopause and the independence of older children occur at about the same age, so it is frequently difficult to separate these events in a woman's life for the purposes of research.

Some women do suffer emotional distress during menopause (see chapters 3 and 12). Several psychologists have attributed this to our failure to fully accept our "feminine" role, claiming that women who do accept this role have less difficulty (Benedek, 1952; Deutsch, 1945). Others attribute depres-

sion in older women to the loss of the child-caring role—the "empty nest syndrome" (Lowenthal et al., 1975). Research findings, however, throw considerable doubt on both these conclusions. Studies with menopausal and postmenopausal women indicate that most women do not view menopause as a stressful or even a very important event in our lives (McKinley and Jeffries, 1974; Neugarten and Guttman, 1968). Other research provides little support for the idea that the empty nest causes distress in women (Campbell et al., 1976; Radloff, 1975, 1980).

In her research on depression in older hospitalized women, Pauline Bart found that "it is the women who assume the traditional feminine role—who are housewives, who stay married to their husbands, who are not overtly aggressive, in short who 'buy' the traditional norms—who respond with depression when their children leave" (1971: 184). In addition, she found that black women are less likely to have depressive reactions in middle age than white women. She attributes this to three factors. First, black women frequently live with relatives and care for their children and so are less likely to lose the "mother" role. Second, black women have traditionally worked and as a result are less likely to be overidentified with children. Finally, the black culture is less likely to view older women as asexual. Bart concludes that the difficulty some women have during menopause results from an overinvestment in our families and the lack of alternative identities.

In a cross-cultural study of women's behavioral changes at menopause, Joyce Griffen notes that in some cultures, there are no associated behavioral changes; in others, postmenopausal women are granted special privileges and status; and in still others, there are negative attitudes toward menopause and associated emotional conflicts. After reviewing the literature on these cultures, Griffen suggests that "the magnitude of symptoms associated with menopause is positively correlated with the paucity of roles (or of availability of demeaning roles only) available to the post-menopausal woman" (1977: 493). A study of American women whose children had grown found them optimistic about the years ahead. Many were pursuing new or second careers, going back to school, and trying out new endeavors. They were enjoying their new-found freedom and feeling positive about themselves (New York Times, 1980). Increasing numbers of writers are depicting older women not as looking backward toward youth, but as changing, developing people who are perceiving and coping with situations in the present.

Changing Therapies

The American Psychological Association has formulated guidelines for the delivery of nonsexist therapy (box 4.6). This is an important step within the profession of psychology as a whole because clinical psychologists have direct contact with a patient population seeking professional guidance. Clinicians

Nonsexist Guidelines for Therapy with Women Box 4.6

1. The conduct of therapy should be free of constrictions based on gender-defined roles, and the options explored between client and practitioner should be free of sex role stereotypes. . . .

2. Psychologists should recognize the reality, variety, and implications of sex-discriminatory practices in society and should facilitate client examination of options in dealing with such practices. . . .

3. The therapist should be knowledgeable about current empirical findings on sex roles, sexism, and individual differences resulting from the client's gender-defined identity. . . .

4. The theoretical concepts employed by the therapist should be free of sex bias and sex role stereotypes. . . .

5. The psychologist should demonstrate acceptance of women as equal to men by using language free of derogatory labels. . . .

6. The psychologist should avoid establishing the source of personal problems within the client when they are more properly attributable to situational or cultural factors. . . .

7. The psychologist and a fully informed client mutually should agree upon aspects of the therapy relationship such as treatment modality, time factors, and fee arrangements. . . .

8. While the importance of the availability of accurate information to a client's family is recognized, the privilege of communication about diagnosis, prognosis, and progress ultimately resides with the client, not with the therapist. . . .

9. If authoritarian processes are employed as a technique, the therapy should not have the effect of maintaining or reinforcing the stereotypic dependency of women. . . .

10. The client's assertive behaviors should be respected. . . .

11. The psychologist whose female client is subjected to violence in the form of physical abuse or rape should recognize and acknowledge that the client is the victim of a crime. . . .

12. The psychologist should recognize and encourage exploration of a woman client's sexuality and should recognize her right to define her own sexual preferences. . . .

13. The psychologist should not have sexual relations with a woman client nor treat her as a sex object.

 (APA Task Force on Sex Bias and Sex Role Stereotyping
 in Psychotherapeutic Practice, 1978:1122–23)

who subscribe to the traditional stereotyped views of women tend to diagnose women's dissatisfactions with stereotypic gender roles as evidence of neurosis. The goal of their therapy has been to adjust the woman to what is considered to be her natural, feminine "biologically determined" role.

Feminists are arguing against a view of mental health which postulates that any deviation from a "feminine" norm is evidence of maladjustment (Den-

mark and Black, 1980). New theoretical models of women are needed for nonsexist therapy. Phyllis Chesler, a psychologist and feminist, has discussed the antitherapeutic aspects of the traditional psychotherapy relationship (1972). According to Chesler, the female patient is often placed in a dependent and submissive role in relationship to a male authority figure. This kind of relationship duplicates the status differences between women and men in society at large, which are themselves occasionally responsible to some extent for women's psychological problems. Rather than encouraging the woman to become a mature, assertive, and independent adult, this kind of "therapeutic relationship" fosters "infantilism," which is consistent with stereotypical femininity. In addition, Chesler objects to the traditional orientation in therapy which assumes that the locus of pathology is within the woman herself, rather than in the society at large. This focus diverts attention away from the social causes of women's problems.

Today, psychologists are increasingly aware of current social dynamics and their relationship to "feminine" behavior in women. This will balance what was previously an almost exclusive emphasis upon emotional, early childhood, and anatomical determinants of gender differences. The past as well as the present must be accounted for when writing the psychology of women. Social realities must be considered in the shaping of women's experience and behavior.

Whereas previously the psychologically healthy woman was expected to be "feminine" and not "masculine" and the psychologically healthy man was expected to be "masculine" but not "feminine," many psychologists today are recognizing the limitations these prescriptions imply. The psychologically healthy person, woman or man, is perhaps the person who can develop a wide range of positive characteristics which are no longer sex-linked but are conceived of as *human* ideals.

Summary

Women tend to be characterized by certain stereotyped psychological traits not shared by men or aspired to by them. Although views on women's traits are formulated within a certain historical and cultural context, these traits are thought of as universal, resulting from a woman's biological role. Much of the research into female and male differences is affected by the biases of the researchers.

Differences in biology, subjective experiences, and socialization practices have all been used to explain why women and men differ. Psychoanalytic theory shows how our subjective experiences influence our feelings and behavior, while theories of socialization show how behavior can vary according to the social context.

From infancy, girls and boys are treated differently based on gender. We

tend to develop in ways that conform to the expectations of others. Mothers in our society have generally acted in such a way as to cultivate autonomous males and domesticated females.

Freudian theory holds that sexual drives start playing a key role in personality development at age three. Freud attributed many developmental consequences, including a sense of inferiority, to girls' "penis envy." Some of Freud's critics question his whole psychoanalytic approach; others take issue only with his view of female personality development.

Other psychodynamic explanations of female development focus on the mother-daughter relationship, which tends to enhance the development of nurturance and impede the development of autonomy.

Cognitive-developmental theory holds that girls and boys feel internal needs as well as external pressure to conform to a gender-appropriate identity. Social learning theory gives greater weight to external factors, such as the reward of gender-appropriate behavior and the punishment of cross-gender behavior.

The social environment contributes to the learning of gender roles. For instance, boys' involvement in group sports teaches them to orient themselves toward accomplishing a task. Because of cultural expectations, some women find "achievement" and "femininity" mutually exclusive. Black women and men have had a more positive attitude toward female competence.

Psychoanalyst Helene Deutsch proposed that a woman's anatomical makeup gives rise to the expression of narcissism, passivity, and masochism. Karen Horney attributed masochistic attitudes in women to social factors, such as woman's dependency on man. Clara Thompson also stressed the role of social-cultural factors.

Although many people associate depression in older women with menopause and with children leaving home, research findings cast doubt on these conclusions. Many women are finding that our later years free us from responsibilities to others, enabling us to pursue and enjoy interests of our own.

Feminists stress the need for professionals in the field of psychology to be aware of the effect of gender biases in their findings and their treatment.

Discussion Questions

1. List three documented differences between women and men. These can be differences in personality, mental ability, or conduct. What kinds of contrasting explanations can you give for them? Which do you find most convincing, and why?
2. At what point does a girl realize that she is female, and how? Give some theories you have read about and explain which among them you find convincing.

3. Freudian thinking dominated theories of personality development for many years. What aspects of Freudian theory have been challenged by feminists? Why? Some feminists such as Juliet Mitchell have argued that certain aspects of Freudian theory have lasting value. What are they?
4. Most psychological theory tends to focus attention on the formation of personality in the younger years. What questions should be explored with regard to mature women?

Recommended Readings

Chesler, Phyllis. *Women and Madness*. Garden City: Doubleday, 1972. Chesler explores mental illness in women as a cultural phenomenon reflecting sexist standards and pressures on women.

Chodorow, Nancy. *The Reproduction of Mothering: Psychoanalysis and the Sociology of Gender*. Berkeley: University of California Press, 1978. Employing psychoanalytic principles, Chodorow develops an original thesis showing how the traditional family structure, in which women have the primary responsibility for child care and nurturing, shapes female (and male) development and results in the generational reproduction of gender roles.

Mead, Margaret. *Coming of Age in Samoa*. New York: Morrow, 1928.
————. *Male and Female: A Study of the Sexes in a Changing World*. New York: Dell, 1949.
————. *Sex and Temperament in Three Primitive Societies*. New York: Dell, 1935. These three books by anthropologist Margaret Mead are pioneer works in the cultural relativity of gender roles and the way in which social structures shape female and male personalities according to the demands of society.

Jean Baker Miller, ed. *Psychoanalysis and Women*. Baltimore: Penguin Books, 1973. This book contains selections from the work of several psychoanalytic theorists such as Karen Horney and Clara Thompson who deviated from the Freudian position. The essays criticize the Freudian perspective on female development and offer additional ideas on this theme.

Tavris, Carol, and Offir, Carole. *The Longest War: Sex Differences in Perspective*. New York: Harcourt, Brace, Jovanovich, 1977. An excellent book exploring the various psychological and sociological theories on female development, gender roles, and female-male relations. It takes a critical look at many social scientists' beliefs, drawing frequently from a cross-cultural perspective.

References

Aberle, David F., and Naegle, Kasper D. "Middle-Class Father's Occupational Role and Attitudes toward Children." *American Journal of Orthopsychiatry* 22 (1952):366–78.

Albin, Rochelle S. "Has Feminism Aided Mental Health?" *New York Times,* June 16, 1981:c1, c3.

American Psychological Association Task Force on Sex Bias and Sex Role Stereotyping in Psychotherapeutic Practice. "Guidelines for Therapy with Women." *American Psychologist* 33 (1978):1122–23.

Bandura, Albert. "Influence of Models' Reinforcement Contingencies on the Acquisition of Imitative Responses." *Journal of Personality and Social Psychology* 1 (1965):589–95.

Bart, Pauline B. "Depression in Middle-Aged Women." In *Women in Sexist Society: Studies in Power and Powerlessness,* edited by Vivian Gornick and Barbara Moran. New York: Basic Books, 1971.

Beal, Frances. "Double Jeopardy. To Be Black and Female." In *The Black Women,* edited by Tone Cade. New York: Mentor, 1970.

Bem, Sandra L. "The Measurement of Psychological Androgyny." *Journal of Clinical and Consulting Psychology* 42 (1974):155–62.

———, and Bem, Darryl J. "Training the Woman to Know Her Place: The Power of a Nonconscious Ideology." In *Beliefs, Attitudes, and Human Affairs,* edited by Darryl J. Bem. Belmont, Calif.: Brooks/Cole, 1970.

Benedek, Therese. *Psychosexual Functions in Women.* New York: Ronald, 1952.

Broverman, Inge K.; Broverman, Donald M.; Clarkson, Frank E., Rosenkrantz, Paul S.; and Vogel, Susan R. "Sex-Role Stereotypes and Clinical Judgments of Mental Health." *Journal of Consulting and Clinical Psychology* 34 (1970): 1–7.

———; Vogel, Susan R.; Broverman, Donald M.; Clarkson, Frank E.; and Rosenkrantz, Paul S. "Sex-Role Stereotypes: A Current Appraisal." *Journal of Social Issues* 28 (1972):59–78.

Campbell, Angus; Converse, Philip E.; Rodgers, Willard L. *The Quality of American Life.* New York: Russell Sage, 1976.

Chappelle, Yvonne R. "The Black Woman on the Negro College Campus." *The Black Scholar* 1 (1970):36–39.

Chesler, Phyllis. *Women and Madness.* New York: Avon, 1972.

Chodorow, Nancy. *The Reproduction of Mothering: Psychoanalysis and the Sociology of Gender.* Berkeley: University of California Press, 1978.

Cohen, Mabel. "Personal Identity and Sexual Identity." In *Psychoanalysis and Women,* edited by Jean Baker Miller. New York: Penguin, 1973.

Cox, Sue. *Female Psychology: The Emerging Self.* Chicago: Science Research Associates, 1976.

Crandall, Virginia. "Sex Differences in Expectancy of Intellectual and Academic Reinforcement." In *Achievement-Related Motives,* edited by Charles P. Smith. New York: Russell Sage, 1969.

Crovitz, Elaine, and Steinmann, Anne. "A Decade Later: Black-White Attitudes Toward Women's Familial Roles." *Psychology of Women* 5 (1980):170–76.

Cummings, Elaine, and Henry, William E. *Growing Old: The Process of Disengagement.* New York: Basic Books, 1961.

Denmark, Florence L. "What Sigmund Freud Didn't Know About Women." Convocation Address, St. Olaf's College, Northfield, Minn. January 1977.

————, and Block, Joyce "The Psychodynamics of Women." *Psychology Update* 1 (1978): Nos. 7 and 8.

————, and Goodfield, Helen M. "A Second Look at Adolescence Theories." *Sex Roles* 4 (1978):375–79.

Deutsch, Helene. *The Psychology of Women.* Vols. 1 and 2. New York: Grune & Stratton, 1944, 1945.

Dill, Bonnie T. "The Dialectics of Black Womanhood." *Signs* 4 (1979):543–55.

Dinnerstein, Dorothy. *The Mermaid and the Minotaur.* New York: Harper & Row, 1976.

Donahue, W., Orbach, H., and Pollak, O. "Retirement: The Emerging Social Pattern." In *Handbook of Social Gerontology,* edited by Clark Tibbitts. Chicago: University of Chicago Press, 1960.

Douvan, Elizabeth, and Adelson, Joseph, *The Adolescent Experience.* New York: Wiley, 1966.

Erikson, Erik H. "Inner and Outer Space: Reflections on Womanhood." *Daedalus* 93 (1964):582–606.

Flax, Jane. "The Conflict Between Nurturance and Autonomy in Mother-Daughter Relationships and Within Feminism." *Feminist Studies* 4 (1978):171–89.

Fliegel, Zenia. "Half a Century Later: Current Status of Freud's Controversial Views of Women." Paper presented at the American Psychological Association Conference, Montreal, Canada, 1980.

Freidan, Betty. *The Feminine Mystique.* New York: Dell, 1963.

Freud, Sigmund. "Some Psychological Consequences of the Anatomical Distinction Between the Sexes." *International Journal of Psychoanalysis* 8(1927):133–43.

Fujitomi, Irene, and Wong, Diane. "The New Asian-American Woman." In *Female Psychology: The Emerging Self,* edited by Sue Cox. Chicago: Science Research Associates, 1976.

Gilligan, Carol. "Women's Place in Man's Life Cycle." *Harvard Educational Review* 49 (1979):431–46.

Ginzberg, Eli. *Life Styles of Educated Women.* New York: Columbia University Press, 1966.

Good, Thomas L.; Sikes, J. Neville; and Brophy, Jere E. "Effects of Teacher Sex and Student Sex on Classroom Interaction." *Journal of Educational Psychology* 65 (1973):74–87.

Griffen, Joyce. "A Cross-Cultural Investigation of Behavioral Changes at Menopause." Reprinted in *Psychology of Women,* edited by Juanita Williams. New York: Norton, 1979.

Gump, Janice. "A Comparative Analysis of Black and White Women's Sex Role Attitudes." *Journal of Consulting and Clinical Psychology* 43(1975):858–63.

————. "Sex-Role Attitudes and Psychological Well-Being." *Journal of Social Issues* 28 (1972):79–92.

————. "Reality and Myth: Employment and Sex Role Ideology in Black Women." In *The Psychology of Women: Future Directions of Research,* edited by Julia Sherman and Florence Denmark. New York: Psychological Dimensions, 1978.

Gutman, Herbert G. *The Black Family in Slavery and Freedom, 1750–1925.* New York: Random House, 1976.

Hammer, Max. "Preference for a Male Child: Cultural Factor." *Journal of Individual Psychology* 26 (1970):54–56.

Hoffman, Lois. "Fear of Success in Males and Females: 1965 and 1971." *Journal of Consulting and Clinical Psychology* 42 (1974):353–58.

Horner, Matina S. "Fail: Bright Women." *Psychology Today* 3 (1969):36–38.

———. "Toward an Understanding of Achievement-Related Conflicts in Women." *Journal of Social Issues* 28 (1972):157–74.

Horney, Karen. *Feminine Psychology*. Edited by H. Kelman. New York: Norton, 1967.

Jones, E. E. *Ingratiation: A Social Psychological Analysis*. New York: Appleton-Century-Crofts, 1964.

Kohlberg, Lawrence, and Zigler, Edward "The Impact of Cognitive Maturity on the Development of Sex-Role Attitudes in the Years 4–8." *Genetic Psychology Monographs* 75 (1967):89–165.

Ladner, Joyce. *Tomorrow's Tomorrow: The Black Woman*. New York: Doubleday, 1971.

Lever, Janet "Sex Differences in the Games Children Play." *Social Problems* 23 (1976):478–87.

Lewis, Michael. "Parents and children: Sex Role Development." *The School Review* 80 (1972):229–40.

Lopata, Helen Z. *Occupation: Housewife*. London: Oxford University Press, 1977.

Lowenthal, Marjorie F. "Psychosocial Variations Across the Adult Life Course: Frontier for Research and Policy. *The Gerontologist*. 15 (1975):6–12.

Lynn, David. "Determinants of Intellectual Growth in Women." *School Review* 80 (1972):241–60.

Maccoby, Eleanor M., and Jacklin, Carol N. *The Psychology of Sex Differences*. Stanford: Stanford University Press, 1974.

McKinley, S. M., and Jeffreys, M. "The Menopausal Syndrome." *British Journal of Preventive and Social Medicine*. 28 (1974):108–15.

Mead, Margaret. *Coming of Age in Samoa*. 1928. New York: Morrow, 1971.

———. *Sex and Temperament in Three Primitive Societies*. New York: Morrow, 1935.

———. *Male and Female*. New York: Dell, 1949.

Mirikitani, Janice. "Too Much to Require." In *Third World Woman*. San Francisco: Third World Communications: 1972.

Mitchell, Juliet. *Psychoanalysis and Feminism*. New York: Random House, 1974.

Money, John. and Ehrhardt, Anke. A. *Man and Woman, Boy and Girl*. Baltimore: Johns Hopkins University Press, 1972.

Moraga, Cherríe. "La Güera." In *This Bridge Called My Back*, edited by Cherríe Moraga and Gloria Anzaldúa. Watertown, Mass: Persephone Press, 1981.

Moss., Howard A. "Sex, Age, and State as Determinants of Mother-Infant Interaction." *Merrill-Palmer Quarterly* 13 (1967):19–36.

Moynihan, Daniel P. *The Negro Family: The Case for National Action*. Washington, D.C.: U.S. Department of Labor, Office of Policy Planning and Research, 1965.

New York Times. "A New Start for Women at Midlife." December 7, 1980.

Nieto-Gomez, Anna. "Heritage of La Hembra." In *Female Psychology: The Emerging Self*, edited by Sue Cox. Chicago: Science Research Associates, 1976, 226–34.

O'Leary, Virginia. *Toward Understanding Women*. Belmont, Calif.: Brooks/Cole, 1977.

Parsons, Talcott. "The Social Structure of the Family." In *The Family: Its Function*

and Destiny, edited by R.N. Ashen. Revised edition. New York: Harper, 1959.

————, and Bales, Robert. *Family Socialization and Interaction Process.* New York: Free Press, 1955.

Radloff, Lenore S. "Depression and the Empty Nest." *Sex Roles* 6 (1980):775–82.

————. "Sex Differences in Depression: The Effects of Occupation and Marital Status." *Sex Roles* 1 (1975):249–65.

Rushin, Donna K. "The Bridge Poem." In *This Bridge Called My Back,* edited by Moraga and Anzaldúa. Watertown, Mass: Persephone Press, 1981.

Sassen, Georgia. "Success Anxiety in Women: A Constructionist Interpretation of Its Source and Its Significance." *Harvard Educational Review* 50 (1980):13–24.

Seavey, Carol A.; Katz, Phyllis A.; and Zalk, Sue R. "Baby X: The Effect of Gender Labels on Adult Responses to Infants." *Sex Roles* 1 (1975):103–9.

Seidenberg, Robert. "Is Anatomy Destiny?" In *Psychoanalysis and Women,* edited by Jean Baker Miller. New York: Penguin Books, 1972.

Sherman, Julia A. *On the Psychology of Women.* Springfield, Ill.: Charles C. Thomas, 1971.

Tavris, Carol, and Offir, Carole. *The Longest War: Sex Differences in Perspective.* New York: Harcourt, Brace, Jovanovich, 1977.

Thompson, Clara. *Interpersonal Psychoanalysis.* Edited by M.R. Green. New York: Basic Books, 1964.

Tresemer, D. "Fear of Success: Popular but Unproven." *Psychology Today* 7 (1974): 82–85.

Tulkin, Steven R., Muller, John P., and Conn, Lane K. "Need for Approval and Popularity: Sex Differences in Elementary School Students." *Journal of Consulting and Clinical Psychology* 33 (1969):35–9.

Turner, Castellano B., and Turner, Barbara F. "Perception of the Occupational Opportunity Structure, Socialization to Achievement and Career Orientation as Related to Sex and Race." Paper presented at the American Psychological Association annual conference, Washington, D.C., 1971.

Weston, Peter. and Mednick, Martha. "Race, Social Class, and the Motive to Avoid Success in Women." *Journal of Cross-Cultural Psychology* 1 (1970):284–91.

Zalk, Sue R. "The Re-emergence of Psychosexual Conflicts in Expectant Fathers." In *Pregnancy, Birthing, and Bonding,* edited by Barbara Blum. New York: Human Science Press, 1980.

5
Social Roles

SEX AND GENDER
Social Definitions
The Social Construction of Gender
The Historical Dimension
Social Science and the Conceptualization of Gender Roles

THEORIES OF SOCIETY
Social Charter Myths
The Search for Social Origins
Evolutionary Theories: Patriarchal and Matriarchal Origins

ASPECTS OF SOCIALIZATION
The Division of Labor by Gender
 Gender Socialization and Work Goals
The Heterosexual Prescription
Marriage as a Legal and Social Institution
 The Social Roles of Wives and Widows
 The Social Roles of Mothers

THE SOCIAL CONTROL OF WOMEN
Physical Control: Clothing and Gender
Vulnerability as Social Control
Language as Social Control

SOCIALLY CONSTRUCTED INVISIBILITY
The Theory of Muted Groups
The Need for New Interpretive Frameworks
The Social Construction of Human Beings

Every human social group uses its perception of biological sex differences in some way to organize gender, kinship systems, social roles, and a division of labor. In preceding chapters, we discussed how physiological sex distinctions have been variously interpreted as indicators of absolute gender differences. Feminist scholars have now begun to demonstrate the extent to which such presumed absolute differences exist primarily in the expectations and assumptions of people, in culture rather than in biological "fact." This chapter deals with the theories and assumptions about "inevitable" gender differences that have affected both the organization of society and the scholarship that seeks to understand society.

In studying society, we focus on aggregate patterns, broadly shared social assumptions. It is in terms of these social assumptions that we seek to raise questions about the "naturalness" of the gender-specific family and social roles women have been assigned in all societies. Sociologists have examined gender roles in terms of their function as well as their structure in society. We wish to examine these roles anew, from a woman-centered perspective, and ask several questions: What functions do such roles serve? Who benefits from them? What assumptions are at work in making the assignment of gender roles, tasks, and behavior?

We presented the theoretical issues of inequality in a previous chapter; here we wish to consider the social patterns of inequality. We shall see the consequences of the two-gender system for the division of labor in societies and for the social roles assigned on the basis of gender. Finally, we shall offer some thoughts about how the gender system has fostered women's "invisibility."

Sex and Gender

Social Definitions

In the biological sense, a "woman" ordinarily is a person whose chromosomes (XX), internal and external sexual organs, and hormonal chemistry mesh in such a way as to warrant the label "female" at birth. This biological "woman" is a human being capable in various phases of life of menstruating, gestating, and lactating. But the rich variety of social arrangements that exist in the world suggests that biological sex alone cannot explain the differing gender roles assigned in these societies. Beyond the biological core, a "woman" in the social sense is a great many other things, depending on which society we are studying. In this sense, a "woman" is a social construct. Part of this social definition, however, is that a "woman" is capable of bearing children. Even though many women never marry, bear children, or nurse them, we are socially defined by our capacity to do so and by the *social expectation* that this capacity is a basic characteristic of our existence.

Social definitions of "women" include many other physical, psychological, and behavioral characteristics, the sum of which, for any one society, represents the gender label "woman" for that group. Since every society makes a gender assignment at birth, an infant is immediately heir to all these social expectations.

Essential to the construction of gender is the notion of polarity: there are only two genders (with some rare cultural exceptions), and each is the "opposite" of the other. Thus "woman," above all else, is "not-man." This underlying concept of "otherness" or "opposites" leads not only to lists of contrasting characteristics, labeled "feminine" and "masculine," but also to contrasting adjectives for the same characteristic. For example, in our society, angry women are called "hysterical"; angry men are "outraged." Women who are

interested in every detail are called "nosy," while the same kind of men are called "curious." Women who are devious and manipulative are called "scheming," but devious men are called "shrewd."

The choice of descriptive adjectives reflects the underlying assumptions or expectations that are socially related to gender. Social constructs represent actual people only to the extent that these people have internalized the socialization to which they are exposed from infancy and have identified with gender stereotypes.

However a particular society characterizes its genders, the gender system itself reflects an asymmetrical cultural valuation of human beings. In each society, whatever socially prescribed characteristics are assigned to the two gender labels, one gender is assigned roles and tasks considered culturally inferior to the other. This gender is almost always "woman." No matter what the social tasks assigned and no matter what behavior is deemed appropriate—and these may be reversed in different cultures—cultural asymmetry based on gender remains the same: "woman" is deemed culturally inferior.

When large numbers of women enter a given profession, for instance, to become doctors in the Soviet Union or bank tellers in the United States, the profession as a whole becomes devalued. Thus, it is not the role or task or even the characteristics ascribed to them, but the *gender that carries out the task* that seems to signify whether it merits social esteem or not. Social norms change over time, but gender asymmetry remains.

"Ain't I a Woman?" **Box 5.1**

Sojourner Truth (1795–1883) was born a slave in New York State and freed in 1827 when all slaves in that state were emancipated. She became a domestic worker. She then became an evangelist and, in her late forties, an active abolitionist. In 1851, at a women's rights convention in Ohio, she spoke out against male delegates who warned women that we were going beyond our true natures when we wished to participate in the world of men.

> That man over there says that women need to be helped into carriages and lifted over ditches, and to have the best place everywhere. Nobody ever helps me into carriages or over mud-puddles, or gives me any best place! And ain't I a woman? Look at me! I have ploughed and planted, and gathered into barns, and no man could head me! And ain't I a woman? I could work as much and eat as much as a man—when I could get it—and bear the lash as well! And ain't I a woman? I have borne thirteen children, and seen most all sold off to slavery, and when I cried out with my mother's grief, none but Jesus heard me! And ain't I a woman?
>
> (Schneir, 1972:94–95)

From an early age, girls work longer and have less leisure than boys. Here a girl in Columbia, South America, carries firewood. (*Save the Children*. Photo by Andy Mollo.)

The Social Construction of Gender

Extreme politeness is considered good behavior for both genders in Japan. A Japanese man who is very deferential, who is reluctant to assert his own opinion to social superiors or guests, and who giggles nervously when urged to do so is conforming to expected gender-appropriate social behavior in the very same way as is a young woman in our society who acts similarly. It is the culture, then, which sets the social norms.

Socialization of children consists of introducing them to these rules or norms of behavior, the social expectations by which they can make sense of how others act toward them and how they should, in turn, behave. The extent to which women and men conform, even partially, to the stereotypes of gender-appropriate behavior depends in part upon their successful socialization, the degree to which they have internalized the cultural pressures to conform (box 5.2).

The social structure, which defines gender-appropriate behavior, is composed of a pattern of values, beliefs, and customs embedded in a specific material way of life. As these variables change through time, the social norms within societies also change. In our society today, the social roles and behavior of women represent some measure of change over past time; yet, such changes have not overturned our most fundamental social expectations based

The Social Construction of Gender Box 5.2

Gender is a socially imposed division of the sexes. It is a product of the social relations of sexuality. Kinship systems rest upon marriage. They therefore transform males and females into "men" and "women," each an incomplete half which can only find wholeness when united with the other. Men and women are, of course, different. But they are not as different as day and night, earth and sky, yin and yang, life and death. In fact, from the standpoint of nature, men and women are closer to each other than either is to anything else—for instance, mountains, kangaroos, or coconut palms. The idea that men and women are more different from one another than either is from anything else must come from somewhere other than nature. Furthermore, although there is an average difference between males and females on a variety of traits, the range of variation of those traits shows considerable overlap. There will always be some women who are taller than some men, for instance, even though men are on the average taller than women. But the idea that men and women are two mutually exclusive categories must arise out of something other than a nonexistent "natural" opposition. Far from being an expression of natural differences, exclusive gender identity is the suppression of natural similarities. It requires repression: in men, of whatever is the local version of "feminine" traits; in women, of the local definition of "masculine" traits. The division of the sexes has the effect of repressing some of the personality characteristics of virtually everyone, men and women. The same social system which oppresses women in its relations of exchange, oppresses everyone in its insistence upon a rigid division of personality.

(Rubin, 1975:179–80)

Copyright © 1975 by Rayna R. Reiter. Reprinted by permission of Monthly Review Press.

on gender. For example, married women who pursue jobs outside the home may still feel the stress of pulling against cultural norms. If we have children, we must continually balance the roles we are expected to play as "mothers" against the socially defined behavior expected of us in any other role: "wives," "lovers," "employees," "poets" "airline pilots." Women who pursue jobs or activities whose pattern of behavior has traditionally been defined by men experience daily conflict between the male-defined norms of that activity and the social roles expected of us as women. Being "women" automatically sets boundaries on our range of acceptable behavior and activity, creating serious tension for those who seek to combine two different sets of roles traditionally divided along gender lines.

As women we experience social restrictions regarding education, choice of work, mobility, forms of cultural expression, and political participation. We also face social controls over our health and whether we may—or must—have children. Among the strongest social pressures we face are those which

insist that women rather than men fulfill the role and perform the tasks of "mothering." These social controls limit our choices from the moment of our birth and affect the range of our individual autonomy and self-expression. They govern our social realities as women. This is the meaning of the social construction of gender.

The Historical Dimensions

It is important to remember that the ways in which a society is organized—its kinship structure, its dominant patterns of marriage and family life and of reproduction and production—vary over time. Social roles today represent new solutions to ever-changing circumstances. Humans adapt to their material world. As we have noted, until recently, historians have taken into account changes in large-scale social patterns while ignoring changes in the realms in which women predominate. Men, as contemporary record keepers and historical interpreters of those records, have focused on those aspects of society which have seemed important to them. Until recently, the questions historians have asked have been directed only at activities led by and of special interest to men: politics, war, economic organization, and "public" institutions. In fact, women have been involved in these activities too, but our presence has been rendered invisible by the theoretical assumptions that have consigned us to unchanging and narrowly circumscribed domestic roles.

Such skewing of our knowledge of the past has had important consequences for all scholarship that draws upon the past to help understand the present, or seeks theoretical constructions to explain how societies function. Theories about society that make assumptions about the universal, unchanging nature of gender roles, for example, are no longer valid when we recognize their failure to take account of the very real differences in those roles at specific historical times. In formulating theories to *explain* social reality, men have simply perpetuated their view of women as subordinate actors. New questions raised by historians about change over time in the most intimate as well as the most impersonal realms of society increase our knowledge of history and must call forth new theories about society (Carroll, 1976; Sherman and Beck, 1979; Spender, 1981).

We cannot overstress the significance of the "invisibility" of women in history to thinking about society. To find what women have done in history, to determine what our activities and lives have been like, has involved methodological innovations such as the imaginative use of demography (population information) and local records of all kinds and the asking of new questions from the perspective of women's experience of traditional sources. Historians have begun to realize the need to examine the structure of domestic life, families, childhood, and the relations between the genders because they are not always the same in all times and places (Bridenthal and Koonz, 1977; Lerner,

1979; Tilly and Scott, 1979). Class, race, and ethnicity create differences even within one society. This realization is important to our study of women in society (Joseph and Lewis, 1981; Hull et al., 1982).

Social Science and the Conceptualization of Gender Roles
Social scientists, like historians, have traditionally concentrated their attention on the world as men see it. Sociologists, for example, have been especially concerned with "public" or group activities and questions of power, authority, and social order as they are created by groups. The activities studied have primarily involved men, and the authority wielded has primarily been in the hands of men. Women have been visible when sociologists have dealt with the family, but even there the focus has been on the function served by the family in the larger society. Sociologists have failed to look at the family's relations with society from the point of view of those whose roles have been confined to the family. As the editors of an important collection of feminist essays on sociology state, "Sociology has focused on public, official, visible and/or dramatic role players and definitions of the situation" (Millman and Kanter, 1975:x). This focus produces a distorted view of social reality, since, as these writers point out, "unofficial, supportive, less dramatic, private, and invisible spheres of social life and organization may be equally important" (Ibid.).

Feminist scholars can help us to understand how social systems actually function. They can help us to see women's realities. In the words of one feminist sociologist, both classical and modern sociology have failed to account for women because they have excluded the personal, "virtually the only means by which the majority of women have been able to shape and articulate their own social reality" (Gould, 1980:463).

Sociology as written and developed by men has often failed to consider the influence of gender on social behavior, even though it may often be the most important factor. For example, sociologist Gaye Tuchman (1975) has shown that studies of recruitment into artistic careers fail to consider gender as an important variable in career choice. Many sociologists have too often discounted the possibility that women can be serious artists.

Sociologists have also assumed that women's roles have been unchanging and therefore not worthy of serious study. Like historians, however, some have begun to realize that maternity, child care, and domestic relationships have been as subject to change as any other kind of human phenomena. But because the tools of sociological analysis developed from and are finely tuned to men's activities, they do not yet provide the questions, concepts, images, or even vocabulary necessary for a thorough investigation of women's experiences. The problem is endemic in the social sciences, and will remain so until careful conceptual work is undertaken that will develop a new sociology of

knowledge embracing all aspects of women's experiences. Such a task requires the work of more than a few feminist scholars; it requires the activity of whole fields of scholars in search of truth (Smith, 1979).

Feminists are also concerned with what "knowledge" in these areas has been—*and ought to be*—used for. Much purportedly "objective" social science research has actually served to uphold traditional social patterns that oppress women. Not only have social structures and gender roles embodied the denigration of women, but the very studies which should have enabled us to see this have themselves reinforced these bonds.

Social science is not value-free, despite claims to the contrary. Those who assert universal reality for what is in fact the perspective of males have also claimed to be engaged in "objective" studies which have actually been limited by race and class perspectives. At the least, what is necessary is clear recognition of the perspectives and values that do shape our work. For example, in discussing her approach to the black women she was studying, black sociologist Joyce Ladner explains how it differed from what a white, male sociologist might bring to a similar study: "I soon began to minimize . . . the importance of being 'value-free,' because the very selection of the topic itself reflected a bias, i.e., I studied Black women because of my strong interest in the subject. I decided whose side I was on and resolved within myself that as a Black social scientist I must take a stand and that there could be no value-free sanctuary for me" (Ladner, 1972:7–8; see also Ladner, 1978).

Theories of Society

Just as modern social scientists need to understand the values and perspectives feminists bring to our work, we should recognize the values and perspectives that have been implicit in all theorizing about social origins. Where myth and ritual have been very important in socializing each new generation in the customs, values, and beliefs of the parent generation, such myths have involved stories about social origins that represent implicit gender assumptions. Myths contain moral prescriptions for social behavior based on implicit theories about society and social order; they exemplify social ideals, explain social norms, and transmit social values.

Social Charter Myths

A particular kind of myth which serves these functions among a number of South American Indian tribes has been described by anthropologist Joan Bamberger (1974) as a *social charter* myth because it explains the structure of society in relation to a presumed earlier social order that reversed the gender roles. Social charter myths tell a tale of a past time when women ruled over men. Among Yamana and Selk'nam tribes of Tierra del Fuego, at the tip of South America, young men are told the myth at a ceremony initiating them

into the secret society of adult males. The purpose of the ritual is to impress the excluded female population with the superiority and greater power of males.

According to the Yamana origin myth, the women of their tribe were the first to possess its secrets and, as a result, women gave the orders and men obeyed them. Men were expected to do all the work of child care, fire-tending, and animal skin cleaning and had to sit in the rear of the canoes. To maintain their rule, the women painted their bodies and wore masks to resemble spirits. So disguised, women ran among the men, yelling and roaring, frightening them into continued submission. When some men discovered women washing off the paint and learned that these fearful spirits were really their wives, all the men stormed the women's secret lodge and killed the women. From then on, men put on masks in their turn to terrorize women and rule over them, keeping men's secrets well guarded. The Selk'nam version of this social character myth differs primarily in its emphasis on the women's use of magic arts or witchcraft to maintain their rule over men.

Yet another version of the myth is found among the Jurupari tribes of the northwest Amazon, in central Brazil. This myth depicts women as having become the possessors of special, sacred musical instruments, which they kept hidden in order to maintain their ascendancy over men. By this means, women forced men to carry the firewood and water and make the bread. Finally, growing tired of their subservience, the men rebelled and conquered the women in battle, making them the subordinate sex. In one account of this myth, the Jurupari women had gained control of the men as a direct result of handling the sacred musical instruments. After touching the instruments, the women had touched their own bodies and, for the first time, grew bodily hair. This enhanced their sexuality and enabled them to use their sexual power to enforce their rule over the men.

As cautionary tales, such social charter myths taught each new generation of young men why the symbols and rituals of men's estate had to be kept a closely guarded secret from the prying, inquisitive eyes of women. The myths also taught men that it was necessary to terrorize women in order to keep us from learning men's secrets, for only rule by men created a "moral" social order in which women took our proper subordinate place. Keeping women frightened and submissive was therefore a public duty that men undertook for the "good" of society. Bamberger cites the use of gang rape throughout the Amazon region as a standard means of exerting male social control over women, and especially to punish any woman who had caught sight of the "sacred male paraphernalia."

The Search for Social Origins

Societies in the past have generally used myths to explain and justify the subordination of women to the rules of men, and to suggest the importance

of maintaining that pattern of social organization. The stories of Adam and Eve or of Pandora's Box function in the same way as the Indian social charter myths. In these stories, women, because of our "weakness" in giving way to our intellectual curiosity, inadvertently release "evil" into the world. Our actions "prove" how untrustworthy women are and how necessary it is for men to control us to prevent further harm to society.

More modern societies are not immune from the same kind of logic. During the latter half of the nineteenth century, speculation about the origins of society became a preoccupation of many social theorists. One reason for this concern was increased scientific interest in evolutionary theories. In his *Origin of Species,* published in 1859, Charles Darwin (1809–1882) formulated an evolutionary explanation for the changes in living organisms that had taken place over eons of geological time. Darwin's evolutionary theory clearly placed humans within the development of the animal kingdom and raised fresh questions about the earliest forms of human society. Another stimulus to this new concern was scientific study of the human past and of human nature and organization. (In the course of the next fifty years, such study led to the formal creation of the fields of anthropology, psychology, and sociology.) In addition, increased information about non-Western peoples stimulated Europeans to investigate the different social arrangements characteristic of different human cultures.

An evolutionary mode of thought set the framework for studying the variety of social arrangements, customs, beliefs, and kinship structures that were found throughout the world. People in nineteenth-century Europe and the United States were conscious of rapid and extensive material changes in their world: industrialization, urbanization, the development of railways and the telegraph, and technological inventions of every sort. Living through such a time and influenced by evolutionary theory, social theorists tended to see themselves and their social arrangements as the culmination of human progress to that time. Different cultures and less materially developed societies seemed extremely backward in comparison, both in intellectual and material terms. Such societies, it was reasoned, must represent earlier stages of human history and therefore could shed light on the origins of human society.

To understand this nineteenth-century frame of mind, it is crucial to know the assumption about gender relationships that social theorists brought to their speculations about the origins of society. Victorian theorists, who were generally upper-middle-class men, lived at a time when, partly in practice and especially in ideology, society consisted of "separate spheres" for women and men. Women's "natural" sphere was defined as the private, domestic world; men's sphere was the public world of business and government. Even for women— largely in the lower classes—who worked outside the home, there was a high degree of gender segregation, both in workplaces and in kinds of work performed (as indeed there still is). The "naturalness" of this arrangement (then as

now) was understood in terms of women's biological role as childbearers. All socially assigned tasks of child care, food preparation, and general domestic maintenance were seen to follow naturally from the childbearing role. Because Victorians viewed themselves as the most advanced of human societies, they drew two conclusions about their own arrangements. One was that women's reproductive function kept us closer to nature than men and that our social roles, as wives and mothers, were—and had always been—permanent, unchanging aspects of society. The other conclusion drawn was that Victorian men, in contrast, represented progress, control over nature, and the development of culture (Ortner, 1974; Rosaldo, 1980).

Seeking to explain the origins of society and the development of social organization, therefore, Victorian theorists looked primarily to the changing roles of men to explain human progress. In the growth of complexity in men's occupations, they sought the clues which would unfold the historical evolution of such social structures as the family, the community, and the state. Just as the lower animals were understood to be governed by instinct, so women, with their "maternal instincts," were thought to be less "evolved" than men (Hubbard, 1979; Tanner, 1981). Men represented rational culture imposed upon animal nature; men were the creators of civilization. To declare that women's proper place was in the home was to invoke a moral prescription for social order. Like the Yamana, Selk'nam, and Jurupari with their social charter myths, Victorian men subscribed to the view that a proper social order was one in which women were subordinate to men's rule. To the extent that evolutionary theory built on such assumptions, it too became a social charter myth.

Evolutionary Theories: Patriarchal and Matriarchal Origins
The gender system served Victorians and their scholarly heirs of the twentieth century as both a description of society and an explanation for its structure. Gender described and explained the split between a maternal domestic sphere of the family and a "public" sphere in which men were the principal actors. Such were the ground rules for the intellectual debate concerning the earliest forms of social organization that ensued after the publication of Darwin's *Origin of Species*. The first theorists to debate early social relationships were Maine, Bachofen, McLennan, and Morgan. All were trained in law; two taught Roman law and were steeped in classical literature; and only one had actually lived among people of a different culture, the Iroquois of New York State. Out of their intellectual battles came the ongoing scientific concerns that shaped several later generations; and their assumptions about gender arrangements have only recently been challenged. Their actual clashes over theory centered on the question of whether earliest human society took a patriarchal or a matriarchal form (Fee, 1974; Helly, 1978).

From a study of Roman law, the Old Testament, and early Hindu law

codes, Henry Sumner Maine concluded that the earliest form of society was patriarchal (1861). According to Maine, the earliest rule over people was the rule of the father (*patria potestas*), which included life-and-death authority over wives, children, children's children, servants, and slaves. Associated with patriarchal power were the rites of male ancestor worship, which required male heirs to perform them. In the earliest form of social organization, personal status was based on family membership. Individual, contractual commitments to nonfamily members were a later development. Maine based his conclusions on his reading of the *Institutes of Gaius*, a description of Roman law dating to the second century A.D. that made clear the power of the father in the Roman family. Maine was not the first person to identify ancient society with patriarchy, but he was the first to raise this analysis to a general theory about the origins of society.

An opposing theory of social origins was published in Switzerland by Johann Jakob Bachofen in *Mother Right* (1861). Using ancient Greek tales and legends about earlier peoples who traced descent through their mothers, Bachofen suggested that the earliest form of society was "primitive promiscuity," by which he meant the existence of no social order at all. The first kind of social organization and regulation of behavior then occurred by means of the invention of planting by women. At this stage, women, worshipping an earth goddess, ruled over our families and our communities and passed on our names and property through our daughters. "Mother-right" brought to an end the unchecked promiscuity of the previous period and established marital ties. Mother-right, which Bachofen identified with matriarchy, thus enforced sexual restraint and a sense of universal kinship.

This rule by women gradually weakened until men triumphed over women, asserting their partriarchal rule. As in the other social charter myths, men are depicted as acting in unison to assert their control over women in order to win "the liberation of the [male] spirit from the manifestations of nature" (Bachofen, 1967:109). Bachofen clearly identified mother-right with the facts of reproduction, which related women more closely to nature, and "father-right" with a more advanced, spiritual principle. He also believed the custom of descent through mothers only was synonymous with rule by women. He used the language of opposing categories to identify (negative) female and (positive) male principles: passive/active, moon/sun, left/right, death/life, mourning/rejoicing.

Within a few years of these publications, and without having read Bachofen, a Scottish lawyer, John F. McLennan, wrote *Primitive Marriage* (1865) in order to overturn Maine's patriarchal theory. Interpreting various marriage customs as symbolic relics of an early practice of bride capture, McLennan suggested that at an early stage of society, a scarcity of women necessitated, literally, the capture of brides. He reasoned that scarce resources led to female infanticide—as more recently anthropologist Marvin Harris (1977)

has proposed—reducing the number of "useless mouths" in a society battling for food supplies. This in turn, claimed McLennan, created a scarcity of women that led to bride capture and wife-sharing (polyandry). McLennan, like Bachofen, pictured the earliest stage of society as having been that of a "promiscuous horde" and envisioned the first tracing of a line of descent as naturally tied to mothers. Despite his disagreement with Maine about first organizing principles, McLennan, no less than Maine and Bachofen, accepted the coming of the patriarchal family as the beginning of true "civilization."

The next major social theorist to challenge the patriarchal origins of human society was Lewis Henry Morgan, an American lawyer who had studied the Iroquois Indians in his home state of New York. Morgan, in his *Systems of Consanguinity and Affinity of the Human Family* (1871), outlined an evolutionary progression from a "primitive" stage of unrestricted sexual intercourse to group marriage, to matrilineal clans with communal households, to pairing marriage, to the "high" point of the patriarchal family.

What Bachofen had derived from classical legends, McLennan and Morgan had found in contemporary non-Western cultures: social organizations with matrilineal descent systems. All three saw in such evidence "proof" of prehistoric rule by women. By this they meant a mirror image or role reversal of rule by men, entailing the subordination of men to female domination. Just as in other social charter myths, therefore, the prior existence of such matriarchies was used to demonstrate that patriarchy was a more "advanced" social order. But Morgan was at least sensitive to the loss of communal decision-making power Iroquois women had experienced by this development. He was the only one of these Victorian social theorists to suggest that the status enjoyed by women became worse, not better, under the patriarchal family (box 5.3).

Morgan's work was used by Frederick Engels in his *Origin of the Family, Private Property, and the State* (1884) to analyze the rise and triumph of the patriarchal family, a process which he called the "world historical defeat of the female sex" (Engels, 1972:120). Engels sided with Morgan, McLennan, and Bachofen against Maine's view that human society in its earliest form was the patriarchal family. But Engels identified the subsequent rise of patriarchal power with the subordination of all women.

It is possible that in using the term *matriarchy,* these nineteenth-century social theorists may not have meant "that women ruled in public life but, rather, that humanity's first social forms gave women an important place because public society was not yet differentiated from domestic realms" (Rosaldo, 1980:404). On the other hand, using the hierarchical model of male dominance as their yardstick, Victorian men who envisioned an early time when women dominated men could have understood such domination as a reverse or mirror image of rule by men. The idea of a prehistoric matriarchy clearly influenced Sir Arthur Evans in the twentieth century to claim he had

Western Patriarchal Culture and Native American Women Box 5.3

As many as 280 distinct aboriginal societies existed in North America prior to Columbus. In several, the roles of native women stand in stark contrast to those of Europeans. These societies were matriarchal, matrilineal, and matrilocal—which is to say that women largely controlled family matters, inheritance passed through the female line, and upon marriage the bride usually brought her groom into her mother's household. . . .

Although the lives of Native American women differed greatly from tribe to tribe, their lifestyles exhibited a great deal more independence and security than those of the European women who came to these shores. Indian women had individual freedom within tribal life that women in more "advanced" societies were not to experience for several generations. Furthermore—in contrast—native women increased in value in the estimation of their society as they grew older. Their cumulative wisdom was considered one of society's more valuable resources. . . .

. . . White Anglo males from a rigidly paternalistic, male-dominated society refused to recognize and deal with the fact of Navajo matriarchy. Instead, they dealt only with Navaho males on all matters where the two cultures touched. As a result, more and more of the women's roles were supplanted by male actors and then male takeover.

(Witt, 1976:250–57, passim)

found archeological evidence of such a government in the ruins at Cnossus on Crete (Pomeroy, 1982). More recently, feminist scholars have reexamined the notion (Webster, 1975).

Modern anthropologists generally reject the view that matrilineal descent systems occurred at any fixed "stage" of historical development. They also acknowledge that such systems do not necessarily imply rule by women, especially as it may have been understood by the Victorians (Schneider and Gough, 1962). What is significant about the Victorian clash over patriarchal *versus* matriarchal origins of human society, however, is the way such views reflected the values and assumptions of those who adhered to them.

This Victorian intellectual debate is representative of the outlook of the period, in which other theories of society were developed. For example, founders of modern sociology in the late nineteenth and early twentieth centuries —men such as Herbert Spencer, Émile Durkheim, Max Weber, and Vilfredo Pareto—all expressed views of society in terms of biologically based rather than socially constructed gender systems. Their analyses of society accepted gender asymmetry as given, even if not necessarily desirable. They sought to explain the relationships between the genders in terms of their "natural" biological roles. Thus, early in its conceptualization and establish-

ment as a discipline, sociology, like other social sciences, tended to treat women as invisible, as part of an unchanging and relatively uninteresting aspect of society.

Aspects of Socialization

The Division of Labor by Gender

Social theories built on assumptions about gender definitions and "separate spheres" have until recently prevented close analysis of the way labor has been divided arbitrarily by gender assignment. Everywhere societies divide economic tasks between women and men; yet the division of tasks in one society may be substantially the reverse of that in another. Two tasks which fall to women's lot almost everywhere are the nourishment of newborn infants, our own or others', and food preparation. Whatever pattern the division of labor takes in a particular society, it can be seen to relate directly to the gender relationships of that society.

Measurement of the "labor force" in the United States today counts persons working for pay and those actively seeking employment. It excludes the kind of work daily done by wives and mothers in our own homes, by the women of the family on farms or in small businesses, and any other work not paid directly, such as work done on a volunteer basis. By this narrow, official definition, the fact that almost all women work becomes invisible; the fact that our work is in fact essential to society and the economy has thus been obscured (Acker, 1978). The concept of "work" as exclusively a labor market activity and the ideology of separate spheres are inextricably linked.

When women work in the home, rearing children and caring for the personal needs of husbands, our labor not only benefits these men but also performs a crucial service for their employers. A male worker can be asked to devote at least half of his waking day, and sometimes more, to his job, and he will still have time for leisure activities *because* he has a wife, a person whose job it is to care for his food and clothing needs, rear his children, and provide him with companionship. At higher economic levels, men in corporate and professional fields can be asked to work long hours at the job, at home, or traveling *because* they have wives who run their households, attend to their personal needs, and perform social duties that can enhance their careers.

If women have jobs, or even careers, our domestic services are not as readily available to our families. In the ideology of separate spheres, the gender division of labor makes our primary careers our domestic roles: personal and sexual services for our husbands and care for the needs and proper socialization of the next generation. No wonder women have usually been socialized to view the attainment of this goal as an ideal, this provision for men of a "haven in a heartless world" (Lasch, 1977). No wonder the upsurge

A Yörük woman of Turkey makes flat bread. Women are expected to perform a variety of tasks to sustain our families; this work is then viewed as "women's work." Such expectations constitute a "social role" which is extremely difficult for women to resist. (Photo by Daniel G. Bates, 1969)

in labor force participation by women in the last generation and the increase in the number of divorces and single-parent households are viewed with alarm in many quarters. If there are no wives and mothers to take care of husbands and children and households, who will?

Gender Socialization and Work Goals. About forty million women are in the "labor force" in the United States today. Despite our numbers, women have not organized by the millions to protest lower salaries and unequal opportunities to compete for higher-level occupations. Even among the lowest paid workers, women have often been slower than men to organize in our own interests. Middle-class women today are seeking occupations outside

Woman spinning and weaving. From this early fourteenth-century book illustration we have a sense of the ages-old assignment to women in the Western world for the care of such domestic needs as the clothing of the family. Other cultures, as in many of the countries of North Africa, may assign to men the tasks of sewing, tailoring, and clothing making. (MS Cod. gall. 16 folio 20x, Bayerische Staatsbibliothek, Munich)

the home in greater numbers than ever before. Some do so out of a desire to make use of education and talent; many more do so because, like the earnings of working-class women, those of middle-class women are important to our families' standard of living. Still others have no choice; women who are single, divorced, or widowed must support ourselves, and often children as well.

Women may learn about the greater opportunities and wages available in fields not traditionally open to us. Even so, most women persist in seeking jobs in areas traditionally labeled "women's work," where we know we will earn less. When asked to explain such a decision, women may reply that we are just not interested in these fields or that we consider them "too masculine." We may lack self-confidence in our own skills or ability to learn "men's trades." Such replies show women responding to barriers erected early in our socialization as "women," barriers that reflect our internalization of our society's traditional division of labor by gender.

Sociologist Carol Ireson (1978) notes that two-thirds of all job categories

are still virtually closed to women, and that almost 80 percent of women who do work, do so in dead-end clerical, factory, service, or sales jobs, compared to 40 percent of men who do so.

On the one hand, the economy reflects the social ideology that divides labor by gender and creates segregation of work and workplace. On the other, socialization ensures that women will accept such economic designations. Girls are taught, directly and indirectly, at home, at school, and by their peers, that "femininity" and achievement, both academic and occupational, are potentially at odds. "Femininity" means attractiveness as "women," both to men, sexually, and in women's own culturally defined image of what we should be like. Such images, of course, vary in different cultures. But the socialization of women everywhere teaches us specific expectations for ourselves as persons and as members of our gender.

Our society characterizes "women" as ideally warm, gentle, tactful, dependent, and submissive. We are also expected to be less competent than men in those areas labeled "men's work," especially the academic fields of mathematics and science and the practical field of mechanical activities. Whether or not we have aptitude in such fields, we begin to avoid them in our high-school years; this in turn affects our ability to pursue them in college and to prepare for careers. Knowledge of the occupational segregation of the adult world influences the aspirations of girls growing up.

Family life and adult work patterns all convey the idea that women should be subordinate to and dependent on men, even when we enter the workplace. Working women must usually submit to men's rules as completely as wives are expected, under the law, to submit to husbands (see below and chapter 7). Sexual harassment in the workplace arises in part from these social expectations concerning gender relationships.

Traditional views have great power over our lives. Even though young women recognize that "men's work" is greatly valued by society, we also learn that to aspire to such occupations may call into question our femininity, as it is socially defined. "What do you want to be when you grow up?" is a socially loaded question for children, and both girls and boys soon learn what answers are socially acceptable. Discouraged in the past by guidance counselors as "unrealistic" and ridiculed by peers for "crazy" views, girls have not found it easy to pursue trades and careers that do not fit the conventional pattern of the gender division of labor in our society. Those with great determination can often succeed, but not without experiencing the painful dilemmas our society poses for women who disregard its conventions.

The higher the education pursued and the more specialized the training, the lonelier women may feel. If we marry and have children, we may find ourselves attempting to achieve our career goals while performing full-scale domestic roles, a situation that constantly presents role conflicts (box 5.4). In the end, women who ignore social expectations pay a price, whether in

"Cassandra": A Victorian Daughter's Complaint Box 5.4

Why have women passion, intellect, moral activity—these three—and a place in society where no one of the three can be exercised? Men say that God punishes for complaining.

... Look at the poor lives we lead. It is a wonder we are so good as we are, not that we are so bad.... Women are never supposed to have any occupation of sufficient importance *not* to be interrupted... ; and women themselves have accepted this, have written books to support it, and have trained themselves so as to consider whatever they do as *not* of such value to the world or to others, but that they can throw it up at the first "claim of social life." They have accustomed themselves to consider intellectual occupation as a merely selfish amusement, which it is their "duty" to give up for every trifler more selfish than themselves.

... Women never have an half-hour in all their lives (excepting before or after anybody is up in the house) that they can call their own, without fear of offending or of hurting someone.... a woman cannot live in the light of intellect. Society forbids it. Those conventional frivolities, which are called her "duties," forbid it. Her "domestic duties," high-sounding words, which, for the most part, are bad habits (which she has not the courage to enfranchise herself from, the strength to break through) forbid it.

... The family uses people, *not* for what they are, nor for what they are intended to be, but for what it wants them for—its own uses.

 (Florence Nightingale in Strachey, 1978: Appendix)

feelings of guilt about whichever role is currently slighted or in the toll taken by trying to play "superwoman" (see chapter 15). As more women make choices that counter traditional expectations, however, we can help one another to feel less alone. We recognize the social role "woman" as the continuation of an ideology of separate spheres designed to keep us *in our proper place,* defined as the domestic sphere.

The Heterosexual Prescription

Whatever the society, girls are taught that the prescribed social roles for women include becoming wives and mothers, roles which involve caring for husbands, homes, and children. We learn that adulthood for women is usually measured in terms of marriage and motherhood. Should personal ambition or sexual orientation preclude one or both of these social scripts, a woman will have to pay the price exacted of all who do not conform to social expectation: personal pain and the pressure of being treated as a social misfit.

Adrienne Rich has explored the roots of what she calls compulsory heterosexuality. She argues that heterosexuality, like motherhood, "needs to be recognized and studied as a *political institution*" (1980:636–37). Rich takes

Heterosexuality as a Political Institution Box 5.5

Characteristics of male power include: *the power of men*

1. *to deny women* [our own] *sexuality*
 [by means of clitoridectomy and infibulation; chastity belts; punishment, including death, for female adultery; punishment, including death, for lesbian sexuality; psychoanalytic denial of the clitoris; strictures against masturbation; denial of maternal and postmenopausal sensuality; unnecessary hysterectomy; pseudolesbian images in media and literature; closing of archives and destruction of documents relating to lesbian existence];

2. *or to force it* [male sexuality] *upon them*
 [by means of rape (including marital rape) and wife beating; father-daughter, brother-sister incest; the socialization of women to feel that male sexual "drive" amounts to a right; idealization of heterosexual romance in art, literature, media, advertising, etc.; child marriage; arranged marriage; prostitution; the harem; psychoanalytic doctrines of frigidity and vaginal orgasm; pornographic depictions of women responding pleasurably to sexual violence and humiliation (a subliminal message being that sadistic heterosexuality is more "normal" than sensuality between women)];

3. *to command or exploit their labor to control their produce*
 [by means of the institutions of marriage and motherhood as unpaid production; the horizontal segregation of women in paid employment; the decoy of the upwardly mobile token woman; male control of abortion, contraception, and childbirth; enforced sterilization; pimping; female infanticide, which robs mothers of daughters and contributes to generalized devaluation of women];

4. *to control or rob them of their children*
 [by means of father-right and "legal kidnapping"; enforced sterilization; systematized infanticide; seizure of children from lesbian mothers by the courts; the malpractice of male obstetrics; use of the mother as "token torturer" in genital mutilation or in binding the daughter's feet (or mind) to fit her for marriage];

5. *to confine them physically and prevent their movement*
 [by means of rape as terrorism, keeping women off the streets; purdah; foot-binding; atrophying of women's athletic capabilities; haute couture, "feminine" dress codes; the veil, sexual harassment on the streets; horizontal segregation of women in employment; prescription for "full-time" mothering; enforced economic dependence of wives];

6. *to use them as objects in male transactions*
 [use of women as "gifts"; bride-price; pimping; arranged marriage; use of women as entertainers to facilitate male deals, e.g., wife-hostess, cocktail waitress required to dress for male sexual titillation, call girls, "bunnies," geisha, *kisaeng* prostitutes, secretaries];

7. *to cramp their creativeness*
 [witch persecutions as campaigns against midwives and female healers and as pogrom against independent, "unassimilated" women; definition of male pursuits as more valuable than female within any culture, so that cultural values become embodiment of male subjectivity; re-

striction of female self-fulfillment to marriage and motherhood; sexual exploitation of women by male artists and teachers; the social and economic disruption of women's creative aspirations; erasure of female tradition]; and

8. *to withhold from them large areas of the society's knowledge and cultural attainments*

[by means of noneducation of females (60% of the world's illiterates are women); the "Great Silence" regarding women and particularly lesbian existence in history and culture; sex-role stereotyping which deflects women from science, technology, and other "masculine" pursuits; male social/professional bonding which excludes women; discrimination against women in the professions]. (Rich, 1980:638–40)

Copyright 1980 by Adrienne Rich. Based on the analytical framework (given here in italics) in Kathleen Gough's "The Origin of the Family." In *Toward an Anthropology of Women*, edited by Rayna R. Reiter. New York: Monthly Review Press, 1975:69–70. Reprinted by permission.

as a frame for her analysis eight characteristics of male power identified by anthropologist Kathleen Gough. She then cites examples of how each of these powers have been used by men to enforce heterosexuality on women (box 5.5) to convince them that marriage, and sexual orientation toward men, are "inevitable, even if unsatisfying or oppressive components of their lives" (Rich, 1980:640).

Marriage as a Legal and Social Institution
Marriage is an oral or written contract agreed to by individuals; its validity depends on its recognition by customary authorities or the legal system of the society involved. Civil laws, religious and political regulations, and judicial precedents may also set the obligations and privileges of the married partners. In the United States, if women fail to fulfill our legal obligations to our husbands, they may use this as grounds for legal separation and ultimately for divorce. It is therefore important that we know the laws. Wives have no legal right to any financial compensation from husbands for performing tasks legally expected of us. Husbands have an absolute right under most state laws to have sexual intercourse with their wives; if wives deny husbands that marital privilege, they have the legal right to use force to exercise it. In 1981, laws in all but five states (California, Connecticut, Massachusetts, Minnesota, and New Jersey) held that wives could not accuse husbands of rape.

Although states vary in their laws, some give the husband the right to choose where the couple will live; the wife must accompany him or be charged with legal abandonment. In New York State, assaulted wives are not allowed to take criminal action and may only seek a court order for legal

protection for up to one year. If husbands assault wives despite such a court order, the most severe punishment they will receive is rarely more than six months in jail.

In all states, the primary legal responsibility of husbands is economic. Husbands must supply wives with "necessaries," usually defined as the standard of living they have established together. Husbands also must support their children, but should they fail to do so, that legal obligation passes to wives. The social reality—that wives have rarely received the training to become economically independent, let alone capable of supporting children— is often simply ignored.

Legal provisions such as these both define and control social behavior. With these laws, the state legitimizes the husband as "head of the household," endorsing his economic obligations as central to marriage and endorsing the subordinate position of the wife. This view in turn underpins the economic system which considers the man the permanent member of the work force and his wife as primarily a homemaker and child rearer and only an occasional wage worker. Such a legal system is the product of male legislators and judges, reflects male perspectives, and protects male control over society's resources (Lipman-Blumen, 1976).

Marriages are subject to social customs as well as to legal provisions. Some forms of marriage and some kinds of taboos regarding who may marry exist among all peoples (Leibowitz, 1978). As we noted when examining theories of social origins, marriage customs have sometimes been considered a key to understanding the structure of kinship arrangements and the ways different kinds of families function. *Endogamous* (marrying-in) marriages, like the cross-cousin marriages engaged in by Southern plantation owners in the United States before the Civil War, are ways of keeping property and wealth within a single family lineage. *Exogamous* (marrying-out) marriages are ways of exchanging women to cement family alliances across lineages. In exogamous marriages, wives may have only rare opportunities to revisit natal families, and may be subjected, as strangers in new households, to special kinds of suppression (see chapter 7).

Among traditional Mongolian tribes, for example, a young wife brings with her property that remains under her own control and takes up residence far from her own village among her husband's family, where she must conform to strict behavior and linguistic taboos. She must not use the name of her father-in-law or even any phonetic part of his name in her ordinary speech, a particularly trying feat since Mongolian names are made up of ordinary words for things. In the opinion of anthropologist Caroline Humphrey (1978), such a taboo reflects the family's attempt to control the young married woman. Until she has borne sons into her husband's family, she cannot be trusted. The language taboo helps to isolate her and suppress attention to her by her husband or any family elder.

An example of the way gender assignment of domestic tasks changes with the culture. Here a woman of the nomadic Yörük people of southeastern Turkey takes charge of the camel which carries the family's tent and the baby. She leads the camel in a caravan which takes the tribe from one camp site to another. (Photo by Daniel G. Bates, 1969)

Social rules created by marriage take their specific shape depending on how the marriage is brought about, what cultural customs are required, what the economic facts of life are for the marriage partners, and when in history they are living. Generally speaking, marriages are either family-arranged or male-initiated. Despite the significant number of women who remain single in some societies, unmarried women are viewed as deviant. We have failed to take part in the social institution by which society legitimizes the reproduction and socialization of the next generation while maintaining the social order inherited from the previous one. Women with property and wealth have historically had less freedom of choice about whether or whom to marry than have women who are penniless.

The Social Roles of Wives and Widows. The activities expected of wives focus on the care, feeding, and emotional support of adult men, many of whom pass from the care, feeding, and emotional support of their mothers directly to the hands of their wives. Wives are expected to place the physical and emotional needs of our husbands before our own, and we are praised or blamed accordingly. When husbands wish to relocate, wives are expected to follow them without demur. Husbands feel it is their right to protest the loss of wifely services, or even to forbid that loss, when wives seek activity such as a job or education outside the home. When wives wish to attend college or to work to augment the family income, we must often prove we are capable of meeting our household obligations at the same time. A study of working-class wives in England since the late nineteenth century indicated that even when pregnant, women allocated scarce food resources first to husbands, second to children, and only last to selves (Oren, 1974). To do otherwise would be to fail to conform to a socially defined role.

At the same time, many middle-class wives in the United States in the late nineteenth and early twentieth centuries undertook a variety of social causes outside the home, often with the explicit justification that we were acting to safeguard those homes. Women joined temperance associations, organized to reform prostitutes, took positions on public school boards, and joined movements to end corruption in local government (Wortman, 1977). Place, time, class, and culture are obviously important variables in the social roles of wives.

Widowhood, depending on the circumstances, may greatly change women's social roles. With adequate nutrition, women tend to live longer than men. Therefore, married generally at a younger age than men, more and more wives in modern times live on as widows. For some women, life without husbands enables us, often for the first time in our adult lives, to make real choices, to take care of our own affairs, and to set personal goals never before contemplated. Some widows have continued to pursue a husband's craft or run a family farm. Today, as "senior citizens," such women may find enjoyable avenues for self-fulfillment. The social pressures on widows in the past to remarry were considerable: to find a husband who could continue a business, work a farm, or carry on a craft. The desire of widows to resist such family and community pressures may have been greater than success in evading these social controls, or so we may suppose from the number today who, given the opportunity, choose not to remarry.

The Social Roles of Mothers. Mothers are expected to take full responsibility for the daily life and welfare of children. In living up to these social expectations, mothers may experience joy, pleasure, satisfaction, and pride, but we also experience frustration, pain, anger, and self-pity. The mother role

is unique in that its measure of success is the ability to achieve functional obsolescence. Mothers, we are told, are powerful shapers of children's lives; a message we usually interpret to mean people can blame mother for whatever goes wrong. As mothers, we are awed by the idea of such tremendous power, but we rarely can believe in it. We find our efforts to shape our children's lives circumscribed, frustrated, and subject at every turn to the counterforces of daily life. Mothers are told how to use these superpowers by pediatricians, schoolteachers, advice columnists, and fathers, yet we frequently emerge from doing battle with our children with tears of frustration and a sense of despair and defeat. Sara Ruddick (1980) has analyzed what she sees as "maternal thinking," but for every source of power for goodness and wisdom she describes, she acknowledges that individual mothers are often tempted to act out of selfishness on behalf of our own children rather than benevolence and generosity.

Women in the past and in all cultures have usually realized that our reproductive powers are important to us as a source of adult status, respectability, bargaining counters, and economic insurance, at the same time that they constitute possible limitations on autonomy, health, and life itself (see chapter 8). When old age brings loss of economic security, children are an insurance policy. When status in a husband's family depends on the production of sons and heirs, achieving that goal is central to survival. In agricultural communities, where every set of hands augments economic livelihood, large families of children are often encouraged. However, for women who live on the borderline of economic subsistence, motherhood may be an intolerable burden, a serious drain on the ability to survive (box 5.6). Whatever the social realities, women have had to adapt to them in our roles as mothers.

Mothers may also be stepmothers, foster mothers, godmothers, mothers-in-law, and grandmothers. In each role, we face special social expectations, exercise some authority, and experience satisfaction or discomfort. Mothers-in-law, for example, are faulted for asserting undue power over the lives of sons-in-law, in the case of daughters, or over sons, in the case of daughters-in-law. Fathers and fathers-in-law are expected to assert authority. Mothers-in-law who do so are depicted as interfering, domineering, critical, and demanding. There are no father-in-law jokes. Foster mothers and grandmothers, on the other hand, meet with approval when acting as surrogate mothers, carrying out nurturing roles above the call of biological duty.

The Social Control of Women

Every society imposes physical, spatial, and intellectual controls on women. Here we will consider the ways clothing, sexual vulnerability, and language aid men in the systematic control of women.

Welfare Motherhood: 1970–Style Box 5.6

Despite what they say, I don't think the welfare department checks too deeply into eligibility. They use a cheaper system. They just keep putting you off and telling you to come back the next day. After a few days of that, if you can scrounge up money anywhere else, you will. On my third day I threw a fit that outdid every crotchety baby in the center. Within fifteen minutes I was a bonafide welfare recipient with a yellow card to prove it.

Anyone who can live on welfare should be courted by Wall Street. He is a financial genius. I paid $40 a month rent and received $69 every 15 days. That included an extra amount for electricity since I lived in a dark apartment. . . .

I had as an investigator a man extremely gung-ho about filling out forms. He had gold teeth and a glint in his eye behind his gold-rimmed glasses that made me believe that within a few years he'd probably have a whole section of the welfare office under his supervision. He was on my doorstep so often that I assumed he must have been as tired of looking at me as I was of him. I made him an offer: if he arranged for the city to supply me with a homemaker and carfare for me to finish my last semester of college, within a few months a family of three would be off the welfare rolls at, in the long run, a considerable saving to the city. He almost had apoplexy on my livingroom floor. The City of New York does not send mothers to school, and if I came up with the money to do it on my own, I must report it to him immediately so he could throw me off welfare. (Clark, 1970:65–66)

Physical Control: Clothing and Gender

Clothing can symbolize the frailty, frivolity, and delicacy of women in contrast to the strength, seriousness, and aggressiveness of men. It reinforces the ideology of separate spheres for women and men by exaggerating differences in body shape, and it often literally constricts women's physical freedom as well. Clothing can enforce a cultural ideal of passivity and decorativeness, as was the case with the tiny waists and rounded silhouettes of the Victorian "lady." Victorian fashion tightly encased a woman's arms, preventing her from raising them to make a bold gesture. The crinoline cage, numerous petticoats, and tied-back skirts and trains of Victorian fashion made sitting, much less movement of any kind, a matter of constant restraint and were an enjoinder to a passive demeanor. Beyond confined limbs encased in delicate embroidery and lace, the physical ideal of womanhood has demanded at times a small waist, emphasizing the enlarged bust above and enlarged hips below it. The encased bone and even steel corsets and tight lacing required to make the waist look small made breathing difficult and occasionally resulted in displaced internal organs and spinal curvature (Roberts, 1977). The pre-

revolutionary Chinese practice of binding the feet of high-status women resulted in deformities, making feet so tiny as to be almost solely of decorative use.

Not surprisingly, feminist protest has often included the rejection of constricting fashions in clothing. In the nineteenth century, the Rational Dress Society in England and the followers of Amelia Bloomer in the United States—who advocated freer legs dressed in pantaloons or "bloomers"—protested clothing that restrained bodies as symbolic of the way societies restrained the minds of women.

In the twentieth century, a revolution in women's clothing in Europe and America occurred at the end of World War I. Skirts rose from ankle to knees, and tight corsets disappeared under looser fitting drapery, removing many pounds of cloth from women's bodies. The post-World War II era, when women were encouraged to remain at home, brought high, spiked heels into fashion again, creating physical restrictions on walking and running. In the conservative reaction of the late 1970s, high heels again became fashionable after a period in which more comfortable footwear was popular.

In the Muslim world, today as in the past, veils not only symbolize the secluded domestic roles that upper- and middle-class urban women are supposed to play but also act as heavy physical constraints on women's movements. Those women for whom such constraints are not practical—such as lower-class women in the cities and women in rural villages—do not wear the veil every day. These veils, also known as *chador*s, range widely in style, but all consist of layers of cloth that conceal all of the face except the eyes and make venturing outdoors a hot, sweaty, and undesirable experience. The religious government in Iran set up after the overthrow of the shah in 1979 called for all women to wrap themselves again in the traditional *chador*. "Why does symbolism always fall on the backs of women?" asks one Middle Eastern feminist (Manny, 1981:61). In this case, the answer lies in the fact that a return to traditional customs as a protest against Western values is a return to the traditional ways men of this culture exercized control over women.

Vulnerability as Social Control
The spaces that women may or may not inhabit can be controlled by threats to our sexual vulnerability. Whether communicated by mothers to daughters, by press reports to readers, or by fictionalizations in print or on film to readers and viewers, the physical threat of rape serves as a warning to women to watch our behavior, curtail our freedom of speech and movement, and conform to social expectations concerning our demeanor, actions, and use of public space. This implicit threat of violent retribution for gender-inappropriate or "provocative" behavior is itself a social stereotype. It offers conventional wisdom about female and male sexuality, it confirms the erro-

neous view that the safest place for women is at home, and it confirms the cultural definition of woman as subordinate and passive, as victims.

Rape has sometimes been characterized in ways that conceal the issue of social control implicit in it. Especially in literature by men, rape terminology becomes merely the essential sexual relationship between males and females: the desire of men to conquer their prey and the desire of women to be "taken." In press accounts or fictionalized versions on film, rape may be presented as an exceptional event, involving a pathological and sexually frus-

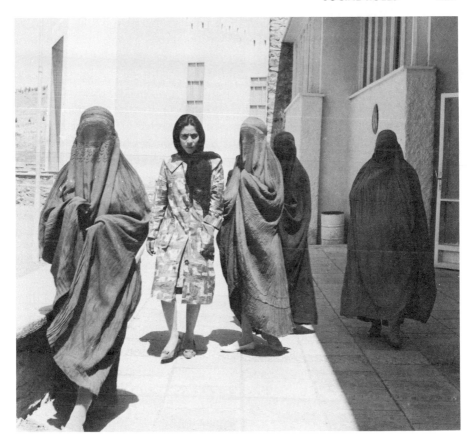

Veils and *chador*s. Ranging widely in style depending on the particular Muslim society, layers of cloth—highly decorated or exceedingly plain—cover all but the eyes of women who daily live with a reminder of the constraints that their culture places on their activities. Veils and *chador*s may still be worn by older women in a household where younger Muslim women have begun to adopt Western clothing styles. The decorated veil (left) covers the face of a mother in a nomadic tribe in the United Arab Republic, while shrouded and Westernized women (above) exist together on the streets of Kabul, the capital of Afghanistan. (Photo of veil by George Holton, courtesy of UNICEF; of *chador* courtesy of the United Nations)

trated male. This view of rape as an isolated crime, unconnected with the social fabric of daily life, makes it seem almost happenstance that the woman is the victim. In still another version, one that has most blatantly been expressed by police investigators, defense attorneys, and imprudent judges, the victim is thought to have in fact precipitated or even invited the alleged assault. Indeed, in this version, it is the rapist who is seen as the real victim because the woman obviously "asked for it." Thus female hitchhikers who accept rides, women who allow ourselves to be driven home from some social event, and women who answer our front doors in dressing gowns, leave

windows open, take walks at night, drink with strangers in public places, or *act in any number of ways that would be acceptable if done by a man* have precipitated any violence or assault that then occurs.

The stereotype of rape is far removed from its reality. It is as likely that the rapist is known to his victim as acquaintance, friend, neighbor, or relative as that he is a total stranger. The rape is more likely to occur in the home of victim or offender than on dark streets and in deserted places. Furthermore, most rapists are neither psychopaths nor insane. Studies of men convicted of rape show clearly that they differ in no significant way from "normal" males except in a greater likelihood to express violence and rage (Amir, 1971; Brownmiller, 1975; Smart and Smart, 1978).

The same point may be made about sexual harassment in the workplace or in the university. Gender inequality has been as much a part of the fabric of female and male sexuality, of concepts of feminity and masculinity, of hetero-sexual attractiveness, as it has been a part of other aspects of society.

Sexual harassment may occur when male sexuality is aroused by the sense of female sexual vulnerability. It often has less to do with sexual desire than with the habits by which men humiliate women. If a situation is predicated on inequality, on superior economic or any other kind of authority, the temptation to take advantage of the defenseless, the vulnerable, the subordi-nate will not always be resisted. Sexual inequality as a result of gender inequality is part of sexual politics, and for that reason the burden of proof that women must face, the proof—especially "corroborative evidence"—that what has occurred has exceeded the expectations of 'normal" heterosexual encounters, is often beyond our power to provide. Such has been the case repeatedly in attempts by women employees and university students to win legal cases on grounds of sexual harassment (MacKinnon, 1979).

Language as Social Control
When nineteenth-century American feminists issued a new Declaration of Independence at Seneca Falls, New York, in 1848, called the Declaration of Sentiments, they made clear how they understood that the generic "man" of the first document obscured the rights of women.

> We hold these truths to be self-evident: that all men and women are created equal. . . . The history of mankind is a history of repeated injuries and usurpa-tions on the part of man toward woman, having in direct object the establishment of an absolute tyranny over her. . . . He has endeavored, in every way he could, to destroy her confidence in her own powers, to lessen her self-respect, and to make her willing to lead a dependent and abject life. (Martin, 1972:43–44)

The important issue is how much language, as the medium by which we express what we perceive, shapes perception itself because of the accumulated cultural meanings attached to the words we use (Fried, 1979). There is a complex relationship between language, thought, and reality. The words we

learn to use to express our genetic sex carry with them the cultural meanings of gender identity that we have been discussing in this chapter. A language that conveys the notion that there is an absolute polarity between "female" and "male" behavior also conveys the culturally defined notion of separateness and inequality. So long as the words we use carry with them sexist perceptions of the world, and we learn to use these words as we learn about our world and our expected roles in that world, we participate in the continuation of language as a means of social control over our lives (Thorne and Henly, 1975).

Socially Constructed Invisibility

Men know a great deal about women, but they remain puzzled. They ask, as Sigmund Freud did, "What do women want?" Women have been relatively less articulate about ourselves, at least to men, than men have been about themselves. Women have generally understood what men and the society defined and controlled by men have expected of us, whether in family or social roles. Men—or so they have said—have been less clear about what women expect of them, but the patterns of male dominance, male-centered values, and male-manipulated social controls have made the matter of little interest to the majority of men and simply an intellectual puzzle to the rest.

Preceding chapters have investigated the various cultural, philosophical, biological, and psychological definitions conventionally applied to the social construct "woman." It should be evident by now that both genders begin life with relatively few anatomical and physiological differences, and that even these differences take their significance thereafter from the specific social context. Yet, conventional wisdom persists in viewing women and men as "fundamentally different."

The "puzzle" men claim they find in women is an expression of some dim awareness of a lack of perfect fit between what a society and the men who dominate it decree to be woman's "nature" and what we perceive to be our own reality. This lack of perfect mesh is often not noticeable to men, for women generally have acted well within the roles set for us. To the extent that women have formulated our own models of behavior or our own understanding of society and men have become aware of it, such men (like Freud) have acknowledged their puzzlement. The problem women face in articulating our own views, consonant with our own reality, is compounded by the fact that we must use the language and formulations of the dominant group to be understood and taken seriously by them.

The Theory of Muted Groups

One theory to explain this discordance between what men expect women's behavior to be and what women actually do is called the *theory of muted*

groups. According to this explanation offered by British anthropologists Edwin and Shirley Ardener (1975), every society has a dominant ideology which describes all social behavior. That dominant ideology shapes thinking about social norms and expectations, supplies the vocabulary used to describe these matters, and reflects the image of reality held by the dominant groups. Suppressed subgroups whose views differ considerably may lack the language to express their own views or even an adequate vocabulary by which to conceptualize their differences. Or they may adopt the prudent course of not airing those differences beyond their own subgroup to avoid antagonizing those more powerful.

According to the theory of muted groups, the dominant male perception may provide a model of the world whose existence and pervasiveness impede the creation of alternate models. Women, raised in a world where the dominant model of reality is male-created, may characteristically be less articulate because we must express ourselves through that male idiom. No adequate formulation exists to express matters of special concern to ourselves. Women who are trained in academic disciplines whose theoretical models correspond to a male perception of reality may find it equally difficult to find the conceptual framework and vocabulary to express our own perception of reality (Smith, 1974).

Consider women who are wives and mothers in middle-class households who desire to establish careers. We are very much aware of the social expectation that our husbands share with the rest of "society" that somehow we are uniquely responsible for the care of the household and children. We are also aware that our husbands have advanced their own careers by using our services as hostesses, social companions, and errand runners. We are not immune to the power of the social definitions of our status as wives and mothers but our discontent with them grows as the desire for a career engages our minds and imaginations. We realize that we must explain our extrafamilial goals in a way that will make them seem consonant with the dominant ideology that our actions further our husbands' interests. We may simply state how our work outside the household might bring real benefits to the family. We might suggest family projects that can be accomplished more quickly, or even considered for the first time, if we add our salaries to our husbands'. We may indeed believe all these things at some level, but we also recognize—at another level—that we must use the language of the male model of the world if we hope to accomplish a goal that springs from a different perception of it.

There are many more juggling acts along the way to our goals. Our previous obligations are part of the socially defined roles of wife and mother, and it will probably be, at least at first, necessary for us to fulfill these obligations along with the new ones we assume. Many husbands support the idea of working wives without feeling any need to adjust their own participation in household

and child-care activities. Many will "help out" and be thanked for doing so, or even voluntarily share coresponsibility, but the force of social expectations often works against the genuine sharing of tasks. Children also absorb certain social expectations as they grow up. Even women who have worked throughout our children's early years note that these children still accept to some extent the social prescription of the homebound mother. In our status as mothers, women will have to face such expectations in our own children, in their doctors, their teachers, and their peers. We will have to balance the weight of their social expectations against our own self-definitions and choices. In doing so, we are more likely to concur in the dominant ideology and accept ourselves as exceptions than to formulate any alternate models of our own. The power of the dominant ideology to define our behavior may leave us without even the language with which to shape such an alternative ideology, or the matter may be of such great personal importance that we do not risk the time, energy, and discomfort that such a formulation would entail. We are, according to this analysis, members of a "muted group."

Thus, women may understand at a basic level that conventional wisdom often dictates the need to remain mute. Even when we speak with one another, we may find it difficult at first to describe our views. When we learn to do so, we may still find ourselves unable to articulate clearly to men what seems clear when we express our views to other women. The theory of muted groups suggests that this may occur because as women we must translate our views into the dominant ideology to be understood by men, but the concepts of that ideology are not adequate to the task. To develop a vocabulary for expressing our own reality and goals, women need to talk and work together and to find, as we indicate below, a new conceptual framework for understanding the world.

Related to the theory of muted groups is the way in which women have tried to create personal space without challenging the dominant male structures. Sometimes we can follow our own models just by doing those things deemed unimportant by men. An example of this kind of creative response has been the use of unofficial, or vernacular, language when it has been viewed as socially unimportant by the dominant males, who use an "official" language. At the Japanese court early in the eleventh century, for example, the official language was Chinese. Young women were not supposed to learn that official "male" language, but no one cared if they wrote in the vernacular Japanese. Allowed this freedom to write in the "unimportant" language of the court, Lady Murasaki produced *The Tale of Genji*. It is a tale of a Japanese prince that still evokes the sights and experiences of a world almost a thousand years away. Lady Murasaki found it possible to write out of a personal vision because there were no official models to follow when writing in Japanese at this time. The chapters that follow will point out other ways in which women have sought to define some personal space.

The Need for New Interpretive Frameworks

Whether the problem is seen as one of inarticulate or silent female voices, or of the need to create a radically new conceptual framework, women need to find our own voices. We need to determine what questions must be asked and how to interpret the answers. According to anthropologist Michelle Z. Rosaldo, fieldworkers have no dearth of information about women's lives, relations with husbands and children, ties to kin and the politics of marriage, the sense of our own strengths and triumphs, and disappointments (Rosaldo, 1980). But we need to "make sense" of what we learn in a way that accounts for women's experiences, rather than in a way that leaves them out. According to Rosaldo, questions about the origins of social institutions only lead back to the static assumptions about innate gender differences that framed these issues in the nineteenth century. Instead, she asks us to turn to a study of the significance of gender for the organization of all social forms and to a search for ways of conceptualizing society that avoid the traditional categories and biases characteristic of male theorizing in the past. Women's roles must no longer be assumed to be universal or unchanging, but must be seen as the "product of human action in concrete, historical societies" (Rosaldo, 1980:416).

Gender inequality, or asymmetry, is itself a social construct. To be a "woman" or a "man" in a society is to have been shaped already into a role. To make women's lives "visible," we must not only look at them but also find the questions that will help us to understand them. Because the language we use to describe women's lives is already culturally shaped to express difference and inequality, the search to understand women's realities and women's choices (no matter how limited) is only at a beginning stage. These first steps into a new perspective, however, are crucial. We need to look anew at women's relationships in and out of the family, with other women and with men in all aspects of society. Out of this reexamination we hope will come a re-vision of reality.

The Social Construction of Human Beings

Overcoming the perpetuation of gender oppression will require more than new languages and new theories. A vast array of changes in social practice and thought must also occur. Consider the reactions of people to a young adult dressed and groomed in such a way that it is not possible to tell whether that person is female or male. Responses may vary from discomfort or anxiety to intense curiosity or great disgust. But why do people feel compelled to place human beings immediately into the social category "woman" or "man"? Are all our responses to people so categorized that we do not know how to react to a person without a definite gender? Since gender implies social placement, which in turn implies a pattern of dominance and subordination, does our unease at an indefinite gender suggest that we are

socialized to accept others only in such terms? Can we respond to people simply as fellow human beings?

Our need to identify the gender of any human being seems to stem from the thorough duality that underpins our social construction of reality. Yet human beings have more in common with one another than we have with the rest of the world. If gender assignment to nurturing roles were less rigid—if all children grew up expecting to nurture the next generation—it might be less necessary to emphasize differences between two genders (see chapter 8). The concept of the human continuum, in which personality and preference (rather than assigned gender) lead to the performance of social—and family—roles, would help us think in terms of "human beings" rather than "woman" and "man." To do so would truly widen our range of human choice, would begin to address the problem of unequal access created by sexism, and would help us find ways of ending other kinds of human oppression as well.

Summary

A "woman" is a social construct, based in part on the definition of woman as capable of bearing children. A society's particular definition of women creates certain social expectations for our behavior as females, as opposed to males. Women internalize these expectations in the process of socialization.

The gender system is variously defined in different societies, but in every society the system is asymmetrical. One gender is considered inferior to the other, and that gender is nearly always female. The social construction of gender shapes and governs a woman's social reality.

The ways that women's roles have changed over time have been neglected because the sphere of women's activities has not been of great interest to historians, who have been primarily male. Social scientists have also focused their attention on the world as men see it and so have failed to look closely at women's roles as women see them. Many social scientists still fail to take into account the influence of gender on social behavior.

Theories about society reflect conventional assumptions about gender. Social charter myths seek to explain the structure of society in relation to an earlier social order that reversed gender roles. These myths teach males to guard the secrets of their power and to keep women subordinate. More recent theories about the origins of society make use of the evolutionary framework; they imply that the male sphere of activity is the more highly developed. Some early social theorists debated whether the first human societies were patriarchal or matriarchal, but most agreed that the patriarchal was the more advanced social order.

Societies everywhere divide tasks arbitrarily by gender assignment. In our society, "work" is considered an activity of the labor market, and the work

that women do in the home is devalued. The ideology of separate spheres of activity for women and men supports the notion that a woman's primary obligation is to fulfill domestic roles as wife and mother. Women are socialized into accepting this ideal.

The role of wife is governed in many societies by legal provisions that control women's social behavior and uphold the privileges and rights of husbands. In some societies, social customs prescribe whom to marry. The social roles of wives include the care and feeding and emotional support of our husbands. Mothers learn that our reproductive powers may give us status, respectability, and economic insurance later in life, though this is often false. Other "mother" roles include stepmother, godmother, grandmother, and mother-in-law.

Every society imposes physical, spatial, and intellectual controls on women. For example, women's fashions emphasize gender differences and constrict our physical freedom. Women's sexual vulnerability restricts the places we may go and emphasizes gender inequality. Language is another means of reinforcing gender differences and restricting women's ability to express our experiences.

The fact that women lack the vocabulary and conceptual framework to express our own perceptions of reality is the basis of the theory of muted groups. If women are to become visible, we must find our own voices and ask the kinds of questions that will help us to understand our realities. The social constructs of "woman" and "man" must give way to the social construction of "human being" before gender asymmetry can be overcome.

Discussion Questions

1. How can we account for socially assigned gender roles? Consider some of the arguments based on biological factors (see chapter 3) and on the hypothetical evolutionary sequences proposed by social philosophers in the late nineteenth century. How have these arguments been affected by *existing* social conditions?

2. In order to see how differently societies can shape the roles assigned to women, read about women in a society very different from your own—another country, another time period, or another ethnic group. What kinds of work, talents, and personality characteristics are assigned to women there, and how do these differ from your own experience? What do you think accounts for the difference?

3. How are women channelled into the role expectations society has provided for us? Give some examples of the way society controls women; such as appearance, verbal communication, and conduct in public and private places. How do these factors affect our perceptions of ourselves?

4. In what sense are women "invisible"? How is our "invisibility" experienced on a personal level, and how is it experienced by women as a "muted group"? Finally, how do women compare to other "muted groups" in society?

5. Is it possible for women to take an active part in changing the roles assigned to us on the basis of gender? Discuss some measures that you believe would be particularly effective, and consider the barriers and opportunities for taking these measures, with reference to specific roles.

Recommended Readings

Rosaldo, Michelle Z., and Lamphere, Louise, eds. *Woman, Culture, and Society.* Stanford: Stanford University Press, 1974. One of the most important books of the modern woman's movement, shaping the questions feminists of every discipline ask about women's lives and strategies. Sixteen women anthropologists focus on women's activities in culture and society and point out the distortions and omissions of the conventional approaches to their disciplines.

Millman, Marcia, and Kanter, Rosabeth Moss, eds. *Another Voice: Feminist Perspectives on Social Life and Social Science.* Garden City, N.Y.: Doubleday, 1975. Twelve essays by sociologists who challenge traditional assumptions in their discipline from a feminist perspective. They look at groups of women hitherto invisible in traditional sociological research, examining gender as an essential factor in human behavior and exploring the gender differences that contradict previous sociological generalizations.

Bridenthal, Renate, and Koonz, Claudia, eds. *Becoming Visible: Women in European History.* Boston: Houghton Mifflin, 1977. Twenty essays spanning history from the earliest possibly egalitarian societies (Eleanor Leacock) through ancient, medieval, early modern, and modern European eras by scholars who address the past from a feminist perspective. The book contains the famous essay by Joan Kelley "Did Women Have a Renaissance?" and ends with "Family Models of the Future" by Andree Michel.

Frontiers: A Journal of Women Studies, Volume VI, Number 3, Fall 1981. This issue is devoted to Native American women, including interpretive essays, oral history, poems, and an extensive bibliography. It is an important compilation, focusing on the experience of women whose social roles and cultural values were so deeply affected by the coming of European white settlers to the Americas.

References

Acker, Joan. "Issues in the Sociological Study of Women's Work." In *Women Working: Theories and Facts in Perspective,* edited by Ann. H. Stromberg and Shirley Harkness. Palo Alto: Mayfield, 1978.

Amir, Menachem. *Patterns of Forcible Rape.* Chicago: University of Chicago Press, 1971.

Ardener, Edwin. "Belief and the Problem of Women." In *Perceiving Women,* edited by Shirley Ardener. London: Dent, 1975.

Ardener, Shirley. "Introduction." In *Perceiving Women,* edited by Shirley Ardener, London: Dent, 1975.

Bachofen, Johann Jakob, *Myth, Religion and Mother Right: Selected Writings of J. J. Bachofen.* 1861. Translated by Ralph Manheim. Princeton: Princeton University Press, 1967.

Bamberger, Joan. "The Myth of Matriarchy: Why Men Rule in Primitive Society." In *Woman, Culture, and Society,* edited by Michelle Z. Rosaldo and Louise Lamphere. Stanford: Stanford University Press, 1974.

Bridenthal, Renate, and Koonz, and Koonz, Claudia, eds. *Becoming Visible: Women in European History.* Boston: Houghton Mifflin, 1977.

Brownmiller, Susan. *Against Our Will: Men, Women, and Rape,* New York: Simon & Schuster, 1975.

Carroll, Berenice A., ed. *Liberating Women's History: Theoretical and Critical Essays.* Urbana: University of Illinois Press, 1976.

Clark, Joanna. "Motherhood." In *The Black Woman: An Anthology,* edited by Toni Cade. New York: New American Library, 1970.

Engels, Frederick. *The Origin of the Family, Private Property and the State,* 1884. Trans. by Alec West. Edited by Eleanor B. Leacock. New York: International Publishers, 1972.

Fee, Elizabeth. "The Sexual Politics of Victorian Social Anthropology." In *Clio's Consciousness Raised,* edited by Mary Hartmann and Lois Banner. New York: Harper & Row, 1974.

Fried, Barbara. "Boys Will Be Boys: The Language of Sex and Gender." In *Women Looking at Biology Looking at Women,* edited by Ruth Hubbard, Mary Sue Henifin, and Barbara Fried. Cambridge, Mass.: Schenkman, 1979.

Gould, Meredith. "The New Sociology." *Signs* 5 (1980):459–67.

Harris, Marvin. *Cannibals and Kings.* New York: Vintage, 1977.

Helly, Dorothy O. "Patriarchal Theory: A Victorian Revival." Paper presented at the Fourth Berkshire Conference on the History of Women. Mt. Holyoke College, 1978.

Hubbard, Ruth. "Have Only Men Evolved?" In *Women Looking at Biology Looking at Women,* edited by Hubbard et.al.. Cambridge, Mass.: Schenkman, 1979.

Hull, Gloria T., Scott, Patricia Bell, and Smith, Barbara, eds. *But Some of Us Are Brave: Black Women's Studies.* Old Westbury, N.Y.: The Feminist Press, 1982.

Humphrey, Caroline. "Women, Taboo and the Suppression of Attention." In *Defining Females,* edited by Shirley Ardener. London: Croom Helm, 1978.

Ireson, Carol. "Girls' Socialization for Work." In *Women Working,* edited by Stromberg and Harkness. Palo Alto: Mayfield, 1978.

Joseph, Gloria, and Lewis, Jill. *Common Differences: Conflicts in Black and White Feminist Perspectives.* Garden City, N.Y.: Doubleday, 1981.

Ladner, Joyce A. *Tomorrow's Tomorrow. The Black Woman.* Garden City, N.Y.: Doubleday Anchor, 1972.

———, ed. *The Death of White Sociology.* New York: Vintage, 1978.

Lasch, Christopher. *Haven in a Heartless World: The Family Besieged.* New York: Basic Books, 1977.

Leibowitz, Lila. *Females, Males, Families: A Biosocial Approach.* New York: Holt, Rinehart & Winston, 1978.

Lerner, Gerda. *The Majority Finds Its Past.* New York: Oxford University Press, 1979.

Lipman-Blumen, Jean. "Toward a Homosocial Theory of Sex Roles: An Explanation of the Sex Segregation of Social Institutions." *Signs* 1 (1976):15–32.

MacKinnon, Catherine A. *Sexual Harassment of Working Women.* New Haven: Yale University Press, 1979.

Maine, Henry Sumner. *Ancient Law.* 1861. Reprint. New York: E. P. Dutton (Everyman's Library), 1960.

Mamiy, Laurie. "Behind the Veil." *Odyssey Magazine.* Boston: Public Broadcasting Associates, 1981.

Martyna, Wendy. "Beyond the 'He/Man' Approach: The Case for Non-Sexist Language." *Signs* 5 (1980):482–93.

McLennan, John F. *Primitive Marriage: An Inquiry into the Origin of the Form of Capture in Marriage Ceremonies.* 1865. Reprint. Edited with introduction by Peter Rivière. Chicago: University of Chicago Press, 1970.

Millman, Marcia, and Kanter, Rosabeth Moss, eds. *Another Voice: Feminist Perspectives on Social Life and Social Science.* Garden City, N.Y.: Doubleday, 1975.

Morgan, Lewis Henry. *Systems of Consanguinity and Affinity of the Human Family.* Smithsonian Contributions to Knowledge, vol. 17. Washington, D.C.: Smithsonian Institution, 1871.

Oren, Laura. "The Welfare of Women in Laboring Families: England 1860–1950." In *Clio's Consciousness Raised,* edited by Hartman and Banner. New York: Harper, 1974.

Ortner, Sherry. "Is Female to Male as Nature is to Culture?" In *Woman, Culture and Society,* edited by Rosaldo and Lamphere. Stanford: Stanford University Press, 1974.

Patai, Raphael. "Familism and Socialization." In *Readings in Arab Middle Eastern Societies and Cultures,* edited by Abdulla M. Lutfiyya and Charles W. Churchill. The Hague: Mouton, 1970.

Pomeroy, Sarah. "Selected Bibliography on Women in Classical Antiquity." In *Women in the Ancient World,* edited by John Peradotto. Albany: SUNY Press, 1982.

Rich, Adrienne. "Compulsory Heterosexuality and Lesbian Experience." *Signs* 5 (1980):631–60. Anthologized in Catharine R. Stimpson and Ethel Spector Person, *Women—Sex and Sexuality.* Chicago: Chicago University Press, 1980.

Roberts, Helen E., "The Exquisite Slave: The Role of Clothes in the Making of the Victorian Woman." *Signs* 2 (1977):554–69.

Rosaldo, Michelle Z. "The Use and Abuse of Anthropology: Reflections on Feminism and Cross-Cultural Understanding." *Signs* 5 (1980):380–417.

Rubin, Gayle. "The Traffic in Women: Notes on the 'Political Economy' of Sex." In *Toward an Anthropology of Women,* edited by Rayna Reiter. New York: Monthly Review Press, 1975.

Ruddick, Sara. "Maternal Thinking." *Feminist Studies* 6 (1980):342–67.

Schneider, David M., and Gough, Kathleen, eds. *Matrilineal Kinship*. Berkeley: University of California Press, 1962.

Schneir, Miriam, ed. *Feminism: The Essential Historical Writings*. New York: Vintage, 1972.

Sherman, Julia, and Beck, Evelyn Torton, eds. *The Prism of Sex: In the Sociology of Knowledge*. Madison: University of Wisconsin Press, 1979.

Smart, Carol, and Smart, Barry. "Accounting for Rape." In *Women, Sexuality and Social Control*, edited by Carol Smart and Barry Smart. London: Routledge & Kegan Paul, 1978.

Smith, Dorothy E. "A Sociology for Women." In *The Prism of Sex*, edited by Sherman and Beck, Madison: University of Wisconsin Press, 1979.

————. "Women's Perspective as a Radical Critique of Sociology." *Sociological Inquiry* 44 (1974):7–13.

Spender, Dale, ed. *Men's Studies Modified: The Impact of Feminism on the Academic Disciplines*. New York: Pergamon, 1981.

Strachey, Ray. *The Cause: A Short History of the Women's Movement in Great Britain*. 1928. Reprint. London, Virago, 1978.

Tanner, Nancy M. *On Becoming Human: A Model of the Transition from Ape to Human and the Reconstruction of Early Human Social Life*. New York: Cambridge University Press, 1981.

Thorne, Barrie, and Henley, Nancy, eds. *Language and Sex: Difference and Dominance*. Rowley, Mass.: Newbury House, 1975.

Tilly, Louise A., and Scott, Joan W. *Women, Work, and Family*. New York: Holt, Rinehart & Winston, 1978.

Tuchman, Gaye. "Women and the Creation of Culture." In *Another Voice*, edited by Millman and Kanter. Garden City, N.Y.: Doubleday, 1975.

Webster, Paula. "Matriarchy: A Vision of Power." In *Towards an Anthropology of Women*, edited by Reiter. New York: Monthly Review Press, 1975.

Witt, Shirley Hill. "Native Women Today: Sexism and the Indian Woman." In *Female Psychology: The Emerging Self*, edited by Sue Cox. Chicago: Science Research Associates, 1976.

Wortman, Marlene Stein. "Domesticating the Nineteenth Century American City." *Prospects: An Annual of American Cultural Studies* 3. New York, 1977.

II
The Family Circle

Introduction

In our effort to define women, we have examined a series of perceptions recorded in scientific experiments, case studies, and artistic and philosophical observations. These perceptions have played backwards and forwards on the process of social formation. Women are what we are trained to be by our society. Our society trains us to be what it thinks a woman should be. There is nothing inherently wrong or destructive in this. It is the process by which all of us come to understand who we are as members of a particular group, class, nation, or culture and who we are as individuals at variance from the norms established by the group.

The difficulty has been that women are so commonly cast in the role of "other" by men who dominate the cultural and social process. In Part II, we shall attempt to translate this theoretical proposition into an expression of women's real experience. The central portion of this book concerns women in the family context: daughters, sisters, wives, and mothers. It concludes with a consideration of women who, by design, have found ourselves outside the family circle. We shall attempt consistently to contrast the images or norms that govern these roles with an analysis of the choices and strategies that individual women have employed within the given environment.

When we consider what a family is, images of tidiness, order, and disciplined confinement spring readily to mind. A family is a lineage, a line, an arrow through time linking ancestors and posterity in a chain based on genes and family names. A family is a circle, enfolding into its encompassing warmth a group related by love and mutual service. Families are the building blocks of society. No individual is left out. Every child has a biological mother and a sociological father. They all belong somewhere, even if the society has to intervene by creating fictional or institutional families in which to place them.

The family may be defined in terms of certain kinds of units. For nine months at least, a family is a neat and easily defined physical unit: a mother and child supplemented at least for a few minutes by a father who participated in the generation. We can, therefore, begin to think about families as two parents and a child. Siblings also start with a biological bond, sharing at least one parent. Even if their mother or father has several mates, brothers and sisters may be viewed as members of a single family.

But a family need not be tied by biological bonds. Persons related by blood may be practical strangers to one another. Some parents die, and others give

children up for adoption. Siblings marry and go their separate ways. Single parents marry or remarry and recombine their family units. Other persons perform the nurturing and fostering tasks of the biological relative. We might say, then, that a family is a social unit whose members are self-designated and tied by sentiment and common interest. Nowadays, persons who are not legally married, both heterosexual and homosexual, are beginning to claim the right to recognition as both couples and families. Persons who have fostered the biological children of other people lay claim to being the "real" parents. All societies recognize that a family is more than a biological accident encompassed by a brief sexual encounter and its procreative result.

Finally, a family may be thought of as a subsistence unit which produces and distributes the material necessities of life. This arrangement is not stable. From cradle to grave, the life cycle turns as individuals move from dependency to support and authority and back to dependency again.

Daughter, sister, wife, mother. Most societies have an ideal vision of what these roles entail, and women are shaped as far as possible to fit these molds. But these categories split the whole woman. Socially, they deprive us of an effective expression of the integrity of our personalities. For women, the prevailing notion of family makes nonsense of the unified reality of our own experience. Women do not cease to be daughters or sisters because we marry. We do not cease to be wives because we retain legal or emotional ties with our parents. One of life's most painful conundrums is the supposed conflict between wifehood and motherhood. Yet within this fiction most women play out entire lives.

Every culture has a series of elaborate terms and concepts describing the relationships of people to one another. Aunts, uncles, and cousins are distinguished by the maternal line or the paternal line. Sometimes different terms are used to distinguish generational or age ranking. Other terms describe relationships created by marriage or ritual (for example, godparents), or by tribe, clan, or nation. These relationships can be very luxuriant or, as in American society, relatively sparse. They function to sort out individuals and place them into a defined and ordered relationship with one another.

The ideal of a society may be an infinitely spreading kinship network, encompassing a vast jungle of alliances. Or it may be a continuously pruned family tree concentrating wealth and authority at a nucleus. Elaborate sets of rules and taboos lead individuals into choices and life strategies which make the ideal concrete. But no set of rules or ideals is strong enough to offset the influences of time, fatality, and chance, which determine the actual numbers of people available to play the roles set up. Thus, few societies actually realize their ideal kinship structures.

Household composition also varies widely according to accident and design. But households are more easily made to conform to a recognized ideal than are kinship structures. Some analysts choose to approach the study of the family from the point of view of the old Latin *familia,* a word which represented that complex of relatives, spouses, adopted, illegitimate, and biological children, servants, retainers, and concubines who shared living quarters under the authority of a *pater familias.* Many societies aim for the creation of a joint family

household in which several married couples with their attendant relatives and retainers and progeny share a common roof. Others prefer a *small nucleus* founded by two newly married persons and eventually expanded to include their children. Again, however, the accidents of time and place will finally dictate the actual composition of a household, whatever the ideal.

Certain social necessities ultimately shape the final composition of a family. Who is ranked in the lineage or folded into the family circle will to some extent be decided by the following family functions:

1. The reproduction and socialization of children. These tasks require a sexual union and a period of dedication to the task of nurturing and training, usually delegated to individuals willing to play the maternal and paternal roles.
2. The production and consumption of goods. Each society tends to assign the tasks involved to different family members on the basis of gender and age.
3. Emotional and sexual supports. These supports are exchanged between individuals who are usually designated family partners for that purpose. The family regulates the amount and kind of affection and support that each member may expect from the others.
4. Discipline and diplomacy. A hierarchy of family roles usually maintains internal discipline, while external politics are carried on by one member designated to use the combined resources of the family to mediate with the outside world and forward the interests of the family as a group.

Within the household, as within our kinship circles, women pursue our own ends and interests in a never-ending series of choices, alliances, and manipulations, shifting from role to role as the situation demands. Some women, by a combination of opportunity and skill, function in ways defined by society as "male"; we inherit the position and authority of our fathers or our husbands or act in the name of minor children. More commonly, women act through men.

Recent changes have caused many people to express fears that the family is threatened with extinction. However, it is highly unlikely that the freedom of women will result in the disappearance of the family. What is likely is that the structural characteristics of the family that have traditionally favored the interests of men will be modified to the extent that the circle better accomodates the lives of women. Along these lines, new experiments in living are being made daily.

6

Daughters and Sisters

DAUGHTER IN THE FAMILY
Female Infanticide
The Value of Daughters
 Daughters' Work
Naming the Daughter

FAMILY RELATIONSHIPS: PARENTS
Daughters and Mothers
Daughters and Fathers

SISTERS: SIBLING RELATIONSHIPS
Sisters As Opposites and Companions
Sister-Brother Relations
 Aunts

INHERITANCE

THE SISTERHOOD OF WOMEN

In the guise of a swan, Zeus, high god of Olympus, raped Leda. That same night, Leda mated with her husband, and from these two unions she bore two daughters, Helen and Clytemnestra. Clytemnestra was wedded to Agamemnon, king of Mycenae. The beautiful Helen was wedded to Menelaus, king of Sparta, but she subsequently eloped with the prince of Troy. The princes of Greece responded by making war on Troy for ten years. To gain safe winds for their ships, Agamemnon gave Clytemnestra's daughter Iphigenia as a sacrifice to the goddess Artemis. When he returned home, Clytemnestra, with the help of her lover, killed him. But her second daughter, Electra, refused to forgive her mother for thus avenging her sister's death. She rejected her mother totally and mourned constantly at her father's tomb, awaiting the return of her exiled brother. Her devotion to her dead father prevented her from accepting a husband. Finally, her brother returned, and together they slew Clytemnestra and her lover.

This tangled romance of a legendary family in ancient Greece has been used many times since to elucidate the patterns of a woman's life. The great modern dancer Martha Graham saw the legend from the point of view of Clytemnestra's obsession with "Helen and I, sprung from the same egg," a twin destiny of sisters and daughters. Helen and Clytemnestra, Iphigenia

216

and Electra, love and death, life and hatred, binding women in a myth for all ages.

The tie between women and our natal families lasts beyond our girlhoods. Eventually, most women leave home, marry, and in turn become mothers. Male viewpoints in the study of family history or comparative kinship structures have tended to emphasize the role change to wife and mother, and thus to draw attention away from our permanent attachments to our parents and siblings. These relationships, however, constitute the formative experience of our lives, and they continue in some form or another until our deaths.

No amount of legal sleight-of-hand can disguise the permanency of these links once we are determined to examine them. To begin with, there is an enduring genetic legacy which ties us as daughters, and in turn our children, to the family of our birth. We carry similarities of feature and build with us wherever we go. The strengths and weaknesses that women carry in our genes are transmitted to the next generation. No change of name or status can affect that transmission. Even death, accident, or a parental decision to put a child up for adoption cannot sever that tie.

In addition, our girlhood experiences mold us socially. From our natal, adoptive, or foster families, we derive our notions about human relationships. Families share small mannerisms, private jokes and recipes, and customary ways of doing tasks that tie them together as a group. Families also assign different roles to different members based largely on sex, age, and birth order. These early role designations continue to affect people throughout their lives. Both biological and psychological differences have been used by society to set sisters and brothers apart. Parental expectations differentiate between one sibling and another. Out of the politics and emotional currents that are played out in girlhood, the woman emerges. Our first role in life is as daughter/sister. In many ways, it is also our last.

Daughter in the Family

The conception and birth of a child is usually a welcome event in the history of a family. Sometimes, however, it is inconvenient or even disastrous. The physical survival of the mother and older children, especially an unweaned child, might be threatened by the arrival of another child. Where contraceptive and abortive methods are unknown, unavailable, or undependable, the only "choice" may be infanticide. Even in societies with forms of birth control available, infanticide has been practiced.

Those readers who believe that there is a "maternal instinct" which naturally causes mothers to protect our children must wonder what could prompt us to kill them instead. Inability to care for a child, particularly if it is illegitimate or if the other parent or other members of the society are not available for assistance, may be a motive. Where infanticide is a socially

recognized option, it may be the father alone who makes the decision, and it may be the midwife or another party who carries it out. Historians and anthropologists have not documented the emotions of mothers in the face of such directives. Indeed, remarkably little has ever been said or recorded about so widespread a phenomenon. Perhaps mothers, hoping to forget our part in a conspiracy against our offspring, have chosen to be silent.

Female Infanticide

In 1 B.C., a husband in Alexandria wrote to his wife in the Egyptian country-side: "I beg you and urge you . . . if by chance you bear a child—if it is a boy, let it be; if it is a girl, cast it out." (Hunt and Edgar, 1932). Until recent times, female infanticide has been the only method of population control which enables the responsible parties to make decisions on the basis of sex. It is well known that the Greeks abandoned many more girls to die than boys, and the Romans had a law requiring fathers to raise all healthy sons but only one daughter (Pomeroy, 1975). Even in medieval Christian society, where church law strictly forbade infanticide, we have evidence that it was carried on quite extensively. Penitential literature gives fairly lengthy advice to confessors dealing with women who claim to have accidentally "overlaid" (smothered) children at night. It has been argued that girls were the most common victims of these accidents. Certainly when foundling homes were established, as in Florence in the fourteenth century, the records provide incontrovertible evidence that parents discarded many more females than males (Trexler, 1973).

Today it is possible to perform tests in early pregnancy to discover the sex of the fetus. A study a few years ago in one Chinese province showed that all abortions performed after such tests were upon women bearing female fetuses (Kingston, 1978). In the United States, more couples still prefer to have a son than a daughter, particularly if it is the first child (Jaccoma and Denmark, 1974; Williamson, 1976), and statistics show that many couples tend to keep on having children until they have a son. Then they stop. There is virtually no society that positively prefers girl babies to boys.

Where infanticide has not been practiced, we would imagine that the genetic advantages of girls (discussed in chapter 3) would result in our making up slightly more than half of the adult population. Often this is not the case. This raises the question of why in many societies more girls than boys should die in infancy and early childhood (Dickemann, 1979). One answer seems to be that some children get better treatment than others. If one child is systematically allotted less food, neglected during illnesses, and overworked or abused physically, that child is likely to die. In early Mediterranean societies, girls were traditionally nursed for one year and boys for two. The rations furnished by various states to mothers of boys were higher than those allocated for mothers of girls (Pomeroy, 1975). In many families, when protein has been scarce, women have customarily stinted ourselves

and our daughters in favor of the husband and sons. This has not only prejudiced the daughters' chances of survival but also has helped to socialize those who survived to play the same role later in our own households. The neglect of daughters is masked almost everywhere by the assertion that girls do not require as much food as boys. This belief might account for more discrepancy in the size and physical strength of girls and boys than is generally acknowledged.

The Value of Daughters

The selective destruction of female babies by individual families reported in various groups throughout history would not have been possible unless society as a whole condoned it. Why the murder of female children should be a method of population control, why it took so long to develop effective and safe contraceptives, why these contraceptives, though available, are often not used, and why so many people display a preference for sons over daughters are questions that all who study women must ask. Much of the answer must lie in the social patterns which define women's place and our value to the society at large.

One theory that has received much publicity matches female infanticide with the high valuation of males in societies engaged in chronic warfare. If men are the warriors (and they always are), sons must be raised and "masculine" qualities stressed. Because investment in daughters detracts from investment in sons, daughters are sacrificed. The evidence supporting this argument shows systematic correlation between female infanticide, chronic warfare, and male supremacist cultural values (Divale and Harris, 1978).

Another theory rests on speculations concerning the marital strategies of individual families. Where the potential marital pool is known and limited, parents may decide to sacrifice daughters for whom there are no possibilities of a profitable future settlement (Coleman, 1976). In many societies, brides must be accompanied by wealth when we leave our fathers' houses. In others, daughters represent potential wealth which will be paid our parents in return for us (see chapter 7). Clearly these economic prospects play an important role in the family's decision-making.

These decisions seem to be based on men's values about the aggregation of wealth, political alliances, and the relative importance of warriors vs. mothers. Decisions that favor women seem to exist only in the realm of fantasy. Ancient Greek myths about Amazons tell of women warriors who preferred girl babies to boys. According to the legend, sons were maimed or killed or immediately sent to their fathers. Feminists have adopted this myth about strong women but have modified its ugly features. In *The Female Man* (1975), Joanna Russ created a fictional utopia where women live without men and have only girls. Reproduction is accomplished by the merging of ova, and children are raised communally.

Daughters' Work. Some daughters, even when mature, are retained by parents to perform daughters' work and do not marry. Daughters serve as old-age security, and we are generally expected to provide our parents with a home, personal care when needed, affection, and other emotional supports. Sons are also liable for the same responsibilities, but all too often they limit their contributions to cash or manage to escape altogether. It is an old saying among the Turks that only a daughter can be relied upon on a dark day. The son will defect to his wife's family when he is most needed. There is also a saying in the Western world that "a son's a son till he gets him a wife / A daughter's a daughter the whole of her life."

The care and services of a daughter are often very highly esteemed even when they are not a dire necessity. It is not uncommon for a father to refuse to give his daughter in marriage because he wishes to reserve her services for himself, particularly if he is widowed and does not wish to remarry. If he does agree to part with his daughter, he may often demand much bride wealth in compensation for the loss.

Daughters have a certain intrinsic value in that we represent the reproducers of the next generation. If there is to be a future generation, women must be raised to produce it. The universal taboos against the mating of members of the immediate family make it necessary to procure a daughter-in-law for the production of grandchildren. The most common way in which a family gets a daughter-in-law is in exchange for a daughter. Indeed, some societies operate on a fairly rigid one-to-one basis: the even exchange of cousins, for example, is seen as the right and normal way of pairing off young people. Thus daughters are valuable directly or indirectly in that we represent chips in the bargains that make up the composition of society.

Girls occupy an important position within our natal families on the basis of the work we perform. Women are usually assigned a specific series of tasks considered to be beneath the attention of men. But these tasks must be done, and in most households daughters are trained to care for younger siblings and to assist in food preparation and other domestic chores. We fetch water and firewood, feed, chickens, go to the market, help with the dairying, and undertake income-producing tasks like lacemaking. All this work may go unnoticed by a girl's father or brothers until it is left undone, but they depend on it nonetheless. The value mothers place on the help of daughters can hardly be overestimated.

Families without daughters or girls to perform daughters' work often adopt us or bring girls in from other sources. Many girls abandoned by parents or exposed to die have been adopted in this informal manner. A warm relationship can develop, and the unwanted daughter may come to occupy a valued and secure place in the new home. In the ancient world, girls were also raised as slaves and often trained as prostitutes by the men and women who owned brothels.

Buying Daughters in Traditional China **Box 6.1**

Among the sellers with their ropes, cages, and water tanks were the sellers
of little girls. . . . There were fathers and mothers selling their daughters,
whom they pushed forward and then pulled back again. . . . My mother
would not buy from parents, crying and clutching. . . . My mother would
buy her slave from a professional whose little girls stood neatly in a row
and bowed together when a customer looked them over.

(Kingston, 1976:93)

The Woman Warrior: Memoirs of a Girlhood Among Ghosts. Copyright © 1975,
1976 by Maxine Hong Kingston. Reprinted by permission of Alfred A. Knopf, Inc.

A young woman, then, starts her life on the basis of a series of considera-
tions about our future worth to the family. We then enter into a political
system in which parents, sisters, and brothers all figure in a series of shifting
alliances and antagonisms. We struggle for identity and material advantage
within a pattern imposed by chance and social convention.

Naming the Daughter

The names given us at birth are sometimes the most powerful indicators of
our place in the social scheme. Our names give the value of our family status.
They describe our placement in the structure of the family. Because the
process of naming is profoundly political, we can learn much about the status
of women in different societies by understanding the naming patterns.

To begin with, a name designates the sex of a child. The more emphasis a
society places on the difference between girls and boys, the more carefully it
will distinguish their names. Medieval Europeans usually got through life
with a single name which often repeated the father's name or embroidered on
it, such as Charles, Charlotte, or Charlene. When named for fathers,
daughters were given a close feminine form of his name: John/Joan; Robert/
Roberta.

Boys are almost never given names that signify girls, but the reverse can
occur, perhaps reflecting the greater worth attached to male associations.
Indeed, many names originally assigned to men, such as Evelyn, Beverly, and
Shirley, have become incontrovertibly female by virtue of such transfers. Sons
are frequently named for their fathers. Daughters are far more rarely named
for our mothers (although one of the most popular of Western names, Elea-
nor, was first bestowed on the twelfth–century heiress of Aquitaine to cele-
brate the memory of her mother, Anor; thus she was named Ali-anor, the
other Anor).

Custom may reserve the privilege of naming sons for fathers and give
mothers the right to select names for daughters. Mothers often seek to ex-

press pleasure in having daughters or to transfer desirable qualities through a name like Joy, Linda ("beautiful" in Spanish), or Miranda ("marvelous"). Mothers frequently name daughters for lovely or admired objects such as flowers or jewels or for a character in a movie or novel. Sometimes mothers may even signal private dreams in the name of a girl. Among medieval Jews living in Islamic Cairo, infant girls bore names like Nasr ("victory") or Sitt-al-Jami ("she who rules over everybody") (Goitein, 1978).

The importance of children for the continuity of a lineage is reflected in the use of *patronymics* (fathers' names). For example, the ancient Romans did not name their daughters at all. A daughter was automatically called by the feminine form of the father's name. Thus, all the daughters of a Claudius were called Claudia and referred to informally in numerical order: Claudia prima, Claudia secunda, Claudia tertulla (the little third). In view of the later development of the patronymic into surnames, it appears that Roman girls had no individual names at all. In some areas, patronymics continued to be used into modern times. The heroine of a Scandinavian novel by Nobel-prize winner Sigrid Undset (1882–1949), set in the fourteenth century, was called Kristin Lavransdatter (daughter of Lavrans). Similarly, the heroine of Tolstoy's novel (published in 1875–1877) was named Anna Arkadyevna (daughter of Arkady) Karenina (wife of Karenin). In our society, the use of patronymics has commonly rigidified into a permanent family name (such as Jackson or Richardson). But it is rare to find in modern times a perpetuation of the old system of using matronymics where the mother may have been the better known or wealthier of the parental couple (Maryson or Margaretson) (Herlihy, 1976). Slaves in the American south named sons for their fathers in an effort to retain family ties despite the common breakup of the conjugal unit through sale (Gutman, 1977).

Other forms of family names developed extensively in Europe from about the ninth century on as the practice of bestowing "Christian" names became popular. The frequent use of John, Mary, and other saints' names often made the addition of some other name a necessity for identification. Names associated with a parent, a profession, or a geographical location gradually hardened into the "family" name bestowed alike on daughters and sons at birth. These names reflect the perpetuation of a male lineage since they are derived from the father's name, profession, or place of birth.

Generally, a daughter's surname changes at the time of marriage. Women often report feelings of a loss of identity when this happens, as, for instance, Mary Jones "disappears" and in her place is Mrs. James Smith. A woman's married name designates a position rather than a person, and a first Mrs. Smith may be replaced by a second or third with the same name (see chapter 7).

In Spanish-speaking societies, women often retain our father's names by adding them (with "y") to the husbands' names. Among noble families, it is

often possible to trace a whole genealogical history by a recitation of the full name of an individual. In other societies, children will often perpetuate the name of their mother's family as a middle name.

Many couples today experiment with combining both names as a family name, or women may keep our names when we marry, as we are legally entitled to do. It is still most common for American children to have the surnames of their fathers, but it is perfectly possible to register the children under other names, alternating the names of mother and father with each child, for example, according to the sex of the child. In a society where the names of women prevailed as often as the names of men, whatever loss of identity resulted from the losing of one's name would be a burden shared by women and men equally. Some women reject the surnames of both fathers and husbands and choose our own, as did, for instance, artist Judy Chicago (see chapter 1).

Family Relationships: Parents

From the moment girls are born and named, we are started on a track that will take us through our whole lives. Our parents react to us in ways prescribed by social convention or by their own emotional preferences. We are handled and dressed and trained to fulfill a role in the family as daughters. Our siblings shape our personalities by assigning us an individual role among themselves.

Daughters and Mothers

Children experience the mother as the first "other" and a daughter's sense of self must be forged out of that opposition. But since the mothering person is nearly always a woman, daughters tend also to experience stronger feelings of identity with the mother than do sons (Chodorow, 1978). The first task of individuation that we as daughters must undertake is the discovery of the ego boundaries between ourselves and our mothers. All children have the task of separating psychologically from their mothers, of discovering where one ends and the other begins. This is more difficult for girls, as we will discuss later.

The developmental task is made even harder if mothers see daughters as a reflection of ourselves as children. In relatively simple societies where girls grow into women looking forward to a predictable life, this is probably not a matter for distress and does not seem to create a great deal of tension between generations. Mothers act easily as role models and guides for young women. In complex societies, however, particularly those that reward a highly developed sense of individualism, daughters may suffer much confusion in separating ourselves from our mothers, as is suggested by the title of Nancy Friday's *My Mother/My Self: The Daughter's Search for Identity* (1977) (box 6.2).

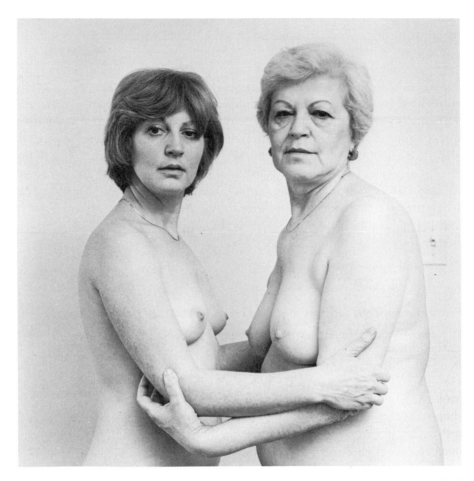

The younger woman is the photographer who is seeking in her own way here to establish both the identity and separateness of herself and her mother. Struck by the similarities of face and feature, she is aware at the same time that each represents a different generation, a different stage in the life cycle, and an ongoing relationship at different stages in their own lives. (Photo by Niki Berg)

Very often, mothers tend to inhibit the development of this separate sense of identity in two ways. First of all, we expect our daughters to remain at home more often than we expect it of our sons. Nursery schools, for example, receive far more applications for boys than for girls. This may indicate that parents are more willing to pay for a boy's education and set higher expectations for his future achievements. But it may also reflect a more universal pattern in which the boy is sent out into the world at a relatively early age to shape himself for his predicted adult role (Lewis, 1972). Second, girls are generally expected to help our mothers with "women's work"

Mothers and Daughters Box 6.2

They perpetuate themselves
one comes out of the other
like a set of Russian dolls.

Each is programmed to pass on
her methods to the daughter
who in turn becomes a mother.

They learn to cry and get
their way and finally to say
"I did it all for you."

When they are old and can't
be mended they're either burnt
or laid in boxes in the dark.

Russian Dolls. (Photo by Richard Zalk)

Sometimes their sons are sad.
Their daughters go away and weep
real tears for themselves.
(Feaver, 1980)

© Vicki Feaver, 1980. Reprinted by permission.

around the home even after we have started school. In this way, a daughter is shaped into a "little mother," taught nurturing skills and the mother's special techniques in performing them. Mothers may mold daughters in our own images, or we may consciously set out to create daughters who will not repeat our experiences but will live out a life that some ill fate snatched from us.

The tie between mothers and daughters may, through this process, become extremely close, particularly when the daughter becomes an adult. A young wife in seventeeth-century Hamburg (Germany) remembered with great delight that she and her mother, living in the same house, were pregnant simultaneously. The mother gave birth only a week after seeing the daughter safely delivered (Glückel of Hamelin, 1690, 1977).

In urban areas where families can live close together, the clustering of daughters within the neighborhood of our mothers' homes is common, and by no means accidental. A study of a London working-class neighborhood in the 1950s demonstrated the mechanics whereby mothers secured news of vacated houses from the local rental agents and moved to secure them for newly married daughters (Young and Wilmot, 1957). Mothers may behave in the same manner today in securing vacancies in large urban housing developments. Indeed, the marked ethnic character of many urban neighborhoods in the United States often results from the efforts of daughters and mothers to keep families in close proximity.

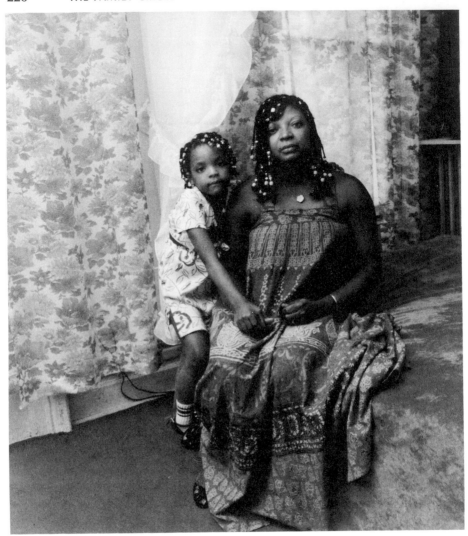

Black daughters often experience mother relationships with grandmothers and aunts as well as mothers. Here the hairdo as well as the face and the tightly clasped hands suggests the closeness of this relationship. (Photo by Niki Berg)

These "pseudomatrilineal" arrangements bear the mixture of anxiety, tension, and love that the natal family itself offers to the young girls. The support and affection enjoyed by young daughters in our maternal homes may be extended into our married lives, but only if husbands tolerate it and usually at the price of conflict with the interests of the married couple.

The poet Honor Moore has recounted her fears of failure and insanity growing from too close a sense of identity with her grandmother Margarett, a painter who unaccountably ceased to paint in middle age, and her mother,

> **My Grandmother Who Painted** Box 6.3
> I write about Margarett to find out, concretely, for myself. That silence,
> that unused canvas, thwarted passion and talent passed down a matrilin-
> eage to me. My mother has nine children, survives a near-fatal automo-
> bile accident, a nervous breakdown to put herself first, to commit herself
> to writing. She publishes one book, but in two more years, at fifty, she
> dies of cancer. Talent. And failure. Failure to hold, failure to focus, failure
> to hold the focus to the hot place so the transformation can occur, carry
> you out of self, so what you create may support, steady, nurture and
> protect you. (Moore, 1980:52)
>
> Copyright © 1980 by Honor Moore. Permission granted by the Julian Bach Liter-
> ary Agency, Inc.

who unaccountably delayed the beginning of her writing career until the same age and then died before she could develop her talent (box 6.3).

But mothers may also be the strongest allies in helping daughters to realize our dreams. In *Sido* (1930, 1953), the French author Colette wrote with warmth and pleasure of the encouragement and help she received as a child in her mother's house. The leader of the militant British suffrage movement, Emmeline Pankhurst (1858–1928), raised her daughters to lead independent and creative lives. Sylvia Pankhurst first chose an artistic career and then became the socialist leader of working-class women. Christabel Pankhurst became a leader, with her mother, in the fight for women's rights. Adela Pankhurst emigrated to Australia, where she became a social reformer.

Black women write of mothers and mother surrogates with respect and affection (Joseph, 1981). Grandmothers may become surrogate mothers, especially when the biological mother is young and continues to live at home. The relationship between mothers and daughters gradually shifts as mothers begin to accept those daughters—now mothers themselves—as equals (Ladner, 1971). Sometimes, in order to permit the biological parents to carve out a better life, children are sent away to be raised by grand-mothers (box 6.4).

The literary critic Mary Helen Washington acknowledges the persistent image of the strong black mother and dedicates her anthology, *Black-Eyed Susans: Classic Stories by and about Black Women* (1975), "to the fine black women who brought me up." Yet she also perceives the theme of mother-daughter conflict in the literature of black women. The mothers are prag-matic and conservative while the daughters are idealistic and reject "the good life" as defined by those mothers. According to Washington, "the conflict is not only personal but historical. And the resolution of the conflict can be discovered only as one comes to terms with history" (Washington, 1975).

"I Know Why the Caged Bird Sings" Box 6.4

When I was three and Bailey four, we had arrived in the musty little town, wearing tags on our wrists which instructed—"To whom It May Concern"—that we were Marguerite and Bailey Johnson Jr., from Long Beach, California, en route to Stamps, Arkansas, c/o Mrs. Annie Henderson. . . .

Years later I discovered that the United States has been crossed thousands of times by frightened Black children traveling alone to their newly affluent parents in Northern cities, or back to grandmothers in Southern towns when the urban North reneged on its economic promises. . . .

We lived with our grandmother and uncle in the rear of the Store (it was always spoken of with a capital *s*) which she had owned some twenty five years.

Early in the century, Momma (we soon stopped calling her Grandmother) sold lunches to the sawmen in the lumberyard. . . .

To describe my mother would be to write about a hurricane in its perfect power. . . . My mother's beauty literally assailed me. Her red lips (Momma said it was a sin to wear lipstick) split to show even white teeth and her fresh-butter color looked see-through clean. . . . I knew immediately why she had sent me away. She was too beautiful to have children. I had never seen a woman as pretty as she who was called "Mother." Bailey on his part fell instantly and forever in love. I saw his eyes shining like hers; he had forgotten the loneliness and the nights when we had cried together because we were "unwanted children." He had never left her warm side or shared the icy wind of solitude with me. She was his Mother Dear and I resigned myself to his condition.

(Angelou, 1969:29–30)

The ability of daughters to define and redefine ourselves can be evidence of assertiveness and strength. But it can also betray the absence of a sense of a fixed inner core. A common motif in the work of women artists is the mirror in which women search for ourselves and beautify our bodies. In her painting of a mother and daughter, Mary Cassatt portrays a mother who is helping her daughter find the image of herself in a mirror. Women's art is commonly haunted by the fear that a woman will look into the glass and see nothing; it is "an allegory of non-identity . . . fear of desertion, of dependence upon an insufficiently integrated self" (Peterson and Wilson, 1976:4). The double female image is another frequent theme, for we frequently view ourselves as part of a mother-daughter dyad.

Young women frequently find that our struggles to break away from the pattern of our mothers' lives tangle us ever more deeply in a mesh of invisible threads. Daughters who have grown up, married, and become mothers in turn may still be haunted by the nagging voices of our mothers telling us how

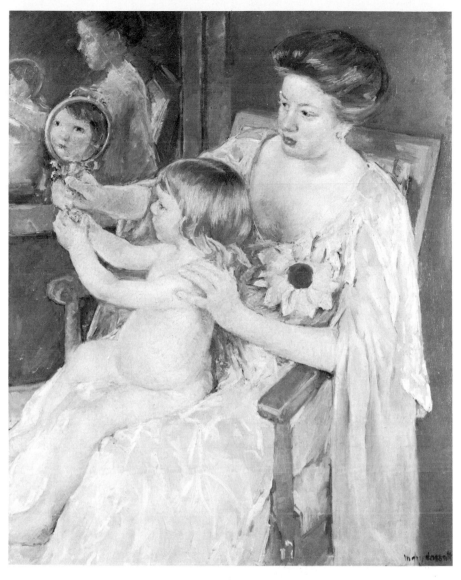

"Mother and Child" (c. 1905) by Mary Cassatt (1845–1926) uses the mirror motif, which often symbolizes the way women at all ages seek to find our identity by searching in a reflecting glass. We look in a mirror as we look in other's eyes to find out what it will tell us about who we are. (National Gallery of Art, Washington. Chester Dale Collection)

Older women, whether related or not, often give each other close companionship. Twin sisters who dress to match each other make an additional statement about their close and enduring claims on each other. (Photo by Richard Zalk)

to do everything, setting standards of perfection that we can never reach. This is an irritating experience if the voices come to us daily over the telephone or in person. It is even more maddening if the maternal voice has been internalized in the daughters' sense of permanent inadequacy.

Some daughters react with rage to our mothers' dependency. Others react against our mothers' independence. The Clytemnestra/Electra antipathy has not yet been solved in the relations of women across the generation gap.

Daughters and Fathers

Our relationships with our fathers are fraught with tension and instability. Daughters often find ourselves in league with our mothers against the foreign male element represented by our fathers. On other occasions, our hunger for the approval of our fathers makes us vulnerable indeed to the subtle training they give us on how to become attractive and socially desirable women in maturity.

Fathers who want to bring their daughters up as "little women" will actively discourage our efforts to break out of the conventional restrictions of our feminine role. They will compliment us on pretty clothing and beguiling ways. They will frown on us if we are messy or "tomboyish." They will let us know that straightforward competition will not earn paternal respect. When Elizabeth Cady Stanton (1815–1902) strove for and won a first-place Latin award in school in order to compensate her father for the son he had lost, her father sighed heavily, "You should have been a boy" (Stanton, 1971:23). Only after years of marriage and motherhood, conforming to the roles so clearly marked out for her, did Stanton finally return to the ambitions of her youth, pursuing a career as a writer and feminist agitator.

Fathers may encourage their daughters to reject our mothers and love them alone. Freud came to believe that when his female patients talked of incest with their fathers, they were revealing wishes rather than reporting facts. But today in clinics and hospitals and psychiatric centers, incest between father and daughter is the most frequently reported infraction of the general taboo against sexual intercourse among close relatives. Very little is known about the occurrence of mother-daughter and sister-sister incest. Mother-son incest is apparently rare. There is increasing evidence that brother-sister may in fact be the most common form, though not always as traumatic as that between father and daughter.

The effects of father-daughter incest are manifold. Research indicates it may leave a deep and lasting trauma. The experience may drive girls away from home as runaways, often to a destiny of drug addiction and prostitution. Even if girls remain at home and the relationship runs out its course, we may be haunted by anxiety attacks or adult sexual dysfunctions (Blumberg, 1978; Weitzel et al., 1978). When fathers use force to rape their daughters, step-daughters, foster daughters, or even the daughters of women with whom

Male Parenting **Box 6.5**

It is precisely *because* he cannot carry the baby in his belly or give it milk from his bosom that the human father—with his capacity to imagine being what he is not, doing what he cannot, seeing what is gone or not yet here or out of sight—feels an especially vivid urge to use his other, more singularly human, capacities to nurture the baby. To him the neonate is not the small, writhing and squeaking, special-smelling lump of flesh that it is for the tomcat. It is a daughter or a son, a being started with his own seed whose long, mysterious gestation in the dark inside of another person he has typically been thinking about—often with impatience and jealousy—for many months; a being whose resemblance to his dead grandparents he is excited to notice, whose future as a companionable child and supportive adult and maker of grandchildren he anticipates, whose bodily growth and steady stream of ordinary achievements will soon be flooding him with joyful pride.

So far, men have had to act on this urge mainly in indirect ways. . . .

It is now for the first time possible for us to rearrange the structure of our primary-group life so that men can act directly, rather than indirectly, on this specifically male and human urge of theirs, *this impulse to affirm and tighten by cultural inventions their unsatisfactorily loose mammalian connection with children.* They need leeway to work out ways of making their actual . . . contact with the very young as intimate as woman's. And with the very young, actual contact is the bodily contact that keeps them clean, fed, tranquil, safe, rested, and mentally stimulated. "As intimate," obviously, does not mean qualitatively identical. It is precisely the irreducible qualitative *difference* between motherhood and fatherhood—the physical difference, as it is reflected and reworked in the parents' thoughts and feelings—that gives men's passion for babies its own special male edge, its characteristic paternal flavor. (Dinnerstein, 1976:80–81)

The Mermaid and the Minotaur: Sexual Arrangements and Human Malaise Copyright © 1976 Dorothy Dinnerstein. Reprinted by permission of Harper & Row, Publishers, Inc.

they live, the physical and psychic trauma are magnified. Even when a more subtle and seductive approach is taken, father-daughter incest or its semblance is a cruel relationship of power and dominance between unequals.

The experience may be made even worse for the daughters if it becomes public knowledge. To prevent this, mothers and daughters may engage in a conspiracy of silence lest the offending fathers be imprisoned and their wages lost to the family. They may also fear the removal of the daughter to a hostile or at least unfamiliar environment. If daughters seek help, we may be made responsible for the dissolution of the family, punished for "misbehavior," and loaded down with a misplaced burden of guilt that may emotionally cripple us forever. If daughters become mothers of our fathers' children, the damage to all concerned may be extraordinary.

Fathers can, of course, be very supportive. Many prominent women have noted with gratitude the approval of their fathers in helping them to a career beyond the domestic sphere. In many cases, however valuable the emotional support of mothers to aspiring daughters, the sheer material support which the father commands can make the difference in determining our fates. Marie Sklodowska (1867–1934) began her scientific career under the instruction of her father, a professor of physics in Warsaw. Without his assistance, it is doubtful that she would ever have been sent to study in Paris, have married Pierre Curie, and used his laboratory facilities in her discovery of radium. In England, the annual allowance of £300 assigned to Barbara Leigh Smith Bodichon (1827–1891) by her father when she turned twenty-one gave her the independence to pursue feminist causes, including women's suffrage, even after her marriage. Maria Mitchell, the astronomer from Nantucket, began by spending many hours with her father gazing at stars through his telescope. In 1847, she discovered the comet that is named for her.

The relationships of women with our fathers have not received much attention in recent feminist literature. At present, it appears that domineering fathers may provoke reactions in their daughters that release our feminist impulses and creative potential. But it is also true that the fathers of many feminists and women artists, scientists, and other creative women were sympathetic and actually involved in the rearing of their daughters. What we can say with confidence is that equal participation by both parents, where possible, will often provide children with the best chances finding helpful role models, and with the support necessary to develop and cultivate their talents.

Sisters: Sibling Relationships

The most common means of discriminating among siblings is age-ranking. In some ways, age-ranking is a simple and inescapable result of the facts of nature. The first-born child will, in the course of events, tend to be given more responsibility for the care of younger children and given leadership in the organization of family chores. The older child will generally go to school first and break the path in obtaining privileges, such as an extended bedtime, from the parents. In addition, of course, many societies reserve very specific privileges for older children. For example, the upper ranks of English society long held to a tradition of passing the family wealth and property to the oldest male offspring. Parents in that society also discouraged younger daughters from marrying until an older sister was settled. Folklore and fairy tales are often dominated by the plight of the younger children obliged to make their way in a hostile world controlled by their elders.

Age-ranking tends to impose personality characteristics on the children. An older child will very often emerge as the more aggressive, achievement-oriented, responsible member of the family. A younger child is likely to feel

cheated; she or he is outfitted with hand-me-down clothes and toys and constantly treated as an inferior in the games and conversations of older siblings. But younger children may also emerge as more insouciant, carefree personalities, the darling of parents and older siblings (Sutton-Smith and Rosenberg, 1970). The family implications of age-ranking are carefully spelled out by the elder Miss Browning in *Wives and Daughters,* first published in 1857 (1969), by Elizabeth Gaskell (1810–1865). She explains that the domination of her younger sister in their joint ménage is necessary because household arrangements cannot be stably maintained unless one member of a pair assumes a position of authority and keeps to it.

A fictional illustration of the interaction of age-ranked siblings that conforms to the findings of modern psychologists can be found in *Little Women* by Louisa May Alcott (1823–1888), which first appeared in 1873 (1977). In the book, four sisters struggle to help their mother make ends meet while their father is away at war. Their life experiences shape their parts in the family scenario. Meg, the oldest, is the "little mother," the somewhat straitlaced, responsible leader of the flock. Her seriousness and occupation of the adult role leave the next sister, Jo, free to occupy the part of tomboy, mischief maker, and, eventually, liberated woman. The third sister, Beth, is the family saint whose peacemaking role continues even after her pathetic death. Amy is the family beauty whose childish vanity and self-centeredness are a cause of concern for her censorious older sisters. A similar assortment of role assignments can be seen among the Bennet girls in the 1813 novel of English sisterhood *Pride and Prejudice* (1959), by Jane Austen (1775–1867).

The dynamics established in childhood among siblings may last throughout life. Many people feel that the sense of place or role developed in childhood may never be overcome. Younger siblings never lose the sense of following in the footsteps of older children. The labeling imposed by parents, rivalry between siblings, and reactions against family roles sometimes influence young adults into certain career paths and life goals. Even late into life, jealousy of one another and rivalry for the attention of parents who may long since have died can mark the relationship.

Siblings can be sources of strength as well as conflict. In a period of widespread divorce, many individuals find relationships with sisters and brothers a core of stability in lives that are otherwise gravely troubled. Continuing and successful sibling relationships appear to have wider effects in heightening women's sense of security and in improving our social skills in the wider community.

Sisters as Opposites and Companions

The Bible provides us with two examples of sisters who reflect and complement one another: Leah and Rachel in the Old Testament and Martha and

Mary in the New. Leah was the older, maternal sister, while Rachel, young and long childless, was the well-beloved sister for whom Jacob was willing to work for fourteen long years. Martha was the careful, domestic sister engaged in making Jesus and his companions comfortable in her house. Mary was the intellectual, visionary sister who cast aside her domestic responsibilities in order to listen to Jesus' teaching. Such polarizations between sisters can be interpreted as two sides of a single personality as well as two possible choices in life.

Despite our occasional rivalries and jealousies, even tantrums, sisters have loving and affectionate bondings as well. Swapping of clothes, boyfriends, advice, and support often overshadow hostility. We play against one another in lifelong dialogue. This was dramatically expressed by Jessamyn West in her memoir *The Woman Said Yes* (1976), a record of her sister's bout with cancer in which the author assisted her first with home care and finally with a peaceful death. In the course of the long ordeal, the sisters spent the nights reliving their youth together, comparing and reconciling the differences in their experiences.

Older sisters provide models and assistance to younger ones. Traditionally, one of the roles of married sisters is to chaperone younger sisters at social gatherings and to use our husbands' contacts to look for husbands for our sisters. We may also provide a home for younger sisters or brothers who leave the family home for a new location. Thus, older sisters may emigrate to a city, marry or become established in jobs, and provide a base for following siblings who come looking for similar opportunities.

Sister-Brother Relations

Age-ranking is often nullified by sex-ranking. All too frequently, the privileges and importance that a girl might expect as the oldest child are brutally cancelled out by the appearance of a brother. Many feminists received the first jolt of awareness of "woman's place" when we suddenly realized that the leadership role was destined for a new baby by right of his gender alone. Throughout the early years, girls and boys are almost always routed along different tracks. This is often formalized by the practice of special initiation ceremonies for boys alone. A young girl attending a *brith* (a Jewish circumcision ceremony) was told not to be distressed at the baby's discomfort. "For," said her aunt, "it is a small price to pay for being a man." In some societies, boys are "breeched" or otherwise endowed with the garb of a man at an early age, while girls have traditionally never changed our mode of dress to signify womanhood.

In a horticultural community in Kenya, girls aged five to seven may spend half their time doing chores, while boys of the same age spend only 15 percent of their time at work and never do woman's work unless there is no sister available to help the mother (Ember, 1973). Among the Hopi, men

teach boys to weave cloth and women teach girls to weave baskets. In the United States, even though it is the law that both girls and boys must go to school, girls tend to be steered into different and less educationally valued subjects and different extra-curricular activities on the basis of gender (see chapter 11).

In all too many families, the achievements and talents of sisters may be subordinated to the ambitions of brothers. In the nineteenth-century, for example, Dorothy Wordsworth devoted her life to the care of her poet brother William. Alice James became an invalid and toward the end of her life kept a diary to give her thoughts expression, while her author brothers William and Henry became outstandingly successful. The talents of Charlotte, Anne, and Emily Brontë far overshadowed those of their brother Branwell, but they were able to gain recognition only by publishing their novels under male pseudonyms.

Sometimes the talents of sisters and brothers make up a team. Fred Astaire has always maintained that his sister Adele was the finest dance partner he had ever had, but she retired relatively early from their joint career. Similarly, in recent years, Marie and Donnie Osmond commanded a large television audience. Sister acts are also common in the entertainment world, but the talents of sisters may be sacrificed to the success of our brothers. Virginia Woolf expressed this idea again and again, conjuring up an imaginary but equally talented sister for William Shakespeare (see box 11.1) and writing bitterly and at length upon the failure of "educated fathers" to provide as much education for daughters as for sons (Woolf, 1963; 1966).

Sisters may resent the preference that our families show to our brothers. We may resent their freedom, education, friends, and the favored treatment they receive at home. Resentments of this kind may open deep gulfs between sisters and brothers and may be reflected in our relationships with our spouses and our own children.

Age-ranking still plays a role in establishing the relationships between sister and brother. Older sisters may well be forced to give precedence to our brothers in the family strategies, but we may also be cast in the role of "mothers" to them, establishing a burden that may last throughout life. On the other side, older brothers tend to play the masculine role toward their sisters, taking a protective and even bullying tone with them. They become stronger and more confident as they grow older, while we may find ourselves restricted by limitations and a suffocating protection that deprives us of the confidence that can come only from experience of success. Even older sisters may come to appear fragile and in need of protection. Often societies impose this role on young men whether they like it or not. "A man's honor lies between his sister's legs" is a common saying throughout the Mediterranean world. Young men are thus encouraged to police the behavior of their sisters and personally to avenge any infringement of the customary male code of

honor by both the sisters and their chosen lovers. In some societies, the brothers take an active role in arranging their sisters' marriages, even if the fathers are still alive, on the understanding that it is they who will have to live longest with the proposed brothers-in-law.

Aunts. The relationships of sisters with our siblings may, after the marriages of one or both of us, continue throughout later life and across the generations. In patrilineal societies, aunts may have a strong role in the lives of our brothers' children, just as uncles provide the ultimate authority over their sisters' children in a matrilineal society. Aunts may also play much the same role in the development of our nieces as do older sisters in providing models and assistance to younger sisters. Aunts sometimes provide our sisters' daughters with a temporary home in a city or in some other setting where the young girls may begin to search for careers or husband. Aunts may also provide nieces with temporary refuge from family strife or with a permanent home in case of death. A wealthier sister may provide poor nieces with various advantages.

European and American novels of the nineteenth century were particularly sensitive to the importance of the aunt in the lives of young women. In the novels of Jane Austen, it is commonly the aunt who provides the mainspring of the action. For example, in *Mansfield Park,* the heroine, Fanny Price, was taken out of the poverty-stricken home of her many siblings and mother by an aunt who had had the fortune to marry a wealthy man. The best-known of all American novels about nineteenth-century girlhood, Louisa May Alcott's *Little Women,* features a similarly benevolent but tyrannical maiden aunt, Aunt March, who provides her nieces with gifts and favors in return for their sedulous attention to her incessant demands.

Aunt March exemplifies the "maiden aunts" who for one reason or another did not marry and who remained members of natal families for life. In large wealthy families, such unmarried aunts are usually absorbed into the original family circle and passed on to the next generation as a sort of upper servant. These women act as baby sitters, chaperones or housekeepers, channels of gossip, and performers of small errands. The heroine of Jane Austen's *Persuasion* had settled into this role after her early disappointment in love before the beginning of the novel, though fate eventually endowed her with a home of her own.

Where there is money, women who are frozen in the daughter/sister role can be maintained indefinitely. Often, in Hispanic countries, we will slip into the role of *beata,* women informally devoted to religion, living in the bosom of our natal families where we make ourselves useful to others. Alternatively, the heroine of Edith Wharton's "The Old Maid" hid a more adventurous past under her spinsterish persona. Like the heroine of Sylvia Townsend Warner's *Lolly Willowes,* who reacts against the stereotypes of the maiden

aunt to become a witch, the life of a woman called an "old maid' might move into strange and convoluted directions in the struggle to throw off an identity imposed ruthlessly by a society that cannot see a woman outside of the family circle.

Finally in old age, the original bonds may reassert themselves. Divorced, widowed, and maiden sisters often come at last to a shared household.

Inheritance

Women who leave our natal families to take up our mature lives carry with us the emotional legacies of sibling and parental interaction. But we also have a more formal legacy defined through custom, law, and social institutions. The family is the recognized unit which bestows status, class, property rights, privilege, or position upon its members, whether biological or adopted. The determination of legitimacy is the first social characteristic that girls derive from our families. If the sexual relationships of our parents have followed a prescribed pattern of propriety, or if they have fulfilled a socially approved set of rituals governing formal adoption, daughters will usually be legitimately established—or confined—in that social place which our parents occupied before us.

The inheritance of social *status* may include legacies from both parents. Women may derive our citizenship in a modern state from either mother or father or both, depending on the laws set by the state. Jews, for example, inherit Jewish affiliation through the mother's line, and therefore the right to claim Israeli citizenship. In the United States, illegitimate children of a woman citizen inherit the mother's position. Often lower status or dependent status (slavery, serfdom, or noncitizenship) comes through the mother. Thus, in the American South, the children of slave women were born slaves, even if fathered by a man who became the president of the United States (as has been asserted in the case of Thomas Jefferson).

Sex is an important factor affecting inheritance among sisters and brothers. *Patrilineal* societies pass authority, property, and descent directly through the male line from father to son. *Matrilineal* societies sometimes pass authority and property through males, but descent passes through females; sometimes productive property passes from mothers to daughters. While matrilineal societies, such as the Native American Navajo and Iroquois and the African Bemba, tend to confer greater authority upon women than do patrilineal societies, observers have noted that these societies have a less rigid system of authority in general. Where extensive trade or manufacturing exists, matrilineal systems appear to vanish and even patrilineal systems are modified in favor of a *bilateral* system, allowing a child to inherit from both parents.

In capitalist societies, patterns of inheritance of property and position favor sons over daughters. Even in the simplest societies, where personal property

is restricted to a few effects that are buried with their possessor, the inheritance of parental skills or privileges will generally be apportioned according to a child's sex. And in socialist societies, which aim to reduce disparities of private property, it remains possible to inherit status or position informally. There, too, it is fairly clear that discrimination favors the male.

Commonly, a system that allows the passage of property to and through women is accompanied by the development of class and caste hierarchies with strict rules for controlling individual heirs, particularly females. Generally, women are admitted to the inheritance of our fathers and/or brothers only when strong measures exist to control our marriages and our sex lives in general. These societies are careful to enforce adultery laws against women, to link "honor" with virginity before marriage and fidelity after, and to endow fathers and brothers with strong coercive powers over the female members of their families (Goody, 1977).

Many societies have laws that restrict the leaving of property. These laws may recognize *primogeniture* (the passage of the patrimony to the first-born son), *entail* (the strict line of succession to property, usually through the oldest related male), and *coverture* (husband's complete control over his wife's property). The more wealthy and productive a society has been the more likely that a social hierarchy of class has formed which has caused women to lose position in a variety of ways.

The Sisterhood of Women

Our identities are formed by our relationships with our parents and siblings in the natal family. These identities are shaped by the tension of closeness and conflict and informed by the ideals of womanhood that the family accepts from the larger community. In this way, we receive two levels of self-consciousness from our childhood: our sense of womanliness and our sense of individuality. Our ability to accept our own identities with self-confidence in our mature life is largely dependent on the feeling that we have developed about other women.

Psychotherapist and political theorist Jane Flax (1980) sees a connection between the development of the feminine personality and a patriarchal society that devalues women. She implies that only a radical transformation of society can bring about changes in family relationships that now undermine the confidence of women and our sense of solidarity with one another. Flax, like Chodorow, notes that the mother functions as the first love object for all her children. Daughters, according to Flax, must suppress our desire for the mother and transfer our sexual feelings to the more powerful father, as society is currently organized. Failure to make the transfer results, as with sons, in a failure to achieve individual autonomy. Yet the identification with the father as an autonomous person, in comparison with the mother, creates

a conflict within women about our own identity. As daughters, we are trained to turn to the father as a source of autonomous identification, but we are also taught that we can never experience his autonomy except in a substantially vicarious manner.

The sibling situation often contributes an external conflict in a woman's development. Siblings of both sexes, of course, experience rivalry and competition with one another but the rivalry is more intense and has more permanent consequences when both rivals are women. Sisters are set to rival one another as well as our mothers for the love and attention of our fathers. Brothers are able to diffuse this rivalry in later life by choosing from a wide range of competitive possibilities, but these possibilities have generally been severely restricted among women.

According to Flax (1978), the rejection of the mother is responsible for the antifeminism of adult women. In such women, the turn to the father results in the effective heterosexual orientation which Freud saw as essential to maturity. But it leaves a legacy of rage and contempt for the mother, which in turn scars daughters as we attempt to work out our own adjustments to life. Nor can we turn to our sisters for support and comfort in the battle because their own maturity has too often depended on rivalry. Heterosexuality based on contempt for mothers and hatred of sisters alienates women; and such alienation is reinforced, according to this analysis, by threats of frigidity or homosexuality as the "penalty" for not winning the struggle for autonomy.

One of the challenges that women's studies must meet in the attempt to redefine women from the center of our own experience is the reconstruction of womanhood as a positive experience. A heterosexuality based on the rejection of mothers and sisters is an identity based on self-denigration and dependency. What kinds of people will women be when we can form our identities from a dual model of mother and father? We will certainly be less role-ridden when we choose to turn from the daughter to the mother role in life. Such a resolution to our conflict—the liberation of our mothers as payment for the liberation of ourselves—might bring all women to an experience of the underlying, universal sisterhood of women.

Many feminists believe that the struggles that now mark the relationships between daughters and mothers are a consequence of inflexible family sex and gender roles and the oppression of women. The differences observable among sisters in the same family point the way to possibilities for future change. The early slogan of women's liberation, "Sisterhood is powerful," sought to establish the bonds between women that male-oriented kinship and political structures have so often obscured. Through the agency of consciousness-raising, many women began painfully to reexamine the real histories of our lives to see how we had been damaged in our individual integrity and alienated from our sister women by false myths and oppositions. Most difficult of all, perhaps, is the effort to reach past the long and

painful barriers of age and experience and see our mothers at last as full members in the sisterhood of women. It is a task that all women must undertake to reach full appreciation of our own selves.

Shall we seek to write a new myth in which Helen and Clytemnestra are allies? Shall we see Electra join with her mother to avenge the death of her sister Iphigenia? Let us begin with the simplest of truths: Every woman is the daughter of another woman. Every mother is a daughter. All women are sisters.

Summary

Virtually no society expresses a preference for girl babies over boy babies. In some societies, the first decision to be made on the birth of daughters is whether we are to live at all. Female infanticide is a way of controlling the population on the basis of sex. In general, girl babies receive less careful treatment than boy babies, thus reducing the girls' chances for survival.

The devaluation of daughters has its roots in the low worth and value placed on woman's place in society at large. Warriors, for example, tend to be more highly valued than mothers. But daughters do provide valuable services to the family. We can be relied on more than sons to take care of our parents in their old age. We help to carry out the household tasks. Daughters also have intrinsic value in that we represent the reproducers of the next generation.

The names given to daughters indicate our place in the social scheme. Most societies are careful to distinguish the sex of the child by the name. Most surnames perpetuate the male lineage, reflecting a name, profession, or place of birth. In general, women have changed our surnames on marriage, but many women today keep our own names.

Daughters tend to identify with our mothers. Gender identity is thereby made easy, but the task of developing our own individuality becomes complicated. Mothers may inhibit this development by expecting daughters to be at home more than sons and to help with "women's work." In this way, daughters are socialized into accepting an established role model.

Mother-daughter relationships may be marked by conflict, especially in the case of daughters who want to break away from the patterns of the mothers' lives or who resent maternal dependency.

Our relationships with fathers are often tense and unstable. Girls often desire paternal approval, which makes us vulnerable to the training fathers give us to become socially desirable women. Father-daughter incest is the most commonly reported type of incest and may cause lasting trauma.

Families commonly discriminate among siblings on the basis of age-ranking. The first-born child enjoys certain responsibilities and privileges denied to later-born children. Certain personality characteristics, which have consequences in later life, also go with our birth order in a family.

Sisters are both opposites and companions. We may be rivals for our

parents' affection, but we also have close bonds with one another. Older sisters often provide role models and assistance for younger sisters.

Sex-ranking may nullify age-ranking. The rights and privileges of the oldest child may be cancelled if that child is a girl and a younger brother is born. Sisters and brothers are further differentiated by division of labor in the house. Our talents and ambitions are often subordinated to those of our brothers.

Age-ranking helps establish the type of relationship a sister and brother have. Older sisters are often cast in the role of "mother" to younger brothers, and older brothers play the role of protector of younger sisters.

The inheritance women can claim is qualified by custom and law. We inherit legitimacy and social status from our parents. Sex often determines legal inherited rights. Most societies favor sons over daughters in the inheritance of property and position. Even where rights may descend from either parent to any of the children, inheritance for women is often curtailed by custom or law.

Women who develop an autonomous self-image by transferring identity from the mother to the father often suffer a conflict about our identity as women. This is complicated by sibling rivalry. Antifeminism in adult women may stem from this rejection of the mother and hatred of the sister. Women need to examine our life histories for sources of alienation from the sisterhood of women.

Discussion Questions

1. Draw a chart illustrating naming patterns of all the members of your extended family. What conclusions can you draw?
2. What changes occurred in your own relationships to your mother and father as you were growing up?
3. Describe your relationships with your sisters and brothers. Are they satisfactory? If you could, how would you change them?
4. Inheritance practices usually favor boys and perpetuate class differences. Gives examples from your own experience.
5. Write a brief essay on the slogan "Sisterhood is powerful."

Recommended Readings

Special issues on mothers and daughters: *Feminist Studies* 6 (1978); *Frontiers* 3 (1978); and *Women's Studies* 6 (1979).

Davidson, Cathy N., and Broner, E.M., eds. *The Lost Tradition: Mothers and Daughters in Literature*. New York: Federick Ungar, 1980. An exploration of the theme of mothers and daughters in literature, including the myths

of ancient Greece, nineteenth and twentieth century writers, and the works of minority women. The book includes an excellent bibliography.

Joseph, Gloria I., and Lewis, Jill. *Common Differences: Conflicts in Black and White Feminist Perspectives*. Garden City, N.Y.: Doubleday, 1981. Section two of this book contains two chapters that deal with the authors' perspectives on growing up as a black daughter and a white daughter, the "messages" about life that mothers convey to their daughters, and the feminist issues involved in mother-daughter relations.

Stimpson, Kate. *Classnotes*. New York: New York Times, 1979. A novel about growing up in the fifties, life in a select women's college, and learning to discover one's own sexual preferences. The author is founding editor of *Signs: A Journal of Women in Culture and Society*.

Strouse, Jean. *Alice James: A Biography*. Boston: Houghton Mifflin, 1980. A psychohistorical study of the youngest child and only daughter in a nineteenth century family that included William and Henry James. Alice James fought to define herself in a family where it was a contradiction to be both a James and a girl. For the diary on which part of this study is based, see *The Diary of Alice James*, edited by Leon Edel. First published 1934. New York: Penguin, 1982.

Woolf, Virginia. *The Three Guineas*. 1938. New York: Harcourt, Brace, 1966. As an "educated gentleman's" daughter, Woolf presents a critique of the educated fathers and brothers who monopolize the ruling structures of the state, its government, educational establishments, and professions to the exclusion of daughters and sisters. Her footnotes present a feminist history of the English women of her class from the nineteenth century to her own day.

References

Alcott, Louisa M. *Little Women*. 1873. New York: Western, 1977.

Angelou, Maya. *I Know Why the Caged Bird Sings*. New York: Bantam, 1969.

Austen, Jane. *Mansfield Park*. 1814. Reprint. New York: Dutton, 1971.

———. *Persuasion*. 1818. Reprint. New York: Dutton, 1977.

———. *Pride and Prejudice*. 1813. Reprint. New York: Dell, 1959.

Blumberg, M. "Child Sexual Abuse: Ultimate in Maltreatment Syndrome." *New York State Journal of Medicine* 78 (1978):612–16.

Chodorow, Nancy. *The Reproduction of Mothering: Psychoanalysis and the Sociology of Gender*. Berkeley: University of California Press, 1978.

Coleman, Emily. "Infanticide in the Early Middle Ages." In *Women in Medieval Society*, edited by Susan Mosher Stuard. Philadelphia: University of Pennsylvania Press, 1976.

Colette, Sidonie-Gabrielle. *My Mother's House and Sido*. 1930. Trans. by Una Vincenzo and Enid McLead. New York: Farrar, Straus, and Giroux, 1953.

Dickemann, M. "Female Infanticide, Reproductive Strategies, and Social Stratification: A Preliminary Model." In *Evolutionary Biology and Social Behavior: An Anthropological Perspective,* edited by Napoleon Chagnon and William Irons. Duxbury, Maine: Duxbury, 1979.

Dinnerstein, Dorothy. *The Mermaid and the Minotaur: Sexual Arrangements and Human Malaise.* New York: Harper & Row, 1976

Divale, William, and Harris, Marvin. "Population, Warfare, and the Male Supremacist Complex." *American Anthropologist* 78 (1978):521–38.

Ember, Carol. "Feminine Task Assignment and Social Behavior of Boys." *Ethos* 2 (1973).

Feaver, Vicki. "Mothers and Daughters." *Times Literary Supplement* February 29, 1980.

Flax, Jane. "The Conflict Between Nurturance and Autonomy in Mother-Daughter Relationships and Within Feminism." *Feminist Studies* 4 (1978):178–89.

———. "Mother-Daughter Relationships: Psychodynamics, Politics and Philosophy." In *The Future of Difference*, edited by Hester Eisenstein and Alice Jardine. Boston: Hall, 1980.

Friday, Nancy. *My Mother/Myself: The Daughter's Search for Identity*. New York: Dell, 1978.

Gaskell, Elizabeth Cleghorn. *Wives and Daughters*. 1866. Reprint. New York: Penguin, 1969.

Glückel of Hamelin. *The Memoirs of Glückel of Hamelin*. 1690. Translated by Marvin Lowenthal. New York: Schocken, 1977.

Goitein, Solomon D. *A Mediterranean Society, the Jewish Communities of the Arab World as Portrayed in the Documents of the Cairo Geniza*. Volume 3. *The Family*. Berkeley: University of California Press, 1978.

Goody, Jack. *Production and Reproduction*. Cambridge, Eng.: Cambridge University Press, 1977.

Gutman, Herbert. *The Black Family in Slavery and Freedom, 1750–1925*. New York: Vintage, 1977.

Hunt, A.S., and Edgar, C.C. *Select Papyri I: Non-Literary Papyri, Private Affairs*. No. 105. Cambridge, Mass: Harvard University Press, 1932.

Jaccoma, Gail, and Denmark, Florence. "Boys or Girls: The Hows and Whys." Master's thesis, Hunter College. 1974.

Joseph, Gloria. "Black Mothers and Daughters: Their Roles and Functions in American Society." In *Common Differences: Conflicts in Black White Feminist Perspectives*, edited by Gloria Joseph and Jill Lewis. Garden City, N.Y.: Doubleday, 1981.

Kingston, Maxine Hong. "Reservations about China." *MS.* 7 (1978):67.

———. *The Woman Warrior*. New York: Random House, 1976.

Ladner, Joyce. *Tomorrow's Tormorrow The Black Woman*. Garden City, N.Y.: Doubleday, 1971.

Lewis, Michael. "Parents and Children: Sex-Role Development." *School Review* 80 (1972):229–40.

Moore, Honor. "My Grandmother Who Painted." in *The Writer on Her Work*, edited by Janet Sternburg. New York: Norton, 1980.

Petersen, Karen, and Wilson, J.J. *Women Artists: Recognition and Reappraisal from the Early Middle Ages to the Twentieth Century*. New York: Harper Colophon, 1976.

Pomeroy, Sarah B. *Goddesses, Whores, Wives, and Slaves: Women in Classical Antiquity.* New York: Schocken, 1975.

Russ, Joanna. *The Female Man.* New York: Bantam, 1975.

Stanton, Elizabeth Cady. *Eighty Years and More.* 1898. Reprint. New York: Schocken, 1971.

Sutton-Smith, Brian, and Rosenberg, Benjamin G. *The Sibling.* New York: Holt, Rinehart, & Winston, 1970.

Trexler, Richard. "The Foundlings of Florence, 1395–1455." *History of Childhood Quarterly: The Journal of Psychohistory* 1 (1973): 259–84.

Warner, Sylvia Townsend. *Lolly Willowes.* Chicago: Academy Chicago, 1979.

Washington, Mary Helen. *Black-Eyed Susan: Classic Stories by and about Black Women.* Garden City, N.Y.: Doubleday, 1975.

Weitzel, M. "Clinical Management of Father-Daughter Incest." *American Journal of Diseases of Children* 132 (1978):127–30.

West, Jessamyn. *The Woman Said Yes.* New York: Harcourt, Brace, 1976.

Wharton, Edith. "The Old Maid." In *Old New York.* 1924. Reprint. New York: Berkeley, 1981.

Williamson, Nancy E. "Sex Preferences, Sex Control and the Status of Women." *Signs* 1 (1976):847–62.

Woolf, Virginia. *A Room of One's Own.* 1929. New York: Harcourt, Brace, 1957.

———. *Three Guineas.* 1938. New York: Harcourt, Brace, 1963.

Young, Michael, and Wilmot, Peter. *Family and Kinship in East London.* London: Routledge & Kegan Paul, 1957.

7

Wives

WHY MARRIAGE?
Reproduction
Minimizing Male Rivalry and Cementing Male Alliances
Reducing Competition Between Women and Men
Personal Reasons

SELECTING A MATE
Society Chooses
Families Choose
Women Choose

MARRYING
Types of Marriage
The Coming of Marriageable Age
The Rite of Passage
The Wedding Night

THE MARITAL HOUSEHOLD
Family Politics
Extramarital Affairs

DIVORCE

WIDOWHOOD

FEMINIST OPTIONS

When the authors of this book discussed what should be said about marriage, we began considering our own personal perspectives. We discovered that we had all been wives at least once in our lives (and sometimes more than once). Then we discovered that nearly everything we had to say about marriage as an *institution* was critical, even negative. Marriage appeared to us the institutional expression of "women's place." We saw that a complex fabric of myth and tradition, social and economic sanctions, religious precepts, and legal coercion has been woven to keep women, as wives, in our "place." Is this why we had married, stayed married, or married again? We felt reluctant to agree to that. Is there more to marriage than social pressure? Many feminists have tried to envision other ways of being "married" than the more oppressive conventions of the past. But to see where we might go, and how far that is, we must look at where we have come from. That is the subject of this chapter.

246

Why Marriage?

What is marriage for? Social scientists usually explain the institution of marriage in functional terms. The many different kinds of functions ascribed to marriage can probably be reduced to two: it is a solution to the problem of male commitment to female-male interdependence in reproduction; and it is a way of minimizing male rivalry for females and providing a means of cementing male alliances. A third function, that of reducing potential competition between women and men by assigning them complementary and unequal social roles, has been less frequently explored, but will be considered here as well.

Reproduction

Marriage is understood as joining together a woman and a man, most frequently for the explicit purpose of rearing children. Humans are not the only species of animals that have stable female-male bonding. Anthropologists Carol Ember and Melvin Ember (1979) studied a large sample of other species of mammals and birds which also engage in long-term female-male bonding and discovered that stable mating was most likely to be found among species in which females could not simultaneously feed themselves and their young, thus requiring another to provide food for the mother. They concluded that this sort of bonding helps ensure reliable care of the young during that early dependency period.

Males in general, it is speculated, cannot be relied upon to cooperate in the care of offspring unless they are certain that these offspring are their own (Wilson, 1975). This accounts, according to some explanations, for the existence of tight social constraints on the sexual relations of wives. The risk of pregnancy by a man other than the husband is eliminated by prohibiting wives from engaging in sexual intercourse with other men. The reproductive function of marriage also explains why marriage nearly always joins a member of one sex to another (though there are exceptions);[1] why sexual intercourse is part of marriage and necessary for its consummation; and why one reason (sometimes viewed as the only legitimate reason) for husbands' repudiation of wives is our inability or unwillingness to bear children. Finally, where inheritance through the male line is practiced, marriage legitimates a wife's children's claim to their father's property, titles, rights, or group membership.

Do women need men to help us rear our children? This depends, of course, on the circumstances. If society denies us the kinds of jobs which pay enough to enable us to support ourselves and our children, or if society denies us the

1. Some societies approve of female-female marriages under particular conditions. In these cases, one woman assumes the legal and social roles of husband and father, while the spouse acts as wife and mother (O'Brien, 1977).

training and education we need to obtain such jobs—and also discriminates against children born "out of wedlock" at the same time it provides no means of avoiding pregnancy—a woman may well *need* a husband. But these facts do not always apply. Among a number of West African societies, for example, women are expected to provide subsistence for ourselves and our children, and these women have the means (resources and training) to do so. Furthermore, during wars, many societies undergo long periods in which most of the men are absent and nonproductive, and women manage to support ourselves and our children. And yet, marriage persists and prevails in these societies as well. Why?

Perhaps the "reproductive" purpose of marriage in this functional analysis is not so much to ensure women a source of support for ourselves and dependent children as to provide a man with a claim on a woman's children. By becoming a husband and making a woman "his" wife, a man guarantees for himself whatever rights a society confers over the woman's children. Thus, while the children may have a right to inherit from him, for example, he may have a right to control them, to command their labor, or to dispose of them as he pleases.

Minimizing Male Rivalry and Cementing Male Alliances

In any society, some of the things people want are scarce, and therefore people compete for them. Marriage has been seen as functioning to reduce competition between men, or to help them to keep peace by means of cooperative agreements. It has been suggested, for example, that marriage reduces rivalry between males over women by assigning women to individual men; social rules enforce (with greater or lesser effectiveness) men's agreements to avoid sexual relations with one another's wives (Ember and Ember 1981:333).

Marriage has also served in many societies as an institutional means of forming or cementing political alliances between groups of men. That is, men offer their sisters and daughters to one another as part of a formal "mutual aid" agreement. In societies where warfare is rife, "marry out or be killed out" may be the only options available (Tylor, 1889). Marriage has regularly been used through history by royal families to create alliances, and it has been used by other families to protect and extend property and to develop allies of various kinds. The politics of marital exchange of women, however, are largely male business. The institution of marriage when used as a political device clearly reduces women to objects of exchange (Lévi-Strauss, 1969).

Reducing Competition Between Women and Men

The institution of marriage has generally been characterized by two complementary but unequal roles: wife and husband. Each role is assigned its own sphere of rights and obligations, activities, and patterns of behavior. By separating the social functons assigned to adults on the basis of a marital

> **The Christian View of Monogamy** Box 7.1
> And [Jesus] answered and said Have ye not read, that he which made
> them at the beginning made them male and female, and said, For this
> cause shall a man leave father and mother and shall cleave to his wife:
> and the twain shall be one flesh? Wherefore they are no more twain, but
> one flesh. What therefore God hath joined together, let not man put
> asunder. . . . Whosoever shall put away his wife, except it be for fornica-
> tion, and shall marry another, committeth adultery: and who marrieth
> her which is put away doth commit adultery. (Matthew 19:4–6;9)

contract between a wife and a husband, society tends to eliminate competi-
tion between women and men for the same social rewards. Wives often make
important decisions that affect daily life, but we more often do not compete
with our husbands' authority in the household—at least directly—and thus
do not challenge male dominance. Indeed, wifehood in some societies elimi-
nates a woman from consideration as an independent adult for serious deci-
sion-making purposes.

Wives' duties to care for home and children tend to keep us out of the
public sphere, hence to reduce or eliminate our ability to compete for prestige
or influence over public decisions of the sorts assigned to men. That leaves to
men the competition for public power. Domestic maintenance roles assigned
to wives also provide for continuity in the care of males from childhood
through adulthood: wives take over where mothers leave off. Thus, husbands
are—in principle—free to act in the public sphere (engage in warfare or
politics) even after they have had children, while wives are tied to domestic
duties even before we have given birth. Wives who are daily engaged in work
that goes beyond household duties undertake that work as an additional, not
a substitute burden (see chapters 13 and 14).

The institution of marriage and the role of "wife" are intimately con-
nected with the subordination of women in society in general. It is the
constraints on women to engage freely in various social activities, whether
in sexual intercourse, economic exchanges, politics, or war, that make us
"dependent" on men, that oblige us to become "wives." By marrying,
women enter into contracts by which we gain protection from sexual moles-
tation by men other than our husbands (and lose our freedom to engage in
sexual relationships with other men if we so choose); we gain a right to our
husbands' economic support (and undertake an obligation to provide for
their domestic support and comfort); and we gain a claim on their posses-
sions and rights for our children (and accept their right to control and
dispose of them as they wish). On balance, it would appear, that husbands
gain much more than wives. They not only gain domestic servants, sexual

Monogamous Marriage as Economic Exploitation Box 7.2

The first class opposition that appears in history coincides with the development of the antagonism between man and woman in monogamous marriage, and the first class oppression with that of the female sex by the male. Monogamy was a great historical step forward; nevertheless, together with slavery and private wealth, it opens the period that has lasted until today in which every step forward is also relatively a step backward, in which prosperity and development for some is won through the misery and frustration of others. It is the cellular form of civilized society in which the nature of the oppositions and contradictions fully active in that society can already be studied. (Engels, 1884, 1972:129)

companions, and producers of children but also political assets, instruments for acquiring allies.

Personal Reasons

Generally, however, women share some personal motivations in getting married. First, young women find that "adult" status can often only be achieved (or recognized) through marriage. That is, it is only when we are wives that we are seen as entitled to have homes of our own, the benefits of motherhood, and some degree of control over matters falling into "women's domain." Second, many women seek social and financial security and success through marriage. Most young women believe (and rightly so, under present conditions) that we will have higher status and a more statisfactory social life—in conventional terms—if we secure the "right" husband. Finally, women are motivated by a desire for emotional as well as sexual intimacy. Traditionally, societies have not condoned this outside of the institution of marriage. Even today, many women need the commitment of marriage in order to feel truly intimate with our mates.

Today in the United States, as elsewhere, many women are economically independent, and increasing numbers are choosing not to have children. Laws give protection to women with or without children, and political alliances are hardly an issue for most of us. Many mothers have supported and cared for our young without the assistance of men; in spite of this, the institution of marriage continues. Why?

It seems to us that the various theories that have been put forth to explain marriage fail to address the emotional and psychological reasons that motivate women and men to marry. One plausible explanation, for example, is that people seek to recreate the family and home environment of their childhood dreams. Individuals need love and intimacy and sharing. Marriage can provide one framework within which this can be achieved. A commitment to

build a life together fulfills many personal needs; and marriage takes on importance to many women and men as a symbol of that commitment. What we are analyzing here, however, is not the bonding of two individuals and the rewards that may bring, but the institution of marriage and the role of wifehood. Indeed, the social roles and expectations for wife and husband may impede the mutuality of the bonds.

The above generalizations and the functional theories that have been applied to the analysis of marriage as an institution and to the role of "wife" also fail to deal with issue of *class*. We will try in some of the examples provided in this chapter to begin to address the complications added by this issue. There is, further, an implication of *passivity* that fails to accord with what we have begun to learn about women's history, and certainly what we know about women's lives today. Women have been constrained by the role of "wife," but we also have interpreted that role in active ways. We have acted as economic and psychological partners despite legal definitions to the contrary; we have even taken the leading part in some relationships. Because we cannot yet recapture the past in the detail that would allow us to make better generalizations, we can only note that systematic subordination of women in the role of "wife" most closely describes what we do know and await further research to tell us more.

Selecting a Mate

Most women grow up expecting to become wives. The only question is, therefore, whose wife? Until recently, most women had little freedom in making this choice. Social customs narrow the range of alternatives even when, ideally, we are presumed to make the choice ourselves. In many societies, the families of prospective brides and grooms play active roles in making choices for them.

Society Chooses

Every society has a set of prescriptions and constraints governing the selection of mates among its members. Almost universally, a woman's recognized or acceptable choice is limited to men. Furthermore, most societies practice some degree of formal or informal *endogamy* (marrying "within"), that is, a woman's prospective mate should come from the same ethnic, racial, religious, educational and/or economic background. In some cases, a custom of endogamy may be enforced by informal sanctions, such as social disapproval of marriage to an "outsider" or refusal of family and friends to accept a husband or wife from the "wrong" class. Sometimes religious or legal prohibitions enforce endogamy. For example, both a priest and a rabbi may refuse to perform a marriage between a Catholic and a Jew. In Egypt, the law forbids a Muslim woman to marry a non-Muslim (but no such ban is im-

Marriage in the English Common Law Box 7.3

By marriage, the husband and wife are one person in law; that is, the very
being or legal existence of the woman is suspended during the marriage,
or at least is incorporated and consolidated into that of the husband;
under whose wing, protection, and cover, she performs everything. . . .
Upon this principle, of an union of person in husband and wife, depend
almost all the legal rights, duties and disabilities that either of them
acquire by the marriage. . . . A man cannot grant anything to his wife, or
enter into covenant with her, for the grant would be to suppose her
separate existence. . . . The husband is bound to provide his wife with
necessaries by law, as much as himself: and if she contracts debts for
them, he is obliged to pay them; but for anything besides necessaries he is
not chargeable. . . If the wife be indebted before marriage, the husband is
bound afterward to pay the debt; for he has adopted her and her circum-
stances together. . . . These are the chief legal effects of marriage during
the coverture; upon which we may observe that even the disabilities,
which the wife lies under, are for the most part intended for her protec-
tion and benefit. So great a favourite is the female sex of the laws of
England.

(William Blackstone (1723–1780), *Commentaries on
the Laws of England, in Beard, 1946:89*)

posed on men). South Africa by law forbids interracial marriage, as did many
of our own Southern states until 1967.

Endogamous customs in many societies involve preferential mating be-
tween kin. That is to say, a person should try to find a spouse from among
cousins. Margaret Mitchell's novel *Gone With the Wind* (1974), first pub-
lished in 1936, illustrates this marriage pattern among some of the nine-
teenth-century slave-owning planter class in the American South. The
daughters and sons of the Hamiltons and Wilkeses were always supposed to
marry one another. Scarlet O'Hara was unable to marry Ashley Wilkes be-
cause he was destined to marry his cousin Melanie Hamilton. When Scarlett
succeeded in breaking tradition by marrying Charlie Hamilton, India Wilkes
lost her intended groom.

No society allows pairing to take place within relationships classed as
incestuous. Sometimes this prohibition includes first cousins; sometimes the
circle of prohibited mates is even wider. For example, in the early Middle
Ages, the European incest prohibition came to include in-laws, on the Chris-
tian principle that marriage makes two people one flesh (see Box 7.1). Yet
other rules of *exogamy,* or "marrying out," apply in many societies, where
people must find mates from a different lineage, clan, or village.

As a result of endogamous and exogamous rules, the available choices for

mates may be few indeed. In a small, rural society, it may be difficult to find a suitable mate, not to mention an attractive or compatible one. But such strict rules and the problems they create tend to break down somewhat in large, complex urban situations, where young people encounter a wider range of choices. However, even in a society as presumably open, mobile, and large as our own, we feel the pressure of customary constraints. Surely we are all familiar with cases of "inappropriate" marriages, where sisters or friends have married outside of the religion or ethnic group or even age group, and encountered social disapproval. Whether we subscribe consciously to such rules or not, most of us do marry within the "right" social categories: someone not too closely related, but from the same social and often even the same geographical background.

Families Choose

In most societies, women's marriages are a matter of concern to all our relatives, particularly when they involve complex negotiations and economic settlements. The determination of our destinies in this context is part of an overall family strategy to ensure the well-being and advantage of our kin groups (Lévi-Strauss, 1969). Sometimes the partners of the future marriage are consulted, and occasionally some allowance is made for real repugnance on the part of one or another party, or for some "unforgivable" breach (such as the girl's loss of virginity). But parental or familial interests are primary, and young women may be subjected to intense persuasion and even physical coercion to bend us to the judgments of our elders. Where "arranged marriage" is customary (and this is very widespread), young women and men generally are informed of the arrangement after it has been made and cannot be easily undone. The preferences of the prospective couple are not thought to be relevant. When the husband of one of the authors of this book told his Indian associate that he was about to be married, the associate offered effusive congratulations. Then he asked, as an afterthought, "And has a bride been selected for you yet?"

In some societies, marriage arrangements are helped along by intermediaries or professional matchmakers. The matchmaker may initiate the entire arrangement by undertaking to find a suitable mate for an individual from her pool of clients. This is vividly illustrated in Sholem Aleichem's story "Tevye the Milkman," on which was based the play *Fiddler on the Roof.* Although everyone in the Russian *shtetl* (Jewish village) knows everyone else, it is unseemly for families to approach one another directly. Rather, the groom or his family goes to the matchmaker for help in approaching a young woman's parents concerning the delicate issue of the daughter's marriage. Matchmaking may even be carried on over long distances, as in the matching of Chinese men who had emigrated to America with "picture brides" from China, described in Maxine Hong Kingston's *The Woman Warrior* (1976).

Contemporary dating services perform an analogous function for young "singles" in many American cities, using computers and video equipment to bring suitable couples together, with (they claim) a minimum of embarrassment or chance of disappointment.

Use of an intermediary also minimizes the risk of conflict in resolving different expectations and protects the dignity of both parties from the humiliation of a "jilt" or the damage of a breach-of-promise suit. Traditional intermediaries or matchmakers sometimes help families to negotiate customary marriage settlements—gifts of goods, money, or land between the families of the bride and groom which are part of the marital agreement.

Marriage settlements have several rationales. They are sometimes viewed as compensation to the bride's family for the loss of the woman's labor (bride price) or, conversely, as compensation to the groom's family for assuming responsibility for the bride's support (dowry). Sometimes they are seen as a deterrent to divorce—the groom is reluctant to return the dowry, or the bride's parents are reluctant to return the bride price, on which the marriage is contingent, so the families pressure the couple to work things out. Finally, the goods, money, or land may be used as capital to start a new household for the couple.

The financial, legal, and political aspects of marriage agreements tend to be drawn up by men, often with the assistance of male agents or lawyers or male-aligned female matchmakers. But it is rare that a girl's mother does not also participate in the arrangement of the daughter's future. For example, Lawrence Rosen observed a Moroccan father in the process of closing a bargain with another chieftain. Veiled and discreet, not venturing beyond the modest bounds set by Islam, the mother undertook to interject herself into the negotiation. In effect, the husband took over the responsibility for securing a sound financial and political settlement, while the mother raised her voice for the personal preference and satisfaction of the daughter. After a lengthy and convoluted conversation, a negotiated compromise finally determined the ultimate choice of the mutual son-in-law (Rosen, 1978).

Women Choose

In most traditional societies, the choice of whether, when, or whom to marry was not ours to make, at least not by ourselves. In modern, complex urban societies for women of legal age, it is ideally the reverse. As we have seen, however, complete freedom of choice is something of an illusion. Society in general, and families in particular, apply subtle (and often not-so-subtle) pressures to induce us to marry and to constrain the kinds of husbands we choose. But even within the constraints of class, religion, ethnicity, race, and similar considerations, a choice must be made. How do we choose?

The popular Western belief is that marriage should be made for love. Romantic love has often been viewed as the antithesis of family loyalty. At

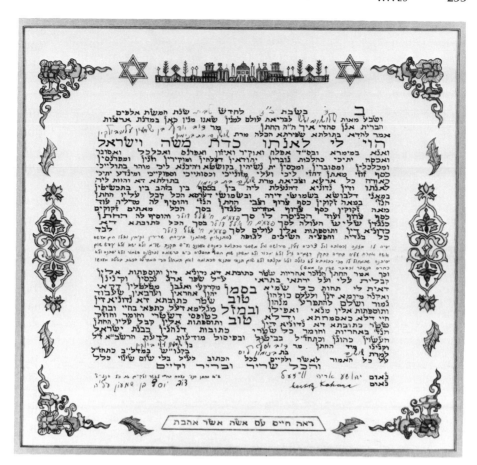

The text of the *ketuba*, or standard Jewish marriage contract, dates to the second century B.C. and is written in Aramaic. Jewish law requires that every Jewish bride be given one. It assures the married woman that her husband will take care of her, provide for and cherish her, and specifies the financial support due to her if he dies or divorces her. The one shown here was prepared for Susan Lees, one of the authors of this text, by her parents.

the end of the sixteenth century, Shakespeare captured this sentiment in *Romeo and Juliet*. A modern musical adaptation of this dramatic tale, Leonard Bernstein's *West Side Story*, expresses the same tragic tension between two kinds of bonds. Despite the appeal of this age-old conflict to writers of fiction, if and when it occurs in reality, it is usually resolved in far more mundane ways.

Carol Stack (1975), for example, tells the story of Ruby, a black woman, who lived in an American urban ghetto. Here, a woman's relatives expected constant favors from one another, often at the expense of her responsibilities (real or imagined) to her husband and her home. To safeguard her projected

Jewish marriage contracts have traditionally been objects of artistic expression. Here, artist Lore J. Lees is shown as she decorates her daughter's contract.

marriage, Ruby knew she would have to move with her husband to another town. But she hesitated and finally returned to her kin network because she feared the loss of strength and support she herself received from them.

But most families encourage the ideal of marriage for love, especially to a suitable partner. Widespread acceptance of the idea of love *before* marriage and as the primary basis of choice of partners, however, is a rather recent phenomenon. Less than a hundred years ago, the desire of women to love whom we pleased appeared as a sort of rebellion against fate.

Emma Goldman, an American anarchist leader and proponent of free love, expressed this attitude in the following description of a scene from her adolescence in early-twentieth-century tsarist Russia. "I had protested [the marriage arranged by her father], begging to be permitted to continue my studies. In his frenzy, he threw my French grammar into the fire, shouting: 'Girls do not have to learn much! All a Jewish daughter needs to know is how to prepare gefüllte fish, cut noodles fine, and give a man plenty of children.' I would not listen to his schemes; I wanted to study, to know life, to travel. Besides, I would never marry for anything but love, I stoutly maintained" (Goldman, 1970:12).

For many women, the quest for freedom of choice in making a marriage may well lead us back into the maze of cultural demands and social pressures from which we had sought escape. As young women, we have often spent our time

The ceremonies attached to the wedding ritual are steeped in cultural and religious symbolism. Married Yörük women are distinguished from unmarried women by headgear and jewelry. When marrying at about seventeen years, women of this group discard the ordinary scarf worn since puberty and put on a cap and a large colorful scarf. On forehead and neck, married women also wear the gold coins presented by the husband's family. These gold coins belong solely to the wife and are not wealth to be shared with the husband. (Photo by Daniel G. Bates, 1969)

grooming ourselves to fit the description of the "ideal" wife. We study what men want and like and try to conform as closely as possible to the conflicting images which guide us—in modern times, in the pages of magazines, in motion pictures, or in television advertising. For some women, wifehood is a career. Even if we consider it only a possibility, we may think twice before undertaking work or studies which we imagine will interfere with marriage. Women today are often not much freer than our predecessors and our contemporaries elsewhere in the world from the informal social and familial pressures that drive many of us into marriages that benefit others far more than ourselves. Only women who have carefully and realistically assessed our own goals, priorities, and capacities are in a position to choose whether to marry and what kind of mate is suitable to that scheme. Even then, if we are mistaken about what we want, or about what we value, we may end up as badly

The Marriage of Catherine of Aragon: I Box 7.4A

In the early sixteenth century, Ferdinand of Aragon [Spain] and Henry VII of England decided to form a political alliance against France. To ensure the continuation of the alliance, they agreed that Ferdinand's daughter Catherine would marry Henry's son Arthur. Accordingly, ambassadors traveled back and forth between England and Spain and finally agreed on a marriage contract. They settled how much Catherine would bring from Spain and in what installments it would be paid. The endowments her husband would bring to the marriage were matched to this contribution. Everyone agreed about how much would be controlled by Henry and how much would be available to Catherine herself.

(Boxes 7.4A–I are based on
Mattingly, 1960;
Neale, 1957; and Scarisbrick, 1970.)

disappointed as any woman forced into an unwanted marriage. This is a theme explored by a number of women novelists, a notable example being George Eliot, in her nineteenth-century novel *Middlemarch*.

Marrying

A marriage may take years in the making. Family negotiations may be lengthy and subject to many changes. The couple may spend years in courtship, particularly if the union is subject to economic or social barriers. They may try out a period of premarital cohabitation. In some societies, a marriage is not considered complete until a child is born. Some couples privately regard their marriages as in a constant state of being made, subject to failure or dissolution at any moment. But for most people it is the wedding that commences the marriage.

Types of Marriage

In our society, a woman may have only one legal husband at a time. *Polygamy* (marrying more than one spouse) is illegal for both women and men. In a few societies, a woman may be wed to more than one husband, a system called *polyandry*. The best-known cases usually involve brothers sharing a limited number of women among themselves, as in Tibet or in ancient Britain.

Polygyny, where women share husbands with one or more other wives, is a relatively more common cultural institution. However, while it may be an ideal form of marriage among some peoples, usually only a small, wealthy minority actually achieve polygynous households. For men, there are a number of advantages in polygyny. In many African societies, for example, where women are important producers of wealth, a man can increase his income

The Marriage of Catherine of Aragon: II Box 7.4B

Catherine was brought as a very young girl to England and married there to Arthur, whom she had never seen before. Arthur died before the marriage was consummated (or so Catherine later testified). Although she had lived for some years as his official wife, she had never shared a household with her young husband. All the marriage arrangements had been carried on with suitable pomp by royal ambassadors—with an exchange of pictures and carefully worded messages sent between the families.

and social standing by acquiring several wives. Futhermore, where marriage is used to create political alliances, multiple marriages can extend the range of a man's allies. Thus, it has been customary in many Asian, African, and Middle Eastern societies for the aristocracy, particularly the royal families, to consolidate alliances with both equals and followers by multiple marriages. The royal family of Saudi Arabia today provides a good example (Cole, 1977).

The advantages of polygyny for women are not so readily apparent, although we shall discuss some later in the chapter. In some cases, wives resist the taking of a second wife. In their daughters' marriage contracts, many Muslims include a promise from the husband not to marry a second wife. However, where *sororal* polygyny (two or more sisters marrying one man) is practiced, wives may welcome the company and help of sisters as co-wives. *Levirate* marriage, in which women marry a dead husband's brother, may be viewed as a form of protection for women, as illustrated in the biblical story of Ruth. According to the Babylonian Talmud, a dead man's eldest brother (or next of kin), even if married already, is obliged to marry the widow. From the male perspective, the purpose is to provide the dead man officially with children to carry on his name in Israel. From the female perspective, such a marriage maintains a woman's status in society. Thus, Ruth, with the help of her mother-in-law Naomi, was able to call upon her dead husband's kinsman Boas to marry her. In Israel today, and among all orthodox Jews, widows without sons must obtain a rabbinical divorce (*get*) from our late husbands' brothers or nearest male kin before we can remarry.

While officially sanctioned, polygyny tends to be limited to the wealthy; unofficial polygyny is nonetheless sometimes practiced among the poor in modern, urban societies. Juan Sanchez, described by Oscar Lewis (1969), supported three common-law wives and their children by him in different neighborhoods of Mexico City. It took years for them to learn about one another's existence.

Monogamy is the most common form of marriage in any class or society,

> **The Marriage of Catherine of Aragon: III** Box 7.4C
>
> When young Arthur died, King Ferdinand wanted his daughter back, and
> he wanted the money he had already paid in installments to come back
> with her. Henry VII was unwilling to give up his Spanish daughter-in-law.
> To prevent Ferdinand from seeking a different political/marital alliance,
> he opened negotiations to marry Princess Catherine to his next son but
> did not press them very effectively. He was unwilling to give up her
> dowry; indeed, he pressed for its payment in full. Catherine herself com-
> plained repeatedly that she was willing to stay as a widow or go home as
> a maid, but she wanted the jewelry and financial support to which her
> marriage contract entitled her.

whatever the social or legal ideal. In Western society, it has been the ideal
since Roman times and is reflected in the general conception of marriage as a
dual partnership. Couples are said to be joined "till death do us part."
However, despite long efforts to legislate otherwise, most societies (including
our own), condone a considerable degree of *serial monogamy,* successive
marriages interrupted by widowhood or divorce.

The Coming of Marriageable Age

A woman may marry at any age. The prevalence of serial monogamy means
that many women are likely to make more than one marriage in the course of
a lifetime, particularly in societies with a high death rate. Our first marriages
are likely to take place when we are fairly young, to men our own age or
perhaps considerably older. Later in life, we may end up marrying men
considerably our juniors.

In some societies, the process of contracting marriage may begin at a girl's
birth, but further action will probably be delayed until puberty, at an age that
is arbitrarily fixed by law or custom. Over two thousand years ago, Xeno-
phon, speaking for the ancient Athenians, placed the ideal age for a bride
roughly at fourteen years. In Europe in the Middle Ages, twelve years was
fixed as the legal majority of girls. Even today, in places ranging from the
Muslim world to the rural United States, it is not uncommon to regard
menarche as making a girl marriageable. For example, in her autobiography
The Coalminer's Daughter (1977), country and western singer Loretta Lynn
recalls her own experiences as a bride in her early teens.

The age of first marriage for girls throughout the world is most commonly
between fifteen and eighteen. As far back as the eighth or ninth century,
however, Western Europe has been an exception to this general pattern, both
women and men marrying later than have people of Eastern Europe or in the
rest of the world (Hajnal, 1965). It is probable that the custom of later

The Marriage of Catherine of Aragon: IV **Box 7.4D**

Catherine's lonely struggle in a far-off land to secure her dowry, her dignity, and her person was ended at last by the death of her father-in-law, Henry VII. Her handsome and tempestuous brother-in-law, who now became Henry VIII, defied the church's incest taboo against marrying a brother's wife and bore all before him in asking the princess to be his wife. The pope gave him a dispensation; his subjects bowed to his royal will; and Catherine agreed to be his queen in the name of Spain. She married him. She always said that she married him because she loved him. But she did not live happily ever after.

marriage contributed greatly to the Western tendency to emphasize the ideal of individual preference in mating. Today, in societies that open educational and career opportunities to women, the average age of marriage also tends to rise (Goode, 1963).

Older brides have more opportunity for personal choices and the emotional maturity to make that choice. To some extent, this maturity helps balance the influence of the particular desires of the bridegroom. In modern Egypt, young men desiring to be supported or to find lodging have advertised publicly to find employed or widowed women as wives. In polygynous situations, a young man may often wish to start with an older woman in order to delay the responsibilities of fatherhood and provide an experienced woman to direct the younger wives he expects to add to the household. Khadijah, the first wife of the prophet Muhammed (570–632), was over forty when she married him (he was about twenty-five). A later wife, Aisha, was so young (eight to nine) that she went to her husband's house with her dolls (Walther, 1981).

The Rite of Passage

For women, the first marriage has traditionally been the most significant rite of passage in life. The wedding ceremony has not only marked the community's recognition of the establishment of a new union but has also symbolized the passage of a woman from girlhood to womanhood. With this change of status may come new modes of behavior and dress and acquisition of a new home, new relatives, and new responsibilities. In our society, a woman's identity shift from the premarital to the married state is so complete that it is traditionally marked by a complete change of name: Miss Mary Smith becomes Mrs. George Jones. These profound changes of status and identity upon marriage for a woman have no parallel for a man, although men also participate in the marital rite of passage.

Because a wedding signifies such an important and far-reaching change in

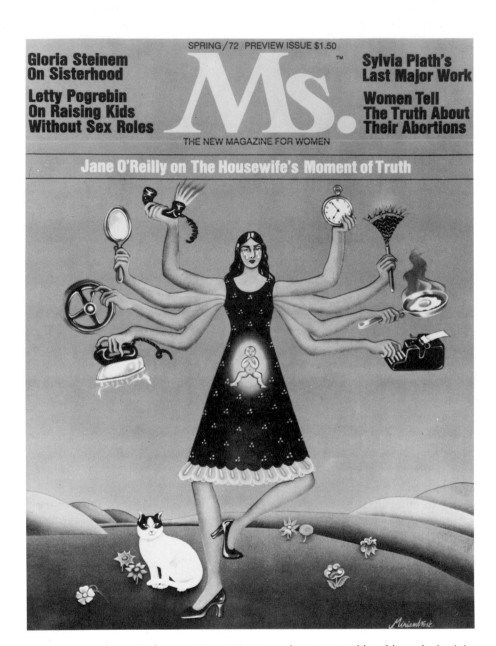

MS. Magazine has raised women's consciousness about our world and brought feminist thinking to hundreds of thousands of women. Here a *Ms.* cover illustration for spring 1972 graphically captured the sense of unending tasks and occupations expected of wives. (Courtesy of *Ms.*)

The Marriage of Catherine of Aragon: V **Box 7.4E**

Catherine had been bedded with the young Arthur to symbolize their wedding, although they were separated thereafter as too young for marriage. During the night, the boy had called out to his attendants, laughing, "Gentlemen, this night I have been in Spain!" Years later, witnesses recalled such "snippets of coarse bravado heard from Arthur's lips" during divorce proceedings instituted against her by Henry VIII (Scarisbrick, 1970:189). But the queen stood sturdily forth in the hostile courtroom and fixed her husband with a steady gaze saying, "And when you had me at the first . . . I was a true maid, without touch of a man." (Mattingly, 1960:272–73). Henry sat silent and did not refute her word.

the status of women, the ceremonies which are central to the wedding ritual are often rich in religious and social symbolism. Some societies dramatize wives' new relationships to our husbands with a ritual capture of the bride. Eskimos cheer enthusiastically when brides put up really convincing struggles against ardent grooms before finally submitting to being carried away to the new home (Freuchen, 1961). Our custom of having the groom carry the bride over the threshhold of the new home has been interpreted as a holdover from earlier bride-capture rituals. Notably, it is not customary in our case for the bride to display any resistance!

In some societies, the centerpiece of the marriage is the symbolic surrender of authority over a woman by the bride's family to the groom. In traditional American weddings, for example, the father (or his equivalent) "gives away the bride." The wedding may also contain a symbol of the couple's consent, as in joining of hands or the lifting of the veil, enabling the couple to see and accept each other for the first time. The bride and groom exchange vows and seal the ceremony with a ring and a kiss. An exchange of rings originally signified the exchange of property previously negotiated in the contract. In this century, it is rapidly becoming recognized as a symbol of the equal nature of the couple's commitment. In modern nations, the final seal is the pronouncement that the state recognizes the couple as "husband and wife." If they want to separate after that, they will have to go to court and get a release.

Weddings are rarely a private matter between bride and groom. Not only the state, but kin and community participate in the legitimizing of a union. Thus, elopements entail both defiance of the couple's (or at least the bride's) parents and denial of a communal celebration. Wedding celebrations usually involve elaborate feasting to mark the event. Those who participate directly, and even friends and relatives from far away, are expected to join in the ritual formation of a new union by contributing gifts, as well as the bride's

The Marriage of Catherine of Aragon: VI Box 7.4F

For many years, Henry VIII advertised himself as a model husband. Although he told his second wife, Anne Boleyn, that she would have to learn to put up with his infidelities as "her betters had before her," he had actually been fairly discreet while married to Catherine. At tournaments he styled himself "the knight of the faithful heart." When he was out of the country, he never hesitated to leave Queen Catherine as his regent, though he made a great display of anger when he returned home from an unsuccessful war against France to find that in his absence his wife had conducted a very successful campaign against Scotland. Even in the last years of their marriage, when he was struggling against the whole world to rid himself of her, Henry VIII sought his domestic comforts in Catherine's boudoir, soothing himself with the food she knew how to order to his liking and the comfort of her conversation.

trousseau. In this way, the wedding becomes an opportunity for a whole community to demonstrate various relationships to bride and groom, to vie for prestige, and to enjoy a fine show. Generally, the higher the status of the couple, the more spectacular the performance becomes. Modern urban civilization has not altered this point, as the wedding of Great Britain's Prince Charles and Lady Diana in 1981 reminded us.

The Wedding Night

The existence of premarital sex (whether or not a couple chooses to engage in it) is so accepted in our culture that it even appears as a topic on television situation comedies as well as more serious media presentations. Nonetheless, the bridgegroom-to-be is likely to confront "locker-room" jokes about the wedding night; the bride may purchase a sexy negligee; and the wedding guests may expect the couple to make an early departure, ostensibly to consummate the marriage. Apparently, the wedding night has important symbolic significance even in our moderately sexually "liberated" society.

In reality, most societies do expect brides to enter the first marriage as virgins. An unmarried girl who is not a virgin is considered "damaged goods." For example, the contemporary women of Bangladesh who were raped by invading soldiers were considered "impure" and were expelled from their homes. These violated women found themselves living together, unable to be absorbed back into their own villages and "unfit" to become wives of the young men in the village (Brownmiller, 1975).

Sometimes the exclusive rights to sexual access that marriage confers on men have been taken so seriously that any damage to unmarried girls' virginity could bring the death penalty on the seducers, and on ourselves if we had

The Marriage of Catherine of Aragon: VII **Box 7.4G**

Catherine was a remarkably successful wife. She maintained the important Spanish alliance in full bloom while endearing herself to the English through her industriousness, virtue, and charity. But she failed to produce a son. After the birth of her daughter Mary, her life was blighted by a long and painful chain of miscarriages. As her childbearing years drew to their end, Henry became increasingly frantic at the prospect of a female succession. Moreover, he became infatuated with a young woman, Anne Boleyn, who refused to give him her favors without marriage. Finally, he sought annulment of his marriage. Catherine resisted and the pope, threatened by Catherine's nephew Charles V, emperor of all the Germanies, king of all the Spains, and victor over the French in Italy, refused. In consequence, Henry withdrew England from the Roman Catholic church, divorced Catherine under English jurisdiction only, and married Anne— who had yielded to him at a critical moment and was already pregnant with the future Elizabeth I.

cooperated. Until the twelfth century, the legal definition of rape in European law codes was the abduction of another man's sexual property. Unless the injured party (father, brother, husband, or other male guardian) agreed to receive compensation, the death penalty could be imposed on the rapist.

Yet not *every* society has demanded virginity of its brides. In Samoa, a period of sexual freedom and experimentation is viewed as a natural part of life for young girls. It is our happy time which we generally seek to prolong before taking up the burdens of wifehood (Mead, 1928). Increasingly, in the United States in the twentieth century, a greater acceptance of premarital sex has contended with the continued strong sentiment of those who are adamant that a "nice" girl will "save herself" for her husband.

Once a woman and man are married, they are expected to engage in sexual intercourse sooner or later. Often when a bride is extraordinarily young, the groom will be encouraged to wait. Still, contemporary reports in India, where child marriage is fairly common, provide extensive testimony to the physical damage done to child brides (India, 1974; Forbes, 1979). There have been strong legislative attempts in that country to correct so oppressive a marital system.

The Marital Household

In many societies, the transition from the status of daughterhood to one of wifehood entitles women to "homes of our own." In theory, the status of wife or "woman of the house" entails a set of rights to make certain decisions for the family which conventionally fall under a woman's domain, and a set

An older couple. Many women have their happiest years in later life. With a clear sense of self, their relations to the men in their lives can take on a new dimension of intimacy and companionship. (Photo by Jean Shapiro)

of obligations which are conventionally assigned to wives. Most of these rights and obligations concern the day-to-day pattern of domestic life, the furnishing of the home, and the feeding and care of its occupants.

The ideal of one married woman in the household is associated with the ideal of the *nuclear family household*. A nuclear family consists simply of a married couple and the immature offspring. In some societies, such as pre-revolutionary China, the ideal was not the nuclear family but the *extended family household*, which contains other adult relatives including married couples, usually representing at least two generations. Typically, an extended family household will have a married couple, one or more of the couple's married offspring, and unmarried children. The status of wives in an extended family household will depend in part on our seniority, in part on how many other wives there are, and in part on whether we have children, particularly male heirs. Thus, women who share households with our mothers-in-law or our husbands' older brothers' wives may find that we have very few decision-making rights and a lion's share of domestic responsibilities. Older women whose sons have brought wives into the household

The Marriage of Catherine of Aragon: VIII Box 7.4H

Maid, widow, wife, mother, and Queen, Catherine never saw her native
Spain again. Even after Henry had cast her off and declared their mar-
riage null and void, she continued to live in his kingdom, in housing
conforming to his pleasure. The Spanish ambassador claimed that her
tyrannical husband greatly hastened her death by keeping her in castles
where the damp weather aggravated her rheumatic condition.

may be delighted to be unburdened from domestic tasks which can now be
assigned to the daughters-in-law, while the mother-in-law assumes the posi-
tion of manager.

Wives' positions in our homes are affected not only by whether or not we
share the home with other married women but also by how the women are
related to us. The nuclear family is usually *neolocal:* the newly married
couple set up housekeeping on their own and form a new establishment.
Many societies, however, like the traditional Chinese, are *virilocal:* the couple
take up residence with or near the husband's relatives. This is likely to be the
case in patrilineal societies, where rights and property are inherited in the
male line. In societies which adhere to a virilocal residence pattern, new
brides must operate as aliens in a strange territory, learning new family
customs and accommodating to the caprices of new people. We may be
hedged in by a variety of traditional constraints which keep us in our place.
For example, in some Islamic groups, as among the traditional Chinese, a
new daughter-in-law is not addressed by name for over a year; being called
simply "son's wife." Among the Turkmen of northeastern Iran, new brides
are returned to fathers' households, and the period of "spouse avoidance"
starts. This period lasts one to three years during which bride and groom may
visit one another if it can be done secretly (Irons, 1975).

An alternative to virilocal residence, found in some matrilineal societies
such as the Hopi and Navajo in the United States, is *uxorilocal* (sometimes
termed *matrilocal*) residence: the couple reside with the wife's family. This is
likely to occur where rights and property are inherited through women. In
uxorilocal residence, a core group of women, mothers and daughters, remain
together throughout life, while the husbands come to join us. Generally,
wives seem to have more power and autonomy in these situations, and
greater ease in dissolving unsatisfactory marriages, than in virilocal situa-
tions. This probably relates both to our greater degree of control over pro-
ductive property in these societies and to the support we have from living
with our own female kin.

The "*Marriage*" of Elizabeth I Box 7.41

Anne Boleyn's daughter Elizabeth came to the throne of England after a
girlhood filled with terror and insecurity. Her own mother had been
beheaded on a charge of treasonable adultery and incest. Four other wives
had followed before Henry VIII ended his royal career. Elizabeth had seen
her older sister Mary—Catherine's daughter—suffer from marital neglect
and thwarted love, even though her submission to her Spanish husband
was so complete as to encourage policies that endangered her possession
of the English crown. Elizabeth, the Virgin Queen, often claimed that she
could never marry because she had already married her people of En-
gland. This was the theme she struck in her last public speech to her
people's representatives in Parliament: "It is not my desire to live or reign
longer than my life and reign shall be for your good. And though you
have had, and may have, many mightier and wiser princes sitting in this
seat, yet you never had, nor shall have any that will love you better."

Family Politics

Although marriage may lay the basis for a new household, wives rarely
establish homes in isolation. As we have already noted, we may live with
in-laws or with a husband's other wives, or we may find ourselves—as is
increasingly the case in our own society—with a husband's children by a
former marriage as well as with our own. Our relationships with these vari-
ous people may be those of cooperation or competition, warm friendship, or
grudging tolerance.

Living with in-laws may pose special complexities for women. In Bosnia,
Yugoslavia, for example, the parents of each spouse become "instant" rela-
tives when offspring marry (Lockwood, 1975). The in-laws, or "*kuma*," are
considered closer to each other than to blood kin. The strategic advantages
for wives in this position may be manifold. We find ourselves in a union
backed and aided by two kin groups. We have enlarged our circle of friends
and relatives as well as our visiting network. We have acquired two sets of
supporters to play against one another or to aid us against our husbands if
that is necessary. On the other hand, we have doubled the disadvantages as
well. Because of the importance placed on the interaction between the parents
and the married couple, we find ourselves being "managed" by both sides.
Two sets of parents and two sets of siblings give us well-meant advice and
expect willing cooperation (Peristiany, 1976).

Women who share a house with women to whom we are not related,
whether our mothers-in-law, sisters-in-law who are married to our husbands'
brothers, or co-wives in a polygynous marriage, may find ourselves at a
disadvantage. We lack privacy, if it is important to us, and we must share the
domestic territory that is commonly considered women's domain, including

the kitchen. Even if the co-wives and children occupy separate apartments or huts, emotional strains such as jealousy, personality conflicts, rivalry, and unpleasantness among the children of different mothers may occur. The Babylonian Talmud advises a man to have three or more wives to dissipate the tension that arises from the quarreling of two women. Today, in some Muslim societies where polygyny is lawful but rarely practiced, taking another wife remains a threat that husbands can use to exercise control over their wives.

However, there may be some advantages for a woman in polygyny. In a society that consistently segregates and isolates women from public life, polygyny provides a domestic society within which there is companionship, cooperation, and emotional support. A Western observer has detailed this comfortable domestic life for a harem in a small Iraqi village (Fernea, 1958). There the co-wives not only cooperated happily in household tasks and child care but made up the core of a wider society of women who spent many hours "roof-hopping" to visit one another, smoking and chatting in the harem out of sight of the men in the main square.

Where co-wives live together, women may be ranked according to preestablished custom or by the personality or authority of individual women. Commonly, first wives are the oldest and most respected because of age and experience in household matters. If we can consolidate this authority, we may become the equivalent of mothers-in-law in controlling the younger wives. We can withdraw from actual housework and assume the task of manager. But we may have to play a subordinate role to a more favored sexual partner of the husband (Hsu, 1949). In other instances, the honor of being "first wife" is given to women who bear the first son, whether or not we were the first wives. In Ottoman Turkey, the sultana who gave birth to the first male child, the successor to the throne, was granted the highest honors and bore the title "head woman." The possibilities for manipulation and political maneuver among co-wives and among children in a polygynous community are varied and sometimes dangerous if the stakes include the eventual power that will accrue to the mother of the heir (Makhlouf-Obermeyer, 1979).

While the politics of polygynous households may seem remote and exotic to the American reader, complex family rivalries and struggles for power in the context of divorce and remarriage are probably more familiar. Many women find that we are tied in many-stranded relationships with our husbands' former wives, our own former husbands, or our former husbands' new wives, in ongoing mutual decisions and interactions regarding children, income, and property. While the various parties to these complex relationships may come to mutual and supportive arrangements, power struggles between new and old spouses, or between children of a former marriage and a new spouse, often create major difficulties for a wife.

Extramarital Affairs

Whether or not we have married for love, many wives have found romance outside of marriage. In the twelfth century, the Countess Ermengarde of Narbonne was reputed to have declared that love could not exist within marriage: since most women of her day married, she clearly meant that women must seek love from men other than our husbands. However, traditionally adulterous wives (and sometimes our partners) have been subjected to terrible penalties, such as starving, burning at the stake, or mutilation. As in other sexual codes, there is a double standard regarding adultery. For men, it is equally "immoral," but it rarely has been punished by such severe measures.

Wives may seek affairs in order to fulfill some of the emotional and sexual needs not satisfied in the marriage. Sexual and emotional intimacy which is free from the constraints of marital roles, obligations, and mutual dependency may provide some women with gratifications they cannot find with husbands. An affair may provide a woman with a remedy for neglect, boredom, or loneliness, or may give a sense of excitement or feeling of desirability. Gustave Flaubert's *Madame Bovary* , first published in 1854, illustrates a woman's search for fulfillment and self-definition through adultery.

Like many a fictional adulteress, Emma Bovary ended her life in suicide. The real tragedy of adultery for women, however, has more often been the threat of occurrence of an illegitimate pregnancy. Before the days of reasonably safe birth control, pregnancy was a likely outcome of any sexual relationship, and an adulterous woman was thus faced with a high risk of discovery.

Today, this risk is not really so great. And although not necessarily overtly condoned, extramarital affairs for women have probably become more common. One study in the United States in the early 1970s reported that 25 percent of married women had extramarital affairs (Hunt, 1974). This is half the number reported by men, but considerably more than most people believe is true for women. Is this evidence of the "sexual revolution"? A previous survey done in the late 1940s actually found a similar incidence of extramarital affairs among women, although the number of women under the age of twenty-five having such experiences was considerably fewer (Kinsey, 1953).

Wives who discover that our husbands have engaged in affairs may under some circumstances have no choice but to tolerate the situation. But we may also feel hurt, humiliated, rejected and betrayed—as might our husbands if the positions were reversed. It is generally understood in the marriage contract that sexual relations are the exclusive reserve of the partners in marriage; by law and custom, wife and husband are "entitled" to feel possessive toward one another. Yet many women, and even some men, have taken a more tolerant view toward a woman's extramarital sex in recent times.

Sexual relations within marriage reflect the gender roles and related sexual

attitudes in any society. If a social system were based on gender equality and positive attitudes about sex and sexual choice, gender relations within as well as outside marriage would be different. Whether the existence of gender equality would diminish the need to find love outside marriage, if that institution actually continued, we will never know. Sexual possessiveness is part of gender attitudes and female-male relationships now embedded in our social structures. Changes in those structures would result in changed expectations about marriage and the issues as they have been discussed here would no longer concern us.

Of course, between any two marriage partners, sexual relations may not be a microcosm of unequal gender relationships in society. For some couples sex may offer a respite from daily battles to survive and to achieve, the only private time wife and husband have in a day to share thoughts and intimacies. Lovemaking for such a couple may be an expression of these mutual feelings and may provide a moment when both can respond to physical needs that transcend social roles.

Divorce

"Can marriage be for life?" This was the question posed by Margaret Mead (1949) in her consideration of the illusions—and disillusions—Americans seem to hold about marriage. To be sure, most societies expect marriage to have some degree of permanence, particularly after the couple have had children. But nearly every society recognizes grounds for marital incompatibility. Indeed, a 1950 study by George Murdock showed that divorce was more frequent in 60 percent of non-European societies he sampled than in the United States.

Yet the highest divorce rate experienced in this country had in fact occurred a few years before Murdock's study. This peak occurred in 1946, just after World War II, when the rate reached 16.3 percent. A brief decline followed, only to be succeeded by a gradual increase. Then, between 1966 and 1976, the annual divorce rate in the United States doubled from 10.9 to 21.1 per 1,000 married women. Of every 100 marriages initiated in 1977, it is now estimated that only 63 will survive to their tenth anniversaries. Second marriages have proven to have an even shorter average duration. For example, by their fifth anniversaries, about 16.3 percent of first marriages (almost one in six) now end in divorce, while 23.6 percent of remarriages (almost one in four) do so (U.S. Department of Health and Human Services, 1980).

The average duration of marriage in the United States has been fluctuating during the past century from between 5.8 and 8.3 years. The median duration of a marriage, for example, declined from 7.5 years in 1963 to 6.5 years in 1974–1976. The longer women remain in a marriage, however, the less

likely we are to get divorced. In 1977, it was found that for every 1,000 women in the United States in our first marriages, there were after three years 34.3 divorces. This compared to women whose marriages had lasted thirty-five years; here there had been only one divorce per 1,000 first-married women. On the average, statistics indicate that the more times a person has been married, the less the time that elapses between marriage and divorce (U.S. Department of Health and Human Services, 1981).

Margaret Mead pointed out that the institution of marriage took shape at a stage in human history when the life span was much shorter than it is today. It was not expected that a couple would spend half a century together. One or another spouse would leave the other widowed; the other would remarry. With the demographic transition to a longer life span, the promise "till death do us part" has become (perhaps unrealistically) a commitment of unprecedented dimensions. Furthermore, contemporary society provides a context of continuous multiple choices in virtually every sphere of life. In this context, having only one, irrevocable choice in the matter of marriage seems by contrast anomalous.

In comparison with the majority of other societies, however, in the United States it is unusually easy to marry and unusually difficult to get divorced. To marry, a couple of legal age need do no more than register, have a blood test (in most states), exchange brief vows in the presence of an official and a witness, and pay a very small fee. Waiting time is usually about three days, often less. No parental consent is needed (once the participants have reached legal majority), nor any promise of family support. To get divorced on the other hand, couples usually require lawyers, various legal documents, a court hearing (or several), and often a considerable amount of time, even when both parties are in agreement. If the couple disagree about the terms of the divorce, as is likely to be the case when the marriage has dissolved in discord and there are children and property rights in dispute, the legal cost of settlement can be immense, while the costs in time and personal agony may be incalculable. The issue of the burdens borne by children in divorce is usually a matter of profound concern to parents, as well as to the courts and other involved parties.

While these costs may deter some individuals from seeking a divorce, the penalties of an incompatible marriage are deemed by many to be far greater. Reasons for divorce vary and often are not mutual for the couple in question. In addition to personal incompatibility, common grounds in our society and most others are infidelity, mistreatment, economic problems, sexual problems, and premarital misrepresentations about such things as desire for children. In 75 percent of the societies in Murdock's sample, women and men had approximately equal rights to initiate divorce on these various grounds, while in only 15 percent did men enjoy superior rights. In 10 percent, women had superior rights. In a matrilocal society such as the Iroquois, wives can

divorce husbands by dumping their effects outside the door (Murdock, 1950). Divorce is sometimes equally simple for women and men in certain patrilocal, even patriarchal, societies such as the Mongols of central Asia. Islamic law, which is based on the Koran, permits a man to repudiate a wife without giving a reason or going to court. The interpretation of the Holy Scriptures has varied in different times and places. In many Muslim countries today, the divorce law has been modified; in Turkey, a woman can initiate divorce. On the other hand, the men in some Muslim groups like the Bakhtiari of Iran and Pathan of Afghanistan prefer killing their wives because they view divorce as shameful, as admitting that they have failed to bring a wife to "her knees" (Lindholm and Lindholm, 1979).

The larger number of societies disapprove of divorce, and Western society is no exception—as testified by the many legal obstacles to divorce in the laws of both church and state. While laws, rules, customs, and attitudes toward divorce have changed in the West over the centuries, it is undeniable that social stigmas against it remain to this day. There are people who experience a sense of personal failure (or attach personal blame to partners) when their marriages fail. They, and outsiders, are likely to feel that marital failure is due to their own inadequacy rather than to problems inherent in the institution of marriage. It is worth pondering that while the divorce rate is high, the remarriage rate is also high (Laws and Schwartz, 1977). The partners may change, but the institution, embedded in the structure of society, endures.

The process of getting divorced can exacerbate the pain of marital failure. Divorce laws in some states require evidence of misbehavior ("cruelty," for example) or inadequacy, even when both parties agree that neither was "at fault." Rights to alimony may depend not only on the husband's ability to pay and/or the wife's need for support but also on the wife's fidelity. If women have committed adultery, we may have no right to support. Thus, court-mediated settlements involve accusations and denials, recriminations, and bitter counter-recriminations. Although the establishment of "no-fault" divorce options in some states has eased the process for some couples, disagreements over serious issues such as child custody remain very painful for many. To the extent that women are dependent on our husbands economically, socially, and psychologically, divorce is a terrifying situation.

But release from an outgrown or unworkable marriage, no matter how painful the process, can be a step toward liberation for women. As a result of divorce, some women have discovered a "new lease on life." We have returned to school or to previously abandoned careers or have taken up new ones with renewed energy once free of the emotional burden of a miserable marriage. The theme of a woman's growth and liberation consequent to divorce has been explored in a number of contemporary novels, and in such films as *An Unmarried Woman*. Once the bitter period of initial separation is

over, some women can even look back on former marriages fondly, as happy and constructive periods of our lives. Margaret Mead, in her own view, had three successful marriages (Mead, 1972).

Widowhood

Because women in developed societies have a greater life expectancy than men, we stand a good chance of ending our lives as widows. Moreover, it is customary in nearly all monogamous societies for women to marry men older than ourselves. Even in polygynous societies, the elderly (wealthy, high status) men tend to command a large percentage of the numbers of marriageable women and to accumulate more than their fair share of wives. Even if an older woman may be the "first wife," subsequent wives will probably be young. Indeed, the first marriages of many young girls will be to men who may easily die before the marriage is consummated. In all but a few societies, women will probably be widowed at least once and possibly several times.

In some societies, the social structure tends to make women young widows but inhibits our chances to remarry. It is not uncommon for widows to be permanently ensconced in the houses of our in-laws, who possess and control the dowry and the chances of remarriage. Widowed women may be victims of the ill-disguised hostility of in-laws. A most extreme example of this treatment is exemplified in the case of young Indian widows, who are permanently left in the houses of in-laws, barred from remarriage, and treated as pariahs who (according to the laws of Karma) probably caused the death of the husband by some evil committed in a previous life, if not in this one. Traditionally, the women's only recourse was to volunteer for *suttee,* self-immolation on the husband's funeral pyre (Stein, 1978).

Social ostracism is the common way to rid society of women who no longer fit into the structure. Young widows who have escaped from the control of elders and resist taking new husbands threaten a system designed to limit women's choices as well as the self-esteem of men in the community. We also threaten the security of the other women in the community because we are seen as a danger to their own marriages. This potential multiple threat to social structures explains, in part, the excessive pressure and hostility that is applied to young widows. The response has been noted particularly in Mediterranean communities in Greece and southern Italy (Cornelisen, 1969). We are socially shunned and abused unless we capitulate and remarry. In early European society, widows who found ourselves outside the protection of a related male often found ourselves outside the law altogether, with no protection against rape, theft, or other abuses.

Nonetheless, widowhood may have advantages for some women, especially where we have been protected by both religious and secular law from being

obligated to marry a second time. Where women are economically secure, no one can interfere with us. Our increased maturity and independence enhance our chances of choosing a mate to our own liking or remaining single and actively independent. Financial security is all-important in determining the fate of widows; without it, we may quickly fall into the category of objects of charity.

Feminist Options

Is there a feminist argument in favor of marriage? Most feminists who discuss the institution favorably argue for a redefinition which emphasizes and reinforces equality between partners (box 7.5). Given a social environment in which pairing of mates is the norm, these writers believe that there is considerable scope for molding marital agreements according to principles of equality and fairness. Some of the efforts that have been made in this direction will be discussed in chapter 9. But as for the more conventional concepts of "wifehood," there seems little that can be said in their defense. To be sure, most feminists argue for a woman's freedom of choice, and perhaps many of us would freely choose to subordinate our own interests to those of our husbands as conventional "wifehood" would imply. Others believe our best interests lie in the role of wife. But it is at least equally likely that this "choice" is governed by those role expectations in life that most women have been socialized to accept.

Feminist utopian literature seems generally to argue against the institution of marriage. While some utopias, like Marge Piercy's Mattapoisett in *Woman on the Edge of Time* (1976), allow scope for mutually gratifying stable bonding between women and men (as well as same-sex couples), the form of the union is open, flexible, and highly individualized. The role of "wife" has no place in feminist utopian literature.

But utopias are imaginary, and we live in a world where compromises must be made. Many women choose to enter into the legal commitment of a marriage, and for those who want to marry, there are feminist options. Some of the literature on this subject has concentrated on the ideal of equalitarian marriage. Most feminists support the ideal of shared household work, more equitable treatment in divorce, and a fair division of parental and economic responsibilities. Some also argue for the revival of the explicit marriage contract; yet others have made a case for cash payments for housework and other services within the household. Yet other options for family life, such as lesbian households or communes, are explored in chapter 9. Today's economic and social climate, in which many women earn our own incomes and have choices concerning whether and when to have children, favors experimentation with new forms of commitment and family life.

John Stuart Mill on Marriage as Friendship Box 7.5

When each of two persons, instead of being a nothing, is a something; when they are attached to one another, and are not too much unlike to begin with; the constant partaking in the same things, assisted by their sympathy, draws out the latent capacities of each for being interested in the things which were at first interesting only to the other; and works a gradual assimilation of the tastes and characters to one another, partly by the insensible modification of each, but more by a real enriching of the two natures, each acquiring the tastes and capacities of the other in addition to its own. This often happens between two friends of the same sex, who are much associated in their daily life: and it would be a common, if not the commonest, case in marriage, did not the totally different bringing-up of the two sexes make it next to an impossibility to form a really well-assorted union. Were this remedied, whatever differences there might still be in individual tastes, there would at least be, as a general rule, complete unity and unanimity as to the great objects of life. When the two persons both care for great objects, and are a help and encouragement to each other in whatever regards these, the minor matters on which their tastes may differ are not all-important to them; and there is a foundation for solid friendship, of an enduring character, more likely than anything else to make it, through the whole of life, a greater pleasure to each to give pleasure to the other, than to receive it.

(Mill, 1869, 1970:233)

Summary

The institution of marriage and the existence of the complementary roles of "wife" and "husband" are often explained in terms of their social functions. The most common rationales are those related to reproduction: marriage obligates a man to assist a woman in rearing their children and, by requiring the wife's sexual fidelity, reassures him that it is his own offspring that he supports. An alternative perspective on this issue suggests that marriage confers upon a man a right of access to and control over a woman's children, but does not necessarily guarantee his support. A second rationale for marriage is that it minimizes male rivalry over sexual access to women and provides an important means of forming or cementing alliances between men. In this view, women are reduced to objects of exchange between men. A third perspective suggests that marriage reduces competition between women and men by assigning to each distinctive, nonoverlapping roles in life.

None of these explanations address the personal motivations of individuals in marriage. These are variable and include emotional and psychological reasons as well as social ones.

The selection of marital partners is generally conditioned by social constraints and family goals as well as personal preferences. Social customs and laws delimit the circle from which prospective marital partners can be chosen. Rules of exogamy forbid us to marry anyone too closely related, while rules of endogamy enforce marriage within certain social boundaries such as our own religious, ethnic or racial group. Families also traditionally restrict choices, particularly where marriage is arranged by parents and kin for prospective couples. Families tend to search for unions which are advantageous to themselves, though they may take the couple's preferences into account as well. Modern societies permit considerably more latitude for personal choice than traditional ones.

Marriage takes many forms. Some societies encourage arrangements whereby women may have more than one husband (polyandry), but this is rare by comparison with those societies in which women ideally share our husbands with one or more other wives (polygyny). Regardless of ideals, however, monogamy, marriage to a single partner, is far more common in any society, than polygamy, marriage to more than one mate at a time.

A woman may be formally "married" at any stage of life, but most women's first marriages—except in Western European societies—are between fifteen and eighteen years old. Our first wedding is an important rite of passage in which we assume a new, adult identity with new rights and obligations. The wedding ceremony is often replete with symbolic gestures representing a major shift in a woman's social place.

Marital households are as variable in form as are marriages themselves. A couple may reside in a separate domestic establishment or may join other couples, parents, or siblings of the bride or groom. Just where the bride fits in depends on whether we start out alone, with our own kin, with our husbands' kin, or with his other wives.

With reference to extramarital affairs, society tends to hold a double standard, as in many other matters; women tend to be more constrained, and to be more severely penalized for adultery. However, extramarital affairs have long had their attractions for women, despite the risks; in the United States, today about one out of four women report having had such affairs.

Nearly every society, while expecting marriage to have some degree of stability, also recognizes grounds for divorce. In most, women and men have roughly equal rights to terminate a marriage. The divorce rate in the United States is not unusually high, compared to that in non-Western societies. What is universal is the disparity between the ease with which couples in the United States can marry and the difficulties encountered in getting divorced. Divorce tends to be costly, time-consuming, and painful. However, despite the legal, social, and emotional costs, many women have found it an important step toward liberation.

For social or demographic reasons, women stand a very high chance of being widowed. In some societies, the experience of widowhood can be made extremely bitter by systematic constraints, ostracism, or persecution.

Feminist writers have, on the whole, been critical of traditional marital institutions, and many have suggested new options for marital arrangements. In addition to arguing for greater latitude of choice about whether, when, and whom to marry, the greatest concern has been for ways to build equality into the marital agreement. Some of these options are explored in chapter 9.

Discussion Questions

1. Marriage is an institution that is found in all known human societies. Why do you think this is so? What explanations have been offered for the institution of marriage? Do you find any of them convincing? Why?
2. Do you think that the social position and roles of wives have changed through time? Select a specific case and describe what changed and how it changed. What brought about the change?
3. Make a list of the weekly services performed by a wife for a household with which you are familiar. How do these services compare with those rendered by the husband in this household?
4. Do you think a woman is better off married or single? What conditions argue in favor of marriage for a woman, and what against?
5. What, in your view, would be an ideal form of marriage? What kinds of social conditions would be necessary for this kind of marriage to be possible?

Recommended Readings

Bernard, Jessie. *The Future of Marriage.* New York: World, 1972. The past, present, and future of the institution of marriage and related lifestyles, as a sociologist sees them. Useful facts, figures, and proposals.

Chopin, Kate. *The Awakening.* 1899. Reprint. New York: Avon, 1972. A novel about a young wife who fell in love and attempted to extricate herself from an oppressive marriage.

Hartman, Mary S. *Victorian Murderesses: A True History of Respectable French and English Women Accused of Unspeakable Crimes.* New York: Schocken, 1977. A social historian's study of middle-class women who vented frustrations by murdering relatives, lovers, and, in one case, a pupil, as seen in the context of the struggle for domestic power.

Rubin, Lillian. *Worlds of Pain.* New York: Basic Books, 1976. A well-written study of working-class wives in California by a noted sociologist.

Seifer, Nancy, ed. *"Nobody Speaks for Me!" Self-Portraits of American Working Class Women.* New York: Simon & Schuster, 1976. All the women who speak for themselves in this anthology are married; the diverse backgrounds of these ten women who speak for themselves include Irish, Italian, Jewish, black, Chicana, English, white Southern Baptist, French, Norwegian, and German. They live in every section of the United States, in cities, suburbs, small towns, and rural areas.

References

Beard, Mary. *Woman as Force in History.* New York: MacMillan, 1946.

Brownmiller, Susan. *Against Our Will: Men, Women, and Rape.* New York: Simon & Schuster, 1975.

Cole, Donald P. "The Household, Marriage and Family Life Among the Al Murrah Nomads of Saudi Arabia." In *Arab Society in Transition,* edited by Saad Eddin Ibrahim and Nicholas S. Hopkins. Cairo: American University in Cairo Press, 1977.

Cornelison, Ann. *Torregreca: Life, Death, Miracles.* Boston: Little, Brown, 1969.

Eliot, George. *Middlemarch: A Study of Provincial Life.* 1871. Boston: Houghton Mifflin, 1956.

Ember, Melvin, and Ember, Carol R. "Male-Female Bonding: A Cross-Species Study of Mammal and Birds." *Behavior Science Research* 14 (1979):37–56.

Engels, Friedrich. *The Origin of the Family, Private Property, and the State.* 1884. Translated by Alec West, 1942. Edited by Eleanor Burke Leacock. New York: International Publishers, 1972.

Fernea, Elizabeth. *The Guests of the Sheik.* Garden City: N.Y.: Doubleday, 1958.

Flaubert, Gustave. *Madame Bovary.* 1854. Translated by Mildred Marmur. New York: New American Library, 1964.

Forbes, Geraldine. "Women and Modernity: the Issue of Child Marriage in India." *Women's Studies International Quarterly* 2 (1979):407–19.

Freuchen, Peter. *Book of the Eskimos.* New York: Matson, 1961.

Goldman, Emma. *Living My Life.* 1931. Reprint. New York: Dover, 1970.

Goode, William J. *World Revolution and Family Patterns.* New York: Free Press, 1963.

Hajnal, J. "European Marriage Patterns in Perspective." In *Population in History,* edited by David V. Glass and David E.C. Eversley. Chicago: Aldine, 1965.

Heu, Francis L.K. *Under the Ancestor's Shadow.* London: Routledge & Kegan Paul, 1949.

Hunt, Morton M. *Sexual Behavior in the 1970s.* Chicago: Playboy, 1974.

India (Republic), Department of Publication. *Towards Equality.* Report of the Committee on the Status of Women. Delhi: Controller of Publications, Civil Lines, 1974.

Irons, William. *The Yomut Turkmen: A Study of Social Organization Among a*

Central Asian Turkic-Speaking Population. Ann Arbor: University of Michigan, 1975.

Kingston, Maxine Hong. *The Woman Warrior.* New York: Knopf, 1976.

Kinsey, Alfred C., Pomeroy, Wardell B., Martin, Clyde E., and Gebhard, Paul H. *Sexual Behavior in the Human Female.* Philadelphia: Saunders, 1953.

Laws, Judith Long, and Schwarz, Pepper. *Sexual Scripts.* Hinsdale, Ill.: Dryden, 1977.

Lévi-Strauss, Claude. 1949. *The Elementary Structures of Kinship.* 1949. Translated by James II. Bell and John R. von Sturmer. Boston: Beacon, 1969.

Lewis, Oscar. *A Death in the Sanchez Family.* New York: Random House, 1969.

Lindholm, Charles, and Lindholm, Charry. "Marriage as Warfare." *Natural History.* 88 (1979):11–21.

Lockwood, William. *European Moslems.* New York: Academic Press, 1975.

Lynn, Loretta. *The Coalminer's Daughter.* New York: Warner, 1977.

Makhlouf-Obermeyer, Carla. *Changing Veils: A Study of Women in North Yemen.* Austin: University of Texas Press, 1979.

Mattingly, Garrett. *Catherine of Aragon.* New York: Vintage Books, 1960.

Mead, Margaret. *Blackberry Winter.* New York: Morrow, 1972.

———. *Coming of Age in Samoa.* New York: Morrow, 1971.

———. *Male and Female.* New York: Morrow, 1949.

Mill, John Stuart. "On the Subjection of Women." In John Stuart Mill and Harriet Taylor Mill, *Essays on Sex Equality,* edited by Alice S. Rossi. Chicago: University of Chicago Press, 1970.

Mitchell, Margaret. *Gone With the Wind.* 1936. Reprint. New York: Avon, 1974.

Murdock, George P. "Family Stability in Non-European Cultures." *Annals of the American Academy of Political and Social Science* 272 (1950):175–201.

Neale, John E. *Queen Elizabeth I: A biography.* 1934. Reprint. Garden City, N.Y.: Doubleday, 1957.

O'Brien, Denise. "Female Husbands in Southern Bantu Societies." In *Sexual Stratification: A Cross-Cultural View,* edited by Alice Schlegal. New York: Columbia University Press, 1977.

Peristiany, Jean G. *Mediterranean Family Structures,* Cambridge, Eng.: Cambridge University Press, 1976.

Piercy, Marge. *Woman on the Edge of Time.* New York: Knopf, 1976.

Rosen, Lawrence. "The Negotiations of Reality: Male-Female Relations in Safrou, Morocco." In *Women in the Muslim World,* edited by Lois Beck and Nikki Keddie. Cambridge, Mass.: Harvard University Press, 1978.

Scarisbrick, J.J. *Henry VIII.* Berkeley: University of California Press, 1970.

Stack, Carol. *All Our Kin.* New York: Harper & Row, 1974.

Stein, Dorothy K. "Women to Burn: Suttee as a Normative Institution." *Signs* 4 (1978):253–78.

Walther, Wiebke. *Woman in Islam.* Montclair, N.J.: Schram, 1981.

Wilson, Edward O. *Sociobiology.* Cambridge, Mass.: Belknap Press, 1975.

Tylor, E. B. "On a Method of Investigating the Development of Institutions, Applied to Laws of Marriage and Descent." *Journal of the Royal Anthropological Institute* 18 (1889): 245–69.

U.S. Department of Health and Human Services, Vital and Health Statistics. "Duration of Marriage Before Divorce." Series 21, No. 38. Washington, D.C.: Government Printing Office, July 1981.

———. "National Estimates of Marriage Dissolution and Survivorship." Series B, No. 19. Washington, D.C.: Government Printing Office, November 1980.

8
Motherhood

PARENTHOOD VERSUS MOTHERHOOD
Parental Behavior: Instinct and Culture
Motherhood: Ideology and Reality
The Assignment of Mothering to Women: Whose Interest Does It Serve?

THE CULTURAL SHAPING OF BIOLOGICAL EVENTS
Attitudes Toward Pregnancy
Childbirth: A Cultural or a Natural Event?
Breast-Feeding: Attitudes and Choices

MOTHERS AND OTHERS: SUPPORT SYSTEMS
Fathers
Women's Networks
Community Support

CHOICE AND CONTROL
Whether, When, and How Often to Become a Mother
Control Over Children
Working for Wages

IMAGES OF MOTHERHOOD
Perspectives: Who Creates the Image?
"The Happy Mother": Painting as Propaganda
"Ethnic Mothers" and Social Mobility
Motherhood and the Media
Mothers Speak Out.

Motherhood is a central issue to women everywhere, whether we are, intend to be, or intend not to be mothers ourselves. For some women, it is a source of immense pleasure and pride; for others, of conflict and pain. Many feel that it is women's very capacity to become mothers that has been used as a rationale for the unjust and harmful social constraints placed on us. Furthermore, many people believe that society has institutionalized motherhood in such a way as to make the experience of it often degrading, debilitating, and painful, to the detriment of everyone—women, children, and men. Finally, many women feel that the main issue of motherhood lies in the problem of choice. Until recently, few women were able to choose not to be mothers. Now the question is not only whether women must become mothers, but

whether we must make a choice between motherhood and a career. Shouldn't the choice, instead, allow either, or both?

It is difficult to feel neutral about motherhood. Perhaps it is this emotional quality that has prevented much knowledge about the subject. Although great volumes of literature have been devoted to this topic, and although it touches on a vast array of other issues of central importance to human social, psychological, and practical existence, we still know little about the repercussions of the experience of motherhood.

This chapter will focus on a few of the facets of motherhood that relate to its role in society and culture. Because motherhood is often taken so much for granted as a biological "fact," we will begin with an examination of the ways that society has institutionalized women's reproductive role. We will then take a close look at the ways that culture shapes even those events that appear to be most directly associated with biology: pregnancy, childbirth, and lactation. Next, we will address two political issues associated with motherhood: support systems by the family and by society in general, and the control over whether, when, and how a woman becomes a mother. Finally, we will look at the ways that motherhood has been depicted in art, literature, and the popular media. This should help us understand how ideas about motherhood are reflected in and shaped by social processes.

Parenthood Versus Motherhood

Parental Behavior: Instinct and Culture

All organisms come from other organisms. In this sense, all organisms have "parents." Sexual reproduction involves a differentiation of reproductive roles, in that some organisms contribute ova and some contribute sperm, but we do not think of all sexually reproducing organisms as "mothers" and "fathers." Many plants, for example, have female and male reproductive roles, but we do not speak of "mother" and "father" plants. Contributing an egg, then, is not sufficient (or even necessary) to make a female a mother.

It is usually only where parents contribute some care after birth that the terms *mother* and *father* seem to apply. But organisms do not invariably differentiate parental care after birth according to the sex of the parent, or in any particular way. Among many bird species, for example, female and male parents share equally in nest-building, egg-hatching, and feeding and protection of the young. Even among mammals, whose female members lactate (produce milk), there is considerable variability in parental roles. The male marmoset, which is a primate like ourselves, carries and protects his young; he brings them to the female from time to time to be nursed.

How do we account for parental behavior? When we observe it in birds and fish, or dogs and cats, we assume that their activities are "instinctive." By this we mean to say that their nervous systems are so programmed by

genetic inheritance that, given a healthy organism and an adequate environment (proper stimuli), a parent will automatically follow a set of actions (responses). Parents who are not programmed this way will not produce viable offspring, while those who are ensure that their offspring will themselves carry the same program. The females will perform reproductive roles assigned in their species to females, and the same is true for the males.

When we consider more complex animals, particularly primates like ourselves, we begin to question the applicability of the notion of "instinct." We discover that sexually differentiated parental roles are not simple biological "givens." Laboratory experiments with female rhesus monkeys, for example, show that when they are reared in isolation, with no opportunity to observe rhesus maternal behavior, they do not instinctively display maternal behavior toward their own young. Furthermore, normally reared male rhesus monkeys who are placed with rhesus infants in the absence of mature females do display "maternal" behavior. We can conclude from these studies and others that for complex organisms, like monkeys, maternal behavior must be learned, and that its expression by females or males depends on their experience and social conditions. (For a review of these studies, see Liebowitz, 1978.)

If this is true of monkeys, is there any reason to believe it is not true of humans? While it is unlikely that any informed person would deny that learning and circumstances play a role in shaping maternal behavior, it is often assumed that the behavior of human mothers toward our children is somehow "natural" or instinctive, and that women are more biologically predisposed to perform this behavior than men. Is there such a thing as "maternal instinct" in humans, and is it present only in women? The emotional and developmental need of children for "mothering" is most likely one of the progenitors of the role of "mother."

Of course, humans do have some relatively simple "instincts," which we call *reflexes*. We are innately "programmed" to blink our eyes when a foreign object enters or threatens to enter. Women who breast-feed experience the "let-down" reflex (involuntary ejection of milk) in response to the sensation of the infants' sucking. But this type of simple reflex is not what people usually mean when they refer to "maternal instinct."

It can be argued that humans have innate predispositions for complex and varied sorts of behavior. To do so is to maintain that genetic inheritance provides the general pattern, not the details, of such behavior. Humans are innately predisposed to learn to speak, if we are not handicapped and have a proper environment; but *which* language we learn depends on what we have had the opportunity to hear. Do similar sorts of general innate predispositions underlie the parental behavior of either sex? There is no evidence that this is the case, although researchers have been looking into the matter (Rossi, 1977).

Maternal behavior is culturally variable. The San of the Kalahari Desert in Southern Africa carry their infants and nurse them for several years. Here, a San woman relaxing with her child, is depicted in a 1931 bronze sculpture by Malvina Hoffman (1887–1966). (*Mother and Child.* © Field Museum of Natural History)

Interest in the question of what does shape maternal behavior has only served to underline the extent of our ignorance of what maternal behavior is. We know little, for example, about the extent of human variability in parental behavior patterns, although we do know from anthropological and historical evidence that they are, indeed, quite variable. We know little about paternal behavior, perhaps because of the cultural bias of researchers, which leads them to believe that fathers play a less important role in early childhood. Likewise, the bias which holds that motherhood comes "naturally" to women has prevented research into what women actually feel about assuming maternal roles (Denmark, 1978).

Another area of ignorance is the role that infants play in shaping parental behavior. Human parents, like birds and monkeys, respond in ways evoked by the behavior of their offspring. A number of researchers have indicated that early parent-infant interactions affect the quality of later interactions.

In addition to the obvious influence of learning and of environmental and circumstantial conditions, we should consider the possible impact of the experience of pregnancy, childbirth, and breast-feeding on the differentiation of female and male parental roles. While maternal behavior is variable, the fact that mothers usually carry our offspring in our bodies for nine months, give birth to them, and then often hold them close to feed them at the breast for months, even years, afterward, while fathers do not, is likely to have some influence on general differences between maternal and paternal roles. But what are the implications, if any, of these differences? We do not know.

Motherhood: Ideology and Reality

The stereotypical view that motherhood "comes naturally" to women may have no basis in fact, but it does have an influence on women's feelings and attitudes. Many cultures regard motherhood as a major source of fulfillment and satisfaction for women and disapprove of negative attitudes toward childbearing and child-rearing. Despite cultural biases, increasing numbers of women the world over have begun to express feelings of ambiguity, dissatisfaction, fear, resentment, inadequacy, and anger about these experiences.

Some cultures set such high standards and expectations, and so strongly oppose dissent, that feelings of incompetence and frustration would appear inevitable. As Betty Friedan revealed in *The Feminine Mystique* (1963), middle-class American society during the 1950s seemed to carry this to an extreme. Mothers were assumed to love our children infinitely and unreservedly, to be glad to devote ourselves completely to our role, and to want to be with our children at all times. Such idealization evoked disappointment and anxiety in many women, particularly given the social context in which we assumed motherhood roles. Isolated in nuclear families in suburban communities built in response to the postwar "baby boom," women were encouraged to have numbers of children in rapid succession but denied practical

help from husbands, kin, or the public in the form of day care. We had virtually no outlet in the form of other employment, intellectual activity, or social purpose. Raising children was our "job" in life. Because we accepted this definition of motherhood as "natural," we could only attribute any dissatisfaction we might have felt to personal inadequacy.

This idea of motherhood as a "job," akin to other jobs like being a doctor or plumber or salesperson, is a relatively recent innovation, limited to classes of Western cultures sufficiently affluent to keep women out of the wage labor force. In no other time or place (to our knowledge) has child care been considered a full-time occupation for adults except for those hired to do that specific job (i.e., nursemaids, teachers). In any case, motherhood is not a "job" in that there is no pay (box 8.1).

The consequences of the belief that motherhood is, or ought to be, a full-time job are far-reaching for women, children, and whole families (Bernard, 1974). Many women who attempt to live up to this ideal are highly restricted in our activities and become isolated from the adult world. We focus all our emotions, hopes, aspirations, and energies on child-rearing, far more than most children need. If we do go out to work for wages, leaving our children in the care of others, or alone if we must, we feel guilty, and this guilt is magnified by the censure of others. If we do not go out to work, when our children grow up we may suddenly find we have nothing to "do," no purpose in life. Women's life expectancy has risen so dramatically in modern times that the "empty nest" years of life now exceed the number of years spent in child-rearing.

Children raised by full-time mothers may learn independence late in life, since their mothers devote so much attention to filling their needs. Or they may feel resentment at being "smothered." Before technology took productive work out of the home, women and men could be both workers and parents. Children benefited from exposure to the work activities of their parents and by participating in them.

Because "mothering" as a job is assigned to women, fathers may be excluded (or exclude themselves) from an active role in child-rearing. Most important, perhaps, is the asymmetry introduced into female-male relationships resulting from economic asymmetry. Mothers who do not or cannot work at paying jobs must depend on men who are their husbands or lovers or on some such support as welfare or charity. This dependency may often contribute to the paternalistic attitudes of men toward women, and to women's own insecure feelings. Women who are or intend to be full-time mothers may find that our identities become submerged in the identities of our husbands and children. Many popular novels written by women in recent years, such as Marilyn French's *The Women's Room* or Anne Roiphe's *Up the Sandbox,* explore the problems of the full-time mother. These two novels reflect the experience of white middle-class women in particular. Poor

The "Profession"of Motherhood Box 8.1

The "profession" of motherhood is one of low status in our society, witness that standard index—money: mothers are unsalaried. Despite flowery seasonal tributes and nostalgia, mothers have a bad reputation; they are blamed for nearly all social ills by everyone, including their own children. While mothers—"Earth mothers," Mother Machree, mammy— are lauded in greeting card verses and sentimental songs, and policemen, smiling benevolently, stop traffic on busy streets for pregnant women to walk across, the popularization of Freudian-based psychology encourages each of us to condemn our mothers for thwarting us, repressing us, rais-ing us for selfish purposes, refusing to let us go, even dominating our emotional lives after their deaths. . . .

As daughters, our learned expectations of our mothers are of great proportions: "Mother-love is supposed to be continuous, unconditional. Love and anger cannot coexist." [Rich, 1976:46] We hold the belief that mothers love their daughters by definition, and we fear any signal from our own mothers that this love, which includes acceptance, affection, admiration, and approval, does not exist or is incomplete. Since these signals must be constantly apparent to get that definition, we all can assume that we have gotten a "bad" mother. So many of us prefer the mother of a close friend, the one whose home and habits seem to reflect the kind of care we have been taught that mothers are supposed to give. We want the mother who does what the books, starting with *Little Women*, lead us to expect: mothers of perfection—the ones whose under-standing and sympathy never fail, whose only desire in life is that we be happy, and who never make us feel guilty because that is their only reason for existing—mothers as angels—beautiful and soothing presences who have no human needs or flaws. (Pildes, 1978:1–2)

This article first appeared in *Frontiers: A Journal of Women Studies*, Vol. 3, No. 2 (Summer 1978), pp.1–2.

women or highly trained women who work full-time outside the home have had a different experience than mothers who stay at home. Generally, work-ing women leave our children in the care of surrogate "mothers"—a grand-mother, an aunt, a hired babysitter, or a nurse. Maya Angelou, in her auto-biographical book *I Know Why the Caged Bird Sings* (1971), writes about the relationships of a young girl with her mother and grandmother who care for her through most of childhood.

Are oppressive conditions the inevitable consequence of motherhood? Some feminist writers see the roots of women's oppression in our reproduc-tive function (Firestone, 1970). Because only women can bear children, men, who are excluded from this creativity, create everything else and deny women access to their world (de Beauvoir, 1953). Other feminist writers argue that it is not motherhood itself, but the way that society has institutionalized it that

oppresses women, children, and men (Rich, 1976). Charlotte Perkins Gilman's 1915 fantasy novel *Herland* (1979) depicts a world in which motherhood is gratifying but not oppressive, a world in which motherhood does not preclude other forms of creativity and achievement. This world, however, has no men.

We need not turn to the imagination to see alternative forms of motherhood and different notions of what it ought to be. Motherhood as an institution has been variable through time, and it changes from place to place. The behavior, attitudes, and feelings that different cultures attribute to or expect from mothers change with different social conditions (Mead, 1962). Demography, technology, economic conditions, and family form are all variables that affect the institution of motherhood. But perhaps the most significant is the variable relationship between women and men. Many feminists believe that more equitable relationships between women and men can, and will, lead to forms of motherhood that are more rewarding to all concerned.

In America today, as in other countries, diverse forms of family life have emerged which have important repercussions for the institution of motherhood (Bernard, 1974). Extended families, communes, and single-parent households provide contexts that radically challenge the ideal of motherhood as the ultimate, full-time job of a woman. In these contexts, women who are mothers either can or must assume other identities and share child-rearing with others. Even within the once standard nuclear family, mothers' roles have shown considerable change. The number of working mothers of small children has dramatically increased (see chapter 13), and more and more fathers are participating in child-rearing for both practical and ideological reasons. Many contemporary American families have found the experience of more balanced parental care beneficial not only to the mother, but to the father and the children as well.

The Assignment of Mothering to Women: Whose Interest Does It Serve?
A woman's biological contributions to reproduction, though costly in time, energy, and risk, are of relatively short duration compared to the social role of motherhood, which lasts decades. But even the brief time span of pregnancy, childbirth, and breast-feeding involves a major commitment on the part of the woman who undertakes biological motherhood. Most women seem to feel that these events create a permanent change in our lives. While our children are young, most mothers are tied down by child-care responsibilities, particularly if we are nursing. Spending almost all our time with children, we are excluded from many public activities. Through our association with small children, mothers tend to be belittled by others as typically engaged in the trivial repetitive tasks of domestic life. Rearing children is very hard work, and usually it is mothers who have tended to bear the primary responsibility for this indispensable contribution to society.

> **Women's Mothering** Box 8.2
>
> The early experience of being cared for by a woman produces a funda-
> mental structure of expectations in women and men concerning mothers'
> lack of separate interests from their infants and total concern for their
> infants' welfare. Daughters grow up identifying with these mothers, about
> whom they have such expectations. This set of expectations is generalized
> to the assumption that women naturally take care of children of all ages
> and the belief that women's "maternal" qualities can and should be ex-
> tended to the nonmothering work that they do. All these results of
> women's mothering have ensured that women will mother infants and
> will take continuing responsibility for children.
>
> The reproduction of women's mothering is the basis for the reproduc-
> tion of women's location and responsibilities in the domestic sphere. . . .
> That women mother is a fundamental organizational feature of the sex-
> gender system: It is basic to the sexual division of labor and generates a
> psychology and ideology of male dominance as well as an ideology about
> women's capacities and nature. . . .
>
> Women's mothering also reproduces the family as it is constituted in
> male-dominant society . . . it produces men who react to, fear, and act
> superior to women, and who put most of their energies into the nonfamil-
> ial work world and do not parent . . . it produces women who turn their
> energies toward nurturing and caring for children—in turn reproducing
> the sexual and familial division of labor in which women mother. . . .
>
> . . . Women in their domestic role as houseworkers reconstitute them-
> selves physically on a daily basis and reproduce themselves as mothers,
> emotionally and psychologically, in the next generation. They thus contri-
> bute to the perpetuation of their own social roles and position in the
> hierarchy of gender. (Chodorow, 1978:208–9)

Presented in this negative light, motherhood would seem to be unattractive
to women. And yet, in most societies, most women generally *want* to become
mothers. What are the reasons? If we dismiss some sort of mysterious, un-
proven "maternal urge," we can still come up with a variety of answers.
Women learn from early childhood on that we ought to want children, that
motherhood is venerated, and that adult status is sure to be achieved with
motherhood. We may also come to believe that motherhood will bring us
security by attaching us more closely to our husbands or our families through
our children. Thus, motherhood may be a way of seeking social approval and
acceptance. Unless in religious orders, women in the past who did not have
children have generally been pitied and stigmatized, and sometimes even
thought to be cursed.

There are many external pressures on women to have and rear children,
but we should not lightly dismiss the real pleasures that so many derive from
motherhood. Acts of nurturing—cuddling, loving, playing with children,

tending to their needs—are a delight to many people, and not only mothers. The sacrifices a mother makes, such as staying up all night to care for a sick child or interrupting work to listen to a child's troubles, are burdens often gladly undertaken out of love, and do not require external forces to explain them. We might even ask if it is fair to men to exclude them from maternal pleasures.

Some writers have pointed out that the unpaid work of mothers serves captialism: mothers produce the next generation of workers and service the current generation for free (Dalla Costa, 1972). The fact that mothers and others see women's primary job as childbearing helps to justify low levels of job-training, high levels of unemployment, and low pay for women. Thus women form a pool of cheap labor. In socialist societies, the provision of maternity leave, day care, and family allowances helps to mitigate the costs of motherhood to women and to spread them more evenly. Capitalist societies, especially the United States, have resisted the reduction of the imbalance in the costs of motherhood. Few companies allow flexible work hours so that both parents can work and share child care responsibilities, nor do they commonly provide day care for children of working parents.

Not only business, but military interests are served by the assignment of mothering to women. Women are encouraged to produce soldiers as well as workers. And men are kept free of child care to be ready for war. Of course, men do have the task of initiating boys in their role as warriors.

It may be the exclusion of men from motherhood and their consequent mystification of it, rather than simply the assignment of that role to women, that accounts for the peculiar behavior of men toward women (see chapters 1 and 2). Is this what underlies the oppression of women, not motherhood itself? Some have even speculated that motherhood is the source of women's power, giving rise to the saying that "the hand that rocks the cradle rules the world." Either position suggests that motherhood and power are closely intertwined.

The Cultural Shaping of Biological Events

Attitudes Toward Pregnancy
Our emotional state, attitudes, and reactions to our social environment can all influence the way we experience any physiological process. How women experience pregnancy, for example, will depend in part on whether the pregnancy was wanted or unwanted, planned or unplanned. It will also depend on the social support system we have, our attitudes toward motherhood, perhaps our relationship with our own parents, and perhaps with the father of the expected child. And it will depend on whether this is our first pregnancy, on the nature of our previous experiences, and on our expectations.

Pregnant women must adjust simultaneously to both physiological changes

(in hormones and body shape and weight) and changes in self-perception. These adjustments will be affected by often dramatic changes in other people's reactions to us. If our pregnancies are received with social approval, as when we are eagerly expected to produce heirs, we may get flattering extra attention at this time. If our cultures define pregnancy as a vulnerable, fragile, or even polluting state, we may feel anxious, isolated, or undesirable. In our society, it has been shown that men's attitudes toward pregnant women are often filled with conflict. Not infrequently, men living with pregnant women feel competitive and will become particularly active in producing something creative themselves (Bittman and Zalk, 1978). Some men feel not only envy but rage; the "battered wife syndrome" may start with pregnancy.

Most societies have sets of rules and beliefs which dictate how a woman ought to feel and act during pregnancy. Depictions of pregnant women in painting and sculpture are found as far back as early antiquity, probably the paleolithic era. Current interpretations suggest that they represent the notion of fertility, and that pregnancy was a desirable, even venerated state.

In many societies, pregnancy involves numerous taboos such as prohibitions on certain food, or on attending certain rituals or viewing certain events. These taboos are generally interpreted as existing for the protection of the unborn child. The mother's experiences and feelings during pregnancy are thought to affect the health, even the sex, of the child as well as the relative ease of childbirth.

In the middle and upper classes of European society, pregnant women were once secluded from public life; it was thought improper for us to be seen in the pregnant state. Even in this century in the United States, obstetricians advised pregnant women to avoid a variety of activities, including bathing, physical exercise, and sexual intercourse. Today, however, healthy pregnant women in the United States are encouraged to engage in all activities until the last few weeks before childbirth.

Taboos and prescriptions may also apply to the male parent. The Arapesh, for example, believe that the sperm contributes to the fetus's growth; thus, the parents are expected to engage in frequent sexual intercourse so that the father can supply the necessary material for his child's formation during pregnancy (Mead, 1962). Such social beliefs have no obvious relation to the strict biological facts of pregnancy, but they can affect its course through influencing the pregnant woman's emotional and physical state.

There is speculation that modern science will soon have the capacity to eliminate pregnancy altogether. It is now possible to produce fertilization of the ovum in a dish; will it be long before a fetus can be brought to term in an artificial womb? Science fiction (like Marge Piercy's *Woman on the Edge of Time*, 1976) has long considered the possible implications of such a development. Would it help to equalize female-male relations by producing a more balanced parenthood?

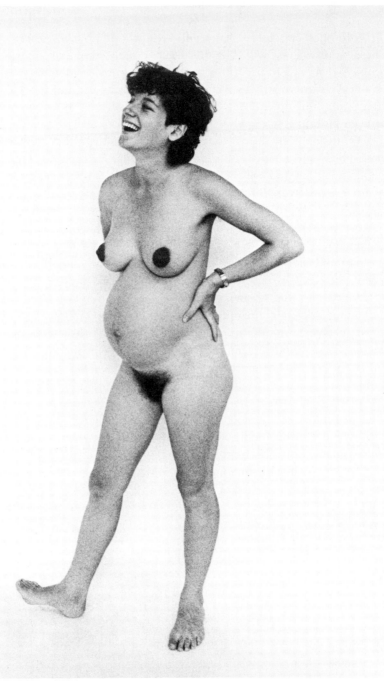

A desired pregnancy may be a source of joy, as it evidently is for the woman in this photograph. (Photo by Jamie Robinson, 1982)

Childbirth: A Cultural or a Natural Event?

Today most American women give birth in hospitals, where the process is monitored and controlled by medical professionals (see chapter 12). Increasing numbers of women, however, have taken an interest in home birth. Many believe that there is something "unnatural" about hospital births and are looking to older traditions to provide a more "natural" model.

For humans, there is really no such thing as "natural childbirth." Every society has beliefs which provide the basis for expectations, attitudes, and practices that shape this event. It is culture that informs women and other participants at birth about what should be done, who should do it, and how. Our culture relies on medical practitioners to intervene in childbirth. Many societies take a more positive and relaxed attitude than our own, allowing women more scope for personal preferences in birthing (Jordan, 1978), although this is not invariably the case.

Typical American birth procedures are unusual in a number of respects. Women in hospitals generally give birth lying on our backs (for the convenience of the obstetrician), but more common delivery positions elsewhere in the world are kneeling, sitting, and squatting. There is ample evidence that these positions facilitate delivery. Hospitals rarely allow friends and relatives to attend births, as they get in the way of the hospital staff; if anyone is admitted, it is likely to be the father of the child. But elsewhere, birthing women are attended by female kin and neighbors as well as midwives; rarely are strangers admitted. Husbands often play a key role, whether in direct assistance to the birthing woman or indirectly, through prescribed rituals. By contrast, American fathers typically have fairly little to do, and the key roles are played by strangers.

Finally, hospital births suggest that birthing should be viewed as a medical event, with associations of illness. Other societies vary greatly in their attitudes, ranging from beliefs that childbirth is dangerous or defiling to beliefs that it is a blessed achievement. Where childbirth is considered a normal and positive event, it appears that women experience less trouble and pain than elsewhere (Newton and Newton, 1972). It is worthwhile considering whether the experience shapes the attitude or the attitude shapes the experience.

Childbirth, then, is an event shaped by culture. More importantly, for our purposes, it is an event heavily influenced by more general social attitudes toward women, attitudes which have a significant political component. The history of the "natural childbirth" movement illustrates this.

Judith Triestman (1979), an anthropologist and trained midwife, places the rise of the natural childbirth movement in the framework of social concerns about decreases in rates of childbearing. Toward the end of the nineteenth century in England, the birth rate began to decline, and more and more single middle-class women went to work outside the home. At the turn of the century, the Boer War made many public figures aware of the poor health of

the lower classes and conscious of the fact that the healthier middle classes were producing fewer potential soldiers than the lower classes. This alarm increased with the enormous death toll among young men during World War I. Nonetheless, the women of the middle classes showed no inclination to reverse the declining birth rate.

There was a parallel concern about birth rates during the latter part of the nineteenth century in the United States. Concern was expressed that the white middle class would soon be swamped by the poor, particularly by blacks and the large number of immigrants from Eastern and Southern Europe who were entering the country. Birth control for the middle class was viewed by such alarmed and racist observers as race suicide. Middle-class white women were exhorted to have more babies to preserve their race and even "civilization" itself, which was equated with white middle-class culture (ibid.; Gordon, 1976).

In order to encourage middle-class women to have babies, men in politics and the clergy tended to glorify motherhood: it was a woman's duty to have babies. While in earlier times such spokesmen counseled resignation to the pain of childbirth, "Eve's curse" (see chapter 1), medical experts now sought to reassure women. Pain could be eliminated with ether or with other drugs. At the same time, childbirth itself was promoted as "naturally" desired by women, an exalted state which should not be missed.

The two messages were contradictory. The early form of the natural childbirth movement, started by Grantly Dick-Read in England, resolved the contradiction. Dick-Read believed that the pain of childbirth was merely the result of culturally induced fear; if women were not afraid, they would not feel pain. He opposed the use of anesthesia, which he thought denied women the supreme joy of the childbirth experience.

The idea of natural childbirth was transformed by French and Russian physicians between the 1930s and the 1950s. Both countries suffered tremendous population losses in the First and Second World Wars, giving them impetus to encourage higher birth rates. In the Soviet Union, ideas about behavior-conditioning led to a new approach to childbirth. "Prepared childbirth" involved mental concentration so that women could control our awareness of contractions as pain before we experienced them. We would learn how to recognize "stages" of labor, how to interpret these levels of sensation, and how to concentrate on different methods of breathing to manage our responses to each stage. A French doctor who was sympathetic to such ideas eagerly adopted the approach. This was Dr. Fernand Lamaze, whose name is commonly associated with prepared childbirth in the United States.

In America, the Lamaze method was popularized by several authors, particularly Marjorie Karmel, who in *Thank You, Dr. Lamaze* (1965) wrote a testimonial to its effectiveness, and Elizabeth Bing, who wrote an instructional manual, *Six Practical Lessons for a Easier Childbirth*, during the

1960s. It began very much as a liberal middle-class phenomenon and to a great extent remains so.

In effect, then, there is nothing particularly "natural" about "natural child-birth," despite its emphasis on avoidance of anesthesia. The very concept of natural childbirth has changed as cultural and social needs have changed. Today it is leading to yet new developments. Triestman (1979) points out that many American women first learned about the importance of self-determination and the role of the larger social context in our private lives through our experiences in the natural childbirth movement. Group sessions in prepared childbirth encouraged us to speak to one another and to publicize our experiences. The increased awareness that resulted from the movement led to greater demands for individual, private control of childbirth and a gradual drift away from the ritualized dogma once taught in prepared childbirth classes. The current resistance by many women to standard hospital routines and the growing popularity of home births, or birthing in those hospitals where midwives assist, are two manifestations of these new trends.

Breast-Feeding: Attitudes and Choices
Political and cultural factors also affect breast-feeding practices. These factors shape both the biological aspects of lactation and the treatment and welfare of babies. Women who have positive attitudes about breast-feeding and are supported by our social environment are more successful at it, for stress and distractions can interfere with a mother's production of milk. If mothers can afford a reasonable substitute, such as a safe and nutritious formula, and our infants can tolerate such a replacement, the children generally suffer no deleterious consequences. But many women throughout the world cannot afford an adequate substitute, with the result that children suffer from malnutrition and other illnesses.

Most women at most times in most parts of the world have had no choice: breast-feeding was the only way to nourish infants. Work did not interfere with breast-feeding: mothers simply brought our infants with us wherever we went. There was considerable variation in style, however. In some societies, like that of the Kalahari desert dwellers, babies were nursed all day at short intervals of less than an hour apart. American mothers today are generally advised to schedule nursing at intervals of two to four hours. In many societies, children are nursed for three or four years; most American breast-fed babies are weaned some time during the first year of life.

Substitutes for breast-feeding do have a long history. In the Athens of Pericles, in imperial Rome, in France during the reign of Louis XIV, and in early eighteenth-century England, wealthy women had an option other than nursing: the use of wet nurses, who breast-fed other women's infants. Poor and urban working women in Europe also used wet nurses at various times, and in the nineteenth century, there were attempts at bottle-feeding.

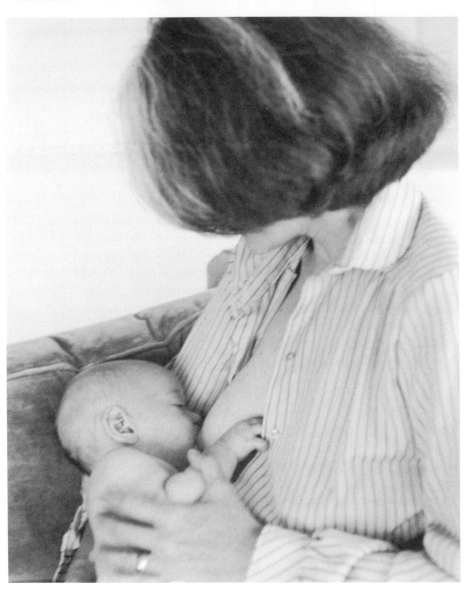

For some women, the experience of breast-feeding is physically and emotionally satisfying. (Photo by Richard Zalk)

In this century, however, it was women from the prosperous middle class who first led the way in giving up breast-feeding and then later reversed the trend by taking it up again. At the turn of the century, 90 percent of American mothers breast-fed. By mid-century, the number had dropped to 12 percent. But in 1966, it had risen again to 20 percent, and that upward trend has continued (McCary, 1973). Similar patterns were found in Europe (Newton, 1968). Among poor women, the decline in breast-feeding came later and has not reversed itself. And in the low-income nations of the world, the decline in breast-feeding has begun more recently and is continuing.

When breast-feeding first declined in the United States, infant mortality rates went up. Concerned health-care officials here and in Europe waged campaigns to encourage women to breast-feed and to penalize women who did not (Brack, 1975). While it is difficult to reconstruct all the factors that led to the decline at that time, it is not so difficult to see what is happening in today's less-developed nations. Ambitious advertising by baby-formula companies has encouraged many uneducated and insecure women to switch to bottle-feedng, which they then may be unable to afford to keep up at adequate levels. These companies supply free samples to new mothers and promote the idea that their formulas are better for the babies' health. Counter-campaigns to encourage breast-feeding do not include the establishment of places for mothers to nurse in public or at work. Poor women are especially vulnerable to commercial sales propaganda for formula because we often must work out of the home for wages. Frequently we are forced to water down the formulas to make them go further, which deprives our children of nutrition. In the meantime, we have lost the ability to breast-feed.

Women receive all sorts of conflicting messages regarding breast-feeding. On the one hand, American mothers may be told that our own milk is best for our babies. On the other hand, our culture shuns nursing in public and sometimes treats the nursing mother as a social outcast. Furthermore, American women are taught to think of our breasts in erotic terms; husbands have even expressed resentment and jealousy at having to share their wives' breasts with a new infant. There is some evidence that less autonomous women, who feel less in control of our lives and more subordinate to men, are less likely to want to breast-feed than more autonomous women (Brack, 1975). But even autonomous women usually cannot bring our babies to work, and middle-of-the-night feedings can wear out the strongest of women. Someone else in the family can give the baby a bottle, but not a lactating breast.

Some women resent the idea of being tied down to a nursing schedule or feel that breast-feeding is uncomfortable and exhausting. Others find the experience sensually and emotionally gratifying. Should it not be possible for women to make a choice concerning breast-feeding, as well as childbirth, not on the basis of stereotypes and cultural strictures, but to suit our own personal beliefs, desires, and circumstances?

Mothers and Others: Support Systems

Motherhood is a social institution both in the sense that it is a creation of society and in the sense that it normally is a collective effort. Bringing up a child usually involves some degree of cooperation between mothers and other people, including perhaps the child's father, our own parents, our siblings, our other children, and our friends and neighbors. Some of the roles that these others play may be socially prescribed; some vary with personal preference and individual circumstances.

The Western industrialized world, particularly its middle class, emphasizes the nuclear family, mobility, and domestic privacy. As a result, mothers of young children are often subject to extreme isolation, especially if we live in suburbs. Isolated motherhood can be an alienating experience for women, and our own alienation can lead to emotional problems for our children (Bernard, 1974). Women who are single parents, whether through choice or as a result of divorce, desertion, or widowhood, may experience isolation similar to that of the suburban married mother as a result of similar social conditions.

However, such isolation is neither typical of other parts of the world nor historically characteristic of motherhood. Far more often, mothers of young children receive practical and emotional support from various sources, including fathers, other women, and the community at large.

Fathers

As Margaret Mead pointed out in *Male and Female* (1949), human fatherhood is culturally variable, but it is also universal. That is, every known human society has "some set of permanent arrangements by which males assist females in caring for children while they are young." In some societies, such as the Arapesh, mentioned above, the father's nurturing role is believed to begin during his wife's pregnancy. In some societies, fathers undergo a ritual version of childbirth, called *couvade,* where they imitate (and sometimes claim to feel) the pains of labor and childbirth, and later observe a variety of postpartum taboos. In other societies, fathers are kept at a distance until their children are older, but they contribute to the material support of children and mothers.

In addition to the considerable cultural variation in the kinds of support fathers are expected to give, there is also considerable personal variability. Many fathers in the United States today, for example, are playing a much greater role in the daily care of their small children than fathers normally did a generation ago. The trend toward greater participation of fathers in all aspects of child-rearing suggests that the ideal of equality in parenting is not just a utopian dream. On the other hand, current research shows that fathers living apart from their children contribute little to their support, and this

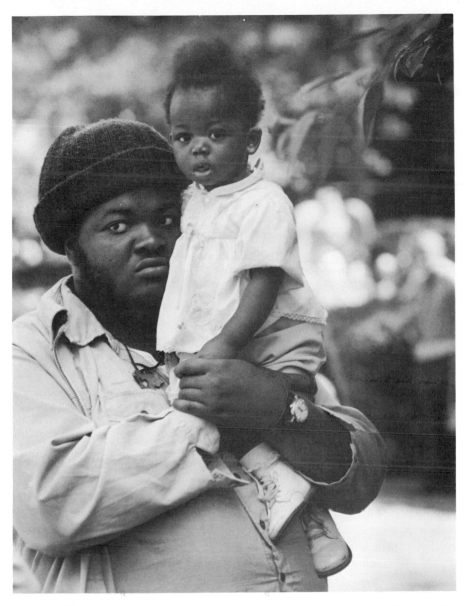

Fathers are nurturers too. Given the opportunity, many men enjoy caring and loving roles. Feminists have encouraged the idea of equal parenting as beneficial for both generations. (Photo by Jean Shapiro)

neglect is evident regardless of income. Sixty percent of such fathers with earnings below $5,000 pay nothing, and 52 percent of these fathers with incomes of more than $10,000 pay nothing. Overall, the total monetary contribution which American fathers make to support their children not living with them averages only 2 to 5 percent of their income (Bergmann, 1981).

Women's Networks

Most American mothers get some support from the fathers of our young children. Many may feel the lack of support from other women. Traditionally, female support networks, primarily kin, were extremely important to mothers. This continues to be the case among many black families in the United States today, particularly those who live in poverty (Stack, 1975). In many societies, mothers of young children could turn to our own mothers, to our sisters and other kin, and to our female friends. This network of women not only helped us by caring for our young children while we worked, attended to the needs of our other children, or even took a little time off, but it also helped us to learn *how* to be mothers. Our female support network might provide us with advice, sympathy, and emotional support or just necessary adult companionship. Today, it is not uncommon for mothers of young children in the suburbs and the cities to form networks of similar women to take the place of the traditional female support systems to which we no longer have access.

Female health-care professionals are also part of the female support system. Traditionally, women would be attended by a female professional, usually a midwife, during pregnancy, childbirth, and the postpartum period. Today, childbirth tends to be dominated by male obstetricians, but increasing numbers of women are choosing instead to use female midwives whose approach is more "supportive" than oriented to medical intervention. Many women continue to get advice and guidance after childbirth from females who are nurses.

Community Support

Unlike kin-based support systems, institutionalized community support in the form of day care is a fairly recent phenomenon. In some countries, institutionalized group support for child-rearing is an ideological issue. The traditional private nuclear family, for example, may be frowned on as antithetical to true socialism.

Institutionalized day care may be as much a practical as an ideological issue, although the two are closely related. That is, if all adult members of society, including mothers of young children, are to be employed outside the home, regardless of the "approved" family form, children must be cared for by people other than mothers. In many industrialized countries other than

our own, including capitalist ones, day care tends to be provided on a systematic basis.

As child care moves from the private family sector to the public sector, questions about the rights and responsibilities of mothers, and of others toward mothers, are fought increasingly in the political arena. If mothers depend on others, what are our rights and obligations? In a rapidly changing world, the old answers no longer seem to apply.

Choice and Control

Because motherhood inevitably involves the interests of more than one person, it is not surprising that it has never been a strictly private matter. Who should decide whether, or when, or how often women should have children, or if and how we should bring them up? If the interests of women, our families, communities, and others appear to conflict, resolution of these questions is difficult and complicated. Feminists have long protested against the traditional denial to women of rights to control our own bodies and lives. Recent developments, and new legal decisions, have brought to light past abuses of women's rights and possible directions of future change.

Whether, When, and How Often to Become a Mother

It is sometimes hard to remember that reliable birth control is a very recent phenomenon. In the past, the question was rarely whether or not to become a mother at all, but rather how often and at what intervals. Too many children too close together caused problems for women and our families, particularly where resources were scarce. In some societies, an extended ban on postpartum intercourse, or on intercourse while women were still breast-feeding our last infants, contributed to spacing pregnancies. Societies have had a variety of practices for abortion of unwanted pregnancies, although these may have been relatively ineffective or quite harmful. In some cases, women resorted to infanticide as a more or less acceptable way of limiting the number of children.

Only in this century has considerable effort gone into the development of safe and effective contraceptive devices. The majority of these devices are for women's use, not men's. To the extent that there is risk or discomfort involved, it is largely women who bear the burden. On the other hand, to the extent that there is choice of and responsibility for birth control, these devices emphasize the woman's role.

Despite the imbalance in responsibility assigned to women and men for having or not having babies, there has been a history of legal obstacles to our control over our own reproduction. In England, the first laws banning abortion altogether were passed in 1803; the Catholic church banned abortion for its communicants in 1869. In the United States, abortion up until "quickening," or the second trimester of pregnancy, was legal in most states until the

middle of the nineteenth century. After the Civil War, many states outlawed abortion entirely. In 1873, as part of a new restrictive attitude toward sexual expression ("social purity"), the federal government passed the Comstock Law, which banned dissemination of pornography, methods of abortion, and all means of preventing conception (Gordon, 1976).

Efforts to open birth control clinics in Europe and the United States in the late nineteenth and early twentieth centuries were met with strong state and church opposition. The depression of the 1930s, when economic conditions discouraged large families, resulted in the loosening of restrictions on birth control in the United States. By 1940 every state except Massachusetts and Connecticut had legalized the dissemination of contraceptive information. Family planning clinics, some publicly funded, began to be established. In 1964 the Supreme Court held that an individual's right of privacy encompassed the right to make decisions on whether to conceive children and, therefore, to have free access to contraception. Elsewhere in the world, countries that are predominantly Catholic still outlaw use of contraceptive devices. Other countries, concerned about severe poverty in the midst of a rapidly expanding population, have made it official policy to encourage contraception, as in the case of India and of the People's Republic of China.

In order to make a choice, women need not only legal backing and access to technical devices but full knowledge and awareness of the options. Social conditions have not fostered an atmosphere conducive to real choices. Rather, women have been pressured to become mothers from early childhood on. Motherhood has been praised and exalted by women and men alike; its anxieties, its costs, and conflicts were rarely made clear to young girls. Traditionally, men could divorce women for barrenness; women who depended on husbands for economic support and protection had no choice but to try to become mothers.

Today, some women ask themselves honestly whether they want a child (Klepfisz, 1977). More and more women have indeed become aware of the options available to us and are making choices with regard to birth control. But the question of the rights of others remains an issue. It can be argued, for instance, that if the father of a child is legally responsible to contribute to its support, he should also have a say in birth control. Should the father be able to insist upon, or prevent, an abortion? Should this be true for a pregnant woman's parents if the woman is a minor and unable to support a child? The U.S. Supreme Court said "no" to both these questions in 1964, but these issues continue to be debated.

Because women now tend to bear most of the responsibility for using birth control devices and for our own childbearing, it seems logical and just to place the right to determine control over childbearing in our hands. This does not, however, dismiss the fact that child-rearing should be a cooperative endeavor, for while it takes only two to conceive a baby, it often takes many

more to bring up a child. The commitment of others, including the father, is not simply financial but often moral and emotional. While there are no legal obligations on women to take these matters into account, the ethical issue remains. Should women, *before* we become pregnant, have the agreement of others whom we expect to participate in rearing the child?

Control Over Children

While women in the past were obligated, for the most part, to bear children if we could, the extent to which we had control over our children once they were born was quite variable. Patriarchal societies have viewed children legally as well as by custom as the "possession" of their father and his kin group, and these relatives have determined how children should be raised, taught, married, and employed. Often this kin group was not formally obligated to consult or even inform the children's mother about decisions that had been made for them. If women left our husbands, we were often obliged to leave our children as well. This was true in Victorian England, for example, until the 1850s, when laws made it possible for women to claim physical custody over children under seven years old. In the United States the issue has been dealt with on a state by state, case by case basis. In the twentieth century, women were generally able to win legal custody; courts in the United States ruled, until recently, that mothers should have custody of our children if our marriages ended in divorce. In recent years, some states have made custody decisions that reflect a changing view of the best interests of the child. A father who wants custody no longer has to show that the mother is morally unfit to have custody (mentally ill, alcoholic, "immoral") but only has to argue why his custody may be better for the children. Judges now exercise greater authority over what the "best interests" of the child or children require. The women's movement and concurrent rethinking of parental roles have led more fathers to seek physical and legal custody of their children, and more judges have awarded them such custody. Another recent development is the increasing number of cases in which parents agree to have joint custody of children.

Lesbian mothers have generally not fared well in the courts. Some judges have held that a woman who is a lesbian is by definition an unfit mother, and have flatly denied custody. Other judges have held that custody requests by lesbian mothers must be examined case by case, in some instances deciding that it is in the best interest of the children for the mother to have custody. The tendency in the courts has been to remain intolerant of nonheterosexual preferences and to grant custody to lesbian mothers only on condition that we not live openly in a lesbian relationship.

Poor women often find our rights to our children denied by the courts in the United States. Abuse and neglect laws, designed to protect children, ironically have often been used as weapons against poor (and frequently minority)

women who have not in fact neglected or abused our children. In many instances, mothers have been charged with neglect or abuse of children because of the condition of our homes (too crowded, too dirty) or because a social worker disapproves of our methods of child-rearing (often stemming from a different cultural background). In some cases, a child is placed in "temporary" foster care that sometimes lasts until she or he reaches adulthood. Occasionally, children are taken from the mother and adopted by someone else, permanently cutting off all ties with the mother. Poor women are often unable to fight the actions because of inadequate or nonexistent legal help.

Questions about our rights to keep and make decisions for our own children are sometimes related to our financial responsibility and that of others. Are mothers legally responsible for the economic support of our children? If a father is present, is the mother exempt from that responsibility? Traditionally, the father was responsible, but laws holding *only* the father responsible may be unfair. If mothers are to share legal responsibility for the economic support of our children, how are we to get the means to provide it? This brings us to the issue of work and motherhood.

Working for Wages
Although a recent phenomenon, the ideal of full-time motherhood has become so strong that it affects everyone, including poor women who have always worked for wages when it was possible. Thus, women of all classes feel social pressure to keep out of the workplace and stay in the home when we have young children.

These pressures are augmented by additional conflicts. One is the desire on the part of many mothers of very young children not to be separated from them for long hours. For many women, this is a special time of our children's lives, which we cherish and enjoy. We want to be present during the day, to teach our children and watch them grow.

And yet economic realities often conflict with social ideals and personal preferences. Today vast numbers of mothers of young children must work for wages in order to help support our families. Many are single parents. Others live with the children's fathers or with other adults but need at least two incomes to get by. And still others feel that despite the attractions of spending time with our children, we cannot afford to take time out from our careers or education. All these women who must be away from home face major obstacles. Two will be considered here: job discrimination and lack of day care options.

It is not unusual to find job discrimination against mothers, even where discrimination against women in general is not so apparent or clearcut. Women commonly report losing our jobs when we become pregnant, although this is now illegal discrimination. As yet, few women in the United

States get paid maternity leave. In some jobs, women who have babies are obliged to take leave without pay whether or not we want it. Some women return to find our jobs filled by someone else.

The most serious problem for working mothers in America today is day care for our young children. As we have noted, many industrialized countries provide government or industry-sponsored day care and family allowances. Trained caretakers look after children as a matter of course while mothers are at work. In the United States, federal, state, and local-level organizations have made some efforts to establish day care centers, but these are rare and limited. Community-led cooperatives provide an option for some mothers, while others resort to private day care centers at a fairly high cost.

Those who can afford full-time employees to tend to children at home often find that few qualified people are interested in doing this kind of domestic work. Some mothers are fortunate in having close relatives, often our own mothers, available and willing to look after the children while we work.

The shortage of acceptable day care options in the United States hurts children most of all. Sometimes mothers have no choice but to place our children in substandard facilities, or we are obliged to give up or refuse employment, to go on welfare, and to subsist on a marginal income at best. Failure to provide adequate day care facilities discriminates against women, keeps us weak and dependent, and perpetuates gender inequality.

Making real choices, not only about whether and when to become a mother, but also *how*, such as how much time to spend with children, and what to do with them during that time, depends in part on having the right and opportunity to choose to work, or not to work, for wages. This issue, like birth control, is very much affected by public policy. Public welfare policy has fostered the traditional arrangement in which mothers stay home to care for our children. If we have no other means of support, we are usually entitled to receive welfare payments, at a subsistence level, until our youngest children are eighteen years old. Some states have introduced "workfare" provisions, requiring the mothers of school-age children to work for these payments; other states allow mothers to supplement welfare payments by working and provide work-related expense money and child care payments to help us.

Women are becoming increasingly aware that motherhood is a political issue, involving power relationships and political action. While this has been the case all along, it has been difficult for many people to see the connection because motherhood has generally been regarded as a private, personal, and family matter. Many of the central political issues concerning motherhood are now being fought in courts and legislatures in the United States. For example, should women share control over our reproductive capacity? How much of a role, if any, should others than the mother play in raising children?

Who should accept responsibility for providing basic necessities for the next generation of citizens: the parent(s) only or the whole society also?

Images of Motherhood

As a symbol, motherhood conveys a wide variety of meanings, ranging from patriotism to sexual virtue. Images of mothers, depicted in myth, art, and literature, are often of central importance in teaching women and men their respective roles in society. And yet there has been surprisingly little investigation of the symbolic aspects of motherhood, particularly in historic times and in cultures other than our own. We will draw from the more recent Western heritage to provide some examples of the treatment of motherhood in art, literature, and commercial media.

Perspectives: Who Creates the Image?

Images project and convey the ideas of their creators. The creators of imagery of mothers have been predominantly people looking at motherhood from a child's point of view, rarely from a mother's. Why do we rarely see motherhood from the perspective of mothers ourselves? One reason is obvious: most of the professional image makers (such as writers and artists) have been men. When a male artist or writer depicts motherhood, he draws from his experience as a son or other observer of mothers. In addition, mothers are usually very busy people, with little privacy, time, or freedom to paint or write (Olsen, 1978). Still, there have been women artists and writers who were also mothers; why have we written so little about our experiences of motherhood? Poet Adrienne Rich sees this as a consequence of the social devaluation of women and our experiences. Motherhood has been so trivialized and stereotyped that even artists and writers who are mothers have not estimated our experiences as worthy of literacy or artistic attention. "Once in a while someone used to ask me, 'Don't you ever write poems about your children?' The male poets of my generation did write poems about their children— especially their daughters. For me poetry was where I lived as no one's mother, where I existed as myself" (Rich, 1976).

While as mothers we may not consider maternal experience as something to write about, we as children often do. As adults we repeatedly turn our attention at crucial stages of our lives to the individuals who played a pivotal role in our earlier development: our mothers. We look backwards to place blame or praise, to feel guilty about or angry at or proud of the first object of our emotional engagement: our mothers.

Daughters' explorations of our relationships with our mothers are a relatively new phenomenon in Western literature (box 8.3). The relationships of sons with their mothers have received considerably more attention. To illustrate, we can examine two powerful Greek myths which appear in poetry

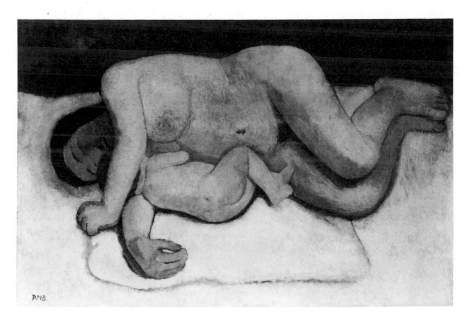

How do mothers see themselves? In her painting "Mother and Child" (1907), Paula Mondersohn-Becker (1876–1907) portrayed the sensual intimacy of which some mothers speak when they examine their personal experience of motherhood. (Nationalgalerie, Berlin [loaned by Staatliche Museem Preussischer Kulturbesitz, Berlin])

created by men more than twenty-five hundred years ago. The two stories deal with extreme forms of sons' feelings toward their mothers. One son loves his mother too much, the other too little. The "loving son" is Oedipus. Without knowing who his natural parents were, he murdered his father and subsequently married his mother and had four children by her. When he discovers that he has committed incest and patricide, he is tortured by guilt and blinds himself. The son who is deficient in love is Orestes. To avenge his father, Orestes murders his mother (his father's assassin). He, like Oedipus, is tormented by a guilty conscience. The gods then invent the first court of law in order to try the case of matricide. Two great Olympian gods declare that a father is more truly a parent than a mother, and Orestes is acquitted. The myths illustrate a more general theme: sons must disassociate themselves from their mothers and identify with their fathers, or pay an enormous penalty.

Male authors of the twentieth century, heavily influenced by Freudian theories, write in a similar vein of the destructiveness of their mothers' seductive and engulfing love, of conflicts of interest between growing sons and overpowering mothers. This literature depicts mothers as emasculating and possessive, dangerous and antithetical to adult maleness. Only by overpower-

Separation and Autonomy Box 8.3

I closed my eyes and breathed evenly, but she could tell I wasn't asleep.

"This is terrible ghost country, where a human being works her life away," she said. "Even the ghosts work, no time for acrobatics. I have not stopped working since the day the ship landed. I was on my feet the moment the babies were out. In China I never even had to hang up my own clothes. I shouldn't have left, but your father couldn't have supported you without me. I'm the one with the big muscles."

"If you hadn't left, there wouldn't have been a me for you two to support. Mama, I'm sleepy. Do you mind letting me sleep? I do not believe in old age. I do not believe in getting tired." . . .

. . . "There's only one thing that I really want anymore. I want you here, not wandering like a ghost from Romany. I want every one of you living here together. When you're all home, all six of you with your children and husbands and wives, there are twenty or thirty people in this house. Then I'm happy. And your father is happy. Whichever room I walk into overflows with my relatives, grandsons, sons-in-law. I can't turn around without touching somebody. That's the way a house should be." Her eyes are big, inconsolable. . . .

The gods pay her and my father back for leaving their parents. My grandmother wrote letters pleading for them to come home, and they ignored her. Now they know how she felt.

"When I'm away from here," I had to tell her, "I don't get sick. . . . I've found some places in this country that are ghostfree. And I think I belong there, where I don't catch colds or use my hospitalization insurance. Here I'm sick so often, I can barely work. I can't help it, Mama."

She yawned. "It's better, then, for you to stay away. The weather in California must not agree with you. You can come for visits." She got up and turned off the light. "Of course, you must go, Little Dog."

A weight lifted from me. The quilts must be filling with air. The world is somehow lighter. She has not called me that endearment for years—a name to fool the gods. I am really a Dragon, as she is a Dragon, both of us born in dragon years. I am practically a first daughter of a first daughter.

"Good night, Little Dog."

"Good night, Mother."

She sends me on my way, working always and now old, dreaming the dreams about shrinking babies and the sky covered with airplanes and a Chinatown bigger than the ones here.

(Kingston, 1976:122, 126–27)

The Woman Warrior: Memoirs of a Girlhood Among Ghosts. Copyright © 1975, 1976 by Maxine Hong Kingston. Reprinted by permission of Alfred A. Knopf, Inc.

ing the mother can the son free himself of infantilism and go forth into the civilized world of adult men. As a metaphor, the assertion of manhood by over throwing the control of a once-powerful mother is similar to the social charter myths discussed in chapter 5.

"The Happy Mother": Painting as Propaganda?

Depictions of mothers, fathers, and children in paintings have a long history in the Western world, but the nonreligious image of the mother in blissful ecstasy as the center of domestic life was an innovation in French art in the eighteenth century (Duncan, 1973). This image, first exemplified by Greuze's painting *The Beloved Mother* (1765), portrays marriage and domestic life as a major source of happiness, not simply as a legal and economic structure. The new emphasis on personal happiness and the elevation of maternity to an exalted state challenged earlier assumptions about marriage, families and children. The new style in art represented a shift in attitudes that accompanied economic and social changes in the eighteenth century.

It was during this period that modern bourgeois culture began to take shape. Growing numbers of people could achieve social mobility through their own personal efforts in the commercial and professional world. Chance and heredity had less to do with one's success in life. The environment of the home for educating and forming children took on increasing importance. Parents were now assumed to be responsible for what happened to their children and were required to focus more attention on their health and happiness. The rewards for parents, it was assumed, were the simple gratifications of domestic bliss.

The contrast between public and private life came to be emphasized as economic enterprise moved out of the home and into the marketplace. The home was seen as a haven of warmth and comfort, in contrast to the harsh competitiveness of the business world. The home was a place of protection and a place to be protected. Women were responsible for making the home a warm and happy place as well as for the health and welfare of our children. It was assumed that motherhood itself was natural for women and that we derived great pleasure and fulfillment from devoting ourselves to the tasks of child-rearing and homemaking.

The eighteenth-century paintings convey a clear moral message. They tell women and men that women should be ecstatically happy in the home, making babies. They say that men's responsibility is to help women find happiness by keeping their wives at home with plenty of children. And they suggest that for women to feel or wish otherwise is unnatural. This early form of media propaganda finds expression today in women's magazines, television, and advertising.

"Ethnic" Mothers and Social Mobility

The United States, a nation comprised largely of immigrants, has displayed an enduring fascination with ethnicity. The literature of the twentieth century is replete with ethnic and racial stereotypes. Among these stereotypes, two female figures are particularly striking as peculiarly American phenomena: the "Jewish mother" and the "black mother." Both are familiar to Americans through literature, movies, and television; the stereotypes depicted in the public media have also been the object of study in the scholarly literature of sociology and psychology.

The stereotypic Jewish mother in literature has undergone dramatic changes that correspond to changes in the Jewish family itself in American society during the century. As the family and its social position have changed, the image of the Jewish mother has shifted from an object of veneration to an object of ridicule (Bienstock, 1979).

The first depictions of the American Jewish family, Bienstock argues, were written by men whose parents immigrated from Eastern Europe from the 1880s to the 1920s. In the "old country," Jewish families had often (though not always) lived in *shtetls* (small villages and towns) dominated by their cultural traditions. The roles of wife and husband were clearly defined: wives were responsible for the material welfare of families, and husbands were, ideally, pious scholars. While men studied and prayed, women might run small businesses to support the family.

In the New World, the system of roles and status underwent a change. Immigrant families, poorer than ever, continued to rely on the strong and practical housewife for material support, but the prestige of the pious scholar was left behind; the husband and father, often seen as unfit for the hard labor of the sweatshop, suffered a great loss of dignity and self-esteem. Sons depicted Jewish mothers of this period as supporters of traditional family values and respect for the father and as self-sacrificing protectors of the children.

Gradually, Bienstock continues, the situation of the family changed. Mothers, caught between cultural traditions and the practical changes in our lives, served as mediators between husbands and children. The children began to make their way in the New World by adopting new, materialistic values, with their mothers' encouragement. The image of the fathers began to fade; they were depicted as weak, as outsiders, while the mothers became the de facto heads of families, adjusting to necessary changes as we went along. We became increasingly ambitious for our children, pushing them toward upward mobility through education. The children measured their achievements by our yardsticks.

By the end of the 1930s and into the 1940s, Jewish sons began to question the perceived materialistic goals of their mothers, and to rebel. Their liberal bias led them to reject the crass materialism of American life as well as the traditions of their fathers. Their mothers came to represent all that was

wrong with the past and the present. The mothers were now blamed for stunting the sons' emotional growth by overbearing protectiveness and over-weening social ambition. As the sons became more integrated into American society, they became more ashamed of their ethnic and lower-class origins. Their mothers came to represent for them this shameful past, even though the sons had achieved their positions in the American cultural establishment largely through their mothers' efforts to help them obtain education.

By the 1960s, Bienstock concludes, the image of the pushy Jewish mother had become ubiquitous in American literature and the popular media. She had at once become a comic figure and an object of alarm. Freudian theory suggested to these writers that their emotional problems stemmed from their early erotic relationships with their mothers; maturity required breaking away. The Jewish son saw in his mother the primary obstacle to his own maturity and freedom. Turning her into a comic figure was a way of reducing her imagined power. In effect, it was also a way of belittling the past, of denying its value and importance.

In an era of rapid social change, when people felt uneasy about undefined roles for women and men, the problem of the Jewish son and his mother held a message comprehensible to a broad range of Americans who could identify with the hostility and anxiety of the uprooted, upwardly mobile son. Although mothers were the immediate targets of the sons' rage, we represented much more. We stood for virtually every social inhibition, every anxiety-provoking element of the past. Recognition of the pain of the American experience was made tolerable through ridicule.

The black experience in America was very different from the Jewish one, and yet there are elements of similarity. Like the Jewish mother, the black mother has been stereotyped. In this case, we address the stereotype pro-moted by black authors, not the "black mammy" stereotype familiar from American movies and novels like *Gone with the Wind*. This stereotype had its roots in the slave experience which, like the experience of immigration, evoked extreme strength and endurance from mothers to protect families.

After slavery, black families were faced with economic survival in America. Racial prejudice virtually barred social mobility for blacks and denied job opportunities in nearly every sphere. Those jobs which were open to men paid very little and offered no security. In order to feed their children, women were obliged to work at low-paying menial tasks.

While black men suffered low esteem and humiliation in American society, black women struggled to keep our families together morally and physically. Black mothers, like Jewish mothers, were seen as the moral backbones of our homes. And, like Jewish mothers, the idealized black mothers "pushed" our children upward, emphasizing education and achievement in our ambition for their future.

The image of the strong, supportive, and protective black mother grew

along with an image of a weak, ineffective black father. Sociological litera-
ture refers frequently to the "matrifocal household" as if it were the product
of slavery or the African heritage; in fact, where it exists it is part of a
survival strategy, an adjustment to contemporary conditions (Stack, 1975).
The image promoted by literature and popular media is that of a strong
mother figure and a weak or absent father figure. As the family becomes
more involved with the mainstream of American life, mothers are more and
more mediators between past and present. We are depicted as the source of
our children's strength. But, already subjected to one attack in the *The Negro
Family* (Moynihan, 1965), the image of the black mother may suffer a fate
similar to that of the Jewish mother. From an object of respect and sentimen-
tal reverence, we may become increasingly an object of anxiety and ridicule.
On the other hand, the strong feminist voices of our black daughters may
prevent that fate.

Motherhood and the Media

An idea of motherhood is "sold" to us along with a variety of commercial
products in the public media. Magazine advertising and television commer-
cials are blatant in the image that they convey of how motherhood "ought to
be." Those who advertise their products are also supporting the magazine
stories and television programs which sell a lifestyle in which the products are
likely to be used; the message in these stories and programs is more indirect,
and perhaps even more effective as a result.

Television programs do not feature women as much as men; only 20 to 40
percent of all figures on television are women. Women appear more in come-
dies than in any other form of television program. Two out of three women
on television are depicted as wives, while few men are depicted as married.
Most women on television are represented as incompetent. We nearly always
fall into the categories of sex object, housewife, or mother. Twice as many
women as men are shown with children. Seventy-five percent of the advertise-
ments that show women have us in either the kitchen or the bathroom
(Tuchman, 1978).

Since television is a domestic medium, a family pastime, it should not be
surprising that we find motherhood portrayed so frequently on TV. The
image of the television mother has changed over the past twenty years or so,
but it continues to represent a stereotype. One of the early images was that of
the series "I Remember Mama," a sentimental reconstruction of immigrant
Swedish family life in San Francisco based on memoirs written by a daughter.
That mother was gentle, comforting, a moral force, and a hard-working
housewife. The mother image of the 1950s on television was typically a much
weaker figure. Mothers did very little, had few significant anxieties or func-
tions, and were always neat, well-dressed, calm, and eminently middle-class
and suburban. We had no jobs, made no major decisions, and showed few

emotions. We were sexless and characterless. By the 1970s, however, several stronger images began to appear. There were some "ethnic" mothers, including black, Jewish, and Italian women. Some were "liberated" women; some were even divorced. A number of these mothers did voice opinions, have jobs, and display emotions and anxieties about serious problems. But with few exceptions, the characters were unrealistic idealizations playing out exaggerated roles—now as "feminists." Always, these "mothers" achieved a superiority in whatever role they portrayed that the average mother could not attain. Modern television mothers may be "hip," with lives of our own—work, outside interests, sex lives—but rarely do we grow or change. Idealized, we are again trivialized.

Magazines intended explicitly for parents demonstrate most fully what the image of motherhood means in the popular media. Motherhood is marketable; magazine stories and features, like the advertisements that support them, create "needs" by spelling out the requisites of mothering. We learn that the tasks of parenting are still mainly the responsibility of the mother; virtually all the visual images show women with children. The few men depicted are "experts," primarily obstetricians and pediatricians. The "experts" are rarely women ourselves. Mothers are shown as dependent on these experts for constant advice on the most trivial matters. Although the articles purport to be reassuring, they in fact merely emphasize the mothers' helplessness. The stories and articles address such issues as how to select your child's blocks and what to do about thumb-sucking. Although it is frequently suggested that it is normal for mothers to have jobs outside the home, we are not depicted at work. Rather, we are shown attending to our babies' comfort; mother is, above all, a source of physical comfort and protection. The mother is expected to purchase a vast array of lotions, powders, toys, furniture, and gadgets. One company even packages a "breast-feeding kit" with all sorts of equipment for women who may have thought that we were fully equipped by nature.

Do these magazines serve the interests of their readers? By fostering feelings of personal inadequacy and dependency, they serve the interests of the commercial enterprises which sell products and of the medical profession on which mothers now depend for expert advice. The trivial nature of many of the issues the magazines explore means a waste of time to mothers. Yet these magazines claim a readership of over a million each month.

If the public image of motherhood reflects women's social position in general, we must conclude that despite considerable changes in our economic roles during the past generation, little has changed in our social roles. Parenting is not generally assumed to be the equal responsibility of both women and men. Women are still assumed to be mentally inferior, and our vulnerability as childbearers and childraisers continues to be exploited.

Mothers Speak Out

The women's movement has encouraged awareness and self-expression by mothers on the contradictions and conflicts of our experience. Some of this self-expression has taken the form of autobiographical literature. We find such writings as Phyllis Chesler's diary of her first year of motherhood, *With Child* (1979); Jane Lazarre's autobiographical book *The Mother Knot* (1976); and Adrienne Rich's treatise on motherhood *Of Woman Born* (1976), which combines autobiography with search for meaning.

These writers conclude that much of their own agony in their experience of motherhood is derived from the false image held in our society of what motherhood ought to be. It is impossible to live up to the standards that have been set for mothers, so as mothers we are bound to feel inadequate, lonely failures. Ideal mothers love children perfectly; real mothers feel ambivalence toward our children—love, to be sure, but also frustration, resentment, and anger. Part of the conflict results from the isolated position mothers are placed in by society. Emotional problems that might be irritating but manageable become overwhelming when women consider how inadequate are our sources of support (box 8.4).

Some aspects of the pain and frustration of motherhood may be inevitable, but they are magnified by social taboos against admitting such feelings. Past acquiescence in the image of model motherhood has led to a self-destructive silence that these writers hope to break. By revealing our own feelings of conflict, we may help to relieve women of all ethnic groups and classes of the prevailing sense of inadequacy and guilt that seems to impair our enjoyment of the real pleasures of having children.

Most important, however, the women who now write about motherhood "from the inside" contribute to an understanding of mothers as persons rather than stereotypes. While we use, of necessity, the language and imagery current today, we try to convey an idea of mothers as whole persons, not one-dimensional readers of a social script. The point is not that mothers have mixed feelings about our children—and ourselves—but that we have rich and complicated lives, with all sorts of pressures and interests which include—but are not completely subsumed by—our children. From the mother's perspective, we see individuality in growth, struggle, and realization of a personal life.

As this new literature accumulates, we may begin to see motherhood as an active and positive force, a part (but not the whole) of some women's lives. While in the past motherhood itself was assumed to be the fulfillment of womens creativity, it may now become a source of expressive creativity of another kind. As women come to value ourselves and our own experiences, we may examine and use our lives in more positive and interesting ways than ever before. In the process, we will replace the inhibiting, destructive constructs of the past with images of our own making.

Carriages and Strollers Box 8.4

My first words as I came from under the ether after I had my son were, "I think I made a mistake." Unfortunately, since then, and one more child later, I've had very little reason to change my mind. This is not to say that children cannot be lovable. It's not them, it's all the foolishness that goes on in the name of them. From the beginning, motherhood took on the complexion of a farce.

To begin with, aside from the indignity of being trussed up like some sort of sacrificial pig in order to be delivered, there was the matter of nursing. I chose to brew my own rather than to spend the next few months encumbered by a slew of rattling bottles. At first the hospital staff were rather sweet and condescending about it. They'd bring me the baby, say something like, "Aren't you a good little mother," and then whip those bed curtains around to screen me from my roommate as if a little infant fellatio was the very least that was going to happen inside my hutch. . . .

I may be more upsettable than most, but during the years I was involved with carriages and strollers and wagons and tricycles, I was always getting bugged. Why wasn't there, even in the children's section of a department store, a high chair so you could deposit your child and spend your money in some sort of comfort? Why did it have to be a major struggle to get a stroller or a shopping cart across a street; would it cost so much to rake the curbs? And why did the entrance to the playground offer the steepest curb of all? Small enough problems, but enough to clue in to the fact that the last people anyone in charge of planning the city is concerned with are mothers and children. (Clark, 1970:63–64)

Summary

Parental roles among humans do not develop by instinct but are primarily learned. We actually know very little about what constitutes maternal behavior. We know even less about paternal behavior and the effect of children on parental behavior.

In American society today, woman's attitudes and feelings are shaped by the prevailing view that motherhood "comes naturally" to us and that it is our full-time job. Women who try to live up to this ideal often experience anxiety, frustration, and isolation. Society institutionalizes motherhood so that it oppresses women, men, and children. More equitable relationships with men may lead to more rewarding forms of motherhood.

Many women welcome motherhood. We have been taught from childhood to expect it, and the pleasures of mothering are very real. However, mothers also serve the interests of business by producing and servicing workers, without pay, and by forming a pool of cheap labor. Women also serve military interests by providing soldiers. Some observers speculate that the exclusion of men from motherhood is a source of their oppression of women.

The way women experience the biological events of pregnancy, childbirth, and breast-feeding varies with personal circumstances and social environment. Sometimes the cultural shaping of these events has a political component, as when natural childbirth was promoted as a means of encouraging women to have more babies at a time of low birth rates.

Mothers have need of the practical and emotional support of others, but the nature and extent of that support differs from one society to another. In many societies, fathers play an active role from pregnancy onward, in others, fathers have little to do with child-rearing. Traditionally, female support networks, especially kin, have been important to mothers. Many countries today provide support to mothers in the form of institutionalized day care.

Feminists argue that women should decide for ourselves whether, when, and how often to become mothers. The choice of and responsibility for birth control tends to be given to women, although a number of legal obstacles have been thrown in our way through the years. In the past, when a marriage ended, women were obligated to yield custody of children to fathers, but in this century we have usually been given legal custody. Today, judges are more likely to award custody on the basis of specific circumstances in accordance with their view of the best interests of the child. Lesbian and poor women often have difficulty keeping our children.

Images of mothers in the past have usually been produced by sons. Comments by daughters have been a relatively recent phenomenon. Mothers have often been too busy to create, or have thought our experiences too trivial to record. Two female figures commonly portrayed in stereotypical ways in literature are the Jewish mother and the black mother.

In the eighteenth century, art began to portray the "happy mother" in scenes of domestic bliss. This theme coincided with the beginnings of modern bourgeois culture, with its emphasis on the warm and happy home in contrast to the harsh workplace.

Today popular magazines and TV programs, commercials, and advertisements often portray women as either home-bound or sex objects. Magazines directed to parents emphasize women's helplessness and capitalize on our desire to be "good" mothers.

Some mothers today are writing about our experiences in order to revise the image of model motherhood that has made so many women feel inadequate or guilty. We are attempting to portray mothers not as stereotypes but as whole persons who lead rich and complicated lives.

Discussion Questions

1. List some of the sources from which an American woman learns how to be a mother.

2. Discuss the impact of advertising and technology on the mother-child relationship.
3. Calculate monetary costs of a child to a mother from the time of conception until the child is about eighteen.
4. What happens to mothers when our children leave the "nest"? Discuss the physical and psychological effects of the "empty nest" on a woman whose whole identity has been as mother (review chapter 4).
5. How would you define the role of grandmother and mother-in-law (hers and his)?
6. The "good and nurturing mother" and the "terrible mother" are important mythic figures. Find examples from literature and popular fiction, films, and folk tales to represent the devaluation and simultaneous exaltation of mothers.

Recommended Readings

Bernard, Jessie. *The Future of Motherhood*. New York: Dial, 1974. A sociologist explores the implications of economic, social, and technological change in our times for the institution of motherhood. She examines new and emerging options for women who choose not to be or to be mothers and considers the social context which affects our choices.

Colette, Sidonie-Gabrielle. *My Mother's House and Sido*. 1930. Translated by Una Vincenzo and Enid McLeod. New York: Farrar, Straus, and Giroux, 1953. This volume by a distinguished French writer is her loving reminiscence of her own mother and a search for beneficient influences she had on Colette's early life. The author depicts the warm, rich atmosphere of the rural home where she grew up—a product, she claims, of her mother's creation.

Kingston, Maxine Hong. *The Woman Warrior*. New York: New York: Knopf, 1976. A Chinese American woman's depiction of her maternal forebears in China and America. Kingston writes vividly of her mother's life as a doctor in China and as an immigrant in the new world. We are provided with an unusual view of mother-daughter relationships in a highly patriarchal cultural setting.

Lazarre, Jane. *The Mother Knot*. New York: Dell, 1976. An autobiographical account of a mother living in contemporary New York. It explores her conflicting feelings about maternity, her child, and her husband. So rarely have women written about ourselves as mothers that books such as this one can be considered a unique product of the contemporary women's movement, which has encouraged women like Lazarre to speak out on such personal and intimate matters.

Rich, Adrienne. *Of Woman Born: Motherhood as Experience and Institution.* New York: Norton, 1976. A controversial examination of motherhood as a social institution and the way that it has evolved from antiquity to the present. The author shows how relationships between women and men are reflected in the institution of motherhood and how concepts related to this institution change with changes in women's status. Rich, a feminist and poet, draws from her own experience as well as the scholarly literature.

References

Angelou, Maya. *I Know Why the Caged Bird Sings.* New York: Knopf, 1969.

Beauvoir, Simone de. *The Second Sex.* 1949. Translated by H. M. Parshley. New York: Knopf, 1953.

Bergmann, Barbara. "The Economic Support of 'Fatherless' Children." In *Income Support: Conceptual and Policy Issues,* edited by Peter G. Brown et al. Totowa, N.J.: Rowman & Littlefield, 1981.

Bernard, Jessie. *The Future of Motherhood.* New York: Dial, 1974.

Bienstock, Beverly Gray. "The Changing Image of the American Jewish Mother." In *Changing Images of the Family,* edited by Virginia Tufte and Barbara Myerhoff. New Haven: Yale University Press, 1979.

Bing, Elisabeth. *Six Practical Lessons for an Easier Childbirth.* New York: Bantam, 1969.

Bittmann, Sam, and Zalk, Sue Rosenberg. *Expectant Fathers.* New York: Dutton, 1978.

Brack, Datha Clapper. "Social Forces, Feminism, and Breast Feeding." *Nursing Outlook* 23 (1975):556–61.

Chesler, Phyllis. *With Child: A Diary of Motherhood.* New York: Crowell, 1979.

Chodorow, Nancy. *The Reproduction of Mothering: Psychoanalysis and the Sociology of Gender.* Berkeley: University of California Press, 1978.

Clark, Joanna. "Motherhood." In *The Black Woman,* edited by Toni Cade. New York: New American Library, 1970.

Dalla Costa, Mariarosa. *The Power of Women and the Subversion of the Community.* Bristol, Eng.: Falling Wall Press, 1972.

Denmark, Florence. "Psychological Adjustments to Motherhood." In *Psychological Aspects of Gynecology and Obstetrics,* edited by B.B. Wolman. Oradell, N.J.: Medical Economics, 1978.

Duncan, Carol. "Happy Mothers and Other New Ideas in French Art." *The Art Bulletin* (December 1973): 570–83.

Firestone, Shulamith. *The Dialectic of Sex.* New York: Morrow, 1970.

Friedan, Betty. *The Feminine Mystique.* New York: Dell, 1963.

Gilman, Charlotte Perkins. *Herland.* 1915. Reprint. New York: Pantheon, 1979.

Gordon, Linda. *Woman's Body, Woman's Right: A Social History of Birth Control in America.* New York: Grossman, 1976.

Jordan, Brigitte. *Birth in Four Cultures.* New York: Eden, 1978.

Karmel, Marjorie. *Thank You, Dr. Lamaze.*New York: Dolphin, 1965.

Kingston, Maxine Hong. *The Woman Warrior.* New York: Knopf, 1976.

Kitzinger, Sheila. *Women as Mothers, How They Seem Themselves in Different Cultures.* Glasgow: Fontana, 1978.

Klepfisz, Irena. "Women Without Children/Women Without Families/Women Alone." *Conditions:Two* (1977):72–84.

Lazarre, Jane. *The Mother Knot*. New York: McGraw-Hill, 1976.

Liebowitz, Lila. *Females, Males, Families: A Biosocial Approach*. New York: Holt, Rinehart, & Winston, 1978.

McCary, James L. *Human Sexuality*. 2nd ed. New York: Van Nostrand, 1973.

Mead, Margaret, *Male and Female*. New York: Morrow, 1949.

———. *Sex and Temperament in Three Primitive Societies*. New York: Morrow, 1935.

Moynihan, Daniel P. *The Negro Family: The Case for National Action*. Washington, D.C.: U.S. Department of Labor, Office of Policy Planning and Research, 1965.

Newton, Niles. "Breast Feeding." *Psychology Today* 2 (1968):34, 68–70.

———and Newton, Michael. "Childbirth in Cross-Cultural Perspective." In *Modern Perspectives in Psycho-Obstetrics,* edited by J.G. Howells. New York: Mazel, 1972.

Olsen, Tillie. *Silences*. New York: Delacorte, 1979.

Piercy, Marge. *Woman on the Edge of Time*. New York: Knopf, 1976.

Pildes, Judith. "Mothers and Daughters: Understanding the Roles." *Frontiers* 3 (1978):1–11.

Reed, Grantly Dick. *Childbirth Without Fear*. 2nd rev. ed. New York: Harper & Row, 1944.

Rich, Adrienne. *Of Woman Born: Motherhood as Experience and Institution*. New York: Norton, 1976.

Rossi, Alice. "A Biosocial Perspective on Parenting." *Daedalus* 106 (1977):1–31.

———. "Transition to Parenthood." *Journal of Marriage and the Family* 30 (1968):26–39.

Sanger, Margaret. *Motherhood to Bondage*. New York: Bantam, 1928.

Stack Carol. *All Our Kin*. New York: Harper & Row, 1974.

Triestman, Judith. "Natural Childbirth: A Millenarian Movement." Thesis, Master of Science in Nursing. New Haven: Yale University School of Nursing, 1979.

Tuchman, Gaye. "The Symbolic Annihilation of Women by the Mass Media." In *Hearth and Home: Images of Women in the Mass Media,* edited by Gaye Tuchman, Arleen K. Daniels, and James Benet. New York: Oxford University Press, 1978.

Washington, Mary Helen. *Midnight Birds*. Garden City, N.Y.: Doubleday, 1980.

9
Choosing Alternatives

COMMUNITIES OF WOMEN
Religious Communities
Educative Communities
Laboring Communities
Support Networks

UTOPIAN AND EXPERIMENTAL COMMUNITIES
Utopian Literature
Experimental Communities
 Nineteenth-Century Utopian Experiments
 Twentieth-Century Intentional Communities
Criticisms of Experimental Alternatives

ALTERNATIVE FAMILY FORMS
Role Reversals
Egalitarian Households
Families of Women
Single Parent Households
Choosing Not to Mother

WOMEN ON OUR OWN
Sexual Freedom
Notes of Caution

Every society has some kind of conventional pattern of family life, a cultural norm for the expected behavior between people defined by the society as "kin." Laws and Schwartz (1977) use the term *scripts* to refer to the behavior and feelings ascribed to culturally defined roles. In their view, the roles of daughter, wife, husband, and mother inform women (the actors) of how we are expected to perform in society. We learn our scripts as we become socialized; that is, as we grow up we learn how we are supposed to act and feel in the various positions we are expected to hold during our lives. But what happens if a person does not feel comfortable, happy, or competent in following the standard script? Most societies, for example, expect adult women to be wives to men; our culture tells us what the script "wife" entails. But some women may not wish to become wives, or having become wives, may wish to get out of marriage, or may wish to play a wifely role which differs from societal conventions. For such conditions, a society may provide alter-

native scripts. Our society has developed such scripts as "single woman," "career woman," and "divorcée" to prescribe conduct for adult women who are not wives. New scripts, being written for patterns that once were more rare but now are common or have taken on a new meaning, are the "dual career" marriage and the "working mother."

This chapter is about institutionalized or "scripted" alternatives to conventional family life. Such alternatives are deviations from a standard pattern, but they differ from personal or individual deviation, which is "unscripted." Anyone who occupies a social role, whether standard or alternative, may deviate in some way or another from the script; perhaps we all do. This kind of deviation may cause the individual to feel insecure, alienated, isolated, or even inferior. For example, it is in the script for married women in our society to feel happy, proud, and fulfilled when we become pregnant. But particular married women may feel very unhappy about our pregnancies. Because such feelings are not in the script, we may believe there's something "wrong" with us. We may experience guilt or shame; we may hide our misgivings or seek professional counseling. Even though many, and perhaps the majority, of women may feel at least ambivalence about our pregnancies, if this feeling is unscripted, it can be considered a deviation rather than an alternative.

Women who select alternative scripts start out as deviators as a result of failing to follow a typical script. We later discover that one or another of the alternative scripts available suits us better. When large numbers of people turn to alternative scripts, the alternatives may become the new social norm.

Whether or not women succeed in alternative roles depends on many things. First, as we shall see, many idealistic and adventurous efforts in alternative living arrangements have failed or been deflected from their original intentions because the participants did not achieve an independent source of economic support. Second, we may find that our intentions run counter to the wishes of others, to whose wills we must submit. If the alternative arrangement was designed by men, or even by women and men, for purposes other than the provision of a satisfying life for women, it may prove to be even more oppressive for us than the traditional life it seeks to replace. Finally, the new scripts may be fully satisfying in a variety of ways but so shaped that they can be only a temporary refuge from the ongoing demands of a woman's life.

The scripted alternatives to conventional family roles and lives are extremely diverse. This chapter is concerned mainly with the options that women have shaped for ourselves, with ways of living that we have chosen, or designed, or dreamed of—although in many cases the outcomes were influenced by external forces. In this chapter, we begin with considerations of different types of communitites of women—religious, educative, work-oriented, and supportive. We then turn to nonconventional communities of

women and men, both utopian dreams of communal organization and actual experiments in communal life. We will then look at families that retain some features of conventional family life but whose members have reshaped roles by choice. These include role reversals, egalitarian households, families of women, and single parent households. Finally, we consider the lives of women who choose to be on our own.

Communities of Women

Many of women's options have flourished best when we have grouped together to form our own communities. In the absence of men, we have been able to do work otherwise denied us. Free from the service required of wives and mothers, we have been able to develop careers and skills requiring our full attention. Finally, communities of women sharing common values and interests have provided incomparable moral support and companionship, a support many women need when embarking on new ventures in a sometimes hostile environment.

Religious Communities

Buddhist and Christian orders of nuns have enabled sizable numbers of women to live outside the boundaries of the family circle. Christian convents are found on every continent. In 1975, there were 359 Roman Catholic orders in America alone and innumerable convents of these orders of Christian nuns (Bernstein, 1976). Christian convents go back to the fourth and fifth centuries in the Mediterranean area and, like the churches to which they are attached, have had a complex and varied history. Buddhism also has a long history of monasticism for women, with a parallel geographical extent in the East and a comparable complexity (Falk, 1980).

In their pristine form, both Buddhism and Christianity are turned intensely toward an otherworldly vision. They are indifferent to the social institutions of this world. This attitude provides the basis for monasticism. However, both Buddhism and Christianity as male-run systems have distrusted women who aspired to a monastic life. Eight provisions were added to the basic rule of the *Sangha* to ensure that Buddhist nuns would continue to be subordinated to the male monks. Similarly, Christian nuns were placed under a severe rule in the fifth century by Caesarius of Arles, who wrote the first rule for nuns in the West at the request of his sister Caesaria. Nuns were never to come out from behind convent walls, and all necessary business with the outside world was to be done through the intermediacy of male monks (Bolton, 1976).

In writing regulations for female convents, Caesarius and his successors were aware that the cloister would severely hamper the nuns' ability to be self-supporting. Accordingly, he prohibited the admission of nuns who could not

provide a "dowry" sufficient for self-support in the communal life. Medieval annals are filled with accounts of women whose genuine longing for the celibate religious life was frustrated by an inability to supply the needed dowry. Some women lamented the unwillingness of families to relieve us from the duty to marry and bear children. In the hope of gaining release from these secular pressures to marry, some women fled from home, went disguised as men, or even disfigured ourselves to become less marriagable. (McNamara, 1976).

Despite these frustrations, the convents of Europe and the Orient provided an arena in which many women not only realized religious aspirations but also found scope for economic, political, and intellectual talents. The convent provided women with opportunities to exercise abilities in administration, handiwork, learning, and spiritual exploration which we could not find outside those walls. Not everyone praised our successes. Regularly, in both societies, nuns were threatened with the dissolution of our communities. We were the butt of salacious jokes and stories that often led to serious vilification. In the past, nuns who ventured out even to perform acts of charity, which were in fact much-needed social services, were criticized and disciplined. Female Buddhist orders were periodically dissolved in China, and Christian ones attacked in Europe. They were perpetuated only through the constant persistence of women seeking an extrafamilial way of life. The willingness of these beleaguered women to contend with such systematic opposition is eloquent testimony of our desire to find a different way of life. Renunciation of sexuality was not too high a price for the many women of every rank and condition who chose this alternative.

During the religious crises of the sixteenth and seventeenth centuries, nuns were able to expand our areas of activities, to overcome the restrictions of strict cloistering, and to emerge in teaching, charitable, and nursing orders. The nun of early modern times stood out as a public model for generations of European women seeking an alternative to conventional duty to home and hearth.

Today, convent life takes many different forms; women who are nuns vary widely in work, dress, and social relationships. What we have in common are a dedication of our lives to God (though this may take many forms), a decision not to marry or engage in any sexual relationships, and a commitment to a community of like-minded women organized in convents and orders. The vows of poverty, chastity, and obedience taken by nuns today may be interpreted in different ways than in the past among different orders.

Noncontemplative orders are extremely variable in their patterns of life. Members of these orders may be committed to teaching or nursing (the two most common kinds of work), helping the poor, providing shelter for orphans or unwed mothers, working with drug addicts, or fighting for human rights for Chicano migrant laborers or disenfranchised Southern blacks. Like the members of contemplative orders (those dedicated to prayer), women in

these orders generally take vows of poverty, chastity, and obedience. Many women religious continue to observe traditional, sometimes highly stylized, patterns of prayer, dress, and daily ritual, while others lead lives whose outward pattern seems little different from many secular women who are single.

By renouncing intimate personal ties, women who become nuns hope to come closer to God. The family in particular is seen as a distraction from complete concentration on devotion (Bernstein, 1976). While the rewards of this sacrifice are primarily spiritual, they have a practical quality as well. By renouncing family obligations, nuns are able to follow careers, whether in prayer or in some sort of social service work. By submitting to set rituals of daily routine and to formalized patterns of dress and conduct, nuns are freed from the constant need to make trivial decisions. And sacrificing control over material possessions results in freedom from economic anxiety. In addition, for many women the companionship and support of like-minded women is an attraction.

Many church officials today recognize the costs of the sacrifices convent life entails. Modern orders often permit fulfillment of some human inclinations (such as permitting friendship or personal expression in clothing). The costs of sexual continence are also more widely recognized, although today, as in the past, those who wish to marry must leave the convent life.

With the wider availability of other alternatives and a decline in the authority of organized religion, many nuns today leave orders while relatively few women decide to join. As a consequence, convent life as a significant alternative has declined (Bernstein, 1976). One component of dissatisfaction with convent life has been resistance by women to the rule of men (see chapter 10). The Catholic church is still dominated by men who see women as subordinate by necessity. The church has taken a few steps to give convent women greater participation in the governing of religious life, but it lags far behind the secular community in responding to women's demands for equality.

History shows that women did gain considerable power through convent life in such periods as thirteenth- and fourteenth-century England and tenth-century Germany. It is possible, therefore, that the impact of the contemporary women's movement will once again allow women in religious life to come into positions of power and authority in the church. Perhaps, as some believe, new forms of religious communities will attract women who no longer find the traditional Christian forms acceptable. Otherwise, the role filled by convents for two thousand years may in the future be filled by yet other forms of organized alternatives to family life.

Educative Communities

Convents have traditionally housed schools for girls, and many modern women's institutions have been based on that model. Many women have

Modern Maryknoll Sisters, no longer wearing the traditional habits of nuns, work with women in communities in Latin America, Asia, and Africa. Discussing the problems of these far-flung areas, nuns report that, freed from the clothing that once signified their separateness as a group, religious women are able to make better contact with the people among whom they labor. (Maryknoll Sisters)

enjoyed a brief intermission from the traditional roles of the female life cycle in single-sex schools, both as students and as teachers. The first known example was created by Sappho in ancient Greece.

Sappho's legacy consists of but a handful of beautiful broken lines—hardly a sufficient basis from which to draw any but the most tentative conclusions. But in them a fleeting world glimmers—a world of girlhood that existed two centuries before the misogynistic social system we identify with classical Athens. It would be wrong to consider Sappho as the headmistress of some sort of young ladies' seminary, but we are equally unjustified in making hers an esoteric sexual circle. What comes through in her poetry is the memory of a golden moment in life between childhood and marriage when the young women of the island of Lesbos were released from the family circle into one another's company. Sappho's lyrics express the love they felt for one another

and their sorrow over the permanent parting that marriage entailed for those who left the island never to return (box 9.1).

A similar world of female bonding in nineteenth-century America is revealed to us through the letters and diaries of women separated from one another by marriage (Smith-Rosenberg, 1975). The same sense of shared emotions and of love and sorrow was depicted by Charlotte Brontë in the early sections of *Jane Eyre* (1980), first published in 1848, which described the love and caring that linked Jane with the dying Helen Burns during their terrible days in Lowood Academy. Rosamund Lehman's *Dusty Answer* (1927) explores the emotional ties and explicit lesbian experience of a pair of young women in an English school.

A continuum exists for women that includes the short-term sharing of emotions, longer-lived close relationships characterized by care and tenderness, and an emotional commitment that may include the sexual expression of love. All women have experienced these feelings, but until recently such relationships have been ignored by society or thought not to exist: if they were discernible, they were condemned outright.

As a woman's community, the boarding school or women's college is but a temporary release from the men's world in which women will function for most of our lives. Only for some of the teachers is the experience more or less permanent. Nonetheless, these experiences provide women with an opportunity to study, excel, and develop skills and goals without the pressures and restrictions inherent in settings dominated by men.

Sometimes the desire for female bonding is evident in the existence of sororities. Although occasionally imitative of male fraternities, sororities can be an alternative familylike grouping. Women choose their "sisters," frequently live together in a sorority house, and follow codes set down by the group. As such, sororities provide a stable circle of friends and a sense of belonging.

School experiences often bear fruit in lifelong relationships, such as those delineated by Mary McCarthy in *The Group* ([1963], 1972). The range of leadership roles possible in single-sex education has created advocates for such experiences, and we will explore their views in chapter 11.

Laboring Communities

Many women, by necessity or choice, have attempted to become self-supporting outside a family circle. Social pressure in the form of low wages, abuse of unprotected women, and, sometimes, outright coercion has often led working women to organize on a collective basis. In medieval Belgium, for example, unmarried women, including widows, formed quasi-religious communities based on the idea of collective housekeeping and economic enterprise. The religious element in these *beguine* organizations ensured their social respectability and enabled members to claim the protection of local ecclesiastical

Sappho, fragment 94 Box 9.1

. . . and I honestly wish I were dead.
Weeping heavily, she left me,
and said, "Our anguish, Sappho,
is terribly deep—
I am really leaving you against my will."
And I answered her with this:
"Go, be happy—and
remember me—for you know
how I have cherished you,
and if you doubt it, let me call to mind for you
. the beauty we shared,
the times when you would wrap around yourself,
beside me/a profusion of garlands,/
of violets and roses, woven together . . .
and thick-plaited, sweet-smelling wreaths,
fashioned of blossoms,
you hung at your soft throat . . .
. . . and when you had anointed . . .
with rich and regal scents,
upon the soft bed you would fulfill your desire
for the lovely . . .
and no one . . . nor a holy . . .
. that we were absent from . . .
nor a grove . . .
. . . sound . . .

(Sappho, 1966:43)

authorities. Even so, women met with hostility and even violence from the guildsmen who would neither admit us to the craft "brotherhoods" nor allow us to compete by working for lower wages or longer hours (McDonnell, 1976). In nineteenth-century France, "secular convents" of women, working as free-lance textile manufacturers, were also attacked for competing successfully with men (Donzelot, 1979). Indeed, it may be that the growing emphasis on family roles as the only proper career for women during this period was, at some level, a social reaction to the threat that industrialization posed to the male-controlled family.

Nor was this experience confined to the Western world. In Canton, the center of the Chinese silk industry in the nineteenth century, the "purity" of unmarried women was thought to act favorably on the development of the silkworms. Consequently, the women of Canton were customarily housed for a finite period between childhood and marriage in "women's houses." These houses grew into real communities of women, often welcoming and protecting

married women who had fled from unhappy homes. Many sought to continue lifelong residence in the women's houses, and women found it possible to avoid unwelcome marriages, occasionally in favor of lesbian relationships. A few of the houses even formed a series of fictive kinship relationships to provide ancestral altars which would care for the members' ghosts after death (Topley, 1975). The depression that hit the silk industry late in the century destroyed this way of life, but a number of the residents were identified among the unmarried women who flocked to the rapidly growing city of Hong Kong to take up domestic service. These women were conspicuous among the servants of the city for unusual energy in forming working women's associations for mutual aid and protection from exploitation (Sankar, 1978).

Industrialization in the nineteenth century brought a major social shift away from the organization of production by the individual artisan to factories and machines owned by industrial capitalists. In the early stages of industrialization, factory owners tended to act like sovereigns or fathers with absolute control over their dependents. Especially where mill workers lived in a closed community under the supervision of the owners, the latter tended to be very paternalistic. A feature of these early factory communities was the careful supervision and control of unmarried girls and young women who had left home to work in the mills.

The most famous experiment of a protected mill community was located in Lowell, Massachusetts, in the 1820s. Rural New England girls and young women were recruited into the textile factories by the lure of a new model of industrial life. For two decades, the famous "Lowell girls" were reported on by Charles Dickens and other enthusiastic writers who contrasted neat, highly respectable, well-tended Yankee mill girls with the ragged and filthy appearance of mill workers in England. These new industrial paragons lived in company boarding houses, where morals as well as physical needs were carefully monitored. "On the corporation," as it was put, the women enjoyed the benefits of urban life; lectures and other culturally enriching events were scheduled in the few leisure hours. Several young women produced a magazine, *The Lowell Offering,* a few being sufficiently inspired to go on to more rewarding careers (Eisler, 1977). Lucy Larcom (1824–1893), who worked in the factories for ten years from the age of eleven, remembered the experience as a great opportunity. After the freedom and autonomy she experienced there, she never married but went on to become a teacher, writer, and editor. Reflecting in later years, she concluded that it was "one of the privileges of my youth that I was permitted to grow up among those active, interesting girls, whose lives were not mere echoes of other lives but had principle and purpose distinctly their own" (Brownlee and Brownlee, 1976).

The Lowell experiment, however, was short-lived and not to be repeated. For most women, the experience of the factory system was not an idyll but a nightmare of hard labor, tuberculosis, and, not infrequently, sexual exploita-

tion. But the point is that for some women in England and New England, industrialization made possible a new image as well as new kind of roles. Similarly the silk workers of Lyons in France and Canton in China were provided with an alternative to conventional family roles. Women need not marry; we need not be mothers.

The new image emerging at this time, the "working girl," grew slowly out of the new industrial life of the mill towns. She was a spunky, bright, enterprising, earnest person. She worked hard and, in legend, seemed never to have been depressed at her failure to rise above a certain level of success. In this she lagged behind Horatio Alger's heroes, who usually ended up marrying the boss's daughter. Yet, for women who had been deprived of any image of an autonomous life, whose only alternative to unpaid but respectable status doing domestic tasks as wives was low-paid, low-status domestic employment as servants, the working girl was a real alternative.

Support Networks
With the growth of the nation state and industrialization, the confines of the family were broken down for various groups of people; women emerged as breadwinners, social reformers, and even political revolutionaries. Our personal lives have been greatly misrepresented by traditional modes of writing history. The marital difficulties and conflicts experienced by active women like Elizabeth Cady Stanton, reformer and suffragist, or Eleanor Roosevelt have been examined in great detail, as have relatively happy unions such as those of the poets Elizabeth Barrett (1806–1861) and Robert Browning, and Lucy Stone (1818–1893), a feminist social reformer, and Henry Blackwell, brother of the first American woman physician. Even such unorthodox heterosexual arrangements as those of the women who chose the literary names of George Eliot (1819–1880) and George Sand (1804–1876) have been widely discussed by their biographers. But the affective relationships of these women with members of their own sex have barely been noticed at all. Moreover, women who had no known heterosexual connections have been traditionally treated as though we lived alone and were utterly unloved.

In reality, these women often had the love and support of networks of female colleagues, companions, and often lovers (Faderman, 1981). At Hull House, the social reformer Jane Addams (1860–1935) enjoyed the support of a community of women who gave her the love and loyalty she needed to continue her work. The same kind of network is now known to have existed for Eleanor Roosevelt, who has previously been depicted as a lonely woman, permanently scarred by the infidelity of her famous husband (Lash, 1982). Modern feminists have uncovered evidence of these past communities, even as we seek to build new networks to strengthen us in our present struggles. One writer observes that "the power of communities of independent women, and of the love between individual women, expressed not only sensually but

in a range of ways, is part of the history that has been taken from us by heterosexual culture. To recognize this history is to recognize our own personal forces of energy and courage and the power to change" (Cook, 1979).

Historians have found the informal connections which cement men's relationships, but women's bondings exist in less visible places where, historically, women have worked out our strategies for survival. Such groups often have neither constitutions nor fixed composition; they are characterized by shifting, changing relationships, devised to meet the needs of the moment. For example, middle-class young women, leaving home for the first time or seeking jobs after college, have often sought support in a female community. Not long ago, if we were trying our luck in the city, we would probably take up initial residence at a YWCA or a somewhat more expensive women's residence. Eventually we might find a roommate or two and rent an apartment. Rona Jaffe vividly described this kind of life in her novel of career women *The Best of Everything* (1958, 1976).

Many of these relationships prove to be ephemeral. The women part and go separate ways. But throughout life, most of us seek the support of some community of women, whether it be the ongoing coffee klatches of the suburbs depicted by Marilyn French in *The Women's Room* (1977) or the consciousness-raising groups of the early 1970s, in which women tried to become aware of why our lives were so oppressive by sharing personal experiences. Today, in nearly every area where women are striving to find a place for ourselves in the world outside the family circle, networks of women are being formed (box 9.2). They exist to counter the alienating effects of exclusion from "old boys' network," but they also exist because they provide an essential mode of mutual support.

Utopian and Experimental Communities

Some women and men have envisioned communities that alter the structure of the conventional family, which they view as an impediment to the development of human potential. Philosophers since the time of the Greeks have imagined whole societies that are founded on new domestic principles, sometimes eliminating marriage, sometimes the individual control by parents of their offspring, sometimes both. The general idea has usually been that such societies would produce more altruistic individuals and would provide the context for greater fulfillment of human potential, often for both women and men. Not all utopian visions have sought to abolish or alter the family, of course; but in this section we will consider only those which did suggest alternatives to prevailing family forms.

During the nineteenth century, a large number of experimental communities, some religious, some secular, attempted to make utopia real. Each tried to put into practice its ideas of reforming institutions of marriage and child-

Feminist Family Circles Box 9.2

In the years since my divorce, I seem to have created a new extended family that consists not only of my own children but also friends on whom I can always depend for a bed and a loving ear. Although I live alone in my little house in Sag Harbor, my family stretches from California to Cambridge. And there is an authentic note of family reunion as we who founded N.O.W. a generation ago reconvene for the Assembly on the Future of the Family, our sons and daughters at our sides, our hands extended to men. As our children grow up and leave home, as more of us struggle with the problems of husbands' strokes and heart attacks, and our own illnesses and loneliness, we admit our needs and vulnerabilities to each other. We get love and support from this family that was knit together in our battle for equality. The movement itself has become "family," and now we call each other long distance just to say "hello" as families do. (Friedan, 1979:102)

rearing—and most communities foundered in the process. Today's experimental communities number perhaps in the thousands. A few are derived directly from a utopian text; others, usually known as "communes," result from an unplanned process of trial and error. Still others, such as the kibbutz in Israel, combine explicit social philosophy and practical modification. So far, none have approached the Christian convent in longevity, geographical scope, or popularity. Are altruism and fulfillment of human potential more difficult to achieve when women and men live together? Or when children are born and raised within the community? What seem to be the elements of success—and failure—for these alternatives to family life?

Utopian Literature

The most frequently cited utopian writer of antiquity is the Greek philosopher Plato. His *Republic,* written in the fourth century B.C., is perhaps the prototype of antifamily utopias. He imagined a state governed by an elite group, the "guardians," in which women and men participate on equal terms. Sexual relations, particularly reproduction, are carefully regulated. At certain times of the year, women and men of prime reproductive capacity are brought together to mate. When children are born, they are taken from the mother and put under the supervision of special caretakers who can be either women or men. Mothers are brought to the nursery to breast-feed at random and are prevented from knowing which of the infants are ours. Women, thus freed from child care and other domestic duties, can join the men in the job of governing and defending the republic. Parents, freed of feelings of favoritism for their *own* children, feel concern and affection for all the society's children.

 In the centuries that followed, few utopian writers addressed themselves

imaginatively to the questions of marriage and child-rearing. The utopias of the Renaissance, for example, seem to take marriage and the nuclear family for granted, with one minor innovation: communal meals to reinforce group solidarity. One writer of the early modern era, Gabriel de Foigny, however, takes his imagination to the extreme, eliminating not only marriage but sex itself. In his book *A New Discovery of Terra Incognita Australis* (1676), he writes of an androgynous (he calls them hermaphroditic) population. He describes childbirth (the first such description in utopian literature) as follows:

> As soon as an Australian has conceived, he quits his apartment and is carried to the Heb, where he is received with testimonies of an extraordinary bounty, and is nourished without being obliged to work. They have a certain high place, upon which they go to bring forth their child, which is received upon some balsanick leaves; after which the mother (or person that bore it) takes it and rubs it with these leaves, and gives it suck, without any appearance of having suffered any pain.
>
> They make no use of swaddling clothes or cradles. The milk it receives from the mother gives it so good nourishment, that is suffices it without any other food for two years; and the excrements it voids, are so small a quantity, that it may almost be said, it makes none. (Bernini, 1950:193–94)

While many utopian writers took a dim view of marriage and parental control over children, their ways of solving the problems were far less innovative than their suggestions for dealing with government or property. Perhaps this has to do with the fact that they were all men; there are no utopias written by women before the twentieth century (Lane, 1979). Since marriage and child-rearing were not as central to their lives as they were to women's, men devoted attention to things they believed were more important, at least until the nineteenth and twentieth centuries.

A number of modern utopias have been conceived by women. The two examples considered here both challenge the institution of marriage and the practices of child-rearing; in both cases, the solution has a "technical" as well as a social component.

Herland, a utopia described by Charlotte Perkins Gilman in the early 1900s, solves the problem of the family (and all other social problems, apparently) through the simple device of eliminating men from society altogether. Here, women have found a way to conceive children by means of parthenogenesis (nonsexual reproduction by a single parent). Motherhood is a venerated achievement. All of society, in fact, is oriented toward nurturance. Besides caring for offspring, the inhabitants of Herland are engaged in all the arts of growing and cultivation. Life is predominantly rural, and women are engaged in attending gardens, fields, and forests. Domestic lives are simple and austere, but the surroundings are lush and bountiful. As a conservation measure, the inhabitants have given up raising animals and eating meat. The women are highly cooperative, noncompetitive, strong, and healthy, but are

also gentle, nonviolent, and self-controlled. This is a society of mothers and women who see ourselves as potential mothers because we do not ever have to be wives.

Mouth-of-Mattapoisett, a utopia placed in the future, has been fashioned by Marge Piercy in *Woman on the Edge of Time* (1976). Unlike Gilman's utopia, it includes men as well as women. Like Herland, it is a community oriented toward nurturance and mothering. It begins with an androgynous conceptualization of humanity. Language does not distinguish female from male, either by pronouns or by names of individuals. People form domestic groups solely to raise children to puberty. Such groups include three adults (in any combination of sexes), with no person economically dependent on the others. The three join together for the express purpose of nurturing a child.

Children are conceived and born outside the womb, in test tubes or tanks, and cared for by specialists. The children are raised in nurseries but maintain a special relationship with the three parents. All three (whether women or men) are "mothers." Men may choose to receive hormones to enable them to breast-feed. Thus motherhood need not be denied to anyone merely on the basis of sex. However, the physical burden of childbearing falls on no one person, nor is child-rearing a private affair. Special nurses tend babies, and children live separately from "mothers" for life. Puberty is celebrated as a crucial rite of passage that effectively separates adolescents from the primary emotional bonds with the early co-mothers and encourages full autonomy. Piercy suggests that the solution to the problem of harmony between the sexes and between generations lies in reducing gender distinctions and generational privileges by removing the exclusivity of personal relationships. Instead, the emphasis is on bonding temporarily and freely, without long-term possessiveness. She poses for women the question of whether, when the mother-child bonds are relaxed, we gain in freedom as much as we lose in strong emotional ties.

While people's lives in this society are not austere, the emphasis is on conservation and ecological balance rather than consumption and exploitation. Technology is geared toward security and cautious use, not bounty. Perhaps more important, individuals, although encouraged to serve community interests in some ways, are also encouraged to fulfill personal potential, whether through artistic, scholarly, or other creative endeavors. Individualism is fostered to the benefit of community life. The education of children and the economic activities of adults are designed so as not to inhibit the free expression of individuality.

Thus utopian ideals, inasmuch as they are directed to family life, tend to see the oppression of women as a consequence of our roles as wives (not as mothers, necessarily), and the development of selfishness and competitiveness as a consequence of possessiveness by parents toward children and spouses toward one another. The remedies envisioned are radical in the extreme,

suggesting paradoxically that perhaps the biology of reproduction itself is at fault, after all. The question of biological determination becomes all the more serious when we turn to the efforts people have made to put utopian ideas into practice.

Experimental Communities
Nineteenth-Century Utopian Experiments. Perhaps because of the opportunities offered by the frontier, the dislocations caused by industrialization, or yet other reasons, utopia became more than a literary exercise in nineteenth-century America. Hundreds of utopian or "intentional" communities were founded. A number of these experiments lasted a generation and some even lasted several generations; most, however, failed in a few short years. Many experimented with alternative forms of family life because they saw families as divisive, detracting from community loyalties. Others saw families as the source of human, particularly women's, oppression. Yet others saw families as arbitrarily limiting *human* potentiality, particularly in sexual expression. When communities failed, it is not always clear whether failure was due to the social experiments themselves, to economics, or to external pressures. In any case, the formation of an intentional community, with special rules and regulations applied to personal conduct, inevitably meant intervention in family life.

The most direct and common form of intervention in the nineteenth century was the imposition of celibacy. Some utopian communities imposed celibacy for economic reasons; others, such as the Shakers, required it for theological reasons. The Shakers, founded by Ann Lee, also preached women's equality. Celibacy reordered the priorities of community members, establishing the interests of the community over those of the individual (Muncy, 1973).

A number of communities permitted, even condoned, familism (retention of personal ties between wife and husband, parents and children) but intervened in family *functions* such as food preparation and dining. The Mormons were an example of a religious utopian movement that for half a century was familistic and also preached polygyny. Apparently the women of the community resisted polygyny at the outset, and even subsequently, but on the whole believed the sacrifices being made in this world would be rewarded in the next (Muncy, 1973).

There were experimental communities that frowned on marriage but took a positive attitude toward sex. Some of these communities advocated "free love," and among these most were anarchists in general philosophy; members believed that no arbitrary rules or governmental structure should control people's lives. Other communities engaged in nonstandard sexual practices under the control and leadership of a single charismatic individual whose philosophy had religious overtones. The most famous and long-lived of these

was Oneida, settled by the Perfectionists under the leadership of John Humphrey Noyes. The Perfectionists practiced "complex marriage," in which each member was formally married to every other member of the opposite sex; exclusive attachments between couples were forbidden. Each member had her or his own room. Members were encouraged to engage in sexual intercourse with a variety of partners, but sexual relations were monitored by a committee of elders. The elders initiated the young, both girls and boys.

Noyes preached separation between sexuality and reproduction. For twenty years, sex for reproduction was prohibited; birth control was the responsibility of the men, who were enjoined to avoid ejaculation. Female orgasm was the ultimate objective of every sexual encounter, and failure was deemed to be the fault of the male partner. After twenty years, the community engaged in a ten-year eugenics experiment (selective mating to improve the race or species), controlled by a committee that selected couples to mate and bear offspring. More women than men volunteered for the experiment (Carden, 1969; Muncy, 1973).

In 1869, Noyes required the young women of Oneida to take an oath which stressed that in decisions about who should bear children, women belonged not to ourselves, but to God and, secondarily, to Noyes, God's representative. "That we have no rights or personal feelings in regard to child-bearing which in the least degree oppose or embarrass him in the choice of scientific combinations. That we will put aside all envy, childishness, and self-seeking and rejoice with those who are chosen candidates; that we will if necessary become martyrs to science . . . 'living sacrifices' to God and true Communism" (Kern, 1979: 184–85).

This oath of loyalty to Noyes contrasts sharply with the oath taken almost two decades previously, in 1851, by the first generation of young women of the Oneida community. Enjoined to throw all dolls upon a great fire to symbolize the rooting out of the "maternal instinct," which was equated with female selfishness, girls were asked to become committed to individual development instead: "We think this doll spirit that seduces us from a Community spirit in regard to helping the family and that prevents us from being in earnest to get an education is the same spirit that seduces women to allow themselves to be so taken up with their children that they have not time to attend to Christ and get an education for heaven" (Kern, 1979:181).

As a result of eugenic planning, some fifty-eight children were born in the decade following 1869. The children were raised by a group of specialists, consisting of fifteen women and three men. Mothers could visit offspring but were discouraged from forming exclusive attachments (Muncy, 1973).

These young women of the 1870s willingly consented to an experiment in breaking down the exclusivity of families. But the next generation of women at Oneida reconsidered support of this "scientific" selection of parents. Some were reluctant to renounce all rights to motherhood, and others desired to

retain control over children. The community began to flounder when these women rejected male definitions of women's proper communitarian roles and demanded autonomy within the more traditional nuclear family (Kern, 1979).

The positions taken by the experimental communities on women's rights varied. On the whole, the rights of women were greater in the celibate communities, while in the familistic communities our status resembled women's traditional status in the wider society. The Mormons ignored women's rights. The reformists, the economic cooperatives, and the anarchists all championed women's rights and tried to establish equality. But the societies that sought equality tended to fail and to be strongly resisted by the women. Why? A frequently cited cause is friction between the mothers and the rest of the community over control of children. A look at more recent experiments may help provide tentative answers.

Twentieth-Century Intentional Communities. The intentional communities of the present show an even greater range of variability than in the past. They are found all over the world. As in the past, many are religious; others are purely secular groups, linked together by political beliefs, moral principles, and at times economic necessity. Some are rural, some urban. Some are communistic, some anarchistic, some joined together under the influence of a charismatic leader. In those cases where celibacy is not the rule, the problem of what to do about marriage and children often becomes the undoing of the commune (Kanter, 1973).

There are communes where children simply are not welcome. Other communes, however, find women with children attractive for the income they are able to provide by means of government welfare payments. (Few communes run economically successful ventures, and many depend on outside subsidies.) In the less organized, more anarchist communes, responsibility for raising the children is either not delegated or extremely diffuse. Children might even be treated as adults, left to themselves as much as possible. There are communities that give considerable thought to raising children, as for example, Twin Oaks, a community based on B. F. Skinner's *Walden II* (1962), which places a high priority on methods of child-rearing. Such communities appear to be in the minority, however; surprisingly few studies have been done of mother-child relationships in communes (Bernard, 1975).

The Israeli kibbutz has long been viewed as the solitary success in the tradition of communes based on socialist ideals of equality and shared effort. Since 1909, the kibbutz has explored the communal alternative, providing collectivized "domestic" services for its members (food preparation, clothing maintenance, health care, child care) in return for their labor in communal enterprises which are primarily rural but may include some industrial production. The ideology of women's equality with men and the subordination of private family interests to those of the collective have been fundamental to

CHOOSING ALTERNATIVES 337

the kibbutz movement throughout its history. Women, married or single, are classed as independent autonomous members of the community, with full voting rights in its organization and full economic rights in its collective resources (Tiger and Shepher, 1975).

Observations of recent conditions in these kibbutz communities, however, show that women participate less than men in governing and supervision and often follow separate educational careers. Traditional gender distinctions emerge. Women engage overwhelmingly in service work, clothing care, cooking, and child care, while men tend to be employed mainly in farming and industry. Kibbutz women have long argued, unsuccessfully, that labor-intensive cultivation, in which we could engage while remaining close to the children's quarters, was preferable to heavy-machine, large-scale crops. The men of the kibbutz, however, have preferred the larger return from mechanized farming and have outvoted the women. Faced with the choice of a long day's absence or domestic labors, women have not elected to abandon our children completely. Instead, in recent years, women have shown an increasing inclination to return to a strong family life, centering on our relationships with our children. Asked to lead lives according to men's priorities, kibbutz women have apparently rejected those parts which do not satisfy our own preferences.

On the whole, men have elaborated communal ideology in the past. Even where women's equality has been part of that ideology, women's roles have in fact closely resembled those of women in the rest of the world. Women bear the major burdens of child care and domestic upkeep and tend to be socially subordinate to men. As in the last century, women in modern communes have expressed dissatisfaction with the tendency to exploit our labor and with the inadequacy of arrangements for the care of children.

A very recent development has been the emergence of women's communes—that is, women's communes which are not convents. The *New Women's Times* describes rural communes open to women and children in a number of states. For example, in Oregon,

> OWL Farm is a beautiful 150 acres in a protected valley with a relatively moderate climate. She is probably the only women's land which is "owned" by *all* women. She belongs to you and me and is there for our use anytime, now or in the future. In the warm weather there are usually enough women around to help raise the $360.00 per month morgage payments—not much considering there's a well-built two story log house, a "children's house," a "quiet house," several tipis, a barn, a good well with running water in the main house, plenty of open fields for farming and timberlands for wood. (*New Women's Times*, 1980)

The letter indicates that all women's communes have difficulty in raising the funds necessary for survival.

People are motivated to join communes for a wide variety of reasons. Almost invariably, however, there is dissatisfaction with standard family life.

Some people are motivated to join communes in order to help establish a new morality; some desire to gain greater intimacy with others, to relieve the loneliness and isolation of our particular nuclear families. Whatever the motives, people usually discover that group living involves unanticipated problems whether they be economic support, domestic upkeep, or personal conflicts over sexual relations or child-rearing. Many of the problems of communal life are identical with those of standard families; the disagreements which undermine the unity and survival of communes are those which lead to the breakup of conventional families as well. This suggests that it is not just the structure of families or communal living that is "at fault" but problems people have in relations with others in general: problems of role expectations, attitudes, self-expression, and learning to cooperate, listen, and tolerate.

But experimental communities have the further problem of potential conflict with the wider community. Like convents in the past, experimental communities which have not become part of the establishment are targets of suspicion, criticism, and efforts at outside control, especially when sexual practices deviate from the social norm.

Criticisms of Experimental Alternatives

Persecution suggests that many in the dominant society view the existence of alternatives as threatening. The failure of most communes to survive may be seen as partially, if not largely, due to lack of general social support. But some writers such as Alice S. Rossi, suggest that the experiments with new forms of family life fail because of inadequate provision for the expression of biologically rooted sex differences, particularly in regard to child-rearing. According to Rossi, the experiments show us that there are limits to the extent to which we can (short of biological intervention) successfully modify the social roles of parents, particularly mothers (Rossi, 1977).

Rossi criticizes the current literature on family alternatives (and alternative practices themselves) for overemphasizing adult sexual relationships rather than considering the implications of these relationships for parenting. Ego indulgence, immediate gratification, and catering to male preferences for variety in sexual partnerhood all occur at the expense of children's needs. She cites studies that document the stressful childhood of children raised in communes, particularly urban ones. "Just as the sexual script, so the parenting script in the new family sociology seems to be modeled on what has been a male pattern of relating to children, in which men turn their fathering on and off to suit themselves or their appointments for business or sexual pleasure. . . . It is not at all clear what the gains will be for either women or children in this version of human liberation" (ibid.:16).

Rossi suggests that both our biological and our cultural heritage link mating and parenting more closely for females than males and "the high probability that the mother-infant relationship will continue to have greater

emotional depth than the father-infant relationship" (ibid.:18). Only the extensive training of men will help to "close the gap produced by the physiological experience of pregnancy, birth and nursing" (ibid.). Few experimental noncelibate alternatives to family life have endured long enough to provide a test of Alice Rossi's arguments. However, we need not postulate a biological base to the attachment mothers feel for our children to understand the conflicts that can occur when we are separated from the nurturing of our offspring.

Utopian models for social life, generally designed by men, do not make much allowance for the desires of women to associate closely with our own children: many utopias seek actively to intervene in maternal attachment, seeing it as a source of evil or distraction from community commitment. History indeed does seem to indicate that mother-child attachments may undermine community commitments and frequently cause conflict in real experimental communities. But we know of no noncelibate experimental communities designed or led by women in the past, and as yet we know nothing about how those that exist today are working out. Present studies suggest that if children are to be reared, no experimental communal alternative to the family designed by men has been more satisfactory *to women* than some family form.

It is only in women's utopian fantasies that we see possible alternatives acceptable to women. *Herland* and *Woman on the Edge of Time* give motherhood its due and emphasize this attachment. These ideal forms do not provide a practical model for the present, but they do express values that are not allowed to flourish in sexist societies. We do not find conventional nuclear families in women's utopian fantasies, but rather a variety of flexible social arrangements. Nor do we find exclusive attachments, but scope for many loving, supportive relationships between individuals. These fantasies do not picture a separation between parents and very young children (although responsibilities for child care tend to be communalized); if separation occurs, it happens later in life. Motherhood rarely is seen as a threat to these utopias; instead, it is depicted as a beneficial and rewarding experience to be shared more widely (Pearson, 1977). While the prerequisites for these utopian fantasies are often remote or impossible events (parthenogenesis, cataclysms which eliminate men), it is possible that less radical changes could bring us closer to the values they express. Let us consider, for example, some alterations in conventional family form that have been tried.

Alternative Family and Household Forms

The "ideal" family in our society—one that lives in a household consisting of a father as sole wage earner, a mother as full-time housewife, and one or more dependent children—is a statistical minority. While all societies, like

ours, have an "ideal" form of family that occupies a household, a large proportion, perhaps even the vast majority, of living arrangements do not actually conform to the ideal.

We often fail to understand how social norms differ from social realities. A *social norm* is what most people in a society say and believe is right and proper; what people *do* might be quite different. In fact, every society has some alternatives to the normative or ideal family and household pattern. In a number of African societies, for example, the ideal family is represented by a polygynous household. But in order to acquire wives, men must pay the kin a bride price, and most men cannot afford to pay for more than one wife. Thus, while the social norm may be a polygynous household, the statistical norm is often a monogamous one.

Our impression that people in tribal and peasant societies have no choice but to live in heterosexual households is reinforced by the emphasis often given to the economic basis of marriage. The basic division of labor in simple societies is by sex and age. Because each sex contributes something essential to the survival of the other, individuals presumably have no choice but to marry. In fact, the apparent universality of economic interdependence of women and men is as illusory as the apparent unformity of household structure: both represent ideal rather than real situations. Not only do all societies have individuals who fail or choose not to achieve the norm, but many if not most, societies have institutionalized alternative social scripts.

Role Reversals

Among the best-known types of "exotic customs" widely found in tribal societies is the provision of institutionalized means of crossing gender roles. A typical example is that of "women marriage" among the Igbo of Southeast Nigeria. Women may marry other women by paying a bride price. This Igbo institution provides an opportunity for women who have skills and economic resources to operate as men do, within socially sanctioned patterns (Uchendu, 1965). The option to cross gender roles has been documented as available for men as well. A well-known case is that of the *berdaches* of the Cheyenne, men who adopt the clothing and behavior of women and become "wives" of other men (Hoebel, 1960:77).

Gender-role reversal in Western society is not institutionalized as it is in these indigenous Western African and North American examples, but it does occur. It provides a comic theme in the popular media, but also a serious option for many couples who feel their talents lie in areas usually assigned to the opposite gender. Thus, we find that men who wish to be "house husbands" take on full responsibility for homemaking and child care, financially supported by working wives. This alternative has social problems for the couples who choose it because of general societal disapproval of gender-role reversal; couples determined to define their own lives must ignore such disap-

Three fathers, taking care of their children, meet in an art gallery. In egalitarian families, tasks such as child care are shared. Assuming gender roles for which we have not been trained may be hard at first; these fathers seem to be willing, if a little awkward, to learn a new role. (Photo by Richard Zalk)

proval until people around them recognize the good reasons they have for not associating roles with gender as has conventionally been done.

Egalitarian Households

Feminists are beginning to define the family in new ways that will give more autonomy and genuine support to its individual members. We have embarked, with considerable energy, on a redefinition of marriage (see chapter 7).

A historical precedent was set in 1855, when Lucy Stone married Henry Blackwell after a long and determined resistance to his suit. The pair signed a contract which was a manifesto criticizing and abjuring the legal authority of husbands, their conjugal rights to sex on demand, the female duty of constant childbearing, and the obliteration of the wife's personality by the imposition of the husband's name. This marriage resulted in a forty-year partnership in pursuit of women's rights (Rossi, 1973).

The example of Lucy Stone had immediate repercussions. Followers across

the country, "Stonerites," refused to change our names on marriage and demanded similar contracts. This example influences women today who are experimenting with an ever-increasing loosening of the legal bondage of marriage. Many women and men are experimenting with new arrangements for the sharing of domestic, economic, and social responsibilities (Libby and Whitehurst, 1977).

Such arrangements, which may be called *egalitarian households*, involve equal sharing by adults of the work and rewards of both family life and opportunities outside the home. This sharing means that both partners contribute to the economic and physical maintenance of the home and both have the opportunity and the responsibility to pursue other interests. Both need not do all these things simultaneously; each may take turns at completing educational programs or starting new jobs or caring for young children, but one may not do so repeatedly at the expense of the other. A couple may also choose to divide up household tasks according to personal inclinations; one may do most of the cooking while the other does the laundry or marketing. But in terms of contribution and responsibility, there must be true parity (Held, 1979).

Truly egalitarian marriages are still rare exceptions. More often, when women join the work force, we are not relieved of our household work and responsibilities by a parallel shift of roles by men. Instead, women who hold outside jobs tend to work a "double shift"—one at work and one at home (see chapter 13). However, as Jessie Bernard (1981) indicates, couples are increasingly striving to design relationships that meet the egalitarian ideal.

Families of Women
Women have long been accustomed to setting up housekeeping together. It is the customary social solution for women who from some accident of fate find ourselves outside the traditional family circle. The arrangement has commonly been viewed either as transient or unfortunate. When young women share a household, we are considered to be marking premarital time until our real domesticity begins. Older women have commonly been classed as "spinsters." Both never-married and formerly married women have been scorned as second-class citizens making the best of our manless state. In the fantasy world of men, which a majority of women in the past have accepted as a universal truth, any woman living without a man must necessarily be lonely, unhappy, or misguided. The idea of a fulfilled, stable, enduring relationship between women, especially lesbians, is alien to conventional views. To admit that such relationships can be very satisfactory would threaten the notion that men and marriage are essential to women's happiness.

Only with the emergence of lesbian consciousness in the context of the modern feminist movement has the concept of lesbian families gained clarity. It stems from the insistence by women that we have the freedom to define

ourselves. The law defines a family in terms of blood relationships and heterosexual marriage, shared property, and the legitimation of children. Individual women may consider ourselves families, however, if we feel that we are experiencing the commitments of emotion, property, and time that warrant the label.

Laws are made by people, and people can change the laws. In recent years the traditional legal definitions of families have been challenged by "palimony" suits (payment to one member of a couple whose members have lived together without legally binding marriage) and by the development of homosexual marriage ceremonies. Contracts and wills have also been used to separate the property commitment of individuals to one another from the overall legal framework of marriage and family.

The recognition of lesbian families has been helped by the slowly growing success with which lesbians have defended rights to the custody of children. This has been a long struggle. In current legal doctrine, the "good of the child" has been used by judges to separate children from lesbian mothers because of social attitudes about lesbianism which they have shared (Lewin, 1981). Mothers who wish to be free of oppressive marriages do not by any means also want to abandon our children. Women who choose lesbian relationships may not lose the desire to have children or maternal affection for children we already have. Poet Adrienne Rich (1980), a highly articulate lesbian mother, has exposed the stereotypical thinking which has caused even the most "enlightened" to imagine that the categories of lesbian and mother are mutually exclusive. Another poet, Audre Lorde, who is concerned with racial as well as sexual labeling, argues that black children of lesbian mothers have a special awareness "because they learn, very early, that oppression comes in many different forms having nothing to do with their own worth" (Lorde, 1979).

Single Parent Households

Increasing numbers of women are separating the function of motherhood from the function of wife. Many of these are divorced women who may or may not have chosen to become the heads of single parent households. In the United States in 1981, 18 percent (more than five million) of the families with children were headed by mothers only. (Two percent were headed by fathers only). Of these women heads of households, roughly 68 percent were divorced or separated and 11 percent widowed. Other women have borne children by partners who were chosen as fathers but not as husbands, or have chosen to raise the children from an unplanned pregnancy. Of the single mothers, 17.6 percent were never married (U.S. Bureau of Census, March 1981:9;141). Single women have also chosen to adopt children.

If women are to bring up children in an atmosphere in which we are free to make decisions to suit our own temperaments, economic autonomy is vital.

Loving women. Until recently, lesbians remained hidden from history and the contemporary record. Today women not only exhibit their love for one another openly, but also celebrate that love in prose, poetry, and graphic art. (Photo by Joel Cohen)

Our ability to support ourselves and our children plays a large role in our freedom to ignore those who do not approve of our choices. Unfortunately, in the United States these choices are limited by an economic system which provides fewer social services and less social support for human needs than almost any other any other advanced industrial economy (see chapter 13).

Single mothers and married mothers face similar problems in child-rearing. In addition, single mothers face the emotional stresses of unstable relationships, unwelcome social pressures, and loneliness. Nonetheless, many unmarried women have chosen to raise children.

Choosing Not To Mother

Motherhood is not the only family form available to women. Today, increasing numbers of women choose to live with other women as couples without having children. Whereas once women achieved adult status primarily by becoming mothers, now many other roles define adult status for us. Careers, avocational interests, and community activities provide rewards, personal gratification, and a sense of identity. Some women feel that children would substantially hinder our pursuit of these commitments and undermine our goals. In the past, couples without children were pitied; childlessness was seen as an unfortunate fate. Today, especially in the West, the choice not to have children is increasingly accepted as valid (see table 9.1).

Women on Our Own

The 1982 census figures showed an increase over the 1970 figures of 52 percent in the proportion of American women between twenty-five and thirty-four years who were unmarried (U.S. Bureau of Census, July 1982). Many women have decided to marry later than our mothers did, if at all. Some women may choose never to marry, and growing numbers may choose to dissolve the marriages we make. With improved medical knowledge and a rising life expectancy, a growing number of healthy, active widows are also joining the ranks of single women in our society. The possibility of economic independence or at least a greater number of life choices brought young women in the 1960s to attend college in larger numbers than ever before. The demand for affirmative action, which grew out of the civil rights movement of the same decade, also brought women without college educations new opportunities in various well-paid sectors formerly closed to us such as business, management, and the construction industry. In 1980, for the first time, the numbers of women in colleges and some professional schools were equal to and, in some cases, surpassed the numbers of men. One source of this increase is the large number of women over thirty who are now returning to complete or supplement the education abandoned earlier for marriage.

With all these changes, the need to marry for economic security has seemed

Table 9.1 The Percentage of Childless Women Who Do Not Expect To Have Children

Age Range	Single Women	Married Women	Combined Total
18–19	13.9	3.1	17.0
20–21	16.6	5.0	21.6
22–24	20.2	5.8	26.0
25–29	30.5	5.3	35.8
30–34	53.7	6.4	60.1
	—	—	—
Total 18–34	21.9	5.7	26.6

Source: Adapted from U.S. Bureau of Census, December 1980:22 (Table 5, Part C); 24 (Table 6, Part A).

less compelling to women. The first requirement for women's emanicipation, and for a greater range of choices, is an independent source of income. "Five hundred pounds and a room of one's own" was the formula supplied by Virginia Woolf in 1928 (1963).

Nowadays women are viewed less and less as either accessories to men or, if single, social rejects. The title *Ms.*, which has growing acceptance, helps to obliterate the emphasis society once placed on a woman's marital status. The "single girl" who is celebrated in various magazines is a glamorous and attractive image around which commercial activity revolves. Studies have suggested that unmarried women are often emotionally healthier than married women or unmarried men (Bernard, 1972; Gove, 1972; Knupfer, Clark, and Room, 1966). Unmarried women have also been found to have higher intelligence, more education, and greater occupational success than married counterparts. This relationship is not found with men; successful men are more likely to marry than successful women (Spreitzer and Riley, 1974). It is clear that permanent or intermittent singlehood has emerged as a workable alternative to marriage or long-term coupling. It is no longer regarded as a mistake, an accident, or a tragedy. There is not only a real increase in the numbers of women who choose to be unmarried but also a revision of our social perceptions of this state. We are liberating ourselves from the traditional scripts.

Sexual Freedom
Being single, women are able to choose whether or not to have sexual relations. Throughout history, for religious or personal reasons, some women have preferred to live without sexual relations, either temporarily or permanently. Indeed, a number of active feminists in the past, particularly when "conjugal duties" produced large families, maintained that women could do

very well without sex. Such was the view, for example, of Elizabeth Cady Stanton, herself a mother of five and an important figure in the nineteenth-century suffrage movement (Rossi, 1973).

However, most women wish to have sex. We wish to enter into free and loving relationships with persons of our choice. With few serious restrictions, men have always enjoyed a considerable measure of sexual freedom, but it has rarely been granted to women. We have most commonly been confined to the bonds of heterosexual marriages.

The freedom to love cannot be achieved until it is accompanied by freedom from the fear of involuntary maternity. Whether or not we have sufficient financial independence to support children on our own, the threat of un-wanted children is a fearsome barrier to our enjoyment of our sexuality. No revolution has been more important in the liberation of women from the old patriarchal family circle than the development of birth control devices. Perhaps no revolution has been more persistently and more violently contested. For well over a hundred years, the opponents of women's rights to control our bodies have been fighting back. Earlier in this century, they sought by law even to withold knowledge of the existence of choice from women. In our own time, such opponents continue to seek by law to withold the exercise of such choice, focusing on abortion rights.

With the availability of more reliable modes of contraception in the 1960s and the legalization of abortion through the 1970s, women have felt less constraint in expressing our emotions and desires and have sought greater sexual satisfaction. Some women, delighted with the opportunity to enjoy the bodies of men in relationships that entailed no commitments, joined Erica Jong in celebrating "the zipless fuck," the expression she used to refer to this experience (1973). For others, the "free love" advocated in the sexual revolution of the 1960s all too often turned into an exercise in realizing male sexual fantasies. Some women discovered that "sexual liberation" meant only freedom for men to enjoy the bodies of women. For us, a more genuine sexual liberation has meant the confidence to say "no" without fear of offending men on whom we were, or might have to be, dependent. And it has meant the possibility that the relations we would enter into, whether short-term or long-term, would be genuinely voluntary.

Some women have discovered the possibilities of lesbian love. It is only recently that substantial numbers of women have been willing to comment publicly on this sexual preference. Few have had the courage of Gertrude Stein (1874–1946) who lived as she wished, disdaining public opinion. For too many, the tragic experience of lesbians depicted by Radclyffe Hall in her *The Well of Loneliness* (1926, 1975) represented the truth.

For these reasons, lesbians of the 1970s and 1980s represent a new development. Today's lesbians are the first to express the quality of lesbian experi-

ences. Some writers suggest that all women are really lesbians; others define lesbians as women who make other women the primary center of our emotional, social, and erotic lives, regardless of the details of our sexual relationships (Cook, 1979). These definitions are derived from women's own experiences and feelings about lesbianism, not from men's fantasies and images.

Ultimately, the significant question is, Who are the label makers? The threat of being labeled "unfeminine" has long confined women to socially approved roles. Blanche Cook (1979) argues that the idea of a lesbian, not as an absolute sexual category but as an acceptable self-image of women who love women, is enormously useful. So long as women who form bonds with one another, be they professional, social, domestic, or sexual, react to the label of lesbian as though it were a criminal charge against which we must defend ourselves, the accusation will force us back into the rigid molds of the conventional family.

A major achievement of a new feminist consciousness today is renewed interest in and care for women by other women. Too long has the male-defined consciousness of women as competitors for men's favors separated and divided us. Loving women, caring about women, and being interested in women's lives all exist along a single continuum which is characterized by support and concern, not competition and jealousy. Women's sympathy for one another is a new source of strength.

Notes of Caution
Freedom to find love outside of marriage and the family and the opportunity to be self-supporting are prerequisites to the choice of singlehood. Otherwise, most women would not find being single desirable or even feasible. We have emphasized the changing circumstances that have made the option of not marrying more attractive to more women today. Some notes of caution must be added. First, this option is not available to the vast majority of women in the world, whose societies do not readily condone singlehood and continue to censure the independent and autonomous woman. In most of the world, women are still expected to fall under the protection and control of a family. Second, most women do not earn enough money to live comfortable lives. Today, in the United States, where job opportunities for women have increased during the past century, women working full-time and year-round still earn on the average only 59 percent of what men earn. The vast majority of poor people are women and children. Thus, being single by choice still entails considerable sacrifice, both social and economic.

The search for personal autonomy may be difficult and costly even for women with economic means. Pressures to marry and have children continue to be great. It takes considerable psychic and emotional strength to resist such pressures which, in fact, most women have internalized from childhood.

Summary

Socially scripted options have historically been available to women who wished to live outside the conventional family circle. These choices presented possibilities for roles other than those of the conventional daughter, wife, and mother. From the perspective of history, we can see that women have increasingly impressed our own wishes upon the design of alternative roles and family organizations.

Communal arrangements provided some of the earliest options for women to leave the family circle. The best documented of these are the religious communities of women, the convents of Christianity and Buddhism. Although convent life relieved members of the domestic constraints of marriage and motherhood, control by external male authorities tended to diminish women's autonomy.

Women have also spent intermittent periods living in single-sex educative communities, such as boarding schools and women's colleges. Some women have by necessity or choice joined other women in a laboring community. This kind of life gave rise to the role of "working girl." Finally, women have long enjoyed the support of other women in informal networks.

Philosophers have from ancient times depicted utopian communities for women and men that alter or abolish conventional family life. In the nineteenth and twentieth centuries, communal experiments appeared. All too often, these communities were oriented toward fulfillment of men's utopian ideals, without taking women's wishes and perspectives into account. Consequently, women members tended to be dissatisfied with our roles. If we compare these experiments with women's literary utopias, we see that women view the ideal society differently from men. Women's utopias emphasize a reduction or elimination of gender-role distinctions and maintain a continuous respect for parent-child bonding.

Communal arrangements are only one form of alternative to the conventional family. Women and men may reverse roles or share equally in family tasks. Women may choose to live with men on our own terms, or to couple with other women. We may decide to unmarry and live as single parents or marry and not have children.

Free choices are increasingly possible to contemporary women with good jobs. Many of these women are choosing to live independently and maintain relationships of our own choosing. In this role, we are aided by the fact that birth control has separated the maternal function of women from our sexual enjoyment and search for emotional fulfillment.

For women who choose to live outside the conventional family, the ability to command a sufficient income is essential. Another prerequisite is social independence. Women who have attempted to live outside "respectable" social boundaries have often experienced severe disapproval and even physical

abuse. One of the most powerful constraints on women's freedom of choice has been our own internalization of conventional societal values.

Discussion Questions

1. Discuss your own utopia: are there "families" in it? How are they organized?
2. If you could write your own script for your role in the family, what would it be? What would be the roles of others in your family?
3. In what ways is (was) your family "nonconventional"?
4. Do you belong to a "women's network"? What kind of network would be most helpful to you now? Explain.
5. What are the risks of writing your own script?
6. Which of the alternatives presented here appeals to you the most? Why? Which appeals the least? Why? What options might you choose that have not been mentioned?

Recommended Readings

Baldwin, Monica. *I Jumped Over the Wall. Contrasts and Impressions After Twenty-Eight Years in a Convent.* New York: Rinehart, 1950. An autobiography recounting the experiences of a nun who decided to leave the convent.

Bulkin, Elly, ed. *Lesbian Literature.* New York: Persephone, 1981. Writings by lesbians about their family relationships, love relationships, "coming out," and getting along.

Faderman, Lillian. *Surpassing the Love of Men: Romantic Friendship and Love Between Women from the Renaissance to the Present.* New York: Morrow, 1981. An historical exploration of romantic friendship between women. With or without sexual expression, such choices were alternatives to social expectations for women.

Piercy, Marge. *Woman on the Edge of Time.* New York: Knopf, 1976. An exploration of the place of women in the present and in two possible futures, one sexist and the other nonsexist.

Sullivan, Judy. *Mama Doesn't Live Here Anymore.* New York: Fields, 1974. A woman who grew up in a small town and married at eighteen because she had become a mother makes a new start. She reenters college, earns a degree in art history, reassesses her life, and leaves her husband and daughter.

References

Bernard, Jessie. *The Female World*. New York: Free Press, 1981.

———. *The Future of Marriage*. New York: World, 1972.

———. *The Future of Motherhood*. New York: Penguin, 1975.

Bernini, Marie Louise. *Journey Through Utopia*. London: Routledge & Kegan Paul, 1950.

Bernstein, Marcia. *The Nuns*. New York: Bantam, 1976.

Bolton, Brenda. "Mulieres Sanctar." In *Women in Medieval Society*, edited by Susan Stuard. Philadelphia: University of Pennsylvania Press, 1976.

Brontë, Charlotte. *Jane Eyre*. 1847. Reprint. New York: Oxford University Press, 1980.

Brownlee, W. Elliot, and Brownlee, Mary M. *Women in the American Economy*. New Haven: Yale University Press, 1976.

Carden, Maren Lockwood. *Oneida: Utopian Community to Modern Corporation*. Baltimore: Johns Hopkins Press, 1969.

Cook, Blanche W. *Women and Support Networks*. New York: Out and Out Books, 1979.

Donzelot, Jacques. *The Policing of Families*. Translated by Robert Hurley. New York: Pantheon, 1979.

Eisler, Benita, ed. *The Lowell Offering: Writings by New England Mill Women*. New York: Harper & Row, 1977.

Faderman, Lillian. *Surpassing the Love of Men: Romantic Friendship and Love Between Women from the Renaissance to the Present*. New York: Morrow, 1981.

Falk, Nancy Auer. "The Case of the Vanishing Nuns: Fruits of Ambivalence in Ancient Indian Buddhism." In *Unspoken Worlds*, edited by N.A. Falk and Reta Gross. New York: Harper & Row, 1980.

French, Marilyn. *The Women's Room*. New York: Summit, 1977.

Friedan, Betty. "Feminism Takes a New Turn." *New York Times Sunday Magazine*. November 18, 1979:40.

Gilman, Charlotte Perkins. *Herland*. 1915. New York: Pantheon, 1979.

Gove, W.R. "The Relationship Between Sex Roles, Marital Status, and Mental Illness." *Social Forces* 51 (1972):34–44.

Hall, Radclyffe. *The Well of Loneliness*. 1928. New York: Pocket Books, 1975.

Held, Virginia. "The Equal Obligations of Mothers and Fathers." In *Having Children: Philosophical and Legal Reflections on Parenthood*, edited by Onora O'Neill and William Ruddick. New York: Oxford University Press, 1979.

Hoebel, E. Adamson. *The Cheyennes: Indians of the Great Plains*. New York: Holt, Rinehart, & Winston, 1960.

Jaffe, Rona. *The Best of Everything*. 1958. New York: Avon, 1976.

Jong, Erica. *Fear of Flying*. New York: Holt, Rinehart, & Winston, 1973.

Kanter, Rosabeth Moss, ed. *Communes: Creating and Managing the Collective Life*. New York: Harper & Row, 1973.

Kern, Louis J. "Ideology and Reality: Sexuality and Women's Status in the Oneida Community." *Radical History Review* 20 (1979):180–205

Klepfisz, Irena. "Women Without Children/Women Without Families/Women Alone." *Conditions: Two* (1977):72–84.

Knupfer, G; Clark W, and Room, R. "The Mental Health of the Unmarried." *American Journal of Psychiatry* 122 (1966):841–51.

Lane, Ann. "Introduction." In Charlotte Perkins Gilman, *Herland*. New York: Pantheon, 1979.

Lash, Joseph. *Love, Eleanor. Eleanor Roosevelt and Her Friends.* Garden City, N.Y.: Doubleday, 1982.

Laws, Judith Lang, and Schwartz, Pepper. *Sexual Scripts: The Social Construction of Female Sexuality.* New York: Dryden, 1977.

Lehman, Rosamund. *Dusty Answer.* 1927. New York: Harcourt, Brace, Jovanovich, 1975.

Lewin, Ellen. "Lesbianism and Motherhood: Implications for Child Custody." *Human Organization* 40 (1981):6–14.

Libby, Roger, and Whitehurst, Robert, eds. *Marriage and Alternatives: Exploring Intimate Relationships.* Glenview, Ill.: Scott, Foresman, 1977.

Lorde, Audre. "Man Child: A Black Lesbian Feminist's Response, Not Only of a Relationship, but of Relating." *Conditions: Four* (1979):30–36.

McCarthy, Mary. *The Group.* 1963. New York: New American Library, 1972.

McDonnell, Ernest. *Beguines and Beghards.* New York: Octagon, 1976.

McNamara, Joann. "Sexual Equality and the Cult of Virginity in Early Christian Thought." *Feminist Studies* 3 (1976):145–58.

Muncy, Raymond L. *Sex and Marriage in Utopian Communities in 19th Century America.* Bloomington: Indiana University Press, 1973.

New Women's Times, February 1–14, 1982.

Pearson, Carol. "Women's Fantasies and Feminist Utopias." *Frontiers* 2 (1977):50–61.

Piercy, Marge. *Woman on the Edge of Time.* New York: Knopf, 1976.

Rich, Adrienne. "Compulsory Heterosexuality and Lesbian Existence." *Signs* 5 (1980):631–60.

Rossi, Alice. "A Biosocial Perspective on Parenting." *Dedaelus* 106 (1977):1–31.

———, ed. *The Feminist Papers.* New York: Columbia University Press, 1973.

Sankar, Andrea. "Female Domestic Service in Hong Kong." *Michigan Occasional Papers in Women's Studies* 9 (1978):51–62.

Sappho. *The Poems of Sappho.* Translated by Suzy Q. Groden. Indianapolis: Bobbs-Merrill, 1966.

Skinner, B.F. *Walden II.* New York: Macmillan, 1962.

Smith-Rosenberg, Carroll. "The Female World of Love and Ritual: Relations Between Women in Nineteenth Century America." *Signs* 1 (1975):1–29.

Spreitzer, E., and Riley, L. E. "Factors Associated with Singlehood." *Journal of Marriage and Family* 36 (1974):533–42.

Tiger, Lionel, and Shepher, Joseph. *Women in the Kibbutz.* New York: Harcourt, Brace, Jovanovich, 1975.

Topley, Marjorie. "Marriage Resistance in Rural Kwangtung." In *Women in Chinese Society,* edited by Margory Wolf and Roxanne Wilke. Stanford: Stanford University Press, 1975.

U.S. Bureau of Census. *Fertility of American Women.* Current Population Reports, Series P-20, No. 358. Washington, D.C.: Government Printing Office, December 1980.

———. *Household and Family Characteristics.* Current Population Reports, Series P-20, No. 381. Washington, D.C.: Government Printing Office, March 1981.

———. Current Population Reports, Series P-20, No. 372. Washington, D.C.: Government Printing Office, June 1982.

Woolf, Virginia. *A Room of One's Own.* 1929. Reprint. New York: Harcourt, Brace, 1957.

Uchendu, Victor. *The Igbo of Southeast Nigeria.* New York: Holt, Rinehart & Winston, 1965.

III
Women in Society

Introduction

The previous sections of this book have explored various ways women have been defined by others, the roles we have been assigned in the family, and the alternative living arrangements we have chosen. This final section will deal with our relationship to what has been called the "public" sphere. This section explores the contributions of women to the fields of religion, education, health, the working world, and political power, and it suggests directions for the future.

Women have always participated in the world beyond the family circle, but often our contributions and efforts have been undervalued or ignored. For many people, the primary threat of feminism is the growing power of women in the public domain and the redefinition of our roles in what has been misleadingly called the "private" domain. Although women have consistently met with difficulty when challenging men, it is hoped that as we participate more fully in all aspects of life, a more cooperative and caring society will evolve.

Religion has been a continuing force in the lives of many women. Religions prescribe human behavior and provide models for human aspiration. Women have often been viewed only as saints or sinners. Many women through the years have chosen a "religious life" as an acceptable alternative to secular life and marriage. We have not only been involved as worshipers and followers, but we have also taken leadership roles, ranging from curers to clergy.

Feminists are beginning to reinterpret theological doctrines and to question the sexist bias of the language and cultural practices in which religious dogmas are framed. Feminists today also seek a religious expression for self-affirming beliefs in womanhood.

Education stimulates us to ask questions and search for answers. Too often, those who do not have the advantage of an education do not learn how to question the nature of our environment and experience. Women's education is a controversial issue. Will it provoke us to challenge the status quo? What is appropriate for women to learn? Access to certain fields often requires specific educational preparation. In the past, women were not permitted to obtain instruction in the male-dominated professions of the clergy, law, and medicine. Women today are challenging long-held beliefs about our lack of ability for scholarship. In our research, we are beginning to ask questions which differ from the traditional approaches of the past and are adding to our knowledge about women and men.

Standards for the health of women have very often been based solely on our

reproductive roles. The norms for women's physical and emotional health have usually been defined by men, who assumed that we would be more fragile and physically dependent than they. Women have not been encouraged to be responsible for our own well-being, especially as men have invaded the field of women's health care. When we rebelled against our assigned roles and asserted ourselves, the health care system labeled us "sick." By contrast, men who asserted themselves were labeled mature and healthy. These discrepancies lead us to question commonly held notions of healthy behavior based on gender stereotyping.

Health and medical care have become major political means for controlling the activities of women. Who should be able to make decisions about women's bodies is a controversial national issue. Those who wish to challenge the legal right women have to terminate a pregnancy advocate an amendment to the United States Constitution to ban abortion. Similarly, contraception and sterilization are significant political issues.

Work has usually been devalued when labeled "women's work." Much of the work done by women has been interwoven with the traditional roles of housewife and mother—maintaining the household, gathering and preparing food, preparing and cleaning clothing, and nurturing the young, the sick, and the old. Within the context of the household, women have rarely, if ever, been paid or given credit for our work. Our important contributions to the economy have only recently begun to be recognized.

With the advent of industrialization, much of the work formerly done by women in the home was transformed into activities increasingly performed outside the home for wages—for example, spinning, sewing, education of the young, and care of the sick. Some of the traditional areas of women's work were taken over by men in factories, schools, and hospitals. When done by men, the status of the work and the pay received for it rose. In the industrialized world, technology continues to change the nature of work, and more women are seeking a place in the paid labor force than ever before—as well as demanding respect for those tasks that we have traditionally performed.

Politics and the power to change society are crucial to women's lives. Where there is power, there are means for exerting social control. Those who wield power are not quick to redistribute or relinquish this advantage. In societies where particular characteristics are ascribed to groups of people by virtue of race, religion, ethnic origin, or gender, it has been difficult for the oppressed group to gain sufficient power to alter the status quo. This pattern can be seen in women's struggles for our political rights. Chapter 14 presents some of the background of the women's movement today in the United States and the primary issues being addressed by feminism.

As you read this section of the book, it should become apparent that politics and political realities are crucial to the process of shaping our society. Isolating issues from the political process cannot bring about lasting change. The manipulation and distribution of power is an issue in which women have a significant stake.

Should women strive to reform the existing social system, or will nothing less than its major restructuring be necessary? Different women have different political objectives. Women do not make up a homogeneous group, but we can and do support each other in realizing a variety of shared goals.

10

Women and Religion

RELIGIOUS BELIEFS
The Organization of Religion
The Religious Experience of Women
Origin Myths
Females in the Supernatural World
 Immortal Women: Souls, Saints, and Ghosts
 Goddesses
The Gender of God

RELIGION AND SOCIAL CONTROLS
Family Cults and Controls
 Life-Cycle Rituals
 Sexual Controls
Protection of Women
Public Cults and Controls
 Women as Worshipers
 Popular Religions

WOMEN AS RELIGIOUS LEADERS
Shamans
Missionaries and Martyrs
Religious Rebels

RELIGION AND INDIVIDUAL FULFILLMENT
Mysticism
Possession

AMERICAN WOMEN AND RELIGION
Leadership by Women
 Protestant Denominations
 Jewish Denominations
 Catholicism

FEMINIST CONTRIBUTIONS TO RELIGIOUS CHANGE

Radicals and reformers the world over have perceived organized religion as a bastion of conservatism. Religion seems to represent stability; it derives legitimacy from ancient tradition and custom and lends support to the preservation of old familiar patterns of belief and behavior. Those who hope to bring about radical change are often directly opposed to religious beliefs, organizations, and practices. This has been true of many active feminists in the women's movements of both this and the last century. Yet, feminist leadership has also come from within religious institutions: some feminists cherish aspects of our religious experience and beliefs. Such women are struggling to reform repressive customs and legislation.

For many, the struggle has been painful, as Sonia Johnson discovered in 1977 when the Mormon church excommunicated her for attempting to secure ratification of the Equal Rights Amendment. Frequently, the struggle requires overcoming deep inhibitions. It took a great deal of courage for Sister Mary Theresa Kane to stand up in Washington, D.C., in 1980 to issue her dignified plea to visiting Pope John Paul II that the Roman Catholic church consider allowing women into the clergy.

In a religious society, a change in religious institutions is a necessary aspect of a change in social consciousness, in the social perception of what is right and good. A revision in the social order requires examination and criticism of its bases in ideas and belief, and the introduction of new elements of thought and faith. This is what feminist activism in religion aims at.

This chapter considers religious beliefs, mainly of the traditional varieties, in their social context: how they affect the roles of women and values concerning women. We will look at constructs of the supernatural world—such as gods, spirits, saints, and ghosts—and the ways these relate to the social realities of gender distinctions. We will consider the value systems supported by religious beliefs and the ways that these systems have exerted social controls on women. And we will see how women are changing religion.

Religious Beliefs

People everywhere throughout history have believed that there exists something beyond our perceived material surroundings. This "something," which many refer to as the supernatural, has variously been described as a cosmic design governing the world, as a realm of spirits or forces of nature which control our lives, or as a great power which is anthropomorphized (endowed with human qualities) to make it more comprehensible to ordinary mortals.

However it is conceived, the supernatural is thought to have a power beyond our own. It inspires and awes. For many people, the supernatural serves as an ultimate point of reference on "right" or "wrong" behavior. Religion is often of great importance to an understanding of any society. What people believe about the supernatural is reflected in the ways that they order their social relationships.

The Organization of Religion

We do not know how the first religions were formed, but archeological evidence suggests that even in the earliest religions documented, there were what are now termed *shamans,* persons with special skills in communicating with what was thought to be the supernatural world to bring about desired events in our world (Malefijt, 1968). There have always been some individuals with special knowledge, learning, or understanding who have interpreted their views of the supernatural to others in society. They tell people what is required of them to follow right principles of behavior. But in simple societies, and often in new religions or the religions of the very poor and the oppressed, these specialists are like ordinary people in most other ways. Women or men, they have to do what others do to earn a living, and they influence others by example and guidance, not by force.

As societies become more complex and the division of labor more elaborate, formal institutions, including religious institutions, are established to deal with matters that specifically fall within their domains. Institutions develop which are staffed by priestesses and priests, theologians and teachers, persons who are socially recognized as religious "authorities." Such organizations usually determine which ideas are acceptable and which must be rejected (sometimes classed as *heresy*). They codify (write down) the ethical regulations designed to control the actions of individuals within the society and sometimes enforce control by threatening divine sanctions for misbehavior. In many societies, there is no clearcut division between the organizations which govern religion and those which rule secular affairs. Where there is such a separation, religious organizations generally have considerable influence on secular institutions anyway. For example, voters in the United States may be influenced by the official views of their churches, and American presidents may consult with religious leaders on sensitive social issues.

The organization of religious institutions usually reflects the organization of society at large. In a complex and hierarchical society, dominant religious institutions are complex and hierarchical as well. In societies which deny leadership roles to women and minorities, such roles will also be denied women and minorities in religious institutions. Currents of change and rebellion against the status quo are manifested in challenges to the structure of religious institutions. The organization of a new religion often expresses the dissatisfaction its adherents feel about the established social order.

The Religious Experience of Women

Modern feminists, like our sisters in the past, realize that most of the organized religions which have dominated the historical and modern world have been profoundly sexist. They have not only denied women a place in leadership but have promulgated ideas that devalue women in general (see chapters 1 and 2). Why, then, are women in great numbers the world over devoted members of religions?

Women's personal experiences of religion suggest that we see and feel something beyond and apart from the negative messages that male clergy, ritual, and teaching convey. Women often make aspects of religion that are underplayed by the male hierarchy the essence of our own belief. For example, many Christian women have concentrated on the figure of Christ as healer and nurturer and have focused on the figure of Mary rather than on the patriarchal Father-God (Fiorenza, 1979a).

While the major religions have produced formal codes, the great masses of their adherents have developed their own versions of belief and practice. Catholic women are everywhere excluded from the clerical hierarchy of "Catholicism." In belief and practice, rural Italian Catholic women may well resemble rural Mexican or Irish or Peruvian Catholic women more closely than we do the urban Roman priest. In some respects, rural Catholic women may share certain religious attitudes and interests with rural Islamic and Hindu sisters which neither share with the men who dominate the systems of codified knowledge. The "popular" versions of religions of the world have often provided a scope for women's activities denied us by the male governing elite in the formalized versions of these religions. For the majority of religious women in the past, this appears to have been enough. For a few, as we shall see, it was not; and today numbers of women are demanding an equal place "at the top."

Many feminists are attempting to discover more about ancient religions which did accord women a high place, which had priestesses and worshiped goddesses. These religions are now obscured by time and male renderings of history. Feminist scholars have been particularly interested in how these early religions came to be abandoned or overthrown in favor of patriarchal ones. Peggy Sanday (1981), an anthropologist, hypothesizes that societies which see nature as beneficent, depend on agriculture, and are centrally concerned with fertility tend to accord women great ritual power and worship female deities. Societies which undergo considerable stress from natural or social pressures come to view nature as threatening and to depend for survival on the aggressive acts of men. According to Sanday, these societies tend to view women as dangerous and threatening and tend to worship male deities. They are more concerned with war and destruction than with fertility. Not only are female deities irrelevant to their predominant interests, but they appear to undermine these interests. Feminist theologians like Rosemary Reuther find similar

patterns of change in human interrelationships and relations with nature in the religious beliefs of contemporary societies. These scholars see change in religion as an imperative step in restoring natural and social balance for the sake of our future survival (Reuther, 1979).

Origin Myths

Most religions provide a creation myth, which tells of what are thought to be the first humans and how they came to be. The creation myth subscribed to by Jews, Christians, and Muslims, the story of Adam and Eve, is much more, of course, than a tale of the first humans. Like other peoples' creation myths, it provides a "charter" and a "plan" for relations between people and the supernatural, between women and men, and between humans and nature. We have already discussed some of the implications for women of the Adam and Eve myth in chapter 1; let us now examine a feminist perspective on its history.

Peggy Sanday reconstructs the context for the codification of the Adam and Eve story as follows (1981:216–25). The ancient Hebrews were a nomadic herding people who migrated into the land of Canaan, an agricultural area. As herders in a harsh natural and social environment, they had come to depend on the aggressive acts of men in subsistence and war, and concomitantly to worship a male deity. The gentler conditions of life and worship in Canaan were attractive to the settling Hebrews, particularly to the women, who clearly held an inferior place in the masculine orientation of the Hebrew religion. The Canaanites worshiped a female fertility goddess who was sometimes represented as a tree. However, this agricultural deity, appropriate to the Canaanites, posed a threat to the historical social identity of the Hebrews. Women, and through them men, began to adopt religious beliefs and practices alien to the older, dominant Hebrew tradition.

The codifier of the myth used a popular and widespread story to make a strong point. He used his poetic skill to emphasize and elaborate features of the ancient myth that would articulate a perceived social and political problem and that would clarify his (and his patron, the king's) position on this problem. In his version of the creation myth, the "tree of life" symbolized Canaanite fertility worship, which was so attractive to the Hebrew women living in Canaan but which undermined the authority of the traditional Hebrew deity. The message was clear to the people of his time: it is wrong for Hebrews to worship the foreign goddess, known in Canaan as Anath; Hebrew men may be tempted into this error by women, who are most attracted to her worship.

The meaning of the myth has changed, of course, with radically changed circumstances. Anath has been forgotten, so the initial intention of the codifier has been obscured. Yet the myth retains its symbolic power because the general circumstances were, and still are, relevant. The religious and social

traditions which subscribe to this origin myth have continued to exclude female deities associated with fertility (nature's generosity) and to accord females (and female characteristics) a second place, if any, in worship. Thus deprived, women are tempted to stray from the intolerant masculinist tradition, hence from the dominant social identity, whatever it might be. The myth reminds all concerned that this is thought to be wrong. The reminder is successful because it occurs in a social context in which male aggression is the prevalent mode of social survival.

While the growth of population and the spread of colonialism over the world have brought more and more people into the fold of patriarchal religions and the stressful environmental conditions which have supported them, ethnologists have preserved records of the religious traditions of sufficient numbers of cultures to show that patriarchal origin myths are by no means universal. In an extensive cross-cultural survey, Sanday (1981) found that in societies in which women and men are more equal to one another, origin myths contain a primary female or couple, while in inegalitarian societies, the original creator is male or an impersonal force.

Females in the Supernatural World

Perhaps because it is easier for people to think in concrete terms, most forms of religious belief include some conceptualization of a supernatural world that is inhabited by forces with superhuman qualities. These saints, ghosts, and spirits of various sorts are often considered more approachable, and more interested in "ordinary" people, than are the great deities of their religions. Although the formal traditions of Judaism, Christianity, and Islam are monotheistic (believing in a single divinity), the "folk" or "popular" versions of these religious traditions have always included belief in lesser supernatural forces.

Immortal Women: Souls, Saints, and Ghosts. The question of what happens to the soul after death is a critical one. Many people believe that the soul persists, to occupy a place in the supernatural world or to return to life in another body. The latter, called reincarnation, as represented in Hinduism and Buddhism, involves belief in an ascending scale of perfection which an individual can climb or descend, through successive lifetimes, depending on how virtuously each life was lived. Individuals are destined to be reborn again and again, to endure the pain of existence, until they reach the pinnacle of perfection, after which they are released. The most virtuous life is one devoted to study, meditation, and unconcern about worldly things (like marriage, children, wealth, and comfort, even eating and sleeping). But women are very unlikely to have the opportunity to pursue a life of study and meditation in Hindu and Buddhist societies. "In Hindu mythology, women came to symbolize the eternal struggle that men must wage between material-

ity and spirit. Kali (the Goddess) symbolizes the womb, connected with re-birth and consequent illusion and entanglement in the world" (Hoch-Smith and Spring, 1978:4).

Christianity and Islam teach direct individual immortality, with the soul experiencing punishment or reward in accordance with the virtues and vices of a single lifetime. These religions strongly espouse the idea that souls are essentially without sex, and that salvation is open to both women and men. Some souls, because of unusual virtue, become saints. They continue to provide blessings for the living who appeal to them. Fiorenza (1979b) argues that "the lives of the saints provide a variety of role models for Christian women. What is more important is that they teach that women, like men, have to follow their vocation from God even if this means that they have to go frontally against the ingrained cultural mores and images of women" (ibid.:140).

Most religions believe in the existence of ghosts as opposed to immortal souls. A ghost is someone whose spirit outlasts the physical body for some period. Ghosts are thought to be capable of beneficence, particularly as protectors of their survivors in the family. But if maltreated or forgotten, they are also believed capable of vengeance. Bad luck, sickness, nightmares, and even psychic persecution are often blamed on ghosts. Ghosts differ from saints in that they are interested in their own families and they require appeasement and respect, not veneration.

The family is usually regarded as the proper channel for the satisfaction and control of the dead. This is true of ancestors as well as ghosts. In most ancestor-worshiping societies, however, women do not fare very well in receiving the worship of descendants. In such societies, the significant ancestors usually are male and require male descendants for their worship. The male ancestors of wives, however, are not worshiped by husbands and sons. In the ancestor cults of China, only the mothers of sons are included on the family altars of husbands (Jordan, 1972). In many modern cults, the spirits of women are considered weaker than those of men and not entitled to worship as ancestors (Lewis, 1975).

Despite, or perhaps because of, the poor position of women as ancestors, we figure extensively as ghosts. For example, in a study of a Taiwanese village, a high proportion of the ghosts that were thought to regularly disturb the villagers were divined to be the spirits of women demanding a place on a family altar. These spirits were generally women who had died before being received into a husband's family or whose marital histories featured some irregularity that left them stranded between family altars (Jordan, 1972).

Goddesses. Many people believe that the supernatural world comprehends elevated regions inhabited by deities of wider sway than spirits, saints, and ghosts. This cosmos is generally perceived to be inhabited by a number of

divine persons paired and grouped in relationships not unlike those found on earth. The Hindu Shiva and Devi, for example, are regarded as the primeval twofold personalization of the Absolute (Zimmer, 1946, 1978).

In the great polytheistic religions of later antiquity, goddesses appear with a variety of powers and attributes. They are patronesses of cities (Athena), of marriage (Hera), and sex (Aphrodite). They are in charge of agriculture (Demeter) and human fertility (Artemis). In the ancient Near East, it was the drama of the sacred marriage, the death and resurrection of the consort of the goddess, that provided the framework for the rituals that kept the universe running harmoniously (Frazer, 1960:164–69). Many peoples have worshiped goddesses who were believed to control matters of the most profound significance to human life. The Hopi farmers of the American Southwest venerated the Corn Mother, who represented the nourishing functions of the earth (Hoch-Smith and Spring, 1978), and the Innuit, maritime hunters of the Arctic, venerated Sedna, goddess of the sea (Frazer, 1960:64).

The goddess, like the unfettered woman of male fantasies, is often envisaged as a threatening and terrible being. This is the case with the Innuit goddess Sedna. In Hindu mythology, the goddess is dark Kali (see page 30), whose orgiastic dancing brings death and destruction on the world. But when she submits to her husband Shiva, the goddess becomes beneficent; her energy is harnessed for good by the rational principle of maleness. In the countryside, however, peasants in the nineteenth century prayed to Kali alone as the good mother: "Though the mother beats the child, . . . the child cries mother, mother, and clings still tighter to her garment. True I cannot see thee, yet I am not a lost child. I still cry mother, mother. All the miseries that I have suffered and I am suffering, I know, O mother, to be your mercy alone" (Eliot, 1962 II:287–88). Tamed and controlled, a goddess may become a great and well-loved figure, worthy of the worship of men as well as women.

Buddhism has sometimes been called an atheistic religion because in its most sophisticated vision of the cosmos, all personality and individual attributes are wholly dissolved into divine unity, Nirvana. However, the religion provides focus for worshipers in figures of Bodhisattvas, personages whose perfection has freed them from mortal life but who choose to remain in a personalized existence in order to be accessible to the appeals of the struggling faithful. The greatest and most popular of all is Avalokiteśvara, the Bodhisattva of compassion, who appears as a goddess in one manifestation. Avalokiteśvara originated in India but is worshiped in Tibet as Tara, in China as Gaunyin, in Japan as Kwannon, and by other names throughout the Orient. Guanyin is the very quintessence of the compassion of the Buddha. Pregnant women turn to her for help, and she cooperates with mediums seeking communication with ancestors or ghosts.

Avalokiteśvara is a compound of the less important female deities of the

Asian world, gathering their attributes, powers, and myths into her own powerful and universal cult. A similar transformation befell the great goddess of antiquity, Isis. She began as a local Egyptian goddess associated with the cult of her husband Osiris, a dying and rising vegetation god. By Hellenistic times, she was the center of a cult in which she ruled alone, although she was sometimes pictured as a mother with her baby. She had the attributes of compassion and love associated with the controlled goddess.

In the sixth century B.C., the Jews brought monotheism to the Holy Land from Babylon. At that time, the Old Testament was edited into the ongoing revelation of a single god which is familiar to us today. The goddess Asherah and other goddesses once worshiped by the Hebrews were cast out, an event which repeated itself periodically when the wandering Hebrew tribes feared assimilation into the peoples among whom they settled. When European pagans became Christians and adopted the Jewish tradition of monotheism for their own, they turned their backs on the gods and goddesses of the Greek and Roman worlds, reducing them to hollow idols. Some second-century Christians favored endowing the Holy Ghost with a feminine persona, but this impulse was rejected, and all three persons of the Christian Trinity became male or without gender. Some centuries later, the Muslims in their turn rejected the goddesses of their ancient Arabian tribes in favor of the one (male) god of Abraham.

For most ordinary worshipers, however, none of the three monotheistic religions has entirely excluded the old female deity. The relatively complete monotheism of the Jews is, perhaps, but one effect of the violent rupture between the people and their ancient lands. The Christians exalted the memory and attributes of Mary, "mother of God [Jesus]," in direct proportion as God himself became increasingly patriarchal (Fiorenza, 1979b). In many respects, Mary seems hardly distinguishable from the great goddesses of the ancient world whom she supplanted. A stranger unacquainted with the formal theology of Catholicism would not hesitate to advance the idea that the great cathedrals and shrines were devoted to the worship of a great goddess (Mâle, 1949).

The Gender of God

Some feminists feel that the social position of women can be enhanced by the worship of a goddess, and that belief in a female deity would give religion more usefulness and meaning. This has been the position taken by such leading theologians and feminists as Mary Daly (1973), Carol Christ (1979), and Naomi Goldenberg (1979). They believe that the image of the deity we worship is important to our understanding and appreciation of ourselves. In patriarchal religions, divinity is male; hence, men see an image of themselves in the divine, while women are denied this identification with divinity.

The goddess symbol that is being created for the contemporary woman is,

"The Synagogue" by Sabina von Steinbach, dating to the early thirteenth century, is one of the sculptures on the south portal of the Strasbourg Cathedral. Little recognition has been given so far to the role of women like von Steinbach as cathedral builders. (Musées de la Ville de Strasbourg)

for some, an inspiring reaction to the repression of patriarchal monotheistic religions. The goddess symbol means above all "an affirmation of the legitimacy and beneficence of female power." The goddess is not limited to the female symbolism of good and evil as represented by Mary and Eve but is "(1) divine female, a personification who can be invoked in prayer and ritual; (2) the goddess is symbol of the life, death, and rebirth energy in nature and culture, in personal and communal life and (3) the goddess is symbol of the affirmation of the legitimacy and beauty of female power" (Christ, 1979: 278).

Female spiritual leaders, such as Starhawk, have prophesized the dawning of a new religion: feminist witchcraft. Witchcraft is the first modern theistic religion to conceive of its deity, the Goddess, mainly as an internal set of images and attitudes (Goldenberg, 1979:89). Most modern witches use the Old English term *wicca*, meaning "wise woman." Witches use a goddess concept to give women positive self-images in all stages of life: maiden, mother, and crone (Goldenberg, 1979:97). The wicca are developing rituals and designing ceremonies around the symbolism of womanhood. The woman god appears at all stages and situations in a positive light, shedding the demeaning attributes that patriarchal religions have given to her. According to modern proponents of feminist witchcraft, the image of woman elevated in the symbolism of the goddess will have a positive effect on real women (Starhawk, 1979).

Mythologists have sometimes argued that the rule of a great goddess in the early periods of human civilization was reflected on earth by a matriarchy (see Stone, 1979, for a review of the evidence and arguments). Certainly, in periods for which we have historical documentation, cults and sects which accorded the deity a female nature, in part or in whole, accorded women a higher position in religious belief and practice. The vestal virgins in ancient Rome were respected and provided with special honors by their social peers. Probably this was also the case in other goddess cults of the ancient world. Many sects of early Christianity believed that God had a female component as well as a male one; they also had female clergy, prophets, and teachers (Fiorenza, 1979a). The presence of a goddess or quasi-goddess in a religious system has the psychological value of providing women with a role model and an object for supplication. On the other hand, such figures can be employed as models to confine the ambitions of women.

Some gods are thought to incite enthusiastic female worship and appear to prefer female devotees. Dionysus, Krishna, and Jesus have all been particularly venerated by women. Dionysus liberated the frustrated and confined women of ancient Greece periodically with ecstatic experiences of dancing and frenzied activity. Krishna, who is often represented as a baby, is associated with a sect of female worshipers who call themselves "Mothers of God" (Freeman, 1980). As young men, all three gods are represented as attractive and loving of women, posing in their lives as our

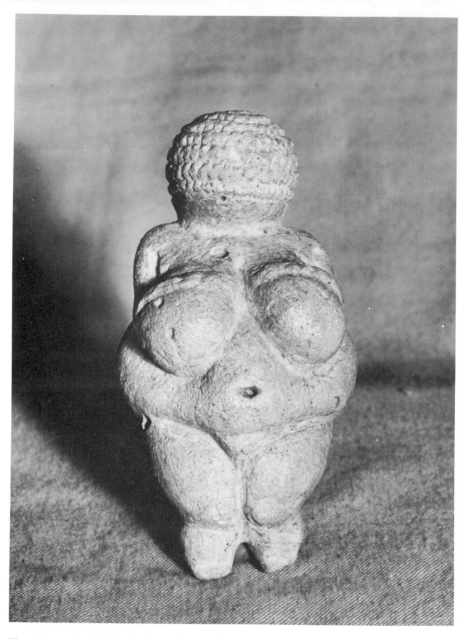

The "Venus" of Willendorf, as this prehistoric figurine has been called, is taken as a prototype of the neolithic goddesses. Faceless, with an elaborate headdress and exaggerated breasts, thighs, and buttocks, she has been interpreted as a fertility goddess. This figurine, carved from stone, sometime between 25,000 B.C. and 20,000 B.C., is only 4 ⅜ inches high. Others, also small, were made in ivory, clay, and other materials. Their actual purposes are not known. (Austrian Institute)

protectors. They continue to attract the warm affection of women in their apotheosized state.

As deities have become the focus of wealth and status on earth, men have tended to dominate their worship. The deities loved exclusively by women have become marginal or nonconformist deities, or they have made some comfortable arrangement with the ruling establishment while retaining certain of their less official qualities. The position of goddesses in polytheistic societies varies widely, as did the positions of women in ancient Athens and ancient Rome. Similarly, there is such wide variation in the position of women in monotheistic societies that it becomes difficult to generalize about the influence of women's roles on beliefs about the gender of God and vice versa. Not everyone is convinced, then, that we need a female deity to improve the status and position of women in our society, or that belief in such a deity would support that goal.

Religion and Social Controls

Religion provides more than the imagery by which we can conceptualize the supernatural world. It provides a basis for a code of ethics to govern human conduct. Although philosophers argue that the validity of moral principles is independent of religious teaching, for many people, ethical principles must rest on some higher authority than ourselves. In highly organized religions, clergy and other specialists interpret and sometimes enforce a code of ethics grounded in religious belief. But all religious systems have some means for exerting control over human conduct, ways of informing their adherents of what is right and proper and what is wrong and improper.

Family Cults and Controls

As the kinship/family group lies at the base of society, so does it lie at the social base of religion. In addition, however, community codes and ceremonies strengthen the authority of the kinship groups, usually the authority of the head of the family, and train each generation's successors, whether female or male offspring.

Life-Cycle Rituals. As we have already seen, the family provides the framework within which women are confined and socialized. Public performance of rituals during the life cycle, such as initiation and marriage, enhances the power of the family, the relationships considered proper for its members, and the control of those individuals in accordance with the decorum of the community.

For men, life cycle rituals are usually occasions which help to define and enhance their potency and social power as they advance toward full adult membership in the community. The major life cycle rituals for Jewish males,

for example, are the *brith millah,* the circumcision ritual of eight-day-old infant boys which provides them with a physical identity as Jews, and the *bar mitzvah,* the ritual of first participation in adult study and prayer which marks the entry of a thirteen-year-old boy into the community of adults. For infant girls, there is no equivalent of the *brith,* and only in reform Judaism is there a girl's equivalent to the *bar mitzvah,* a *bat mitzvah.* Unlike the *bar mitzvah,* the *bat mitzvah* is not essential to girls' membership in the Jewish community, nor does it mark our "coming of age" in the traditional sense. While Jewish women are considered to be the sole transmitters to our children of the right to be a Jew, we ourselves are not formally inducted into either membership in the Jewish community or adulthood.

Female circumcision (removal of clitoris and/or labia minora), while not a Jewish custom, is prevalent in East Africa, particularly in the Muslim nations of Sudan and Egypt, and Christian Ethiopia. Feminists have condemned this type of genital mutilation of women as an odious and oppressive custom. Unlike the circumcision of boys, it is not dignified with religious prescription. Instead of being a mark of honor, it is intended to keep women from becoming sexually active and from enjoying our sexuality.

In patriarchal, patrilineal societies, the most important life cycle ritual or rite of passage for women is likely to be the wedding ceremony. This marks the major transition from our families of birth to our husbands' families. Since divorce for women may be difficult or even impossible in such societies, women are likely to undergo this ceremony only once. It may last for days, preceded by months of preparation and preliminary rituals. In Western societies, weddings have traditionally spotlighted the bride. They are our one and only major ritual role. Neither menarche nor childbirth (unless it is the birth of a royal son and heir) are accompanied by equivalent attention.

This is not the case in matrilineal societies. Marriage does not substantially alter women's social position, since we remain in our own matrilineage for life. If there is a major life cycle ritual, it is likely to be associated with menarche, when we become of reproductive age, ready to contribute new members to the matrilineage. A good example is the *chisungu* ceremony of the matrilineal Bemba, a large and complex society of Zimbawe. Periodically, all the girls of a district whose first menstruation has occurred since the last *chisungu* participate in the month-long ceremony. The initiates are honored by the whole community; the women sing and dance before these girls, and parents, fiancés, and prospective in-laws contribute to the expenses of the ceremonial feasting.

During the complex ceremony of initiation, the Bemba girls pass through several role changes, beginning with separation and seclusion, physical degradation (such as being prohited from bathing), and testing for strength and courage. The ritual ends with reentry and renewal. After initiation, the girls are believed to be protected from any ill effects of menstruation, prepared for

In the first communion ceremony, little girls traditionally dress up with finery suggestive of bridal rituals. (Photo by Jean Shapiro)

marriage and reproduction, related to other women in a new, more intimate way, and newly knowledgeable about the role requirements of women (Richards, 1956).

Feminist critics of Western religious systems have favored the establishment of a meaningful life cycle ritual for women in connection with menarche. Theologian Penelope Washbourne believes that such a ritual would help young women deal with our ambivalent feelings about menstruation and achieve our new adult identities.

> Experiencing menstruation creatively is of immense importance, for it lays the foundation for resolving the next life crises which have to do with personal selfhood and expressing sensuality to others. A woman will be unable to experience menstruation gracefully unless the family and community provide a context within which the graceful and demonic elements of life crisis may be expressed and her new identity as a woman is celebrated. Perhaps in a time of secular culture it is the role of the immediate family and friends to provide that context in a ritual and symbolic form, since it is from them that a woman learns her sense of what is ultimately valuable in the first place. (Washbourne, 1979:257)

Sexual Controls. For women, life cycle rituals are often constraining. They are intended to control and inhibit our power and remind us of the limits of our expectations. At puberty in most cultures, the freedom we might have enjoyed as little girls is sharply curtailed. We may be told that we are unclean

and must learn to control the possible ill effects of our polluted nature. At the same time, we may be schooled in the hard facts of our vulnerability both to public censure and physical attack. The leaders of every major literate religion in the world have produced literature against the sexuality of women. Representatives of the major religious hierarchies have continually urged women to contain ourselves within the narrow limits of our homes and the narrower limits of female modesty and decorum, threatening us with both earthly and eternal punishments for the sins of our "nature."

The most effective method of controlling the dangers represented by women's sexuality is to ensure that we are kept under the authority of our male kin. Patriarchal religions offer a chief (or only) god as role model for the father of the family. At puberty, men are proclaimed mature and ready to undertake public responsibilities. Many societies begin a process of weakening the control of the father over his son at this point to free the son for service in the greater community. Women, however, are not released from our fathers' power; rather, fathers are given the right to hand us over to the power of a husband. This right to "give" a daughter in marriage has been, until recently, the sovereign right of the father. Even in Christian societies which defended the individual's right of consent to marriage, the economic dependency of daughters usually made us subject to paternal authority.

Religious laws in patriarchal societies often protect men from the "dangers" of pollution inherent in close proximity to women during our menstrual periods. In the Koran, the sacred book of Islam, men are ordered to separate themselves from their wives until we have taken the ritual bath at the end of the menstrual period (Delaney et al., 1977). The same religious proscription on sexual relations between husband and wife applies to Orthodox Jews. Such laws, no doubt, reinforce women's own fears about menstruation and undermine our self-esteem by labeling us as periodically "unclean." Still other religious laws give the husband substantial advantages within the couple relationship; for instance, adultery is often made a greater sin for women than men, and greater strictures are placed on women's rights to divorce than on men's.

The codes of most religions urge husbands to use their authority prudently. They warn of the damage that may be caused to a family by the despair of unhappy women. They remind men of the blessings of a home cared for by a contented wife. But while men are subjected to moral suasion, women are subjected to physical coercion. The Koran instructs husbands on how to ensure the right behavior in their wives: "Say to the believers, that they cast down their eyes and guard their private parts; that is purer for them" XXIV:30 (Arberry, 1955). Nearly every written religious code is based on double-standard morality. Christianity, whose rhetoric consistently states that what is not allowed to women is not allowed to men either, has never made wide practical application of the rule.

Protection of Women

Religious laws generally offer some protection to the obedient weakling. While they justify authority and preach obedience, they also restrain human authority in the name of a higher power and teach men the limits on their insubordinate will.

In this spirit, the Talmud and the Koran concern themselves at great length with the economic responsibilities of men toward their wives and daughters. The rights of women to dowries, inheritance, and other economic protections are spelled out carefully. Arbitrary divorce is discouraged, and polygyny is regulated to ensure the rights of co-wives. Catholic canon law sanctifies the consensual basis of marriage and protects wives from repudiation by husbands. It defines rape as a crime of violence against women and denies men the right to kill their wives. All the "peoples of the Book" are urged to protect and support widows and orphans and to treat moral and observant women with respect and kindness.

Within that framework, religion acts to establish and enforce the norms of family life. Sexual relationships between wife and husband resulting in the birth of children are universally viewed as divinely ordained. Deviation from that pattern is sometimes considered immoral and sometimes violently punished. Christianity and Buddhism, which were initially relatively antipathetic to sexual activity and procreation, gradually modified and shifted their positions. By the seventh century A.D., the exclusivity of the monastic route to salvation for the Buddhists had given way to the growing popularity of Mahayana, a variant of Buddhism emphasizing the values of marriage, sexual and parental love, and familial virtue. This route was considered particularly appropriate for women.

Public Cults and Controls

Outside the religious activities of the family, most societies engage in a wider set of ceremonies, celebrations, and rituals devoted to the deities worshiped in the community. These require the services of a professional and trained clergy who enjoy the accoutrements of public art and architecture, conduct time-consuming and often occult rituals (sometimes in a language unknown to the laity), and make use of an extensive tradition of myth and law to enforce their social authority.

Women As Worshipers. Nearly all religions encourage, indeed command, the active participation of women as worshipers. But even as worshipers, we are subjected to a variety of restrictions. Lay participation in the performance of rituals is usually restricted to men. Except in Reform Judaism, Jewish women are not counted in the *minyan,* the quorum of ten required for the conduct of certain services. There are no altar girls in Roman Catholic churches.

Moreover, many congregations discriminate against the ordinary participa-

tion of women. Orthodox Jews and Muslims seat women apart from men during services. In fact, many synagogues, mosques, and several American Protestant churches were built to provide for separate or secluded seating arrangements for women. Until recently, American Catholics followed the prescription of Paul that women must veil their heads in church and refrain from speaking.

And yet, any traveler in a Catholic country must be struck by the idea of the church as "woman's space." It may be dominated by an all-male hierarchy, but every day the women spend hours there in devotion and conversation with one another. Even from the earliest times, Christian moralists have complained about the habits of women in using the church as a social center. Similarly, the shrines of Sufi saints are centers where Islamic women meet daily for rest and relaxation and to confide in the sympathetic saint (Fernea and Fernea, 1972). Underneath the restrictive and apparently prohibitive structure of the great religions is the elusive, often undocumented world of women.

Popular Religions. On the fringes of the "established religions" are hosts of *syncretic* religions, each of which combines elements from a variety of others. They flourish today as they have throughout history. For the sake of simplicity, we shall restrict our discussion to a small sample of groups found in the Americas today. However, the findings of historians and anthropologists bear ample witness to the presence of similar "popular" religions throughout the world.

Many syncretic religions have spun off from Catholicism. The black leaders of the ancestor religions of the Caribbean see no contradiction between their beliefs and Catholicism. Indeed, they maintain that the one is not possible without the other (Simpson, 1978). Women outnumber men four to one in these religions and are the principal dancers in the Shango and Big Drum sects. Similarly, the women of Haiti dominate the popular religions there, even though excluded from men's groups in that society.

A study of black religious sects in America has shown that contrary to dominant belief, these women believers are not salvation-oriented (Simpson, 1978). In these sects, we can therefore afford to be indifferent to the sacraments in such cults as Vodun, to continue to speak of ourselves as Catholic and never question church dogmas, because we are, like so many rebellious "Catholics" the world over, anticlerical.

In North America, where the dominant form of Christianity has generally been Protestant, Mambo and other African cults have been syncretized to particular sects, principally variants of Baptism (Simpson, 1978). In these groups, women often emerge as preachers and leaders. Women are also prominent among the Quakers and other nonhierarchical dissenting sects. Women assume much more important places in both leadership and partici-

pation in dissenting and popular religions than in established ones, whether or not we see ourselves as opponents to established authority.

Women as Religious Leaders

Only rarely do women enjoy the authority of clergy, and when we do our range of activities is usually restricted. The most highly organized religions welcome women clergy the least. Thus, in Catholicism, the clergy has not only been restricted to men but only to celibate men since the eleventh century. Eastern Christianity (the Greek and Russian Orthodox churches) allows women to marry priests but not to be ordained ourselves. Only very recently have a few women been ordained in some of the larger, institutionalized Protestant churches.

Women tend to emerge as ministers in sects which do not control their clergy and which depend on genuine spontaneous religious emotion, as opposed to a weighty establishment supported by endowments and state cooperation. Thus, the loosely organized pentecostal or evangelical sects are frequently ministered by women.

Women have customarily been kept from the rabbinate. Since Jewish girls are not required by religious law to study the scriptures and sacred texts as boys are, it has only been the exceptional Jewish woman who has qualified, in the past, for the specialized learning of the rabbi. However, Judaism, like Protestant Christianity, lacks a single central hierarchy, so it allows for a proliferation of congregations of varying opinions on matters of administration and discipline. In Reform Judaism, the predominant form in many areas of the United States, female rabbis have been ordained in the past decade.

Islam, like Judaism, has no formal clergy and no "church" hierarchy. Professional mullahs and ayatollahs in the Shi'ite branch along with other teachers and prayer leaders serve many of the functions of clergy, such as officiating at marriage and funeral rites and interpreting customary law. Women are not numbered among these revered individuals. The conventions of purdah (segregation of women) and veiling severely restrict Muslim women from participating in services and prayers with men, not to mention leading them. These same conventions have in some places given rise to a class of female mullahs whose job is to minister to women, to teach the rudiments of the Koran and to conduct rituals with women at home.

Shamans

Women excel at ritual and spiritual services connected with nurturance and healing. In folk traditions around the world, both in the countryside and in the cities, women have served our communities as curers and midwives. These traditional arts are generally thought to have a supernatural or spiritual component as well as a practical one. Both illness and childbirth are

One of the consequences of the modern women's liberation movement has been the assertion by women of leadership roles in large-scale religions.

(Opposite top) The Rev. Ellen Barrett, first declared lesbian ordained an Episcopal priest, January 10, 1977. (Photo by Bettye Lane)

(Opposite bottom) Sally Priesand, the first woman to be ordained a rabbi, June 2, 1972. (Photo by Terry H. Layman)

(Above) The Rev. Pauli Murray, first black woman ordained an Episcopal priest, January 8, 1977. (Photo by Susan Mullally Weil)

widely viewed as spiritually dangerous states. Curers, generally termed *shamans* by anthropologists, are active in societies where it is believed that illness—or certain types of illness—is caused by supernatural agency. Both curers and midwives are thought to have esoteric knowledge about how to fend off or appease threatening supernatural beings. Traditional curers of this sort need not be exclusively female, but they often are, and midwifery almost everywhere is a woman's profession.

To cure an illness, the shaman often enters a trance state, during which she (or he) communicates with the spirit world for assistance in the restoration of health. For example, in parts of southern Mexico, people believe that a traumatic experience of some sort may cause the victim's soul to leave the body, where it is snatched by an underground spirit, Nahual. As a result, the victim experiences sleeplessness, headaches, and general malaise. To cure this illness, the victim must obtain the services of a shaman, who knows how to speak to the spirit and convince it to release the victim's soul. Family members, neighbors, and even passers-by witness and participate in the curing ceremony. They listen sympathetically to the victim's recounting of the terrible experience and support the curer as, together, they vanquish fear and evil.

The curer, the midwife, and the medium (who puts her clients in touch with departed souls) all have a nurturing, supportive relationship to clients, unlike the often nonpersonal and authoritarian relationships that male physicians and priests tend to have with those who come to them for help. Yet curers, midwives, and mediums can be professionals too, often devoting years of training to such careers (Hoch-Smith and Spring, 1978).

Women play these spiritual roles in vastly different sorts of societies, from South Africa to north Florida, from Southeast Asia to Latin America. Some feminist authors have deplored the loss of these roles among the middle class and wealthy women of the Western world as the healing professions have been gradually taken over by men (Ehrenreich and English, 1979). Herbalists, midwives, and other sorts of woman healers have often been classed with fraudulent mediums by professional clergy and professional male healers, whose reasons for doing so may involve a defense of their professional (and male) monopoly.

Missionaries and Martyrs

The great religions of the world, distinguished by monumental places of worship, a professional clergy, a written literature, and a large following, reflect the institutionalized worlds of men. But the great religions started as popular religions, often as sects of rebels against a greater system, as the Hebrews in Egypt, the Christians within the Roman empire, or the Buddhists in India. They have all known periods of danger and persecution; they have all entered into periods of struggle to win recognition for themselves. During these times, women often played significant roles.

"Without a husband I shall live happily" Box 10.1

According to folk tales dating to the early seventeenth century, the Nišan Shaman was a young widow who dutifully took care of her mother-in-law and her domestic duties. But she had a far-reaching reputation for her ability to communicate with the dead and bring them back to life. She had a lover who assisted her in her séances. On one ghostly journey, she met her deceased husband who begged her for resurrection. She refused, saying:

> "Without a husband
> I shall live happily.
> Without a man
> I shall live proudly.
> Among mother's relatives
> I shall live enjoyably.
> Facing the years
> I shall live cheerfully.
> Without children
> I shall live on.
> Without a family
> I shall live lovingly.
> Pursuing my own youth,
> I shall live as a guest."

 (Durrant, 1979:345–46)

Reprinted by permission of the University of Chicago Press.

Where the role of a missionary is dangerous and the reward often death, women have found favorable conditions for the expression of our zeal and spirit of adventure. Women were welcomed into the original Buddhist fellowships for our missionary contributions but later restricted as the religion became established and more secure (Carmody, 1979). The brief period of Jewish missionary activity in Hellenistic times saw the inclusion of women in public meetings and an extraordinary emphasis on the heroines of Israel like Ruth, Judith, and Esther. But with the end of that period (about the seventh century A.D.), women were restricted to the role of assistants to husbands and teachers of sons (ibid.).

Women have enjoyed a long and honorable history in Christian missions. The Samaritan woman whom Jesus sent to spread news of his coming among her people might be called the first of all Christian missionaries. In the conversion of Europe, Christian queens opened the way for priests and monks by marrying pagan kings and converting them; the most famous of these was Clotilda, wife of Clovis, King of the Franks at the beginning of the sixth century A.D. Modern Christian missionary women tend to fall under the control and supervision of men: Catholic nuns by supervisory

priests and Protestant missionaries by husbands, male relatives, or male mission heads.

If women are welcomed by churches as missionaries, how much more welcome we are when a religion is in need of martyrs. Every religion which seeks converts has produced its martyrs, and all too often the blood and mutilation of women have seemed to constitute the most persuasive testimony of faith. Such instances are traditionally held up to Catholic girls, for example, as part of our religious education.

Religious Rebels
In Europe, in the second century A.D., women predominated in the large-scale heretical movements and organized and led many small heretical sects. Our ardent participation in these movements is generally conceded to arise from social rather than intellectual motives. Women saw in early Christianity a vehicle for liberation, for activity on a broader scale than was offered by the traditional homebound destiny, and we rebelled against Christianity when the development of the church sought again to restrict these activities.

In the major religious rebellions in Europe in the sixteenth century, Protestant churches freed themselves from the authority of the pope and his orthodox establishment. In the process, women again took an active part as defenders and preachers of both new and old religions. But Catholics and Protestants alike were alarmed by the apparent assumption on the part of women that the new conditions would offer us a broader field of activity. Both acted to put an end to the threat. Catholic women like Angela Medici and Mary Ward who thought the time was ripe for a more active public role for nuns were severely disciplined. Protestant women like Anne Askew were executed for thinking that the priesthood of all believers urged by Luther and his contemporaries included women (Dickens, 1964:194).

The late medieval period in Europe had also been a time of great social upheaval. From the fifteenth century on, women were perceived to be behaving in a variety of eccentric and unconventional ways. An outstanding example from the early fifteenth century was Joan of Arc, who led troops of French soldiers against the invading English armies. The English burned her at the stake as a heretic and witch, but the French supported her memory as a martyr, and she was finally canonized by the Catholic church (box 10.2).

Joan was reported to be the object of admiration and emulation by other women. Moralists of the period complained of women who roamed about the land dressed as men, showing their legs and frightening passers-by by brandishing daggers. This appearance of restless and discontented women apparently seeking a freer life coincided with the rise of Protestantism. At the same time, men became obsessed with the notion of demons. The long-standing policy of the Catholic church that there could be no such thing as witchcraft was reversed at the end of the fifteenth century, when the *Hammer of Witches*

The Trial of Joan of Arc Box 10.2

Joan of Arc, at the instigation of "voices" sent by God, took up arms against the English occupation of France. Her military victories against the English began the process of ultimate French victory in the Hundred Years War. She was captured by the English and tried. Her prosecutors dwelt particularly on her insistence on wearing male clothing:

> "You have said that, by God's command, you have continually worn man's dress, . . . that you have also worn your hair short, cut *en rond* [a "bowl" cut] above your ears, with nothing left that could show you to be a woman; and that on many occasions you received the Body of our Lord dressed in this fashion, although you have been frequently admonished to leave it off, which you have refused to do, saying that you would rather die than leave it off, save by God's command. And you said further that if you were still so dressed and with the king and those of his party, it would be one of the greatest blessings for the kingdom of France; and you have said that not for anything would you take an oath not to wear this dress or carry arms; and concerning all these matters you have said that you did well, and obediently to God's command."

> (Scott, 1968:156)

From *The Trial of Joan of Arc* published by The Folio Society for its members in 1956. Reprinted by permission.

or *Malleus Maleficarum* (1486) was written as a "handbook for Inquisitors" (Clark and Richardson, 1977:116). This work insisted that witches were primarily women, and it was women—often elderly spinsters or widows—who were the victims of the some one hundred thousand witch trials of sixteenth- and seventeenth-century Europe (Monter, 1977:130).

Historians have recently been attempting to reinterpret the great witch craze in the light of work of anthropologists on witchcraft in other cultures. The accused witches in eastern England, southwestern Germany, and Switzerland, for example, seem to have been the same sort of women accused in Africa and elsewhere outside Europe: old women, deprived of the protection of husbands or sons, living on the risky margins of society. These were the women who irritated and angered neighbors with efforts to gain assistance and ill-tempered cursing of the ungenerous.

Another theory, advanced by Margaret Murray (1967) and made popular recently by some modern feminists, is that there really was a witch religion to which large numbers of common people, including Joan of Arc, subscribed. Although much of Murray's evidence has not withstood scholarly scrutiny, we do know that under the apparently monolithic facade of the medieval church, there was a world of popular religion. Wise women devoted to

healing and prophesying flourished, not unlike the female curers and sha-mans found in Catholic countries in Latin America today. The popular religion of the middle ages was full of vestiges of paganism, rituals, incantations, herbalism, and magic, both beneficial and malevolent. The medieval church systematically dealt with that religion in a successful manner. The harmless and beneficial practices of the country people were "Christianized"; for example, incantations to old goddesses were retained with the names of Christian saints substituted. The demons of Hell were reduced to mischief makers of limited intelligence and minimal power.

Another set of theories associates witchcraft with heresy. In this view, the sixteenth-century belief in demon-worshipers, and witch churches with covens, sabbaths, "black masses," and other paraphernalia of witchcraft developed as a result of the mentality of the Spanish Inquisition and the fear of women that the Protestant Reformation awoke.

There may indeed have been witch cults. One or two such groups have been uncovered. The women may have been religious visionaries or sexual nonconformists, antisocial rebels of one sort or another. These witches may have been women who had seized upon the illusion of religious and moral freedom which the Reformation seemed to offer, only to learn that the leaders of the new churches were no more welcoming than had been those of the old.

Religion and Individual Fulfillment

We have seen that while women have made many dramatic and effective accommodations to the restraints placed on us by organized religion, our participation is often a marginal activity from the viewpoint of men. We have already posed the question of why women even try to participate in such an unwelcoming atmosphere. Our answer at this point can be that religion is simply one of the most universal and distinctive of human activities, and women are human in every way. We are subject to all the multiplicity of impulses, emotions, and inquiries that lead men to faith. In this sense, religion is necessary to many women for reasons of pure individual satisfaction.

Some women, particularly in patriarchal monotheistic religions, seek individual fulfillment in a greater union with God by means of a life of prayer and meditation. These women seem to compensate for our exclusion from the religious hierarchy and our ignorance of occult languages and rituals by developing a more personal, idiosyncratic approach to religion.

What do women say and do in our personal rites? Catholic women may say the rosary while the priest is chanting mass. One Yemenite Jewish woman said her mother never suffered from not learning Hebrew: "My mother says what she wants to God." Similarly, the Muslim saint, Leila Mimouna, illiterate like most of her sisters, said, "Mimouna knows God

A Moroccan Story Box 10.3

One day two old ladies decided to invoke the Devil and persuade him to part with some of his magic secrets. So they pretended to quarrel, for it is well known that the devil appears whenever there is a dispute. "I am sure that the Devil must be dead," said one old woman. "And I am sure that he is not; what makes you say such a silly thing?" retorted the other, and they went on arguing furiously. The Devil was very flattered to be the subject of their argument and he decided to make himself visible. "Indeed, I am very much alive—here I am!" he said, appearing before the two old ladies. "How can we be sure that you are really the Devil?" asked one shrewdly. "You must prove it to us by doing something extraordinary. Let's see you squeeze yourself into a sugar bowl," added the other. "Easy!" said the Devil and he slipped into the bowl. As soon as he was inside the old ladies put the lid on and held it down firmly. "Let me out and I will do you a good turn," begged the Devil. "How can you do that, Father of Evil?" demanded the old women. "I shall teach you how to dominate men," he replied, and so he did. And that is why witches are feared everywhere to this day, especially by men. (Epton, 1958:44)

© Nina Epton, 1958. Reprinted by permission.

and God knows Mimouna" (Fernea and Bezirgan, 1977:197). Barred from the study of theology even after Protestantism had made the scriptures available in the languages of its adherents, women used the vehicle of the novel, poetry, or the popular hymn to make religious statements. According to Amanda Porterfield,

> Spirituality refers to personal attitudes toward life, attitudes that engage an individual's deepest feelings and most fundamental beliefs. It encompasses the religious attitudes and experiences of individuals and may often be used as a synonym for religiousness. But spirituality covers a larger domain than that staked out by religion because it does not require belief in God or commitment to institutional forms of worship. (1980:6)

Much of the work of poets like Emily Dickinson and writers like Charlotte Brontë, while not explicitly religious, can be viewed as "spiritual" in this broader sense.

Mysticism

Mysticism is the most personal and individualistic expression of religion. It begins with psychological crisis and accumulation of stress and anxiety that drive the individual to a state of intense self-examination and simultaneous rejection of the perceived world in which she or he lives. The mystic moves through the state of pain and disorientation to an altered state of consciousness, a sense of liberation and illumination of the cosmos that releases her or

his confidence, energy, and creativity. Women mystics have sometimes become authors and painters, the founders of female orders, and prophets. In the formal religions of men, women mystics have become saints, exalted into the realms beyond gender.

The rhetoric of mysticism is the rhetoric of romantic love, sometimes in its most intense sexual form. Mystics with a biblical background frequently express the intensity of their experience in the language of the Song of Songs, a section of the Old Testament which, as noted in chapter 1, some authorities have speculated may have been written by a woman. The Bride's cry, "Oh, I am sick with love!" describes the sense that both female and male mystics have that some higher power has ravished them from their senses. This is rhetoric which comes easily to the pens of women mystics and even authors of devotional literature. Mysticism is the one area of religion where women have been unequivocally considered to be equal to men.

Possession

The popular religions of the poor, marginal, and alienated make their mystics the visionaries of ecstasy cults and the mediums of "possession" sects. The possessed woman may be regarded as holy or as unclean, depending on circumstances. Possessed women may become shamans; or we may be thought to be diseased by an infesting spirit whose purpose is malicious, a spirit that is an enemy of the recognized deities of the group. Women who are thus possessed often have reason to complain of our circumstances in the first place. We are frequently the victims of an exogamous marital situation, vulnerable to hostile charges of witchcraft when misfortune strikes any member of our husbands' kin, as well as vulnerable to repudiation, isolation, and lack of support. We may be socially vulnerable in other ways. The classic possession cult is the Zar cult of Ethiopa. Its members are Coptic women who were both alienated from kin and excluded from participation in the local Christian church. In some of the cases which anthropologists have studied, the possessing spirit was thought to be friendly or congenial. It may be one of the woman's own ancestors intervening to prevent abuse by the husband's family (Lewis, 1975).

Possession has been found, sometimes in mass outbreaks, among women in every area of the world. Historical records and contemporary observations are in general agreement as to the nature of the phenomena and their social causes and effects. The orgiastic ecstasies of the Bacchae (followers of Bacchus) of ancient Greece have been compared to the epidemic seizure of the members of a seventeenth-century convent at Loudun. In Africa, the Arctic, Mongolia, Latin America, and modern Italy, similar outbreaks have been charted. Possession tends to afflict alienated people who are responding to the strains of oppression. It is an experience that is guaranteed to gain attention for a discontented woman. And it provides a vehicle for revenge against

an oppressive husband, co-wife, mother-in-law, or, in the case of nuns, father confessor (Simpson, 1978).

Possession serves a variety of purposes for the possessed. First of all, for example, it frees women from the guilt associated with rebellion and also from responsibility for antisocial behavior. We can say and do things that would never be permitted if we were in control of ourselves. Where the religious structure is not too rigid or highly controlled, possession gives women access to real cultic power. Many of the possessed women are believed to gain sufficient control over spirits to have the ability to work healing magic, divination, or other powerful spells. Such women are particularly useful in curing similarly afflicted women. For many women, possession, like mysticism, has proven to be the first stage of a liberating experience that culminated in a more active life of social service and reform (Simpson, 1978).

The male establishment tends carefully to control possessed behavior. The mechanics of exorcism, for example, often involve much physical abuse of the possessed woman (to guard against faking). The saint is never far from accusations of malicious witchcraft or heresy. Like Joan of Arc, saints will be allowed to obey "voices" only up to the point where established authorities are not discomfited. But the dominating powers are generally willing to allow some latitude to these strong spirits to avert a more general social disruption. Thus female cults, like some of the more expressive churches organized by black prophets in America, are often on the edge between the socially acceptable role of releasing strong emotions and the socially unacceptable role of revolution.

In modern countries where religion is effectively separated from the state, women enjoy a fairly wide opportunity to participate in religious sects of our own devising. Women who have been excluded from positions of active leadership in more formal religions have been welcomed into spiritualist and pentecostal sects which emphasize the individual experience of grace above the organized ministry. The testimony of grace is an experience invaluable to many women. Amanda Smith, a young black woman who was a former slave, testified at a camp meeting that the experience of grace freed her from reticence, her fear of whites, and her fear of men and enabled her to begin preaching and speaking of her own experience with confidence (Hardesty, Dayton, and Dayton, 1979).

American Women and Religion

The formal separation between church and state in the United States has not prevented special forms of dialogue between religious organizations and the government. Religious groups committed to major social reforms have spearheaded important political and legal changes; other religious groups, more conservative in orientation, have provided focal points for resistance and

reaction. It has been largely through our participation in religious groups, rather than in government itself, that women have had a strong voice in political processes. In particular, feminism, with its call for women's rights and its role in other legislative reforms (most notably abolition of slavery and suffrage) has had a significant impact on the history of religion in America.

Leadership by Women

Protestant Denominations. Women emerged as religious leaders and reformers early in American history, in the notoriously intolerant context of colonial New England. Anne Hutchinson, a Puritan woman of Massachusetts Bay Colony, was banished for her refusal to stop preaching her doctrine of salvation by grace alone. In 1638, she was driven out of Massachusetts with her husband and children and excommunicated from the Puritan community in Boston. She led her followers to Rhode Island, where she helped to establish a new colony and pursued her evangelical ministry. Finally, she migrated yet again to Long Island, New York, where she and her family were killed by Indians. Her friend Mary Dyer, who supported her throughout her trials in Massachusetts, died on the gallows in 1660 for defending the Quakers who had begun to preach in the colony, and for refusing to accept banishment (Dunn, 1979:120).

The Quakers, or Society of Friends, believed in the equality of all people, including the equality of women and men. They opposed settlement on lands claimed by Indians and particularly opposed the institution of slavery. Despite the hostility of the colonies to Quakerism, the movement spread. Nearly half the Quaker missionaries were women, mostly traveling without husbands, and often with other women. They continued to travel and do missionary work through the seventeenth century (Dunn, 1979). In these early years, while numbers of women's "meetings" (congregations) were established, there was some difference of opinion on how strong they should be or even how legitimate they were. Some women's meetings deferred to men; others were quite assertive of their autonomy and conducted their own affairs. When permanent meeting houses were built, it became common to construct a building to house both women and men, who sat on separate sides. A partition down the center was open for worship but closed for the conduct of their separate business (ibid.).

Quaker women's experience in the organization of religious meetings provided training in the public arena that few women of colonial or postcolonial times had an opportunity to gain. The "Friends" became accustomed to public speaking, to creating organizational structures, and to feeling equal to others. Quakers were disproportionately represented among American women abolitionists, feminists, and suffragists (Dunn, 1979). The Grimké sisters and Lucretia Coffin Mott (1793–1880) are among the most famous of these women in the nineteenth century.

Lucretia Mott, a renowned Philadelphia Quaker preacher and abolitionist, attended the 1840 London Anti-Slavery Convention and preached in a Unitarian Church in London to a mixed audience, a rare event at the time. Mott also helped in planning the first women's rights convention at Seneca Falls in 1848. (The Sophia Smith Collection [Women's History Archive] Smith College, Northampton, MA 01063)

Although Lucretia Mott grew up as a Quaker, she held her own convictions on social reforms, not limited by the views of more traditional Quakers. For example, she was a radical abolitionist, whereas many Quakers prefered gradual emancipation. Mott's reformist views particularly influenced and shaped the abolitionist and feminist movements in America. The formation of her views dates from the time when she attended the world Anti-Slavery Convention in London in 1840, together with Elizabeth Cady Stanton. At the opening of the convention, the question of seating the American women delegates arose. After a long debate, the effort to seat them failed, and Mott and Stanton were relegated to sit behind a bar and curtain and thus forbidden to voice their opinions (Buhle and Buhle, 1978:85). When Mott and Stanton returned to America, they brought a firm objective: to continue to work for both abolition of black slavery and an end to women's inferior property and family rights. Eight years later, under their leadership, the "Woman's Rights Convention" took place in July 1848 at Seneca Falls, New York (see chapter 15). The convention is considered the offical beginning of the women's rights movement in the United States (it is now the site of a national museum).

The Quakers were among the first of a number of sectarian Christian religions which came to flourish in America. The growth of American sectarianism is closely related to the emergence of feminism in the nineteenth century, as increasing numbers of American women sought new forms of religious expression beyond the constraints and limitations of the dominant traditions.

The United Society of Believers in Christ's Second Appearing, better known as the Shakers, was founded and led in colonial America by Ann Lee (1736–1784). The Shakers believe that the "Godhead is defined in four persons—Father, Son, Holy Mother Wisdom and Daughter" (Zikmund, 1979:209). They live a communal life and practice celibacy.

Christian Science, a late-nineteenth-century sectarian religion, also supported women's rights. Its founder, Mary Baker Eddy (1821–1910), believed and preached that God is both masculine and feminine. She frequently refers to God in her writings as Father-Mother God. Christian Science has a very successful and extensive establishment today, including its widely read newspaper *The Christian Science Monitor,* published in Boston, and free reading rooms in towns and cities throughout the world.

Seventh-Day Adventism, an evangelist sectarian religion, was guided by Ellen Harmon White (1827–1915) from its beginning in Battle Creek, Michigan, in 1860 (Zikmund, 1979:219). She emphasized temperance, education, and health, particularly in diet. Her hegemony over Adventism lasted fifty years and was responsible for much of its influence and growth.

Many other American women, black and white, rose to prominence and leadership in evangelical and revivalist movements in the nineteenth and

twentieth centuries. Today, Holiness denominations "have a higher percentage of ordained women than does their mother church, the United Methodist Church" (Hardesty, Dayton, and Dayton, 1979:240). Like Quakerism, the evangelical and revivalist movements have provided a training ground for women activists, providing us with unique opportunities for public speaking and group organizing. Religious activity was practically the only important extrafamilial activity permitted to most women in the nineteenth and much of the twentieth century. Reform-oriented women had to work through the church, and sectarian religions offered us precisely this opportunity. The initial entry of women into reformist movements through evangelical religion served women in good stead during later periods when we entered nonsectarian public arenas as well.

The most eloquent representative of this group of nineteenth-century religious leaders was Sojourner Truth (1797–1833). Born a slave, and brought to preaching by a religious vision, she advocated abolition, women's rights, and the protection of the poor as well as Christianity. As we have seen, in 1851 she made a historic speech to a women's rights convention in Akron (Lerner, 1977:487) that joined the issues of sexism and racism.

Jewish Denominations. American Jewish women contribute to religious life through domestic activities; this role reaches back beyond the Jews' arrival in America through a long history. The heart of Judaism since the diaspora (exile from the Holy Land) has been the ritual of hearth and home. Of major importance to Jewish self-definition is *kashruth,* or purity, particularly of diet. It is the responsibility of religious Jewish women to keep kitchens "kosher," to see that meat and milk are not mixed, that the family consumes no "unclean" foods such as pork or shellfish or improperly butchered meats. We prepare the festive foods for holidays and most particularly for the celebration of the Sabbath. The conduct of conventional Jewish life is completely dependent on women's perpetuation of religious traditions in the home.

Most American Jews are not very traditional in their home life. The most widespread version of American Judaism, Reform Judaism, is "assimilationist" in character. It retains few of the traditional features of Orthodox Judaism, whether these pertain to dietary strictures, language or prayer, or women's roles. From the time of its origins in nineteenth-century Europe, Reform Judaism has advocated women's equality in all forms of worship, most notably in the quorum needed for certain prayers; abolition of a traditional prayer for men which is demeaning to women (box 10.4); and abolition of gender segregation during religious services. Reform Jewish women in America were encouraged to attend the Hebrew Union College Theological Seminary. Since 1972, Reform Jewish women rabbis have been ordained. Another branch of the Jewish religion, Reconstructionism, has ordained

Jewish Prayers Box 10.4
As part of the morning prayers among Orthodox Jews, men say:
 Blessed art thou, O Lord our God, King of the universe, who hast
 not made me a woman.
Women say:
 Blessed art thou, O Lord our God, King of the universe, who hast
 made me according to thy will.

women rabbis since 1974. Neither Conservative nor Orthodox Judaism has yet agreed to ordain women, but quite a few women have, for the past century, served as spiritual leaders of these Jewish congregations without ordination.

Various Jewish women's groups, particularly charity organizations, provide an arena for major public activities. Prominent among these is Hadassah, founded in 1912 by an American woman, Henrietta Szold (1860–1945). In 1893, Hannah Greenbaum Solomon initiated the formation of the National Council of Jewish Women, dedicated to education, social reform, and issues concerning women. These organizations and others like them have provided vehicles for women to learn how to organize publicly and to manage money and fund-raising campaigns and a host of practical matters; they have raised and distributed millions of dollars in the causes they espoused.

Recently, a number of new Jewish women's groups have formed that are devoted specifically to feminism. Ezrat Nashim, the Jewish and Feminist Organization, has held conferences, issued publications, and made action-oriented proposals to reform Jewish practice. *Lilith,* a new magazine devoted to Jewish feminism, publishes a variety of sources of information, generating ideas for new rituals, ceremonies, and activities (Umansky, 1979:348).

Catholicism. Catholic women, in contrast to Jewish women, have had the option of following a "vocation" in religion by becoming nuns. As nuns, American women have played a number of influential roles in American life, particularly in education and nursing.

Today, nuns may be women in street clothes who may or may not wear symbolic head scarves and crosses. We are no longer found only in the shadows of a cloister but also in public places. Since medieval times, nuns have held professional responsibilities in education and in attending the sick and elderly, but today we are also found in executive positions, managing self-supporting philanthropic or educational institutions and projects.

This freedom of American nuns has been made possible largely by historical developments in this country. Nuns who came to America from Europe in the nineteenth century often worked in frontier areas under totally new conditions. Forced to adapt clothing as well as daily routines to the new life in the new country, nuns found it very difficult to lead a cloistered life; many were separated from the "Motherhouse" in Europe by circumstances as much as by distance. In 1850, there were only 1,375 nuns in America; by 1900 the number had almost reached 40,000, the majority in professional roles (Ewens, 1979:272).

A nun who contributed to the founding and expanding of the educational system in the United States was Mother Caroline Friess (1824–1892), superior of the American houses of the School Sisters of Notre Dame. She came to America from Germany in 1847 and was ordered to Milwaukee in 1850 to open a school. Forty-two years later, at the time of her death, she had opened 265 schools in seventeeen states and Canada. Most of these schools were coeducational and attended by both Catholic and non-Catholic students (Ewens, 1979:273).

The dedication of nuns to the needs for education, health care, and social welfare is well illustrated in the life of Mother Elizabeth Bayley Seton (1774–1821) and the order of Sisters of Charity that she founded. In 1975, Mother Seton was canonized as the first American-born saint. It was she who founded the first sisterhood in the United States and the first Catholic free school in America, in Emmitsburg, Maryland. She governed her religious community and administered her school through many early hardships. At the time of her death, Mother Seton's Emmitsburg community numbered fifty sisters. Now six branches claim her as their founder and have remained independent North American groups. One of the best-known institutions run by the Sisters of Charity is the Foundling Hospital in New York City. The hospital cares for unwanted children and gives shelter to young mothers with children. It also provides a residence and training for mothers who have abused children and seek to break such patterns of behavior.

Feminist Contributions to Religious Change

Religious change comes from many different sources and in many different forms. The spokeswomen for the numerous sectarian branches of American religion mentioned above all sought changes in established practice and belief. Elizabeth Cady Stanton, one of the presidents of the National Woman Suffrage Association and co-founder in 1868 with Susan B. Anthony of the radical magazine *The Revolution*, went further than most of her co-workers and even today's feminists in confronting the sexist language of the Scriptures. Maintaining that the Bible contributed to the low self-image of women,

she attempted twice to organize a group to write commentaries on passages from the Old and New Testaments dealing with women. Eventually, between 1895 and 1898, she succeeded in publishing *The Woman's Bible,* parts I and II, and an appendix.

This work is the result of Stanton's belief that the language and interpretations of passages dealing with women in the Bible were a major source of women's inferior status because we turned to the Bible so much for comfort and inspiration. She maintained that the language of the Scriptures had to be rendered in such a way that it would not center only on man, nor celebrate man as the superior creation, nor allow man to dominate women. Certain passages in the Bible, Stanton believed, could be interpreted to conform to women's experiences as humans, as well as men's experiences.

Her attempts were not well received by the majority of suffragists, and the National American Womans Suffrage Association disclaimed any official connection with *The Woman's Bible* in 1895. The organization feared a backlash from society at large on purely religious issues, a reaction which could have halted the political and social changes sought. The decision was based on the view that it was possible to separate political and secular issues from religious ones. Stanton, on the other hand, saw the traditions of religious belief as an important cause of women's subordination.

The Woman's Bible was not reprinted until seventy-five years later. Its language now strikes us as rather mild, but it is widely acknowledged as eloquent testimony to one woman's crusade to redress the seemingly infallible, sexist language of the Bible. Today, many religious groups are attempting to transform the language of the Old and New Testaments, the Talmud, and the language of prayers and hymns.

In addition to changing the language of devotion, feminists in the United States have also been developing new versions of traditional rituals. We are taking out the sexist bases of general rituals and adding new rituals for women to complement those specifically intended for men. For example, some Jewish women have written a complement to the boy's *brith* to bring our daughters into the covenant (Plaskow, 1979). Aviva Cantor (1979) has composed a woman's *haggadah,* a version of the Jewish Passover text that traditionally celebrates freedom from slavery and oppression, while others have developed Sabbath prayers for women (Janowitz and Wenig, 1979).

For some religious feminists, the old traditions are insufficient, even when revised. Some call for a menstrual ritual to be performed for girls at the time of menarche. Zsuzsanna Budapest writes of a "self-blessing ritual," derived from oral tradition and feminist beliefs, to be performed by all women in private (1979:269). Budapest also writes "of witchcraft in its modern form— of the ways in which contemporary women could free themselves from internalized male values and learn to cherish their own bodies, thoughts, and wishes" (Goldenberg, 1979:95). Others offer language and earthly images for

the "transformation of our culture away from the patriarchal death cults and toward the love of life, of nature, of the female principle" (Starhawk, 1979:268) (box 10.5).

Summary

Religion and society affect each other. As societies become more complex and hierarchical, so do their religious institutions. In societies that deny leadership roles to women, religious institutions do so too. Religious beliefs about what is "good behavior" influence societies.

Despite our devalued status in religion, women have been active participants in religions throughout history. Many of us focus on certain aspects of religion (such as the healing Christ or the Virgin Mary) that appeal to our concerns and evolve from our beliefs and practices. "Popular" versions of traditional religions often provide scope for women's activities.

Some ancient religions included goddess worship and gave women a high status. but these religions have been overthrown in favor of patriarchal ones. The origin myths of many of the major religions support the dominant religious and social roles of men.

Most religions have conceptions of supernatural beings, and women are featured among them. These beings may be souls, saints, ghosts, and goddesses. The goddess is often envisaged as a threatening being who is tamed and controlled by being linked to a male god. As monotheism entered religious belief, the goddesses of ancient religions were dropped in favor of a single male God. Some feminists believe that worship of a female God would enhance women's social position.

Religious codes serve to govern human conduct and exert social controls. Life cycle rituals for men enhance their power and status in the community, but the wedding ceremony, the most important ritual for women in patrilineal societies, serves only to shift control over us from the father to the husband. Matrilineal societies, on the other hand, celebrate menarche, the woman's coming of age.

Religious leaders in many societies attempt to control female sexuality by urging us to stay within the home and to be modest and decorous. Many religious laws require women and men to be separate during the menstrual period. Religious codes also protect women and promote family life and procreation.

In public worship, women are subject to a number of controls. We are frequently prohibited from lay participation in rituals and sometimes segregated from men. Even so, it is women who spend the most hours of devotion in the church.

The most highly organized religions are least welcoming to women as clergy. Many women find that we can play far more active roles in the

Invocation to the Goddess **Box 10.5**

Queen of the night
Queen of the moon
Queen of the stars
Queen of the horns
Queen of the earth
Bring to us the child of light.

Night sky rider
Silver shining one
Lady of wild things
Silver wheel
North star
Circle
Crescent
Moon-bright
Singer
Changer!
Touch us!

See with our eyes
Hear with our ears,
Breathe with our nostrils,
Kiss with our lips,
Touch with our hands,
Be here now!

(Starhawk in Goldenberg, 1979:86–87)

Reprinted by permission of the author.

religions that are on the fringes of or in conflict with "established" religion. Often we emerge as preachers or leaders of these sects.

Women excel at ritual and spiritual services connected with nurturance and healing. That is why so many women are numbered among the shamans, or curers, of societies. Women have also served our religions as missionaries and as martyrs.

Women have been active as rebels in religious movements, probably because we have often seen rebellion as the only means of winning more liberation for ourselves. During the Reformation, women heretics were frequently accused of being witches. Some women have found fulfillment in religions through an individual idiosyncratic approach. Mysticism and possession by spirits are both highly personal expressions of religion.

Women, especially Quakers, were among the early religious leaders and reformers in American history. In the nineteenth century, women had important parts to play in the founding and organization of the Shakers, Christian

Science, Seventh-Day Adventism, and a number of evangelical movements. Jewish women have been responsible for maintaining religious traditions in the home and are active in the public arena by means of various Jewish women's groups. American nuns have played influential roles in education and nursing in the United States.

Feminists have contributed to religious change. In the last century, Elizabeth Cady Stanton wrote a commentary on the Bible, *The Woman's Bible,* while feminists today are developing new versions of traditional rituals and adding new rituals for women as well.

Discussion Questions

1. Nearly everyone receives some religious education—in the home, in school, in church, in the community at large—on both a conscious and an unconscious level. What do you think you learned about relations between women and men from this background? What were the sources of what you learned (the Bible, ritual, prayer, and the like)?
2. In various times and places, women have emerged as important religious leaders. Select one you have heard of from ancient times, the recent past, or the present. Tell about her life, her accomplishments, her beliefs, and her influence.
3. Does the gender of God matter to you? Why or why not? What have been the arguments offered on both sides of this issue?
4. Study some of the representations of Isis, Diana, the Virgin Mary, and Avalokitésvara (Guanyin or Kwannon). What do these images have in common? What type of convictions do you think they reflect?

Recommended Readings

Christ, Carol, and Plaskow, Judith, eds., *Womanspirit Rising: A Feminist Reader in Religion.* San Francisco: Harper & Row, 1979. A collection of feminist views on religion, ranging from fairly conservative to radical. Discussions of religions, the need for change, and recent feminist innovations.

Daly, Mary. *Beyond God the Father: Toward a Philosophy of Women's Liberation.* Boston: Beacon, 1973. Daly, a feminist and radical Catholic theologian, argues that women have to look beyond the image of a male God in order to create new visions through which our spiritual experiences can be expressed.

Goldenberg, Naomi R. *Changing of the Gods. Feminism and the End of Traditional Religion.* Boston: Beacon, 1979. A study of the psychological

effects of patriarchal religions on women. Goldenberg offers suggestions for bringing about fundamental changes in religious thought and practices.

Reuther, Rosemary, and McLaughlin, Eleanor, eds. *Women of Spirit: Female Leadership in the Jewish and Christian Traditions*. New York: Simon & Schuster, 1979. A collection of original essays on women's religious leadership with an emphasis on historical developments in Europe and America.

Sanday, Peggy, *Female Power, Male Dominance*. Cambridge, England: Cambridge University Press, 1981. An anthropological study of the relationships between religious beliefs, the spiritual and social roles of women and men, and the material environment. Sanday looks at some sixty different societies, mostly "simple" hunting-gathering and agricultural groups, to understand these linkages.

References

Budapest, Zsuzsanna E. "Self-Blessing Ritual." In *Womanspirit Rising: A Feminist Reader in Religion*, edited by Carol P. Christ and Judith Plaskow. San Francisco: Harper & Row, 1979.

Buhle, MariJo, and Buhle, Paul, eds. *The Concise History of Woman Suffrage: Selections from the Classic Work of Stanton, Anthony, Gage, and Harper*. Urbana, Ill.: University of Illinois Press, 1978.

Cantor, Aviva. "Jewish Women's Haggadah." In *Womanspirit Rising*, edited by Christ and Plaskow. San Francisco: Harper & Row, 1979.

Carmody, Denise. *Women and World Religions*. Nashville, Tenn.: Abingdon, 1979.

Christ, Carol P. 'Why Women Need the Goddess: Phenomenological, Psychological, and Political Reflections." In *Womanspirit Rising*, edited by Christ and Plaskow. San Francisco: Harper & Row, 1979.

Clark, Elizabeth, and Richardson, Herbert, eds. "The Malleus Maleficarum: The Woman as Witch." In *Women and Religion: A Feminist Sourcebook of Christian Thought*. New York: Harper & Row, 1977.

Daly, Mary. *Beyond God the Father: Toward a Philosophy of Women's Liberation*. Boston: Beacon, 1973.

Delaney, Janice, Lupton, Mary J., and Toth, Emily, eds. *The Curse: A Cultural History of Menstruation*. New York: New American Library, 1976.

Dickens, A.G. *The English Reformation*. New York: Schocken, 1964.

Dunn, Mary Maples. "Woman of Light." In *Women of American: A History*, edited by Carol Ruth Berkin and Mary Beth Norton. Boston: Houghton Mifflin, 1979.

Durrant, Stephen. "The Nišan Shaman Caught in Cultural Contradictions." *Signs* (1979):338–47.

Ehrenreich, Barbara, and English, Deidre. *For Her Own Good: 150 Years of the Experts' Advice to Women*. Garden City, N.Y.: Doubleday, 1979.

Eliot, Charles. *Hinduism and Buddhism*. Vol. II. London: Routledge & Kegan Paul, 1962.

Epton, Nina. *Saints and Sorcerers*. London: Cassell Ltd., 1958.

Ewens, Mary. "Removing the Veil: The Liberated American Nun." In *Women of Spirit: Female Leadership in the Jewish and Christian Traditions*, edited by Rosemary Reuther and Eleanor McLaughlin. New York: Simon & Schuster, 1979.

Fernea, Elizabeth W., and Bezirgan, Basima Q., eds. *Middle Eastern Muslim Women Speak*. Austin: University of Texas Press, 1977.

Fernea, Robert A., and Fernea, Elizabeth W., "Variation in Religious Observance Among Islamic Women." In *Scholars, Saints, and Sufis*, edited by Nikki R. Keddie. Berkeley: University of California Press, 1972.

Fiorenza, Elisabeth Schüssler. "Feminist Spirituality, Christian Identity, and Catholic Vision." In *Womanspirit Rising*, edited by Christ and Plaskow. San Francisco: Harper & Row, 1979. (a)

———. "Word, Spirit, and Power: Women in Early Christian Communities." In *Women of Spirit*, edited by Reuther and McLaughlin, New York: Simon & Schuster, 1979. (b)

Frazer, Sir James. *The Golden Bough, A Study in Magic and Religion*. 1890. Abridged ed. New York: Macmillan, 1960.

Freeman, James M. "The Ladies of Lord Krishna." In *Unspoken Worlds*, edited by Nancy Falk and Rita Gross. New York: Harper & Row, 1980.

Goldenberg, Naomi. *Changing of the Gods: Feminism and the End of Traditional Religions*. Boston: Beacon, 1979.

Hardesty, Nancy, Dayton, Lucille Sider, and Dayton, Donald. "Women in the Holiness Movement: Feminism in the Evangelical Tradition." In *Women of Spirit*, edited by Reuther and McLaughlin, New York: Simon & Schuster, 1979.

Hoch-Smith, Judith, and Spring, Anita. *Women in Ritual and Symbolic Roles*. New York: Plenum, 1978.

Janowitz, Naomi, and Wenig, Maggie. "Sabbath Prayers for Women." In *Womanspirit Rising*, edited by Christ and Plaskow. San Francisco: Harper & Row, 1979.

Jordan, David K. *Gods, Ghosts, and Ancestors*. Berkeley: University of California Press, 1972.

Lerner, Gerda, ed. *The Female Experience: An American Documentary*. Indianapolis: Bobbs-Merrill, 1977.

Lewis, I. M. *Ecstatic Religion*. Baltimore: Penquin, 1975.

Mâle, G. *The Gothic Image: Religious Art in the Thirteenth Century*. Translated by Dora Nussey. New York: Harper & Row, 1949.

Malefijt, AnnMarie. *Religion and Culture*. New York: Macmillan, 1968.

Monter, E. William. "The Pedestal and the Stake: Courtly Love and Witchcraft." In *Becoming Visible: Women in European History*, edited by Renate Bridenthal and Claudia Koonz. Boston: Houghton Mifflin, 1977.

Murray, Margaret. *The Witch in Western Europe*. Oxford: Clarendon, 1967.

Plaskow, Judith. "Bringing a Daughter into the Covenant." In *Womanspirit Rising*, edited by Christ and Plaskow. San Francisco: Harper & Row, 1979.

Porterfield, Amanda. *Feminine Spirituality in America*. Philadelphia: Temple University Press, 1980.

Reuther, Rosemary Radford. "Motherearth and the Megamachine." In *Womanspirit rising*, edited by Christ and Plaskow. San Francisco: Harper & Row, 1980.

Richards, Audrey. *Chisungo*. London: Faber & Faber, 1956.

Sanday, Peggy. *Female Power, Male Dominance*. Cambridge, Eng.: Cambridge University Press, 1981.

Scott, W.S., ed. and trans. *Trial of Joan of Arc*. London: Folio Society, 1968.

Simpson, George E. *Black Religions in the New World*. New York: Columbia University Press, 1978.

Stanton, Elizabeth Cady. *The Woman's Bible*. 1895–1898. Reprint. Parts I, II, and Appendix. Arno, 1972.

Starhawk. "Witchcraft and Women's Culture." In *Womanspirit Rising*, edited by Christ and Plaskow. San Francisco: Harper & Row, 1979.

Stone, Merlin. "When God Was a Woman." In *Womanspirit Rising*, edited by Christ and Plaskow. San Francisco: Harper & Row, 1979.

Washbourne, Penelope. "Becoming a Woman: Menstruation as Spiritual Challenge." In *Womanspirit Rising*, edited by Christ and Plaskow, San Francisco: Harper & Row, 1979.

Umansky, Ellen M. "Women in Judaism: From the Reform Movement to Contemporary Religious Feminism." In *Women of Spirit*, edited by Reuther and McLaughlin. New York: Simon & Schuster, 1979.

Zikmund, Barbara Brown. "The Feminist Thrust of Sectarian Christianity." In *Women of Spirit*, edited by Reuther and McLaughlin. New York: Simon & Schuster, 1979.

Zimmer, Heinrich. *Myths and Symbols in Indian Art and Civilization*. Princeton: Princeton University Press, 1978.

11

Women and Education

WOMEN'S KNOWLEDGE, WOMEN'S LITERACY, WOMEN'S PLACE
The Present State of Women's Literacy and Education

FORMAL EDUCATION IN THE PAST
The Ancient World
The Middle Ages
Renaissance Humanism and Early Modern Europe

THE TRADITIONAL GOALS OF WOMEN'S EDUCATION DEBATED

THE MODERN EDUCATIONAL REVOLUTION
The Achievement of Elementary and Secondary Education
The Education of Black Women in America
The Struggle for Higher Education

EDUCATION AND CAREER CHOICE
Women's Education and Women's Realities
Professional Advancement
The Limitation of Women's Choices
 Educational Experiences in the Early Years
 Later Educational Experiences
Exceptions: Women Who Achieved
Reentry Women
New Beginnings for Women

One morning in May 1853, the home of Mary Douglass in Norfolk, Virginia, was raided; she was subsequently tried, found guilty, and sentenced to one month in prison for violating a state law. Her crime was the teaching of reading and writing to black children. A former slaveowner herself, she was aware that it was against the law to provide instruction to slave children; she did not know it was also illegal to teach free black children. Ignorance of the law did not prevent her trial and imprisonment (Hellerstein et al., 1981:80–83).

Why should it have been a transgression against the rules laid down by the men in the Virginia legislature to teach little children to read and write? Mary Douglass's school, taught by her daughter and herself, consisted of twenty-five pupils, both girls and boys. It was obviously considered a threat to the social order that these pupils be educated, even using the books given them by the Christ Church Sunday School. Douglass said at her trial: "I felt certain

that there could be nothing wrong in doing during the week what was done on Sunday by the teachers in that school, who were members of some of the first families in Norfolk, nor in using the very books that were given to the children there taught" (ibid.: 82).

Why should the dominant group in any society fear education in the hands of an oppressed subgroup? Does literacy bring power? Consider Table 11.1, based on UNESCO figures, defining an illiterate person as one who "cannot with understanding both read and write a simple sentence in his [sic] everyday life" (Finn, Dulberg, and Reis, 1979:479). Few places today remain totally untouched by economic and technological change; yet literacy, which is a first step toward reshaping individual lives in such a society, has a lower rate among women than among men throughout the world. We must conclude that even where access to education is easiest, it is still more difficult for women than for men to acquire education. In areas where literacy is relatively scarce, women fall far behind men in acquiring it. This gender-specific pattern is uniform. Why should this be so?

This chapter investigates the difficulties women have faced in achieving literacy and obtaining formal education, and the achievements of women in bringing about a modern revolution in our education. It considers the way women have been treated as subject matter in education and in formal theories about knowledge. We start with the view that literacy and education are potentially liberating, and conclude that women's studies has become a powerful liberating force for women today.

Women's Knowledge, Women's Literacy, Women's Place

Women have always had a great store of knowledge about our immediate world which we have taught our daughters and our daughters' daughters. From earliest times, we have taught ourselves and other women how to find, prepare, and preserve food, and we formed the first pots in which to cook it. We developed the art of cultivation and learned how to domesticate and use animals. We have shorn the wool from sheep, spun it, and woven it into cloth; milked animals and turned the milk into dairy products; designed, built, and carried tents and learned to make and keep fires going; taught ourselves the lore of herbs and the arts of healing; and organized the secrets of birthing, the tasks of child care, and the rituals of dying and mourning the dead. Women have worked out the ways of barter and exchange and organized market life and long-distance trade.

Women's knowledge has been of direct benefit to our families and our communities. To the extent that women have organized and cared for the needs of daily life, men were able to devote more of their time to the generation of other knowledge. For example, men were probably responsible for the early development of pictographs and alphabets upon which the written

Table 11.1 Percentages of Illiteracy, 1970

	Women	Men
North America	1.9	1.1
Europe and USSR	4.7	2.4
Asia (excluding Arab states)	56.2	36.6
Africa (excluding Arab states)	82.7	64.6
Arab States	85.7	60.5

Source: Adapted from Finn, Dulberg, and Reis, 1979:480. Copyright © 1979 by President and Fellows of Harvard College.

word has been built. From the first, power over the word has been important, and the elite male groups who have monopolized this power have played a significant role in the development of societies. Through time, women have struggled to achieve equal access to literacy and formal education. When women have succeeded in becoming "learned" in the formal learning primarily shaped and shared by men, we have been labeled "exceptions," monstrous parodies of men, "unnatural," and a danger to traditional social arrangements.

The Present State of Women's Literacy and Education

In the United States and Western Europe today, where literacy rates are relatively high, we still find a higher school dropout rate for women than for men. Girls take fewer mathematics and science courses than do boys in the early years, and those girls who go on to college and universities tend to study the arts and humanities. Often, we compete for teaching jobs in an overcrowded market. Women in rural areas are frequently discouraged by our parents from continuing our formal education, though daughters may be encouraged to learn music and domestic arts. In Eastern Europe and the Soviet Union, where female literacy and employment rates are equally high, women are still overrepresented in fields identified with our gender. Here both medicine and teaching are seen as appropriate for women, and here too the role of women at the higher levels of authority and prestige disappears. Instead, there continues to be "the belief that women do not have the necessary time for demanding positions" (Lapidus, 1976; Springer, 1976:297). Social expectations about gender roles underlie educational and occupational "choices."

Basic literacy levels suggest the general picture of education elsewhere in the world. The female populations in predominantly Muslim countries such as Egypt, Iran, Libya, and Morocco are between 81 and 94 percent illiterate. In Egypt, 13.3 percent of girls complete primary education but only 2.5 percent go on to the secondary level. Especially in the upper classes, women in the Muslim tradition are not expected to enter the work force as paid

A classroom in an elementary school for girls in the Philippines, operated by Catholic nuns. This temporary structure was built with the aid of parents. Education for girls, at least at this level, was considered an important community priority. (Courtesy of the United Nations)

laborers and traditionally have been sequestered from puberty onward from contact with any men beyond the immediate family. In this century, Turkey, Tunisia, and Iran introduced legislation to improve women's status, but social practices have lagged behind formal pronouncements. Iran overturned its Westernizing government at the end of the 1970s and reinstated Islamic law, which calls for a return to women's traditional status and does not permit extensive education for women.

The small number of upper-class women who have been educated in a Western style tend to lead socially isolated lives in such societies, restricted by what is expected as gender-appropriate behavior. In India, where school attendance is compulsory for girls and boys for five years, three-quarters of the girls drop out long before that time. In Sri Lanka, compulsory schooling for eight years for girls and boys is the rule but, as in India, most tradition-bound families disapprove of higher education for women (Finn, Dulberg, and Reis, 1979).

In Africa, especially where nineteenth-century colonialism brought Christian missionary education, not as many girls were expected to take advantage of the new learning as boys. Despite African women's strong traditional role in agriculture, the Western agricultural techniques introduced under colonial

regimes followed Western gender stereotypes and were taught exclusively to men. Even after independence, African countries have not committed themselves to the education of women. Women who achieve literacy are generally white-collar workers in the cities, nurses' aides, typists, telephone operators, and saleswomen. Uneducated women in the cities work at light industry or turn to petty trading, brewing, or prostitution. Educated wives of the elite class do not pursue vocations or professions but maintain households for the ornament and pleasure of husbands. "The urban educated wife's dependence on her husband follows the Western pattern" (Van Allen, 1976:43).

In the 1970s, some 40 percent of the world's women were illiterate, compared to 28 percent of men. Even if girls have access to formal education, social customs and cultural attitudes may curb school attendance at an early age, or they may encourage extensive academic and vocational training in fields identified primarily with women.

Women who have acquired formal education have not easily achieved the positions of power open to men. Here, too, sterotypical assumptions about gender roles intervene. Today, more and more women in the United States, for example, have achieved male-associated educational credentials; yet, we find ourselves with disproportionately fewer of the rewards conventionally attached to them. The gains women once made and continue to make in formal education do not automatically create social acceptance. Many occupations are still identified only or largely with men.

Formal Education in the Past

The Ancient World

In the ancient Greek world, athletics, music, and reading were formal educational requirements for young males destined to become full members of the citizen class. Occasionally, young upper-class Athenian girls were taught to read and write by tutors hired for their brothers. After marriage, the educational training of girls was organized by husbands, who were typically fifteen to twenty years older. No formal education existed for lower-class or slave women.

In the late sixth century B.C., the famous poet Sappho, who lived on Lesbos, is thought to have taught a few select young maidens. And the philosopher Pythagorus was known to have women disciples. By the fourth century B.C., there were women who studied and practiced poetry, music, and painting as well as philosophy as professions (Pomeroy, 1975). Women learned medicine in classes taught by physicians and even wrote gynecological texts (Pomeroy, 1977). But these cases were rare.

During those years when Roman sons acquired formal education, daughters prepared for marriage. However, Romans of the propertied classes considered it desirable for their daughters to read Latin and Greek

literature, play the lyre, and know how to dance. Some writers were even moved to criticize Roman matrons who displayed learning by correcting male companions at dinner (Pomeroy, 1975).

In the late fourth century A.D. in Egypt, a woman named Hypatia, the daughter of a learned father, received an education in mathematics and philosophy that allowed her to teach at the University of Alexandria. According to one of her famous students, the philosopher Syneius of Cyrena, Hypatia invented instruments for studying the stars, distilling water, and measuring the specific gravity of liquids. She also wrote a treatise on astronomy, which was discovered in the Vatican Library in Rome in the fifteenth century (Osen, 1974:27–28).

The Middle Ages

Property, wealth, and family position could open opportunities for formal education for women. This was true for women in the middle ages in Japan as well as Europe, as we learn from the *Tale of Genji*, written by Lady Murasaki who lived at the Japanese royal court in the eleventh century. In Europe, the emperor Charlemagne's daughters as well as his sons were taught by royal tutors in the late eighth and early ninth centuries. Education was more typically received in the West in Christian monasteries and convents. At first young women were the main beneficiaries of such education; for many centuries it was thought more important for young men of propertied families to learn how to use the sword and engage in field sports than to read. Scholarship was left to the clergy and to the women placed by families in convent schools as a safe harbor until marriage. As a result, outside the Church there were probably more literate women than men in Europe from the ninth to the twelfth centuries.

The intellectual activities of a few famous learned women during these years included Latin plays by Hroswitha, a tenth-century nun in Gandersheim, Saxony (Germany); the poems of eleventh-century women troubadours in Provence; and mystical writings by the Abbess Hildegard of Bingen in the twelfth century. Equally famous were Helöise—renowned for her learning even before Abelard became her tutor—and Marie de France, who wrote short verse tales (*lais*) in twelfth-century France (Ferante, 1980). By the thirteenth century, formal education in Europe came to be dominated by the universities, where admission was restricted to men being trained in theology, law, and medicine. Nonetheless, women did achieve some recognition in medicine, for we know of one female physician who attended King Louis IX of France (ibid.).

Renaissance Humanism and Early Modern Europe

In the fourteenth and fifteenth centuries in Italy, a trend toward secular learning once again allowed daughters of wealthy or learned fathers to par-

ticipate in higher education. The new humanistic ideas of the time adopted by the aristocracy placed a value on cultivated women. In practice, however, after a period of adolescent study when young women were free to pursue knowledge at leisure, the truly learned woman was faced with an absolute choice—either marriage and abandonment of these studies or withdrawal from the ordinary social world to a convent or a solitary, book-lined cell (King, 1980).

The learned women of Italy during these centuries composed letters, delivered orations, and wrote dialogues and treatises and poems, all in the style of the scholarly male humanists of the day. Although praised extravagantly, these women were never actually received as equals into the company of learned men, nor given any opportunities to enter the learned professions. Male admirers likened educated women to Amazons, by which they meant unnatural women. Real women were those who wanted love, marriage, and motherhood, for which the active intellectual life must be put aside. One exception was Christine de Pizan (1365–1431). Brought from Italy to the French court by her physician father, she took advantage of her early education to support herself as a young widow with children. She wrote lyric poetry, courtly romances, and tracts on moral conduct and public matters, and was commissioned by the brother of King Charles V to write a history of his reign (Davis, 1980). She also wrote *The Book of the City of Ladies* in 1405 in praise of famous women of legend and history (Pizan, 1982).

By the sixteenth century in Europe, education for women in the upper classes became more common. Royal and noble families educated both their daughters and sons. Catherine of Aragon was one of the four well-educated daughters of Queen Isabella of Spain. After she had married King Henry VIII in England (see chapter 7), she brought Juan Luis Vives to the English court to educate her daughter Mary. Vives eventually wrote two treatises, *A Plan of Studies for Girls* and *The Instruction of a Christian Woman* (1523), but both advocated only a limited amount of formal education and emphasized instead ladylike conduct and theologically sound reading. Vives's chief concern was to teach young women to be humble and virtuous and to remain silent lest the frailties of our female minds spread false opinions about our subjects of study (Kaufman, 1978).

Reopening of educational opportunities meant that there were many more learned women in the sixteenth century than in any earlier period. We studied Latin and European languages and, as in the case of the French regent Anne de Beaujeau, some were so placed as to educate a number of other young women who would in turn become rulers. Two powerful women rulers in this period, Catherine de Medici in France and Elizabeth I in England, were well-educated humanist scholars, reading works in their original languages, especially the ancient texts surviving from the Greek and Roman world.

The Protestant reformers of the sixteenth century placed an emphasis on reading the New Testament, recommending education of this sort for girls as well as boys. Yet they too believed that women should confine ourselves to our own homes and keep silent in public, lest we spread "false opinions." Despite these male attitudes, some female scholars in the sixteenth century did teach outside the family and the court circles. One of these was Olympia Morata, whose father was a tutor of princes. From him she acquired enough classical learning by the age of thirteen to be employed to teach the princesses at the court of Duchess Renée of Ferrara (Bell, 1973:208). Of course, the emphasis of families of wealth and position was on training cultivated daughters, not learned scholars.

The invention of printing in the late fifteenth century and the development of the book trade in the sixteenth century were accompanied by a remarkable increase in literacy and learning among men, including those engaged in skilled artisan crafts as well as men of rank and wealth. For women, however, the revolution in literacy was of lesser magnitude. Village schools were often built for boys only, and if girls were admitted, we were not taught Latin because this would have introduced us to "immoral" and "pagan" writers (box 11.1).

Similarly, larger educational institutions in growing cities were for boys only. Women of the wealthier classes were tutored privately, but only a few had the courage or determination to become serious scholars. Historian Natalie Davis (1975) finds that few women in the French countryside in the sixteenth century even knew the alphabet, while male artisans in towns exhibited far greater literacy than their wives. The convent still educated a small number of elite women, but as a study of Lyon from the 1490s to the 1560s reveals, there were only five women teachers and eighty-seven schoolmasters. The Ursuline nuns in France developed schools for girls at the end of the sixteenth century which numbered over three hundred a century later. They offered religious instruction and the elements of reading, writing, and arithmetic to day students and provided a slightly higher level of study to boarders. As before, more serious studies had to be pursued privately (Lee, 1975).

In seventeenth-century Paris, there was a flowering of literary salons organized by fashionable aristocratic women wealthy enough to obtain private education. Feminist literature condemning the double standard in education also began to appear. Its message was that only education could lead women to virtue because only a knowledge of the good made it possible to realize virtue.

Seventeenth-century French feminists also challenged the existing social hierarchy, arguing that only those whose moral worth merited it should be called noble. Condemning the view that high birth alone marked the aristocrat, these women created salons as "schools for the assimilation of aristo-

Shakespeare's Sister Box 11.1

[Let us suppose] that Shakespeare had a wonderfully gifted sister, called
Judith. . . . Shakespeare himself went, very probably—his mother was an
heiress—to the grammar school, where he may have learnt Latin—Ovid,
Virgil and Horace—and the elements of grammar and logic. . . . [He
went] to seek his fortune in London. . . . Very soon he got work in the
theatre, became a successful actor, and lived at the hub of the universe,
meeting everybody, knowing everybody, practising his art on the boards,
exercising his wits in the streets, and even getting access to the palace of
the queen. Meanwhile his extraordinarily gifted sister, let us suppose,
remained at home. She was as adventurous, as imaginative, as agog to see
the world as he was. But she was not sent to school. She had no chance of
learning grammar and logic, let alone of reading Horace and Virgil. She
picked up a book now and then, one of her brother's perhaps, and read a
few pages. But then her parents came in and told her to mend the stock-
ings or mind the stew and not moon about with books and papers. They
would have spoken sharply but kindly, for they were substantial people
who knew the conditions of life for a woman and loved their daughter—
indeed, more likely than not she was the apple of her father's eye. Perhaps
she scribbled some pages up in an apple loft on the sly, but was careful to
hide them or set fire to them. Soon . . . she was to be betrothed to the son
of a neighboring wool-stapler. She cried out that marriage was hateful to
her, and for that she was severely beaten by her father. . . . She . . . let
herself down by a rope one summer's night and took the road to London.
She was not seventeen. . . . She stood at the stage door; she wanted to act,
she said. Men laughed in her face. . . . no woman . . . could possibly be an
actress. . . . She could get no training in her craft. Could she even seek her
dinner in a tavern or roam the streets at midnight? . . . At last the actor-
manager took pity on her; she found herself with child by that gentleman
and so who shall measure the heat and violence of the poet's heart then
caught and tangled in a woman's body? —killed herself one winter's night
and lies buried at some cross-roads where the omnibuses now stop.
 (Woolf, 1929, 1957:80–84.)

cratic manners" by nonaristocratic men (Lougee, 1976:53). French feminists
called into question the authority of tradition, custom, and religion and
advocated wider, nondomestic roles for women of rank. When Molière in his
play *Les Preciuses ridicules* (1659) ridiculed such women, he was denouncing
the pretensions of social climbers and defending the aristocracy of birth more
than condemning the feminist view of education (Lougee, 1976).

Although hampered by class assumptions, the feminists raised questions
about the conventional limited roles assigned to women in marriage and the

sexual double standard. These French women were also instrumental in defining the literary culture of the times. The collected letters of Madame de Sévigné, numbering over a thousand, offer us a vast amount of information about women's lives in the aristocratic circles at court and in the countryside of seventeenth-century France.

The negative reaction to these feminists was a protest against the ways in which women, by intermarriage between the classes and by social leadership, were challenging the position of the old aristocracy. The conservative reaction among the old nobility was that women must be taught to remain in our "proper" spheres, invisible to the world. Those who saw a link between feminist writings and social change in the seventeenth century put a renewed emphasis on circumscribing women's education.

The Traditional Goals of Women's Education Debated

From the seventeenth century on, the proper education for women was a topic of much serious discussion. In France, renewed interest in the proper education of young aristocratic women led to the establishment of a special school at Saint-Cyr for the daughters of impecunious aristocrats. The school was supervised by Madame de Maintenon (1635–1719), who became the second wife of Louis XIV. The curriculum was influenced by the writing of the Abbé Fénelon, whose *Education of Girls* (1687) was dedicated to ensuring that no girl conceived "aspirations above her fortune and condition." "The knowledge of women, like that of men," Fénelon wrote, "ought to limit itself to instruction in connection with their functions; the differences of their employments ought to make the difference of their studies. . . . The good woman spins, confines herself to her household, holds her tongue, believes, and obeys" (in Lougee, 1976:182, 184, 187).

In the case of Saint-Cyr, the "proper" education of women was one that trained us to please and obey our future husbands. Such education was not meant to expand our intellects, but to restrain and direct us to the proper sphere of womanhood within its class context. The basic lesson was a reminder that women were dependent on others for our welfare. It prepared girls to submit graciously to that fate (Stock, 1978). Saint-Cyr became a model for eighteenth-century French convents which educated the daughters of various segments of the aristocracy and middle classes (Lee, 1975).

Across the channel in England, the first woman to write a treatise on the education of women was Bathsua Makin, with *An Essay to Revive the Ancient Education of Gentlewomen* (1673). English plays of the late seventeenth century suggest the nature of what must have been an ongoing debate, deploring as they do by their plots the dangers to society posed by rebellious daughters, emancipated wives, and "she-philosophers," "all rebels against male authority" (Kinnaird, 1979:53). What was caricatured on stage did

characterize some of the books and pamphlet literature of the day. For example, Hannah Woolley, a schoolmistress and writer of books on cookery and household management, began her advice book *The Gentlewoman's Companion* (1675) with a diatribe on the right of women to a better education (box 11.2).

Aphra Behn, whom we have discussed previously, was the first woman dramatist in English. She supported herself through her wrtitings, including over twenty plays between 1670 and 1689 as well as a novel, *Oroonka*. When she employed the same sexually explicit language used by the male playwrights of her day, however, she was accused of "bawdiness" (Mahl and Koon, 1977:167).

As Saint-Cyr was becoming established in France, Mary Astell in England was calling for a true institution of higher learning for women in her *Serious Proposal to the Ladies for the Advancement of Their True and Greatest Interest* (1694). Astell was influenced by the philosophical and scientific ideas of her time. Dismissing all conventional arguments about women's inferior intellects, she took the radical position that God had given the same intellectual potential to all human beings, poor and rich, female and male. As to claims men made for their superiority, she wrote with heavy irony: "Have not all the great Actions that have been perform'd in the World been done by Men?. . . . Their vast Minds lay Kingdoms waste, no Bounds or Measures can be presciib'd to their Desires. . . . They make Worlds and ruin them, form Systems of universal Nature and dispute eternally about them" (Kinnaird, 1979:63).

Astell did not dispute the claims of marriage on women, but she insisted that women who marry should be highly educated for our responsibilities. Only serious education could fortify women enough to aid us in building strong and happy marriages and rearing our children properly. Her plan for a "Female Monastery" was aimed at strengthening the thinking powers of women. Although she preached women's duties, not women's rights, she believed those duties entailed realizing women's full potential as thinking persons.

Among Astell's circle in early eighteenth-century England was Elizabeth Elstob, one of the first scholars to study the Anglo-Saxon language and its literature (Beauchamp, 1974). Another noteworthy companion was Lady Mary Wortley Montagu, whose letters, like those of Madame de Sévigné, display her education, wit, and ability to comment with keen perception upon the follies of her world. Another feminist of the period, Eliza Haywood, supported herself by writing romantic novels and plays and publishing *The Female Spectator* from 1722 to 1746. This was the first magazine published by and for women; written largely by Haywood herself, it dealt with questions of female education, literature, the arts, and philosophy. For example, she wrote in the 1740s:

Seventeenth-Century English Feminism Box 11.2
The right Education of the Female Sex, as it is in a manner everywhere
neglected, so it ought to be generally lamented. Most in this depraved
later Age think a Woman learned and wise enough if she can distinguish
her Husbands Bed from anothers. Certainly Mans Soul cannot boast of a
more sublime Original than ours, they had equally their efflux from the
same eternal Immensity, and [are] therefore capable of the same improve-
ment by good Education. Vain man is apt to think we were meerly
intended for the Worlds propagation, and to keep its humane inhabitants
sweet and clean; but by their leaves, had we the same Literature, he
would find our brains as fruitful as our bodies. Hence I am induced to
believe, we are debar'd from the knowledge of humane learning lest our
pregnant Wits should rival the towering conceits of our insulting Lords
and Masters. (Hannah Woolley in Kinnaird, 1979:53)

It is entirely owing to a narrow Education that we either give our Husbands
room to find fault with our Conduct, or that we have Leisure to pry too
scrutinously into theirs:—Happy would it be for both were this almost sole
Cause of all our Errors once reform'd; and I am not without some Glimmerings
of Hope that it will one Day be so.
 ...O but, say they, Learning puts the Sexes too much on an Equality, it
would destroy that implicit Obedience which it is necessary the Woman should
pay to our Commands:—If once they have the capacity of arguing with us,
where would be our Authority! (Mahl and Koon, 1977:223–25, 234–35)

Like Paris, London in the eighteenth century had salons at which some of
the intellectual women of English society, called bluestockings, mingled with
literary men of the day. At the same time, the debate over women's education
continued. For every woman like Astell who called for the development of
women's reason to make us better wives and mothers, there were men and
women who emphasized that girls should be taught patient submissiveness to
male authority. The most articulate spokesperson for this view was the "radi-
cal" French philosopher Jean Jacques Rousseau.

In his treatise on the ideal education for a young man, *Émile* (1762),
Rousseau takes up the psychological, moral, and social consequences that
must follow from the physical distinctions between the sexes, concluding that
"by nature" women have been intended to obey men. Thus, the same phi-
losopher who proclaimed in that very year in *The Social Contract* (1762) that
might never makes right, and that human beings should only obey govern-
ments to which they consent, failed to extend this view to women's relations
with men. Rousseau took instead the traditionalist view. In *Émile*, the educa-
tion of Sophie was designed to make her completely submissive to her future
husband. The proper study of women, according to Rousseau, was men,

whose traits and dispositions we must observe in order to bend easily to them and for whose pleasure we were in fact created (Keohane, 1980).

The first feminist response to Rousseau came from Catharine Macaulay, a historian whose eight-volume *History of England*, appeared between 1763 and 1783. In her *Letters on Education* (1790), she asserted the need for women and men to understand each other better. Coeducation was her solution. If both sexes shared the same curriculum and the same physical exercises, women would learn alongside men to develop our intellectual and physical powers. As educated members of the state, women would then undertake our share of its political responsibilities (Boos, 1976).

Another response to Rousseau came from Mary Wollstonecraft, a writer who had supported herself since the age of nineteen as a lady's companion, needleworker, governess, schoolmistress, journalist, and translator. By 1786 she had written her first book, *Thoughts on Education of Daughters*. In it she deplored the useless "accomplishments" society thought appropriate to the education of young women. Self-educated like many other intellectual women in the past, and inspired by Catharine Macaulay's views and the revolutionary developments in France, Wollstonecraft wrote her passionately felt *Vindication of the Rights of Woman* (1792). She attacked the conservative views which promoted ignorance in young women in order to keep us innocent. She attacked Rousseau, pointing out scathingly that since Sophie's reasoning powers were left uncultivated, she would make a very poor mother for Émile's children. Wollstonecraft also advocated coeducation, insisting that young women must receive an education that would enable us to be rational, competent, and independent (see chapter 2). She did not ignore the reality that the majority of women would become wives and mothers; instead, she claimed most earnestly that we could fulfill those roles best if we learned first to respect ourselves as individuals (Sapiro, 1974).

The Modern Educational Revolution

In the two hundred years since Wollstonecraft "debated" with Rousseau over the proper education of women, people's beliefs have undergone a true revolution. Gradually, the view that the modern state has an obligation to offer at least elementary education to all its citizens has gained influence in much of the world. But how much education and for what purposes have been the subject of continued debate. The same social conventions that hindered the acquisition of learning by women in earlier centuries still limit the nature of our educational opportunities. Even in countries offering high levels of education to women, the problem of defining educational goals for women today remains fiercely controversial.

As in earlier centuries, our struggle since 1800 to achieve an ever higher

level of education has been led by women who simply refused to accept the view that we are intellectually inferior. Such women in the nineteenth century sought to prove that women could excel in the educational curriculum pursued by men; more recently, we have emphasized the need for women's search for self-knowledge and self-definition. Like our learned sisters before us, women involved in educational reform have been caught in the paradox of society's gender definitions. By this measurement, if women succeed in our intellectual pursuits, we are no longer "true women." This gender distinction has been used time and time again to make women limit ourselves and our attempts at self-definition.

The Achievement of Elementary and Secondary Education

In colonial America, the simple rudiments of education—reading, writing, and arithmetic—were often supplied in "dame schools" run by women for girls and boys. But formal education for women beyond the most elementary level was considered inappropriate, dangerous, and unsettling to women's domestic duties. Thus Anne Bradstreet (1612–1672), the daughter and wife of two governors of the Massachusetts Bay Colony and the mother of eight children by the time she was thirty-eight, was still stung by the criticism lodged against her writing of poetry:

> I am obnoxious to each carping tongue,
> Who sayes, my hand a needle better fits.
> A poets pen, all scorne, I should thus wrong;
> For such despight they cast on females wits (Cott, 1977:102).

Studies on the literacy of women and men through the colonial period conclude that while the male literacy rates may have been as high as 80 percent by the late eighteenth century, women's rates were as low as 45 percent (ibid.:102–3). Abigail Adams(1744–1818) felt it necessary to remind her husband John, who would become the second president of the United States, of the neglect to female education that characterized their young country: "If we mean to have heroes, statesmen, and philosophers, we should have learned women" (ibid.:106). Yet when the Young Ladies' Academy of Philadelphia opened its doors in 1787, its curriculum included neither classical languages nor advanced mathematics.

Wollstonecraft's *Vindication of the Rights of Woman* was reprinted in Philadelphia soon after its English publication. It was soon followed, however, by a *Memoir* of her life, written by her husband, William Godwin. In the book he revealed that she had lived with a previous lover as well as with himself before she married him. Also, she had previously had an illegitimate daughter before dying in giving birth to her second daughter. Wollstonecraft became identified with free love and political radicalism, and her views became unacceptable. The opinion that prevailed in the early American republic

"Young Woman Plucking the Fruits of Knowledge and Science" (1892) by Mary Cassatt is the center panel of the mural "Modern Woman," painted for the Woman's Building of the World Columbian Exhibition held in Chicago in 1893. Cassatt's imagery captures the idea that women have had to take the initiative to gather the fruit of the tree of knowledge for ourselves and the generations of women to come. (Chicago Historical Society)

was that a proper education for women made us virtuous examples for our brothers, husbands, and sons and true mothers of future heroes and statesmen (Kerber, 1974:51–52).

After the American Revolution, a small number of boys' academies were opened to girls, especially to sisters, but it was the custom to teach us separately, either in different spaces or at different times. In the early decades of the nineteenth century, a number of all-female academies opened. Emma Willard proposed in 1819 that the New York State legislature sponsor a publicly supported female seminary. She engaged the sympathies of the legislators by pointing out that this action would help meet the increasing need for teachers. Women, she said, were "natural" teachers of the young, and it was easy to hire us at lower wages than were paid men (Cott, 1977:117–21). Unable to enlist their financial support, Willard went on to establish her own female seminary in Troy, New York, in 1821.

Emma Willard devoted the rest of her life to educating women to be well-trained teachers. Her views on women's education and careers became important in reshaping education throughout the new nation. Her message to each succeeding class of young women over the next three decades was the same: women can study any academic subject we choose; we should prepare ourselves to be self-supporting in a profession; and marriage for women is

not an end in itself. Graduates of Troy Female Seminary formed a network whose members were committed to the education of women and to the professionalization of teaching (Scott, 1979). Other networks of a similar kind were being formed by Catharine Beecher (1800–1878) in her Hartford Female Seminary and Mary Lyon (1797–1849) at Mount Holyoke.

The argument that a developing nation required an educated people gradually led a number of Northern states to provide free public elementary education by the mid-nineteenth century. This took place at a time when the developing industrial economy of the nation was providing attractive alternative careers for the traditional schoolmaster. To meet the growing demand for teachers, increasing numbers of young women turned to this occupation and agreed to far lower wages. By 1870, of the more than two hundred thousand teachers in American public elementary and secondary schools, over half were women.

The state of Massachusetts set patterns of education that were followed elsewhere as the country developed. By the early 1830s, women made up slightly more than half of the teachers of the state; by 1860 we accounted for over three-quarters. Most elementary school teachers were the products of the public or "common" schools, and only gradually did we begin to attend teacher-training or "normal" schools.

Catharine Beecher encouraged the graduates of her Hartford Female Seminary to seek posts where we would be needed in the West. One woman who opened a school in a log house with forty-five pupils wrote to Beecher:

> I board where there are eight children, and the parents, and only two rooms in the house. I must do as the family do about washing, as there is but one basin, and no place to go to wash but out the door. . . . The people here are very ignorant; very few of them can read or write, but they wish to have their children taught. . . . My school embraces both sexes, and all ages from five to seventeen, and not one can read intelligibly. . . . There is so much to do. (Woody, 1966, I:486–88)

Down to the 1880s, women were increasingly employed as teachers, consistently underpaid, and generally praised for our dedication to the profession (box 11.3). Late in the century, a reversal of attitudes developed. Because women teachers had followed the conventional expectations of the day by marrying eventually, criticism was raised against training us in public normal schools in return for just a few years' service. In addition, critics complained that American boys were being "feminized" by their exclusive exposure to female teachers. Women were accused of failing to provide that adequate "manly" role model needed by older boys. The dearth of male teachers now came to be seen as a grave peril, and women were accused of driving men from the profession because we accepted such low wages. One critic, steeped in gender stereotypes, claimed that the long-range effection of the feminization of the teaching profession was "a feminized manhood, emotional, illogical, non-

Equal Pay for Women Teachers, 1853 Box 11.3

In 1853, Susan B. Anthony, a teacher and leader in the nineteenth-century women's rights movement, attended an education convention at Rochester, New York. She listened to long discussions of the low prestige in which the teaching profession was held, compared to the law, medicine, and the ministry. The discussion was conducted entirely by men, "the thousand women crowding that hall could not vote on the question," nor did they venture to speak. After asking to be heard, and waiting for a further half-hour discussion on whether her request would be granted, she spoke:

> It seems to me, gentlemen, that none of you quite comprehend the cause of the disrespect of which you complain. Do you not see that so long as society says a woman is incompetent to be a lawyer, minister, or doctor, but has ample ability to be a teacher, that every man of you who chooses this profession tacitly acknowledges that he has no more brains than a woman? And this, too, is the reason that teaching is a less lucrative profession, as here men must compete with the cheap labor of women. Would you exalt your profession, exalt those who labor with you. Would you make it more lucrative, increase the salaries of the women engaged in the noble work of educating our future Presidents, Senators, and Congressmen."

(In Lerner, 1977:234–36)

combative against public evils. . . . Men think in terms of steamships, railways, battleships, war, finance, in a word, the greatest energies of the world, which the woman's mind never, in a practical way, really concerns itself with, nor can it do so" (Woody, 1966, I:512).

What if a woman married but wanted to keep teaching? Many school boards at the turn of the century decided that it was in fact improper to employ married women teachers. It was thought that wives should be supported by husbands and leave employment opportunities to the unmarried. As passed by the New York City school board, the only exceptions to such a rule could be wives whose husbands were mentally or physically unable to earn a living or who had been deserted (ibid.:590). This New York City regulation was revoked in 1920, but women teachers continued to experience discrimination throughout the country. We even had to adhere to rules about our appearance and behavior *outside* the classroom. Women teachers were expected to conform to social ideals in private as well as in public.

The revolution in secondary school instruction in the United States took place in the second half of the nineteenth century. Although the first public high schools for girls were founded in Worcester, Massachusetts, in 1824 and in New York City and Boston soon thereafter, only gradually did such institutions become graded schools whose curriculum was taught at levels above

those of elementary schools. Although many public high schools remained gender-segregated, the pattern by the end of the nineteenth century was co-education. By 1900, there were some six thousand public high schools in the country. Girl students outnumbered boys in attendance and in the number who graduated by a ratio of three to two (Woody, II: 1966) (Table 11.2). Some reasons have been suggested for this differential. Families who could afford it sent boys to private schools. In rural areas, boys were kept out of school during peak cultivation and harvesting seasons, while girls were sent to school because the time left each day still allowed us to do our domestic chores. In the cities, poorer families expected boys to leave school as soon as possible to add to the family income, while school was seen as a place that kept girls out of trouble. The high numbers of educated women in the latter part of the nineteenth century created a new supply of workers for the developing clerical and sales opportunities opening up in business offices and department stores (see chapter 13).

The Education of Black Women in America

The states in which slavery continued to exist in the first half of the nine-teenth century, as we noted earlier, legislated against the provision of educa-tion to blacks, free or enslaved. Free blacks before the end of slavery sought education outside the South; afterward, freed blacks turned to education in great numbers in search of opportunities for personal and community ad-vancement. Black women were in the forefront of such activities. An unusual woman who managed to achieve an education and become a published poet in the eighteenth century was Phillis Wheatley (1753–1784). Brought to Boston on a slave ship at the age of seven or eight, she was purchased by John Wheatley and taught to read by his older children. She was frequently used as an example by early abolitionists in the North to demonstrate what could be accomplished by black people if given opportunities.

After the Civil War, many white women teachers from the North along with educated black women volunteered to teach freed children in schools established by the Freedmen's Bureau set up by Congress in 1865. Women made up almost half the nine thousand teachers in this program. All were intimidated, but the black women teachers fared the worst. We were whipped, raped, and killed (Lerner, 1977:237).

Despite the intimidation, many black women were able to take advantage of new educational opportunities during this period. Lucy Craft Laney was in the first graduating class of Atlanta University in 1873, and after ten years of teaching, she opened her own school in Augusta, Georgia. The school, which exists today, was the first to introduce kindergarten instruction and nursing education in Augusta (Loewenberg and Bogin, 1976:296–97).

Afro-American women who assumed positions of leadership needed to articulate the special problems of race and gender. Frances Jackson Coppin

Table 11.2 Public High School Graduates in the United
States (in round numbers)

	Percent of 17-year-olds	Female	(%)	Male	(%)
1870	2.0	9,000	(56)	7,000	(44)
1880	2.5	13,000	(54)	11,000	(46)
1890	3.5	25,000	(57)	19,000	(43)
1900	6.3	57,000	(60)	38,000	(40)
1910	8.6	93,000	(59)	64,000	(41)
1920	16.3	188,000	(60)	124,000	(40)
1930	28.8	367,000	(55)	300,000	(45)
1940	49.0	643,000	(52)	579,000	(48)
1950	57.4	629,000	(52)	571,000	(48)
1960	63.4	966,000	(52)	898,000	(48)
1970	75.6	1,351,000	(51)	1,314,000	(49)
1980	73.6	1,560,000	(51)	1,503,000	(49)

Source: U.S. Department of Commerce, 1975:379; U.S. Department of
Education, 1982: Table 60.

(1837–1913) was one who felt this dual responsibility. An aunt had pur-
chased her freedom, and she was encouraged to pursue her education by the
Northern family for whom she worked as a domestic servant. Eventually, she
studied Greek, Latin, and mathematics and from 1860 to 1865 attended
Oberlin College, the only college that would admit a black woman. She was
the first black woman to earn a degree there, going on to teach at and
become the principal of the Female Department of the Institute for Colored
Youth in Philadelphia (Loewenberg and Bogin, 1976:302–16).

Another distinguished Oberlin graduate was Anna Julia Cooper (1858–
1964), a black woman who made the education of black girls her special
concern. Born a slave, she was freed at the time of the Civil War and began
teaching at the age of nineteen. Married and widowed within a span of two
years, she went to Oberlin College to earn her degree in 1884. She taught in
Washington, D.C., and argued for the establishment of higher education for
black women and men. When she retired as a schoolteacher, she went to
Paris in 1924 and earned a Ph.D. in Latin.

At the end of the nineteenth century, Anna Cooper compiled some statis-
tics about black education. Less than three decades after the emancipation of
slaves, two and a half million black children had already received an elemen-
tary education from 22,956 black teachers, mostly women. She counted
25,530 black schools in the United States. Black women had completed the
B.A. course at Fisk University, Oberlin College, Wilberforce University, the
University of Michigan at Ann Arbor, Wellesley, Livingstone College, and
Atlanta University. Reflecting on these numbers, she stated her views in the
Higher Education of Women (1892) (box 11.4).

Anna Cooper on the Higher Education of Women Box 11.4

In the very first year of our century, the year 1801, there appeared in Paris a book . . . entitled "Shall Woman Learn the Alphabet?" The book proposes a law prohibiting the alphabet to women, and quotes authorities weighty and various, to prove that the woman who knows the alphabet has already lost part of her womanliness. The author declares that women can use the alphabet only as Molière predicted they would, in spelling out the verb *amo;* . . . while Sappho, Aspasia, Madame de Maintenon, and Madame de Staël could read altogether too well for their good; finally if women were once permitted to read Sophocles and work with logarithms, or to nibble at any side of the apple of knowledge, there would be an end forever to their sewing on buttons and embroidering slippers.

. . . Now I claim that it is the prevalence of Higher Education among women, the making it a common everyday affair for women to reason and think and express their thought, the training and stimulus which enable and encourage women to administer to the world the bread it needs as well as the sugar it cries for . . . that has given symmetry and completeness to the world's agencies.

In Loewenberg and Bogin, 1976:318–19, 321)

The Struggle for Higher Education

Relatively little resistance accompanied the establishment of coeducational public elementary schools and all-female and coeducational high schools in the United States. The real struggle took place over the issue of higher education, which was identified with the male professions of college teaching, the ministry, the law, and medicine. The establishment of colleges for women, the attempts to gain entry into all-male universities, and the struggle to gain theological, legal, and medical degrees took place in the second half of the nineteenth century.

The success of women's colleges depended to a large extent on the compromises made by their organizers, administrators, and students. For the freedom to follow the male-defined curriculum, they committed themselves to maintaining a high level of feminine decorum. Higher education for women was bought at the price of what sociologist Sara Delamont calls "double conformity." "This double conformity—a double bind or catch 22—concerns strict adherence on the part of both educators and educated to two sets of rigid standards: those of ladylike behavior at all times *and* those of the dominant male cultural and educational system" (Delamont, 1978a:140).

The pattern for such a compromise was set in the experiences of women who entered men's colleges in the first half of the nineteenth century. These colleges were reluctant to admit women because college education was considered training for a profession, and the professions, particularly the minis-

try, were viewed as men's occupations. Thus the notion of allowing women to attend was contrary to the domestic ideology of separate spheres. Oberlin College in 1837 was the first to accept women for its collegiate program. Of state universities, only Iowa admitted women from the beginning, starting with four out of eighty-nine students in 1855. The decline in university enrollments during the Civil War led a number of other schools to admit women. By 1870, eight state universities were open to women, but many only in separate "female departments" (Newcomer, 1959).

Oberlin's policies illustrate the prevailing attitudes toward higher education for women. When the college was founded in 1833, it announced that one of its purposes was "the elevation of the female character, bringing within the reach of the misjudged and neglected sex, all the instructive privileges which hitherto have reasonably distinguished the leading sex from theirs" (Hogeland, 1972–1973·163). Young women made up one-third to one-half of the student body, mixed freely with young men in classrooms, at meals, and on social occasions, and were excluded only from the religious functions of the men. Oberlin was established to train men to the ministry, especially for the newly opened West. Its "Ladies' Department" offered a course of study that differed from the regular collegiate program in that it required no Latin, Greek, or higher mathematics.

A study of the first four decades at Oberlin reveals that despite the appearance of coeducation, women were admitted primarily for the well-being of the male students, to provide the future clergy with suitable wives who were cultivated, discreet, religious, and good, prudent housekeepers. From the beginning, women students were expected to wash and repair the clothing of the "leading sex," care for men's rooms, and take charge of dining hall tasks. In addition, the presence of women was expected to elevate and refine the manners of the male students, while helping to counteract their "morbid fancies" about us. We were to offer properly supervised, healthy relationships for the men and a pool of potential wives to choose from upon graduation. Supervision consisted of lists of prohibitions concerning the conduct and appearance of the *women* (Hogeland, 1972–1973).

When Lucy Stone (1818–1893), later a leader in the American women's rights movement, entered Oberlin in 1837, she and three other young women were permitted to take the regular four-year collegiate course after completing the preparatory one of equal length in the Ladies' Department. Even when she was admitted to classes with men, she was not allowed to engage in debates or read her own essays in class. When she graduated, she refused to write the commencement address that was hers by right of intellectual achievement because the college would not let her read it at the ceremony (Harris, 1978; Lerner, 1977).

Another of these four pioneers for the collegiate degree at Oberlin in 1837 was Antoinette Brown (1825–1921). She announced upon graduation that

she wished to become a minister, to the horror of her teachers and her parents. Although she was admitted to the Oberlin Theological School as an "exception," and parts of her dissertation—a critique of the writings of St. Paul on the subject of women—were published in the *Oberlin Quarterly*, the college authorities refused to give her a student's license to preach. In 1850, when she finished the theological course, the college also refused to confer on her the divinity degree she had earned. When she did achieve ordination in 1853, in a Congregational church in New York State, she became the first woman to be an ordained minister in the United States (Harris, 1978:87–88).

By 1870 the results of the efforts to achieve higher education for women were meager (table 11.3). Some three thousand women were studying for a liberal arts degree, twenty-two hundred of them in women's colleges. Although about forty private coeducational institutions were "open" to women, the number of women in their collegiate departments was not over six hundred. The number of women in the eight state universities which admitted us was some two hundred (Newcomer, 1959:19). Coeducation was virtually nonexistent in the East. Swarthmore College in Pennsylvania admitted women in 1870, and Cornell did so two years later.

The move to establish separate, private women's colleges contributed to the founding of Smith and Wellesley colleges in 1875, Bryn Mawr in 1885, and Radcliffe College in 1893. In addition, Mary Lyon's Mount Holyoke became a college in 1888. But during the 1870s, there was also renewed resistance to the idea of higher education for women.

Dr. Edward Clarke, until 1872 a professor of medicine at Harvard University, was keenly aware that women were not only demanding higher education but were even "knocking loudly at the door of medicine." In 1873 he published *Sex in Education; or, A Fair Chance for the Girls*, which immediately became a best-seller on both sides of the Atlantic. Dr. Clarke argued that women experienced a sudden spurt of growth at puberty, during which the development of our reproductive systems took place. If anything happened which interfered with this development, the entire system was threatened. If, for example, our nervous energies were expended elsewhere, rather than concentrated upon the reproductive system, we would not develop into normal, healthy young women but would suffer physical deterioration, accompanied by menstrual disorders, constant headaches, and even hysteria. Thus higher education threatened women with "monstrous brains and puny bodies; abnormally active cerebration and abnormally weak digestion; flowing thought and constipated bowels" (Burstyn, 1973; Walsh, 1977:119,124–26).

The influence of Clarke's challenge must be gauged by the debate which continued through the next thirty years. One of the first public replies to Clarke questioned the scientific grounds of his observations; this was *The Question of Rest for Women During Menstruation* (1876) by Dr. Mary Put-

Table 11.3 Higher Education Degrees Conferred in the United States

Year	Bachelor's or First Professional Degree			Master's or Second Professional Degree			Doctor's or Equivalent		
	Female	(%)	Male	Female	(%)	Male	Female	(%)	Male
1870	1,378	(14.7)	7,993	—	—	—	—	—	—
1880	2,485	(19.2)	10,411	—	—	879*	3	(5.6)	51
1890	2,682	(17.2)	12,857	—	—	1,015*	2	(1.3)	147
1900	5,237	(19.1)	22,173	303	(19.1)	1,280	23	(6.0)	359
1910	8,437	(22.6)	28,762	558	(27.8)	1,555	44	(12.8)	399
1920	16,642	(34.2)	31,980	1,294	(30.2)	2,985	93	(15.1)	522
1930	48,869	(39.8)	73,615	6,044	(40.4)	8,925	353	(15.4)	946
1940	76,954	(41.2)	109,546	10,223	(38.2)	16,508	429	(13.0)	2,861
1950	103,217	(23.8)	328,841	16,963	(29.2)	41,220	643	(9.7)	5,990
1960	136,187	(34.9)	252,996	25,727	(33.1)	51,965	1,028	(10.9)	8,801
1970	343,174	(41.4)	484,174	82,667	(39.1)	125,624	3,976	(13.3)	25,890
1980	473,221	(47.3)	526,327	147,332	(49.4)	150,749	9,672	(29.7)	22,943

Source: U.S. Department of Commerce, 1975:385–86; U.S. Department of Education, 1982: Table 108.

*No breakdown by sex available; therefore placed in this column.

nam Jacobi. As a result of questionnaires and tests on the general health of a sample of young women, some of whom were studying medicine, she found that women who maintained normal work patterns suffered less menstrual discomfort than those who did not (Walsh, 1977). As another response to the health issure, physical training developed as a required part of women's higher education. Although it gradually evolved an educational rationale of its own in the twentieth century, the concern for the health of the college woman remained an important reason for its existence as a general requirement.

Most female college graduates gravitated to the socially acceptable positions of teacher and librarian (Garrison, 1979). The more adventurous created new professions for women. This may have been a reason for the popularity of settlement house work in the slums of major cities (Rousmaniere, 1970). Three-fifths of all settlement house workers between 1889 and 1914 were women, and nine-tenths of these women were college graduates. Apparently this social reform movement provided two important opportunities for women who had been to college. The first was the residence itself, which allowed us to continue the close peer group relationships which had characterized our college years, and the second was the sense of mission which it gave us, a sense of doing the world's work. Seeing ourselves as a new phenomenon, college-educated women, we saw in settlement house work both adventure and an opportunity to demonstrate our "refinement, taste, travel, and culture" and to act as mediators between the idle rich and the working poor (ibid.). It was also a profession which gained respectability because it fit so well with the values of "nurturance, sympathy, domestic management and

Jane Addams surrounded by settlement-house children. As a young woman college gradu-
ate in the 1880s, Addams sought a way of putting her higher education to work. At age 29,
after a visit to Toynbee Hall in London, the first settlement house in the world, she
established Hull House in Chicago, the first settlement house in the United States. She
maintained a connection with Hull House the rest of her life. (University of Illinois Library
at Chicago Circle Campus, Jane Adams Memorial Collection)

self-sacrifice" that society identified with the condition of being a woman
(Harris, 1978:118).

It has also been suggested that the women who graduated from women's
colleges before and after 1910 differed significantly in the number who mar-
ried and had children, had occupations, and went to graduate school. Analyz-
ing the alumnae rosters of Bryn Mawr and Wellesley colleges, one study finds
that among the group who graduated before 1910, far fewer married; those
who did marry had fewer children; and far more took jobs than in the later
group. The conclusion is that larger numbers of women among the first
generations of graduates chose to remain unmarried and to achieve indepen-
dence by pursuing careers, but that in the longer run, college "did not perma-
nently change the domesticity cult which prescribed a role of subservience
and dedication to the home and family for women" (Wein, 1974:45).

To some extent, this conclusion is borne out by the development of domes-
tic science and home economics as a professional movement, both within and
outside colleges, early in the twentieth century. The women who pioneered
the new home economics field were academic women whose careers had

begun as challenges to male professional preserves. For example, Ellen Swallow Richards became the first woman to earn a B.S. degree at the Massachusetts Institute of Technology, in chemistry. Although MIT allowed her to do graduate work, it refused to grant her a Ph.D. because she was a woman. She married an MIT professor and established her own women's laboratory in order to train women scientists, contributing her own money to keep it in operation (Harris, 1978:114–15).

Shut out from a scientific career as it would have been pursued by a man, Richards pioneered the application of modern science to cooking, nutrition, sanitation, and hygiene. She developed courses in these areas and organized the American Home Economics Association in 1908 (ibid.:135). By 1927, domestic science and home economics courses or majors were available in over 650 colleges and normal schools (Walsh, 1977:190). At Cornell University, the first women to achieve faculty status were professors of home economics, Martha Van Rensselaer and Flora Rose; even so, when they were appointed in 1911 it was recommended that they not attend faculty meetings until some of the opposition to appointing women to faculty rank subsided (Conable, 1977:127).

Education and Career Choices

Women's Education and Women's Realities

In 1980, women comprised 51.4 percent of all college students; yet we constituted only 28.2 percent of all students in first professional degree programs. More women than men were enrolled as part-time students in higher education, from undergraduate through graduate and professional schools. Only 1.8 percent of all women who attended college were in single-sex women's colleges. By fall 1980, women earned 47.3 percent of the bachelor's degrees awarded in the United States; 49.4 percent of the master's degrees; and 29.7 percent of the doctorates. But despite the achievement of more higher degrees than ever before, women still find strong barriers of discrimination and social injustice in our paths (U.S. Department of Education, 1982: Tables 73, 78, 108).

Educated women are entering the labor force in larger numbers than ever before. By June 1982, 52.8 percent of all women aged sixteen years and over were in the paid labor force in the United States (Department of Labor, July 1982). Yet our distribution across occupational fields did not differ significantly from that of earlier years. The largest category was still clerical workers, at 35 percent. Professional and technical work involved only 7 percent (ibid., March 1982). At every educational level, women earn less and have fewer opportunities for choice and advancement than men.

Choices are even more limited for minority women. As college undergraduates, minority women enroll in numbers proportionate to the distribution in the general population, but in graduate and professional schools, representa-

A domestic science class early in the twentieth century. Such classes became a standard part of the public school curriculum for girls, based on the assumption that since all women would undertake household responsibilities, they should be trained to carry them out efficiently. (Photo by Jacob A. Riis. Jacob A. Riis Collection, Museum of the City of New York)

tion falls far below this level. By 1978–1979, minority women were earning 6 percent of all bachelor's degrees, 6.3 percent of all master's, 3.1 percent of doctorates, and 2.6 percent of first professional degrees, such as law and medicine (Department of Education, 1981). We earned 8.7 percent of all associate or two-year college level degrees. Compared to minority men, minority women earned slightly more bachelor's and master's degrees, but fell behind at the doctorate level (Office of Civil Rights, 1981).

As educators, women are still the majority of elementary and secondary school teachers, but we continue to be strikingly underrepresented at administrative and policy-making levels. In fact, the proportion of women administrators in education has declined since 1930. In 1978, three-quarters of all college and graduate school administrators were men. In 1982, only 9 percent of all college presidents were women. Women number fewer that 10 percent of deans at coeducational institutions, and hold less than 10 percent of full professorships and 25 percent of associate professorships at these institutions. These percentages are often much smaller at the most elite institutions. The largest proportion of women are in untenured and part-time positions, and our salary levels in 1980 at every level were several thousand dollars below those of men. (Howard, 1978; National Research Council, 1980).

Professional Advancement

The traditional professions have been the ministry, law, and medicine. Because the practice of these professions takes place outside the domestic sphere, in the nineteenth century they were viewed by definition as men's activities. That definition, in the late twentieth century, is still slow to change. Not only have men guarded the custom and privilege of the professions as their "right," but women have been socialized to agree with them. Our efforts to break through these barriers have taken such sheer determination that it is more surprising that many achieved our goals than that many more were deterred from trying.

Female ministers were rare in the last century because the largest churches—Roman Catholic, Episcopalian, Lutheran, Presbyterian, Methodist, and Baptist—would neither ordain women nor allow us to occupy their pulpits. Those who did by 1890 were the Congregationalists, Universalists, Protestant Methodists, and German Methodists (Harris, 1978:88, 113). The continuing struggle of women to achieve theological degrees and become ordained in the modern era has been discussed in chapter 10.

Becoming a lawyer in America proved just as difficult for women. The first woman admitted to the bar was Arabella Babb Mansfield in Iowa in 1869. The same year Illinois turned down the application of Myra Bradwell, who had studied law with her husband, an attorney in Chicago. When Bradwell appealed to the United States Supreme Court, the majority denied her case on technical grounds, but by this time the Illinois legislature had passed the necessary enabling act (see chapter 14).

A struggle was necessary in nearly all the states where women sought to become lawyers, and it took years for the first woman to be allowed to practice before the U.S. Supreme Court, in 1879. By 1920, only 3 percent of lawyers were women (Harris, 1978:112). The real change in women's access to legal training came in the 1970s. By 1981, women constituted 35 percent of law school enrollments.

The struggle by women to obtain medical degrees has been marked by continual setbacks. Mary Roth Walsh (1977) has written a history of this struggle, appropriately titled (from a 1946 newspaper advertisement), *"Doctors Wanted: No Woman Need Apply."* Occasionally wartime and personnel shortages lowered the barriers, but they were always raised again once the crisis was past. Women pioneers in the field were forced to create female schools and infirmaries before all-male medical schools began to admit us early in the twentieth century. New medical schools that needed the enrollment, as in the case of Tufts, admitted women, but our numbers were reduced as soon as qualified male applicants appeared. Thus, women made up 42 percent of Tufts graduates in 1900 and 2 percent in 1919 (Walsh, 1977:199, 202). Walsh concludes that women were never accepted "as a result of any commitment to their medical

Elizabeth Blackwell (1821–1910). The first woman in the United States to earn a medical degree, Blackwell founded an Infirmary for Women and Children in New York in 1857 to provide a clinic where women who wished to become doctors might train. The difficulties women faced in obtaining medical training led Blackwell to found a women's medical college in 1868. (New York Academy of Medicine Library)

education," but only in direct response to men's institutional needs (ibid.:242).

Feminism played a crucial role among the women who sought to become physicians in the nineteenth and early twentieth centuries. At the end of the nineteenth century, 96 percent of women physicians were affiliated with women's institutions. In 1892, 63 percent of women in medical schools were in all-female ones. In time, the nineteenth-century women's medical colleges merged with men's medical schools, to the detriment of the women. Within twelve years of the merger of the New York Infirmary and Cornell University Medical School, for example, there were no women left on the staff (ibid.:261–63).

Although the number of women applicants to American medical schools between 1930 and 1966 increased 300 percent, the proportion of women accepted in male-run medical schools decreased while that of male students increased. Quotas restricting women had become common practice, which meant that the small number of women actually admitted were far better qualified than the men (ibid.:242–45).

Those women who managed to enter medical school were exposed to sexist attitudes on the part of fellow students, teachers, administrators, and postgraduate colleagues. A group of women students at Harvard Medical School in 1974 could still document experiences involving "condescension, hostility, role stereotyping, sexual innuendo, and ignoring female presence in a group situation" (Walsh, 1979:455).

One might wonder why the pioneeer medical women so readily gave up all-female institutions for inclusion in schools and hospitals run by men. After all, women's schools had educated 541 physicians by the mid-1890s, and the number of women physicians in 1910 was greater than it would be in 1940. According to Walsh, by the late nineteenth century, "seemingly assured of ultimate success, many physicians and their supporters began to abandon some of the weapons they had employed in the battle" (1977:182). Lulled into thinking that our struggle for advancement was won, women allowed the very sources of our strength, our independent institutions, to slip away. When the number of medical schools run by men declined from 162 in 1906 to 69 in 1944, women not only had to compete for fewer places but were also subjected to arbitrary and unpublished quotas, as were all black and Jewish students (ibid.:191). Mistaking a temporary and calculated welcome for a permanent commitment on the part of the male medical establishment, women found we could as easily be closed out again.

Lately, women have made a comeback in the medical profession. In the first flush of a renewed women's movement in the 1970s, the number of women medical students has increased dramatically. The breakthrough came as a result of a class action suit brought by the Women's Equity Action League (WEAL) against all medical schools on the charge of illegal discrimination in admission practices. By 1980, women again constituted 25 percent of enrollment in medical schools.

Women have also begun to question the nature of the medical training that we receive at male-dominated medical schools. We have become more conscious of the sexist language and innuendos of standard medical textbooks, and of the male-centered focus of the curriculum. Women medical students have begun to protest the absence of female role models among those who train us. We have even questioned the premises of the health care delivery system into which we are indoctrinated as medical students (Walsh, 1979:455–57). Only female solidarity successfully launched women into

medicine in the United States in the nineteenth century. Women medical students today are learning that only female solidarity can help us change the profession we wish to make our own.

The Limitation of Women's Choices

Educational Experiences in the Early Years. Despite extensive education and academic achievement, women are still faced with a pattern of limited career choices. Why should this be so? Some feminists have analyzed the content of children's books to see what sorts of aspirations are held out to young girls. Elizabeth Fisher (1974) pointed out that the fantasy world of the much-admired picture books used widely with small children, such as those of Maurice Sendak, Dr. Seuss, and Richard Scarry, is primarily a male world. In Sendak's and Seuss's books, the characters are almost entirely male, and friendships occur between boys or even boys and girls, but never between girls. In Scarry, male characters are busy digging, building, breaking, pushing, and pulling, while female characters sit and watch.

A report called *Women on Words and Images* (1974), which analyzed 134 elementary school readers with 2,760 stories, found that stories in which boys were the center of focus outnumbered stories about girls five to two. Stories in which male adults took center stage outnumbered stories focusing on female adults by three to one. Male and female characters in animal stories appeared in a ratio of two to one and in folk and fantasy tales in a ratio of four to one. Moreover, in stories about cruelty or meanness, 65 out of 67 were at the expense of girls. There were 147 role possibilities for male characters in contrast to 25 for girls.

School textbooks, especially in science and mathematics, made it clear that girls would grow up to be passive mothers and boys active fathers. In mathematics texts, the wording of the problems themselves revealed gender bias. Girls were off to the store to buy materials for sewing or cooking; men and boys did woodwork, sailed, climbed mountains, and went to the moon. In "new math" texts, which arranged people in *sets*, groups of men appeared as doctors, fire fighters, chefs, astronauts, pilots, letter carriers, painters, and police officers, ignoring the existence of women in several of these occupations. Women on the other hand were grouped as waitresses, nurses, stewardesses, and funny-hat wearers (Federbush, 1974). The role of the male achiever dominated textbooks in general. Girls were rarely depicted as capable of independent thinking. Such books were often written by women; their messages reflected our own well-internalized socialization (U'Ren, 1971:325).

Later Educational Experiences. The books by which little girls begin to learn about the world and to acquire formal knowledge lay the groundwork for the limiting of choices later in school. The mathematics dropout rate for girls

Girls in a woodworking shop in a public school. In response to new questions raised by women about gender-segregated craft activities in schools in the 1970s, "shop" activities were opened to girls and boys alike. (National Education Association Publishing. Photo by Joe De Dio)

becomes dramatic in the high school years. High school counselors have sometimes urged girls to avoid the more rigorous courses of study and to set our sights on traditional female roles, including teacher, nurse, and secretary. Of students entering the University of California, Berkeley, in 1973, only 8 percent of the women, compared to 57 percent of the men, had taken the four years of high school mathematics which would allow us to choose majors and ultimately careers in scientific and mathematical fields (Ireson, 1978). Teachers are trained to think about children in terms of gender stereotypes. For example, one teacher education textbook, published in 1978, was still instructing its readers that girls "know less, do less, explore less, and are prone to be more superstitious than boys" (Sadker and Sadker, 1980:41).

In college, women again receive vocational counseling that sets us on traditional career paths. Often male professors make it clear that they do not expect women to pursue "serious" work (Roby, 1973:50–51). Women's academic success has regularly been attributed to diligence, not brilliance (Schwartz and Lever, 1973:61). In graduate school, more women than men drop out, even though women represent a smaller percentage of graduate students. It has been found that when graduate students marry each other,

the woman is likely to undertake all the household tasks; and once we have become mothers, we find it very difficult to continue our studies. Women who have dropped out have often cited as reasons not only these new burdens that have been assumed, but also the emotional strain involved, pressure from our husbands, and a belief that our professors did not take us seriously anyway (Patterson and Sells, 1973:87–88).

Exceptions: Women Who Achieved

What kind of educational experiences *do* encourage achievement in women? M. Elizabeth Tidball has studied the relationship between single-sex education and coeducation. She investigated the college background of women whose achievements were listed in *Who's Who of American Women* and whose college experience occurred between 1910 and 1960. She concluded that women's colleges produced more achieving women in each of the five decades than did coeducational institutions. She decided that one of the chief reasons for this significant difference was the greater number of women faculty and administrators in women's colleges who provided role models (Tidball, 1973, 1980).

Tidball's conclusions were reinvestigated by Oates and Williamson, who suggest a slightly modified interpretation of these findings. They categorize the achieving women—using Tidball's measurement—into the graduates of the women's Ivy-League colleges (called the "Seven Sisters"), the graduates of other women's colleges, and the graduates of coeducational institutions. They divide the categories further into the size of the graduating class, and hence of the college itself. They find that the Seven Sisters produced sixty-one achievers per ten thousand students, while the other women's colleges and small coeducational schools produced eighteen per ten thousand. The larger colleges in every case produced fewer achieving women. On the other hand, women graduates of coeducational colleges achieved greater prominence as government officials and as faculty members and administrators in professional schools producing teachers, librarians, and home economists (Oates and Williamson, 1978). This study suggests that the social and economic backgrounds of the women graduates of the Seven Sisters also may have a great deal to do with our successes. The factors that aid women to become achievers after college are still under consideration.

Reentry Women

In the 1960s, there began a trend for adult women to "drop back in" to colleges to complete unfinished educational goals and to prepare ourselves for employment or career transitions. Women were enabled to do this where there existed flexible and part-time course schedules, counseling and efforts to help us adjust to educational requirements, and special programs aimed at building our self-confidence. Denmark and Guttentag (1966, 1967) showed

Women's Education at Hunter College Box 11.5

A study of undergraduate institutions that ranked highest in the number of
female and male graduates who obtained doctorates in the period 1920–
1973 placed Hunter College first among all institutions educating women,
with a total number of 1,110. Hunter College also ranked within the first
four among those institutions whose women graduates obtained doctorates
in physical sciences and engineering, life sciences, social sciences, arts and
humanities, and education (Tidball and Kistiakowsky, 1976). Established
in 1870 as New York City's first public normal college for women, Hunter
had developed by 1914 into a full liberal arts college named after its first
president, Thomas Hunter. Hunter College became fully coeducational in
1964. As part of the City University of New York, it remains committed to
giving women the kind of education that allowed its earlier women gradu-
ates to outnumber the women of other institutions in the pursuit of higher
education. The women's studies program at Hunter College was initiated
in 1971 and by 1976 offered both a collateral major and minor (Helly,
1983). The student body at Hunter, taught by the authors of this text, is
still composed of three-quarters women. Hunter students reflect the many
cultural, ethnic, and religious groups who make up New York City and
include a large proportion of adult students.

that even attending college for only one semester was significant in reducing
the discrepancy between the mature woman's ideal and actual self-concepts.

Two models emerged in the 1960s. One was the Radcliffe (now Bunting)
Institute for Independent Study, which sought to give individual women sup-
port for independent projects pursued part-time or full-time, depending on
our needs, surrounded by other women at similar career stages. The other
model was the program for returning women in separate centers for the
continuing education of women, pioneered by Sarah Lawrence College in the
East and farther west in the big city centers of the universities of Minnesota,
Wisconsin, and Michigan (Campbell, 1973:97–98). These programs gave
special assistance to adult students to help build up our self-confidence and to
help us with the problems of combining studies and family responsibilities.
By the 1970s, colleges and universities across the country were finding new
and flexible ways of accommodating "nontraditional" students, a large num-
ber of whom continue to be adult women. In addition, specific reentry pro-
grams in the sciences have begun to be developed to allow women who had
majored in science in college to catch up to enable us to pursue employment
in these fields.

New Beginnings for Women

As women became more self-conscious and we began to explore our experi-
ences with each other, we also began to question the assumptions about

women we learned in traditional disciplines. Ad hoc courses on women and gender roles and gender differences sprang up in the second half of the 1960s because women wanted to learn more about ourselves and our assigned place in society. California State University at San Diego was the first institution to develop a program of women's studies courses by 1970 (Boxer, 1982). The first graduate seminar in the psychology of women was organized by Florence Denmark and her students at Hunter College. Women explored whether we were portrayed in literature in other cultures and other times as deviants of male patterns. Increasingly, it became clear that education at every level delivered knowledge which reflected the gender of the writer, and that the very theories used to explain the world were theories seen through a male perspective. These insights generated new courses and research and has initiated a serious and sustained reevaluation of all knowledge.

At first, women scholars sought to correct the distortions and omissions that were found to underpin theories of knowledge, our knowledge of the past, and our understanding of contemporary society. Women's studies courses developed just as women were "dropping back in" to colleges and universities and were very eager to find out more about ourselves. Women's studies not only contribute to the new feminist critique of knowledge but also to the raising of women's consciousness of our realities and our choices.

The scholarship in women's studies began to be disseminated through new journals such as *Feminist Studies, Women's Studies, Signs, Sex Roles,* and *Psychology of Women Quarterly.* Women's issues became the subject of new courses and the focus of new centers for research on women at such institutions as Wellesley, Stanford, and the Eagleton Institute at Rutgers University, which has a special program for "policy research on women." Articles, monographs, and anthologies brought new reading lists to courses on women. The assumptions underlying past research were looked at anew, and every field from literary criticism, to psychology of women, to history, anthropology, economics, sociology, biology, and education itself received a scrutiny which has questioned the traditional framework of knowledge. *Women Looking at Biology Looking at Women* (1979), for example, was written by a biology professor and her students who examined the false assumptions of traditional theories in biology since the middle of the nineteenth century. The whole world of knowledge suddenly seemed open for reassessment, including the vocabularies that have communicated traditional male perspectives.

Soon after the new courses appeared, majors and minors in women's studies programs and even advanced degrees began to take shape. When the first National Women's Studies Association convention took place at San Diego, California, in 1977, it was estimated that some four thousand such courses existed across the country (Tobias, 1978:90). A listing of women's studies programs in 1983 included 432 and three departments at institutions

public and private, large and small, single-sex and coeducational. Many of these programs were concerned about larger issues in their academic and social communities, including reentry women students; sex discrimination in faculty appointments, promotion, and retention; the free expression of sexual preferences; health care; legal services; and child care.

A discipline new unto itself is emerging, challenging some of the assumptions of traditional disciplines such as literature, history, or biology, in which until recently women have been largely ignored or else "measured in masculine terms" (Westkott, 1979:423). If we find that in the light of our new focus on women's realities and the new theories which emerge we are reordering the universe, if we find that our new theories help us to order and organize the findings of other disciplines to our own use, we have indeed embarked upon an exciting adventure. The future holds the possibility that by means of women's studies we will find a way to restructure knowledge, to make it resonant with women's perceptions of the world and women's consciousness, as well as men's. If we do so, we will indeed have wrought an intellectual revolution.

Summary

Throughout the world, the pattern today is for women to be less literate than men, either because formal education is not provided us or because we have been socialized to believe it is not necessary. Even when women make gains in formal education, we still are shut out of many occupations identified with men.

Formal education in the past has been directed primarily to males, although occasionally, as in fourth century Greece, some women studied and practiced various professions. During the early middle ages, women in Europe were more literate than men in secular society, since boys were taught martial and sports skills while scholarship was left to the clergy and the young women who attended convent schools.

Although the Renaissance period valued cultivated women, most women had to decide between abandoning studies for marriage or continuing studies in the convent or in solitude. More educational opportunities for upper-class women opened up in the sixteenth century, but it took considerable determination to be a serious scholar. Feminists in France in the seventeenth century challenged the social hierarchy by calling into question the authority of tradition, custom, and religion.

From the seventeenth century on, the goals of women's education were given serious consideration. Many schools and tutors decided that the "proper" education was one that would train women to obey and please our future husbands. Some feminists in seventeenth- and eighteenth-century England protested this view and advocated serious education for women.

In the last two hundred years, an educational revolution has taken place. Many nations have undertaken the obligation of providing free elementary and secondary education to both girls and boys. But the questions of how much education women should have and for what purposes are still debated. The all-female schools of nineteenth-century America produced many educated women who went into the teaching profession. Many of us were subject to discrimination by local school boards. Black women—as well as other women of color—have had to fight both racism and sexism in our struggle to get educated.

In the last century, most male institutions of higher education refused to admit women because higher education was considered preparation for professions still reserved for males. Those women who did enroll in these colleges were often prohibited from full participation in the curriculum. Separate private women's colleges were established to enable women to enjoy the same kind of education men were receiving, but the price these all-female institutions had to pay for social approval was strict conformity to traditional ideas of feminine decorum.

Although women today are achieving higher levels of education and training than ever before, we are still finding our career choices far more limited than men's. In this century, women have had to struggle to enter the ministry, law, and medicine. Part of the reason women are so limited in our choices is that from childhood we have been exposed to books and teacher expectations that stress the submissive role of girls and the active role of boys. With this exposure, girls do not attempt later on in school to take the mathematics and science they identify as "male," but choose fields such as education and home economics because we consider them gender-appropriate. Those women who are achievers have tended to come from women's colleges and smaller coeducational schools. A recent and growing trend is the reentry of women into college to complete unfinished educations and to prepare for new careers.

Women's studies programs have allowed women to learn more about ourselves and about the ways that knowledge has been delivered through male perspectives. Using our new focus on women's realities, we may find we are rethinking everything we have learned.

Discussion Questions

1. How do the world figures for literacy reflect the position of women in various societies? Why did early feminists believe that education was important for women—and why was this idea resisted?
2. Do you think the expansion of educational opportunities for women in the United States since 1800—at the elementary, secondary, and college levels and in professional training—would have occurred without special efforts by women?

3. Evaluate the education of women at your college. Do you think there are any special advantages or disadvantages to gender-segregated education?

4. Trace the history of education of the women in your family as far back as you can go. What were the educational experiences of specific women (your grandmothers, aunts, mother, and so forth)? How do their experiences compare with your own, and how do you account for the differences and similarities?

5. What are the opportunities and obstacles in education for the career of your choice? (If you haven't yet decided on a career, select an interesting one to think about.) Start with early education, even at the preschool level, and continue through all the other levels of educational training.

Recommended Readings

Harris, Barbara. *Beyond Her Sphere: Women and the Professions in American History.* Westport, Conn.: Greenwood, 1978. An important contribution to understanding the difficulties and ideological constraints women have faced in obtaining an equal education. The book begins with a good general introduction to recent scholarship on women and shows how women's educational progress—or lack of it—fits into this framework.

Stacey, Judith, Bereaud, Susan, and Daniels, Joan, eds. *And Jill Came Tumbling After: Sexism in American Education.* New York: Dell, 1974. One of the earliest books to pull together attempts by contemporary feminists to criticize the shaping of women's lives by the modern educational system.

Stock, Phyllis. *Better than Rubies: A History of Women's Education.* New York: Putnam's, 1978. An excellent survey of the subject, spanning its history in Europe and the United States since early modern times.

Woolf, Virginia. *A Room of One's Own.* 1929. Reprint. New York: Harcourt, Brace, 1957. The now classic exploration of the ways women have been prevented from achieving higher education and what this has meant for our lives, independence, and creativity.

References

Beauchamp, Virginia Walcott. "Pioneer Linguist: Elizabeth Elstob." *University of Michigan Papers in Women's Studies* (1974):9–19.

Bell, Susan Groag, ed. *Women from the Greeks to the French Revolution.* Stanford: Stanford University Press, 1973.

Boos, Florence S. "Catherine Macaulay's *Letters on Education* (1790): An Early Feminist Polemic." *University of Michigan Papers in Women's Studies* 2 (1976):64–78.

Boxer, Marilyn. "For and About Women: The Theory and Practice of Women's Studies in the United States." *Signs* 7 (1982):661–95.

Burstyn, Joan N. "Education and Sex: The Medical Case Against Higher Education for Women in England, 1870–1900." *Proceedings of the American Philosophical Society* 117 (1973):79–89.

Campbell, Jean. "Women Drop Back In: Educational Innovation in the Sixties." In *Academic Women on the Move*, edited by Alice S. Rossi and Ann Calderwood. New York: Russell Sage, 1973.

Conable, Charlotte Williams. *Women at Cornell: The Myth of Equal Education.* Ithaca: Cornell University Press, 1977.

Cott, Nancy F. *The Bonds of Womanhood: "Woman's Sphere" in New England, 1780–1835.* New Haven: Yale University Press, 1977.

Davis, Natalie Z. "Gender and Genre: Women as Historical Writers, 1400–1820." In *Beyond Their Sex: Learned Women of the European Past*, edited by Patricia H. Labalme. New York: New York University Press, 1980.

———. *Society and Culture in Early Modern France.* Stanford: Stanford University Press, 1975.

Delamont, Sara. "The Contradictions in Ladies' Education." In *The Nineteenth-Century Woman: Her Cultural and Physical World*, edited by Sara Delamont and Lorna Duffin. New York: Barnes & Noble, 1978.

———. "The Domestic Ideology and Women's Education." In Delamont and Duffin, eds., *The Nineteenth-Century Woman*. New York: Barnes & Noble, 1978.

Denmark, Florence L., and Guttentag, Marcia. "Dissonance in the Self-Concepts and Educational Concepts of College and Non-College-Oriented Women." *Journal of Counseling Psychology* 14 (1967):113–15.

———. "The Effect of College Attendance on Mature Women: Changes in Self Concept and Evaluation of Student Role." *The Journal of Social Psychology* 69 (1955):155–58.

Department of Education. National Center for Education Statistics. *Digest of Education Statistics.* Washington, D.C.: Government Printing Office, 1981.

Federbush, Marsha. "The Sex Problems of School Math Books." In *And Jill Came Tumbling After: Sexism in American Education*, edited by Judith Stacey, Susan Bereaud, and Joan Daniels. New York: Dell, 1974.

Ferrante, Joan M. "The Education of Women in the Middle Ages in Theory, Fact, and Fantasy." In *Beyond Their Sex*, edited by Labalme. New York: New York University Press, 1980.

Finn, Jeremy D., Dulbert, Loretta, and Reis, Janet. "Sex Differences in Educational Attainment: A Cross-National Perspective." *Harvard Educational Review* 49 (1979):477–503.

Fisher, Elizabeth. "Children's Books: The Second Sex, Junior Division." In *And Jill Came Tumbling After*, edited by Stacey et al. New York: Dell, 1974.

Garrison, Dee. *Apostles of Culture: The Public Librarian and American Society, 1876–1920.* New York: Free Press, 1979.

Harris, Barbara. *Beyond Her Sphere: Women and the Professions in American History.* Westport, Conn.: Greenwood, 1978.

Hellerstein, Erna Olafson, Hume, Leslie Parker, and Offen, Karen M., eds. *Victorian Women: A Documentary Account of Women's Lives in Nineteenth-Century England, France, and the United States.* Stanford: Stanford University Press, 1981.

Helly, Dorothy O. "Women's Studies at Hunter College: Strategies in an Institutional Environment." *Women's Studies Quarterly* XI (1983):41–44.

Hogeland, Ronald W. "Coeducation of the Sexes at Oberlin: A Study of Social Ideas in Mid-Nineteenth Century America." *Journal of Social History* 6 (1972–1973):160–76.

Howard, Suzanne. *But We Will Persist: A Comparative Research Report on the Status of Women in Academe.* Washington, D.C.: American Association of University Women, 1978.

Ireson, Carol. "Girls' Socialization for Work." In *Women Working: Theories and Facts in Perspective,* edited by Ann H. Stromberg and Shirley Harkness. Palo Alto, Calif.: Mayfield, 1978.

Kaufman, Gloria. "Juan Luis Vives on the Education of Women." *Signs* 3 (1978):891–96.

Keohane, Nannerl O. " 'But for Her Sex. . . ':The Domestication of Sophie." *University of Ottawa Quarterly* 49 (1980):390–400.

Kerber, Linda. "Daughters of Columbia: Educating Women for the Republic, 1787–1805." In *The Hofstadter Aegis,* edited by Eric L. McKitrick and Stanley M. Elkins. New York: Knopf, 1974.

King, Margaret L. "Book-Lined Cells: Women and Humanism in the Early Italian Renaissance." In *Beyond Their Sex,* edited by Labalme. New York: New York University Press, 1980.

Kinnaird, Joan K. "Mary Astell and the Conservative Contribution to English Feminism." *Journal of British Studies* 19 (1979):53–75.

Lapidus, Gail W. "Changing Women's Roles in the USSR." In *Women in the World: A Comparative Study,* edited by Lynne B. Iglitzin and Ruth Ross. Santa Barbara, Calif.: Clio, 1976.

Lee, Vera. *The Reign of Women in Eighteenth-Century France.* Cambridge, Mass.: Schenckman, 1975.

Lerner, Gerda. *Black Women in White America: A Documentary History.* New York: Pantheon, 1972.

———. *The Female Experience: An American Documentary.* Indianapolis: Bobbs-Merrill, 1977.

Loewenberg, Bert James, and Bogin, Ruth, eds. *Black Women in Nineteenth-Century Life: Their Words, Their Thoughts, Their Feelings,* University Park: Pennsylvania State University Press, 1976.

Lougee, Carolyn C. "Modern European History." *Signs* 2 (1977):628–50.

———. *Le Paradis des Femmes: Women, Salons, and Social Stratification in Seventeenth-Century France.* Princeton: Princeton University Press, 1976.

Mahl, Mary R., and Koon, Helene, eds. *The Female Spectator: English Women Writers Before 1800.* Bloomington: Indiana University Press and Old Westbury: Feminist Press, 1977.

National Research Council. *Science, Engineering, and Humanities Doctorates in the United States: 1979 Profile.* Washington, D.C.: National Academy of Science, Commission on Human Resources, 1980.

Newcomer, Mabel. *A Century of Higher Education for American Women.* New York: Harper, 1959.

Oates, Mary J., and Williamson, Susan. "Women's Colleges and Women Achievers." *Signs* 3 (1978):795–806.

Office of Civil Rights. *Data on Earned Degrees Conferred by Institution of Higher*

Education, By Race, Ethnicity and Sex, Academic Year 1978–1979. Volume I. Washington, D.C.: Government Printing Office, 1981.

Osen, Lynne M. *Women in Mathematics.* Cambridge, Mass.: MIT Press, 1974.

Patterson, Michelle, and Sells, Lucy. "Women Dropouts from Higher Education." In *Academic Women on the Move,* edited by Alice S. Rossi and Ann Calderwood, eds. New York: Russell Sage Foundation, 1973.

Pizan, Christine de. *The Book of the City of Ladies.* 1405. Translated by Earl Jeffrey Richards. New York: Persea, 1982.

Pomeroy, Sarah. *Goddesses, Whores, Wives, and Slaves: Women in Classical Antiquity.* New York: Schocken, 1975.

———. "Technicai Kai Mousikai: The Education of Women in the Fourth Century and in the Hellenistic Period." *American Journal of Ancient History* 2 (1977):51–68.

Roby, Pamela. "Institutional Barriers to Women Students in Higher Education." In Rossi and Calderwood, eds., *Academic Women on the Move.* New York: Russell Sage, 1973.

Ross, Ruth. "Tradition and the Role of Women in Great Britain." In Iglitzin and Ross, eds., *Women in the World.* Santa Barbara, Calif.: Clio, 1976.

Rousmaniere, John P. "Cultural Hybrid in the Slums: The College Woman and the Settlement House, 1889–1894." *American Quarterly* 22 (1970):45–66.

Rousseau, Jean-Jacques. *Émile.* Translated by Barbara Foxley. New York: Dutton, 1974.

Sadker, Myra Pollack, and Sadker, David Miller. "Sexism in Teacher Education Texts." *Harvard Educational Review* 50 (1980:36–46).

Sapiro, Virginia. "Feminist Studies and the Discipline: A Study of Mary Wollstonecraft." *University of Michigan Papers in Women's Studies* 1 (1974):178–200.

Schwartz, Pepper, and Lever, Janet. "Women in the Male World of Higher Education." In Rossi and Calderwood, eds., *Academic Women on the Move.* New York: Russell Sage, 1973.

Scott, Anne Firor. "The Ever-Widening Circle: The Diffusion of Feminist Values from the Troy Female Seminary, 1822–1872." *History of Education Quarterly* 19 (1979):3–26.

Springer, Beverly. "Yugoslav Women." In Iglitzin and Ross, eds., *Women in the World.* Santa Barbara, Calif.: Clio, 1976.

Stock, Phyllis. *Better than Rubies: A History of Women's Education.* New York: Putnam, 1978.

Tidball, M. Elizabeth. "Perspective on Academic Women and Affirmative Action." *Educational Record* 54 (1973): 130–35.

———. "Women's Colleges and Women Achievers Revisited." *Signs* 5 (1980):504–17.

———, and Kistiakowsky, Vera. "Baccalaureate Origins of American Scientists and Scholars." *Science* 193 (August 20, 1976):646–52.

Tobias, Sheila. "Women's Studies: Its Origins, Its Organization and Its Prospects." *Women's Studies International Quarterly* 1 (1978):85–97.

U'Ren, Marjorie B. "The Image of Women in Textbooks." In *Women in Sexist Society: Studies in Power and Powerlessness,* edited by Vivian Gornick and Barbara K. Moran. New York: New American Library, 1971.

U.S. Department of Commerce. *Historical Statistics of the United States: Colonial Times to 1970.* Washington, D.C.: U.S. Government Printing Office, 1975.

U.S. Department of Education. National Center for Education Statistics. *Digest of Education Statistics*. Washington, D.C.: U.S. Printing Office, 1982.

U.S. Department of Labor. *Employment and Earnings: June 1982*. Bureau of Labor Statistics, Press Release, July 1, 1982.

————. *Employment and Earnings: March 1982*. Bureau of Labor Statistics. Press Release, April 1, 1982.

Van Allen, Judith. "African Women." In *Women in the World*, edited by Iglitzin and Ross. Santa Barbara, Calif.: Clio, 1976.

Walsh, Mary Roth. *"Doctors Wanted: No Women Need Apply:" Sexual Barriers in the Medical Profession, 1835–1975*. New Haven: Yale University Press, 1977.

————. "The Rediscovery of the Need for a Feminist Medical Education." *Harvard Educational Review* 49 (1979):447–66.

Wein, Roberta. "Women's Colleges and Domesticity, 1875–1918." *History of Education Quarterly* 14 (1974):31–47.

Westkott, Marcia. "Feminist Criticism of the Social Sciences." *Harvard Educational Review* 49 (1979):422–30.

Women on Words and Images. "Look Jane Look. See Sex Stereotypes." In *And Jill Came Tumbling After*, edited by Stacey et al., New York: Dell, 1974.

Women's Studies Newsletter 8 (1980):19–26.

Woody, Thomas. *A History of Women's Education in the United States*. 1929. 2 volumes. Reprint. New York: Octagon, 1966.

Woolf, Virginia. *A Room of One's Own*. 1929. New York: Harcourt, Brace, 1957.

12

Women and Health

HISTORICAL BACKGROUND
Views on Women's Health
Interaction between Women and the Medical Profession

BODY IMAGE—EXTERNAL PERCEPTIONS
Breasts
Body Size and Nutrition
Aging

BODY IMAGE—INTERNAL PERCEPTIONS
Common Menstrual Abnormalities
Menopause
The DES Dilemma
Infertility
Hysterectomy

PREGNANCY, CHILDBIRTH, AND CONTRACEPTION
Pregnancy and Childbirth
The Medicalization of Childbirth
Teenage Pregnancies
Contraception
Sterilization
Abortion

SEXUALLY RELATED HEALTH PROBLEMS
Female Sexuality
Sexually Transmitted Diseases

MENTAL HEALTH AND WOMEN
Women in the Mental Health System
Women and Substance Dependence
Women and Assault and Battery
Rape

WOMEN AS PROVIDERS IN THE HEALTH CARE SYSTEM
Nurses
Midwives
Women Physicians

APPROACHES TO THE HEALTH CARE OF WOMEN

The mind and body have often been discussed as mutually exclusive parts of the same organism. Similarly, the question of health has been separated from other aspects of living. In fact, there is no way to separate issues of women's health from the total social experience of women. For the purposes of this chapter, we will isolate health issues to learn what they are, but we also attempt to show how they interact with other aspects of women's lives.

Historical Background

Views on Women's Health

One of the earliest writers on the subject of the health of women was Soranus of Ephesus (28–138 A.D.), in whose work the topics of obstetrics and gynecology are treated as but one aspect of that health. Soranus declared that women and men had the same physical and health problems with the sole exception of the areas of reproduction (Marieskind, 1980). A more misogynist view was taken by Galen (c. 130–200 A.D.), a physician whose writings influenced Western medicine for centuries thereafter. He taught that women were "inside-out men." According to Galen, women have insufficient body heat to force our genitals outward. Thus, using man as his measure, Galen viewed women (as Aristotle had) as "defective" persons. Since women were thus "inferior," it followed that our diseases were caused, almost entirely, by our inferior genitalia (Marieskind, 1980).

As we saw in chapter 4, Freud, writing early in this century, reinforced this notion of female inferiority by his emphasis on "penis envy." Freud postulated that women could never be truly "healthy" emotionally until we accepted our defective structure, with its implications for our inferior abilities and social roles. Illnesses such as hysteria and "melancholia" in women were thought to be caused by our failure to accept our inferior status and by our continuing desire to "be men" (Freud, 1927).

Michel Foucault, a contemporary French psychologist and philosopher, has written about the "hysterization of women's bodies," which he says began to take place during the eighteenth and nineteenth centuries. As the Industrial Revolution began to change the structure of Western society, women were placed in an illogical, dichotomous position. While women's bodies continued to be considered pathologic, women were considered the moral guardians of society responsible for the bearing and raising of children. The positive cultural image of "mother" was allied to the negative image of the "nervous woman" (Foucault, 1980:104). During the nineteenth century, medicine became an organized profession controlled by men, many of whom built their

medical fame on their ability to control women and women's bodies (Barker-Benfield, 1976). In the United States, the medical profession developed surgical solutions—the clitoridectomy, ovariectomy, and hysterectomy—to "cure" hysteria, insanity, and masturbation. The diagnosis of such "disorders" might be based on "symptoms" that included participation in women's agitation for the vote or for greater opportunities for education (Marieskind, 1980).

By the 1920s, in many Western countries, obstetrics and gynecology, dominated by men, had replaced the profession of midwifery, dominated by women. After a long struggle, the medical profession had succeeded in imbuing midwifery with the image of dirtiness and incompetence (Brack, 1979; Donnison, 1977; and Versluysen, 1981), a campaign which gained credibility from the cultural notion that women's expertise was intrinsically inferior to that of men.

While women's bodies were subjected to medical control in the belief that all our disorders of mind and body were ultimately caused by our delicate reproductive capacity and defective physical makeup, our bodies were also confined to asylums on the grounds that we had lost our reason. Foucault (1973) has pointed out that the only criterion necessary for committing a woman to an asylum for the insane in Europe in the eighteenth and nineteenth centuries was a legal order obtained by a father or husband. The grounds for commitment might be any kind of "disorderly" behavior: vagrancy, slovenliness, flirtatiousness, or disobedience. In seventeenth-century France, special rooms were set aside in asylums for prostitutes, unmarried pregnant women, and poor women deemed disorderly. By the end of the nineteenth century, the larger number of persons described as "mad," by both physicians and novelists, were women (Chesler, 1972) (box 12.1).

What critiques like those of Foucault and Chesler help us understand is that madness or insanity is in fact culturally defined. The label may be used to indicate persons whose behavior radically departs from what is socially prescribed. Depression, sexual "frigidity," suicidal tendencies, or "promiscuous" behavior on the part of women have therefore been deemed at various times as "symptoms" to justify institutionalizing women (ibid.).

Bodies and minds do not exist separate from each other or from the culture in which they exist. It has been argued that "culture" may be defined as a long-standing set of habits which have "worked" for some people for some of the time. Thomas Szasz has used such a definition, identifying cultural conflicts not as conflicts between absolutes of right and wrong, but as struggles between people who have power and try to use it to oppress others and their victims, who are trying to break free. If the power wielders can make those who are oppressed *believe* in their own inferiority and their need to be controlled, the oppression can continue (Rosner, 1972). It is possible to view what has happened to women and our health for centuries in such terms.

Women and Madness **Box 12.1**

Women are impaled on the cross of self-sacrifice. Unlike men, they are categorically denied the experience of cultural supremacy, humanity, and renewal based on their sexual identity—and on the blood sacrifice, in some way, of a member of the opposite sex. In different ways, some women are driven mad by this fact. Such madness is essentially an intense experience of female biological, sexual, and cultural castration, and a doomed search for potency. The search often involves "delusions" or displays of physical aggression, grandeur, sexuality, and emotionality—all traits which would probably be more acceptable in female-dominated cultures. Such traits in women are feared and punished in patriarchal mental asylums. . . .

Neither genuinely mad women, nor women who are hospitalized for conditioned female behavior, are powerful revolutionaries. Their insights and behavior are as debilitating (for social reasons) as they are profound. Such women act alone, according to rules that make no "sense" and are contrary to those of our culture. Their behavior is "mad" because it represents a socially powerless individual's attempt to unite body and feeling. . . .

What we consider "madness," whether it appears in women or in men, is either the acting out of the devalued female role or the total or partial rejection of one's sex-role stereotype. (Chesler, 1972:31,56)

Interaction between Women and the Medical Profession

Women have been encouraged to perpetuate the myth of female frailty—in some measure depending on rank in society—in order to receive rewards from men for good behavior. Men have tended to be indulgent to women who have behaved in that culturally approved manner, withdrawing support from those of us who have appeared too strong or self-sufficient. Thus, femininity has been equated culturally with weakness (Corea, 1979). Weakness in turn has been equated with illness; and taken to its logical extreme, at times, ill health was deemed the characteristic of true women. "Good health is a sure indication of want of refinement," wrote O. S. Fowler, a popular health activist in the United States in the 1840s (ibid.:15).

Since the definition of women as fragile—all too often equated with bad health, real or imagined—made it seem desirable to be ill, some upper-class women cultivated "illness." Poor health could be used as a weapon in sexual politics, whether it meant an "inability" to take care of children and homes or became the only acceptable excuse to avoid intercourse (Corea, 1979). Invalidism has even been used by women to run our lives as we wished. This kind of "creative malady" was used by Florence Nightingale after a triumphant return from reforming the British field hospitals in the Crimean War in the 1850s. She took to her bed as a "sick woman," saw only those she

wished, and carried out the work she set for herself, promoting the nursing profession and the improvement of military sanitation (Pickering, 1974).

For a long time, female sexuality itself was seen as a symptom of illness; it was called "nymphomania," "ovariomania," or "uterine madness" by various physicians of the late nineteenth century. Although women were supposed to conceive, bear, and raise children, our sexuality was negated. Birth control, which would have made possible the expression of sexuality without fear of pregnancy, was opposed by the medical profession in the United States as immoral. Margaret Sanger (1879–1966), a leading advocate of sex education and birth control for women early in this century, was arrested for her part in disseminating such information.

To the present day, male physicians have the power to define the nature of women's physical condition. The menstrual cycle, pregnancy, and menopause tend to be viewed as "unhealthy" conditions, making women unreliable for holding responsible positions. While pregnancy is seen as a step toward maturity for "an emotionally healthy married woman," it is not considered a fit condition for someone who wants to earn a living. Insurance companies, while paying total benefits to male workers for sex-specific illnesses (prostate disabilities, for instance), often pay no, or only partial, benefits to female workers for sex-specific disabilities, especially if the condition relates to our reproductive systems.

As we reach our menopausal years, we are again denigrated. In his book *Feminine Forever* (1966), Dr. Robert A. Wilson described a menopausal woman as going through the "death of womanhood," as having a "serious, painful and often crippling disease," and as "castrated" (Corea, 1979). The question of how these and similar myths are perpetuated, *and accepted* by many women, needs to be examined (Grossman and Bart, 1979).

We find that the medical system in general in the United States is based not on a health model, but on a disease model dominated by doctors and hospitals. This control is determined by the economics of the system. More money is involved in the effort to cure diseases than is involved in the maintenance of health as a system, which does not produce large medical fees. The illness model used in this country centers on the notion of a private relationship between patients and physicians, with fees for services rendered as the underlying structure (Boston Women's Health Book Collective, 1973).

The World Health Organization defines health as "a state of complete physical, mental, and social well-being, and not merely the absence of disease and infirmity." The medical system in the United States has maintained itself in the past by denying women adequate access to health-promoting education, along with birth control information and supplies, and by denigrating the issue of women's health. This system has not radically changed, particularly for women who are poor (and black or members of other minority groups), although affluent women too are often treated by the system as

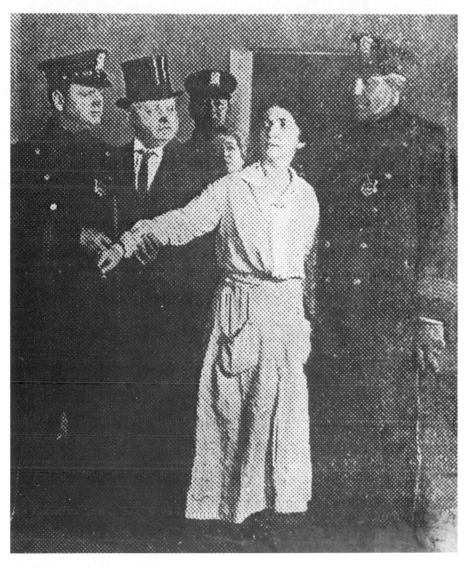

In 1916, Margaret Sanger opened a clinic in Brooklyn, New York, to provide birth control information. In consequence, she was arrested for "maintaining a public nuisance" and accordingly sentenced to thirty days in a workhouse. Five years later, undaunted by such setbacks, she founded the American Birth Control League. (The Sophia Smith Collection [Women's History Archive] Smith College, Northampton, MA 01063)

children who cannot be considered responsible for our own lives and bodies (Boston Women's Health Book Collective, 1973).

The image of physicians as the guardians of mysteries lay people cannot know also helps to perpetuate the medical system. The awe-inspiring machinery, the medical jargon, even the white coats tend to reinforce feelings of inferiority in the women who make up the bulk of patients (Boston Women's Health Collective, 1973; Marieskind, 1980). The image of the physician as protective, authoritative, helping, and informed is inculcated into everyone in Western society. It is socially expected behavior for women to be passive, accepting, and childlike in many areas, but this is especially true in connection with our medical relationships.

Psychological factors also help to perpetuate the dependency relationship which is encouraged between women and physicians. Most of us have been socialized to depend on the opinion of authorities or experts and to *want* to be told what to do. Illness also reduces people to a position of physical dependency which encourages them to regress to more childlike states. During such a time, the physician is *expected* to be onmipotent (Notman and Nadelson, 1978). Barriers to communication and lack of mutual respect are often the outcomes of such a relationship. While many (even most) physicians prefer the omnipotent role, those who do not may still have to deal with overly compliant patients. Such patients reject taking an active part in medical decisions— whether through ignorance or the desire to be "good patients" (socially defined as those who are passive to the point of outright submissiveness).

Since women have long been viewed as "weak" or "sick," it should not be surprising that today we make up a larger percentage of patients than do men. And because it is culturally expected that women will be sick, men's illnesses are usually treated as more "real" or "serious" than women's. On the one hand, men who become ill are sometimes accused of "acting like a woman," or they themselves complain of being "emasculated"; on the other hand, their illnesses are accorded greater status than is given those of women.

As greater numbers of women enter the medical profession, our impact may begin to be felt in the years ahead. In the meantime, more education is needed *outside* the hierarchy of the medical profession to assist women in reaching a sense of security about asking and receiving information and taking personal responsibility for our own health (box 12.2). Women also need to learn to expect better health care from the traditional providers.

Body Image—External Perceptions

Body image is a concept which refers to the perceptions we have of our bodies, both internally and externally. It encompasses the positive or negative feelings we may have about our bodies as well as the feelings we may have

about the way they function. Those aspects generally thought of as external are: breast size; size of body generally, including fatness or thinness; and youth, beauty, and aging.

Breasts

In our culture, breasts have long been associated with sexual attractiveness. From adolescence on, women are concerned with the size of our breasts. Are they too small? Too large? Are they shaped properly? Since breast development occurs at puberty, breasts are also a symbol of a sexually mature woman. The cultural emphasis on the size and shape of women's breasts has created a demand for altering or preserving the shape for cosmetic purposes.

Reconstructive cosmetic surgery (plastic surgery) has grown in popularity for both women and men, but so far social pressures have made women the major consumers. Because cosmetic surgery is expensive and is generally not covered by insurance plans or government aid, it is a choice made by those who can afford it. Cosmetic surgery is seen as a way of remaining "competitive" in the power games of sex and marriage. The most frequently sought changes are face lifts (tightening the facial and neck skin) and increasing or diminishing the size and shape of the breasts. Breast size can be increased by implanting silicone under breast folds, while reduction occurs by removing excessive tissue.

Dissatisfaction with our body structure may be based on our perception of our sexuality, which is very much affected by social norms related to our partners' expectations. Women alter body structure for sexual purposes in many cultures. As we noted in chapter 1, cultural symbolism of femininity leads us to elongate our ears with ear plugs, our lips with lip plugs, and our necks by adding ever more neck rings, or we keep feet tiny by binding them (Waters and Denmark, 1974).

Coupled with the emphasis on female breasts as the symbol of femininity in contemporary culture is the fact that breast cancer is the leading cause of death for women between the ages of forty and forty-four (Kahan and Gaskill, 1978). It is estimated that one in fifteen American women will contract breast cancer (American Cancer Society, 1977). If left untreated, cancer leads to death. Until recently, many women faced the choice between loss of breast or loss of life, and radical surgery, in which large amounts of surrounding tissue in addition to the cancerous lesion was removed, was seen as the only solution. Women felt mutilated, and the surgery often did not cure the disease.

In recent years, in the wake of wider publicity about breast cancer generated by such public figures as Betty Ford (wife of President Gerald Ford) and "Happy" Rockefeller (wife of the late New York governor), less extreme methods of treatment have been attempted—radiation therapy, lumpectomy, and simple mastectomy (removal of the breast without removal of the surrounding muscle tissue). Only recently, too, have the feelings of the women

Guidelines for the Woman Who Is Going Box 12.2
to See Her Health Care Practitioner

These suggestions for what to consider before, during, and after going to a clinician are written for women who share the following assumptions.

> — It is healthy to be skeptical of our medical system.
> — It is healthy to know about ourselves.
> — It is healthy to make our own decisions about what we do with our bodies.

1. Before going:
 A. Figure out what you want specifically. Ask yourself what you'll be content to get out of this visit:
 — a specific medication or lab test?
 — reassurance that it's not serious?
 — to know what it is?
 — validation of your present self-treatment?
 — eradication of a specific symptom?
 B. Make a list of the things you've already done for this problem: first aid, over-the-counter medication, rest, diet.
 C. Give the dates of previous such episodes. What was the diagnosis and treatment given? How did the treatment work? How is this time different?
 D. What important events have just happened or are coming up soon in your life?
 E. List all the medications you are taking.
 F. Figure out the date of your last menstrual period.
 G. Make a list of what you think could possibly be wrong. Which do you consider most likely? Which scares you the most?
 H. Why do you think this happened just now?

2. In the office:
 Take your answers to A. through H. [above], a pad, and a pencil. If you're very nervous, a friend or a tape recorder might help.
 In a well-taken medical history, your concerns should come up. If they don't, you may be able to sneak them in. "Do you think ——— might have anything to do with this?" "You know, I just got back from Mexico." "My sister told me she has the same thing, and her doctor said ———."
 A. When you're given a diagnosis, ask the following:
 — What are all the names for this condition?
 — Are you absolutely sure that's what I have? If not, what else might it be? What's the worst it could be?
 — How did I get it? Is it contagious or hereditary?
 — Do you see a lot of this? Is it rare or common?
 — Is this something that will come back, or never quite get better?
 — Is there anything I could have done to prevent it, or to save myself the office visit?
 — Where can I read more about this?
 — How long will it take to get better or go away? When should I decide it's not getting better fast enough?
 — How will this interfere with my work and the things I like to do?
 B. If given a medication, ask the following:

— Is this optional? What would happen if I don't take it, or if I stop taking it when I feel better?

— Are there ways to speed recovery without medication?

— How can this medication kill me?

— What will I feel when I take this? Will it interfere with my activities?

— What will I feel if I'm getting a serious side effect?

— Is this the cheapest brand?

— (When the problem is recurrent) If I get this again, can I refill the prescription without seeing you?

C. If given a return appointment, ask the following:

— What is the followup visit for?

— What is the reason for its timing? (Why three days, not three months?)

— Could I just call you instead of coming in?

— Should I come back even if I'm feeling fine?

3. When you get home:

A. Think about your practitioner.

— How did you feel in the clinician's company?

— Was it difficult to say what you were concerned about?

— Do you believe what you were told? To double check information, consider getting a second opinion from another practitioner, or a friend in health care, going to the library, asking the pharmacist about any drugs which were prescribed, or looking in the phone book for such groups as the Arthritis Foundation or Alcoholics Anonymous.

B. Think about being a woman:

— How were you treated differently from a man with the same complaint?

— If you saw a man clinician, do you think a woman would have treated you differently? Why?

— Could this problem actually be part of every woman's development, and not a disease? If so, what are other women doing about it or for it?

C. Evaluate your health knowledge:

— How did your diagnosis and self-care compare to what you were told in the office? If they were different, why?

— What key information did they have that you didn't have or overlooked? If they coincided, was the visit a waste of time, or did you get something else out of it?

D. Other things to think about:

— How much did it all cost?

— Is there anything occupational or environmental about this problem?

— Is the diagnosis a "label" that will make people treat you differently? If so, how will you handle that?

— If you liked this approach to health care, how can you "spread it around"? What about women who can't read this handout, or those who have no choice of which practitioner they will see? (Martin, 1982).

involved been examined. Betty Rollin wrote a sensitive book, *First You Cry* (1976), about her experience with mastectomy. But the norm is still to keep discussion of the topic to a minimum.

Women are not educated to recognize what normal breasts feel like (they are often lumpy), to know what fibrocystic disease is (a nonmalignant condition characterized by movable masses which may get larger toward the beginning of a menstrual period), and to detect actual breast cancer (which is usually a hard, nonmovable lump). Booklets are now available which discuss in simple terms what normal breasts are like, what questions women have concerning them, what conditions are abnormal, and what treatments exist for both cancerous and noncancerous conditions (American Cancer Society, 1977).

Since men have typically been the medical health providers in American society, women have often hesitated about asking for information about what constitutes normal and abnormal conditions. We have too often been reluctant to *touch* our own breasts to examine them, a reluctance that seems to have been reinforced by male notions of what is correct behavior for women. Recent research, stimulated in part by women, has broadened the possible treatment approaches to breast cancer. But physicians may not always offer women the option of an active role. They may still ask us to consent to a radical mastectomy prior to a confirmed diagnosis of cancer. During a period of stress, such as that which accompanies fear of breast cancer, women may simply allow physicians to make the medical choices for us. Physicians who do not want women to control our own bodies will not emphasize the choices available. Many physicians will mention options as a formal gesture to avoid later lawsuits, but their manner will still discourage a woman's participation in the decision-making process.

Body Size and Nutrition

Body size is affected by genetic makeup and nutrition, but our *perceptions* of our bodies are very often governed by the culture. Most present-day media images of women are of slender people. If we do not fit this image, we may feel ugly and undesirable. Since women are often in control of both family food purchasing and meal-planning as well as our personal food intake, we are also the direct targets of media promotions. It has been found that it is women who are most likely to succumb to fad diets, unneeded vitamins, and useless food supplements (Neumann, 1979).

Obesity is a widespread problem in the industrially developed world for both women and men, but it is more prevalent among women. Fatness is also generally denigrated more in women than in men. Food is a means of social exchange. Women who want to feel liked, who want to feel that we are "doing the right thing," will serve families and friends foods that are cur-

rently being promoted as desirable. Often these foods are high in calories and low in nutrition (Orbach, 1978).

A serious condition related to nutrition and body size is *anorexia nervosa.* Adolescent girls are its most likely victims. Often young women who feel "fat" will begin a diet. This diet then becomes an obsession until we refuse to eat at all and will vomit if force-fed. Anorexia victims see ourselves as fat even though we are emaciated. The condition is affected by cultural beliefs that "thin is beautiful." It sometimes ends in death.

In those areas of the world where there is a shortage of food, women suffer more from malnutrition than do men. The male head of household is usually served, along with other adult males, the best portions and greater amount of the food available, particularly the protein-rich foods, which build tissue. Children are usually served next, and any adult females come last. This custom is widespread and occurs even though it is women who menstruate and become pregnant, conditions which require additional iron and protein for tissue synthesis. Women are taught that it is right to put ourselves last, even though such behavior may compromise our health (Steinem, 1980).

Aging

The maturational process, or aging, affects all human beings. Women in modern technological societies live longer than do men. Many hypotheses exist to explain this phenomenon, but no one theory totally and systematically explains why women, if they have proper nutrition, outlive men. One commonly held assumption has been that because women "stayed at home," we had fewer stress-related problems. The stay-at-home woman, however, was never measured for stress levels. Now that a majority of women in the United States are in the work force, there is more investigation of women's stress levels, especially in light of the fact that women are frequently responsible for two jobs—employed worker and housekeeper (Haynes and Feinlieb, 1980). What stress research will reveal, if anything, about women's longevity remains an open question.

In the United States, heart disease is the leading cause of death in both women and men. Before menopause, women experience fewer cardiovascular problems than men. After menopause, the relative risk rate accelerates and approaches that of men. This is thought to occur because of the decrease in estrogen, which is believed to help prevent the condition in women. Synthetic estrogen does not seem to be as effective as the normally produced hormone in preventing cardiovascular disease.

Aging in modern Western society has primarily negative connotations. Loss of self-esteem frequently accompanies the process of decreasing physical power and increasing social isolation (Cummings, 1975). The events of aging are usually unwelcome in our youth-oriented culture. A great deal of anxiety

is often generated about sexuality as aging progresses. It is a myth in our culture that older people lose their sexuality—that they are neither sexually attractive nor sexually interested. Older people today, especially older women, are giving us a truer view.

More women than in the past report today that we are enjoying growing older and changing our social roles. More women have entered new careers in mid life as opportunities have expanded. Older women feel freer to do as we please than we did when home and family were our primary responsibilities. However, the image of the pitiful, powerless old woman continues as a foil to our culture's emphasis on the desirability of youth and beauty.

Body Image—Internal Perceptions

Body image perception is affected by our internal structures and the ways our bodies function as well as by our external forms. Women are not aware of our uteri in an observable sense, but we are very aware of having them because of the monthly menstrual cycle (see chapter 3). Menstruation is the process most commonly associated with health care issues in women. A survey of middle-class adolescents only a few years ago found that many of the taboos and myths of the past continued to be influential (Whisnant and Zegans, 1975). One myth commonly held at least since Victorian times is that menstruation is an illness causing women on a monthly basis to behave in a sick and irresponsible manner (see chapter 11).

Common Menstrual Abnormalities

Some women do experience painful menstruation, or *dysmenorrhea.* There are many possible causes of menstrual pain. For example, structural abnormalities and/or high levels of natural chemical substances in the body may be possible sources of such discomfort. There are two types of dysmenorrhea: *spasmodic,* involving cramplike pains in the abdominal region; and *congestive,* a bloated feeling in the breasts, abdomen, hands, and face. Medical research has begun to test various ways to control or diminish the strength of these symptoms. It has been learned that, on the whole, women who remain active and continue everyday activities during menstruation fare best; only when (or if) the discomfort actually prevents such activities are women now advised to discontinue them.

Another condition which many women have experienced is called *endometriosis.* This condition occurs when the lining of the uterus also builds up in areas other than the uterus, such as in the fallopian tubes, the ovaries, or other internal organs. When the normal hormonal shifts accompanying menstruation occur and the top layer of the lining is shed in the uterus, the lining is shed from those other organs as well, causing pain. In addition, the tissue in these other organs may scar and block the fallopian tube(s) partially or

Kathe Kollwitz (1867–1945) lived in Germany. She is known for her stark black and white drawings of the victims of hunger and war. This self-portrait (1934), one of over a hundred made through her life, catches the beauty and strength in the face of a woman as she ages. (Los Angeles County Museum of Art, Los Angeles County Funds)

completely. Treatment for endometriosis has included the use of oral contraceptives to prevent the normal hormonal shifts and allow the tissue to heal, and at times surgery has been used to remove scar tissue. Occasionally, pregnancy corrects endometriosis, but often the condition may prevent fertilization of the ova in the fallopian tube. Endometriosis is not a malignant disease; rather it is an abnormality of growth of the lining of the uterus and can usually be corrected.

Adolescents may experience *primary amenorrhea,* the failure of menstruation *ever* to occur. This diagnosis is not usually made until after a young woman is sixteen to eighteen years old. Another form of amenorrhea is called *secondary amenorrhea,* the failure to menstruate for several months after a regular cycle has been established. The causes of this difficulty may be genetic or may arise from structural abnormalities or endocrine difficulties, as well as from chronic disease and emotional stress. Throughout a woman's approximately forty-year menstrual phase, variations in regularity, amount of bleeding, and length of a menstrual period may occur for any of these reasons.

Menopause
Generally, women in their late forties begin to notice changes in the amount and regularity of the menses. Usually the changes are gradual, until around fifty years of age menstruation ceases. Along with the cessation of menstruation are alterations in and a lessening of the amounts of estrogen and progesterone production. Some women experience various symptoms associated with changes in hormonal levels, such as hot flashes, dizziness, nervousness, fatigue, dryness of the vagina, itching, painful intercourse, and weight gain.

Menopause has traditionally been viewed as the great "illness" of the middle-aged woman, causing mental and physical degeneration. There are, in fact, physiological reactions to the cessation of estrogen and progesterone production, but many of the extreme responses attributed to menopause are culturally determined. In technologically underdeveloped nations, most women die early, often in childbirth; to reach menopause is an achievement. In such cultures, old age in women—as in men—is equated with success and wisdom.

Physicians have attempted to treat the symptoms of menopause with synthetic estrogen, but estrogen replacement therapy (ERT) is a source of controversy. Two studies (Smith, 1982; Ziel and Finkle, 1975) have suggested a strong link between use of synthetic estrogen and the development of endometrial cancer. It has also been suggested that there may be a link between ERT and breast cancer (Hoover et al., 1976). Although ERT has been effective in controlling the discomforts of menopause for some women, it does not prevent the development of arteriosclerosis (fatty deposits in the arteries which may lead to heart attack or stroke) and osteoporosis (the development of brittle, porous bones), two conditions associated with aging.

For many women, however, menopause represents a new freedom. Eighteen months after we cease to menstruate we can be sexually active without using contraceptives. Sexual intercourse after menopause can be facilitated, if necessary, by the use of vaginal lubricants. Remaining sexually active helps prevent shrinking of the vaginal tissue.

The DES Dilemma

The synthetic hormone diethylstilbestrol (DES) was developed during the 1940s to help maintain a potentially threatened pregnancy. Its use also prevents a fertilized egg from becoming implanted in the uterus when it is taken in a large dose as a "morning-after" contraceptive. However, in 1971, findings linked the ingestion of DES by pregnant women to the development of a rare type of cancer in our female offspring during adolescence (Herbst, Ulfelder, Poskanser, 1971). In 1975, the Federal Drug Administration (FDA) banned the use of the hormone during pregnancy; however, it is still used as a contraceptive following cases of rape.

Subsequent research has demonstrated that DES also exposes both female and male fetuses to a risk of abnormalities of the reproductive organs. Young women whose mothers were given DES need to be examined at puberty and frequently throughout life for development of this generally rare type of cancer. Moreover, menstrual irregularities are common, and infertility problems appear to be more frequent in DES-exposed females. DES-exposed male offspring often have structural problems with sex organs, such as small penises, undescended testes, and very few active sperm, which may create infertility difficulties.

Although there is now greater publicity about this problem, there was a long period between its discovery and the dissemination of information to the public. This experience has clearly demonstrated the need for women to be fully aware of the possible consequences of any medication prescribed for us for any condition. DES-exposed daughters and our mothers have experienced a great deal of rage and anxiety since these facts emerged. Mothers have expressed guilt about having caused potential damage to such children; daughters have expressed anger that this should have happened at all. Through the efforts of concerned women and the physicians who did the original research, a national reporting system and a publicly funded screening program have been established. During 1980, a legal action was decided in favor of a plaintiff who sued the pharmaceutical company for marketing DES without adequate research and follow-up after initial studies suggested a possible linkage to cancer.

Infertility

Infertility is a multifaceted problem. Traditionally, when women did not conceive, we were blamed. In most cultures, infertility provides the legal

grounds for a man to divorce his wife. This usually occurs without diagnostic tests, on the assumption that it must be the woman's fault. Infertility, however, may occur in either the woman or the man; and occasionally problems may appear in both partners. At times women may not ovulate, or we may ovulate sporadically. Men may have low sperm counts or other reproductive difficulties. In the United States, couples are increasingly aware that either partner may have a fertility problem, and many methods have been developed to help couples conceive. The alternatives, to adopt children or the decision to have none at all, become important considerations for women confronting infertility (see chapter 9).

Hysterectomy

Hysterectomy is one of the most common surgical procedures experienced by women. It involves removing the uterus and, at times, the ovaries and fallopian tubes as well. For women who have not yet experienced menopause, this surgical procedure ends menstruation. If the ovaries remain, they will continue to secrete estrogen and progesterone. If they are removed, an instant rather than a gradual withdrawal of these hormones occurs. Decisions to remove the ovaries should therefore be based primarily on how high a risk of developing cancer the woman faces. When benign growths such as fibroid tumors precipitate the hysterectomy, there is no need to remove the ovaries.

Too often, hysterectomies have been done without compelling health reasons. Certainly, cancer of the reproductive organs is a compelling reason, and other noncancerous conditions *may* warrant this procedure. But all too frequently physicians remove a uterus to aid "mental health," to correct a cystocele (relaxed bladder, due usually to multiple pregnancies), or because a woman has reached "the right age." Because women have too often accepted a passive, even helpless role and have viewed physicians as all-knowing and omnipotent, we have generally complied with a physician's recommendation for surgery without seeking a reliable second opinion.

A hysterectomy can be performed vaginally or abdominally. It takes about six weeks to recover from the surgery itself, but it may take a longer time for women to adjust to the loss of the uterus, depending on what it symbolized. For some women, a sense of gender identity is intimately related to this loss; these women may suffer postoperative depression. Other women welcome an end to menstruation and the risk of pregnancy.

Pregnancy, Childbirth, and Contraception

Pregnancy and Childbirth

In the past, pregnancy was one of the most common killers of women. As health care knowledge, practice, and technology have advanced, mortality and morbidity (sickness) have fallen, but pregnancy is still often considered a

pathological process rather than a *physiological* one (Anderson, 1977). The issues currently under debate revolve around the following questions: Who delivers the infant—the woman or the physician? Should the delivery take place at home, in a birthing room, or in a hospital delivery room? Should childbirth occur with or without the use of complicated mechanical monitoring devices? Will women and our families participate in the delivery, or will we be with strangers?

The Medicalization of Childbirth

In the last two centuries, pregnancy and childbirth became regimented and medicalized by the developing medical profession. Until recently, women were expected to remain as passive and compliant through the medically directed childbirth experience as in any other medical experience.

In the twentieth century, as we noted in chapter 8, notions about childbirth have undergone considerable change. The Lamaze method of prepared childbirth, which emphasizes active participation by both the mother and the father, has become increasingly popular. The training involved teaches both parents about the various stages of labor and delivery and makes use of relaxation techniques during the labor and delivery experiences. It is now believed that prepared childbirth results not only in less use of anesthesia but also in healthier babies and more confident parents.

Only twenty years ago, few physicians recommended the Lamaze method. Marjorie Karmel wrote a book called *Thank You, Dr. Lamaze* (1959) to describe her ordeal searching for a physician who would work with her in participant childbirth and a hospital that would allow her infant to "room in" with her during the hospital stay. Yet today these practices too have been taken over by the medical establishment. As participant childbirth, rooming-in, and breast-feeding have gained in popularity, so too has the attitude that "you *must* do it this way" to be an adequate woman. Some hospitals now refuse to allow a father to be present for his child's birth if he has not taken the Lamaze or some equivalent preparation.

The medicalization of Lamaze training again threatens to deprive women of independence in making decisions about our own lives. In her short story, "Still Life with Fruit," Doris Betts (1974) criticizes the standardization of these "new" techniques and discusses the unwillingness of the medical establishment to permit women to exercise a range of choices which would allow us to maintain control over our behavior.

Women are faced with a dilemma in our desire for control over our bodies. Becoming pregnant is a normal female body function, not a pathological process. Yet it *is* important for women to seek care during pregnancy. There *are* complications which arise, and help should be readily available when needed. Women have a vested interest in both our self-care and the care we receive from professionals. The quality of the care will affect both mothers

and infants. Conflict arises when, as all too often happens, women who want good professional care *and* to control our lives find the two incompatible.

An interesting example of this conflict is shown in the recently developed "do it yourself" pregnancy tests. These highly reliable tests enable women to diagnose our own pregnancies. Those who object to the test fear that women will not seek adequate care if we are able to test ourselves. More importantly, however, they understand that placing the *diagnosis* in the hands of women demystifies part of the process by which physicians earn their living—and deprives physicians of an opportunity to charge the patient for the diagnosis.

Many books and health education programs are available to assist women and our families to prepare for the process of childbirth and the special needs of pregnancy, such as diet, exercise, rest, and avoidance of X-rays and unnecessary medications. Yet technological advances sometimes force women to participate in a medicalized childbirth. For instance, many hospitals have invested in fetal monitoring devices. These undoubtedly prove necessary in some cases, but the greater number of deliveries are uneventful and do not need them. Yet women are often made to feel that we may jeopardize the life and future health of the fetus if we do not use this complicated, expensive machinery.

In addition to the increased use of fetal monitors, there has been an increase in the use of caesarean sections, a surgical procedure used when a woman's pelvis is too small to permit the passage of the fetus, the placenta is defective, or the umbilical cord or some other source of pressure threatens the fetus. Sometimes, however, the procedure appears to be done merely to allow attending physicians to "time" the delivery for their convenience.

The health of women and communities is often judged by the maternal mortality (death rate) and morbidity (illness rate). Economic class appears to have a significant effect on these statistics. Women who are poor are often not as healthy as more affluent women; we may lack knowledge about or the resources to obtain nutritional foods. The health care system itself is often not responsive to the needs of poorer women. Lower-cost clinics may be overcrowded and the time spent with poorer women as a result shorter; yet, poorer women may need more information and care to ensure healthy pregnancies.

Teenage Pregnancies
One out of every five births in the United States is to a teenage mother. Morbidity and mortality rates for pregnant adolescents—and our offspring—increase the lower our age. The physical and mental health of very young women who face motherhood is of critical concern as well as the health of our infants. The younger the teenage mother, the more likely that she has not developed sufficiently physically or emotionally to handle pregnancy well, or to take on the responsibilities of raising a child. For these reasons, informa-

tion on ways to prevent pregnancy, obtain abortions, and get adequate health care is of crucial importance to young women. Often it appears that young girls become pregnant in order to alter an unsatisfactory style of life. Unfortunately, research has shown that patterns of life are often repeated, and that pregnancy does not offer an escape from restrictive situations but actually increases preexisting problems (Vincent, 1961).

Contraception

Whether women should have control over our own reproductive capacities has long been a major political, social, and religious issue (Gordon, 1976). This question has affected the delivery and access to birth control information, research efforts to improve contraceptive technology, and acceptance of various methods by the public. Religious groups (dominated by men) that believe sexual intercourse should occur for procreation only usually object to any kind of contraceptive measures. They object particularly to what they call "nonnatural' methods which foster a climate of sex for pleasure. The underlying belief is that pregnancy should be the aim of married women and a punishment for sexual intercourse by unmarried women.

Most modern contraceptive methods have been designed for use by women. Table 12.1 shows the more common methods of contraception presently used. One study has suggested that the male role in birth control responsibilities is weak because men have not been pressured or even *encouraged* by society to take an active role in contraception. Although 75 percent of the adult men in one survey felt both partners should accept responsibility for contraception, it was found that "few [men] have attempted to accept responsibility. (*New York Times*, 1980). Meanwhile, women have been socialized to *expect* to carry the major responsibility for birth control, even though the use of many contraceptive devices by women involves greater risks for us than the use of contraceptive devices does for men.

Contraception has often been equated with "family planning," with an emphasis on the timing of births rather than their prevention. Access to birth control methods has been considered more acceptable for married women than for unmarried women. Teenage women in particular often encounter difficulties obtaining and using contraceptives, and the only age group in the United States that experienced an increase in the birth rate in the mid-1970s was the thirteen-to-fifteen year-old group.

Sterilization

Sterilization has been a paradoxical issue within women's health care. In the past, women who requested sterilization had to meet a set of arbitrary requirements determined by the legal and medical professions. We had to be a certain age, to have borne a certain number of children, and to have our

Table 12.1 Major Contraceptive Methods

Types	Effectiveness	Safety and Side Effects
Withdrawal Removal of the penis from the vagina prior to ejaculation.	Difficult to predict. Semen often escapes before ejaculation.	No untoward effects but anxiety may decrease sexual pleasure.
Rhythm The restriction of sexual intercourse to periods when the woman is not ovulating.	Difficult to predict ovulation accurately. Low effectiveness rate unless sexual activity is greatly curtailed.	May decrease sexual pleasure.
Chemical Methods Spermicidal foams, creams, jellies, vaginal suppositories.	Used alone, 60 percent effective. If used with barrier methods, effectiveness percentage increases.	Occasional allergic reaction.
Barriers 1. *Condom.* A sheath rolled on erect penis and held in place on withdrawal when detumescence of penis has occurred.	If used with spermicidal chemicals and at each intercourse, 90 percent effective.	No deleterious effect.
2. *Diaphragm.* A round rubber device which is placed in the vagina to prevent the passage of sperm into the uterus.	If used with spermicidal cream or jelly and used at *every* intercourse, this method is considered 95 percent effective. Requires a fitting.	No known deleterious effects.
Intrauterine Devices A variety of inert plastic devices which fit into the uterine cavity. They create an environment non conducive to the maintenance of pregnancy.	These are considered 95 percent effective. Require a pelvic examination and insertion. They may be spontaneously expelled; therefore, a woman needs to check the strings in vaginal canal.	*Major discomforts:* Cramping, heavy bleeding. *Major untoward effects:* Infections, perforation of the uterus.
Oral Agents Primarily combinations of synthetic estrogen and progesterone; some agents are only progesterone. Given on a 21-day or 28-day cycle. Prescribed for a particular woman; pills should	If taken accurately and daily, they are 98 percent effective. Contraindicated in women with history of high blood pressure, cancer, diabetes, clotting difficulties, or migraines.	*Major discomforts:* Bloated feeling, fragile emotions, nausea, tender breasts, skin eruptions, migraines. *Major untoward effects:* Clotting problems, de-

Experimental Methods

Method		
Female and male devices implanted in the tubes where the gametes pass to control their flow.	So far these devices have been reasonably effective.	Long-term effects unknown.

Sterilization Methods

Method		
1. *Vasectomy.* The cutting and severing of the vas deferens to prevent the passage of sperm.	After the stored sperm have passed from a man's body (6 weeks after the procedure, this method is considered 100 percent effective.	Minor surgical risks. Has been questionable associated with auto-immune reaction. Possible negative emotional response.
2. *Tubal Ligation.* The cutting and severing of the fallopian tubes to prevent the sperm from reaching the ovum or the ovum from reaching the sperm.	This method is considered 100 percent effective. There are several methods for performing the surgery.	Generally minor surgical risks, but a more complicated surgical procedure than a vasectomy.

Abortion

Method		
1. *Suction Method.* Removes uterine contents by the use of a suction machine.	Interrupts a pregnancy.	Used most commonly for pregnancies of under 12 weeks gestation. Now being recommended (dilation and evacuation) for use until about the 18th week of gestation. Low complication rate.
2. *Saline Method* ("Salting out"). Encourages the uterus to contract by altering the internal environment. Uterus expels the product of conception.		Used in the middle of the second trimester of pregnancy (16–20–24 weeks). Complications rate increases with length of the gestation.

Prostaglandins

Method		
Fatty acid substance which causes uterus to contract and expel the products of conception.		May be used in first 12 weeks, but used most commonly in the second 12 weeks. Unpleasant side effects frequently associated with method.

12.4–12.7

459

husbands' permission. This was not the case for men. On the other hand, various state legislatures have discussed laws to require that women on public assistance who had more than one illegitimate child be sterilized by the state.

It was revealed in the 1970s that some young black girls had been sterilized, apparently with the permission of their mothers. But once the information became public, it became clear that neither mothers nor daughters had understood the permanent nature of the surgery. Both racist and sexist attitudes are involved when poor, minority women are subjected to sterilization, while affluent white women are equally subject to control by having desired sterilization withheld.

Abortion

Abortion is a highly controversial issue. Many feminists consider it the single most important issue of the twentieth century. Health care providers have varied widely in their attitudes about abortion (Smith, 1982). In the past, it has often been physicians alone who have had the power to make the decision, which meant exploring and judging the events surrounding a woman's pregnancy. Because abortion was illegal, except in very rare circumstances, women without life-threatening illnesses often had to claim we were "suicidal" or "losing our minds" in order for the medical establishment to grant an abortion. All too often, women could only get abortions in the illegal marketplace, or by self-inducing the abortion process, both of which were dangerous and degrading.

The legalization of abortion in the United States in 1973 created a climate of choice for women. In its landmark decision, *Roe* v. *Wade* (1973), the Supreme Court decided that a woman (in consultation with her "attending physician,") should finally be in control of requesting the termination of a pregnancy. For many women, legalization reduced the guilt, shame, and stigma previously attached to the act.

Ambivalence in the decision to have an abortion is not uncommon. However, after an abortion, most women respond with relief and report feeling little guilt or depression. Women who appear to be extremely ambivalent about the decision to have an abortion have often been raised in traditional religious and family circumstances that have clearly disapproved of abortion. Women who feel ambivalent to begin with more often experience a sense of post-abortion depression, and depressive reactions may recur yearly on the anniversary of the event (Cavenar, Maltbie, and Sullivan, 1978). One of the most difficult social factors that women encounter when they have experienced an abortion is a sense of psychological isolation, because "people just do not talk about abortion."

Some women plan a pregnancy, but then, because of our age, genetic factors, exposure to selected viruses, or other factors, decide to abort the fetus. Often this decision is fraught with sadness and grief, but the women are more comfortable about the procedure because there is a medical reason for it.

At the present time, abortions are the most common medical procedure in the United States. However, a rising tide of conservatism among powerful, well-financed groups have backed attempts to pass a constitutional amendment banning abortion. Many efforts also have been made to ban the use of public funds for poor women to have abortions, even when we have been the victims of rape or incest. Today, women who can afford to pay for an abortion may still legally obtain one; if the proposed constitutional amendment became law, this recently won control by women over our own reproduction will again be denied us.

Sexually Related Health Problems

Sexual health is a significant component of the total health of women. Sexual dysfunction had not been openly addressed until the research of the 1950s and 1960s. Indeed, useful questions about sexuality are just beginning to be asked and all answers are still tentative. More research needs to be conducted on matters related to female sexual responses and health, topics that have all too often been misrepresented.

Female Sexuality

Understanding of female sexuality is still emerging as an expanding body of knowledge. Too often woman's sexuality has been either denied or overlooked. However, the first extensive study of the subject has described women as multiorgasmic, with significant sex drives (Masters and Johnson, 1966) (see chapter 3). But this image too may create problems for women because it may set false standards, encouraging expectations for sexual activity as though for a performance marathon. Women are often as anxious under these circumstances as we were when our "normal" sexuality was viewed as minimal.

During the 1970s, many types of clinics focusing on sexual dysfunction emerged. Most offered legitimate resources. But this field has been particularly vulnerable to exploitation by unqualified practioners. No one approach to evoking sexual responsiveness has been universally accepted, nor can it be. No "method" will be correct for everyone.

Sometimes women experience discomfort associated with sexual activity. Infections of the urinary tract and/or vagina may occur as a result of sexual activities or poor hygienic practices. A greater willingness to discuss such matters can lead to help, for these conditions can be treated to relieve such symptoms.

Sexually Transmitted Diseases

Venereal diseases are basically a group of diseases (see table 12.2) spread by vaginal, oral, and anal sexual contact. The lesions of many conditions are found at the point of contact, and often they clear up externally within a short period. But the disease organisms remain internally, causing continued

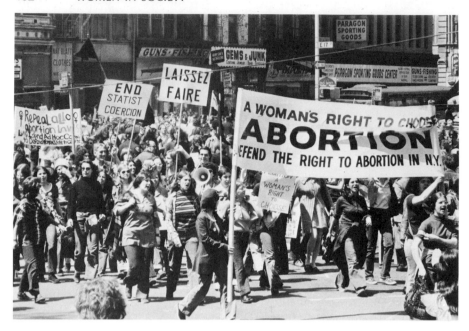

An early focus of the contemporary women's movement was the organization of political agitation to make abortion legal and a matter of a woman's decision over what happened to her own body. The group pictured here rallied in New York City, May 7, 1972. (Photo by Bettye Lane)

health problems. Antibiotics are used to treat many infections, but some infections are resistant to specific drugs. It is therefore important to consult health care providers before taking any kind of medication. If these diseases are not cured, they may have far-reaching consequences, such as pelvic inflammatory disease, sterility, and birth defects in newborns.

Preventive measures include simple cleanliness—washing the genitals and other parts of the body frequently. In addition, use of a condom by a man can prevent infection of his partner as well as protecting him from acquiring an infection. Sexual activity with many partners increases the chances for infection and helps spread infections.

Most sexually transmitted conditions must be reported to state health agencies. When a condition is diagnosed, the individual involved is interviewed confidentially by a health agency representative to ascertain the names of recent sexual partners. Many people find this practice intrusive, and it may provoke a great deal of anxiety. Women fear that if the confidentiality is broken, we will be subject to sexual harassment or public vilification. In fact, such public health reporting is much more likely to occur when the person involved has a lower social status. Middle- and upper-class persons are more likely to use a personal physician who will treat them privately and attempt to find and treat their contacts similarly. Venereal disease is a condition which affects all strata of society, but because the more affluent have

Table 12.2 Major Sexually Transmitted Diseases

Name	Symptoms	Treatment
Gonorrhea	1. Often women are unaware that the disease is present. 2. If untreated, it can lead to sterility as it localizes in the pelvic area. 3. Newborns can acquire the disease from the birth passageway. It may cause blindness if the newborn's eyes are not treated.	Penicillin compound or other antibiotics. Refrain from intercourse until disease is treated
Syphilis	1. Presence of chancre or sore at point of contact. This disappears, but the organism remains in the blood stream. If untreated, it can lead to general symptoms of malaise and a rash. If untreated indefinitely, it can lead to chronic general deterioration including the central nervous system. 2. Crosses placental barrier for fetus in utero after 4 months' gestation. The fetus in utero will respond to treatment. If untreated, it can seriously damage the fetus.	A penicillin compound or other antibiotic. Refrain from a variety of sexual activities until disease abates.
Herpes Virus Type II	1. Sores present on the cervix, vagina, and labia or site of sexual activity. 2. Pain associated with the lesions. 3. Chronic reappearance of the lesions. 4. If woman has an active case at the time of delivery, a caesarean section is recommended so that the fetus will not get the disease, which can be lethal to a newborn.	Cannot be cured. Treatment only relieves the symptoms as the virus remains dormant in the tissues. Usually topical ointment applied. Avoid sexual activity involving the lesions.

access to private medical practitioners, it is often associated primarily with those who are poor.

A viral infection which has received a great deal of publicity recently is herpes progenitalis. This sexually transmitted disease is extremely painful and presently incurable. The symptoms may be treated, but the virus endures with recurrent pain. Blisters containing the virus occur on the cervix and vagina. This virus is related to the fever blister, chicken pox, and shingles viruses. The disease may become dormant, but if a woman becomes pregnant and the virus is active, a caesarean section delivery is usually recommended. The newborn who contract the infection may become mortally ill. An increase in cervical cancer has also been associated with this disease.

Mental Health and Women

In examining the health of women, it is important to review concerns related to our mental health as well as our physical health.

Women in the Mental Health System

It is estimated that over 60 percent of the total mental hospital population is female (Chesler, 1972), and that women are usually "in therapy" twice as long as men (Fabrikant, 1974). Brandon (1972) has also indicated that women stay in mental hospitals longer and are given more ECT (electro-convulsive therapy) treatments than men. Women who seek psychotherapy are often treated with psychotropic (mood-altering) drugs—in fact, over 70 percent of these drugs are consumed by women (National Institute on Drug Abuse, 1978).

Such findings raise questions about the assumptions that practitioners in the mental health field have made regarding women. Chesler (1972) found that women more often than men were labeled as depressed, frigid, paranoid, neurotic, suicidal, and anxious, whereas men more often than women were labeled as addicts (alcohol and drugs) and as having personality disorders and brain diseases. Kjervik (1979) has suggested that the categories assigned women are generally considered more treatable, encouraging a situation in which we can be kept dependent on health practitioners, who are mostly male.

For example, Houck (1972) proposes that the way to assist women troubled by mental health problems is to help us to concentrate on our husbands, homes, and children. Husbands of emotionally strained women are accordingly encouraged to be more asservtive and supportive, in order to give us "someone to lean on." Such medical advice reinforces the notion that women are better off in a dependent and childlike relationship. It assumes that to be a healthy *woman* means to conform to the cultural definition of feminity, which includes many socially undesirable traits from the perspective of healthy "adults" (see chapter 4). Broverman (1970) found that female therapists usually adopt the traditional gender stereotyping used by the male therapists who train us (box 12.3).

Similarly, women who have given birth may suffer from short-term postpartum depression. Hormonal shifts, lack of support systems for motherhood, and an individual's previous mental state are factors which may precipitate this condition. Treatment for severe cases has included the use of psychotropic medications, extended psychotherapy, and hospitalization. Often new mothers are viewed (and may view ourselves) as abnormal and "sick," thus prolonging the condition. If this condition is viewed simply as a temporary reaction that may follow childbirth, and not as a pathological condition, we are likely to recover much more rapidly.

Women and Substance Dependence

Since Chesler's study *Women and Madness* in the early 1970s, more women have been diagnosed as dependent on drugs, including alcohol. Women who become alcohol-dependent are frequently suburban homemakers who first indulge in alcohol as part of our social life and then grow to depend on it as a

Has Feminism Aided Mental Health? Box 12.3

In little more than a decade the feminist movement, some recent research suggests, has already had a beneficial effect on the mental health of women.

That observation has been made repeatedly as scientists take on the difficult job of assessing how an improving job market for women has affected their emotional well-being. The conclusion persists, despite criticism that it is premature and that the elements in the issue are too vague to define rigorously.

Among those who see a clear relationship between feminism and mental health is Dr. Grace Baruch, a Wellesley College psychologist. Following her new study, she declared: "The mental health of women has improved with the women's movement. Feminism leads to equality and equality to mental health."

In 1978, Dr. Baruch and Dr. Rosalind Barnett began to study almost 300 women from the ages of 35 to 55. Interviewers asked the women about their work and family life, their expectations and satisfactions. They found, reports Dr. Baruch, that "women who work enjoy greater self-esteem and suffer less anxiety and depression than women who do not work."

The prestige of a woman's work, as one might expect, had an added impact: Those in high status occupations showed a greater sense of mastery—a feeling of control over what is important to them—than other women.

"Marriage and children did not affect feelings of mastery." Dr. Baruch says. "Nor did the presumed strain of multiple roles. The women with the highest rates of life satisfaction had both families and high prestige jobs."

The sense that good jobs may serve as a kind of preventive medicine emerged from a National Institute of Mental Health study of 2,300 Chicago adults. Dr. Frederic Ilfeld, a psychiatrist at the University of California at Davis, found that high status occupations tended to protect women from psychiatric symptoms.

The research showed, Dr. Ilfeld explained, that "women suffered twice as many symptoms as men," and that "only among women with high status jobs were symptoms as infrequent as among men."

Dr. Ilfeld speculated that this select group of women perceived themselves as having more control over their lives and enjoyed a greater sense of self-esteem and self-sufficiency. "It makes clinical sense that equality and mental health are related," he said. "When there is not equality, self-image suffers."

The idea that work plays a central role in life satisfaction is not new but is given a novel twist by research showing that it applies to women as well as to men. The customary thinking has been that satisfaction for a woman comes largely from her role in the family and home and not in the outside world, and most of the research on job satisfaction has focused on men. (Albin, 1981)

means of escape. Women who come from backgrounds where the use of alcohol is a regular part of daily life are at high risk for alcoholism.

More attention is being directed to pregnant women who consume a significant amount of alcohol. Since many substances cross the placental barrier, pregnant women need to be informed of the risk to our infants of all drug substances, including alcohol. A "fetal-alcohol syndrome" can lead to a defective newborn. A women's addiction to narcotics or barbiturates can similarly damage the fetus, and the new-born may be found to be addicted.

A common path to addiction is the legally prescribed tranquilizer. In her autobiographical book *I'm Dancing as Fast as I Can*, Barbara Gordon (1979) describes her addiction to Valium, the medication most frequently prescribed for women. Instead of noting the increased requests for the drug, many physicians continue to refill the prescriptions on demand. Gordon accuses physicians of preferring to pacify women with tranquilizers rather than attempting to diagnose and treat the real cause of our difficulties. Treating drug dependence and alcoholism, however, is difficult. Although both women and men find it equally hard to break such a dependency, a double standard of socially acceptable behavior forces alcohol- and drug-dependent women to bear a greater social stigma.

Women and Assault and Battery

Women seeking health care are often not taken as seriously as men, a situation which reflects the tendency of society to devalue our experiences. The problem has been particularly noticeable in cases of physical and sexual violence, such as assault, battery, and rape.

Between 1975 and 1977, more than one million women *reported* being beaten by the men we lived with (*PHA Times*, 1978). Such a figure does not take into account the many cases that go unreported. Because both lawmakers and law enforcers are reluctant to interfere with what are considered (by men) private family matters, it is rare to find the assaulting of wives labeled as a criminal act (see chapter 14). From the perspective of women's health, we find that when women are assaulted, the common (and rhetorical) questions all too often asked are "What did she do to precipitate this?" and "She's masochistic, isn't she?" These questions reflect the tendency of society to blame the victim. Abused women are frequently made to feel guilty about the fact that we have been abused, which only serves to deepen our depression and to leave us feeling trapped. In our own desire to deny or cover up what is happening to us as battered women, we often close our eyes to how potentially lethal these attacks are, physically and emotionally, until it is too late.

Recently, temporary shelters have been opened to receive battered women. These efforts to treat women's physical problems and to supply much-needed psychological support have been made by women in response to the vacuum which existed in the male-dominated health care system. But women who

have been repeatedly battered by our husbands or the men in our lives need more than patience, care, and support. We need a clear idea of the options available to us and the strategies that have proven useful in assisting other abused women.

Rape

Rape is a crime of violence which uses sex as a weapon. Although it is a crime if committed outside of marriage, in only four states is it possible to treat it as a crime within the context of marriage (see chapter 14). The mental and physical effects of rape occur regardless of whether it takes place within the context of marriage or not.

The rage that women feel after rape or even a rape attempt is often coupled with feelings of frustration and despair at our vulnerability and helplessness. Victims frequently experience insomnia, eating problems, nervousness, nightmares, and phobias (Burgess and Holmstrom, 1974). Children of both sexes are vulnerable to sexual assault, but female children are more often its victims, and it is adolescent females, in particular, who risk long-term psychological problems from such attacks.

Women who are raped often feel violated again when being physically examined following the attack. We may also feel dirtied by as well as guilty about the attack, especially if health care personnel misinterpret our reactions. Health care providers often expect women to be very upset and tearful, but a victim's response can range from overt distress to quiet withdrawal. If overt responses are not present, those who try to help us may feel dubious about what happened and even express the view, "She wasn't really raped" or "Maybe she really did enjoy it."

Law enforcement officials have sent out mixed signals about how women should respond to rapists. Some officials tell us to be passive, to accept the rape in order to avoid being injured or killed. However, other officials tell women to scream and otherwise attempt to fight off the would-be rapist. The assumption that follows is that women who *do not* struggle "really want it." Neither approach gives women any feeling of being competent to handle the problem (box 12.4).

Through the efforts of feminist activists, laws regarding rape were reworded in the late 1960s and the 1970s to narrow the legal requirement for third-party corroboration of the victim's accusation and to extend the issue to marital rape. In addition, police and health professionals have been reeducated. In New York City, for example, Women Against Rape has provided advocacy for making rape an issue that must be confronted and trained support groups for rape victims. Columbia University's College of Physicians and Surgeons, in collaboration with New York Women Against Rape, has established a research clinic which investigates the long-term effects rape has on victims' lives. However, much more research and application needs to be

The Legal Bias against Rape Victims **Box 12.4**

Few rapists are punished for their crime simply because the law itself discriminates against their victims. According to a note in 61 *California Law Review* 919 (1973), "A man who rapes a woman who reports the crime to police has roughly seven chances out of eight of walking away without a conviction. Assuming only one woman in five reports the crime, his chances increase to thirty-nine out of forty."

In urging the House of Delegates to approve a resolution calling for a redefinition of rape, Connie K. Borkenhagen of Albuquerque, New Mexico, pointed out one reason why most rape victims prefer not to press charges by imaging how it might sound if a robbery victim were subjected to the kind of cross-examination that the rape victim usually must undergo:

"Mr. Smith, you were held up at gunpoint on the corner of First and Main?"

"Yes."

"Did you struggle with robber?"

"No."

"Why not?"

"He was armed."

"Then you made a conscious decision to comply with his demands rather than resist?"

"Yes."

"Did you scream? Cry out?"

"No. I was afraid."

"I see. Have you ever been held up before?"

"No."

done, both to assist women who have been raped and to find better methods of preventing the crime.

Women as Providers in the Health Care System

The provision of health care is the second largest industry in the United States. Seventy-three percent of these providers are women (Marieskind, 1980). Control of the system, however, is dominated by male physicians, administrators, trustees, insurance specialists, and bureaucrats. Women in health care tend to be registered or licensed practical nurses, attendants, and technicians. This means that the people most often in contact with patients are women, while the decision makers, often separated from patients by distance and concern, are men.

Nurses

An analogy to the traditional nuclear family has often been drawn by those examining the roles of the health team members:

"Have you ever *given* money away?" **Box 12.4**
"Yes, of course."
"And you did so willingly?"
"What are you getting at?"
"Well let's put it like this, Mr. Smith. You've given money away in the past. In fact, you have quite a reputation for philanthropy. How can we be sure that you weren't *contriving* to have your money taken from you by force?"
"Listen, if I wanted. . . "
"Never mind. What time did this holdup take place, Mr. Smith?"
"About 11:00 P.M."
"You were out on the street at 11:00 P.M.? Doing what?"
"Just walking."
"Just walking? You know that it's dangerous being out on the street that late at night. Weren't you aware that you could have been held up?"
"I hadn't thought about it."
"What were you wearing at the time, Mr. Smith?"
"Let's see . . . a suit. Yes, a suit."
"An *expensive* suit?"
"Well—yes. I'm a successful lawyer, you know."
"In other words, Mr. Smith, you were walking around the streets late at night in a suit that practically advertised the fact that you might be a good target for some easy money, isn't that so? I mean, if we didn't know better, Mr. Smith, we might even think that you were *asking* for this to happen, mightn't we?" (American Bar Association Journal, 1975)

Reprinted with permission from American Bar Association Journal.

Physician_____Father
Nurse_____ _____Mother
Patient_____Child

This pattern can be viewed as reflecting traditional attitudes about the social roles of women and men. The heritage of the nursing profession is linked closely to the nurturing role traditionally expected of women. Many of the values that are frequently associated with nursing—selflessness, obedience, and dedication—have been reinforced by the religious and military roots of the nursing discipline. Patients, as we have seen, tend to support the pattern by adhering to notions of hierarchy and responding in a childlike and obedient manner appropriate to what they believe to be their role. Indeed, patients are often very dependent on health professionals for care during medical crises.

Florence Nightingale initiated major reforms in hospital management in nineteenth-century England and revolutionized the care of the sick by training nurses in a systematic way under secular auspices (Fitzpatrick, 1977). But Nightingale also emphasized that the "nurse's training was to understand

how best to carry out orders" (Glass and Brand, 1979:38). This behavior was not exhibited by Nightingale herself, for she dared to challenge the decisions of the civilian and military male establishment that regulated the British health care system.

Nursing functions within an entrenched hierarchical system which often prohibits unified action on the part of nurses and creates a climate for "keeping women in their place." Because of the low professional status and remuneration of nursing within the larger health care field, feminists have tended to encourage women to enter the more prestigious male-dominated medical fields. Some feminists have devalued nursing as a profession because it seems to represent a career based on the traditional female role. Some nurses have responded in anger to this devaluation. They see the women's movement as devaluing a pattern of behavior to which they feel committed. Recently within nursing there has been a shift toward valuing assertive, independent behavior.

Nurses have contributed significantly to health care delivery in the United States. Important leaders in the profession include Clara Barton (1821–1912), who established the Red Cross, Lillian Wald (1867–1940), who established the community health nursing system; and Margaret Sanger, the birth control pioneer. Following the examples of these leaders, nurses today are again beginning to expand the boundaries of the profession. Not only are nurses now engaged in delivering primary health care, providing specialized hospital care, and developing specialized roles such as hospice work with terminally ill patients, we are also becoming increasingly active within feminist health-care systems.

As part of a new and broader definition of nursing and inspired by a feminist analysis, nurses are becoming politically active within the larger medical profession as well as the community at large. These nurses are seeking to be, as well as to influence, the policy makers in health care. This strategy is designed to alter the present medical system as well as to alter its domination by men and technology. The objects are to change the emphasis from illness to health while changing the structure of the system from a hierarchical to a cooperative one.

Midwives

"From earliest times, women have assisted other women in childbirth" (Brack, 1979:83). The use of midwives (a term that derives from the Old English "with woman") to care for women before, during, and after childbirth has traditionally been part of women's health care systems around the world. Generally, midwives were members of the local community, knew what the cultural expectations were for childbirth, and acquired skills by on-the-job training. We might move in before the event was expected and remain for a short time, giving advice on child care and even taking care of

the household. In the United States in 1968, over 98 percent of deliveries were performed by physicians (93 percent of whom were male) in hospitals (Brack, 1979).

Men first became midwives in Europe in the seventeenth century, but they were also university-trained physicians and attended only upper-class women. Yet as late as 1762, the first formal midwifery training (offered at the University of Edinburgh Medical College) was reserved for women. Male midwives at first gained power in this professional battle by developing the use of obstetrical forceps to extract the baby from the mother, and by keeping this instrument a medical secret. It was the growing dominance of the male physicians in the medical profession during the nineteenth century that enabled medical men to develop and legislate standards and licensing procedures to oust midwives from the occupation in the United States. By the twentieth century, as we have already noted, with increasing knowledge of technical ways to monitor childbirth, the process was turned into a surgical event at which the "patient" awaited the intervention of the trained male professional (Brack, 1979). Midwifery schools updating the medical standards of the profession were developed in Europe, but in the United States, where the supply of trained physicians grew faster than elsewhere, the male-dominated medical profession successfully achieved a monopoly over birthing.

Today, in the United States as in England, nursing has become the prerequisite to the professional training of "nurse-midwives." The term clearly locates the practitioners as paraprofessionals ultimately under the supervision of physicians. But the number of women who feel we receive more personalized care from a midwife than from a physician is growing. Midwives are being called upon both for home delivery and hospital delivery as some hospitals begin to allow us to practice. Homelike birthing facilities have been developed in hospitals and in separate maternity centers where technological resources are available if needed.

Women Physicians

As we noted in chapter 11, more women are entering medical schools today (25 percent of incoming medical students in 1980). The medical profession, like the economy in general, has tended to segregate women in fields of specialization. Thus, more women have traditionally trained in pediatrics than in other specialties. As more women enter medical schools, however, our numbers may increase in other areas. Surgery still remains a male monopoly. More women are entering such areas as internal medicine, obstetrics and gynecology, and radiology. An encouragement to women entering medical research is the award of a Nobel Prize in 1978 to Dr. Roslyn Yalow, a Hunter College graduate, for her research in the analysis of blood number chemistries.

The increased number of women being trained in medical schools does not

ensure that women physicians will differ from our male role models. There is a real danger that we will treat our female patients in the traditional manner and will deprecate other workers in the health care system as our male colleagues do. This danger has been recognized by some women in medical schools, who question the sexist language of our teachers and textbooks (Walsh, 1979). Whether our presence can lead to change in an entire system is the challenge we face. Only sustained efforts by women both within and outside the health care system to resist sexism and assert self-control over our health will bring about significant change.

Approaches to Health Care of Women

Within women's health care, the *art* of healing is receiving more attention. An approach is developing which emphasizes the consumers' rights to choose among therapies and to be responsible for our health care. The women's movement has created a more open climate for women-to-women and self-care activities. Health education programs encourage us to learn about our own anatomy and physiology and to be aware of the care we receive or give. Many women are now learning more about our bodies and about *how* to be responsible for our health. All too often, however, women in smaller cities and rural areas do not have access to the groups which support women in larger metropolitan places. It is particularly difficult for poorly educated women to organize the kind of resources we need to interact successfully with institutional structures, medical, legal, and governmental.

The self-help concept is still in its infancy, but it is potentially a powerful agent for change. An important focus for women in the 1980s should be to develop methods to improve the health care system not just for a privileged few, but for all women.

Summary

The issue of women's health cannot be separated from other aspects of social experience. The historical view of women has been that our bodily illnesses were a result of our inferior ("defective") anatomy. Women who engaged in nontraditional activities were often diagnosed as suffering from "female disorders" or emotional illness. Expression of female sexuality was also viewed as a symptom of illness. Because women have been made to believe in our own inferiority and our need to be controlled, we have been subjected to male control in the health field for centuries.

Male physicians are able to define what women are and can do. This is because our medical system is disease-oriented rather than health-oriented. Women are not only denied access to health information but are also treated like children by an "omnipotent" physician.

Members of the Los Angeles Feminist Health Center demonstrate to some women in New York City the techniques of vaginal self-examination. One of the results of new feminist questioning of the unlimited control male medical professionals have asserted over women patients has been a movement by women to take back control over our bodies and health. (Photo by Bettye Lane)

Body image refers to the perceptions we have of our bodies. Our culture emphasizes breast size and shape, but it does not encourage women to examine our breasts for abnormal conditions. Body size is also important in our culture, which values slenderness, especially for women. Aging has had negative connotations for women in American culture contributing to low self-esteem. But many older women find new roles in life are enjoyable.

The internal perceptions we have of our bodies include awareness of the menstrual cycle. Although menstruation is a normal body process, it is often perceived as an "illness," as is menopause. Infertility, a problem that may be caused by the woman or the man, has traditionally been blamed on the woman. Although many women undergo hysterectomies (removal of the uterus), this surgery is sometimes performed unnecessarily.

Pregnancy is often considered a pathological rather than a physiological process. Although women today are asking for more control over pregnancy and childbirth, they face a conflict between the desirability of self-control and that of professional care. Male physicians and technological products tend to dominate the process.

Teenage pregnancies occur at a high rate in the United States. Many pregnant girls are not mature enough to take on the responsibilities of a child, yet we are often denied the option of abortion.

Contraceptive devices today are designed primarily for women. Married women have had better access to birth control than unmarried women. Sterilization may be difficult to obtain for women who want it and yet enforced on poor women who may not want it.

Abortion is still a highly controversial issue. Today, women who can afford to have an abortion retain this choice, but conservative groups in the United States are working to eliminate it.

Women may suffer various discomforts or diseases as a result of sexual activity. Venereal diseases can often be prevented by precautions, including cleanliness; many but not all can be cured by antibiotics.

The mental health of women has been connected with gender-linked expectations. Mentally ill women tend to be labeled as depressed, frigid, paranoid, neurotic, suicidal, and anxious. Women who have given birth may suffer postpartum depression for a time, depending on many factors.

Many women face problems of dependency on alcohol or drugs, while others use tranquilizers, freely prescribed by physicians, to the point of addiction.

Women who are physically abused by our mates not only suffer physical harm but also are made to feel guilty, depressed, and trapped. Rape victims suffer not only the pain of the initial assault but also endure the long-term physical and psychological consequences.

Although most health care providers are women, we are concentrated in the lower realms of the health care hierarchy, as nurses and technicians.

Many feminists have tended to encourage women away from nursing in favor of more prestigious medical fields. Nurses today, however, often carve out special roles, as midwives for instance, and are becoming politically active. While increasing numbers of women are becoming physicians, the medical training we receive encourages us to follow a male medical model in our relations with female patients and lower-level health care workers.

Many women are turning to self-care activities. We are learning more about our bodies and how to be responsible for our health.

DISCUSSION QUESTIONS

1. Discuss your concept of a healthy person. What are the similarities and/or differences you see between a healthy woman and a healthy man? Do you think there is any relationship between our body images and our perceptions of health?
2. The majority of health care providers are women, but very few women occupy positions of responsibility and authority. How has the historical development of the health care of women led to its control by a male-dominated medical system?
3. What are the major differences between contraceptive methods in terms of preventing pregnancy? What are their primary side effects? Is this kind of information available to teenagers where you live? How?
4. What are the major health problems women face today? Do you know of any local women's centers or groups that deal with these problems? Discuss what they do. Are there any groups dealing with health hazards for working women?
5. How do women "fit" into the health care system in the United States? Is this true in your area? Do you see any signs of change that suggest more women are taking control over our own health?

Recommended Readings

Cooke, Cynthia, and Dworkin, Susan. *Ms. Guide to Women's Health.* Garden City, N.Y.: Doubleday, 1979. This book by *Ms.* magazine confronts common myths and misconceptions and examines every aspect of women's health from infancy to old age, including puberty, menstruation, childbirth, menopause, birth control, common diseases of women, abortion, rape, and infertility. Sound advice on hygiene and health maintenance.

Smith, E. Dorsey, ed. *Women's Health: A Guide to Patient Education.* New York: Appleton-Century-Crofts, 1981. A compilation of topics pertinent to the health care of women. The book was designed to give guidance to health providers in a hospital setting, but it has implications and information pertinent to women in general.

Stewart, Felicia, Stewart, Gary, Guest, Felicia, and Hatcher, Robert. *My Body, My Health*. New York: Wiley, 1979. Written by physicians in collaboration with women who were non-physicians. Clear and specific in citing pertinent information about current medical practice.

Corea, Gena. *The Hidden Malpractice*. New York: Morrow, 1977. This feminist book was one of the first to address the health policy system and its clear assault on women. It documents the male physicians' strong influence on defining a healthy woman and their efforts to continue to infantilize women.

References

Alan Guttmacher Institute. *11 Million Teenagers: What Can Be Done About the Epidemic of Adolescent Pregnancies in the U.S.?* 1976.

American Cancer Society. *Teaching Breast Self-Examination*. 1977.

American Bar Association Journal 61 (1975):464.

Anderson, Sandra F. "Childbirth as a Pathological Process: An American Perspective." *MCN: The American Journal of Maternal Child Nursing* 2 (1977): 240–44.

Barker-Benfield, G. J. *The Horrors of the Half-Known Life: Male Attitudes Toward Women and Sexuality in Nineteenth-Century America*. New York: Harper & Row, 1976.

Betts, Doris. "Still Life With Fruit." *Ms.* 2 (1974):50–53.

Boston Women's Health Book Collective. *Our Bodies, Ourselves*. New York: Simon & Schuster, 1973.

Brack, Datha Clapper. "Displaced—The Midwife by the Male Physician." In *Women Looking at Biology Looking at Women*, edited by Ruth Hubbard, Mary Sue Henifen, and Barbara Fried. Cambridge, Mass.: Schenckman, 1979.

Brandon, Sydney. "Psychiatric Illness in Women." *Nursing Mirror* 34 (1972):17–18.

Bruch, Hilda. "Anorexia Nervosa." *Nutrition Today* 13 (1978):14–181.

Burgess, Ann W., and Holstrom, Lynda L. *Rape: Victims of Crisis*. Bowie, Md.: Brady, 1974.

Cavenar, Jesse O., Maltbie, Alan A., and Sullivan, John L. "Aftermath of Abortion." *Bulletin of the Menninger Clinic* 42 (1978):433–44.

Chesler, Phyllis. *Women and Madness*. New York: Avon, 1972.

Corea, Gena. "Medicine and Social Control." In *Women's Health Care: Nursing Dimensions*, edited by Karen Kowalski. 8 (1979):15–21.

Cummings, Elaine. "Engagement with an Old Theory." *International Journal of Aging and Human Development* 6 (1975):187.

Donnison, Jean. *Midwives and Medical Men: A History of Inter-Professional Rivalries and Women's Rights*. London: Heinemann, 1977.

Egdahl, Richard, ed. *Women, Work, and Health: Challenges to Corporate Policy*. Boston: Boston University Press, 1980.

Ehrenreich, Barbara, and English, Deirdre. *Witches, Midwives, and Nurses: A History of Women Healers*. New York: Feminist Press, 1973.

Fabrikant, Benjamin. "The Psychotherapist and the Female Patient." In *Perception*

and Change, edited by Violet Franks and Vasanti Burtle. New York: Bruner-Mazel, 1974.

Fitzpatrick, M. Louise. "Nursing." *Signs* 2 (1977):818–34.

Foucault, Michel. *The History of Sexuality. Volume I. An Introduction.* 1976. Trans. by Robert Hurley. New York: Vintage Books, 1980.

———. *Madness and Civilization. A History of Insanity in the Age of Reason.* 1961. Trans. by Richard Howard. New York: Vintage Books, 1973.

Freud, Sigmund. "Some Psychological Consequences of the Anatomical Distinction Between the Sexes." *International Journal of Psychoanalysis* 8 (1927):133–43.

Glass, Laurie, and Brand, Karen. "The Progress of Women and Nursing: Parallel or Divergent?" In *Women in Stress: A Nursing Perspective*, edited by Diana Kjervik and Ida Martinson. New York: Appleton-Century-Crofts, 1979.

Gordon, Barbara. *I'm Dancing as Fast as I Can.* New York: Harper & Row, 1979.

Gordon, Linda. *Woman's Body, Woman's Right. A Social History of Birth Control in America.* New York: Grossman, 1976.

Grossman, Marilyn, and Bart, Pauline. "Taking the Men out of Menopause." In *Women Look at Biology Looking at Women*, edited by Hubbard et al. Cambridge, Mass.: Schenckman, 1979.

Haynes, Suzanne, and Feinleib, Manning. "Women and Coronary Heart Disease: Prospective Findings from the Framingham Health Study." *American Journal of Public Health* 70 (1980):133–41.

Heide, Wilma Scott. "Nursing and Women's Liberation—A Parallel." *American Journal of Nursing* 71 (1971):1542–47.

Herbst, Arthur, Ulfelder, Howard, and Poskanser, David. "Adenocarcinoma of the Vagina: Association of Maternal Stilbestrol Therapy with Tumor Appearance in Young Women." *The New England Journal of Medicine* 284 (1971):878–81.

Hoover, Robert, Gray, Laman A., Cole, Philip, and MacMahon, Brian. "Menopausal Estrogen and Breast Cancer." *The New England Journal of Medicine* 295 (1976):401–5.

Houck, John. "The Intractable Female Patient." *American Journal of Psychiatry* 129 (1972):27–31.

Kahan, Eileen B., and Gaskill, Elizabeth B. "The Difficult Patient: Observations on the Staff-Patient Interaction." In *The Woman Patient, Medical and Psychological Interfaces*, edited by Malkah T. Notman and Carol C. Nadelson. New York: Plenum, 1978.

Karmel, Marjorie. *Thank You, Dr. Lamaze.* Philadelphia: Lippincott, 1959.

Kjervik, Diane, and Martinson, Ida. *Women in Stress: A Nursing Perspective.* New York: Appleton-Century-Crofts, 1978.

Krieger, Dolores. "Therapeutic Touch and Healing Energies from the Laying-On of Hands." *Journal of Holistic Health* 25 (1976):25–30.

Marieskind, Helen. *Women in the Health System: Patients, Providers, and Programs.* St. Louis: Mosby, 1980.

Martin, Judith. "Guidelines for the Woman Who Is Going to See Her Health Care Practitioner." Unpublished MS. Stanford University Medical Center, 1982.

Masters, William, and Johnson, Virginia. *Human Sexual Response.* Boston: Little, Brown, 1966.

National Institute on Drug Abuse. *Women and Drugs: Information from the Drug Abuse Warning Network.* 1978.

Neumann, C. "Nutrition and Women: Facts and Faddism." In *Becoming Female, Perspectives on Development,* edited by Claire B. Kopp. New York: Plenum, 1979.

New York Times. "Study Urges a Greater Male Role in Birth Control Responsibilities." December 14, 1980:28.

Notman, Malkah T., and Nadelson, Carol C. *The Woman Patient, Medical and Psychological Interfaces.* Volume 1. *Sexual and Reproductive Aspects of Women's Health Care.* New York: Plenum, 1978.

Orbach, Susan. *Fat Is a Feminist Issue.* New York: Berkeley, 1978.

Pickering, George. *Creative Malady.* New York: Oxford University Press, 1974.

Public Health Association Times, 1978.

Reuben, David. *Everything You Ever Wanted To Know About Sex but Were Afraid To Ask.* New York: Bantam, 1966.

Rollins, Betty. *First You Cry.* Philadelphia: Lippincott, 1976.

Rosner, S. Steven. "The Rights of Mental Patients." *Mental Hygiene* 56 (1972):117–19.

Rothman, Sheila. *Woman's Proper Place.* New York: Basic Books, 1978.

Shafer, Nathaniel, and Shafer, Robert. "Potential Carcinogenic Effects of Hair Dyes." *New York State Journal of Medicine* 76 (1976):394–96.

Smith, E. Dorsey. *Abortion: Health Care Perspectives.* New York: Appleton-Century-Crofts, 1982.

Steinem, Gloria. "The Politics of Food. *Ms.* (February 1980): 48–49.

Versluysen, Margaret C. "Midwives, Medical Men and Poor Women Labouring of Child: Lying-In Hospitals in Eighteenth-Century London." In *Women, Health, and Reproduction,* edited by Helen Roberts. London: Routledge & Kegan Paul, 1981.

Vincent, Clarke. *Unmarried Mothers.* New York: Free Press, 1961.

Walsh, Mary Roth. "The Rediscovery of the Need for Feminist Medical Education." *Harvard Educational Review* 49 (1979):447–466.

Waters, Judith, and Denmark, Florence L. "The Beauty Trap." *The Journal of Clinical Issues in Psychology* 6 (1974):10–15.

Whisnant, Lynn, and Zegans, Leonard. "White Middle-Class American Attitudes Toward Menarche." *American Journal of Psychiatry* 132 (1975):809–14.

Zelnick, Melvin, and Kanter, John. "Sexual Experience of Young Unmarried Women in the United States." *Family Planning Perspectives* 4 (1972):9–18.

Zeil, Harry, and Finkle, William. "Increased Risk of Endometrial Carcinoma Among Users of Conjugated Estrogen." *The New England Journal of Medicine* 293 (1975):1167–70.

13

Women and Work

THE LABOR OF WOMEN
Production and Reproduction
Maintenance of the Domestic Unit
Women's Work in the Marketplace
The Contribution of Women to Wartime Economy
The Contribution of Women to Economic Development

THE DOMESTIC MODE OF PRODUCTION: AN INTEGRATED SYSTEM
Food Production
Maintenance
Exchange and Marketing

THE CAPITALIST MODE OF PRODUCTION: AN ALIENATED SYSTEM
Urbanization and Class Distinctions
Working for Wages: Its Organizational Prerequisites
Division of Labor by Gender: Women's Work
 Slaves and Serfs
 Working-Class Women: Skilled Labor; Domestic Wage Labor; Factory Workers
 The Pink Collar Worker
 The Professions
Minority Women and Work in the United States
The Multinational Corporation
Self-employment
Women in Corporations
Unemployment

THE POLITICS OF WORK: BARRIERS AND STRATEGIES
Conflict and Competition Between Women and Men
Nuclear Families, Labor and Capitalism
Sexual Harassment and Other Problems
The Dual-Career Family
Social Support for Working Women
 Unions
 Professional Organizations
 Networks
Government and Law
Protective Legislation
Laws Against Sexist Job Discrimination
Equal Pay—Comparable Work
Socialist and Communist Impact on Gender Division of Labor

NEW DIRECTIONS
Impact of the Women's Movement
The Double Burden

If life is to be sustained, certain tasks must be done. An individual must procure enough food, water, shelter, and clothing to prevent death from starvation or exposure, and usually these are produced through work. For most people, labor is often hard, unpleasant, exhausting, and boring. But labor also makes it possible to have our lives matter, to use our energy in ways that change our environment, and to express our uniquely human capacity to transform the world. Many people who truly enjoy their work would rather work than play. Work often provides one of the most important aspects of a person's identity.

Human societies generally organize the work needed for survival by dividing the tasks among their members. Individual work assignments are decided in a variety of ways: strength and skill are obvious and basic determinants. In addition, considerations of status and value also influence work patterns. Some tasks are thought to merit higher rewards, both concrete and intangible, than others. All known societies have used gender as a criterion for work assignment. That the assignment is largely arbitrary becomes clear when we discover how greatly the content of the role varies from culture to culture and time to time. In nonagricultural societies, for example, hunting of big game might be done by men and gathering of vegetable foods largely by women. In a pastoral society, herding might be assigned to men and farming to women. Yet we can find certain societies in which herding is women's work, and societies in which farming is men's work. In our society, secretarial work and primary school teaching are assigned mainly to women. But less than a century and a half ago, these jobs were assigned almost exclusively to men.

Many societies, including our own, judge the value of work in terms of economic rewards to those who buy and sell labor. To ask the question "Do you work?" means, for many people, "Do you earn money?" That is why the idea that a housewife does not "work" is prevalent in our society. Although the labor involved in housekeeping can be bought and sold, when this labor is performed for "free," it is not considered "work." To question this idea, as many feminists have done during the past century, is to challenge basic assumptions most people hold about the nature and definition of "work" itself.

The prevalent low valuation of unpaid labor does not, however, correctly express the significance of that labor for the economy, much less for the society. Unpaid labor often contributes enormously to the provision of goods and services that are necessary to keep people and society alive, well, and functioning. Masking the economic value of women's work serves the interests of those who have property and power. Failing to acknowledge the value

of such work beyond its economic value illustrates the extent to which a society exaggerates economic value over other kinds of value.

In recorded history, the rise of social stratification has been accompanied by a concentration of control over the means of production in the hands of a few, and those few have always been predominantly men. The labor of those who do not control property has been progressively devalued, and the labor of women has been devalued most of all.

Many social theories about relationships between people hold that they are fundamentally based on economic power. Social inequalities between women and men, in particular, are often seen to be based largely on economic inequalities. This chapter will examine some aspects of these ideas in order to understand women's roles in society.

We will examine the relationships between production and reproduction, particularly the implications, for women's status, of the ways that society integrates the tasks of raising and maintaining a family with other kinds of work. We will be concerned with the impact of economic change on women's roles within and outside the family. Shifting from general theoretical concerns to the more concrete realities of women's work, we will consider in detail the various types of work women have done and the obstacles we have faced as women workers. Finally, we will look at the roles played by support groups of various sorts, by government, and by the women's movement in influencing women's opportunities to work.

The Labor of Women

Production and Reproduction

We have seen that every known society has had some sort of division of labor by gender. Although the work done by women and men has varied from society to society, the work done by women has almost always been valued less than the work done by men. An activity that is highly regarded in one society, when done by men, may be considered unimportant in another society, when done by women.

The division of labor by gender has often been related, not surprisingly, to the differences in the roles in reproduction assigned women and men. Since women necessarily bear, and until recent times have necessarily nursed infants, we have always been assigned the additional social role of caring for the young, even though this assignment is not necessitated by either function. Yet the physical burdens we bear while pregnant and nursing are often assumed to place some limitations on our ability to participate fully in the productive economy. An examination of women's roles in a variety of preindustrial as well as developing societies, however, shows that we do engage in fairly strenuous economic activities even while pregnant and nursing. It is

more convincing to argue that women's reproductive roles provide rational-
izations, rather than reasons, for our exclusion from certain types of produc-
tive labor in most societies.

The labor involved in reproduction itself is essential for any society. It
provides the workers of the next generation. This labor, including especially
the care of young children, demands time, effort, and skills, but it rarely has
an "exchange value" because it is socially assigned to the "private" domestic
sphere. It is something women are thought to do simply for our own families.
With the exceptions of those hired to care for the young or participating in
communal experiments, most women receive no economic compensation for
mothering, even though societies could not exist without the work involved.

Maintenance of the Domestic Unit
To the extent that women are involved in the care of young children—and
this extent varies historically and cross-culturally—the other work we do
must be possible to do at the same time. What is defined as "housework,"
such as cooking and cleaning, generally falls into this category. Like repro-
duction, this work serves an important economic function: it "services" the
male worker so he can return, fed and refreshed, to the workplace the next
day. But the housewife is not compensated for this work either.

In most parts of the world for most of human history, virtually all produc-
tive labor was domestic, performed without compensation for the benefit of
family members. Under these conditions, the labor done by women and men,
although often differentiated, was viewed as making equivalent contribu-
tions. *Social labor,* labor done for the good of the larger social unit beyond
the family, did have social value, earning an esteem for the laborer that went
beyond family rewards.

As the social labor sector grew with increasing urbanism and capitalism, it
became an increasingly large component of the economy as a whole. With
this change, women began to lose ground. That part of our efforts confined
to domestic work not only had no social value but also diminished our
opportunities to participate in valued social labor outside the home. While
the work women have performed has been essential to the economy in pro-
viding and servicing workers, it has generally not been recognized as having
either economic or social value (Dalla Costa, 1972). Feminists in recent years
have called attention to how misleading, and damaging to women, are many
traditional conceptions of the "private" and "domestic" spheres of life.

The fact that many sorts of work can be combined with child care is often
overlooked. Work that is done in or near the home, such as weaving and
making pottery, is a good example. Businesses such as beauty parlors or
family grocery stores can be run in or near the home. Alternatively, societies
may take responsibility for making child care facilities available so that both
parents can work at other jobs.

Women's Work in the Marketplace

Even though women's participation in the market economy has been limited by our assigned responsibilities in the domestic sphere, many women have managed to sell some of our labor, and larger numbers are continuing to do so. However, because of the devaluation of women, resulting at least in part from the devaluation of our domestic labor, the labor we have sold *in* the marketplace has also been devalued. That is, when a job was done by a woman, it was valued less than the same work done by a man. Women have often been excluded from a wide variety of jobs open to men; when we were permitted to enter a given line of work, we were paid less. Secretarial work, for example, was initially a male-assigned profession. When women entered the field in increasing numbers, wages dropped accordingly, as did the status of the profession. The conclusion we are obliged to draw is that when work is divided along gender lines, it is not the work itself which determines its value, but the gender of the person doing it.

The Contribution of Women to Wartime Economy

Virtually every society assigns combat warfare exclusively to men. When men are involved in combat, particularly when it takes place far from home, women tend to fill the men's roles in the economy. Under these circumstances, women may fill a double economic role, continuing to fulfill our "normal" duties in connection with home and child care while also performing economic tasks outside the home. Between wars, or when a war is over, men return from combat, displacing women from the more desirable jobs we have held.

The economic roles that women undertake when men are at war undermine assumptions about the exclusion of women from certain forms of labor on the basis of home and childcare demands. Our work outside the home is economically valued so long as there are not large numbers of men around to do it. When men are not at war, it is assumed that we should stay at home and attend to "women's" domestic duties. This suggests that the low value placed on the economic contributions of women is directly associated with competition between women and men for the same work outside the home. The power of men to control the way women and men view their "appropriate" roles influences how these roles are viewed more than does any inherent capability of women or men for different kinds of work.

The Contribution of Women to Economic Development

A critical factor in the modern division of labor by gender and the distinction between the domestic and productive spheres of work is industrialization. The organization of industrial labor today tends to exclude the presence of young children in the workplace. Few paid jobs provide child care and offer economically competitive wages. Consequently, as long as women are expected to be

Women's Work Outside the Home: Box 13.1
A Debate by the Mills

It is not desirable to burthen the labour market with a double number of competitors. In a healthy state of things, the husband would be able by his single exertions to earn all that is necessary for both: and there would be no need that the wife should take part in the mere providing of what is required to *support* life: it will be for the happiness of both that her occupation should rather be to adorn and beautify it.

(John Stuart Mill, 1831/1832, in Mill and Mill, 1970:74–75)

Assuming that to lay open to women the employments now monopolized by men, would tend, like the breaking down of other monopolies, to lower the rate of remuneration in those employments; let us consider what is the amount of this evil consequence, and what the compensation for it. The worse ever asserted, much worse than is at all likely to be realized, is that if women competed with men, a man and a woman could not together earn more than is now earned by the man alone. . . . The joint income of the two would be the same as before, while the woman would be raised from the position of a servant to that of a partner. Even if every woman . . . had a claim on some man for support, how infinitely preferable is it that part of the income should be of woman's earnings, even if the aggregate sum were but little increased by it, rather than that she should be compelled to stand aside in order that men may be the sole earners, and the sole dispensers of what is earned. . . . A woman who contributes materially to the support of the family, cannot be treated in the same contemptuously tyrannical manner as one who, however she may toil as a domestic drudge, is a dependent on the man for subsistence. . . . The regulation of the reward of labourers mainly by demand and supply [need not] be for ever. . . . But so long as competition is the general law of human life, it is tyranny to shut out one-half of the competitors. All who have attained the age of self-government have an equal claim to be permitted to sell whatever kind of useful labour they are capable of, for the price which it will bring.

(Harriet Taylor Mill, 1851, in Mill and Mill, 1970:104–5)

the primary caretakers of our children, we will be forced into a choice between child care and wage labor. For women who must work for wages or who choose to do so, the problems of arranging for adequate child care may be severe, especially when fathers continue to maintain that these are the mothers' problems.

In the developing countries today, models of economic growth and change have tended to follow patterns set by Western industrialism. That is, the technology selected for modernization has largely been of the sort which removes workers from the home: large-scale, centralized, and capital-intensive.

This is true in rural development as well as urban. Where women were once heavily involved in small-scale agriculture based on intensive labor and simple technology, there is now a tendency to consolidate land holdings (hence economic control), to use industrial machinery, and to emphasize production for the market rather than for the home. It has consistently been men who have been taught to use the new machinery (such as tractors) and given the means to acquire it. As a result of being excluded from modernized agricultural production, women have lost our former voice or control over the deployment of resources, even within the home.

Men who have lost their "jobs" through the shift from labor-intensive to capital-intensive production are viewed as "unemployed," while women in a similar economic position are altogether disenfranchised. We are not considered an economic casualty but are simply invisible. Whereas our work was once one of the mainstays of the economy, what we do outside the home now is considered by our societies as at best a negligible economic contribution and at worst a hindrance to economic development to be targeted for elimination. Feminist analyses allow us to become aware of many mistakes in standard interpretations of economic "development" (Boserup, 1970), and they call for an examination of the relation between the status of women and population growth.

The Domestic Mode of Production: An Integrated System

Anthropologists use the term *domestic mode of production* to describe the organization of simple economic systems, such as hunting-gathering, tribal, frontier, and peasant economies. In such systems, the household is the basic unit of both production and consumption. That is, the household controls resources—land, labor, tools—and makes decisions about their use according to its own needs. Members of the household produce to meet their needs and consume most of what they produce. Only small amounts of surplus are exchanged with other households. The division of labor in the domestic mode of production is by age and gender, with relatively little specialization within these two categories. Women's contributions in economies organized by the domestic mode of production are variable in type and extent. But in all these systems, economic roles are integrated into other domestic roles, both for women and for men.

Food Production
While women's roles in food production (subsistence) are quite variable, some general patterns can be found. In hunting-gathering societies, women are primarily responsible for the collection and processing of plant foods; in some cases, we do fishing. Men hunt large game. In horticultural societies

Box 13.2

Comparison of Time Allocation to Rural Activities

Activity	Average Time Allocated (In minutes)*	
	Women	Men
A. Production, supply, distribution	367	202
1. Food and cash crop production	178	186
Sowing	69	4
Weeding, tilling	35	108
Harvesting	39	6
Travel between fields	30	19
Gathering wild crops	4	2
Other crop-production activities	1	47
2. Domestic food storage	4	1
3. Food-processing	132	10
Grinding, pounding grain	108	0
Winnowing	8	0
Threshing	4	0
Other processing activities	12	10
4. Animal husbandry	4	3
5. Marketing	4	0
6. Brewing	1	0
7. Water supply	38	0
8. Fuel supply	6	2
B. Crafts and other professions	45	156
1. Straw work	0	111
2. Spinning cotton	2	0
3. Tailoring	2	10
D. Household	148	4
1. Rearing, initial care of children	18	0
2. Cooking, cleaning, washing	130	1
3. House-building	0	0
4. House repair	0	3
E. Personal needs	158	269
1. Rest, relaxing	117	233
2. Meals	21	29
3. Personal hygiene and other personal needs	20	7
F. Free time	77	118
1. Religion	2	6
2. Educational activities (learning to read, attending a UNESCO meeting or class)	17	4
3. Media (radio, reading a book)	0	14
4. Conversation	14	69
5. Going visiting (including such social obligations as funerals)	43	19
6. Errands (including going to purchase personal consumption goods, such as kola, next door)	1	6

4. Midwifery	41	0
5. Other crafts/professions (e.g., metal work, pottery, weaving cloth, beekeeping, etc.)	0	35
C. Community	27	91
1. Community projects	27	0
2. Other community obligations	0	91
G. Not specified**	18	0
Total work (A, B, C, D)	587	453
Total personal needs and free time (E, F)	235	387

* Based on time budgets prepared by direct observation.
** When observation did not last the full 14 hours.

Source: McSweeney, 1975:379–84.

Explanation: This table represents the average amount of time spent by women and men on various activities during the first 14 hours in a day. The sample was drawn from a village in Upper Volta, West Africa. Children also worked; girls began early in assuming more work than boys.

Hours of Work

Age	Girls	Boys
7	5.3	0.7
9	7.4	2.8
11	8.5	3.2
13	6.0	5.2
15	3.8	4.4

This goes some way to account for the difference in educational levels for girls and boys, since girls are expected to contribute more to household and other work. Given the heavy pressures on mothers, the help of girls cannot easily be spared.

(societies which depend on cultivated plants), women tend to be mostly responsible for planting, weeding, and harvesting, while men are often assigned the more sporadic tasks of clearing forest for new gardens and the like. In pastoral societies, which depend on herding large animals (sheep, goats, cattle, yak, horses, llamas, alpacas, reindeer), women are often assigned tasks associated with milking, preparation of butter and cheese, and care of the young herd animals, while men are in charge of defense and protection of the herds from raiders and predators.

Increased technology curtails to some extent the participation of women in these traditional activities. For example, while women in a number of herding societies participate in caring for herd animals, we are rarely directly involved in ranching operations, which are oriented toward markets rather than household consumption. When agricultural production is intensified by the use of plow and oxen, men take on the tasks of cultivation. While the digging stick is often a woman's tool, the plow rarely is. Women are generally credited with the invention of most of the techniques of agriculture and storage (pottery and baskets). It is even more probable that we were the inventors of spinning (and later of the spinning wheel), weaving, and other techniques of cloth production. But as with so many of the genuinely creative people in world history, our names and records have been forgotten while the records of profitless military adventures, the activity of men, survive.

Maintenance

Simply producing food by gathering, cultivating, fishing, or herding is not enough to provide for the needs of a family. Researchers who attempt to find a relationship between subsistence activities (food production) and women's status often overlook this point. Food-processing, for example, may be a critical task in subsistence. While Mexican peasant men are primarily responsible for growing their food staple, corn, Mexican peasant women spend considerable amounts of time and energy turning corn into food—husking and shelling it, grinding it, forming and cooking tortillas. Food preservation and storage may also be critical tasks: fish and meat may be dried or smoked or preserved in oil. Such tasks often are assigned to women.

Women also tend to take on the tasks of making and maintaining clothing. The Eskimo men who hunt for sea mammals and caribou could not do so unless provided with warm parkas, leggings, and boots made by women. In societies which use plant or animal fibers for clothing, women generally do the spinning, weaving, and sewing. Women also construct tents and houses in many societies. In addition to food and shelter, women also often have considerable responsibility for the care and health of our families. In many societies, women play important roles as healers of the sick, as midwives, and as "morticians" (laying out the dead).

Exchange and Marketing

While economies based on the domestic mode of production are geared toward production for use in the household, some commodities, including surplus harvest produce and craft items, are often exchanged to obtain goods and services not produced in the household. The household may produce a "cash crop" such as tobacco or cotton or rice for sale; sometimes women are involved in cash crop production or in the manufacture of pottery, weaving, and basketry for market exchange.

In some societies, most notably in West Africa and the Caribbean, women play a significant role as traders, merchants, and brokers. In addition to selling our own products, we may buy from and sell to others. We may establish regular relationships with a network of clients who depend on us not only for connection with a larger market but also for credit to get them through lean times. Women's participation in the market has tended (though not invariably) to be limited to relatively short-distance trade in necessities such as food and utensils rather than long-distance trade in "luxury" items such as precious metals, gems, and ivory. Where women do engage in mercantile activities, we tend to retain considerable control over our income, enhancing our own autonomy and status.

The Capitalist Mode of Production: An Alienated System

Urbanization and Class Distinctions

About seven thousand years ago in the valleys of the Tigris and Euphrates (modern Iraq), the first cities were born. Cities depend on migrants for population growth and maintenance. They attract that part of the population that is often desperately poor. Younger daughters and sons of the rural population come to the city with the hope of finding employment and social mobility. Cities generate new economic needs and new enterprises to fill these needs. With the concentration of resources available to a city, all sorts of diverse occupations are opened up. Men migrating into ancient cities could seek work in the building trades, in a wide variety of craft and commercial enterprises, in the area of learning or clerking, or in service industries. They could become carpenters, cabinetmakers, grocers, bookkeepers, priests, soldiers, or sea captains. Depending on their skill, influence, and luck, they could find a place in the hierarchy of their professions and fit into the niche that profession occupied on an ascending social scale. The development of social stratification, the division of a society into layers of social classes which commanded vastly different shares of the economic resources of the community, was one of the by-products of the development of civilization.

Women migrating into a city rarely found a dazzling array of choices open to us. We usually entered into the class structure only as the appendages of fathers or husbands. If we were totally on our own, we probably sank to the

most diffuse and lowest layers of society where the class structure was at its weakest. We probably found work most readily as servants, or we entered into the ranks of "unskilled" laborers. We were ill-paid, transient, and obliged by the discrimination of most societies against working women to supplement our meager incomes with prostitution.

The idea of selling "labor"—time and effort employed on someone else's raw materials, using someone else's tools, to create a product that belongs to someone else to dispose of—introduces a distinctive set of notions about work. It distinguishes members of a family (whose labor is not "sold") from those who interact outside the family (where labor is sold). Such distinctions are especially applicable in urban contexts, where people interact with others who are mostly non-kin. Where the urban economy plays a large role in agriculture and other rural enterprises, the distinction applies to the countryside as well.

Working for Wages: Its Organizational Prerequisites

In order to "free" labor from the household, which requires work in order to sustain itself, certain basic arrangements must be made. One kind of arrangement involves a division of labor in the social sphere whereby some workers provide, on a regular basis, goods and services once produced only in the home for family consumption. For example, spinning and weaving cloth was once the part-time work of all women. To allow women to work for wages outside the home, more efficient specialists in spinning and weaving outside the home (who might be women) had to be available.

Normally, this organizational change is expressed in the reverse fashion: with a shift toward greater specialization in production through urbanization, capitalism, and industrialization, the economic autonomy of the household decreased. However, by stating that specialization arose as a result of the need to make the labor used on maintaining the household available in the marketplace, we can see the way this reorganization of work "freed" labor so that certain sectors of the society could draw an extra profit. Labor directed strictly to household use profits only the family. When the same labor is sold in specialized production, the owner of the resources, tools, and products takes part of the profit of labor and allows the worker to take only a small share back to the family in the form of wages. The profit taken by the owner is accumulated and reinvested in the production of more materials, tools, and products in order to increase future profits.

Not all goods and services for family consumption are provided by outside specialists. All that is done to maintain workers who labor for others, such as providing meals, caring for their clothing, and the like, may be regarded as a "subsidy" to those who profit from their labor. Since most of this unpaid maintenance work is performed by women within the home, we can regard women as the major "subsidizers" of capitalist industrial production.

Furthermore, productive entrepreneurs (those who own a business or factory) cannot make profits unless they pay workers less than the market value of what they produce—or else there would be nothing left over for the owners. To the extent that women workers are paid lower wages for our work than men (as has invariably been the case), we can say that women have "subsidized" the development of industry and capitalist economies as a whole. This has especially been the case in the recent development of Third World nations. Women there not only provide cheap labor in industry but also continue to produce food and clothing in the rural countryside for our families, who also work for industry. The African or Latin American male laborer who works for low wages in a mine or a factory depends on his wife to grow food to feed the family. The wife's efforts, however, are rarely appreciated as contributing—as they do—to the Gross National Product of the nation: they are a free subsidy to the nation's development. It is doubtful that any country now considered "developed" could have achieved economic development through industrialization had it not been for a similar subsidy—an absorption by women of costs.

Division of Labor by Gender: Women's Work

Slaves and Serfs. In some economic systems, the lowest levels of the working class were slaves, including both women and men who were not paid at all for working. The institution of slavery was known in antiquity, in Biblical times, and in ancient Greece and Rome as well as in the more recent history of South and North America and Africa. Before the end of slavery in the United States as a result of the Civil War (1860–1865), slave-owners depended upon both female and male slaves to produce staple crops, provide skilled labor, and maintain their households through domestic work, including raising their children.

In the American South, black slaves were worked to obtain the maximum amount of labor possible, generally by means of coercion. Women were overworked to an even greater degree than men. In addition to the work we performed for our masters, we also cooked and cared for our own families and produced more slaves for our owners.

Slave women and men resisted and rebelled against their conditions, sometimes by slowing down their labor, sometimes by damaging their masters' property. They ran away and engaged in open uprisings. Many freed slaves who escaped to the North returned to help their sisters and brothers flee. Perhaps the best known was Harriet Tubman (1820?–1913), a leader of the "underground railroad." Called "Moses" and "General Tubman," she continued her activities during the Civil War and posed such a threat to slave-owners that she carried a $40,000 bounty on her head (Hymowitz and Weissman, 1978).

Slavery, however, was often not the mainstay of an economic system. In

Europe, the slave-based economic system of the Roman empire was over-turned in the fifth century and replaced by small-scale economies made up of free and slave labor. There also developed a system of serfdom binding workers to the soil; it existed for centuries. Serfdom gradually gave way to economic systems based on "free" wage labor. "Free" labor has been the most effective source of work in West European economies since the four-teenth century. The broad base of most contemporary economies is the "working class." With the development of capitalism, the vast majority of workers outside the home sell their labor for wages and cannot exist without doing so. They are "free" to accept what work they can find, but not free *not* to sell their labor for wages.

Working-Class Women: Skilled Labor. Until the development of the factory system and of workplaces designed to fit the industrial model, production, as we have seen, was generally a household enterprise. Commerce was carried on in shops and counting houses while those who made the products to be sold lived in the back or upstairs. Most of these enterprises called upon the labor of the entire family with additional help supplied by apprentices, ser-vants, and sometimes slaves.

Although all the family shared the work, members did not do the same things and were not equally recognized for their contributions. In small-scale craft enterprises, it was commonplace for the man to work at the craft, producing goods, while his wife ran the shop, selling goods and keeping the books. This division of labor was even more pronounced in Europe, where the more elite, urban professions and crafts organized themselves into guilds by the thirteenth century. Most of the better, more skilled, and lucrative occupations barred women from membership. The knowledge of the craft was a "mystery" theoretically opened only to licensed apprentices (male). But the regulations of some guilds at least made provision for the master to call upon the assistance of members of his own family and even his maidservants. In other words, he might teach his skill or some aspect of it to women who would assist him in his work. Such female dependents, however, could never threaten the exclusivity of the craft by setting up independently (Tilly and Scott, 1978).

There were some guilds in which women did participate as independent and fully active working members. Out of several hundred crafts registered in thirteenth-century Paris, six were composed exclusively of women: silk spin-ners, wool spinners, silk weavers, silk-train makers, milliners of gold-braided caps, and makers of alms purses. In England, fourteenth-century guilds listed women as brewers, bakers, corders, and spinners and as working in wool, linen, and silk. Florentine statutes of the same period list women as making lace, selling tripe, and making sausages under the auspices of the butchers' guild. In addition, mixed guilds employed both women and men in various

places as ostrich featherers, pearl-cap makers, fur-cape makers, poulterers, pastry cooks, and in many other jobs. Women never appear to have been eligible for office in these guilds. Indeed, it is more likely that the guilds were organized by employers or by civil authorities for the purpose of placing women under surveillance to prevent our pilfering the stuffs we were provided with to take home and work on.

Working-Class Women: Domestic Wage Labor. A vast proportion of wage-earning women have worked as domestic laborers: maids, cooks, and nurse-maids. We have contributed to the maintenance of a distinctive standard of living for men and women of the middle and upper classes, enabling them to occupy large, sometimes sumptuous residences and to enjoy elaborate social lifestyles.

The industrial economies of England and France in the nineteenth century experienced an extraordinary increase in the number of women domestic servants. In London in 1861, for example, one in every three women fifteen to twenty-four years old was a servant. By 1891, this was the occupation of 45 percent of women in Paris (McBride, 1976). "By 1900 there were five million female wage earners in the United States, making up one-fifth of the nation's total work force. Two million of these women were domestics— maids, cooks, nurses, and laundresses, who worked in private homes" (Hymowitz and Weissman, 1978:234). In the South, most female domestics were black; elsewhere, they were primarily recent European immigrants. Scandinavian and Irish women, for example, tended to become domestics, while Jewish and Italian women preferred factory work, even at lower wages. To this day, domestic labor in the United States continues to depend on the availability of black and immigrant women, although the source of immigrants has shifted to Mexico, South America, and the Caribbean.

Domestics had little more freedom than slaves. Our personal lives were closely supervised, and our working hours were ill-defined and long, with very little time off. The less skilled were treated with little respect; indeed, we were often "invisible" to our employers. We had little or no job security or bargaining power, nor opportunity to organize to protest our working conditions or low wages.

Today, in the developed nations at least, the role of female domestics has greatly diminished. Middle-class households depend on servants little or not at all. One important exception, however, should be noted: because of the absence of adequate day care facilities or close kin to help out, working women with young children in the United States have frequently come to depend on hired domestic help for child care and housekeeping. Were it not for the availability of relatively cheap domestic labor, a considerable proportion of women who now have paying careers would be obliged to stay at home to care for our families since few men are yet willing to do so or even

to share equally the responsibility of parenting. Many women acknowledge not only our dependence on these workers but also some sense of guilt. We are conscious that our own ability to pursue careers is built upon a form of exploitation: paying poorer women relatively low wages for this domestic labor. In some areas, domestic workers have begun to form associations to enforce minimum-wage levels.

Working-Class Women: Factory Workers. Between 1900 and 1910, the proportion of workers among women of working age in the United States rose from 20 to 23.4 percent (table 13.1). This was due in large part to a major influx of European immigrants, most of whom worked in factories. Many from Italy or Russia had had previous experience in the needle trades and garment factories. The labor organizer and anarchist Emma Goldman, for example, had worked in a glove factory in St. Petersburg (now Leningrad), and her first job in the United States was in an overcoat factory (Hymowitz and Weissman, 1978).

Female factory workers were not new to the American economy in 1900. In the 1820s and 1830s, single women were employed in textile mills throughout New England. The millowners could recruit us at half or less the pay of men. Mostly young women and the daughters of farmers, we came to work for a short period before marriage to help support our families and ourselves (see chapter 15). We generally began in our teens, working twelve to thirteen hours daily, six days a week. Our lives were closely supervised: we were required to live in company housing and to attend church regularly. Many devoted spare time to studying, reading, and writing. Some had high ambitions, going on to become teachers and writers.

But factory conditions gradually deteriorated at Lowell, Lawrence, Waltham, and the other New England mill towns. Owners began to demand more and give less to their workers. When textile prices fell, the owners lowered wage rates to keep up their profits. From time to time, the workers staged protests, walkouts, and strikes. The first strike by women in America occurred in 1828 in Dover, New Hampshire, when four hundred factory workers protested fines charged for lateness. Some eight hundred women at the Lowell mills went on strike in 1834, and fifteen hundred walked out in 1836 to protest wage cuts. In the 1840s, these millworkers organized an annual petition campaign calling upon the state legislature to set a ten-hour limit on the factory workday (Dublin, 1977). However, our efforts to improve conditions through protest, organization, and alliance with men's groups met with little success. By mid-century, native-born female factory workers were rapidly being outnumbered by poorer immigrant women, initially Irish. These women in turn took over the struggle to organize and protect factory workers. We produced women labor leaders later in the century, like Mary Harris ("Mother") Jones (1830–1930) and Elizabeth Gurley Flynn (1890–

Table 13.1 Women in the Labor Force: Selected Years, 1900–1978*

Year	Women in the Labor Force (thousands)	Women in the Labor Force as a Percent of:	
		Total Labor Force	All Women of Working Age
1900	4,999	18.1	20.0
1910	8,076	21.2	23.4
1920	8,229	20.4	22.7
1930	10,396	21.9	23.6
1940	13,007	24.6	25.8
1945	19,304	29.2	35.8
1950	18,412	28.8	33.9
1955	20,584	30.2	35.7
1960	23,272	32.3	37.8
1965	26,232	34.0	39.3
1970	31,560	36.7	43.4
1971	32,132	37.0	43.4
1972	33,320	37.4	43.9
1973	34,561	38.0	44.7
1974	35,892	38.5	45.7
1975	37,087	39.1	46.4
1976	38,520	39.7	47.4
1977	40,067	40.3	48.5
1978	42,002	41.0	50.1
1979 (6-month average January–June)	43,094	41.2	50.8

*Labor force data for 1900 to 1930 refer to gainfully employed workers. For 1900 to 1945, data are for persons 14 years of age and over; beginning in 1950, data are for persons 16 years of age and over.

Source: U.S. Department of Labor, 1979b:1.

1964). Both traveled throughout the country as labor organizers, participating in strikes (box 13.2).

While women immigrants worked in a wide variety of industries, we were clearly predominant in the garment industry—and still are. It was in this industry that our union activities had the greatest impact. When Rose Schneiderman (1882–1972) arrived as an immigrant, she found work in factories and went on to become a union organizer among garment workers. A strike of women shirtwaist workers in New York City in 1909 brought tens of thousands of members to the International Ladies' Garment Workers Union (ILGWU). Although beaten by hired thugs, the picketing women managed to win an increase in wages. Another goal, recognition for the union, was not achieved until 1913. Then, despite the fact that 80 percent of the garment workers were women, the ILGWU was dominated by men; not surprisingly, it classified the male-dominated crafts of cutting and pressing as

Mother Jones and the March of the Mill Children Box 13.3

In the spring of 1903 I went to Kensington, Pennsylvania, where seventy-five thousand textile workers were on strike. Of this number at least ten thousand were little children. The workers were striking for more pay and shorter hours. Every day little children came into Union Headquarters, some with their hands off, some with the thumb missing, some with their fingers off at the knuckle. They were stooped little things, round shouldered and skinny. Many of them were not over ten years of age, although the state law prohibited their working before they were twelve years of age.

The law was poorly enforced and the mothers of these children often swore falsely as to their children's age. In a single block in Kensington, fourteen women, mothers of twenty-two children all under twelve, explained it was a question of starvation or perjury. That the fathers had been killed or maimed at the mines.

I asked the newspaper men why they didn't publish the facts about child labor in Pennsylvania. They said they couldn't because the mill owners had stock in the papers.

"Well, I've got stock in these little children," said I, "and I'll arrange a little publicity."

We assembled a number of boys and girls one morning in Independence Park and from there we arranged to parade with banners to the court hourse where we would hold a meeting.

A great crowd gathered in the public square in front of the city hall. I put the little boys with their fingers off and hands crushed and maimed on a platform. I held up their mutilated hands and showed them to the crowd and made the statement that Philadelphia's mansions were built on the broken bones, the quivering hearts and drooping heads of these children. That their little lives went out to make wealth for others. That neither state nor city officials paid any attention to these wrongs. That they did not care that these children were to be the future citizens of the nation.

The officials of the city hall were standing in the open windows. I held the little ones of the mills high up above the heads of the crowd and pointed to their puny arms and legs and hollow chests. They were light to lift.

I called upon the millionaire manufacturers to cease their moral murders, and I cried to the officials in the open windows opposite, "Some day the workers will take possession of your city hall, and when we do, no child will be sacrificed to the altar of profit."

The officials quickly closed the windows, just as they had closed their eyes and hearts. (Jones, 1972:71–72)

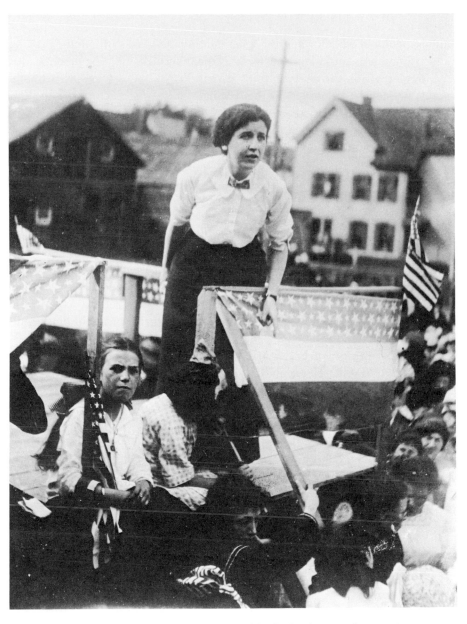

Elizabeth Gurley Flynn was a labor organizer and leader by the time she was sixteen years old. The child of Irish immigrants, Flynn devoted her life to radical and social causes. Here she addresses strikers from Patterson, New Jersey, silk mills in 1913. (Brown Brothers)

highly paid skilled labor and the female-dominated tasks of joining, draping, and trimming as unskilled, and we were paid accordingly. The union leaders did not press for safety regulations demanded by the women, even though many women had perished in the Triangle Shirtwaist Factory fire in 1911 (Kennedy, 1979).

During the Depression in the 1930s, a great deal of propaganda told employed women that we were taking jobs from men. After the Second World War in the 1940s, women were told that for us to work away from home was unfeminine and harmful to our families. The women who had worked in heavy industry during both wars by no means welcomed the opportunity to be relieved of their high-paying jobs. But we had no power to resist layoffs, no means to fight for our interests. A documentary film illustrating such women's histories is *The Life and Times of Rosie the Riveter.*

In the 1970s, a few women began to obtain high-paying heavy industrial jobs at twice the wages we could earn as secretaries. Generally such efforts continue to be strongly resisted by male workers who see us as competitors for scarce jobs. Many women have fought for legal reforms to ban gender discrimination in hiring and promotion. Today, only about one-sixth of American working women are factory workers. Women are still only rarely employed or trained in technical or industrial trades and still routinely excluded from many "skilled" trades. While we have about the same educational levels as men (12.5 years), our vocational training usually prepares us for different kinds of work. Today's working woman is more typically "a typist, maid, teacher, nurse, cashier, or saleswoman" (Kreps and Leaper, 1976). Thus, we now shift our attention to the "pink collar" workers and the "professions."

The Pink Collar Worker. Women today predominate in clerical work, sales, and services. Gender segregation in the workplace is as emphatic as ever: the range of jobs open to women is narrower than that open to men; the jobs largely filled by women are rarely taken by men; and women's jobs are stereotyped in the workplace just as they are in the home (table 13.2). The largest proportion of working women are clerical workers, including one-third of employed married women. The secretarial profession is almost exclusively female; the nursing profession is nearly so. While both women and men work as salespeople, we sell different things. Men, for example, sell cars and insurance; women sell women's clothing and cosmetics. In this century, primary production has been replaced by the service sector as the largest growing part of our economy. The service sector is involved in the sales and distribution of goods and of services themselves. Most women who are employed work in this sector, mainly in exclusively female jobs known as *pink collar* work.

What exactly is pink collar work? Normally, blue collar work is under-

stood to be the manual labor done by the working class, such as that in a skilled trade (by a plumber or steelworker, for instance) or in unskilled work (by a factory production line worker or sanitation worker). White collar work is usually understood to mean middle-class office work, such as that of business accountants, government bureaucrats, and those who work in advertising and public relations. Women office workers have been led to think of ourselves as white collar workers, but our pay has been lower than that of blue collar workers. Feminists classify poorly paid work done almost exclusively by women as pink collar work.

Pink collar workers are female, and often part of our "job" is to look "feminine": to show up for work in attractive clothing, well-coiffed and groomed, or to wear clothes that will appeal to customers. The pink collar worker labors in an office or beauty parlor or restaurant but gets paid at rates comparable to those of an unskilled blue collar worker. The work is often highly impersonal and routine, and we may be segregated from male workers, as in a typing pool.

Clerical and secretarial work became available to women late in the nineteenth century, especially with the introduction of the typewriter, which both speeded up paperwork and contributed to its volume. Almost from the start, the "typewriter" was a woman: it was thought acceptable to train us to use this office machine. With the opening of this new opportunity, thousands of women with a high-school education were drawn to secretarial work as an attractive alternative to becoming sales clerks or telephone operators, the other new service occupations opening up to women with education. In 1890, two-thirds of stenographers and typists were women; by 1930 the percentage of women reached 95.6 percent (Davies, 1978). Today, typing (and increasingly the word processor) is considered essential in most office work open to women. Regardless of our educational background or career aspirations, women looking for work nearly everywhere are met with the question, "Can you type?"

Secretaries are often treated in a degrading manner, particularly by male employers. It has been perfectly acceptable for a male employer to refer to the secretary in his office as his "girl" and to call her by her first name, regardless of their respective ages, while she addresses him in a formal manner, using his surname. Secretaries are often obliged to undertake a variety of personal services for our employers, from getting coffee to taking suits to the cleaners.

Gender attributes are often considered part of job qualifications: preference may be given to women who are young, deferential, and sexually attractive. Pink collar workers are trained in deference and expected to be self-effacing rather than ambitious. What might happen when such social expectations are turned on their head was the plot of the film *Nine to Five*.

In part, the gender segregation of office workers is something of an illusion, a product of labeling the things done by women and men differently. In

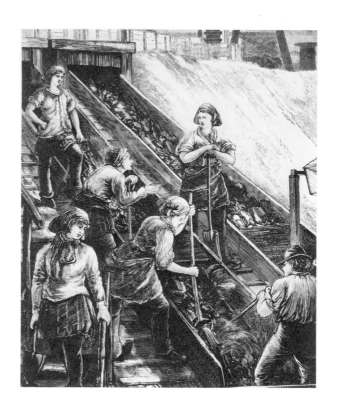

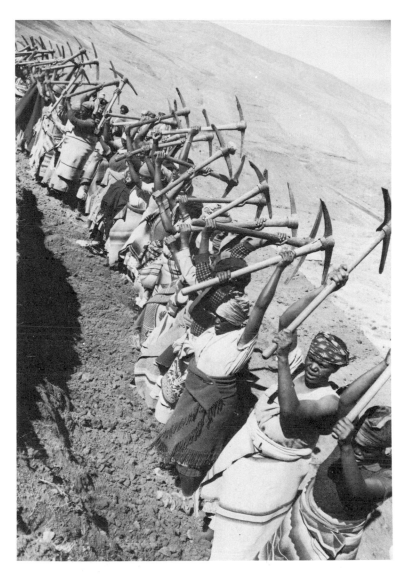

(Opposite top) An illustration depicting women working at the surface of a coal mine in Wigan, England. It appeared in *The Pictorial World,* Saturday, April 18, 1874, reminding Victorian readers that English women worked at hard, outdoor manual labor. (Birmingham Public Libraries)

(Opposite bottom) Workers in a fruit cannery in Australia in the early twentieth century. As countries industrialized, women often found jobs outside the home in areas that were extensions of the work traditionally done in the home. (Culver Pictures, Inc.)

(Above) In debates about the gender segregation of the work force, a case has often been made that women do not have the physical strength to do "men's work." These women in modern Lesotho, a land-locked African state surrounded by the Republic of South Africa, make up a work crew building a cross-country road. As Sojourner Truth commented about her own life of hard physical labor, "and ain't I a woman too?" (United Nations/Mudden)

Table 13.2 Employment in Selected Occupations, 1950, 1970, 1978 (Numbers in Thousands)

Occupation	Both Sexes			Women as Percent of All Workers in Occupation		
	1950	1970	1978	1950	1970	1978
Professional-technical	4,858	11,452	14,245	40.1	40.0	42.7
Accountants	377	711	975	14.9	25.3	30.1
Engineers	518	1,233	1,265	1.2	1.6	2.8
Lawyers-judges	171	277	499	4.1	4.7	9.4
Physicians-osteopaths	184	280	424	6.5	8.9	11.3
Registered nurses	403	836	1,112	97.8	97.4	96.7
Teachers, except college and university	1,123	2,750	2,992	74.5	70.4	71.0
Teachers, college and university*	123	492	562	22.8	28.3	33.8
Writers-artists-entertainers	124	761	1,193	40.3	30.1	35.3
Managerial-administrative, except farm	4,894	6,387	10,105	13.8	16.6	23.4
Bank officials-financial managers	111	313	573	11.7	17.6	30.4
Buyers-purchasing agents	64	361	370	9.4	20.8	30.5
Food service workers	343	323	589	27.1	33.7	33.8
Sales managers-department heads; retail trade	142	212	343	24.6	24.1	37.3
Clerical	6,865	13,783	16,904	62.2	73.6	79.6
Bank tellers	62	251	449	45.2	86.1	91.5
Bookkeepers	716	1,552	1,830	77.7	82.1	90.7
Cashiers	230	824	1,403	81.3	84.0	87.1
Office machine operators	143	563	827	81.1	73.5	74.2
Secretaries-typists	1,580	3,814	4,570	94.6	96.6	98.6
Shipping-receiving clerks	287	413	461	6.6	14.3	22.8

*Includes college and university presidents.

Source: U.S. Department of Labor, 1979b:3.

insurance companies, for example, both women and men process policy applications. The men are higher-paid and called "underwriters" while the women are paid less and called "raters." By giving the same job two different titles, one for men and one for women, companies can classify the title used for women at a lower wage rate.

Women who work in pink collar jobs rarely have any significant opportunity for promotion. We enter at the bottom of the hierarchy and may, if very lucky, end up in the middle. Men enter in the middle and aim for the top. The ultimate achievement for a secretary might be to become executive secretary to the president—but almost never to become president, or even executive vice president of the company.

Women working full-time and year-round earn only about sixty percent as much as men earn (table 13.3). This differential has remained almost the same over some twenty years, although women are entering the work force in greatly increased numbers, and working in jobs formerly held only by men. One argument sometimes made is that the pay differential results from the fact that the entering women are less experienced rather than from discrimination. To test this argument, economists hold constant the variables of age, experience, and duration of the job, and find that women still get paid less than men, and are still promoted more slowly (Rotella, 1980). There is no doubt that discrimination is still rampant.

The Professions. The professions include the arts, law, medicine, teaching, and management. Work in them often requires more training and education than do other kinds of work, although critics claim that the structure of the professions is often designed to preserve class privileges (by requiring, for instance, lengthy training that often only the rich can afford) more than to enhance the quality of the work performed. Most of the professions set their own standards for qualifications and performance and generally pay more than blue and pink collar workers make.

Work in the professions, like other forms of work, is highly segregated by gender. Women professionals tend to hold lower-paying jobs and positions of less authority, power, and prestige. In the United States, women outnumber men in the professions of nursing, elementary and secondary school teaching, social work, and library work. Women are strikingly underrepresented in most other professions, such as medicine, law, science, engineering, higher management, finance, and stockbroking. While many women have been trained and are active in the arts, few have held top-ranking positions in architecture or design, or as producers or directors in theater or film. Women have also experienced systematic discrimination against our work as writers and artists, so that it is harder for us than for men to gain recognition and make a living in the arts. In recent years, thanks in part to consciousness-raising by the women's movement and in part to antidiscrimination laws, increasing num-

Table 13.3 Earnings of Women and Men

Median Weekly Earnings of Full-Time Wage and Salary Workers, by Selected Characteristic: 1970 to 1980 [In current dollars of usual weekly earnings. For 1970–1978, as of May. Beginning 1979 data represent annual average. Due to changes in data collection procedures, data for 1979 and 1980 are not strictly comparable with earlier years.]

	1970	1974	1975	1976	1977	1978
All workers	$130	$169	$185	$197	$212	$227
Male	151	204	221	234	253	272
16–24 years old	112	146	149	159	168	185
25 years and over	160	219	235	251	273	294
Never-married	113	144	153	161	173	190
Husbands	159	216	234	248	272	293
Other marital status	139	194	205	224	239	263
Female	94	124	137	145	156	166
16–24 years old	88	111	117	125	133	142
25 years and over	96	131	146	154	165	175
Never-married	95	120	132	141	150	159
Wives	95	126	139	147	158	167
Other marital status	91	123	138	146	158	168
White	134	173	190	202	217	232
Male	157	209	225	239	259	279
Female	95	125	138	147	157	167

	1979	1980
All workers	$244	$266
Male	298	322
16–24 years old	201	214
25 years and over	322	346
Female	186	204
16–24 years old	153	171
25 years and over	197	217
Husbands	324	349
Wives	189	208
Women who maintain families	190	210
Men who maintain families	301	314
White	249	273
Male	306	329
Female	187	206
Black	204	219
Male	233	247
Female	174	190

Black and other						
Black and other	99	140	156	162	171	186
Male	113	160	173	187	201	218
Female	31	117	130	138	147	158
Occupation:						
Prof. and technical	181	228	246	256	277	264
Managers, administrators[1]	190	250	274	289	302	323
Salesworkers	133	172	189	198	225	232
Clerical workers	109	140	150	158	167	175
Craft and kindred wkrs	157	211	223	239	259	279
Operatives, except transport	(NA)	141	157	162	171	191
Transport equipment operatives	(NA)	180	198	214	231	249
Nonfarm laborers	110	140	154	161	181	193
Private household wkrs	38	50	54	60	59	59
Other service workers	87	117	123	134	142	152
Farmworkers	71	107	111	120	127	139

Hispanic origin		
Hispanic origin	197	214
Male	226	238
Female	156	177
Occupation:		
Professional and technical	316	341
Managers, administrators[1]	349	380
Salesworkers	254	279
Clerical workers	195	215
Craft and kindred workers	303	328
Operatives, exc. transport	211	225
Transport equipment operatives	272	286
Nonfarm laborers	206	220
Service workers	164	180
Farmworkers	157	169

NA Not available

[1] Excludes farm

Source: U.S. Bureau of Labor Statistics. *News,* Oct. 12, 1978, Mar. 27, 1980, Mar. 5, 1981, and unpublished data.

Source: U.S. Department of Commerce, 1981:407

Ed. note: In constant (1977) dollars, compensation per employee-hour dropped 3% between 1970 and 1980.

bers of women have entered and achieved success in professions formerly barred to us.

It is appropriate to consider women in the professions from two points of view: women in those professions which society deems "female," and those in professions which society deems "male." The issues in each are somewhat different.

Within the "women's" professions (nursing, social work, elementary and secondary school teaching, and library work), there is a gender segregation which places men at the highest decision-making levels. More men than women are principals, superintendents, chief officers, and faculty and administrators of professional schools. For the most part, these female professions offer limited career mobility; they are the lowest-paying and least "powerful" of the professions. Yet they are enormously important to society, and they provide large numbers of women with the opportunity to pursue gratifying careers, although society has not elected to reward us with high pay or status. It is likely that we are poorly paid and often belittled *because* we are in women's professions.

The range of "men's" professions is much wider. The occupants of these professions—physicians, lawyers, and professional managers, for example—are dependent on the technical support of an army of trained female employees: nearly all hospital workers who are not physicians are female, and legal secretaries, bookkeepers, and office managers are primarily female. Whereas female professionals who deal with men are likely to be dealing with our superiors, male professionals who deal with women are likely to be dealing with their subordinates. The male-female hierarchy is conspicuous throughout the professions.

Women who enter a "male" profession are likely to encounter a series of social obstacles. Not only will we be in the minority among our peers, but our subordinates, whether female or male, may have difficulty relating to us (and we to them) as superiors or bosses. The hierarchical arrangement that is still (however mistakenly) so much taken for granted comes into question when women hold positions of authority. Hospital patients confronted by female doctors assume we are nurses. Law firms may still hesitate to place female lawyers in charge of a major (male) client's interests, for fear that we will not be acceptable. University colleagues refer to female professors by our first names but refer to male professors by their titles. Many men in many professions are able to use the "surplus skills" of talented women in lower-status jobs to boost their own advancement. Many a mediocre male "writer" or "scientist" has gained promotion as a result of the unacknowledged work of a brilliant female "assistant."

There is a tendency for gender segregation within "male" professions as well. Female physicians tend to go into pediatrics; female lawyers into probate (dealing with wills and property dispositions to widows and offspring); and

female professors into the humanities and social sciences rather than physical sciences. The segregation of genders between professions and even within the professions is in part the result of gender discrimination in education.

While some professionals are self-employed, most are not. On the whole, women professionals tend to be employed as specialists in larger organizations rather than as independent general practitioners.

Minority Women and Work in the United States

Minority women in the United States are not the unified group we are sometimes portrayed as being. Too often, the word *minority* is taken to mean black and Hispanic women, omitting Asian and Native American women. Members of all these groups are in a minority because we are not part of the Caucasian majority of predominantly European heritage. Each of the minority groups represents a different pattern of involvement with the labor force.

Black women often have career expectations and pursuits (Ladner, 1972). In the United States, we have been a significant part of the labor force since the days of slavery. Our labor was expected in the fields, inside the master's house, and for our own families. Black women slaves were also expected to be compliant sexual objects for white masters. When slavery was abolished, many black women turned to employment as domestics, laundresses, and child care workers to help maintain our families. Because black men often found it more difficult to gain employment, black women quickly recognized our importance in economic survival. When unable to rely on black men to care for us, we also became heads of households. In this sense, black women experienced labor force participation along with family responsibilities through the period when fewer white women carried this double burden.

Because of racism, black women have generally been employed at the lowest rung of the labor market—working long hours for meager wages with few job benefits except at the benevolence of an employer, usually a white family or boss. Despite these handicaps, black families have stressed the value of education, especially for daughters. More recently, civil rights legislation has increased access for black children and adults to educational and job opportunities and has allowed many black women to prepare for careers in teaching and nursing, the female-dominated occupations open to us.

Women of Hispanic origin in the United States generally represent three places: Mexico, Puerto Rico, and Cuba. Our cultural patterns are built around a "machismo" norm. This norm, with its emphasis upon the display of male power, places very little emphasis on education for women, promoting instead frequent childbearing without fertility control and a passive female disposition, willingly subordinated to male authority. These conditions often discourage women from entering the labor force (Almquist and Wehrle-Einhorn, 1978:74). Since many Hispanic women are either immigrants or

first- or second-generation Americans, language barriers frequently persist, reinforced by family residential patterns.

In the United States today, a large number of Hispanic women are illegal aliens; in order to avoid apprehension, these women often live in very isolated situations. Many Hispanic women work as migrant farm labor, traveling all over the country picking fruits and vegetables, and in factory work (sweatshops) doing piece work. Both of these endeavors are generally conducted in an exploitative fashion, giving the women little power to shape our work environment.

Asians, particularly Chinese and Japanese immigrants, have a very different profile. Japanese Americans, including women, have the highest educational level of any ethnic group in the United States. Since World War II, Japanese-American women have entered the labor force, in contrast to the passive, subordinate role of the traditional Japanese woman. This has often created conflicts in the immigrant Japanese community. Japanese-American women, like Japanese-American men, often enter the sciences. Chinese women, too, are often highly educated; many of us enter the labor force in the service fields. More recent Asian immigrants, such as the Vietnamese, are slowly finding employment. Like Hispanic women, Vietnamese women are subject to a language barrier, but our cultural patterns encourage the learning of English (Almquist and Wehrle-Einhorn, 1978).

Native American women are the most economically disadvantaged group in the United States (ibid). Many do not enter the work force beyond the reservation. There we may be employed in clerical, craft, or service jobs, but limited education hampers our participation in the wider economy.

The Multinational Corporation

One of the most powerful forces affecting our shrinking world is the multinational corporation. These corporations locate their operations in areas where they can tap cheap, docile labor. Third World women have become the prime targets of the search for cheap labor on the global assembly line. The governments in Caribbean and South American countries, and in many countries in Asia, advertise the availability of a large supply of female labor. Often women in these countries do not have equal rights of citizenship, much less rights to control our work environment. To take advantage of this cheap female labor, factories making computer chips or piece goods are springing up all over the world. Instead of leading to economic gains for those in the underdeveloped countries, much of the "development" conducted by multinational corporations drains resources from Third World countries to increase corporate profits. A thin layer of local elite may also gain, but overall the poor are exploited to enhance the wealth of those abroad (Barnet and Müller, 1974).

Multinational corporations follow labor practices which would be unac-

ceptable elsewhere. Often these practices severely compromise the health and life expectancy of the workers. But the women who enter the labor force in these countries face extreme poverty. We need even the lowest wages for survival, and we have almost no ability to resist exploitation.

Many feminists do not wish to achieve economic advancement for ourselves at the expense of our sisters elsewhere. The avoidance of this dilemma will require the development of far more enlightened policies on the part of corporations and far better foreign economic policies by the United States than are now present.

Self-Employment

Given the various obstacles women face in large work organizations and our own desire not to participate in corporate exploitation, why do we not find more women self-employed?

The fact that relatively few women are self employed can be traced in part to the different socialization of girls and boys. Girls tend not to be taught to take the initiatives, or to be assertive or independent. When we do show these qualities, which underlie successful self-employment, we receive fewer rewards than boys or even negative sanctions. In addition, women have less access to sufficient material or monetary resources to establish independent enterprises. Because we earn less, we can save less. Financial institutions have long maintained discriminatory practices, denying loans and credit to women simply on the basis of gender. While laws today prohibit such discrimination, it is not easy to end traditional attitudes translated into business practices. Without loans and credit, an individual cannot start or run a business in this country.

Even so, some ambitious women have managed to overcome many of the financial barriers to self-employment. But as in the case of other sorts of work, there is considerable gender segregation. A self-employed woman is more likely to be found as a woman's boutique owner, or a free lance illustrator of children's books, or an interior decorator than as a machine-parts distributor or a tax consultant. Women have tended to go into businesses and services long identified with our traditional roles related to home, family, and personal care.

Women in Corporations

Some feminists hope to reform the corporation from within by gaining positions of power. Our ability to do so remains questionable. Corporations have traditionally employed men in the management of the business enterprise. Conformity to an unwritten standard of appearance, background, and social status was expected in order to achieve advancement (Kanter, 1977). Just as women had our designated place in the social environment, so did men in the corporate world. Women were secretaries or personal assistants, job catego-

ries which did not provide entry into advancement within the managerial ranks. A woman who did enter the managerial ranks often did so as a "specialist" and tended to stay in that job. Only recently have women filled positions at upper management levels and entered the boardroom, and we are still present only in token numbers (Hennig and Jardin, 1977). The need to conform to unwritten standards and corporate objectives is still present for those who seek access to rank within the corporation. At this time, only a few women have moved into influential positions in business without losing sight of feminist objectives.

Unemployment

The most serious difficulty women who wish to work may face is the inability to find a job. In most countries, whether capitalist, socialist, or Communist, governments recognize the responsibility to provide jobs to those who cannot find them. The United States is almost alone in denying this obligation, though even those which acknowledge it may also fail to avoid high levels of unemployment. Government attempts to encourage or stimulate so-called "private sector" employment are often unsuccessful, especially for women and minorities who are routinely "last hired and first fired." It has been argued the right of an individual to employment, provided by the government if not available otherwise, should be recognized as a human right (Nickel, 1978).

Unemployment rates are almost always higher for women than for men. Those opposed to the greater independence of women welcome this fact and assert—in the face of clear evidence to the contrary—that it "doesn't matter," because we work because we want to rather than because we need to. If women are to be able to lead decent productive lives, among our first priorities must be the assurance that when we seek employment, jobs will be available. To be able to compete on equal terms with men for an inadequate number of actual jobs will not be enough.

The Politics of Work: Barriers and Strategies

Conflict and Competition Between Women and Men

Although it is interesting for some purposes to view women as a socioeconomic "class" with subordinate economic and political status, much akin to other exploited groups of people within an inegalitarian system, such a view has its limitations (see chapter 14). Women and men have special relationships that are not replicated in any other kind of social relationship. As daughters, sisters, wives, and mothers of men, we are not simply competitors with them for resources, and we cannot entirely separate our own interests from those of the men to whom we are in some way related.

The reverse is also true: men are tied ultimately to women as our fathers,

brothers, husbands, and sons. Why, then, are not men more supportive of women's efforts to gain economic equality? This is a multifaceted issue. First, men may feel that having their wives work for wages will threaten their own authority within the household. Second, women at home usually perform tasks that enhance the status of men and secure their leisure time: we keep house, like servants, freeing men from drudgery. Third, men's social status often relies on their being the only breadwinner in the family. This situation is only beginning to change.

Many households require more than one wage earner. Why do not men whose wives *must* work for wages support advancement for women in the workplace? Men's concern for having a status superior to that of their wives operates here too. But the explanation must also incorporate a broader view of the economic system. In industrialized economies, jobs—or at least "good" jobs—are scarce: there are generally more workers available than there are attractive jobs. By reducing the pool from which prospective employers can draw, those who have or could have "good" jobs hope to reduce competition, to better their chances and force up their pay. By supporting both sexist and racist discrimination in employment, white male workers may believe they are improving their own lot, even though such discrimination undermines their own daughters, wives, sisters, and mothers.

This strategy may backfire, by creating a pool of readily available underemployed female workers who will work for lower pay. Furthermore, the attitude of many men toward the advancement of women in the workplace often undermines their relations with the women in their families.

Nuclear Families, Labor, and Capitalism
The nuclear family in an industrialized economy is particularly vulnerable to the circumstances of gender competition in employment. The nuclear family relies on only one woman to do all the work traditionally done by women at home. Yet it may also require the contributions of two wage earners. The argument frequently given to rationalize lower pay for women is that our pay is supplementary; we do not need to support a household because men do. Increasingly, this is not the case: many households have no men; others have men who are unemployed; many others are "supported" by men who do not earn enough. In addition, the vulnerability of the female worker contributes to the vulnerability of the male worker who has a family to support: the more his wife depends on him, the more he depends on his job. Paying women less also warns men that they can be replaced more cheaply.

The perpetuation of a domestic situation in which women are responsible for all household tasks and child rearing and men are viewed as the primary breadwinners is favorable to the dominant class in a capitalist system: it helps to keep workers in line. If men cooperated with women, supporting social services to relieve parents of some household responsibilities and working for

rights to actual employment and equal treatment, both female and male workers would benefit.

In various social-democratic and socialist countries, the state has taken on some of the domestic responsibility formerly borne by women, such as regular provision of child care and support for time off for mothers. Women and men have more nearly equal opportunity and pay on the job, at least in the lower and middle levels of employment. But discrepancies still exist. Gender division of labor persists at the household level, and there is disparagement of women's abilities at high levels . Women will not have genuinely equal opportunities in employment until fathers take as much responsibility for the care of children and the household, and are as fully supported by the society in doing so, as mothers. Although paternity leaves are not uncommon in Sweden, elsewhere they are rare and often even unheard of.

Sexual Harassment and Other Problems

Women on the job are subject to a variety of problems not often shared or understood by men. Until recently, many of these problems were not addressed by union or legal protection. For example, female pink collar workers are often required to perform tasks not related to our professional skills but rather to our social role as women, such as running personal errands for our bosses and providing psychological support and even sexual favors.

The issue of sexual harassment has only recently come under legal scrutiny. This pervasive problem for women workers is very much underreported. It occurs when an employer or supervisor demands sexual favors from a female employee under threat of dismissal or other reprisal, often not made explicit, or when a woman is subjected to persistent unwelcome sexual advances or innuendos. Women who resist are unlikely to complain, much less take the employer or supervisor to court, but it has now been established in the courts that sexual harrassment is against the law (MacKinnon, 1979).

The problems of pregnancy and employment provide another area of difficulty that is gender-specific. In many areas of employment in the past, pregnant employees were fired when the condition became apparent. Paid maternity leave is still rare. Although socialist countries often grant extended maternity leaves, this may increase rather than decrease gender-role distinctions.

All of these problems are related to women's more general position in society. Although major steps have been taken to correct discrimination and abuse in the workplace through legal means (box 13.4), these changes must go hand in hand with changes in women's roles and status in society at large. Conflict between women and men, seen in economic perspective, supports an exploitative system that favors neither female nor male workers. A more humane organization of economic activity is necessary before women can contribute fully to the human achievement that work allows.

The Dual-Career Family

In families where both husbands and wives have careers, the husbands' careers
generally receive priority. Men usually complete their training first, and fami-
lies usually live where men's jobs are located. This creates problems of geo-
graphical mobility. If husbands have to move, wives may have to give up a
good job and have difficulty finding new ones. If husbands do not move, they
may sacrifice opportunities to rise in their professions. The same is true for
married professional women. Yet traditional expectations may make us feel
obligated to sacrifice our career opportunities in favor of our husbands'. Some
families have made compromises, sometimes by taking turns at whose career
advancement comes first. Other couples set up commuting arrangements—say
a husband in Washington, D.C., and a wife in New York, spending only
weekends together. Such arrangements need careful planning, lest they entail
too many difficulties for both partners, and for any children involved.

Many dual career families have worked out more or less satisfactory arrangements as the situation itself beomes more commonplace. More men are becoming actively involved in child care responsibilities and in sharing household tasks. While the stress of taking care of a family and keeping up with two jobs may be felt by both wife and husband, our marriages may seem more rewarding to both as we work it out together and share our outside interests. Despite the difficulties, many couples consider such arrangements a vast improvement over the kind of marriages of the 1950s caricatured by Betty Friedan in *The Feminine Mystique* (1963) or by Marilyn French in *The Woman's Room* (1977). In these books of non-fiction social comment and fiction, women's and men's worlds were entirely separate, and wives and husbands grew increasingly alienated from one another through different day-to-day experiences.

Social Support for Working Women

Unions. The principal organized support group for working people outside the family is the labor union. In the past, however, unions have not always been particularly supportive of women workers. It is noteworthy that the primary fields of women's employment, whether blue collar, pink collar, or professional, are not unionized. Female domestic workers, clerical workers, secretaries, and nurses are not unionized, and until recently, teachers and librarians were not either. A large proportion of working women have the additional disadvantage of racial and ethnic discrimination; many unions have tended to leave out or discriminate against minority groups, including blacks, Hispanics, and all immigrants.

The conditions militating against women's participation in trade union activity today are much the same as they were over a century ago. Women are seen as dependents, whose primary roles are in the home. The demands of domestic responsibility leave us little time to devote to union activities. We traditionally lack training and experience in public speaking and self-assertion, important aspects of union activity. As the least skilled and lowest-paid workers, we have had little bargaining leverage with employers. We have also faced considerable hostility from working men, who often view us as direct competitors for jobs or union positions and are made uneasy at home by wives who are too "independent" (Kennedy, 1979).

Despite these obstacles, many women have organized ourselves or joined with men to fight for unions and collective bargaining issues. One of the earliest successful women's trade unions was the Collar Laundry Union of Troy, New York, which had some four hundred members at its peak and lasted nearly six years in the 1860s (ibid.). Like many other women trade unionists, these workers were immigrants, in this case Irish. Elsewhere, other largely immigrant women joined to found or to support unions. The Knights of Labor, a national union founded in 1869, offered support to women and

black workers but was soon replaced by the more conservative crafts union, the American Federation of Labor (AF of L) which was interested mainly in skilled white male workers. Despite union organization among women who worked during World War I in machine shops, foundries, railroad yards and offices, on streetcars, and at telephone exchanges, union support for women subsequently fell. Men feared that the presence of women in these workplaces would change working conditions at their expense. Where they could, men defended traditions that barred women from such employment. Women were either relegated to auxiliary groups in unions or remained unorganized (Greenwald, 1980). The highest levels of leadership of labor unions have remained male preserves. Only recently was *one* woman added to the leadership of the AFL-CIO.

Although unions have been extremely slow in overcoming discrimination in their own ranks, unionization has proven beneficial to working women, and existing unions are gradually becoming more aware of women's issues. The United Auto Workers, for example, has endorsed equal pay, gender-integrated seniority lists, day care, and the Equal Rights Amendment. The majority of women workers, however—thirty out of thirty-four million—are still nonunionized. The Coalition of Labor Union Women (CLUW) was formed in 1974 by three thousand women representing fifty-eight trade unions to improve the status of all working women. During the past decade, a number of significant efforts have been made to organize clerical women workers and to negotiate contracts which would address the interests of such workers, including improved opportunities for advancement as well as higher wages. The difficulties faced by a few women who worked in a small-town bank as tellers and bookkeepers, organized a union, and went on strike are vividly depicted in the documentary film *The Willmar Eight*.

Professional Organizations. Professional organizations are often highly conservative bodies, but sometimes their policies have very far-reaching effects, as in the case of the AMA (American Medical Association). Its decisions affect the conduct of physicians toward patients, the public, and one another and the conduct of public policy toward health issues in general. Since women have not been well represented in the professions in the past, we have not figured conspicuously in the leadership of such organizations. Beginning in 1969, groups of organized professional women began to take responsibility for raising the consciousness of the members of our professional organizations to the problems and rights of women, and to the need to include us in leadership positions. One of the authors of this text, Florence Denmark, helped develop a section on the psychology of women in the American Psychological Association and became president of the APA for 1980–1981. Many other professional organizations, such as the American Historical Association, the American Philosophical Association, the American Anthropo-

logical Association, and the American Sociological Association, have experienced the development of women's caucuses. As a result, women are playing a greater role than in the past in keeping these groups alert to the problems of women professionals.

Networks. The family, the union, and the professional association are formal organizations which have a legal standing; networks are informal and have no legal standing. A network is a loose connection among individuals who know one another (or of one another), support one another, and pass along information. They are, for many, the most significant support group in the workplace. They are at once powerful and "invisible," operating to influence career opportunities and the workings of the business and professional worlds but not legally liable or open to attack.

Men in power have always relied on networks. Often, they begin at school, especially private schools, or at colleges, where young men get to know others who share their interests. These acquaintances are often kept up through a lifetime. They are sometimes broadened and shaped through other associations: clubs, civic groups, and special membership organizations. Networks provide their members with access to important information and resources. Leaders in virtually all fields—business, the arts, politics, the professions—rely on them for their continued success. For the most part, women have been excluded from these networks. Men have worked to keep outsiders (including women and minorities) out.

Groups of women who share experiences and interests are now attempting to develop ongoing relationships for mutual aid, sometimes on a formal but more often on an informal basis. The women's movement has created a particularly good climate for the formation of women's networks by keeping women aware of our need for one another and by encouraging our mutual support. Women use professional caucuses, newsletters, and regular meetings as more or less formal networking instruments. Women who "make it" thus lend a hand to others who are not yet there.

Networks operate as support systems in other ways, often equally significant to women. Many women who feel isolated as minorities in the workplace or because we are among the few wives in our neighborhoods to work outside the home need to have the social and emotional support of others who share our feelings, problems, and interests. Groups of women who can share anxieties about children or work, or solutions we have found are extremely important to the adjustment of many women to a stressful life.

Networking of this type is certainly not new to poor women, who have often relied on kin and friends among women to help adapt to a harsh social environment. For these women, household income is not simply low, but unreliable; getting by during hard times requires being able to depend on one's network. When poor women have jobs, turn to our friends, and espe-

cially our kin, for help with child care; when we are out of work, we may receive material help from the network—loans or gifts of food, cash, and the like. Thus the poorest strata of our society, like the wealthiest and most powerful, have long used networks.

Government and Law

Not surprisingly, in societies where women have little political power, laws relating to our ability to control income and property have been largely unfavorable to us. In patriarchal systems in general, women have only rarely been able to control property or income. The money we have earned as workers has fallen under the control of our fathers and husbands. In Western capitalist societies in particular, laws allowing married women control over our separate property were not passed in the United States and Great Britain until 1860 and 1870 respectively.

Protective Legislation

The rationale behind "protective" legislation applied to women's employment, both in this and other countries, has almost invariably been phrased in terms of women's "maternal functions." Conditions that exploited workers in the United States led many progressive reformers—including women leaders—to attempt to regulate industry. They sponsored state laws that prohibited women from such occupations as mining and bartending; limited total hours or days that we might work; prohibited night work; limited the amount of weight we could lift on the job; and so on. They also attempted, unsuccessfully, to guarantee women a minimum wage. A landmark Supreme Court decision, *Muller* v. *Oregon* (1908), upholding a state law restricting women's work hours, reasoned that overwork was injurious to women's physical capacity as mothers, hence threatening to the public interest. Similar arguments have been used in other industrializing countries.

Despite the good intentions of the reformers, such protective laws have in fact restricted our opportunities in the workplace and encouraged other sorts of discrimination against working women. In effect, they were a means of reducing competition for men, of keeping women in certain types of work—and out of others—and of paying us less. If women were prohibited from night work, men would be hired instead. Protective legislation therefore served to protect men and employers more than women. Some restrictions made little sense at all. For example, while women might by law be restricted from jobs requiring us to lift weights of twenty or thirty pounds, we were assumed quite capable of carrying children weighing more.

While laws are certainly needed to protect all workers against unsafe conditions, feminists have viewed many "protective" laws as mere excuses for discrimination. These laws were targeted for abolition by the authors of the Equal Rights Amendment, first introduced in Congress in 1923, but they

were not addressed until 1964, with the equal employment opportunity provisions of Title VII of the Civil Rights Act (Eastwood, 1978).

Laws Against Sexist Job Discrimination

Although no constitutional amendment yet guarantees to women equality under law, two federal statutes enacted in the 1960s provide the legal basis for women's equality in the workplace. One is Title VII of the Civil Rights Act of 1964, amended by the Equal Opportunity Act of 1972; the other is the Equal Pay Act of 1963, amended by the Education amendments of 1972 (Higher Education Act). The Equal Pay Act guarantees to women equal pay for work equal to that of male employees. Title VII of the Civil Rights Act of 1964, particularly Section 703(a), prohibits discrimination on the basis of sex in hiring or discharging individuals and in terms of compensation and conditions of work. It also prohibits classifying (on the basis of sex) either applicants or employees, to avoid adversely affecting our opportunities. The 1972 amendments extended coverage of both acts to executive, professional, and other job categories.13.5

Responsibility for enforcing Title VII is in the hands of the Equal Employment Opportunity Commission, which has the power to initiate court action against an employer. Early court actions in 1969 resulted in substantial payments by Southern Bell Telephone Company and Colgate Palmolive to women and minorities who had been discriminated against, as well as in affirmative action programs to recruit and promote qualified women and minority members. An accord signed by the American Telephone and Telegraph Company with the EEOC and the Labor Department in 1973 set goals and timetables for the hiring and promotion of women and minorities in non–gender-segregated job areas and agreed to some fifteen million dollars in back pay for almost fifteen thousand employees.

Affirmative action requires that employers who have discriminated against women and minorities set goals for reducing or ending such discrimination. For instance, if it can be shown on the basis of population figures or numbers of qualified applicants that a nondiscriminatory hiring policy would have resulted in about a quarter of the workers in a given category being women, an employer may be required to set a goal of 25-percent women employees in that category. In choosing between qualified women and qualified men, the employer might favor women until such a goal had been reached. Preference has often been given to groups such as veterans to compensate for their previous personal sacrifices in the national interest (though many individual veterans suffered little). Affirmative Action is an effort to compensate for past wrongs done by employers, both public and private, to women and members of minority groups.

White males often charge that affirmative action subjects them to "reverse discrimination." Often, it is younger white men who feel this way because

Ladies' Day in the House Box 13.5

On the day the U.S. House of Representatives was supposed to vote on the Civil Rights Bill of 1964, 81-year-old Howard W. Smith of Virginia, Chairman of the Rules Committee, proposed an amendment that sounded like a joke even while the clerk was reading it aloud.

The proposal consisted of the addition of a single word, "sex." Wherever Title VII of the bill on employment prohibited discrimination on the basis of "race, color, religion, or national origin," the Smith amendment prohibited discrimination on the basis of sex, too.

Smith was no feminist. He was a Virginia gentleman who had been defending the Southern Way of Life in Congress for nearly a third of a century. Now that battle was finally lost. Under pressure from President Johnson, Northern Democrats and Republicans had formed a coalition with enough votes to pass the bill giving Negroes really equal access to the polls, schools, public accommodations, and above all, jobs.

Title VII was the most controversial part of the bill. Even people who supported Negro rights were not sure that discrimination in employment could be abolished by law. Midwest and mountain state Republicans were as firmly convinced as Southern Democrats that employers should be allowed to choose their employees on any basis they saw fit. Many feared that Title VII woud destroy a man's right to run his own business as he pleased. Many did not like the idea that the law proposed a new Federal agency, the Equal Employment Opportunity Commission, to dig into individual complaints.

The Southerners knew they were beaten, but they kept chipping away at the bill with amendments that were designed to weaken or ridicule the coalition. . . .

Smith's sense of timing was practiced. He dropped his sex amendment into the hopper just at the moment when it could exasperate his opponents the most, then leaned back, with octogenarian patience, to hear the clerk read out the pages and lines of the bill where the word "sex" was to be inserted. (Bird, 1969:1–2)

they have not yet established themselves in jobs or careers. Older white males with seniority may be relatively unaffected by affirmative action; yet, they are the ones who have benefited most from past discrimination against women and minorities. Instead of attacking affirmative action as unfair, as many have, fairness would require its burdens to be more equally shared among all white males. It is clear that without evidence of the decrease of discrimination, as can be provided by the meeting of goals for women and minorities in employment, employers can go back to excluding women and minorities, no matter how qualified, from all the better-paying and most desirable kinds of work (Bishop and Weinzweig, 1979).

Universities have long claimed to be institutions guided by reason and

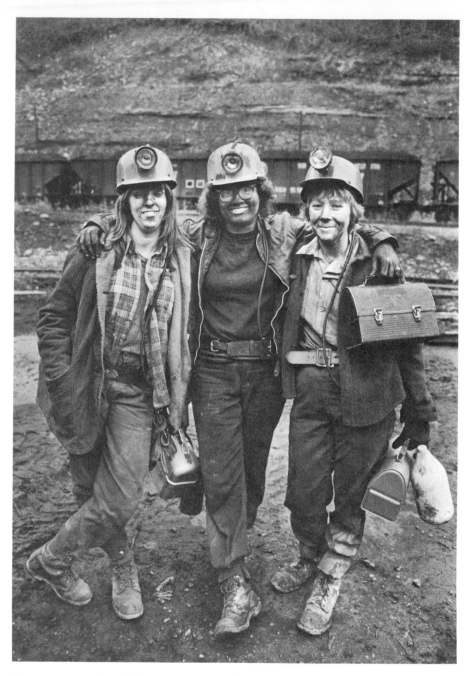

There are approximately 3,000 women coal miners in the United States—just over one percent of the workforce. They are often given the heaviest, dirtiest entry-level jobs and kept there long after men would have been promoted to machine operators. Despite this, many prefer going in the mines in order to be paid three times what they would make in a non-union shirt factory. ("Sisterhood." Three Women Coal Miners, Buchanan County, Va. Photo by Earl Dotter/American Labor)

fairness. Yet before the advent of affirmative action, their senior faculties were composed almost exclusively of white males. In the early 1970s at Harvard University—considered a leader in higher education—the senior arts and sciences faculty consisted of 483 men and not one women. Yet many professors there asserted that Harvard had never discriminated against women! By 1980, Harvard had granted tenure to only 10 women in its Faculty of Arts and Sciences (*New York Times*, 1981). Of Princeton's 390 tenured professors, only 10 were women (Clinton, 1980).

The Equal Employment Opportunity Commission also deals with sex discrimination in fringe benefits, including various kinds of insurance, retirement benefits, and leaves.

Many gains in reducing discrimination are in jeopardy. The Reagan administration came into office with the support of various groups bitterly opposed to affirmative action and has little enthusiasm for governmental action to enforce equality. In addition, the success of conservatives in reducing government employment will have an unfortunate effect on women, since those who seek new jobs in the private sector will encounter greater discrimination and salary inequities than in government employment.

Equal Pay—Comparable Work

Those who have enforced laws against discrimination in the past have applied them only to persons doing the same work. It was illegal for an employer to pay a man more than a woman for doing exactly the same job with the same job specifications. This interpretation may be in the process of changing. Only if it does will a real attack on the inequities faced by women in the labor force be possible, for few women do the same work as men. "Women's work" is generally compensated at rates substantially lower than what men get for work of comparable value. Discrimination against women begins with the initial gender segregation of the tasks and persists into the sphere of remuneration.

Juanita Kreps, secretary of labor in the Carter administration, has pointed out "that many of the occupational groups in which women are concentrated pay low wages while requiring higher than average educational achievement. . . . These higher levels of education do not pay off for either men or women in these 'female' occupations" (Kreps, 1971:40). Demands have developed for "equal pay for work of comparable value." In 1979, in response to some of its women constituents, the AFL-CIO decided to support these demands (*New York Times*, Nov. 20, 1979) This issue is an important focus for feminist efforts in the 1980s.

The occupation of nursing offers an example that illuminates the point. Eight registered nurses working for the city and country of Denver sued these local governments for discrimination in wage reimbursement (*Lemons v. Denver*). The nurses were angry that tree trimmers and house painters were

paid at higher rates, even though nurses' educational backgrounds and job requirements were higher. The nurses claimed that these different rates were the result of sex discrimination. Judge Winner, who presided, ruled against the nurses, stating that the claim was "pregnant with the possibility of disrupting the entire economic system of the United States." In 1979, in the appeals process, the U.S. Supreme Court tacitly upheld this ruling by refusing to hear the case (*Washington Post*, 1979).

Demands for equal pay for work of comparable worth may be the only way to raise the pay levels of those occupations traditionally filled by women. Under such a standard, nurses might receive the same level of pay as, say, accountants. The level of education required for the job and the difficulty of performing it would be what would count, not the job title.

A Supreme Court decision of June 1981 (*County of Washington v. Gunther*) is likely to encourage a new round of lawsuits to attack gender discrimination, especially the kind brought about by the "pink collar ghetto." The Supreme Court narrowly upheld a lower court decision that female matrons guarding female prisoners could sue under the Civil Rights Act for being paid some $200 a month less than male deputy sheriffs guarding male prisoners. While the work involved was not exactly identical, it was sufficiently similar to open the disparity of pay to legal scrutiny. The Supreme Court did not take any stand on the issue of equal pay for work of "comparable worth," but it did not close the door, as it might have, to further developments toward achieving this goal.

Socialist and Communist Impact on Gender Division of Labor
Feminist proposals have often included arguments for social reform or revolution which would eradicate the exploitative effects of capitalism and make production more directly responsive to social interests.

Many democratic socialists consider the Communist bloc countries to be state capitalist rather than genuinely socialist systems, and a study of the Soviet Union shows how government policy that claims to be socialist can fall short of achieving feminist goals (Lapidus, 1978). Women in the Soviet Union enjoy a variety of legal advantages not shared by women in the United States. Legislation provides benefits for pregnant and nursing mothers, and the government is committed to providing child care for working mothers. But actual provision has not kept pace with demand. Shortages are especially acute for very young children. In addition, many parents are dissatisfied with the care provided; the child care workers are inadequately trained. Even though the government absorbs three quarters of the cost, parents still find the fees burdensome. Recently, the government has begun to encourage women to stay home longer to take care of very young children.

There are few scholarly studies of gender-role socialization in the schools in the Soviet Union, but what evidence there is suggests that children are

early socialized to see female and male roles differently. Women are por-
trayed in primarily maternal roles while men are seen in a broad range of
activities outside the home; females are shown as passive and supportive
while men are depicted as active and ambitious. Girls demonstrate consis-
tently higher levels of academic performance, as in the United States, but by
the end of secondary school, girls and boys differ in career orientation. Boys
tend to prefer natural and technical sciences and girls, the humanities; boys
select technical occupations and girls, teaching.

Gender differentiation in the workplace is substantial. While women com-
prise over half the workforce, we are not by any means distributed evenly
over the various occupations. More interestingly, we are very much underrep-
resented in positions of control and prestige.

Given gender segregation in types of work and the scarcity of women in
managerial and other attractive positions, it is not surprising that women's
pay overall is less than that of men. Despite an unusually (for industrial
societies) large proportion of women in heavy, unskilled labor and a high
ratio of female engineers, technicians, and other specialists, Soviet women
have not achieved equality in the workplace. Some analysts link this directly
to the lack of attention to relieving women from housework.

Soviet women spend more than twice as much time as men doing house-
work and have much less free time (Lapidus, 1978:271). Housework itself
includes gardening and repair; women and men share some shopping and
cleaning (but women do most of it); women's work includes cooking and
laundry. Women's household tasks increase radically with marriage and chil-
dren. With more geographical mobility and an increase in nuclear family
households, and hence less help from the members of extended families,
women's work has also increased.

In other countries where revolution has changed the social structure, the
work of women has often remained disappointingly the same. In Cuba, for
example, the Federation of Cuban Women, founded in 1961, undertook the
retraining of domestic servants. During the next decade, over half a million
women were retrained and placed in the labor force. Some five hundred day
care centers financed by the government were established to help nearly fifty
thousand workers. These day care centers, however, were not staffed by
women and men in nonsexist child care environments; instead, they em-
ployed the "retrained" women who had formerly been domestic servants
(Muraro, 1977).

New Directions

Impact of the Women's Movement

From the start, the current women's movement has demanded recognition
of a woman's right to engage in useful, meaningful, and rewarding work. It

has also stood for equal pay and respect for women in the workplace, for equal opportunity in advancement in jobs and careers, and for improvement in opportunity, pay and recognition for minority women. Many feminists have realized that even deeper and more fundamental changes than this in the structures of economic activity are needed, especially in the United States.

Practical arrangements to relieve the burdens of women who work outside the home have been few and far between. The number of day care centers has increased but not nearly enough to accommodate all working mothers, and they are still too costly. A few work organizations have experimented with "flextime," instituting a system of flexible work hours so that women and men could carry out home and family responsibilities during the day and work as well. But such arrangements are unusual. While consciousness and gender images have changed somewhat, practical accommodations have changed rather little.

One of the most important developments within the women's movement in the United States in recent years is the growing recognition that what women want will require *structural* changes in the American economy. Women cannot achieve feminist objectives without a substantial breakdown of the class differences that pit the interests of advantaged women against those of less advantaged sisters. An equal opportunity to exploit the weak is not the aim of the women's movement. More humane and less hierarchical organizations of work are needed along with a concern on the part of society with what work is for—what investments shall be made, what products produced. Work that will serve human needs and interests while respecting the environment will be better for both women and men than work for increased profits. Progress toward these objectives will require fundamental changes in the way the work of both women and men is conducted.

The Double Burden

A recent survey of women college students indicated that many educated and capable young women now feel that given a choice between career and family, we would choose family (*New York Times*, 1980). We feel that the demands made on women by work and family simultaneously are too great. Some of us think we have been misled by the women's movement, which has argued that a woman can do both. Many women who already have careers and families to take care of are now expressing anxiety and resentment at our own sense of "overcommitment"—a feeling that while we *can* manage both, it is exhausting. Is it worth the effort?

Of course, millions of women who had no choice in the past, and have no choice now, do manage jobs and family care. But we also know something about the costs to our own sense of well-being. We know of the hardships suffered by minority and immigrant women who struggled to support fami-

lies while raising them. And we know that economic pressures on families oblige millions of middle-class women to work for pay today.

What we are talking about now is choice: given ideal conditions, what do women *want?* Women have said that we want more social respect for the work of raising and caring for families, and that we want men to share the burdens and rewards of this work. Women also want to have the right to find our identity and sense of personal worth in other creative efforts, jobs, and careers outside the home and family, if we choose.

Tillie Olsen explored some of these issues eloquently in *Silences* (1978). She pointed out that underneath the harsh practical realities of economic stress and work drudgery lie more profound conficts for the creative human being who hopes to raise a family and also "work"—write, do research, paint, build, or whatever. The demands of those we love cannot be put off; if they are, we suffer remorse. But fulfilling these demands interrupts our work; interruptions and delays are destructive, sometimes fatal for the work itself—hence those "silences." Many people feel that the struggle to satisfy the conflicting demands of family (not only children, but parents and other dependents) and work drains human energy and saps the strength to do both adequately. Women have begun to examine these issues and to share our insights into our relationship, as women, to work of our own. A noteworthy collection is called *Working It Out* (Ruddick and Daniels, 1977).

What is the solution? In the past, men have frequently resolved the problem by ignoring family demands, freeing their consciences by placing the burdens of those demands on women. But now many men want the benefits of fulfilling such demands, such as the pleasure of raising their children. And women in the past, when given the choice, have often foregone the rewards of work as long as we could rely on men to provide economic support. Now, many women want those rewards as well, regardless of economic circumstances. Comprehensive day care, available to all who seek it, is undoubtedly necessary. But it will be inadequate because enormous demands will still be made on tired parents after work. And the "day care solution" does not address the complaint of many parents that we do not want relief from the joy of watching our children grow, of teaching them things and enjoying their company.

What we *do* want is relief from the less interesting aspects of family care—laundry, ironing, cooking, shopping, cleaning up, and so forth. To be sure, some industries are devoted to household gadgetry—washing machines, dishwashers, vacuum cleaners—but the work of using them remains. The women's movement has suggested that partial relief may be offered by sharing—men could do half the work. But another solution might be to have these tasks done by specialists on a national and socially subsidized basis. Why cannot laundry and food supply be provided by adequately paid specialists?

This, in fact, has been part of a utopian ideal for many writers, and has

been attempted by such "experimental" societies as the kibbutz. A good literary example is Ursula LeGuin's anarchic society in *The Dispossessed* (1974): family life goes on among those who choose it, but cooking, clothing care, and the like are social, not family, services. Day care is, of course, provided. But people do not spend time and energy on tasks that can be taken care of by others as "jobs"—matters which have nothing to do with love and joy but are simply work. Raising children is not a "job," but doing laundry is. These utopian ideas may provide models for social change. The constraints on change, however, are both political and economic. Radical feminists argue that these constraints cannot be lifted without a major revolution in the structure of the economy and society (Eisenstein, 1981, Kuhn and Wolpe, 1978).

Summary

Every known society has assigned work by gender, and the work done by women has traditionally been valued less than that done by men. Women's reproductive functions have been used as an excuse for division of labor by gender. Although the labor involved in reproduction itself is essential for any society, it is seldom recognized or compensated as such.

Maintaining the domestic unit is also essential to the functioning of society and the economy, but it has been given neither economic nor social value. Women who sell our labor in the marketplace also find our jobs devalued; we have been restricted in our choice of jobs and paid less than men. Women who have taken men's jobs during wartime have proven our capabilities, but we lose these jobs when men return from combat.

When a society's economy is based on a simple domestic mode of production, economic and domestic roles tend to be integrated for both women and men. But as a society modernizes and work becomes capital-intensive rather than labor-intensive, women tend to be phased out of the economy and confined to the domestic sphere. Women "subsidize" capitalist enterprises by servicing workers for free and by providing a cheap pool of labor when needed.

As slavery and serfdom gave way to "free" wage labor, a working class evolved. Within this class, women have been barred from most trades of skilled labor by guilds and craft organizations. Most working-class women have been employed as domestic wage labor. In this century, greater numbers of women, particularly immigrants, have found work in factories. Most women today are employed as pink collar workers, involved in clerical work, sales, and services, in jobs considered "female."

The professions are also segregated by gender, with women tending to enter nursing, teaching, and social work while men become lawyers, doctors, and administrators. Within the "female" professions, most top-level jobs are

held by men. Most women find it difficult to enter a "male" profession, much less to rise within it.

Minority women encounter various obstacles in the job market, but nearly all of us have been exploited and have had little power. Multinational corporations exploit the labor of women living in the Third World.

Few women are self-employed, perhaps because we have not been socialized to be assertive and independent. Women have less access than men to the financial resources needed to establish an enterprise. Few women have advanced yet to high levels within corporations; those who do so are under pressure to conform to corporate standards.

Women find it difficult to compete with men for jobs because our interests are nearly always related to those of men in some way. Men tend not to support our attempts to gain economic equality because they think this would threaten their superior status in the job market. These conditions favor the capitalist system by creating a need for the male worker to depend on his employer in order to support his family.

Women on the job may be subject to forms of sexual harassment, such as pressures for sexual favors, that men are not faced with. In dual-career families, it is generally women who sacrifice our career opportunities for the men's; although more equitable arrangements are now being worked out in some families.

Women who work find social support in unions and professional organizations to some extent, but primarily in informal networks of other women.

Many laws that were passed to "protect" women in the workplace have instead protected the jobs of men. The Equal Opportunity Act and Equal Pay Act were passed to lessen job discrimination against women. Affirmative action programs attempt to improve the opportunities of those who have been discriminated against. Many women today are calling for laws that will require equal pay for work of comparable value.

While communist systems of government have provided some advances in work force participation by women, they have done little to change social attitudes or relieve women of household care.

The women's movement has raised women's aspirations and brought about some changes in attitudes. However, women who choose both a career and a family need to have some relief from the double burden of job and household tasks. It appears that feminist objectives will not be achieved without structural changes in the economy and society.

Discussion Questions

1. Choose three households you know, which vary in a number of ways: income, ethnicity, age of adults, age of children, or other variables. Interview a woman in each household to find out what she does each week

with her time. How can you account for differences and similarities in the work that the three women do?

2. Select a place of work—a hospital, a business firm, a school—to which you have access. Try to list all the types of positions and who holds them, for female and male. Are there particular types of work done mainly or exclusively by women? Also observe ranking: are women found mainly at some levels and not at others?

3. Many women feel that our family obligations pose special problems for us in our pursuit of careers. In what ways does our society provide "relief" for women who work and/or study outside the home; to what extent are these services satisfactory or unsatisfactory? What alternative means for alleviating this problem can you think of?

4. What is affirmative action? How does it work? Is it necessary?

5. If you have a particular career goal, study the roles of women in that career or profession in the past and at present. What proportion of people in the field are women? If there are obstacles to women's success in this field, might they be overcome?

Recommend Readings

Oakley, Ann. *Women's Work: The Housewife, Past and Present.* New York: Vintage, 1976. An examination of the history and nature of housework from the preindustrial period to the present. The book contains interviews with a former factory worker, a middle-class woman who left a career for childbearing, a traditional housewife married to a successful professional, and the working wife of a blue collar worker.

Ruddick, Sara, and Daniels, Pamela, eds. *Working It Out: 23 Women Writers, Artists, Scientists, and Scholars Talk About Their Lives and Work.* New York: Pantheon, 1977. Personal accounts of the problems faced by women who had to carve out their work against the grain of society's expectations. An extraordinary roster of creative women in all fields of work.

Tilly, Louise A., and Scott, Joan W. *Women, Work and Family.* New York: Holt, Rinehart, & Winston, 1978. An important book that explores the roles of single and married women in the preindustrial family economy, the changes wrought by industrialization, and the role played by women as consumers as well as mothers. Although the study is based on England and France, the concepts discussed are of general significance.

Wertheimer, Barbara M. *We Were There: The Story of Working Women in America.* New York: Pantheon, 1977. A history of women working from colonial beginnings to the mid-twentieth century in the United States. The

focus is on wage-earning women; the book includes black women workers in colonial times and as slaves in the nineteenth century.

References

Almquist, Elizabeth, and Wehrle-Einhorn, Juanita L. "The Doubly Disadvantaged: Minority Women in the Labor Force." In *Women Working: Theories and Facts in Perspective*, edited by Ann H. Stromberg and Shirley Harkness. Palo Alto: Mayfield, 1978.

Barnet, Richard, and Muller, Ronald. *Global Reach. The Power of the Multinational Corporations*. New York: Simon & Schuster, 1974.

Bird, Caroline. *Born Female. The High Cost of Keeping Women Down*. New York: Pocket Books, 1969.

Bishop, Sharon, and Weinzweig, Marjorie. Section 7: "Preferential Treatment." *Philosophy and Women*. Belmont, California: Wadsworth, 1979.

Boserup, Esther. *Woman's Role in Economic Development*. New York: St. Martin's Press, 1970.

Clinton, Catherine. "Women's Graves of Academe." *New York Times*, Op-Ed page, November 5, 1980.

County of Washington v. *Gunther* 101 S. Ct. 2242 (1981)

Dalla Costa, Mariarosa. "Women and the Subversion of the Community." In *The Power of Women*. Bristol: Falling Wall Press, 1972.

Davies, Margery. "Woman's Place Is at the Typewriter: The Feminization of the Clerical Labor Force." *Radical America* 8 (1978):1–28.

Dublin, Thomas. "Women, Work, and Protest in the Early Lowell Mills." In *Class, Sex, and the Woman Worker*, edited by Milton Cantor and Bruce Laurie. Westport, Conn.: Greenwood, 1980.

Eastwood, Mary. "Legal Protection Against Sex Discrimination." In *Women Working*, Stromberg and Harkness. Palo Alto: Mayfield, 1978.

Eisenstein, Zillah. *The Radical Future of Liberal Feminism*. New York: Longman, 1981.

French, Marilyn. *The Women's Room*. New York: Summit Books, 1977.

Friedan, Betty. *The Feminine Mystique*. New York: Norton, 1963.

Greenwald, Maruine Weiner. *Women, War, and Work: The Impact of World War I on Women Workers in the United States*. Westport, Conn.: Greenwood, 1980.

Hennig, Margaret, and Jardin, Anne. *The Managerial Woman*. Garden City, N.Y.: Doubleday, 1977.

Hymowitz, Carol, and Weissman, Michaele. *A History of Women in America*. New York: Bantam, 1978.

Jones, Mary (Harris). *The Autobiography of Mother Jones*. 1925. Reprint. Chicago: Kerr, 1972.

Kanter, Rosabeth. *Men and Women of the Corporation*. New York: Basic Books, 1977.

Kennedy, Susan Estabrook. *If All We Did Was to Weep at Home: A History of White Working Class Women in America*. Bloomington: Indiana University Press, 1979.

Kreps, Juanita M. *Sex in the Marketplace. American Women at Work*. Baltimore: Johns Hopkins University Press, 1971.

————, and Leaper, R. John. "Home Work, Market Work, and the Allocation of time." In *Women and the American Economy: A Look at the 1980s,* edited by Juanita M. Kreps. Englewood Cliffs, N.J.: Prentice-Hall, 1976.

Kuhn, Annette, and Wolpe, Ann Marie, eds. *Feminism and Materialism: Women and Modes of Production.* London and Boston: Routledge & Kegan Paul, 1978.

Ladner, Joyce. *Tomorrow's Tomorrow. The Black Woman.* Garden City, N.Y.: Doubleday Anchor, 1972.

Lapidus, Gail Warshofsky *Women in Soviet Society. Equality, Development and Social Change.* Berkeley: University of California Press, 1978.

Leguin, Ursula. *The Dispossessed.* New York: Avon, 1975.

Lemons v. City and County of Denver, 620 F. 2d, 228 (CA 10).

Mackinnon, Catherine A. *Sexual Harassment of Working Women: A Case of Sex Discrimination.* New Haven: Yale University Press, 1979.

McBride, Theresa M. *The Domestic Revolution.* New York: Holmes & Meier, 1976.

McSweeney, Brenda Gael. "Collection and Analysis of Data on Rural Women's Time Use." *Studies in Family Planning* 10 (1979):379–84.

Mill, John Stuart, and Mill, Harriet Taylor. *Essays on Sex Equality,* edited by Alice S. Rossi. Chicago and London: University of Chicago Press, 1970.

Muraro, Rose Marie. "Women in Latin America: Phases of Integration." Occasional Papers Series, No. 6. International Area Studies Programs. Amherst: University of Massachusetts at Amherst, 1977.

New York Times, "Excerpts from Harassment Rules," April 12, 1:1 (1980).

New York Times. New York Times Survey of College Women. December 28, 1:1 (1980).

New York Times. "Harvard Panel Says Sex Bias Led to Denial of Tenure for a Woman." *April 9, 16:4 (1981).*

New York Times, article on AFL-CIO convention proceedings. November 20, II, 14:1 (1979).

Nickel, James W. "Is There a Human Right to Employment?" *The Philosophical Forum* 10 (1978–79):149–170.

Olsen, Tillie. *Silences.* New York: Delacorte Press, 1978.

Rotella, Elyce J. "Women's Roles in Economic Life." In *Issues and Feminism: A First Course in Women's Studies,* edited by Sheila Ruth. Boston: Houghton Mifflin, 1980.

Ruddick, Sara, and Daniels, Pamela, eds. *Working it Out: 23 Women Writers, Artists, Scientists, and Scholars Talk About Their Lives and Work.* New York: Pantheon, 1977.

Tilly, Louise A., and Scott, Joan W. *Women, Work, and Family.* New York: Holt, Rinehart & Winston, 1978.

U.S. Department of Commerce, *Statistical Abstract of the United States,* 1981. Washington, D.C.: U.S. Government Printing Office, 1981.

U.S. Department of Labor, Bureau of Labor Statistics. *Women in Perspective: Working Women.* Report No. 584. Washington, D.C.: U.S. Government Printing Office, 1979.

U.S. Department of Labor. Bureau of Labor Statistics. *Women in the Labor Force: Some New Data Series.* Report No. 575. Washington D.C.: Government Printing Office, 1979.

Washington Post, November 13, 1979.

14

Women and Political Power

FEMINISM AND POLITICS
Stereotyped Views of Political Behavior
"The Personal Is Political"

POLITICAL POWER
What is Power?
Power and Authority
Types of Government
Women's Political Power in the Past
Patterns of Male Dominance

WOMEN AS POLITICAL LEADERS
Women in the United States
 Recent Political Gains
Women in Communist Countries
 The Case of the USSR
 Obstacles to Women's Political Leadership

WOMEN AS CITIZENS
Women and War
Women and Peace Movements
Women and the Law
 Rape
 Women as Interpreters and Enforcers of Law

EQUAL RIGHTS
The Struggle for the Vote
The Modern Women's Liberation Movement
 The Equal Rights Amendment
Feminism and Internal Conflicts

THE POLITICAL CLIMATE OF THE 1980s

No known government has been designed or run exclusively by women, or according to feminist principles. But we can gain considerable insight into women's views of government by reading about feminist utopias, imaginary alternative societies which are both critiques of patriarchal society and visions of new, more just social orders. In her review of a number of feminist

531

utopias, Carol Pearson found that more often than not, they depict social orders without government, laws, force, or hierarchy. She suggests that "women may be able to design societies without dominance, because they lack the experience of dominating" (1977:51–52).

Decisions in feminist utopian societies tend to be made by consensus, and order is kept not by force but by persuasion. The model for these feminist utopias comes from women's own experience in the home, within the family, where the pattern of social relationships is (ideally) cooperative, not exploitative.

Pearson argues that women's positions in patriarchal social orders provide both positive and negative experiences as a basis for designing new orders. The positive experiences come from our socialization to serve the human needs of our families and from the emotional rewards we receive as wives, mothers, daughters, and sisters who give and share our love and knowledge. The negative experiences are those relating to our victimization as objects of violence, repression, and sexist prejudice, and our exclusion from a significant role in the decisions that affect our lives. Such experiences have produced visions of alternative societies that have no dominance, violence, repression, or sexism and that require full participation of all members in decision-making processes. These societies would be modeled on intimate, loving, nurturing familial relationships.

Although there is no evidence of any social order dominated by women in human history, there is considerable variability in the forms that governments have taken. Some forms have allowed women a considerably greater opportunity for participation in public power than others. We will examine these variations in forms of political organization and power, and the roles women have played in them.

Feminism and Politics

Can direct participation of women in "politics" make any real difference? It must be conceded that women are underrepresented in formal political participation everywhere in the world; we occupy few positions of political power, particularly at the top. But if women did occupy such positions, if we had a direct and influential voice in government, would public affairs be different (Diamond, 1977)? Those who would answer "yes" come from both feminist and sexist camps. The former argue that women's equal participation would lead to greater sensitivity to human interests (an end to war, perhaps), while the latter argue that it would lead to inefficiency and ineffectiveness (such as an inability to make war).

Recently, feminists have been asking whether women can achieve political

power without following a male model of success. To be successful in politics, must women conform to the kinds of political strategies characteristic of our male colleagues? Or can we reshape political power more to our own priorities and values and expect men to adopt this alternative pattern? Do women, as a group, actually have particular priorities and a common set of values relating to political power? Are we, in this or any other sense, a "class"? This last question has stimulated a considerable amount of scholarly and polemical writing.

Clearly, on the one hand, women belong to different social classes, traditionally defined in part, at least, by the class membership of our fathers or husbands. On the other hand, all women have a common relationship to the economic system, regardless of social class membership. With a small number of exceptions, we own—or control—little or no capital, and we contribute free labor for basic social maintenance—household management and work, and reproduction—all of which are seen as our "private" responsibility. Furthermore, all women suffer discrimination by virtue of our gender, being excluded from various jobs and social benefits. Does this make of women a "class"? How, then, is identification with a gender "class" to be related to other sorts of class identity, including class privileges and exploitation? This issue is of great significance for the modern feminist movement, as it attempts to reconcile the diverse and competing interests of the different groups of women it hopes to serve.

Stereotyped Views of Political Behavior

Feminists trained in political science have begun to examine the history and theoretical assumptions that characterize scholarship in this field. Most modern political scientists have viewed women as of little consequence to their concerns (Freeman, 1976). These political scientists have largely been white, middle-class, and male. In their ideology, "politics" is what takes place in the "public" sphere of life, and political activity is identified as inherently "masculine." Traits that are said to characterize a proper citizen in a liberal democracy, for example, include those qualities identified in our culture as "masculine": independence, aggressiveness, competitiveness (ibid.). The "citizen" with whom the male political scientist is dealing is his own self-perceived image: male, white, and middle-class.

American political scientists who have studied women's political behavior have measured our voting performance, our participation in political campaigns and political parties, and our presence in political office. On all counts, women have been found less visible than men. When women do express opinions about public issues, we are assumed to have borrowed them from fathers or husbands. Yet women have also been characterized as

Women Do Not Belong in the Public Sphere Box 14.1

Mr. Justice Bradley:

. . . The civil law, as well as nature herself, has always recognized a wide difference in the respective spheres and destinies of man and woman. Man is, or should be, woman's protector and defender. The natural and proper timidity and delicacy which belongs to the female sex evidently unfits it for many of the occupations of civil life. The constitution of the family organization, which is founded in the divine ordinance, as well as in the nature of things, indicates the domestic sphere as that which properly belongs to the domain and functions of womanhood. The harmony, not to say identity, of interests and views which belong or should belong to the family institution, is repugnant to the idea of a woman adopting a distinct and independent career from that of her husband. . . .

It is true that many women are unmarried and not affected by any of the duties, complications, and incapacities arising out of the married state, but these are exceptions to the general rule. The paramount destiny and mission of women are to fulfill the noble and benign offices of wife and mother. This is the law of the Creator. And the rules of civil society must be adapted to the general constitution of things, and cannot be based upon exceptional cases.

. . . In my opinion, in view of the peculiar characteristics, destiny, and mission of woman, it is within the province of the legislature to ordain what offices, positions, and callings shall be filled and discharged by men, and shall receive the benefit of those energies and responsibilities, and that decision and firmness which are presumed to predominate in the sterner sex. (*Bradwell* v. *Illinois,* 1873, in Goldstein, 1979:49–51)

more conservative, more personal and emotional, immature in conceptualizing the political realm, intolerant of others' views, and basically "less reasonable and less competent" than men (ibid.: 244). When women vote, we are described as responding to the candidate's surface personality, and political scientists describe us as "gullible," easily duped by media images. When a large number of men vote for the same candidate, the reason generally given is the sheer force of the candidate's inner personality, or "charisma" (ibid.).

Political scientists have explained women's lack of visibility in politics as the direct consequence of our domestic roles, and, therefore, as a *necessary* consequence of our reproductive function (Lovenduski, 1981). A study of women's political behavior in France, West Germany, Norway, and Yugoslavia sponsored by UNESCO in the early 1950s characterized views about women and politics down to 1970. The study found that women voted less than men, that wives and husbands tended to vote the same way, and that women tended to vote for middle-of-the-road, conservative parties. Very few

women held electoral office in these countries. Those who did concerned themselves with issues of health, family policy, children, and women's rights. The study seemed to support a theory about "women's nature": women are temperamentally unsuited to political activity (the male model of that activity); wives adopt their husbands' political views; women are swayed by candidates rather than issues; and women are more "moralistic" and "emotional" and less politically aware than men (ibid.:92).

Feminist political scientists and sociologists now have begun to explore the roles women play in community-level organizing in various ethnic and racial communities, women's leadership styles, women's intraparty roles and power, and our organization on issues we consider important. We also ask: How have family and school socialized women to be followers rather than leaders on "male issues"? How have women's roles as unpaid volunteers sustained male-dominated community organizations such as local school boards? What changed the political climate for women's activism in national politics in the early 1970s?

A particular class, group, or gender may possess "unintentional power" because of its "position within a set of social structures and arrangements" (Elshtain, 1979:246). The benefits of a privileged position belong to all those within the group, even though such power may be personally unintentional to any one of them. Thus, any white person in a racist society possesses greater unintentional power than does a black person. Similarly, men *as men* have great unintentional power in a sexist society. Both women and men may exercise the power to persuade, manipulate, or coerce the other gender within a personal or familial relationship, "but the male is the sole possessor of unintentional power with a public meaning having political consequences. When he exerts power, it is considered legitimate—perhaps neither wise nor beneficent, but legitimate" (ibid.:246).

Feminists are asking new questions about the function of law in society. Law is viewed as an "instrument of social control in a rational world of men" (O'Donovan, 1981:175). In its regulation of the family, the law's concern is to "create a space in which the male head of the household can exercise power and authority" (ibid.). In effect, by viewing women as belonging to a "private," domestic sphere, the men who make and interpret laws, like the men who theorize about political power, act on assumptions that make women less than full legal citizens and political beings. When women are thus classified as a group, we are subject to gender-based social policies, and our social roles are reinforced by political and legal sanctions.

"The Personal Is Political"

One of the principal ˙effects of the consciousness-raising efforts of the women's movement of the late 1960s and early 1970s was to bring women—

and sometimes men—to an awareness of the political components of our personal lives. Power pervades the relations between women and men. And the distinction between the "public" sphere of politics and the "private" sphere of domestic life obscures the inescapable fact that excluding women from the public sphere deprives us of control over our presumably private existence. Accordingly, many feminists feel that in order for changes to take place in the private relations between women and men, there must be changes in the political structure of society.

This book has repeatedly illustrated the close connection that exists between public and private matters. For example, public laws, made and enforced largely by men, have determined women's rights to say no or yes to a prospective partner (by defining extra-marital sex or lesbian relations as illegal, for example) and to decide whether or not to continue a pregnancy. Public policy, made largely by men, determines women's rights and obligations to our children and women's ability to carry out our wishes with regard to our children's care and education, nourishment, and safety. Public policy also restricts and shapes women's rights and capacities to select ways to support ourselves, and it determines the conditions under which we work. In other words, nearly everything we have been brought up to regard as personal and private turns out to be a matter of public concern. To the extent that the private sphere has been the domain of women, and the public sphere has been the domain of men, politics has been a means for men to control women's lives.

This is not to say that men's private lives are not also politically controlled. But men have a greater opportunity to participate in this control than women do, and to have other lives than private ones. Nor is it to say that all men have an equal opportunity to participate in the determination of public policy, laws, and enforcement. Feminists of this and the last century have been particularly sensitive to the exclusion of anyone—male or female—from political power on the basis of race, ethnicity, and class. Yet, while feminists have been conspicuous in the abolitionist, socialist, and civil rights movements, male support from these movements for feminist goals has not been prominent.

In the civil rights movement of the 1960s, women's place was in the kitchen and the bedroom just as it was outside the movement. Women made coffee and sandwiches and provided sexual comfort for the men, and were excluded from the central policy-making groups (Evans, 1980). It was the realization that all relations between women and men, including sexual relations, were as political as any relations traditionally so labeled, that led to the saying of the women's movement of the 1970s that "the personal is political."

Political Power

What Is Power?

Power is the ability to do something, but the term often implies more. An ant has the power to move a grain of sand; a woman may have the physical power to lift a thirty-pound child. Power is also exercised over others. We can have considerably more power than our own bodies afford because we can either increase our own power directly or influence others in order to get things done. A farmer can move a great deal more soil or corn using the power of a team of horses or a tractor than by means of personal muscle power. An agroindustrial executive, however, has more power than the farmer: the executive may have the power to command scores of farmers to move soil or crops. Power over others fosters relationships of dominance and subordination.

Considered in negative terms, power is the capacity *not* to do something. Some people are more able than others to determine what they will *not* do— not marry, not bear or be responsible for a child, not engage in physical labor, not have sexual intercourse when another demands it. Only those who have sufficient power to protect themselves from the aggression of others can be sure they will not be coerced to the will of others.

Feminists have pointed out that power need not imply dominance. Power— the ability to get things done—can be shared and distributed evenly. This is the notion behind the organization of most feminist utopias. The sharing of power has been attempted on a small scale in communes throughout the world. It was a fact of life only recently in simple societies in regions of Africa and North America, and perhaps among very ancient societies never to be documented. On a large scale in a complex industrial society, the sharing of power has been difficult even to imagine, but it may be the only way to overcome male domi- nance. Feminists seek to *reduce*, at least, the extent to which society is organ- ized hierarchically, with vast disparities of power between those who com- mand and those who must obey.

Power and Authority

There is an important distinction between *power* and *authority*. Those with authority are accepted as being justified in having their power. People who seize power need eventually to find a way of legitimizing it in order to command obedience to decisions without resorting to the continued use or threat of force. Economic power and authority are the ability and accepted right to control the production and distribution of resources; political power and authority are the ability and accepted right to control or influence deci- sions about war and peace, legal protection and punishment, and group decision-making in general, including the assignment of leadership roles. In complex societies, political power usually includes a great deal of economic power, but political and economic power can and do operate separately.

Sometimes they function in a complementary way, while at other times they are at odds.

Although power and authority often are exercised by the same person, they are distinct, and each may be exercised without the other. Women have infrequently enjoyed positions of political authority in which our political power is deemed legitimate, but we have at various times enjoyed some political power without authority by virtue of our relationships with powerful men. Royal mistresses in the courts of European kings in early modern times even had official status. In the United States in the twentieth century, women married to presidents have occasionally exercised notable political power. When Woodrow Wilson collapsed while in office in 1919, his wife Edith Axson Wilson played a crucial role in helping him maintain the presidency. Over a longer period, Eleanor Roosevelt was able to undertake important humanitarian programs because of the influence she exerted over her husband and his associates in government. Yet when her ideas were not endorsed by the president, she was powerless to pursue them. Rosalyn Carter was considered one of her husband's most influential advisers although she held no official position as such. This kind of political power, the exercise of influence, is difficult to establish or assess. Reference to the power of the "woman behind the throne" has more often than not been used by those who wish to justify a status quo in which women have little direct power—or authority—in our own right. So long as women use others as our mouthpieces, it is unlikely that others will act consistently on women's views rather than their own.

Types of Government

As societies have become larger and more complex, forms of government have become more specialized and exclusionary. While both capitalist and socialist nations today refer to their governments as "democratic," relatively few members of complex societies actually participate in public affairs or government themselves. Full participation occurs only in the smallest, simplest societies, such as hunting-gathering bands, where political decisions are made by public discussion and consensus. There are no specialists in government in these societies; leaders arise in particular situations according to need and skills. Thus, an older woman with experience and skill might organize and direct others in food-gathering. But in a negotiation for trade with another group, a person who is a good public speaker might assume responsibility for expressing the will of the community.

In slightly larger and more complex societies, similar principles apply, but on a more restricted basis. That is, some individuals hold positions of authority as "chief" or "war leader" or "council member" while others have less to say about public affairs. In these societies, women tend to be more segregated as a group. If women do play a role in political processes at this level, we

tend to do so *as women,* not as ordinary and equal group members. Thus, among the Iroquois in North America, certain women were entitled to select male group leaders; men did not have this right. The men, on the other hand, were entitled to hold the leadership positions; the women were not (Sanday, 1981).

The most complex forms of government are nation states, which exclude most members of society from direct participation in making governmental decisions. Usually, few women are found in national-level political organization. Women are not alone in being excluded, however; members of minority groups and subject classes are also excluded to a large extent. The manner in which women became excluded from government participation will be discussed below.

At the higher levels of a hierarchical structure, few can participate. But the smaller communities which make up large states do continue to govern much of their business themselves on a local level. Here, participatory democracy may be possible even in a large complex state. Thus, it is at the local level where women's voices are most likely to be heard, if at all. For example, women are found in public councils in Chinese rural production communes and in local governments and activities like school boards and town councils in the United States; and more women are found at the state level of government in the United States than at the federal level.

Women's Political Power in the Past
Recognized leaders have the authority to make decisions of vital importance to the groups that look to them. Their power to carry out such decisions depends on the willingness of others to act as directed by their leaders. Political decisions include the allocation of resources, the adjudication of disputes, the assignment of specific tasks, and the waging of war.

Women have occasionally exercised authority and political power in the past, both in dynastic states in medieval Europe and in precolonial non-Western societies. In the early middle ages in Europe, when a ruler's officials were actually royal household servants (and the head of the household governed the domestic affairs of the royal estate, which was the kingdom), it was considered perfectly natural to place the ruler's wife, or queen, at the head of these servants. When Henry II of England went to war (which was a great deal of the time), he left the queen, Eleanor of Aquitaine, in charge of his household (the kingdom) during his absence. He ordered all his officials to report to her whenever he was away. As regents for their husbands or sons, queens could wield significant political power; they were trusted to act according to the wishes and in the best interests of their male relatives. Only when Henry II began to suspect that his queen favored their sons over him did he discontinue making her England's ruler in his absence (Kelly, 1957).

As the governments of European states became more bureaucratically organized, women were less likely to share in political power. The recognized offices and functions that might hitherto have been delegated to the queen in her own right gradually shifted to ministers, judges, councillors, and other functionaries, who were never women. Even in the reign of Queen Elizabeth I, who governed by virtue of her own inherited right, not a single woman was ever appointed to a ministerial post. Noble women might serve the queen as ladies-in-waiting and exercise some informal power, but her officials were exclusively male (Neale, 1957). In general, as the organized modern national state developed out of the old family-centered monarchies, the power of women was steadily eroded.

Erosion of women's power in non-Western areas often occurred as a result of the imposition of European colonial rule. For example, among the Iroquois, as we have already noted, both women and men participated in village decision-making. The women caucused behind the scenes in town meetings attended by both genders. Women were entitled to demand publicly that a murdered kinswoman or kinsman be replaced by a captive from a non-Iroquoian tribe. A woman's male relatives were morally obligated to join a war party to secure captives, whom the bereaved woman might either adopt and let live or adopt and consign to torture or death. Women also appointed men to official positions in the League of the Iroquois and could veto their decisions, although the men dominated League deliberations. This tension between female and male spheres, in which women dominated village life and left intertribal life to men, suggests that the genders were separate but equal in the exercise of political power during the height of the Iroquois confederacy (Sanday, 1981).

In the early nineteenth century, after a steady encroachment on Iroquoian power by the colonizing British and French over a period of two hundred years, the Iroquois became unable to sustain themselves economically. English Quakers, who actually sought to preserve the Iroquoian culture, suggested solutions that in fact hastened change by pressing for fundamental restructuring of Iroquoian gender relationships. Quaker missionaries urged men to begin to cultivate the soil, a sphere hitherto dominated by women, and urged them to insist on husband-wife nuclear family relationships, which shut out the traditional power of the wife's mother in the family. In imposing their own cultural assumptions, the Quakers helped develop a new pattern of male dominance where it had not existed before (ibid.).

Another example is that of the Igbo of southern Nigeria in West Africa. Precolonial social arrangements among the Igbo included women's councils. By tradition these exercised peacekeeping powers, including the corporal punishment and public humiliation of the offender and the destruction of the offender's property. These local councils had no formal links with one another, but the Igbo women maintained a network of rapid communication

by virtue of their overlapping presence in a number of different markets each week (ibid.).

The imposition of British colonial rule in the late nineteenth century disrupted the cultural patterns which had afforded women real power. The British authorities bypassed the women's councils as irrelevant. After imposing a new tax on all males, the colonial government proposed to take a census of women, children, and animals to assess other taxable wealth. When a local chief sought to carry out this task, he tangled with an elderly woman who literally put up a fight to resist him. Her call for help went out along the women's network, and women from everywhere marched to her aid. The women punished the offending chief, mobbing him, damaging his house, and demanding that he lose his cap of office and be arrested by the British district officer for assaulting the elderly woman. The incident turned into a "war" when some ten thousand women attacked British property—some stores and a bank—released prisoners from the jail, and generally rioted for two days before being dispersed by troops. When an official investigation was conducted, the women were reported as saying, "We are not so happy as we were before. . . . Our grievance is that the land is changed—we are all 'dying'" (ibid.:139–40). What had been "dying" was women's public power.

Patterns of Male Dominance

Anthropologist Ernestine Friedl has defined male dominance as a pattern in which men have better access, if not exclusive rights, to those activities to which society accords the greatest value and by which control and influence are exercised over others (ibid.:164). Thus male dominance means excluding women from political and economic decision-making and includes male aggression against women. Male dominance occurs in various patterns of relationships. It may consist of cultural assumptions about natural male aggressiveness, about being "tough" and "brave." It may involve designating specific places where only males may congregate, like men's clubs and bars, street corners, legislative chambers, courts, or boardrooms. Still other patterns involve wife abuse and battering, the regular occurrence of rape (and sometimes its institutionalization as gang rape), and "raiding" enemy groups for wives. Although women may wield some political and economic power or authority in societies characterized by all or some of these patterns, they do so by the implicit or explicit consent of men, and not from an independent power base or because of authority invested in women as such.

"Male dominance is associated with increasing technological complexity, an animal economy, sexual segregation in work, a symbolic orientation to the male creative principle, and stress," according to Sanday (1981:171). Gender equality, or symmetry, is found in simple gathering, fishing, and shifting cultivation societies. Inequality occurs when animal husbandry is introduced (although it is not yet clear why). In some peasant societies, women may still

exercise real power behind a facade of deference to males (Rogers, 1975). On the whole, where societies must respond to stress—such as pressures on people to migrate, the potential of constant warfare, or a change in ecological conditions that creates chronic hunger—male dominance appears. Especially when women are identified with fertility and growth, stress situations may lead to attempts to control women more completely.

Women as Political Leaders

Women in the United States

Relatively few women have been elected to public office in the United States. This is especially true at the federal level. Women who have sought election have defied social expectations. We have not had easy access to organizations that traditionally launch political careers. And once in office, we have faced greater problems than our male colleagues in getting access to information, influence, and avenues of advancement (Githens and Prestage, 1977:421).

Explanations of women's political behavior, in the years since the Nineteenth Amendment (1920) gave the vote to women in the United States, have centered on early socialization into gender-appropriate roles. Our social norms do not lead us to expect women to hold political decision-making positions. As a result, social expectations about women's proper roles still act as a brake to recruitment into politics and political advancement. As one study has shown, "an obsession with being well prepared, doing her homework, and being known for speaking only when she has something to say is stressed by most women politicians, and connotes anxiety about interaction with male politicians" (ibid.:5).

Until very recently, our stereotype of the "politician" was clearly an "unfeminine" one. Women in higher education who might have turned to politics to achieve leadership positions gave such a career little thought. One study of women and men participating in suburban New York politics, for example, showed that women actually spent more time than men in local political activities. The women in this case were college-educated and upper middle class and could afford the child care needed to release them from domestic duties. Yet, having children at home has also made it less likely that women would run for office because of the unpredictable nature of the political needs to be away from home. As women in our twenties, thirties, and early forties who are engaged in socially approved activities as wives and mothers, we acquire less direct political experience than men of a comparable age. By the time children no longer require the attention that it is expected will be supplied by mothers, women have fallen behind in accumulating political experience. Moreover, even then many women and men do not think it is "proper" for us to run for public office. If interested in politics, we become involved at the organizational and support level for other candidates (Lee, 1977).

A study of the eighty-eight women who entered the House of Representatives between 1916 and 1976 indicates that thirty-six were first nominated to replace husbands who died while in office. Such women were often used by political parties as a "holding action" until some "real" (male) successor was found. A few widows did run again in their own right, having established their political credentials enough to gain the necessary party support (Gertzog, 1980).

Recent Political Gains. In view of the socialization women undergo, the effects of the contemporary women's movement on the pattern of female office-holding are striking. Between 1975 and 1979, the percentage of women holding elective offices across the nation, at municipal, township, county, state, and federal levels, more than doubled (from 5,765 or 4 percent of the total, to 14,225 or 9 percent). But while female state legislators increased from 610 (8 percent) in 1975 to 900 (12 percent) in 1980, the number of female congressional representatives at the federal level has not ever exceeded 19, and no more than two women have ever served in the Senate at the same time. In 1981, there were 18 women in the House of Representatives and 2 women in the Senate. At the local level, the number of mayors and municipal and township governing officials increased from 7,800 in 1975 to 12,459 in 1979, but there were only two female governors that year (Center for the American Woman and Politics, 1980).

Black women as a group have also made advances in political participation. Between 1971 and 1973, 35 black women served in state legislatures, but only 4 in state senates. In 1980, there were 59 black women in state legislatures, 10 of whom served in the upper houses. The first black woman elected to a state legislature, Crystal Bird Fauset, ran for the office in Pennsylvania in 1938, and the first black woman to become a state senator was Cora M. Brown, who was elected in Michigan in 1952 (Prestage, 1977:416).

A study published in 1978 indicates that women held approximately 10 percent of public offices in the country, that we were more likely than men to have held appointive office before being elected, and that women office holders were more active than men in community organizations. The study also shows that women are older than our male counterparts when we enter office for the first time, are less likely to have pursued education beyond the college level (men are especially likely to have gone to law school), and are slightly less likely to be married—79 percent compared to men's 91 percent (Johnson and Carroll, 1978).

Traditionally, male politicians have sought campaign funds from business and community leaders who are interested in backing candidates as a way of establishing future access to them. Women find money-raising more difficult, and we soon face formidable problems if we have no financial base of our

Shirley Chisholm: "I'm a Politician" Box 14.2

I'm a politician. I detest the word because of the connotations that cling
like slime to it. But for want of a better term, I must use it. I have been in
politics for 20 years, and in that time I have learned about the role of
women in power. And the major thing that I have learned is that women
are the backbone of America's political organizations. They are the letter
writers, the envelope stuffers, the telephone answerers; they're the cam-
paign workers and the organizers. . . . When I first announced that I was
running for the United States Congress, both males and females advised
me, as they had when I ran for the New York State legislature, to go back
to teaching—a woman's vocation—and leave the politics to the men.

(In Martin, 1972:148–49)

own. We do not fit into the locker-room camaraderie that is often offered as
a route for males to establish informal contacts, and we do not as yet appear
to offer the kinds of long-term investment that potential donors assume male
political careers to have. Until more women provide models of political suc-
cess patterns, it will continue to be difficult for women to find backers, raise
funds, and create large-scale organizations of devoted followers who see
possible benefit in our election.

Although it is clear that not all women are feminists, it is also clear that
more women than men have feminist views and understand the importance
of women's issues. Whatever political party or label women in office identify
with, we take more feminist positions on women's issues than do our male
colleagues. In the mid-1970s, 47 percent of conservative women and 33
percent of conservative men favored ratification of the ERA, and 68 percent
of "middle-of-the-road" women favored ratification in comparison with 47
percent of similar men. Even in the liberal camp, 88 percent of women
favored ratification compared with 71 percent of men. These political atti-
tudes were demonstrated in a 1977 study by the Eagleton Institute of Politics
at Rutgers University, which found that women office holders took more
liberal positions on such "women's issues" as ratification of the ERA, a
proposed constitutional ban on abortion, homemaker social security, and
government-sponsored child care (Johnson and Carroll, 1978).

The conclusion is obvious: if women's issues are to be dealt with effec-
tively, more women must seek political office at every level of government.
This is the lesson taught us by the failure to ratify the Equal Rights Amend-
ment in the United States. The more women who achieve political office at
higher levels, the more we will wish—or feel free—to identify with feminist
positions. When a lone woman occupies a place of high political authority,

As a black woman and a Congressional Representative elected from Texas, Barbara Jordan was well-prepared to deliver the keynote address at the first Plenary session of the National Women's Conference held in Houston, Texas, November 18–21, 1977. In her remarks she said, "American history is peppered with efforts by women to be recognized as human beings and as citizens and to be included in the whole of our national life." (*The Spirit of Houston*, Washington, D.C.: March, 1978: 223). Photo by Bettye Lane.)

like prime ministers Margaret Thatcher in England and Indira Gandhi in India, the political circumstances that have brought her to such an anomalous gender position and the personality she has formed will mesh with the prevailing profiles of the men against whom she has competed. Only when women exist in significant numbers at such levels will women of strong feminist beliefs generally be found among them.

Women in Communist Countries

What about women as leaders in countries that espouse socialist egalitarianism as an ideal? Do women participate more in politics? The political organization of Communist countries is very different from that of two-party or multiparty systems in the West. Service in lower government positions does not require Communist party membership, but advancement to higher levels does. There is only one party, and that party recruits and selects its own members, as well as individuals who are not members, to serve in official positions. Political power, then, rests with the Communist party.

Does Gender Make a Difference? Box 14.3
Doris Lessing has explored this question in her novel *The Marriages Between Zones Three, Four and Five* (1980), which assumes that there is a difference between the way women and men would rule a society. Her imaginary Zone Three is ruled by a queen. The society is pacific, knowing nothing of strife. It is fruitful, enjoying the bounty of well-developed arts of agriculture and herding. Its people devote their energies to beauty and its appreciation, to poetry and song as well as to production of necessities and comfort. They live at peace with nature, plants, and animals and with one another. They enjoy sexual freedom without dominance, possessiveness, or exclusivity. The queen herself is loved but not feared by her people.

By contrast, the society of Zone Four, governed by a king, is dedicated to war. The king himself is a military ruler who governs by force. Daily life is not eased by physical comfort, and both food production and domestic arts are rather poorly developed. Aesthetics in general are ignored. Women's status is considerably inferior to men's, and the society as a whole is quite stratified. Interpersonal relations are characterized by dominance and inferiority, possessiveness and dependency. The king is admired but also feared. The general atmosphere is one of uncomfortable orderliness, of imposed discipline, rather like a military camp.

Lessing seems to imply that Zone Three embodies the essence of femaleness and Zone Four the essence of maleness. While Zone Three is made to seem attractive and praiseworthy and Zone Four distasteful if not pathetic, Lessing also indicates that neither is perfect. Her novel suggests that health and strength can be achieved only by a "marriage" between the zones (by means of a marriage of their rulers). The benefits of Zone Three are obvious; its shortcomings lie in the ease of life in such a society: some degree of challenge, of struggle and resistance (symbolized by Zone Four), may be essential for human self-realization. Lessing's view, expressed in this novel, is that a combination of the best features of both societies would best serve their mutual interests.

The Case of the USSR. At the local level in the 1970s, women in the Soviet Union constituted nearly half the total number of delegates to the local political units, the soviets. Women's participation at this level has increased substantially since the political reorganization of the country in the 1920s. However, the proportion of women delegates decreases at successively higher levels of the government hierarchy, as the political units involved become geographically larger. At the next higher level in 1978, women constituted 35.4 percent, and at the Supreme Soviet (nationwide) level, 31.4 percent. These figures, however, are not particularly indicative of women's political power or influence. The great majority of male delegates are Communist party members (980 compared to 110 nonmembers), while the ma-

jority of female delegates are not (252 compared to 171 party members). More than half the male delegates are reelected, while only 15 percent of female delegates have served before. The very high turnover of female delegates means that few women have the experience or the tenure needed to move on to positions of greater political power. The issues on which women delegates participate in strength are largely "women's affairs"— health, education, housing, and cultural affairs.

In the Communist party itself, which is the real organ of power in the USSR, women's membership has risen from 7.4 percent in the 1920s to a current level of 24.7 percent, but the disproportionate underrepresentation of women in the ranks of the party has been greater than the figures suggest. Until recently, adult women in the Soviet Union greatly outnumbered men (by 40 percent) because of casualties experienced in the Second World War. Today, 14 percent of all Soviet males over eighteen are party members, compared to only 3.7 percent of all females.

Women's roles in party leadership are even more restricted. With the exception of a few positions reserved specifically for women—such as those dealing with women's affairs, or occasionally health, education, or culture— women do not hold high office in the Communist party. Very few women appointed to high positions have actually been professional (career) politicians; most have served as honorary office holders. Female membership in the party's Central Committee has actually declined since its establishment in 1912, from 8.3 percent to less than 4 percent in recent decades (Lapidus, 1978).

Obstacles to Women's Political Leadership. There are two major obstacles to furthering women's participation in high leadership levels in Communist systems (ibid.). The first is that few women in these countries seem to be interested in undertaking political careers. The reasons for this are familiar ones, beginning with an early socialization which leads girls to avoid political careers. Women learn early not to assert ourselves in public; we develop career expectations in other fields. Later on, more obstacles arise as a result of the double burden—family obligations added to workplace obligations. As we have seen before, men in Communist countries rarely share household and child-rearing tasks. Political careers require extra time that women do not have, and a geographical mobility that we and our families resist.

The second major obstacle is that while Communist party leaders give lip service to proportional representation of women (and minorities), in fact the largely male leadership is reluctant to assign important and responsible positions to women. Special positions involving traditionally female domains— health and "culture" are allocated to women, but leadership in international affairs, financial matters, or military affairs is never assigned us.

While communist and capitalist systems may appear to differ radically in

their objectives regarding women's roles in public power, the outcome is not nearly so different. Table 14.1 indicates the proportion of women in national legislative bodies throughout the world in recent times. The most promising picture comes from the Scandinavian countries, with their mixed economies, and their concerns over many years for both social welfare and fairness.

Women as Citizens

As citizens, women have been subject to the decisions of male political leaders. In this section, we examine women's political subordination in terms of our relative physical weakness and absence from combat warfare, women's efforts to foster peaceful solutions to international disputes, and the pattern of women's subjection to man-made laws.

Women and War

Many of the explanations, both popular and scientific, for the widespread political subordination of women are connected with the observation that we rarely, if ever, engage directly in combat warfare. More often than not, women are the victims of war; we are killed and maimed, raped and captured. Rarely do we possess or carry weapons, much less use them, either aggressively or defensively. Despite the risks to our lives in war, women are said not to be at risk because we do not enter into combat. Consequently, we rarely participate in councils of war, a critical affair of government, and relatively few share in any "spoils" of war or special (veteran) postwar benefits.

The effects of war on women may extend far beyond the denial of a voice in government. Anthropologist Marvin Harris, for example, has argued that the "male supremacy complex" is a direct product of warfare. In simpler societies, population pressure on limited environmental resources led people to fight one another for these resources. As these groups came to depend on male aggression for their survival, they came to value not only aggressiveness but men themselves more highly than women and nurturant qualities. A wide variety of rituals and beliefs were developed to foster and encourage male aggressiveness, including, for example, polygyny as a reward for male success. At the same time, the devaluation of women and feminine activities fostered such practices as female infanticide and institutions for the subordination and control of women. Harris points to the high degree of correlation between institutionalized female subordination, polygyny, female infanticide, and endemic warfare in tribal societies (Harris, 1977).

However, as we saw in chapter 13, modern history seems to present a somewhat different picture. During world wars, women were recruited to work in supporting industries, where we received much encouragement, relatively high pay, and other social rewards for our patriotic contribution to the war effort. Women served not only as producers of food and as industrial

Table 14.1 Women in National Legislative Bodies

Country	Legislative Body	Year	Proportion of Women (%)
Northern and Eastern Europe			
Finland	Eduskunta	1978	22
Sweden	Parliament	1975	21
Denmark	Folketing	1975	17
Norway	Parliament	1978	24
Poland	Parliament	1975	15
Bulgaria	Parliament	1975	19
	Council of the People	1975	37
USSR	Supreme Soviet	1975	35
	Central Committee	1975	2
	Politburo	1975	0
Western Europe, North America, and Oceania			
United Kingdom	House of Commons	1975	4
West Germany	Bundestag	1975	7
Greece	Chamber of Deputies	1975	2
United States	Congress	1979	3
New Zealand	Parliament	1975	5
Switzerland	National Council	1977	6
France	Parliament	1978	2
Asia			
Japan	Diet	1976	5
India	Parliament	1975	5
Bangladesh	Parliament	(15 seats reserved for women)	
People's Republic of China	Central Committee	1977	7
	Politburo	1977	0
Korea	National Assembly	1976	4
Thailand	Parliament	1974	3
Africa and the Middle East			
Israel	Knesset	1973	7
Egypt	National Assembly	1975	2
Lebanon	Parliament	1973	0
Syria	Parliament	1973	4
Tunisia	Parliament	1973	4
Liberia	Congress	1974	7
Sudan	Parliament	1973	5
Guinea	National Assembly	1975	27
Latin America			
Argentina	Legislature	1975	2
Brazil	Legislature	1975	1
Chile	Chamber of Deputies	1969	7
Colombia	Congress	1975	3
Costa Rica	National Assembly	1975	5
El Salvador	National Assembly	1975	3
Guatemala	National Assembly	1975	2
Mexico	Parliament	1975	8
Nicaragua	Legislature	1975	6
Panama	National Assembly	1977	5
Paraguay	Legislature	1973	7

Source: Adapted from Newland, 1979:126–28 (table 6-2).

549

workers, but also in dangerous occupations as field nurses, as ambulance drivers, and as resistance fighters in enemy-occupied territory.

Cases where women have served as fighting soldiers have occurred, but they have been exceptional; some are documented in antiquity as well as in modern times. The Old Testament figure Deborah was a general, as was Joan of Arc in the fifteenth century. The modern armies of Israel and Vietnam train all their women in combat duties, although women soldiers are rarely deployed in actual combat. Women fighters are more commonly found in the more informal armies of rebellions, revolutions, and resistance movements. Women have numbered among the military participants in modern times in the Warsaw Ghetto uprising, the French Resistance of the Second World War, the Israeli War of Independence, the Algerian Revolution, the Vietnam War, and the revolution in El Salvador. There have never been exclusively female armies—despite the myths of Amazons—for the purpose of combat. Women's regiments and branches of armies tend to be assigned to support work, not fighting.

Combat today no longer depends on the types of physical strength which disqualified most women previously. Technology has taken over. Even so, no modern armies employ women on a regular basis in combat warfare using this high technology, such as piloting jet fighters or operating long-range missile installations. Women largely serve in the armed forces in the same positions we do in civilian life: as clerical staff and nurses. More recently, women have been admitted to West Point Military Academy, which produces the highest-ranking army officers, and to the other service academies (Stiehm, 1981). Although women at West Point receive combat training like men, it is unlikely that we will use this training as army officers in the near future.

Should women be drafted as common soldiers? This issue has come up in legislative discussions about reestablishing the draft in the United States, and about the possible implications of the Equal Rights Amendment. If the ERA had been ratified, it might have become illegal to exempt anyone from the draft on the basis of sex; it may already be unconstitutional even without the ERA.

The issue is complex. Some people feel that if women are to receive equal rights and benefits, we must assume equal responsibilities; if men get drafted, so should women. Others argue that nobody should be drafted, nor should anyone go to war—women or men. A third, and slightly different argument, one offered by Virginia Woolf in *Three Guineas* (1938), is that since *men* make war, *they* should fight, and not concern women with the burden of wars we had almost no hand or voice in declaring. Many also argue that at least *until* women are granted equality, we should not have to bear the burden of military service in addition to all our burdens. The Supreme Court decided (*Rostker* v. *Goldberg*, 1981) that it was constitutional for Congress to call for the registration of men and not women, but the issues raised by the

question go to the heart of gender relationships and the issues of autonomy and power.

The notion has been fostered that women should not or cannot fight because we are by nature soft, weak, and yielding. Women on the whole do tend to be more "pacific" than men. In most societies, physical combat symbolizes the contradiction of everything women have been taught about ourselves and our relations with others. It is possible to see this socialization as based on society's concern for survival as well as on a deliberate policy by men to monopolize military decision-making and military rewards.

This does not mean, however, that women cannot be motivated to engage in physical combat. There have been female revolutionaries and terrorists who carry (and use) guns and bombs to wage a guerrilla war against an oppressor. Motivated at some level perhaps by a sense of our extreme power-lessness to bring about radical change in any other way, women may turn to acts of violence. Any other behavior makes us feel like accomplices in a world we utterly reject. The "Weather Group" of radical students in the late 1960s and early 1970s, who rejected American society completely, included a number of women. Those who resort to violence may believe that their actions will somehow prove a shortcut to their goals. A fictional presentation of these issues is found in Marge Piercy's novel *Vida* (1980).

Women and Peace Movements

The plot of the antiwar comedy *Lysistrata,* written by Aristophanes in ancient Greece, involves an agreement among women to abstain from sexual relations with men until their war is brought to an end. Women's organization of peace movements has been an expression of our political disagreement with men's military solutions to international disputes.

In the last two centuries, women in Europe and the United States have organized a number of national and international peace societies. In the late nineteenth century, international socialist leaders Clara Zetkin (1857–1933) and Rosa Luxemburg (1870–1919) were committed to the breaking down of national borders and ending of military competition between nations, positions that were not always taken by their male colleagues. An Austrian woman, Bertha von Suttner (1843–1914), wrote a major book about disarmament, *Down with Arms* (1894), and suggested the creation of the Nobel peace prize. She received it herself in 1905 (Boulding, 1977).

Jane Addams, founder of the first settlement house in the Chicago slums in the 1890s, became a leader in the women's international peace movement during World War I. Addams called for a women's peace conference in 1915 and helped form a Woman's Peace Party (WPP). An International Congress of Women was held in The Hague in April 1915, but once the United States entered the war, only the New York City branch of the WPP continued to demand a pacifist policy. The leader of this effort was Crystal Eastman

(1881–1928), a feminist lawyer and social activist (Cook, 1978; Steinson, 1980).

Other peace societies founded in the early twentieth century also involved women who were active in the suffrage and international socialist movements. Women in countries elsewhere in the world founded such groups as the Pan Pacific and Southeast Asia Women's Association and, after World War II, the All Africa Women's Conference and the Federation of Asian Women's Associations (Boulding, 1977: 172).

During the 1960s, two activist organizations, Women's Strike for Peace and Another Mother for Peace, were founded in response to threats to the world's atmosphere from nuclear testing and to protest United States involvement in Vietnam (Boulding, 1977). One of the founders of Women's Strike for Peace was Bella Abzug, who moved from this organization into politics and became a successful representative in Congress. Many women who became involved in feminist consciousness-raising and in the contemporary women's liberation movement were first active in peace efforts.

Women and the Law

Laws are the governing rules of every human society. The "law" is sometimes conceived to be a force above the vagaries of human will and impulse, an almost divine, implacable, impersonal force. In fact, laws have a history, just as do people. They develop from several sources: from ancient custom, from legislative bodies, from judicial decisions, and from administrative agencies.

It should no longer surprise anyone that traditional moral codes have been based on a double standard or that this double standard has provided the unexamined base of most family law. It has affected criminal law and a large amount of the civil law as well. Moreover, the laws, a society's moral code, and popular conceptions of social norms reinforce each other. Lawmakers, the judicial interpreters of laws, and those who enforce the law start from an idea of what the "normal" family is. They act on the basis of their notions of what women are like and ought to do, and their unexamined assumptions about what women need and want. Anyone who does not conform to their assumptions is either treated as invisible (as battered wives, victims of incest, and working female heads of households tend to be) or is sought out and made the object of pressures to conform (as are homosexuals and "welfare mothers").

Based on a double standard of sexual morality for women and men, laws have treated prostitutes as "deviant" to the point of labeling such women "criminals" but have considered male customers of female prostitutes to be "normal" men indulging a natural appetite. Laws have customarily treated adultery as a serious crime when committed by women while it is often disregarded when committed by men. In Victorian England, for example, men could sue their wives for divorce on a charge of adultery alone; women

had to couple the charge with bigamy, cruelty, desertion, incest, or other "unnatural" offenses. The prejudice in favor of the "unwritten law" which even excuses husbands who murder adulterous wives is still not entirely eradicated from society's practice of law.

Laws have existed that explicitly commanded husbands and fathers to control their families. For that purpose, men were even allowed to beat their wives into submission. Colonial Americans used ducking stools, stocks, and other instruments of humiliation and torture to correct women found guilty of scolding, nagging, or disturbing the peace with our clamor.

The law still acts to oppress women and treat us unfairly in many ways. Laws regulate women's reproductive rights. Lawmakers determine the respective priorities of health services, day care centers, education, job creation, and the defense budget. The government shapes welfare regulations that may force women to choose between husbands and support with which to feed our children.

In studying the lives of young black women in urban America, sociologist Joyce Ladner (1972) has pointed out that our lives are in large part governed by laws, customs, and restrictions that are based on a white middle-class perception of what is normal and what is deviant. For example, until recently, white middle-class norms associated "working mothers" with deviance, yet it was very common for black mothers to hold jobs.

This concept of deviance as a product of someone else's definition of normal has been explicitly applied to a definition of "sexism" by Jessie Bernard. Even laws that were intended to protect women or promote our well-being were inherently sexist because they were aimed at perpetuating or reforming a norm based on

> the unconscious, taken-for-granted, unquestioned, unexamined, and unchallenged acceptance of the belief that the world as it looked to men was the only world, that the way of dealing with it that men had created was the only way, that the values men had evolved were the only ones, that the way sex looked to men was the only way it could look to anyone, that what men thought women were like was the only way to think about women. (Bernard, 1971:37)

Rape. Laws impinge on our lives in determining what constitutes a criminal activity and who is criminal. Take the example of laws regarding rape. Many societies openly accept rape as a method of controlling deviant women. Judging from actual behavior, this attitude is also widely held in societies which do not formally condone rape (Brownmiller, 1975). Many legal codes have viewed rape as a crime of property and aggression between men. Accordingly, they have provided compensation and redress for men whose "property" has been damaged.

Even in the relatively enlightened law codes of the present day, the treatment of rape has tended to proceed from a basic assumption that the normal

man cannot be a rapist, that the criminal must be "sick" or deviant, or that his deviant behavior is due to some powerful impelling circumstance (such as provocative behavior on the part of the woman). The law has traditionally been far more careful to protect men from false accusations (by requiring corroborative testimony) than to protect women from assault. Until feminists organized to protest, to provide an analysis of what was actually happening, and to undermine false assumptions and threaten political action, these assumptions continued to dominate legal thought. And they did so despite the fact that research failed to establish any pathological pattern for rapists, and that, far from vengefully crying "Rape!" women have tended to be too shocked and traumatized even to report the crime, much less press charges (Brownmiller, 1975).

Women as Interpreters and Enforcers of the Law. We have already pointed out that legislative bodies (which introduce and pass laws) have very low levels of representation of women everywhere in the world. Laws are interpreted by local judges, whose decisions can be overturned by judges at higher federal levels. In the United States, women judges at the local appellate and district court levels numbered only 4 in 1977. By 1981, there were 44 women out of 667 judges, or 6.6 percent. At the highest level, the United States Supreme Court, there had never been a woman judge until 1981, when Sandra Day O'Connor became an associate justice. Most judges are recruited from the ranks of lawyers, of whom women constitute a clear minority. Women are also substantially underrepresented in police forces everywhere. Thus, a woman criminal is likely to be a person arrested and taken into custody by male police officers, to be tried by a male judge, and accused and defended by male lawyers for having broken a law made by male legislators (Adler, 1975; Smart, 1978).

Equal Rights

The abolitionist movement in the United States raised women's consciousness, showing white women that oppression took many forms. Sarah M. Grimké (1792–1873), a leader in the abolitionist movement, was an early champion of women's emancipation. She expressed her feminist views as early as 1837:

> All history attests that man has subjugated woman to his will, used her as a means to promote his selfish gratification, to minister to his sensual pleasures, to be instrumental in promoting his comfort; but never has he desired to elevate her to that rank she was created to fill. He has done all he could to debase and enslave her mind; and now he looks triumphantly on the ruin he has wrought, and says, the being he has thus deeply injured is his inferior. . . . But I ask no favors for my sex. . . . All I ask of our brethren is, that they will take their feet

Sandra Day O'Connor. The first woman to sit on the United States Supreme Court, Associate Justice O'Connor breaks an all-male tradition that dates to the founding of the country. Whether she remains an exception or symbolizes real change in our political life is an important question for the future. (The Supreme Court Historical Society)

off from our necks and permit us to stand upright on that ground which God designed us to occupy. (Hole and Levine, 1971:4–5)

We have seen that a meeting on the question of women's rights was held in Seneca Falls, New York, in 1848. The Declaration of Sentiments drawn up there reflected the sense of unfinished business women felt as part of a young republican nation dedicated to equality and to the pursuit of happiness for all:

> We hold these truths to be self-evident: that all men and women are created equal. . . . The history of mankind is a history of repeated injuries and usurpations on the part of man toward woman. . . . Now, in view of this entire disfranchisement of one-half the people of this country, . . . we insist that they have immediate admission to all the rights and privileges which belong to them as citizens of the United States. (Schneir, 1972: 77, 78, 80)

The women at Seneca Falls asserted a right to political personhood that remains unfinished business for feminists today. That unfinished business, highlighted by the failure to ratify the ERA in the United States by June 30, 1982, was underlined at a commemorative celebration of the new national park at Seneca Falls, New York, in July 1982.

The Struggle for the Vote

The Thirteenth Amendment brought an end to slavery in the United States in 1865. When feminists attempted to eliminate the word *male* in the proposed Fourteenth Amendment, which would ensure the "rights, privileges, and immunities of citizens" to freed slaves, we were advised by male abolitionists that it was not yet our turn. After decades of unceasing work in the cause of black emancipation, women found that we could count on no support from our male colleagues when the matter concerned women's rights, in this case, the right to vote.

In 1869, Susan B. Anthony and Elizabeth Cady Stanton organized the National Woman's Suffrage Association (NWSA), which focused on achieving a national suffrage amendment to the Constitution. In 1875, the Supreme Court ruled unanimously that the St. Louis registrar of voters could not be compelled to register Virginia Minor as a voter just because she was a citizen. This court ruling made it clear that only a constitutional amendment could achieve the vote for women. By 1878, the Stanton amendment was introduced into Congress; it was this proposal that would be ratified more than forty years later as the Nineteenth Amendment.

In 1890, the National American Woman Suffrage Association (NAWSA) was formed. Carrie Chapman Catt (1859–1947) succeeded Anthony as its second president, but no major gains were made until Alice Paul (1885–1977), recently returned from the militant suffrage scene in England, became active in 1911 in organizing mass demonstrations. She left NAWSA in 1915 over differences regarding strategies and formed a new radical suffrage

Elizabeth Cady Stanton (1815–1902) bottom row, center, with suffragist committee. Although she advocated women's suffrage at Seneca Falls in 1843, Stanton became a politically active leader in the cause only after twenty years of being a wife and mother (of seven). Susan B. Anthony, whose unceasing political agitation on behalf of suffrage was sustained by her long-time friendship with Stanton, is second from the left in the front row. (Culver Pictures, Inc.)

group, the National Woman's party. To dramatize the hypocrisy of Woodrow Wilson's words when he led the United States into World War I "to make the world safe for democracy," Alice Paul's suffrage group organized a silent picket in front of the White House in 1916. After several months, demonstrators were forcibly removed by the police for obstructing the public way. A total of 218 women from twenty-six states were arrested in 1917. Some of the women arrested were sent to Occaquan workhouse in Virginia, where they decided to express their contempt for their imprisonment by a hunger strike. The government ordered them forcibly fed. The courts ordered their release several months later, on the grounds that both arrests and convictions were illegal. Despite last-minute efforts by antisuffrage groups after the war, proclaiming that enfranchising women would open up a Pandora's Box of evils, the Nineteenth Amendment was passed in Congress in 1918 and ratified by two thirds of the state governments by August 26, 1920 (box 14.4). Finally, American women could vote.

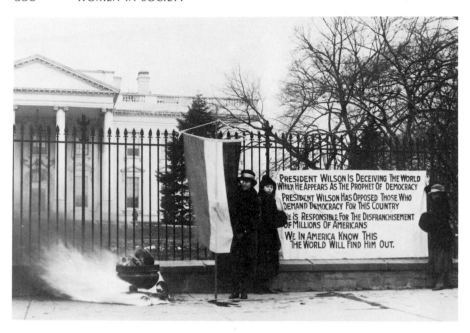

When Woodrow Wilson refused to endorse woman's suffrage at the Democratic Party convention in 1916, militant suffrage leaders Harriet Stanton Blatch and Alice Paul stationed pickets in front of the White House in Washington, D.C., around the clock. When suffrage amendment passed the House of Representatives but not the Senate in January 1919, suffrage leaders again posted pickets, and brought an urn with a perpetual fire. They put up a poster mocking Wilson's defense of democracy abroad while denying it to women at home. Whenever Wilson made such a speech, his words were burned in the fire. (National Archives)

Women's suffrage was achieved in stages in England in 1918 and 1928, after an equally long but far more militant struggle. Women gained political enfranchisement on equal terms with men as early as 1893 in New Zealand and 1902 in Australia, but only as recently as 1946 in France and 1971 in Switzerland. In some countries, women are still not permitted to vote. The right to cast a ballot for largely male candidates for political office has not yet strikingly changed women's lives, but it provides an essential beginning.

The Modern Women's Liberation Movement
The origins of the modern women's liberation movement in the United States are usually traced to two strands of feminist activism beginning in the 1960s. The first developed as a result of the national Commission on the Status of Women, chaired by Eleanor Roosevelt. It was established in December 1961 by President John F. Kennedy. Esther Peterson of the Women's Bureau of the U.S. Labor Department, the only woman he appointed to a federal office, urged this action on the new president as a way of paying his political debt to

Carrie Chapman Catt Remembers **Box 14.4**

To get the word "male" in effect out of the Constitution cost the women of the country 52 years of pauseless campaign. . . . During that time they were forced to conduct 56 campaigns of referenda to male voters; 480 campaigns to get [state] legislatures to submit suffrage amendments to voters; 47 campaigns to get state constitutional conventions to write woman suffrage into state constitutions; 277 campaigns to get state party conventions to include woman suffrage planks; 30 campaigns to get presidential party conventions to adopt woman suffrage planks in party platforms, and 19 campaigns with 19 successive Congresses.

(In Goldstein, 1979:62)

From *Woman Suffrage and Politics* by Carrie Chapman Catt and Bettie Rogers Shuler (New York: Charles Scribner's Sons, 1923). Reprinted with the permission of Charles Scribner's Sons.

the many women who actively supported his campaign. The commission's report concerning the second-class nature of women's status in the United States led to the formation of a Citizens' Advisory Council on the Status of Women in 1963 and, by 1967, to fifty state commissions (Freeman, 1979; Hole and Levine, 1971:19–20, 24)

Dissatisfied with our inability to use these commissions to achieve any gains, several women founded the National Organization for Women (NOW) in 1966 (box 14.5). NOW was initiated by a group of professional women, as were other associations of women that developed, including the Women's Equity Action League (WEAL) and Federally Employed Women (FEW). NOW was conceived as a pressure group to force the government to take seriously the sex-discrimination guidelines (Title VII of the 1964 Civil Rights Act) administered by the Equal Employment Opportunity Commission (EEOC). Some of the founders included Representative Martha Griffiths, lawyers Pauli Murray and Mary Eastwood, EEOC commissioners Richard Graham and Aileen Hernandez, Betty Friedan (author of *The Feminine Mystique*), and the head of the Wisconsin Commission on the Status of Women, Kathryn Clarenbach (Hole and Levine, 1971). NOW became a stong political lobby for many women's rights issues, including the Equal Rights Amendment, child care centers, abortion rights, and equal employment opportunities.

One of the issues that NOW first turned to was the gender-segregated listings used in newspaper want ads. NOW petitioned for hearings by the EEOC in the spring of 1967; in December it filed a complaint against the *New York Times* and set up picket lines. A national day of demonstration against EEOC was organized in several cities, one of the first attempts to mobilize women on a national scale to fight gender discrimination. EEOC

NOW Statement of Purpose: 1966 **Box 14.5**

. . . To take action to bring women into full participation in the main-
stream of American society *now*, exercising all the privileges and respon-
sibilities thereof in truly equal partnership with men.

. . . It is no longer either necessary or possible for women to devote the
greater part of their lives to child-rearing; yet childbearing and rearing—
which continues to be a most important part of most women's lives—still
is used to justify barring women from equal professional and economic
participation and advance. . . . Until now, too few women's organizations
and official spokesmen have been willing to speak out against these
dangers facing women. Too many women have been restrained by the
fear of being called "feminist." . . .

We do not accept the traditional assumption that a woman has to
choose between marriage and motherhood, on the one hand, and serious
participation in industry or the professions on the other. . . .

We believe that a true partnership between the sexes demands a differ-
ent concept of marriage, an equitable sharing of the responsibilities of
home and children and of the economic burdens of their support. We
believe that proper recognition should be given to the economic and
social value of homemaking and child-care. . . .

We will protest, and endeavor to change, the false image of women now
prevalent in the mass media, and in the texts, ceremonies, laws, and prac-
tices of our major social institutions. Such images perpetuate contempt for
women by society and by women for themselves. We are similarly opposed
to all policies and practices—in church, state, college, factory, or office—
which, in the guise of protectiveness, not only deny opportunities but also
foster in women self-denigration, dependence, and evasion of responsibil-
ity, undermine their confidence in their own abilities and foster contempt
for women. . . .

Above all, we reject the assumption that these problems are the unique
responsibility of each individual woman, rather than a basic social di-
lemma which society must solve.

agreed in August 1968 to issue new guidelines prohibiting separate want ad
columns for women and men. A countersuit by the American Newspaper
Publishers' Association early in 1969 failed to change the ruling (Hole and
Levine, 1971).

By this time, WEAL had been formed in Cleveland, Ohio, and had ex-
tended its representation to other states. Its founder, Elizabeth Boyer, saw the
need to focus on three areas of discrimination: employment, education, and
tax inequities. WEAL's first action was to file a formal complaint against the
University of Maryland for its discrimination in hiring and promotion poli-
cies on the grounds that the university received federal contract funds. This
was the first use against an educational institution of presidential Executive

Order 11375, which came into effect in 1968, prohibiting discrimination in the operation of federal contracts or in federal employment. It had taken two years of intensive lobbying by women to bring it into being.

The U.S. Labor Department then brought a class action suit against all colleges and universities, asking compliance review (Hole and Levine, 1971). But the Labor Department did not issue guidelines regarding gender discrimination until still further lobbying by women. As soon as this was accomplished, in June 1970, NOW filed a complaint against thirteen hundred corporations receiving federal funds.

The second source of the modern women's movement was a relatively younger group who had been activists in the 1960s in many New Left and civil rights organizations, where we had experienced second-class status at the hands of male leaders (Evans, 1980). Young white women from the South and the North and young black women, mainly from the South, developed a feminist consciousness working in the ranks of the Student Non-Violent Coordinating Committee (SNCC) in 1963–1964. We helped run the organization; indeed, we maintained it on a daily basis. Yet we became conscious of our relative powerlessness in the male controlled political decision-making process. In a position paper issued in November 1964, three white women compared their situation to that of a token black man hired in a corporation. They charged SNCC leaders with relegating women to clerical and housekeeping chores and charged other women, who did not object, with remaining insensitive to this gender discrimination. Black women, meanwhile, had been more active in challenging gender discrimination and had increasingly come to hold leadership positions (Evans, 1980).

Another part of the second strand of the modern women's movement took shape in the Students for a Democratic Society (SDS), which had developed in northern states in 1960. This student New Left movement was dominated by males to an even greater extent than SNCC. The style of the primarily male leadership was intellectually competitive, aggressive, and self-confident. Women were viewed as attached to particular men, or as "implementers and listeners" (ibid.:113). By 1967, women in the New Left were asserting our own leadership abilities, only to experience increased male domination and disdain. At the National Conference for a New Politics in Chicago in August 1967, a splinter of the women's caucus, led by Jo Freeman and Shulamith Firestone, proposed a militant resolution demanding 51 percent of convention votes for women because women numbered 51 percent of the population in the country. The male leadership shunted them aside.

The women went home and organized and circulated a paper addressed "To the Women of the Left," calling on women "to organize a movement for women's liberation" (ibid.:200). The spark that created a women's group in Chicago spread to New York and New Orleans. Soon the gatherings of women became consciousness-raising groups which began to generate new

Consciousness-Raising and Political Change Box 14.6

Small-group consciousness raising at the beginning of the contemporary women's movement—with its stress on clarifying the links between the personal and the political—led women to conclude that change in consciousness and in the social relations of the individual is one of the most important components of political change. Women talked to each other to understand and share experiences and to set out a firsthand account of women's oppression.

But a great deal of unexpected energy and method came out of these groups. We learned that it was important to build an analysis of sexual politics from the ground up—from our own experiences. The idea that the personal lives of women should be analyzed in political terms both grew out of the experience of women in these groups and served as a focus for continued small-group activity. We drew connections between personal experience and political generalities about the oppression of women: we took up our experience and transformed it through reflection. This transformation of experience by reflection and the subsequent alterations in women's lives laid the groundwork for the idea that liberation must pervade aspects of life not considered politically important in the past. (Hartsock, 1981:7)

Reprinted by permission of the author.

groups at a rapid pace (box 14.6). *Ms.* magazine, founded in 1971 by Gloria Steinem and others, gave women a growing feminist voice that drew national attention. By the 1970s, the two main strands of events had merged to form a movement of great political significance.

The Equal Rights Amendment. An important symbol for all parts of the new women's liberation movement was the passage in Congress in 1972 of a constitutional amendment guaranteeing equal rights under the law to all, regardless of gender. The National Woman's party first proposed an Equal Rights Amendment at the seventy-fifth anniversary conference of the Seneca Falls Convention, in 1923. It was introduced into Congress that year, and repeatedly, for the next forty years. The proposed amendment was controversial even among women in public political life. For example, the Women's Bureau of the U.S. Department of Labor, established in 1920, opposed the amendment on the grounds that it would invalidate the protective labor legislation of the early twentieth century. The Women's party, however, believed that such legislation discriminated against women's labor participation more than it protected us on the job (Hole and Levine, 1971).

The Citizens' Advisory Council on the Status of Women recommended passage of the Equal Rights Amendment in 1970. Hearings were held by the

Left to right, Bella Abzug, Gloria Steinem, and Betty Friedan, three contemporary feminists who have contributed to women's growing political self-confidence: Abzug as an out-spoken leader in and out of political office; Steinem as a journalist, lecturer, and editor of *Ms.*; and Friedan in her books *Feminine Mystique* (1964) and *The Second Stage* (1982). (Photo by Bettye Lane)

Senate Judiciary Committee after presure from NOW. Congress seriously debated the issue for the first time in 1971 and finally adopted the amendment on March 22, 1972 (box 14.7).

Because the Equal Rights Amendment passed the House and the Senate with large majorities, no difficulty was anticipated with ratification by the necessary thirty-eight, or two-thirds, of the states. At first this view was sustained; by the end of 1973, thirty states had ratified. The process then slowed down. By the end of 1975, five more states had ratified, but the controversy over enactment now developed. Anti-ERA forces in states in the South (Alabama, Arkansas, Florida, Georgia, Louisiana, Mississippi, North Carolina, Oklahoma, South Carolina, and Virginia), the Midwest (Illinois and Missouri), and the Southwest (Arizona, Nevada, and Utah) warned voters that the amendment would overturn their way of life. The ERA was pictured as representing all that was antithetical to their personal, social, and religious values. The opposition centered in ultraconservative groups, including the American Legion, the Veterans of Foreign Wars, the Daughters of the American Revolution, the Catholic Daughters of America, the John Birch

> **The Equal Rights Amendment** **Box 14.7**
>
> *Section 1.* Equality of rights under the law shall not be denied or abridged by the United States or by any State on account of sex.
>
> *Section 2.* The Congress shall have the power to enforce, by appropriate legislation, the provisions of this article.
>
> *Section 3.* This amendment shall take effect two years after the date of ratification.

Society, and the Ku Klux Klan (Newland, 1979:22). For them, the ERA became a symbol of disturbing social changes that seemed to threaten the very structure of the family, parental authority over children, and traditional sexual mores. Many women saw their traditional roles denigrated and their lives called into question.

Despite the media coverage of this attack from the Right, and despite the influence of such reactionary groups as the Moral Majority in the 1980 election of a Republican president and Senate, opinion polls in 1981 showed a clear majority of Americans favoring passage of the Equal Rights Amendment. Yet it proved impossible to marshal that support against recalcitrant state legislators by the end of June 1982, when the time limit for ratification (already extended by Congress) ran out.

What are the legal issues that were raised by the Equal Rights Amendment? It would not have outlawed all gender-based legislation; instead, it would have required that any legislation passed by the state or federal governments which discriminated on the basis of gender alone be justified by compelling reasons. The Fifth and Fourteenth amendments to the Constitution, guaranteeing equal protection under the law, as they have so far been interpreted by the Supreme Court are not adequate to assure this.

As we have already noted, the interpretation of legislation by the courts, and in particular by the Supreme Court, has contributed to the inability of women to claim equal justice. As recently as 1961, in *Hoyt* v. *Florida*, the majority on the Supreme Court agreed that a state government had the constitutional right to view women as "the center of home and family life" and *for that reason* to exempt us automatically from jury service unless we individually applied to serve. The Supreme Court simply did not address the issue of the plaintiff Hoyt that an all-male jury might be unfair to a female defendant (Goldstein, 1979).

Ten years later, in 1971, the Supreme Court decided to look more carefully at the "reasonableness" of treating women as a distinct classification for legal purposes. By this time, federal legislation and two executive orders had pro-

hibited discrimination in employment solely on the basis of gender. In *Reed* v. *Reed* (1971), the court majority decided that it was "unreasonable" for the state of Idaho to adopt a statute ordering that in naming administrators of estates, "males must be preferred to females" (Goldstein, 1979:83). Such language, according to the court, did violate the equal protection clause of the Fourteenth Amendment.

In *Frontiero* v. *Richardson* (1973), a plurality of the Supreme Court referred to the recent passage by Congress of the Equal Rights Amendment as indicating the congressional view "that classifications based upon sex are inherently invidious" (Goldstein, 1979:89). The case concerned unequal fringe benefits in the military: married men automatically received housing and medical allowances for wives, while married women had to prove that we supplied over half the living costs of our husbands. The air force justified the practice in terms of administrative convenience, but the court found this reason inadequate.

Just as the ERA ratification process slowed down, however, the willingness of the Supreme Court justices to take these precedents any further also seemed to lose momentum. Gender, unlike "race," has not yet been decisively declared a "suspect category" on which to treat people differently in the law, that is a category requiring special scrutiny by the court. As has been observed many times in our history, the Supreme Court is not immune to the political climate of the country. Thus, passage of the ERA became not just symbolically important, but substantially important to the achievement of equal justice for women under the law. As in the past, every failure to achieve that equality has brought forward renewed efforts. This remains our task today.

Perhaps the most significant development of the last decade is the increased participation of women in the political process. The assumptions of political scientists about the voting behavior of women, that gender as a variable is simply not important, have been proven wrong. According to the Census Bureau in 1982, among the 18- to 24-year-olds who were old enough to vote in 1980, 37.5 percent of the 8,346,000 women and 35.3 percent of the 7,919,000 men reported that they had voted. These totals meant that in this age group, a third of a million more women voted than men. Since the same trend has been noted for women in the age group 25 to 44 since 1976, and women outnumber men in every age bracket, women's greater political participation at the polls will affect politics in the future (Clymer, 1982). The question remains of how women will use this political influence. The potential political power of women at the ballot box has already been noted by the major political parties and the phenomenon dubbed "the gender gap." The greater the number of women who understand the political nature of our lives, the more effective our ballots may become on behalf of all women's needs.

Feminism and Internal Conflicts

This book has often referred to potential conflicts among women with different interests who count ourselves feminists. Feminists are divided by race, ethnicity, class, religion, age, sexual preference, and experiences of all sorts. To illustrate the kinds of conflicts that come up, let us examine a hypothetical example of a division encompassing race, ethnicity, and class. We shall use an issue of considerable importance to women's movements everywhere: quality day care for working mothers.

Most feminists see day care as a high priority, something that society should undertake as a general responsibility. But how might this issue be perceived by two groups of feminists—Anglos and Chicanas—in a state in the American Southwest?

The Anglo women—white, middle-class, well-organized—decide to begin a campaign to influence our state representatives to sponsor a bill providing state financing for a large number of high-quality local child care centers. This, we claim, would provide women throughout the state with an opportunity to work, to achieve the economic self-sufficiency we need to be the equals of men at home and in the community.

Much to our shock, however, we fail to garner support from our Chicana sisters. We know that the Chicanas are poor and need to work, and need to have children looked after, too. In fact, a higher proportion of Chicanas than Anglo women work, and have more small children per woman. Why should the Chicanas object to the plan of the Anglos?

The Chicanas respond that we see things differently. A great many Chicanas are employed, but we work mainly as domestics, cleaning the homes and caring for the children of Anglo women. Day care centers would take away these jobs. There is no guarantee the Chicanas could work in the day care centers instead, at higher pay. "Quality" day care means "professionals." But most Chicanas do not have professional education. We do not even have high school education. At most, the Chicanas would be cleaning the kitchens and bathrooms of the day care centers, and we already do that work in Anglo homes.

The Chicanas would ask how we might benefit. Would we have to pay for day care? If so, we cannot afford it. If the day care is free, it will probably be as bad as the public schools. Such places will teach our children to hate themselves, to reject our culture, language, and traditions, and to perpetuate our degradation. In Chicano neighborhoods, the centers will be understaffed and poorly equipped. It is hard to imagine busing one-year-olds.

So the Chicanas might say the day care centers will help the Anglo women—not us. Why should we work to add to the privileges of an already privileged class? The Chicanas might also feel that we cannot separate our own liberation from that of our whole community. Our lives cannot improve if our sons and husbands and fathers cannot get good jobs and a good

education. To be a Chicana is more than to be a woman. If there is money for day care centers, we might favor using the money for Chicano interests, to employ and educate both women and men in our community so we can all take a place as equals in American society. We may feel that only after this happens will we be able to join hands with Anglo women.

Disparities in the lives of Chicanas and Anglo women in the Southwest present problems for feminist unity (Valdez, 1980). But to begin to understand such differences is to begin to open ways of exploring solutions. Women who study the history of reform movements learn the cost for women of not demanding gains for ourselves until the men of the group to which we belong have achieved justice (see chapter 15). But putting the interests of women first should still mean considering the needs and goals of all women, not just of those who already enjoy a relative advantage. We should not let the racism and class privileges which divide men undermine the growing sisterhood among us.

Black feminists have struggled with the problems of double oppression, as blacks and as women. In 1973, several black feminists founded the National Black Feminist Organization (NBFO). Black feminists acknowledge that sexual oppression is a constant factor in the lives of those of us who are black. But racism is also so much a daily factor in our lives that sorting out the nature of the double oppression we experience has not been easy or painless. Black feminists see the need for continued solidarity with black people. As one group has expressed it, "We struggle together with black men against racism, while we also struggle with black men about sexism" (Combahee River Collective, 1979:366). Black women can see the way gender has played an important role in black male thinking. A black nationalist pamphlet of 1970, for example, took a traditionally sexist view of "natural" gender roles:

> The man is the head of the house. He is the leader of the house/nation because his knowledge of the world is broader, his awareness is greater, his understanding is fuller and his application of this information wiser. . . . Women cannot do the same things as men—they are made by nature to function differently. Equality of men and women is something that cannot happen even in the abstract world. (Combahee River Collective, 1979:369–69).

Barbara Smith, a black feminist, addresses, "in a critical way the reality of violence against Black women by Black men . . . a deeply taboo subject judged politically 'incorrect' in different historical eras and by people of many different political persuasions" (Smith, 1979:127). She acknowledges the danger of being misunderstood but explains the "difficult and challenging" decision to publish her views. She writes,

> By naming sexual oppression as a problem it would appear that we would have to identify as threatening a group we have heretofore assumed to be our allies—

What We Believe: A Black Feminist Statement **Box 14.8**

Above all else, our politics initially sprang from the shared belief that black women are inherently valuable, that our liberation is a necessity not as an adjunct to somebody else's but because of our need as human persons for autonomy. This may seem so obvious as to sound simplistic, but it is apparent that no other ostensibly progressive movement has ever considered our specific oppression a priority or worked seriously for the ending of that oppression. Merely naming the pejorative stereotypes attributed to black women (e.g., mammy, matriarch, Sapphire, whore, bull-dagger), let alone cataloguing the cruel, often murderous, treatment we receive, indicates how little value has been placed upon our lives during four centuries of bondage in the Western hemisphere. We realize that the only people who care enough about us to work consistently for our liberation are us. (Combahee River Collective, 1979:364)

Black men. This seems to be one of the major stumbling blocks to beginning to analyze the sexual relationships/sexual politics of our lives. The phrase "men are not the enemy" dismisses feminism and the reality of patriarchy in one breath and also overlooks some major realities. If we cannot entertain the idea that some men *are* the enemy, especially white men and in a different sense Black men too, then we will never be able to figure out all the reasons why, for example, we are being beaten up every day . . . why we are being raped by our neighbors, why we are pregnant at age twelve and why we are at home on welfare with more children than we can support or care for. Acknowledging the sexism of Black men does not mean that we become "man-haters" or necessarily eliminate them from our lives. What it does mean is that we must struggle for a different basis of interaction with them. That if we care about them and ourselves we will not permit ourselves to be degraded or manipulated. (Smith, 1979:123–24)

The Political Climate of the 1980s

More progress toward feminist goals has been made in the past twenty years than in any other period of modern history. The very fact of such success has set off a strong reaction within the American community. The rejection of the ERA by the successful Republican party in the elections of 1980, its subsequent failure to be ratified, and the efforts of President Reagan and his administration to dismantle the legislative, judicial, and economic gains made over the previous decade present a new challenge to feminists of every kind.

Have there been enough successes for women to build together a significant political force to oppose the incursions on the gains made? Have women developed the networks, the organizations, the ways of offering support to one another to be able to marshal our forces, get our opinions heard, and

make our presence felt in the American political process as never before? Can women save the women's liberation movement? Can we save our gains in women's studies, and can we make further progress toward the goals we have begun to define for ourselves? The answer depends on women.

Summary

Until recently, most political scientists viewed women as of little consequence in politics. Women have been far less visible than men in political activity. The stereotyped view of women is that we are naturally unsuited to act in the "public" sphere and that we adopt the views of our fathers and husbands.

Feminist political scientists call attention to the crucial role women play in community-level organizations and the ways we have been socialized to follow rather than lead. The women's movement has brought out the relation between women's exclusion from the "public" sphere and our lack of control over our "private" lives.

Power is distinct from authority. Women have seldom exercised either power or authority.

As societies become more complex, governmental power tends to be exercised by the few on behalf of the many. Women tend to be segregated as a group, and excluded from political power, along with other minorities. Women who do participate in government tend to do so on the local level.

In the past, some women have exercised political power in our own right in dynastic states and in precolonial tribal societies. But as government became more bureaucratic and as colonial powers altered tribal societies, the power of these women leaders eroded.

In the last decade, the women's movement has encouraged increasing numbers of American women to seek public office. Studies show that regardless of party label or level of office, women office holders take more feminist positions on women's issues than do men.

Few women are found at the higher levels of government in the USSR. Women in Communist countries tend not to seek political careers; sex roles within the family have not broken down, and party leaders do little to develop the political potential of women.

One reason for women's political subordination to men is that it is men who have waged wars and thereby made critical decisions affecting government. The many peace movements that women have been involved in testify to our political opposition to men's wars. While women do tend to be more "pacific" than men, this does not mean that we cannot be motivated to fight.

Laws tend to have a sexist bias because they are based on male-defined norms. Many laws and moral codes are based on a double standard. Family law coerces women into traditional roles. Laws designed to "protect" women actually have the effect of restricting our choices and activities. In the case of

rape, laws have been more careful to protect men from false accusation than to protect women from assault. Women criminals are subject to laws made by male legislators, enforced by male police officers, and interpreted by male judges.

In the United States before 1860, women participated in moral reform organizations and the abolitionist movement. But after black men got the vote in the 1860s, women still had a fifty-year struggle before we were given that right.

The modern women's liberation movement derived from two sources: organizations of women which formed to work for women's equality and a younger, more radical group developing out of the civil rights movement, and concerned with liberation from male domination.

The Equal Rights Amendment took half a century to pass Congress; in June 1982 it failed to win the necessary ratification by two-thirds of the states. Opposition to ERA centers in ultraconservative groups that fear disruption in traditional social norms. The Supreme Court's willingness to press for women's rights in the early 1970s has slowed as the political climate has become more conservative. Yet more women than ever have joined the political process.

Feminist unity is made more difficult by the fact that women come from different ethnic, class, and racial backgrounds, and so have different priorities. Black feminists carry a double burden in having to deal with both sexism and racism.

The need for all women not only to engage in the political process but also to fix clearly on their necessary goals is paramount if we are to ensure that recent gains will not be lost and new gains will be won. We need the unity we can gain from understanding all kinds of sexism.

Discussion Questions

1. Document the life of a woman political leader of your choice. How did she manage to succeed, given the usual obstacles to women's political leadership?
2. Find out what women hold political offices or leadership positions in your town, county, or congressional district. On the basis of what you have read in this chapter, design a questionnaire to find out what these women's positions are on a variety of feminist issues.
3. What kinds of organizations exist in your locality to deal with issues concerning women and the law (such as a rape center, a "battered wife" center, or a group concerned with women in prison)?
4. How do women from different ethnic groups or economic classes differ in our perceptions and attitudes on feminist issues? Select one issue—a "problem" and suggested "solutions"—and consider how women from

two groups might argue from the perspectives of our different backgrounds.

5. Analyze the failure to ratify the Equal Rights Amendment and suggest strategies for achieving the goal of social justice for all women.

Recommended Readings

Brownmiller, Susan. *Against Our Will: Men, Women, and Rape.* New York: Simon & Schuster, 1975. Research on rape, across historical periods and in the present. Brownmiller examines the nature of this crime and the social treatment of its victims and perpetrators. She argues that rape is a terrorist device to control women.

DuBois, Ellen. *Feminism and Suffrage: The Emergence of an Independent Women's Movement in America, 1848–1869.* Ithaca: Cornell University Press, 1978. An important book analyzing the political strategies of Elizabeth Cady Stanton and Susan B. Anthony, early suffrage leaders who saw the Fifteenth Amendment, enfranchising only black men, as poor reward for women's abolitionist efforts. DuBois explores the way the stage was set for a broad critique of patriarchal America by these women's rights reformers.

Evans, Sarah. *Personal Politics, The Roots of Women's Liberation in the Civil Rights Movement and the New Left.* New York: Knopf, 1979. A discussion of the emergence of the recent women's movement in the context of women's activities in the civil rights movement in the 1960s. It tells of women's changing roles in the movement as it grew larger and more successful, and of the contradiction that emerged between the fight for racial minority rights and women's rights.

Janeway, Elizabeth. *Powers of the Weak.* New York: Knopf, 1980. An extended examination of powerlessness, especially as exemplified by the condition of women.

References

Adler, Frieda. *Sisters in Crime: The Rise of the New Female Criminal.* New York: McGraw-Hill, 1975.

Bernard, Jessie. *Women and the Public Interest.* Chicago: Aldine, 1971.

Boulding, Elise. *Women in the Twentieth Century World.* New York: Wiley, 1977.

Brownmiller, Susan. *Against Our Will: Men, Women, and Rape.* New York: Simon & Schuster, 1977

Center for the American Woman and Politics. *Women in Elective Office, 1975–1979.* Fact Sheet Issued by the National Information Bank on Women in Politics. Eagleton Institute of Politics, Rutgers University, 1980.

Combahee River Collective. "A Black Feminist Statement." In *Capitalist Patriarchy and the Case for Socialist Feminism,* edited by Zillah R. Eisenstein. New York: Monthly Review Press, 1979.

Cook, Blanche Wiesen, ed. *Crystal Eastman on Women and Revolution.* New York: Oxford University Press, 1978.

Degler, Carl N. *At Odds: Women and Family in America from the Revolution to the Present.* New York: Oxford University Press, 1980.

Diamond, Irene. *Sex Roles in the State House.* New Haven: Yale University Press, 1977.

Clymer, Adam. "Women's Political Habits Show Sharp Change." *New York Times,* June 30, 1982:A1, D2.

Elshtain, Jean Bethke. "Methodological Sophistication and Conceptual Confusion: A Critique of Mainstream Political Science." In *The Prism of Sex: Essays in the Sociology of Knowledge,* edited by Julia A. Sherman and Evelyn Torton Beck. Madison: University of Wisconsin Press, 1979.

Evans, Sarah. *Personal Politics: The Roots of Women's Liberation in the Civil Rights Movement and the New Left.* New York: Vintage, 1980.

Freeman, Bonnie Cook. "Power, Patriarchy, and 'Political Primitives.' " In *Beyond Intellectual Sexism: A New Woman, a New Reality,* edited by Joan I. Roberts. New York: McKay, 1976.

Frontiero v. Richardson. 411 U.S. 677 (1973).

Friedl, Ernestine. *Women and Men: An Anthropologist's View.* New York: Holt, Rinehart & Winston, 1975.

Gertzog, Irwin N. "The Matrimonial Connection: The Nomination of Congressmen's Widows for the House of Representatives." *The Journal of Politics* 42 (1980):820–33.

Githens, Marianne, and Prestage, Jewel L., eds. *A Portrait of Marginality.* New York: McKay, 1977.

Goldstein, Leslie Friedman. *The Constitutional Rights of Women: Cases in Law and Social Change.* New York: Longman, 1979.

Harris, Marvin. *Cannibals and Kings: The Origins of Cultures.* New York: Random House, Vintage Books, 1977.

Hartsock, Nancy. "Political Change: Two Perspectives on Power." In *Building Feminist Theory: Essays from Quest; A Feminist Quarterly.* New York: Longman, 1981.

Hole, Judith, and Levine, Ellen. *Rebirth of Feminism.* New York: Quadrangle, 1971.

Hoyt v. Florda. 368 U.S. 57(1961).

Johnson, Marilyn, and Carroll, Susan. "Profile of Women Holding Office II." In *Women in Public Office: A Biographical and Statistical Analysis,* compiled by the Center for the American Woman and Politics. 2nd Edition. Metuchuen, N.J.: Scarecrow, 1978.

Kelly, Amy. *Eleanor of Aquitaine and the Four Kings.* New York: Vintage, 1957.

Ladner, Joyce A. *Tomorrow's Tomorrow. The Black Woman.* Garden City, N.Y.: Doubleday, 1972.

Lapidus, Gail. *Women in Soviet Society: Equality, Development, and Social Change.* Berkeley: University of California Press, 1978.

Lee, Marcia M. "Toward Understanding Why Few Women Hold Public Office: Factors Affecting the Participation of Women in Local Politics." In *A Portrait of Marginality,* edited by Githens and Prestage. New York: McKay, 1977.

Lovenduski, Joni. "Toward the Emasculation of Political Science: The Impact of

Feminism." In *Men's Studies Modified: The Impact of Feminism on the Academic Disciplines*, edited by Dale Spender. New York: Pergamon, 1981.

Martin, Wendy, ed. *The American Sisterhood*. New York: Harper & Row, 1972.

Neale, John E. *Queen Elizabeth I: a Biography*. 1934. Reprint. Garden City, N.Y.: Doubleday, 1957.

Newland, Kathleen. *Sisterhood of Man*. New York: Norton, 1979.

O'Donovan, Katherine. "Before and After. The Impact of Feminism on the Academic Discipline of Law." In *Men's Studies Modified*, edited by Spender. New York: Pergamon, 1981.

Pearson, Carol. "Women's Fantasies and Feminist Utopias." *Frontiers* 2 (1977):50–61.

Piercy, Marge. *Vida*. New York: Summit, 1980.

Prestage, Jewel L. "Black Women State Legislators: A Profile." In *A Portrait of Marginality*, edited by Githens and Prestage. New York: McKay, 1977.

Reed v. Reed. 404 U.S. 71(1971).

Rogers, Susan Carol. "Female Forms of Power and the Myth of Male Dominance: A Model of Female/Male Interaction in Peasant Society." *American Ethnologist* 2 (1975):727–56.

Rostker v. Goldberg. 453 U.S. 57(1981).

Sanday, Peggy Reeves. *Female Power and Male Dominance: On the Origins of Sexual Inequality*. Cambridge and New York: Cambridge University Press, 1981.

Schneir, Miriam, ed. *Feminism: The Essential Historical Writings*. New York: Random House, 1972.

Smart, Carol. *Women, Crime and Criminology: A Feminist Critique*. London: Routledge & Kegan Paul, 1978.

Smith, Barbara. "Notes for Yet Another Paper on Black Feminism, or will the Real Enemy Please Stand Up?" *Conditions: Five* (1979:123–27.

Steinson, Barbara J. " 'The Mother Half of Humanity': American Women in the Peace and Preparedness Movements in World War I." In *Women, War, and Revolution*, edited by Carol R. Berkin and Clara M. Lovett. New York: Holmes & Meiers, 1980.

Stiehm, Judith H. *Bring Me Men and Women: Mandated Change at the U.S. Air Force Academy*. Berkeley: University of California Press, 1981.

Valdez, Theresa Aragon de. "Organizing as a Political Tool for the Chicana." *Frontiers* 5 (1980):7–15.

Woolf, Virginia. *Three Guineas*, 1938. New York: Harcourt, Brace, 1966.

15
Changing the Present:
A Look to the Future

WOMEN AND SOCIAL CHANGE
The Early Years
Women's Organizations
Early Radical Feminists
After the Vote
Patterns of the Past

TAKING STOCK OF THE PRESENT: THE EARLY 1980s
An Optimistic Picture?
 Women and Society
 Women and the Family
 Mature Women
 The Popular View
The Other Side of the Picture
 Are We Witnessing a Backlash?
 The Myth of the Superwoman
 A Lesson from History

THE WORLD OF THE FUTURE: WHAT SHOULD IT BE?
Women (and Men) of the Future
 Androgyny vs. Differences
 The World of the Future
 Sisterhood and Feminism
 "A Piece of the Pie" or a New World?
 Women's Condition and the Human Condition
Vehicles for Change
 The Bonding of Women
 Models for Women
 Revolution in the Family: The Overthrow of "Motherhood"
 Power and Politics
Women's Studies and the Feminist Movement

> The hand that rocks the cradle should also rock the boat.
> WILMA SCOTT HEIDE

What do we see for the future? Do we look ahead with optimism, anticipating a better world for women? Or does a cloud of pessimism shadow our visions?

Feminists disagree on our predictions of the future. Our opinions are necessarily based on a historical perspective, how we interpret the patterns of the past and relate them to events in the present. Not everyone has the same perspective, and many find it difficult to get a global picture. Moreover, speculating about the future is a little like asking whether a glass is half full or half empty: do we look at what we have or what we lack? Yet the endeavor is important because it concerns the fate of half the people of the world.

The preceding chapters have addressed many aspects of women's existence. We have looked at women's private space, the self, how we have been defined, and how we have defined ourselves. We have explored the roles we have taken in the family and our relationships to the larger society. We have seen changes over time; we have noted similarities among women as well as differences; and we have seen how many times hopes have been disappointed. Over and over, feminist attempts to change society in ways helpful to women have met with defeat. Yet, the women's movement of recent years and the present has achieved extraordinary gains. It holds out more hope for women than any previous social movement; it may even offer the only hope for the survival of humanity.

Women and Social Change

There have always been women's voices, dissident voices, speaking for human rights and women's interests. We cannot point to a time that marked the beginning of women's challenges to the world we inherited, for we can always find a rebellious female voice that preceded it. To understand the process of change, we will briefly review here women's involvement in social movements over the last two centuries.

The Early Years

The eighteenth century was full of rhetoric and literature about human rights and equality. The newly founded nation of the United States was building a government based on democracy. Its Declaration of Independence asserted that "all men are created equal." This phrase, however, did not apply to women, who were given little consideration in the egalitarian movement. Still, even at this time, women voiced the belief that principles of equality should be applied to us. In 1776, Abigail Adams wrote to her husband John, soon to be the second president of the United States of America:

I long to hear that you have declared an independency—and by the way, in the new Code of Laws which I suppose it will be necessary for you to make, I desire you would Remember the Ladies, and be more generous and favourable to them than your ancestors. Do not put such unlimited power into the hands of the Husbands. Remember all Men would be tyrants if they could. If particular care and attention is not paid to the Ladies we are determined to foment a Rebellion, and will not hold ourselves bound by any Laws in which we have no voice, or Representation. (Rossi 1973:10–11)

In 1792, a similar call was heard from overseas Britain. In *The Vindication of the Rights of Woman*, Mary Wollstonecraft demanded for women the same rights and freedoms that men were claiming during this period. The eighteenth century in which Abigail Adams and Mary Wollstonecraft lived has been called the Age of Enlightenment because of the new questions asked and the new solutions proposed for the reform of society. It was the era of the American and French revolutions, with their themes of liberty, equality, fraternity. Women who understood we were being excluded in the application of these principles raised our voices in protest. But the exclusion continued.

The French Revolution between 1789 and 1795 overthrew the monarchy and created a republic. During these years, French women's voices loudly called for a political liberty and equality that included a legal identity for women in marriage, divorce rights, widows' rights to property and child custody, and more educational opportunities for girls (box 15.1). French women joined in storming the Bastille, where political prisoners were released, in July 1789. Working-class women in Paris created political networks while engaging in women's usual activities in the streets, cafes, markets, and breadlines. In this way, women were able to keep abreast of revolutionary events and form crowds for demonstrations (Levy et al., 1979). One short-lived political club was created exclusively by women. But patriarchy yielded not at all though the monarchy was overthrown, and men of the Revolution joined in defeating the demands of women (box 15.2).

Women's Organizations

In the nineteenth century, the United States saw an increasing number of women's organizations run by volunteers. Unpaid for our efforts, yet outspoken in favor of our ideals, we worked for humanitarian principles. Before the Civil War, many middle-class women identified with such causes as prison reform, expansion of education, and the abolition of slavery; in the second half of the century, we concerned ourselves with the inhumane working conditions of factories and sweatshops, the problems of working women, and the issues of urban reform (good government and improved tenement life, for example).

The General Federation of Women's Clubs, which was interested in com-

> The Declaration of the Rights of Woman Box 15.1
> and the Female Citizen (France 1791)
> Women have resolved to set forth in a solemn declaration the natural,
> inalienable, and sacred rights of woman. . . .
> Article I
> Woman is born free and lives equal to man in her rights. . . .
> Article VI
> The law must be the expression of the general will; all female and male
> citizens must contribute either personally or through their representatives
> to its formation; it must be the same for all: male and female citizens,
> being equal in the eyes of the law, must be equally admitted to all honors,
> positions, and public employment according to their capacity and without
> other distinctions besides those of their virtues and talents. . . .
> Postscript
> Women, wake up; the tocsin of reason is being heard throughout the
> whole universe; discover your rights. . . . Regardless of what barriers con-
> front you, it is in your power to free yourselves; you have only to want to.
> (Levy, Applewhite, and Johnson, 1979:89–90, 92)
>
> Copyright © 1979 by the Board of Trustees of the University of Illinois.

munity and health facilities and child labor laws, developed at the turn of the
century. Black women, excluded from the federation, formed the National
Association of Colored Women and worked for improvements for blacks and
the black community. In 1874, the largest national organization of women
the country had known, the Women's Christian Temperance Union, formed
to protest the abuse of alcohol. Because the WCTU saw the hard-drinking
habits of the day as the source of the woes of many women and children, it
was actually concerned with many social ills (Berg, 1978; Kolb, 1976).

Far from merely advocating humanitarian principles, women actively tried
to implement reforms. The first settlement house in the United States was
founded by Jane Addams in 1889 (see chapter 11). This institution brought
together people from all social classes, provided numerous community ser-
vices, and eventually lobbied for child protection, labor laws, and female
suffrage. Many women activists sought to help workers achieve better wages
and working conditions. At a time when women were working long hours in
factories under hazardous conditions for low wages, male-run unions were
not active in bringing women into their membership. It was middle-class
women, supporting working-class sisters, who enabled the Ladies' Garment
Workers' Union to be victorious in a strike in 1909 in New York City.
Women joined organizations to apply pressure for reform in government and
businesses. We succeeded in bringing about many improvements for women
workers such as better conditions and a shorter day (Kolb, 1976).

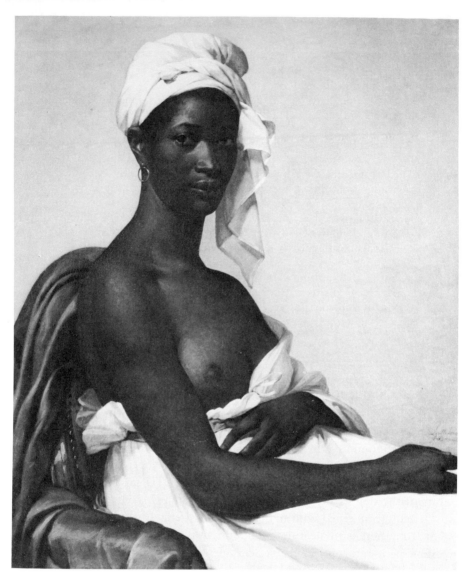

"Portrait of a Negress" by Marie Guillemine Benoist (c. 1800) is one of the rare depictions of a black person in European painting. It is apt for a woman artist to have chosen to immortalize a black woman to symbolize the French revolutionary slogan of liberty and equality. The sitter's dignified, regal beauty dominates the picture despite her semi-nudity, which was the artistic convention during this period for "exotic" people. (Musée National du Louvre)

Women Radicals Suppressed (France 1793) Box 15.2

The suppression of the Society of Revolutionary Republican Women was a deliberate first step in the curbing of radical demands by women and the lower classes in the name of political order. Symbolic of this return to political conservatism was the silencing of the women who had dared to put on the revolutionary red cap and speak up on behalf of their social, economic, and political goals. When they made a last appearance at a public assembly, they were hooted into silence and their deputations outlawed in the name of the restoration of nature and the moral order. In the words of a male official of the Paris Commune:

> The law orders that morals be respected and that they be made to be respected. . . . Since when is it permitted to give up one's sex? Since when is it decent to see women abandoning the pious cares of their households, the cribs of their children, to come to public places, to harangues in the galleries, at the bar of the senate?
>
> . . . Impudent women who want to become men, aren't you well enough provided for? What else do you need? . . . remain what you are, and far from envying us the perils of a stormy life, be content to make us forget them in the heart of our families.

(Levy et al., 1979:219–20)

Although women from all social classes worked for reform and witnessed many successes, we were acting from a base of very limited power. We did not even have the vote. Women had worked fervently for abolition; yet, when the Civil War was over, Congress granted black *men* the right to vote. Feminists, requesting the same human right for white and black women, were turned down (see chapter 14).

Women's efforts for reform have been tireless, but the benefits to us have been slow in coming. For example, many of the volunteer organizations founded by women have been taken over by men when these organizations became powerful and politically credible (Heilbrun, 1979). But women did see some improvements. The reform movements brought more women into the public sphere and taught us how to organize and effect change. These skills served us in finally obtaining the vote in 1920.

Early Radical Feminists

In the early 1900s, radical feminists were writing and organizing to bring about a new kind of society. Among them was Charlotte Perkins Gilman, who published *Women and Economics* in 1898 (1966). She analyzed women's roles within the family, the restrictions on our participation in public life, and the social obstructions we faced in realizing personal goals. She

pointed out how detrimental this situation was to both women and society at large. Gilman advocated outright rebellion and left her husband and child in order to dedicate herself to her feminist writing.

The radical feminists were asking for genuine freedom for women, including the freedom to lead gratifying lives in ways previously considered socially unacceptable. We sought a revision in, even elimination of, the marriage arrangement; freedom from the total responsibility for child care; sexual freedom; and control over our own bodies. These demands sound very similar to some we hear from feminists today.

The writings of Emma Goldman reflected many of the beliefs of the radical feminists. She was an anarchist who advocated radical change in the social system, particularly in capitalism, which she viewed as a major source of women's oppression. She was jailed for her ideas. Margaret Sanger, another radical feminist, worked tirelessly throughout her life for the right of every woman "to control her body," to obtain sexual pleasure without the fear of pregnancy, and to be free to make choices about motherhood (see chapter 12). Although it was against the law, she disseminated birth control information to women and opened a clinic for this purpose. She was particularly sensitive to the needs of poor women, whose daily burdens were compounded by unwanted childbearing (Rossi, 1973).

After the Vote

It has been said that feminism died once the vote was won. Indeed, large-scale organized activity diminished, perhaps due to the Depression (starting in 1929), the political turmoil of the world, and the belief that obtaining the vote would solve women's problems (Freeman, 1976). Feminists in the 1960s had to rediscover many of the ideas of earlier feminists because we grew up knowing nothing of them.

But to conclude that nothing was happening in the women's movement in the interval is misleading. It has been shown that social feminism flourished in the 1920s, creating new organizations in efforts at social reform. The planned parenthood and birth control movement grew. Other women's organizations, each with its own social–justice and progressive goals, formed (Lemons, 1973). However, it is true that women's gains in the educational and work spheres diminished in the struggling economy of the 1930s (Ruth, 1980), and most of the demands of the feminists of the previous decades were rarely heard.

During World War II, when men had to leave their jobs to join the army, women again filled the labor market gap, as we had in the First World War. Government-funded day care programs were proposed, and training programs for women were established. Women successfully took over jobs previ-

Charlotte Perkins Gilman devoted her life to feminist scholarship, analyzing the role economics plays in women's position in society and advocating women's freedom and liberation from family constraints. Her own divorce and relinquishment of the custody of her daughter made her an outcast in the traditional society of her day. (Brown Brothers)

ously considered appropriate for men only. When the war ended, however, the work gains made by women were snatched away from us. The men received their old jobs back and were the first choice for new ones. Day care facilities and training programs—to the extent that they had existed—disappeared. Women who continued to work were generally overqualified for the jobs we held and were underpaid. Jobs were more than ever defined as "female" or "male." In short, women were sent back to the home, and the late 1940s and the 1950s saw a reemergence of traditional family values and of constricting definitions of "femininity" (Freeman 1976).

Patterns of the Past

A review of the decades preceding the 1960s reveals some historical patterns in women's reform movements. Women have traditionally been connected with "charities." As volunteer workers, we have served as a link between the male power structure and its victims and have acted on behalf of children, the poor, workers, and other groups of people oppressed by the system. Economically advantaged women have assisted women from different social classes, and women in all social classes have banded together to fight for our rights. Despite our weak position in society, women have effected change in major areas.

Yet other, less comforting patterns also appear. Women have frequently sacrificed our own cause for other social issues. We have been considered "equal" to men in time of war, when we are needed to fill jobs, but not "equal" when we could be replaced by men. We have been used to fight the battles of others' causes, and then denied a fair share of the gains. Finally, periods of progress have usually been followed by lulls or reversals. Carolyn Heilbrun notes that the women's movement seems to defeat itself after each gain. "Each cycle of progress for women seems to end after a decade or two with precious little real advance toward equality. The complacency in women that a few steps forward induces drains the movement of its energy. Progress halts or is even reversed" (1979:24).

Taking Stock of the Present: The Early 1980s

The status of women today encourages two views—one optimistic and the other more pessimistic. Regardless of how one rates its success, in many ways it appears as though the women's movement is at its height in the early 1980s. Hardly a day passes when a women's issue is not raised in major newspapers. Although newspaper reporting is not always objective, it gives a picture of some of the attitudes and events of the times. It is also a major source of information for the population. The sampling of articles presented below appeared in the *New York Times* during a five-month period. These

articles give some indication of what was occurring around the time of the election of President Ronald Reagan.

1. Nonsexist Mission Rewrites Its Worship Service (September 12, 1980).
2. Federal Job Ratings Study Finds Women Have Made Few Gains (September 28, 1980).
3. In Brazil, Mornings Belong to Feminist TV (November 3, 1980).
4. As Pakistan "Islamizes": Feminists Rise Up in Anger (November 8, 1980).
5. Feminists Trying to Deal with Religions' Confines (November 11, 1980).
6. Church Program Seeks Neutrality: "God the Father" Will Be "Creator" (November 28, 1980).
7. A New Start for Women at Midlife (December 7, 1980).
8. Drug Concern Will Pay $765,000 in Sex-Bias Case (December 15, 1980).
9. Police Force in Philadelphia Gets First Female District Commander (December 24, 1980).
10. Woman to Rule Honolulu Again: First Time Since Queen's Ouster (December 25, 1980).
11. Seminar Advises Women on Careers with the City (December 31, 1980).
12. Poll Finds New View of Women (January 6, 1981).
13. Female Diplomats Take Stock of Gains (January 18, 1981).
14. Bill Seeks Tax Break for Employers' Child Care Centers (January 28, 1981).
15. Women Bid Senate Act on Bias (January 28, 1981)
16. Schweiker Is Critical of Programs on Sex Counsel and Contraception (January 30, 1981).
17. Voice of Authority Still Male (February 2, 1981).

These articles reveal movement in a range of areas covered in this book, and attention to remaining problems.

An Optimistic Picture?
Women and Society. Women in religious organizations are rebelling against both our low status and the sexist imagery and language in religious services. Some groups are receiving support from church officials; others are not. Nonetheless, feminists are taking (we are not being "given") positions of authority in the church and are rewriting the Scriptures (see chapter 10). Women are dissenting in Third World countries as well as in the Western world.

Areas in which women are underrepresented, such as in police forces, corporate hierarchies, and government, show a slight increase of women in high-ranking positions. But these are for the most part token gains. In busi-

ness, women are pressing employers for less discriminatory hiring and pro motion procedures and are frequently successful. Women are demanding training programs which will facilitate our advancement and we are increasingly performing nontraditional jobs such as telephone repair workers, plumbers, jockeys, and construction workers. "Displaced homemaker" programs have been established to counsel women who have spent years as homemakers and now seek job training or retraining.

In the creative arts, women's productions are receiving growing attention. More than in the past, our work depicts the female experience. Women's art galleries, craft centers, and bookstores are beginning to appear in the cities. Women's magazines are increasingly feminist, led by the popularity of *Ms.* magazine. And the media are paying greater attention to women's issues than in the past.

More and more women are acquiring professional training previously reserved for men. Textbook publishers, sensitized to sexist language and concepts, have established guidelines to avoid them. An increasing number of children's books are designed to avoid subliminal sexist messages. At colleges, women's studies programs have increased and, in the face of a considerable struggle for academic credibility, have gained respect. As the preceding chapters indicate, many trained in the older academic disciplines are critically reviewing old assumptions and raising new questions. Sexism is on the defensive. (Denmark, 1980)

Women and the Family. Women's roles in the family are also changing. A growing number of women with preschool children are working at paid jobs, and dual-career families are more common (see chapters 9 and 13). Fathers are playing an increasingly active role in child care. Whereas books on mothering have always been plentiful, the shelves of local bookstores now contain many books for fathers, about fathering, and for parents about parenting.

Child-rearing practices are still largely sexist, but nonsexist ideas are increasingly being communicated in children's entertainment. For example, in the 1970s, Marlo Thomas's record and book *Free to Be You and Me* was a popular gift. This work, written for children, addresses the acceptability of such things as boys crying or playing with dolls and nobody liking to do housework. At the Collegiate School, a private boys' school in New York City, fifth- and sixth-grade boys could choose a six-week course in infant care (Herzog and Mali, 1980).

Mature Women. More attention is being paid to women in midlife, and negative social attitudes are decreasing. A study of women between the ages of thirty-five and fifty-five indicates that many now feel positive about this new stage of life and about the future (box 15.3). These women reported a

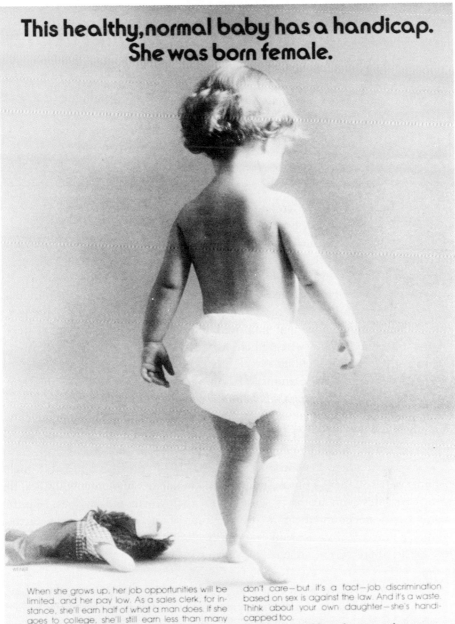

This healthy, normal baby has a handicap. She was born female.

When she grows up, her job opportunities will be limited, and her pay low. As a sales clerk, for instance, she'll earn half of what a man does. If she goes to college, she'll still earn less than many men with a 9th grade education. Maybe you don't care—but it's a fact—job discrimination based on sex is against the law. And it's a waste. Think about your own daughter—she's handicapped too.

Womanpower. It's much too good to waste.

NOW Legal Defense and Education Fund Inc., 132 W. 43rd St., New York, N.Y. 10036

A NOW poster called "Womanpower. It's too good to waste." (NOW Legal Defense and Education Fund, Inc.)

Charlotte Perkins Gilman on Women and Work Box 15.3

One day the girls were discussing what age they would rather be, for life.
Most of them agreed on eighteen, which many of them were at that time.
When they asked me I said fifty. They didn't believe it. "Why?" they
demanded. "Because," I explained, "when I'm fifty, people will respect
my opinions if they are ever going to, and I shall not be too old to work."

(Gilman, 1975:74)

Reprinted by permission of the Schlesinger Library, Radcliffe College.

significant increase in self-esteem and a strong sense of self-worth which
we had not experienced in our younger years. This was as much the case
for women in our fifties as for those in our thirties, and for women in a
variety of roles. The researchers note that "contrary to the traditional
notion that marriage is the most important pillar of a woman's happiness,
our study is finding that, for employed women, a high-prestige job, rather
than a husband, is the best prediction of well-being" (Baruch and Barnett,
1980:199).

The major regret these women had about the past was that we had not
pursued career or educational goals more seriously. The traditional sources of
stress for midlife women, such as menopause and the "empty-nest syn-
drome," appeared to be of little concern. Instead, the women felt optimistic
about the future and the possibilities for travel, work, and study.

It is not accident that women's studies classes draw a noticeably high
proportion of mature women students. A knowledge of women's studies, in
turn, correlates with women's sense of our own worth and abilities. Mature
women may be counted on to provide one of the major strengths of the
women's movement in the lean years of the 1980s. We remember what it was
like before there was a women's movement.

The Popular View. Surveys find that people are expressing a greater accep-
tance of such things as mothers working and women moving up to the higher
positions in politics, business, and the professions. More people are now
supportive of programs to help women, including more and better day care
facilities both at work and in the community (box 15.4). The women's move-
ment is apparently having an impact throughout the country.

The Other Side of the Picture
Are We Witnessing a Backlash? Political sentiments in the United States of
the early 1980s may be an omen of the future. After legislation and court
rulings which promoted women's status in the 1960s and 1970s, 1980 saw

Poll Finds New View of Women Box 15.4

WASHINGTON—Last year, the American public finally began to regard women for the first time as equals to men, entitled to the same jobs, pay and higher levels of responsibility, according to a new study.

The findings represent a dramatic shift in contemporary public opinion. Just four years ago, for example, the majority of Americans still believed that if women worked, they should do so as nurses, secretaries, hairdressers, sales clerks and the like.

Last year, however, professional pollsters discovered unqualified acceptance by husbands of their working wives. The public's view of homemaking changed. Suddenly, the concepts of reproductive freedom and the role of women in public life were supported overwhelmingly.

In 1980 the majority of Americans said for the first time that it makes no difference if a woman is the mayor of the town, if she is a lawyer, a doctor, even "their own boss."

These are the findings of a newly released study entitled, "Today's American Woman: How the Public Sees Her." The study was prepared for the President's Advisory Committee for Women by Public Agenda Foundation, an organization founded by the pollster Daniel Yankelovich and former Secretary of State Cyrus R. Vance.

The study shows both a new acceptance and a new sympathy for the roles women have begun to play. "The general feeling of the American public today," said Deborah Durfee Baron, the Yankelovich vice president who compiled the study, "about the status of women can be described as, at one and the same time, realistic about the problems facing women and optimistic about the progress made thus far and about the future." . . .

Most Americans now believe, for example, that husbands and wives should share financial decision-making as well as household chores and child care, including responsibility for the health and medical care of their children. This, too, represents a pronounced shift from the thinking of the mid-1970's when housework was still defined as women's work in the minds of most Americans. (*Washington Star*, 1981:January 6)

the election of a president whose policies threaten to reverse many of these gains. Ronald Reagan openly opposed the Equal Rights Amendment as well as access to abortions. His spending cuts in social programs represent an enormous setback for women. Many legislators sympathetic to the women's movement were defeated in 1980 and replaced by politicians supported by unusually reactionary groups with substantial followings.

The push for the Equal Rights Amendment itself has had disappointing results, as feminists have failed to obtain sufficient support in state legislatures to achieve ratification. In 1973, the Supreme Court ruled that abortion was the personal right of a woman (in consultation with her doctor). Since

then, antiabortion groups have put powerful pressure on politicians to limit severely the legality of abortions. Reagan's secretary of health and human services, Richard Schweiker, suggests that doctors should not be permitted to prescribe contraceptives to poor, unmarried teenagers under Medicaid. Many legislators and citizens support a constitutional amendment that would make abortion in almost all circumstances illegal. A basic human right that feminists have been demanding for over a century—the right to control whether our bodies are to be used for reproduction—is in jeopardy.

In the personal sphere, traditional attitudes about women are being promoted. The lectures of Marabel Morgan attract large audiences. Her book, ironically titled *The Total Woman* (1973), encourages women to return to the home and to the service of men. She advises women to adopt the image of "sex object." (It is worth noting that she herself is an ambitious, successful woman.) Neoconservative articles warn of the hazards of day care, and books claim that equality for women will cause impotence or violence in men.

What is the appeal of these messages to those women who are influenced by them? Answering this question may help feminists to understand better some of the fears, conflicts, and survival strategies of many of our sisters. It may also provide information about a source of resistance that the women's movement must confront.

On December 28, 1980, the *New York Times* published the results of a survey of Ivy League women college students. The greater number sampled desired to lead rather traditional lives—get married, have a family, and stay at home, for at least a while, to raise children. These traditional family goals were given priority over career goals. While studies at other colleges have not found similar results, the women in this survey represent a group of academically superior students. What phenomena are prompting such a choice?

The Myth of the Superwoman. What is a superwoman? She is a woman who does just about everything—and does it well! The superwoman presented in magazines and newspapers is an ambitious and successful professional who also keeps house for her children and spouse and has an active social life. Superwomen are gourmet cooks, pursue interests and hobbies, give elaborate dinner parties, are at their offices by nine making major decisions, and apparently never show the strains of a person drowning in commitments. Do they sleep? Are they human?

Who can really be a superwoman? Most woman must make choices, choices which can be frightening, especially when we did not learn as children that such decisions are ours to make. In addition, we require support from a variety of sources to do those things most important to us. To combine a career with child-rearing and family life and still have time for special interests appears to require superwoman feats. Is that what the women's

movement has as its goal? We think not. But societal changes are necessary to free women from this *superwoman syndrome*. It is possible that this image, unattainable in reality, is the reason many women with professional promise find the old traditional roles so appealing.

Women are discovering that having a career may mean having two full-time jobs—one in the home and one that pays wages—because men have, by and large, not yet been willing to share the burdens of child care and housework. Is it any wonder some women feel overwhelmed, and retreat from career ambitions to the imagined security of the traditional role? Refusing such a role sometimes requires conflicts with the men we love and do not wish to oppose. The painfulness of the personal struggle for equality is often too much for many women, at least until we have experienced some years of the oppression inherent in traditional roles, and determine to break out of them.

If normal women are to find fulfillment in pursuits outside of the home as well as within the family, revisions in family structure and social support systems will have to occur. Men are going to have to share fully in child-rearing responsibilities, and day care facilities we have confidence in will have to be made available. Nontraditional family and work arrangements must be developed.

A Lesson from History. "Two steps forward, one back." In the history of the women's movement, successes have been followed by reversals or lulls. Is history to repeat itself?

The women's movement has always had strong opposition. As it becomes stronger, so will the resistance. The movement threatens to change the status quo, and any kind of significant change is frightening to many people. Change is even upsetting to people who have little, for they fear they will have even less. Change threatens the power structure, and it threatens men, who fear they will lose their privileged status. It also threatens many women: those who fear losing what is thought of as security; those who believe the women's movement denies domestic values and family life; and those who see a whole pattern of life being questioned by uncomfortable, new points of view.

The women's movement needs to address such fears, not ignore them. The greatest danger facing women is that feminists will become complacent. No situation will improve without organized action. This is a lesson to be learned from the history of the women's movement and from that of the well-organized groups that would oppress us.

The World of the Future: What Should It Be?

Feminists have differing views on the changes women should work for. The issues are numerous, and we can only present a few of the key ones here.

Women (and Men) of the Future

Women have been defined narrowly in definitions that have tied our being to our reproductive and endocrinological systems. In thinking about our future, it is hard for women to free ourselves from the perspective of our experiences and to imagine limitless possibilities. Without doing this, however, we risk reconstructing gender roles, the definitions that others have provided us with. Science cannot tell us what womanhood is, for science does not know woman's potential. "Let us imagine ourselves as selves, as at once striving and female. Womanhood can be what we say it is, not what they have always said it was" (Heilbrun, 1979:34). What then should women strive for as womanhood? As the future of womankind?

Androgyny vs. Differences. Are human characteristics divided into female and male? If so, are we bound by them? Are differences desirable or not? In the preceding chapters, we talked about differences thought to exist between women and men. Some long-held claims have been shown to be false or to have little support from research. Others have been documented as fair generalizations. Some of these differences can be traced to socialization practices. Others may be due to cultural factors, biological ones, or to an interaction between the two.

We learned in chapter 3 that there are greater similarities between the sexes than differences, and that hormonal levels can be affected by factors in the environment. Behavior in nonhuman primates which appears to be tied to biology can be modified by environmental events. This suggests several possibilities. One is that more similar environments for women and men will create greater similarities between the sexes. Nonsexist child-rearing will allow women and men to develop our biological potential without the shaping influence of stereotypic beliefs. More similar living and working experiences may bring about more similar attitudes.

But what if differences still show up despite nonsexist socialization? Are we to assume that these differences are "natural," and should be allowed to develop? Certainly, there are some natural biological differences between women and men; for instance, men have greater upper body strength and will be better at certain sports. To ignore this would be an injustice to women. Perhaps various sports could be geared to certain categories of participants regardless of sex, along the lines of boxing, where weight determines the class in which the boxer will compete. But society must be careful not to unduly favor those activities at which few women can excel. If the bulk of money for sports goes to support football, women will be unfairly left out (Postow, 1981).

Some biological traits are considered desirable or undesirable. Society might modify these in individuals. For example, there is some evidence that males are biologically more aggressive than females. Perhaps it would be

desirable to modify that trait. If women are biologicaly more nurturant (and we do not know this), might we not want to train men in nurturance? Society might foster the "natural" traits of females and dampen the "natural" traits of males, rather than the reverse. In any case, what human beings decide to do about any tendencies that appear to be "natural" is up to us. Disease is often "natural," and what develops without human shaping or intervention may or may not be good for human beings.

We may wish to encourage the development of some characteristics and not others in both women and men. Society has in the past polarized the sexes in terms of many characteristics. Women have been socialized into roles defined by men, and our traits of passivity, dependence, and emotionality have traditionally been considered disadvantageous. Might it be better for us to emulate a male model, one focused on assertiveness, independence, and rationality? Should women be more like men?

Feminists criticize such a suggestion. What have traditionally been viewed as weaknesses in women may in fact be strengths. Most feminists believe that the world would benefit from an infusion of "female" traits: expressiveness, concern for the emotions, humane social priorities, and greater peacefulness. Humane traits are sorely missing from the power structures erected and controlled by men. Women can provide these—if we do not trade our "feminine" characteristics for "male" ones. It seems more reasonable to suggest that men should be more like women. As Nancy Hartsock writes, "generalizing the activity of women to the social system as a whole would raise, for the first time in human history, the possibility of a fully human community" (Hartsock, 1982).

Many feminists favor the androgynous personality, meaning a personality with the capacity to experience a full range of human emotions, and to engage in a full range of actions. While specifically sexual differences may be appreciated, the individual who incorporates both "female" and "male" aspects of personality would be a *whole* individual, a balanced individual. And a "good person," as distinct from a "good woman" or a "good man," would incorporate the best traits of both women and men (Ferguson, 1977; Trebilcot, 1977).

Is androgyny a realistic goal? Many disciplines are witnessing a movement toward this perspective. Psychologists are beginning to view the ideal human as one who balances such traits as assertiveness and cooperativeness. (Bem, 1975, Bem, 1976, Kaplan, 1979). Sociologists (Bernard, 1981) are coming to emphasize the overlapping of "female" and "male" behavior rather than their mutual exclusiveness. They are reworking social theory and definitions of gender roles, and acknowledging the extent to which socialization processes form such behavior and could form different behavior.

An androgynous image is beginning to appear in many forms of communication. According to one writer,

> In all the new critical work on images of women, whether theological, literary, or psychological, there is a central underlying theme—a search for wholeness. A whole and positive image of women would combine power, discipline, and intellectual strength with vulnerability, fecundity, or fruitfulness, and a capacity for rich and complex emotions. . . . the principal property of such a state is its promise of equality between the sexes that would result either from enlargement of society's purposes or from greater flexibility and breadth in the personality traits of individuals. (Giele, 1978:325–26)

Feminists adhering to an androgynous ideal recognize the uniqueness of all individuals and support the variety of individual approaches that may develop. Externally imposed definitions of what is "appropriate" female or male behavior, however, fail to respect individual autonomy. And research indicates that individuals who can combine "feminine" and "masculine" traits are more "effective" people than those who cannot (ibid.:327). A world infused with the best aspects of both female and male tendencies—if these differences exist—would be a better world for everyone than the world of conflict and violence men have created.

The World of the Future. The disagreement among feminists about what we should strive for is based in part on different personal visions and in part on different views concerning the causes of oppression. Some feminists feel that women's equality should be sought through our advancement in existing institutions. Others see the need for radical changes in these institutions. Some see capitalism as the major source of oppression. Others see oppression as resulting primarily from the differentiation of people according to gender.

Almost all feminists, however, recognize that the causes of women's oppression are multiple, and that dealing with them will require changes in many aspects of life and society. "Single-cause theories" are probably of little help to us, since so many factors conspire to keep women "in their place." Women will need to attack the economic, political, legal, social, psychological, moral, aesthetic, cultural, and biological forms our oppression has taken, and in a sense we will have to deal with all these factors at once.

Sisterhood and Feminism. The women's movement has sometimes been accused of being a white middle-class movement, insensitive to and irrelevant for poor and minority women. There is no question that women's concerns throughout history have been articulated by those of us who had the education and social resources to gain a hearing. Moreover, revolutions are always led by those with sufficient material resources to concern themselves with more than survival. But the women's movement today represents far more than just the concerns of middle-class women. The drive for women to be able to control our own reproduction affects all women. Demands for welfare reform and assistance to the poor have been continuing goals; the vast

majority of those who *are* poor are women and children. The mean earnings of fully employed white males in the United States are already three times as high as those of everyone else in the labor force (Thurow, 1981:201). Raising income levels of women, together with those of nonwhites and the unemployed, to the levels of white males would constitute enormous progress toward social justice in the United States, even without any significant shift in the class structure as traditionally understood. But it is highly unlikely that this could happen without many very significant changes in the structure of society. The seemingly more moderate demands of "liberal" feminists and the seemingly more radical demands of "socialist" feminists are coming more and more to coincide. Women realize we will never be able to have genuinely equal opportunities for individual progress without an array of social supports (Eisenstein, 1981).

Whatever alienation from the women's movement some groups of women have felt can be understood in the light of our social structure. It polarizes people: rich/poor, young/old, white/colored, heterosexual/homosexual, male/female.

The important point is that it is white males who gain from pitting the interests of women against those of other disadvantaged groups. Few feminists have swallowed the bait of such divisiveness. Feminists recognize full well that the gains of women must go hand in hand with a decrease in racial and economic injustice.

Women in all social and ethnic groups have many things in common simply by virtue of being women. Our concerns overlap. The women's movement is a liberation movement for all women, and for all who share a common oppression. *Sisterhood,* a term used by the women's liberation movement, refers to the bonding of all women. The strength of this bond is the strength of the movement. Men may choose to join this movement, just as for many years women contributed our energy to efforts to promote "brotherhood."

"A Piece of the Pie" or a New World? Feminists fall along a continuum as to the extent of change we think is required for society and our sisters. Many feminists regard equality in the present capitalist system to be impossible. We believe the system is structured for the benefit of a few and requires the oppression of most of the world's population. Rather than "make it" in the present system, we envision new systems which would emphasize other values than the corporate interests we see as dominant in society in the United States. We want to replace the hierarchical structure of a "business civilization" with an egalitarian one. We want governing institutions that will represent the interests of all people, and in which the people affected by decisions are involved in making them. We strive for a society in which power will not be used in ways that enable some to dominate others, but in which human beings will freely treat one another with respect. We envision a society in

which people will feel concern for the well-being of others, rather than a society in which the strong seek to take advantage of the weak, and usually succeed (Gould, 1976; Hartsock, 1982; Held, 1976; Jagger, 1977; McKenna and Denmark, 1975).

Jo Freeman refers to such rhetoric as the *liberation ethic*. In this view, it is not sufficient to have both women and men participate in the various social roles that now exist; the roles themselves must change (box 15.5). The liberation ethic holds that men as well as women have deplorable lives and are oppressed by the present structure. The system must be transformed to provide humane lives for all (Freeman, 1976).

Other feminists are more concerned with getting a piece of the pie that now exists. We strive for greater equality immediately in the present system. We feel that once we obtain power in existing institutions, we can more easily implement whatever further social and political policies are needed. These feminists among us recognize that major changes have to occur, but do not advocate a radical transformation of the system.

Freeman refers to the goals at this end of the continuum as the *egalitarian ethic*—equality for the sexes and elimination of gender roles. "Our history has proven that institutional differences inevitably mean inequity, and sex-role stereotypes have long since become anachronistic. . . . This means that there will be an integration of social functions and life-styles of women and men as groups until, ideally, one cannot tell anything relevant about a person's social role by knowing that person's sex" (ibid.:253–54). The result will be increased choices and greater diversity for people (Freeman, 1976; Held, 1978).

Feminists who adhere to this position do so either because we think the present economic system should be limited rather than replaced or because we feel it is a more practical and realistic approach. Carolyn Heilbrun agrees with the latter position. She feels that the goal of shattering society and building another may be possible for small groups, but it is too remote for the larger society. Such an attempt would divert attention from the here and now of women's daily lives. She supports, instead, women's struggle for selfhood but points out that even this is becoming more difficult in light of the rise of conservatism (1979).

Freeman cautions that both the egalitarian ethic and the liberation ethic must work in tandem. "To seek for equality alone, given the current bias of the social values, is to assume that women want to be like men or that men are worth emulating. It is to demand that women be allowed to participate in society . . . without questioning whether that society is worth participating in" (1976:254). By definition, the "male" role necessitates a "female" role; it exists by the oppression of women. Equality, Freeman says, requires the destruction of these roles, which will lead to basic changes in the system itself.

Women and Revolution **Box 15.5**

Many women in women's liberation are not revolutionaries. But the demands they make for their own improvement require such a fundamental change in society that they are completely inconceivable without revolution. An understanding is coming out of women's liberation of the way in which the present organization of the family holds women down, together with the recognition of the need to alter dramatically the system by which work is divided between the sexes. Such a change immediately raises the need to transform the whole cultural conditioning of women and, hence, of men, as well as the upbringing of children, the shape of the places we live in, the legal structure of our society, our sexuality and the very nature of work for the accumulation of private profit rather than for the benefit of human beings in general. This is an emerging idea and the means by which it will be realized and the shape it will assume are still not worked out. But the crucial feature of this new feminism as an organizing idea is that these changes will not follow a socialist revolution automatically but will have to be made explicit in a distinct movement now, as a precondition of revolution, not as its aftermath.

(Rowbotham, 1974:246–47)

Similarly, Freeman points out, there are dangers in adopting various existing revolutionary ideologies and programs. It should not be assumed that a social revolution will result in equality for women. She notes that "women have yet to be defined as people, even among radicals, and it is erroneous to assume their interests are identical to those of men" (1976:254). To work for a revolution without paying equal attention to women's roles would be a mistake. Revolutionary systems proposed by nonfeminist theorists have not eliminated sexual inequality or a gender-role structure (Freeman, 1976). Stokely Carmichael, a leader of the nonviolent civil rights organization SNCC, said in 1966, "The only position for women in SNCC is prone" (Morgan, 1970). Nearly all radical and revolutionary groups other than feminist ones have had a gender-role structure. In addition, too much of a focus on a massive global revolution can leave one without a battle to fight.

Separated from each other, the Egalitarian Ethic and the Liberation Ethic can be crippling, but together they can be a very powerful force. . . . Separately, they afford but superficial solutions; together they recognize that sexism not only oppresses women but limits the potentiality of men. Separately, neither will be achieved because both are too narrow in scope; together they provide a vision worthy of our devotion. Separately, these two ethics liberate neither women nor men; together they can liberate both. (Freeman, 1976:255)

Women's Condition and the Human Condition. The women's movement has always been highly sensitive to the human condition. As we have seen, many women have worked to improve conditions for all people. Women are not, however, limitless sources of energy. As individuals and as a movement, we must often choose what to focus on—the larger concern of the human condition or the more narrow area of women's issues as these touch us in our daily lives. These areas are not, of course, mutually exclusive, and the two very often affect each other. However, when it comes to expending time, energy, and money and developing a shared power for the most effective outcome, a single direction at a given time must often be decided upon.

Increasingly, feminists are insisting that women's issues must become the primary concern of women. In the past, women's goals have repeatedly taken a back seat to other concerns. Labor rights took precedence over women's concerns in England in the nineteenth century. Efforts to enlarge the franchise in England and in the United States gave the vote to ever-wider groups of men before any women were given the right. Women were used and scorned in the French Revolution, in the abolitionist movement, in the Russian Revolution, and in the civil rights movement. Many feel that granting priority to "human" concerns, rather than to women's concerns, may continue to support a male culture and male values (Heilbrun, 1979). Of course, feminists need to keep in view the concerns of all women, not just those of a privileged few in the Western World.

One problem is that the dominant culture tends to view women's concerns as trivial. We have been criticized for asking for anything for ourselves, in the face of "more important" matters. Over and over again in history, when men have been granted rights that women have helped them to fight for, and women have asked for these same rights, we have been told "it's not your turn" (Ruth, 1980). Women have been asked to postpone our demands for even the most elementary aspects of equality because of the supposedly "more pressing" concerns of the proletariat or the poor or the racially disadvantaged.

It is difficult for women, particularly when we lack a strong support group, to articulate the things we feel are important when our demands are continually dismissed as insignificant. Thus, men frequently express impatience when women wish to discuss such "unimportant" issues as the division of household chores. Requests by women for even minimal respect are met with ridicule. We saw the advent of women's studies considered trivial by the academic community. When women within scholarly fields do pioneering work in feminist theory, or when we investigate whole areas of economic or historical reality ignored by our male colleagues, our work is often dismissed as "not really scholarly" or as "nonserious."

If women "buy" the male view of what is important, we feel foolish and confused. We cannot dismiss the weight of our own oppression, yet we are

told we are not (and should not feel) oppressed. When feminists talk with each other, when we seriously address the realities of women's lives hidden by centuries of male inattention, we are often able to restore our sense of what is truly important (box 15.6). Obviously, the oppression of half of humanity *should not* be dismissed as unimportant, or turned into a joke.

Strongly asserting that women's aims must be of paramount importance for women, Heilbrun states: "Women have behaved not as an oppressed class struggling to overcome their oppression, but as a caste identifying with their oppressors, internalizing their oppressors' views of them. Since men do not take women's rights seriously, most women also refuse to do so. Until women adopt a model for action that sustains the primacy of their own claims, they will not achieve full equality" (1979: 97).

Vehicles for Change

The Bonding of Women. Women, as well as men, can undermine the momentum of women's liberation. As has been noted, the strength of the women's movement lies in the support and encouragement we give one another. The movement suffers when successful women disavow women's struggles, fail to encourage and admire other women, and are not proud of our female heritage. In essence, such women have sacrificed our identity as women; we have become "honorary men and joined the all-male club" (Helibrun, 1979:211).

We have all seen women of great accomplishments disavow women's causes, as though they themselves were not women. Florence Nightingale, Helene Deutsch, even Golda Meir are examples of women who turned from other women. In 1977, the first woman to receive a Rhodes Scholarship denied sympathy and identification with the feminist movement (Heilbrun, 1979).

Of course, many highly successful women have not felt detached from the feminist movement. Eleanor Roosevelt and Margaret Mead, for example, sympathized with women's struggles. Many successful women have actively contributed to women's causes and received strength from doing so, recognizing our responsibilities to help other women achieve what we have often been able to achieve only by unusual luck and the help of other women. Women's bonding has brought about the greatest gains.

Many feminists warn women against the trap of tokenism, long a technique used by those in power to coopt or buy off opposition. Including a token woman or two in the higher-level male-dominated bastions of business, government, the professions, and the arts allows men to protect themselves better from charges of discrimination. Many an organization displays pictures showing a black and a woman among its smiling, well-dressed employees, even though statistics reveal blatant patterns of discrimination behind the scenes. Men have often found that token women will isolate ourselves from other women and women's causes. Such women fail to see how our token

Stages of Women's Awareness: Box 15.6
The Process of Consciousness-Raising

Stage 1: Curiosity

The woman becomes curious about women's issues. She may feel left out as she sees women she knows involved. She may also feel defensive. Although she makes inquiries, they are cautiously put forth, and she keeps her distance from any real influence of feminists. She denies any feminist identification or any discriminatory experiences. Still, she is intrigued.

Stage 2: Identification

The woman begins to make connections between her own experiences and those of women talking and writing about sexist experiences. She begins to identify with other women and women's issues. She reads more on the topic, spends more time consciousness-raising with other women. She talks more about women's issues, tries to convince others, and is critical of men. Frequently she "exhibits the enthusiasm and missionary zeal of a new convert." She does not undergo radical change in her personal life.

Stage 3: Anger

The woman inevitably experiences anger. It may be private or explosive, continuous or in spurts. Men and the system are oppressive, and the barriers to change seem overwhelming. She views herself as a victim. She begins to change aspects of her life, such as her appearance and wardrobe, and to redefine her relationships. The anger is important and legitimate. It gives her the energy to make changes and is a release for many feelings long unrecognized. "The woman emerging from the anger stage is very likely to be more integrated, self-directed, and confident than before, readier to relate on the level of equals."

status may delay the gains of other women rather than indicate that "if I made it, other women can."

Carolyn Heilbrun calls for solidarity among women this way:

> The failure of women's movements, past and present, to retain the momentum of the years of highest accomplishment can be attributed to three causes. The failure of women to bond; the failure of women to imagine women as autonomous; and the failure of even achieving women to resist, sooner or later, the protection to be obtained by entering the male mainstream. Among these causes, the failure of women to find "support systems" among themselves is certainly close to the heart of the problem. . . . Obviously, it is difficult in a hierarchical society to bond with the powerless against those in power, particularly when the aphrodisiac of power is an added allure. (1979: 26–27)

Even women are not immune to the tendencies of all persons raised in sexist society to value the work of women less than the work of men. A disturbing study showed this (box 15.7).

Box 15.6

Stage 4: Consolidation

The woman recognizes the ways in which she has "collaborated in her victimization" and accepted societies' sexist assumptions about herself. She begins to see how she can influence change in society. Her energy becomes focused into goals and activities to effect change. She identifies with women who have a range of lifestyles and beliefs. She feels a solidarity with women and adheres to "sisterhood is powerful." Far from being temporary, this feeling "leads to a lasting reorganization of her self-image."

Stage 5: Personal Power

The woman emerges from a collective identity of the previous stage and explores her own potential as an individual. Secure in her collective identity, she reenters the system and examines potentials and limits. Traits traditionally considered masculine, such as power, authority, ambition, status, and competing to win are explored. Power becomes viewed as a "tool for personal effectiveness." Still adhering to the theme of "sisterhood," she learns to distinguish "herself on her own merits, and take personal, rather than collective, responsibility for her actions." She "has graduated from being a protegee to being a competitor." The task is to use these skills without selling-out to the system.

To the Student: Can you identify yourself in one of these stages?
(Adapted from Palmer, 1979:1–4, 11)

Reproduced by special permission from *Social Change: Ideas and Applications*, "Stages of Women's Awareness: The Process of Consciousness Raising," by Judith A. Palmer, Volume 9, Number 1, pp. 1–4, 11, copyright 1979, NTL Institute.

The women's movement is helping women (and men) overcome such prejudice. The women's movement is evidence of bonding, as are women's networks in which we share information and support. Successful women will sympathize with and support women's aims when we identify as women, not as "honorary males." The stronger the bonds, the greater the chances of success.

Models for Women. Traditionally, our only models for achievement and autonomy have been male models. In the past, women who have followed such models have frequently adopted a male value system and have often been called "unfeminine." This is a powerful form of social pressure, for it suggests that women must choose between being successful and being women. The culture has perpetuated the fraud that an autonomous, achieving woman is a contradiction in terms. The fact is that *whatever* women do is womanly, by virtue of the fact that we are women doing it.

Are Women Sexist? **Box 15.7**

The unconscious assumptions about a woman's "natural" talents (or lack of them) are at least as prevalent among women as they are among men. Psychologist Phillip Goldberg demonstrated this by asking female college students to rate a number of professional articles from each of six fields. The articles were collated into equal sets of booklets, and the names of the authors were changed so that the identical article was attributed to a male author (e.g., John T. McKay) in one booklet and to a female author (e.g., Joan T. McKay) in the other booklet. Each student was asked to read the articles in her booklet and to rate them for value, competence, persuasiveness, writing style, and so forth.

As he had anticipated, Goldberg found that the identical article received significantly lower ratings when it was attributed to a female author than when it was attributed to a male author. He had predicted this result for articles from professional fields generally considered the province of men, like law or city planning, but to his surprise, these women also downgraded articles from traditionally female fields. In other words, these students rated the male authors as better at everything, agreeing with Aristotle that "we should regard the female nature as afflicted with a natural defectiveness." Such is the nature of America's unconscious ideology about women. (Jagger and Struhl, 1978:11)

Any human goal can be a female goal. Women must act to control our own destinies. The models of *action* have traditionally been male models, but women can transform them to female uses. Feminists point out that there have always been women who have acted, although we may not know about them. We have tried in this book to provide readers with female models.

Feminist writers are creating more female protagonists who are autonomous, ambitious, and adventuresome. The image of a "sleeping beauty" waiting for her prince is fading. To provide female models and to keep them alive, even when the wider culture ignores them, is one of the most important functions women's studies can perform. This can be done through a new look at women's history, through a reinterpretation of women's work in the arts and literature, and through a reexamination of the roles women have taken and are taking in society. With this effort will come the voice of more women, speaking of our own experiences and creating new models.

Revolution in the Family: The Overthrow of "Motherhood." As we have learned in the previous chapters, gender roles and the family structure have been firmly tied together. Family structure so far has been almost universally built on a clear division of labor by gender and sex-stereotyping of female and male behavior. This structure serves a number of purposes: it shapes

stereotypical identities in children, encourages passivity in women and dominance in men, ties women to the home and to a dependence on men, and interferes with women's achievement of selfhood and with men's ability to love and nurture. The constraints of the traditional family bind women tightly. We need to break these ties and to create a revolution in the structure of the family.

This may be the most difficult task of all. No issue unites people more readily than one that threatens the traditional family structure. A woman can be elected head of a country, and it is acceptable to let a few women achieve high status and power, as long as the structure of the family remains intact. How do we explain this?

The family is the foundation on which the larger social structure rests. It is a foundation that allows the continuation of male dominance and power. To revolutionize the family is to threaten that structure and the male monopoly of power.

Inherent in the family structure is the definition of "mother" as female. But the concept of "mother" has more attached to it than just the biological function of giving birth. The social and caretaker roles of "mothering" have been tied to the biological function. "Motherhood" requires the woman to be at home, passive, and dependent on the male. Out of this evolves the definition of "femininity."

To overthrow "motherhood" in this sense is to free women from having the primary responsibility of caring for children. It requires abandoning the traditional myths of motherhood and the romantic fantasies of "femininity." It requires "fathering" children to mean something very similar to instead of something different from "mothering" them. It is to demand that "parenthood" be a shared responsibility. It is to free women to be as active, assertive, ambitious, and independent as men, and to expect men to be as caring, nurturing, and sensitive as mothers. The opposition to such change is bound to be great.

The most revolutionary action most women can take is to refuse to accept "personal" domination by men, especially within the family. Women can often do this only at great personal cost. But the rewards, for individual women as well as for all women and even men, can be great, as we experience how satisfying is a life of self-respect in which we demand recognition of our equal worth as human beings.

It is easy to see how maintenance of the present family structure has become a political issue. Conservatives have acted to thwart the changes toward liberating women that have been taking place. And they have done this in the name of what they call "protecting" the family. Refusing to support public day care facilities, denying a woman's right to control reproduction, resisting the separation of sex and procreation, refusing to recognize alternate forms of family arrangements, and refusing especially to admit that

mothers and fathers could have similar roles, conservatives proclaim their devotion to "the family." What they are clearly devoted to is male control over women.

Overthrowing "motherhood" does *not* mean, as many have implied, neglect of children or the destruction of the family. Quite the contrary, it means caring for children in nonsexist and humane ways, so that children feel wanted and loved by parents who may be fathers *or* mothers. Women's right to decide if, and when, we want children, to select and pursue careers, to implement changes in our lives, and to adopt a life pattern consistent with our needs, as well as with the needs of those around us, allows us to be mothers voluntarily and to form and maintain loving families.

The goal of reconstituting the family will require major changes in social policy. Arrangements and facilities for child care will have to be provided and made available to all people. Economic supports for the family—such as the "family allowances" provided by most industrial societies other than the United States—will be essential. Welfare procedures must support women's roles as workers and men's roles as fathers, while at the same time not enforcing heterosexuality. Health care, social security, and pension systems must follow similar lines. An economic and social value must be put on unpaid housework and child-rearing. Community organizations can provide services and support systems in which members assist one another and share responsibilities. These changes will make it more possible for people to move in and out of the house and workplace as our life situation requires.

The legal system must expand its definition of the family and recognize new arrangements for family life. When and if it is appropriate to involve the law at all (and it may often not be), the law should provide for "marriage" contracts in which partners can establish agreed-upon roles, and in which stable homosexual partners can be parents. Equitable protections for partners and children need to be guaranteed, and society must protect families living under less traditional modes, such as households of unrelated persons and one-parent households, from unfair disadvantages (Giele, 1978).

The female role as the "good housewife/mother" and the male role as the "good provider" bear faint resemblance to the realities of most people's lives in any case. Families frequently find it difficult to manage on one income. Mothers are increasingly entering the work force, and we are demanding greater autonomy. Married women are also demanding that our husbands contribute to child care and housework, although most men have been extremely slow in doing so in more than token ways. Personal struggles for equality in the family are an uphill battle. Not only are women fighting social and political policies that discourage our advance, but men are confronted by standards that view egalitarian family arrangements as "emasculating." Fellow workers accurately view the willingness of some men to share housework

and child care as threatening to their own dominance in the family; they exert pressure on such men to uphold traditional roles (Bernard, 1981).

Deep changes in attitudes and policy are required to facilitate revisions in family arrangements. Society must recognize the legitimacy, even desirability, of such revisions and their ultimate benefit for all people—women, men, and children—and must provide the required supports to make them possible. In the meantime, however, individual women, and those men who are willing to join us, must create these new realities as best we can on the scale of our own lives.

Power and Politics. Power usually acts to maintain itself. The powerful will not give up power voluntarily; it must be taken from them. As Heilbrun notes,

> After itself, power most respects countervailing power. Having long been among women who were careful never to offend the males in power, several of us have discovered that in fighting power we achieved more in a month than submission had accomplished in years.... Power is self-satisfied. Token women, and those men power uses but does not respect, are the tools of power. The men and women who fight power are the only ones with effect. (1979: 203–4)

Power is a word that repels many feminists. It conjures up an image of a male power hierarchy in which the existence of the powerful necessitates the existence of the powerless. At present, women are among the powerless. We do not wish to be powerless, but we also do not wish to use power as men do to dominate and exploit others. However, until society can be reconstructed in such a way that domination is not basic to it (Hartsock, 1982; Held, 1976), feminists want women as a group to have our share of power; without it, the social and political changes women seek will not occur.

Powerful institutions exist in every aspect of our society—in politics, in the marketplace and workplace, in education. These institutions control policy and opportunities. Even words and images have power, for they affect attitudes and values. Nearly all of these work to support the system.

The political system is one of the most powerful bastions of our sexist social structure. Legislation for various forms of equality has been passed, and continues in effect, but the pace at which actual changes that benefit women are made is painfully slow. And much needed legislation still fails to get support. Women who are active in politics are still all too often subordinates (Mezey, 1980).

In the United States presidential election of 1980, for the first time women voted in ways that were significantly different from men. *Far* fewer women than men voted for Ronald Reagan (Steinem, 1981). As more women become aware of how governmental policies affect us—and that increasingly seems to be evident at the polls—we can use the power of our numbers to achieve

changes through the ballot. Unlike minorities, who can always be outvoted, women constitute a majority of voters, a reality that has now been grasped by politicians. We could achieve far more gains than we have through careful voting. The power of the vote should not be exaggerated, for most of the political and economic structures of the United States are now relatively immune to electoral change. The deeper configurations of power in our society—such as the power of corporations and major interest groups to win favorable governmental policies—remain.

The vote could give women power, but only if we act together. We must support candidates committed to women's issues, and these issues must become a top priority for voters and candidates. Feminists must run for office and exert pressure. To do so, we must have the active support of other women. Women must make ourselves heard through petitions and organizational work as well as voting.

To call attention to feminist issues when the normal political channels are not responsive, more militant actions, such as demonstrations, boycotts, strikes, and actions involving civil disobedience, may be necessary. Where power is used unjustly to dominate those with little power, disobedience of existing, unjust law on grounds of conscience may be fully justified (Bedau, 1969; Bondurant, 1965; Held et al., 1972).

As women challenge existing structures of domination, the resistance of those threatened by, and opposed to, the liberation of women will grow. The strength of this resistance is a measure of women's own strength.

Women's Studies and the Feminist Movement

Women's studies is both a result of and a vehicle for the women's movement. It grew out of women's awareness of our past and present roles and communicates this awareness to women. It studies women and encourages the study of women. It takes pride in women and conveys that pride to others. It is the academic discipline of feminism. Women's studies is a growing force in the academic community, a force that sends messages and affects beliefs and behavior far beyond the walls of academic institutions.

In reading this book, you have absorbed a tremendous amount of material. With that background, take a minute to think about the future. What would you like to see happen? Do you think it will happen? How can the changes you hope for be brought about?

Your training in women's studies should provide you with a new perspective when you enter into traditional occupations. It will help prepare you for various newly developing fields. As a result of your awareness of what women have done and are now doing, and your understanding of how societies everywhere subordinate the lives of one gender to another, the world may never look the same to you again. We hope that you will never lose the new perspective that feminism provides.

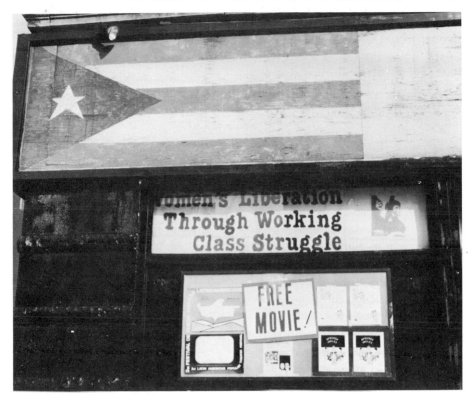

Women continue to search for ways to liberate ourselves and others, as illustrated by this street poster in New York City in 1982. (Photo by Richard Zalk)

It is not our intention to leave you at the end of this book feeling either optimistic or pessimistic about the future. Both feelings are dangerous. Optimism can lead to complacency—the feeling that all will turn out well and the future will take care of itself. Pessimism can lead to apathy, a sense of defeat and the feeling that we have no control over our future. Our hope is that you will finish this book with the belief that women must try to take control of the future, and have the courage to persist. We hope that with the insights you have gained in studying women, you will act to bring about the future that women choose.

Summary

When women have fought for social change, we have frequently contributed to the gains of others but have been denied the realization of our own objectives. This happened in the American and French revolutions.

After women won the vote in the United States, active feminism continued

in the 1920s, but diminished with the depression. Following World War II, women were once again rigidly confined to home and family. In the 1960s, feminism experienced a rebirth. Since then, the women's movement has been increasingly active on behalf of women's rights. Today the movement gets a great deal of publicity, but observers disagree on its effectiveness.

The optimistic view points to gains in religion, the workplace, the arts, and education. Women's roles in the family are changing as fathers take a more active part and nonsexist child-rearing practices take hold. Women at midlife are becoming increasingly aware of, and are taking advantage of, educational and career opportunities. More and more people are accepting the advancement of women and are supporting social policies that will help us.

The other side of the picture is that the conservative political tide in the United States is threatening to reverse the gains of women. Some women are rejecting the prospective role of the "superwoman," who effortlessly combines family and career, in favor of more traditional and secure roles. In order to free women from having two full-time jobs—one in the home and one in the workplace—major changes in family structure and social support systems will have to take place.

Nonsexist socialization practices will probably result in greater similarities between the sexes, although biological differences will remain. Some undesirable biological traits may be discouraged and desirable traits enhanced in society. Many feminists believe that the world would benefit from an infusion of such "female" traits as expressiveness, peacefulness, and care for humane social priorities. Society should foster the developmment of the "good person." Perhaps such a person is one with an androgynous personality incorporating the best traits of both women and men.

The causes of women's oppression are multiple and require a simultaneous attack on several fronts. But the women's movement can be successful only if women unite and support one another. The many divisions of our social structure blur the common oppression that all women endure.

Some feminists urge a radical transformation of the structures of society (the liberation ethic), while others emphasize equality for the sexes and the elimination of discrimination (the egalitarian ethic). It may be that both approaches will lead to similar programs.

Feminists argue that in the future, women must pay more attention to our own needs and give them the importance they deserve. Change will come about as women create bonds with one another, as we are provided with more role models, and as the family structure is revolutionized so that family care is no longer equated with the biological component of motherhood.

Women's studies programs have made an academic discipline of feminism. They enable students to become aware of what women have accomplished and of how we have been oppressed. Once we become conscious of the issues feminists are raising, the world may never appear the same as it did before.

Discussion Questions

1. What factors have led to reversals of the gains made by previous women's movements? Can they be countered in the future?
2. Do you see women as much better off today compared to fifteen years ago or as only slightly better off? What components of people's lives are most important for making such judgments?
3. Would you like to have an androgynous personality? Why?
4. What is meant by the "overthrow of motherhood"? Are you for it.?

Recommended Readings

Women's studies journals and feminist magazines: *Conditions; Feminist Studies; Frontiers; Ms.; Quest; Signs; Women's Studies;* and *Women's Studies Quarterly.*

References

Baruch, Grace, and Barnett, Rosalind. "A New Start for Women at Midlife." *New York Times Magazine.* December 7, 1980.

Bedau, Hugo Adam, ed. *Civil Disobedience: Theory and Practice.* New York: Pegasus, 1969.

Bem, Sandra L. "Probing the Promise of Androgyny." In *Beyond Sex-Role Stereotypes: Readings toward a Psychology of Androgyny,* edited by A. Kaplan and J. Bean. Boston: Little, Brown, 1976.

———"Sex Role Adaptability: One Consequence of Psychological Androgyny." *Journal of Personality and Social Psychology* 31 (1975):634–43.

Berg, Barbara. *The Remembered Gate: Origins of American Feminism.* Oxford: Oxford University Press, 1978.

Bernard, Jessie. "The Good-Provider Role: Its Rise and Fall." *American Psychologist* 36 (1981):1–12.

Bird, Caroline. *Born Female. The High Cost of Keeping Women Down.* New York: Pocket Books, 1969.

Bondurant, Joan. *Conquest of Violence.* Berkeley: University of California Press, 1965.

Denmark, Florence. "Psyche. From Rocking the Cradle to Rocking the Boat." *American Psychologist* 35 (1980):1057–65.

Eisenstein, Zillah. *The Radical Future of Liberal Feminism.* New York: Longman, 1981.

Ferguson, Ann. "Androgyny as an Ideal for Human Development." In *Feminism and Philosophy,* edited by Mary Vetterling-Braggin, Frederick Elliston, and Jane English. Totowa, N.J.: Littlefield, Adams, 1977.

Freeman, Jo. "The Woman's Liberation Movement: Its Origins, Structures, Impact, and Ideas." In *Women's Studies: The Social Realities,* edited by Barbara B. Watson. New York: Harper & Row, 1976.

Freidan, Betty. *The Feminine Mystique.* New York: Dell, 1963.

Giele, Janet Z. *Women and the Future: Changing Sex Roles in Modern America.* New York: Free Press, 1978.

Gilman, Charlotte Perkins. *The Living of Charlotte Perkins Gilman: An Autobiography*. 1935. Reprint. New York: Harper & Row, 1975.

———. *Women and Economics*. 1898. Reprint. Edited by Carl N. Degler. New York: Harper & Row, 1966.

Goldman, Emma. "The Tragedy of Women's Emancipation." In *Anarchism and Other Essays*. New York: Dover, 1969.

Gould, Carol. "The Woman Question: Philosophy of Liberation and the Liberation of Philosophy." In *Women and Philosophy*, edited by Carol Gould and Marx Wartofsky. New York: Putnam, 1976.

Hartsock, Nancy. *Money, Sex, and Power: An Essay on Domination and Community*. New York: Longman, 1981.

Heilbrun, Carolyn. *Reinventing Womanhood*. New York: Norton, 1979.

Held, Virginia. "Marx, Sex, and the Transformation of Society." In *Women and Philosophy*, edited by Gould and Wartofsky. New York: Putnam, 1976.

———. "Men, Women, and Equal Liberty." In *Equality and Social Policy*, edited by Walter Feinberg. Urbana: University of Illinois Press, 1978.

———, Nielsen, Kai, and Parsons, Charles, eds. *Philosophy and Political Action*. New York: Oxford University Press, 1972.

Herzog, Alison C., and Mali, Jane Lawrence. *Oh, Boy! Babies!* Boston: Little Brown, 1980.

Jaggar, Alison. "Political Philosophies of Women's Liberation." In *Feminism and Philosophy*, edited by Vetterling-Braggin et al. Totowa, N.J.: Littlefield, Adams, 1977.

———, and Struhl, Paula Rothenberg. *Feminist Frameworks*. New York: Harper & Row, 1978.

Kaplan, Alexandra. "Changing the Concept of Androgyny: Implications for Therapy." *Psychology of Women Quarterly* 3 (1979):223–30.

Kolb, Frances A. "The Feminist Movement: 1890–1920." In *Women's Studies: The Social Realities*, edited by Barbara B. Watson. New York: Harper & Row, 1976.

Lemons, J. Stanley. *The Woman Citizen: Social Feminism in the 1920s*. Urbana: University of Illinois Press, 1973.

Levy, Darline, Applewhite, Harriet, and Johnson, Mary, eds. *Women in Revolutionary Paris, 1789–1795. Selected Documents*. Urbana: University of Illinois Press, 1979

McKenna, Wendy, and Denmark, Florence. "Women and the University." *International Journal of Group Tensions* 5 (1975):226–34.

Mezey, Susan G. "Women in the Political Process." In *Issues in Feminism*, edited by Sheila Ruth. Boston: Houghton Mifflin, 1980.

Morgan, Marabel. *The Total Woman*. Old Tappan, N.J.: Revell, 1973.

Morgan, Robin, ed. *Sisterhood is Powerful*. New York: Vintage, 1970.

Palmer, Judith D. "Stages of Women's Awareness." *Social Change: Ideas and Applications* 9 (1979):1–4;11.

Postow, Betsy. "Women and Masculine Sports." In *Femininity," "Masculinity," and "Androgyny": A Modern Philosophical Discussion*, edited by Mary Vetterling-Braggin. Totowa, N.J.: Littlefield, Adams, 1981.

Rossi, Alice S. *The Feminist Papers*. New York: Bantam, 1973.

Rowbotham, Sheila. *Women, Resistance, and Revolution*. New York: Vintage, 1974.

Ruth, Sheila. *Issues in Feminism: A First Course in Women's Studies*. Boston: Houghton Mifflin, 1980.

Steinem, Gloria. "Now That It's Reagan." *Ms.* 9 (1981):28–33.
Thurow, Lester C. *The Zero-Sum Society.* New York: Penguin, 1981.
Trebilcot, Joyce. "Two Forms of Androgynism." In *Feminism and Philosophy,* edited by Vetterling et al. Totowa, N.J.: Littlefield, Adams, 1977.
Wollstonecraft, Mary. *The Vindication of the Rights of Woman.* 1792. Reprint. Edited by Carol H. Posten. New York: Norton, 1975.

Index

"The Abandoned Doll," Valadon, 106
Abilities, sex differences, 139
Abortion
 backlash, 461, 544, 587–88
 health care issues, 460, 462
 legal and religious constraints, 301–2, 460
Abzug, Bella, 552, 563
Adam and Eve, myth, 27–28, 102, 359–60
Adams, Abigail, 410, 575–76
Addams, Jane, 329, 420, 551, 577
Adolescence
 gender role development, 152–55
 pregnancy in, 456 57
Affirmative action, 518–21
Aggression, sex differences, biology, 122–23
Aging, 449–50, 451. See also Mature
 women; Older women
Alcoholism, 464, 466
Alcott, Louisa May, 234, 237
Alternatives, choosing, 320–50
 alternative family forms, 339 45
 communities of women, 322–30
 utopian and experimental communities,
 330–39
 women alone, 345–48
Amenorrhea, 452
Androgens, intrauterine influence, 102
Androgyny, 51, 590–92
Angelou, Maya, 228, 287
Anorexia nervosa, 449
Anthony, Susan B., 389, 413, 556
Appearance, and imagery, 38–39
Aristotle, views on women's nature, 25, 63–
 66, 439
Art, and women's self-definition, 41–45
Asian Americans
 education, 508
 gender identity, 155
 work patterns, 508
Astell, Mary, 407–8
Aunt-niece relationship, 237–38
Austen, Jane, 234, 237
Authority, and power, defined, 537–38

Bachofen, Johann Jakob, 183–85
Backlash, attitudes of the 1980s, 544, 568,
 586–88
Battered women, 466–67, 541, 552
Beard, Mary, 14, 17
Beauvoir, Simone de, 6, 17, 60–63, 66, 89–
 90, 287
Beecher, Catharine, 412
Behavior
 gender differences, biology, 121–22
 and medical definition of health, 440–42,
 444
Behn, Aphra, 45, 47, 49, 407
Bemba society, female initiation rites, 368–69
Benoist, Marie Guillemine, 578
Bernard, Jessie, 278, 288, 317, 342, 591,
 603, 607
Biology, defining women, 98–103, 121–26,
 186
Birth. See Childbirth
Birth control, 301 3, 580. See also Contra
 ception.
Birth-order, and siblings, 233–34
Birth rate, and motherhood, 293–94
"Black Venus," Saint-Phalle, 32
Black women, United States
 adolescents, 152
 denied the vote, 579
 education, 414–16
 feminists and racism, double oppression,
 12, 567–68
 gender identity, 152, 155–58
 mother-daughter relationship, 225–27, 242
 mother role stereotype, 310, 311–12
 and National Association of Colored
 Women, 577
 political leaders, 543, 544, 545
 reaction to aging, 164
 and religion, 372, 375, 383, 386
 and slavery, 491
 and social controls, 553
 and Student Non-Violent Coordinating
 Committee (SNCC), 561

support networks, 255, 300
work, 507–8, 514
writers, bibliography, 56, 279
Blackwell, Elizabeth, 424
Bodichon, Barbara Leigh Smith, 232
Body image, external perceptions
aging, 449–50
and breasts, 445, 448
and body size, 448–49
Body image, internal perceptions. *See also*
Pregnancy
hysterectomy, 454
infertility, 453–54
menopause, 452–53
menstruation, 450–52
Body language, symbolism, 39
Bradstreet, Anne, 410
Bradwell, Myra, 423, 534
Brain, hormone effects, 122–25
Breast-feeding, 120, 295–97
Breasts
and body image, 445
cancer issues, 445, 448
Brontë, Charlotte, 236, 326, 381
Brother-sister relations, 235–36
Brown, Antoinette, 417–18
Budapest, Zsuzsanna, 390, 394
Buddhism
goddesses, 362–63
and nuns, 322
women's religious experience, 360, 362
and sexual standards, 371

Capitalism
alienated work system, 489–510
division of labor by gender, 187–91, 491–510
urbanization and class distinctions, 489–90
and working for wages, 187, 490–91
function of motherhood in, 290
Careers. *See also* Work
discrimination, 421–22, 503–7
laws against, 518–21
and education, 421–31
gender socialization, and goals, 188–91
and traditional family goals, 588–89
wife and husband, 513–14
Cassatt, Mary, 228, 229, 411
Catherine of Aragon, 258–61, 263–65, 267, 403
Catt, Carrie Chapman, 556, 559
Catholicism.
and abortion, 301–2
and female martyrs, 378–80
Mary worship, 363
nuns, 356, 388–89
rural women and religious experience, 358
and witchcraft, 378–80
"woman's space," 372
Chadors, 199–201. *See also* Clothing

Chesler, Phyllis, 166, 168, 314, 318, 440, 461
Chicago, Judy, 43–44, 223
Child care. *See* Day care
Child custody, mother's rights, 303–4
Childbirth
biology, 117–18
caesarean, 118
medicalization, 454–56, 470–71
natural or cultural, 293–95
postpartum period, 118, 120
stages of labor, 117–19
Childhood, theories about gender role development, 146–53
Childlessness, and choice, 302, 346
Children's books, and sexism, 426
Chisholm, Shirley, 544
Chodorow, Nancy, 36, 56, 150, 168, 223, 239, 289
Christ, Carol, 363, 365, 393, 394
Christianity
Coptic women, Egypt, 382
goddesses, and monotheism, 363
missionaries, 377–78
and women's immortality, 361
and women's religious experiences, 358
sexual standards, 370–71
Chromosomes, and gender, 98–103, 123–24
Citizens' Advisory Council on the Status of Women, 559, 562
Civil rights' movement, 536, 561, 595
Clarke, Edward, 418–19
Clothing
imagery and symbolism, 38–39
as social control, 198–99
Coeducation, and success of women, 428
Cognitive theory, and gender role development, 150–51
Colette, Sidonie-Gabrielle, 227, 243, 317
College education, struggle for, 416–21
Colonialism, and women's roles, 540–41
Combahee River Collective, 567, 568
Commission on the Status of Women, national, 558–59
Communism
impact on gender division of labor, 522–23
women political leaders, 545–48
Communities of women
educational, 324–26
experimental, 330, 332–39
laboring, 326–29
religious, 322–24
Community support for childrearing, 300–301. *See also* Day care
Competition, reduction as a function of marriage, 248–50
Confucius, 156
Consciousness-raising
and personal change, 598–99
and political change, 562

Conservatism, and feminism, 79–80
Contraception, 457. *See also* Abortion
 methods compared, 458–59
 and motherhood choices, 301–3
Convent life, 322–24, 350, 402, 404. *See also* Nuns
Cook, Blanche, 348, 351, 552, 572
Cooper, Anna Julia, 415–16
Coppin, Frances Jackson, 414–15
Corporations
 male patterns of management, 509
 women as "specialists" in, 510
Couvade, 298
Creation myths, religion, 359–60
Crime, and women, labelled "deviance," 552–53, 554
Cults, women's role, 372–73
Culture
 childbirth, influence on, 293–95
 female personality development, 143–44
 menopausal changes, 164
 and motherhood, shaping of its biology, 290–97
 and parental behavior, 282–85
Curie, Marie Sklodowska, 233
Custody, child, and mother's rights, 303–4

Daly, Mary, 363, 393, 394
Data collection on gender behavior, biases, 135–38
Daughters, 216–33
 in the family of birth, 216–23
 and fathers, 231–33, 243, 254, 256
 images, 306–7
 infanticide, 218–19
 inheritance, 238–39
 and mothers, 223–31, 242
 naming, 221–23
 and siblings, 230, 233–43
 value, and work, 219–21
Day care
 Anglo vs. Chicana: two feminist perceptions, 566–67
 and middle-class households, 493
 and working mothers, 304–5, 523, 544, 580
Declaration of Rights and Sentiments, 1848, 556
Definitions of women
 biological, 94–107
 imagery and symbolism, 23–55
 and men's needs, 64
 as "other," 60–63
 philosophical, 63–66
 psychological, 133–38
 social, 174–80
 women's nature, 60–67
DES (Diethylstilbestrol), 453
Deutsch, Helene, 160–61, 597. *See also* Psychoanalytic theory
Deviance, and sexism, 553–54

Dickenson, Emily, 50, 381
"The Dinner Party," Chicago, 44, 45
Dinnerstein, Dorothy, 147, 232
Directories, women, networking, 53
Discrimination, 560. *See also* Education, Job discrimination, and Supreme Court decisions, and gender
Division of labor by gender
 and cultural definitions, 491–508
 socialization, 187–91
 production and reproduction, 481–82
Divorce, 259, 271–74, 552–53
Domestic mode of production, 485–89
Domestic work, for wages, 493–94. *See also* Working-class women
Domestic science, 421–22
Dominance, male, in politics, 541–42
"Double burden," career and family, 204–5, 524–25, 547–48. *See also* Superwoman myth
Double standard, morality, 236, 238–39, 264–65, 270, 552–53
Drug dependence, 464, 466
Dual-career families, 513–14, 584
Dysmenorrhea, 450

Earnings, women and men, 504–5, 521–22
Earth mother, imagery, 33–36
Eastman, Crystal, 551–52
Economic development contribution, 483–85
Economic exchanges, women and trade, 489
Edelson, Mary Beth, 134
Education, 397–433
 and career choices, 401, 421–31
 discrimination, 421–22
 in early years, 399–401, 426
 higher education, challenged, 416–21
 history, 401–6
 traditional goals, debate, 406–9
 literacy, 398–401
 modern revolution, 409–21
 women who excel, 428
Educational communities of women, 324–26
Egalitarian ethic, and the women's movement, 594–95
Egalitarian households, 341–42
Egg/sperm relationship, 95
Elementary education, achievement, 410–14
Eliot, George (Marian Evans), 9, 258, 329
Elizabeth I, England, 268, 403, 540
Employment, 304–6. *See also* Work
Empty nest syndrome, 163–64
Endogamy, marriage, 251–53
Endometriosis, 450, 452
Engels, Friedrich, 81, 185, 250
Equal Employment Opportunity Commission (EEOC), 518–21, 559–60
Equal pay for comparable work, 521–22
Equal rights movement, 554–68. *See also* Women's liberation movement

Equal Rights Amendment, 515, 517, 544, 550, 562–65, 568, 587
Equality, ideas in the liberal tradition, 67–78
"Ethnic" mothers, changing stereotypes, 310–12
Ethnicity, and feminism, in women's studies, 11–13
Etiquette, as symbolism, 39–41
Eve, myth, 27–28, 66, 102, 359
Evolutionary theory
 and patriarchal and matriarchal societies, 183–87
 sex differences and behavior explained, 125–26
 and two sexes, biology, 94–95
 and woman's place in society, 182
Exchange of women, marriage, 248
Exogamy, marriage, 252–53
Experimental communities of women, 330–39
Extended family, household, 266–67
Extramarital affairs, 270–71

Factory workers, 494–95
Fairy tales, and frightening females, 28–29
Families of women, 342–43
Family, 213–350
 alliances, secured by marriage, 248
 alternative forms, 339–45
 circles of feminists, 331
 contemporary picture, 584
 daughters, 217–23
 functions, 215
 mate selection function, 253–54
 nuclear, and work, 511–12
 overthrow of "motherhood," 600–603
 parents, 223–33
 politics, 268–69
 revolutionary changes in structure, 600–603
 sisters, 233–43
 wives in, 246–78
Fantasies, and defining women, 27–28
Fathers' names, patronymics, 222–23
Father-daughter relationship, 228–33, 239–40
Fathers, parenting, 232, 254, 282–83, 285, 298–300, 341, 584
"Fear of success," 154
Female circumcision, 368
Female infanticide, 218–19
Female-male differences. See Sex differences
The Female Man, Russ, 51, 219, 244
The Feminine Mystique, Friedan, 134, 285, 514, 559, 563
Feminism
 and conservatism, 79–80
 and family circles, 331
 future goals, 574–75, 589–605
 imagery, propagation, 52–53
 internal conflicts and divided loyalties, 11–13, 566–68

and liberalism, 69–71, 76–79, 81
and marriage, 275–76
in mental health movement, 465
and the need to rediscover earlier feminist ideas, 580
and politics, 532–36
principles, 84–88
radical goals, 83–84, 579–80
and social change, 575–605
religious change contribution, 389–91
sisterhood, 592–93
and socialism, 80–83
and women's studies, 4–7, 604–5
work impact, 523–24
Femininity
 and androgyny, 590–92
 and "fear of success," 154
 stereotypes, 133–43
Firestone, Shulamith, 287, 561
Flax, Jane, 81, 90, 150, 239–40
Flextime, work, 524
Flynn, Elizabeth Gurley, 494–95, 497
Food production, and gender roles, 485, 488
Foreplay, sex, 115–16
Freedom, concept, 78–79
Freeman, Jo, 561, 594–95
French, Marilyn, 49, 286, 330, 514
French Revolution, women's rights, 576, 577, 578, 579
Freud, Sigmund, 64–65, 113, 140, 142, 439
Freudian theory. See also Psychoanalytic theory
 female sexuality, 113
 gender role development, childhood, 146–48
 criticism, 147–48
Friedan, Betty, 134, 285, 331, 514, 559, 561, 563
Frightening females, imagery, 28–31
Future, womankind and humankind, 574–606
 androgyny vs. differences, 590–93
 family restructured, 600–603
 a new world, 593–95, 599–600
 "a piece of the pie," 593–95
 sisterhood, 592–93
 solidarity, 597–99
 voting power, 603–4
 women's studies: a new perspective, 596–97, 604–5

Gaskell, Elizabeth, 234
Gender
 and chromosomes, 98–101, 174
 daughters' development, 223–38
 and division of labor, 187–88, 541–42
 new interpretive frameworks, 206
 and the "other," 60–63
 and psychological theories, 146–151, 439–40
 social construction, 143–46, 176–78

and social controls, 198–203, 440
social definitions, 174–76
social science conceptualization, 179–80
and social learning theory, 151
Gender role development, 146–53, 174–80, 186, 522–23
Gender-role reversal, 340–41
Genetics, gender definition, 98–101. *See also* Instinct.
Genital and reproductive anatomy, 103–5
Ghosts, as women, in religion, 360–61
Gilman, Charlotte Perkins, 81, 332, 579–81, 586
Goldenberg, Naomi, 363, 365, 393, 395
God, gender of, 363–67
Goddesses, 361–67
Goldman, Emma, feminist views, 84–85, 256, 580
Government types, and political power, 538–39
Graduate education, and gender discrimination, 427–28
Grandmothers, 197, 227
Grimké, Sarah, 554, 556
Guilds, craft, and skilled women workers, 492–93. *See also* Communities of women.

Hall, Radclyffe, 347
Harem life, 269
Haywood, Eliza, 407–8
Health and women, 438–75
Health care providers
guidelines for patients, 446–47
and health education, 472
women's roles, 468–72
Heide, Wilma Scott, 575
Heilbrun, Carolyn, 582, 590, 594, 596, 597, 598, 603
Herland, Gilman, 288, 332–33, 339
Heroines, imagery and symbolism, 47–48
Herpes virus, 463
Heterosexual prescription, 191–93
High school graduates, percentages, 415
Hildegard of Bingen, twelfth century, 402
Hinduism
goddesses, 362
and widowhood, 274
woman's nature, 68
and women's religious beliefs, 358
women's religious role, 360–61
Hispanic women
Chicanas, 279, 566–67
cultural differences, 159–60
unmarried, 237
and work, 507–8, 514
Hutchinson, Anne, 384
Hormones, brain effects, 122–25
Horney, Karen, 148–49, 161–62. *See also* Psychoanalytic theory
Households
alternative forms, 339–45

of co-wives, 269
extended and nuclear, 265–67
Housework, and women's labor, 482, 488, 511, 523
Hroswitha, tenth century, 402
Hunter College, women's education, 429, 430, 471
Hypatia, fourth century, 402
Hysterectomy, 454

Identity formation, 223–31, 239–41
Igbo women (Nigeria), 340, 540–41
Illiteracy, 398–99
Imagery of women
in art and literature, 41–54
effect on women, 36–37
meaning in the cultural definition of women, 23–55
as mothers, 306–13
predominent types, five, 28–36
propagation by feminists, 52–53
in women's self-definition, 41–55
Immortality and women, religion, 360–61
Incest, 231, 552
Individuation, problem of daughters, 223–28, 239–40
Infancy, female personality development, 144–45
Infanticide, 217–19
Infertility, 453–54
Inheritance, family, 237–39
Insanity, and disorderliness in women, 440–41
Instinct, and parental behavior, 282–85
Intentional communities of women, 336–38
Intrauterine events, sex differentiation, 101–3
Invisibility of women, social construction, 178–79, 203–5
Iroquois women (Native American), 272, 540
Islam
religious leaders, 373, 375
sexual controls, 251–52, 370–71
wives of the prophet Muhammed, 261
women's religious beliefs, 358

Jacobi, Mary Putnam, 418–19
James, Alice, 235, 243
Jewish marriage contract, 255–56
"Jewish mother," stereotypes, 310–11
Jewish religion
goddesses and monotheism, 363
life cycle rituals, 367–68
and origin myths, 359–60
Orthodox prayers by men and women, 388
religious leaders, 373, 375, 387–88
Sexual controls, 370–71
women's role, 387–88
Joan of Arc, 378–79
Job discrimination
capitalism, class distinctions, 489–510

earnings by females/males, white/black, 504–5
laws against, 518–21
and minority women, 507–8
and motherhood, 304–6
resisted, 583–84
within the professions, 503, 506–7
Jones, Mary Harris ("Mother"), 494, 496
Jordan, Barbara, 545
Judges, interpreters of law, 554

Kali, Goddess, 29, 30, 361, 362
Kambari woman, Nigeria, 35
Kelly, Joan, 8, 17, 77
Kibbutz, 336–37
Kingston, Maxine Hong, 48, 218, 253, 308, 317
Kollwitz, Kathe, 451
Koran. See Islam; Muslims

Labor. See Childbirth; Work
Labor force, women, statistics, 495, 502
Labor unions, 514–15
Laboring communities of women, 326–29
Lactation, 120. See also Breast-feeding
Lamaze method of prepared childbirth, 294–95, 455
Laney, Lucy Craft, 414
Language, nonsexist, 40–41, 51–52
Language, as social control, 202–3
Laws
 defined, 552
 discrimination and affirmative action, 518–19, 521, 552–54
 and employment "protection," 517, 562
 gender segregation and equal pay issue, 521–22
 family law, and cultural assumptions, 552
 and social control of women, 553–54
Lawyers, career discrimination, 423, 554
Learned women, history, 401–9
Leadership, women, politics, 542–49, 554
Legislation, women's employment, 517–21
LeGuin, Ursula, 51, 526
Lesbians
 families, and children, 303, 342–44
 as a sexual choice, 347–48, 350, 375, 536
Lessing, Doris, 16, 17, 48–49
Leyster, Judith, 42
Levirate marriage, 259
Liberalism, and feminism, 68–71
Liberation ethic, and the women's movement, 594–95
Linguistic taboos, connected with wives, 194, 267
Literacy, 398–401
Literature, women's self-definition, 45–54
Lorde, Audre, 343, 352
Love, marriage reason, 254–56
"Lowell girls," 328–29
Luxemburg, Rosa, 551

Lyon, Mary, 412

Madness, and medical definitions of women's behavior, 440–41, 464–66
Madonna, as an image of woman, 31–32
Maine, Henry Sumner, 183–85
Male dominance, patterns in power relationships, 541–42, 601–3
Marie de France, twelfth century, 401
Marriage
 ages for, 260–61, 265
 child brides, 265
 choice of mate, 251–58, 261
 defined in common law, 252
 and divorce, 271–74
 as economic exploitation of women, 250
 endogamous and exogamous, 294
 and extramarital affairs, 270–71
 and family politics, 268–69
 feminist options, 275–76
 functions, 247–51
 households, 265–71
 as a legal and social institution, 193–95
 as a rite of passage, 261–64
 settlements (bride price, dowry), 254
 types of, 258–60
 and widowhood, 274–75
Martyrs, religious, 376–78
Marx, Karl, 81, 83
Marxism, and feminism, 81–82
Masculinity, personality stereotypes, 137
Masochism, and female sexuality, 160–61
Mastectomy, 445–48. See also Breasts, health care
Masters and Johnson, and human sexual responses, 113–14
Mate selection, marriage, 251–58
"Maternal thinking," 196–97
Maternal behavior, 217, 282–85, 289–90
Mathematics skills
 and career choices, 427–28
 gender differences, 123–24
Matriarchal society, evolutionary theories, 183–87
Matrilineal societies, 238
Mature women, midlife experiences, 584, 586. See also Older women
McLennan, John F., 183–85
Mead, Margaret, 134–36, 141–43, 155, 168, 265, 271, 272, 274, 288, 291, 298, 597
Media, and motherhood, 312–13
Medical profession, interaction with women, 440–44, 446–47
Medicine, career discrimination, 423–26, 471–72
Menarche, 107, 260. See also Menstruation
Mental health, 463–66. See also Madness
Menopause
 biology, 120–21
 and depression, 121, 163

health aspects, 452–53
medical profession view, 442
psychological reactions, 163–64
Menstruation
common abnormalities, 450, 452
and female reproductive cycle, 107
an issue in higher education, 418–19
and moods, 111–12
negative attitudes about, 107–11
phases of the cycle, 110
religious aspects, 369
Mental health, 463–68
Midlife women, 584, 586
Middle Ages, formal education, 402
Midwives, 293, 300, 440, 470–71
Mill, Harriet Taylor, 73–76, 484
Mill, John Stuart, 63, 484
marriage as friendship, 276
views on equality, 73–76
Ministers, female experience, 384–87, 423
Minority women, United States
and work, 507–8, 514
and writing, 55, 157, 158–59, 160
Mirikitani, Janice, 157
"Misbegotten man," imagery, 36
Missionaries, 376–78
Mitchell, Juliet, 82, 147
Models of achievement for women, 599–600
Monogamy, in marriage, 259–60
Christian view, 249
as economic exploitation, 250
Mood, and menstruation, 111–12
"Moon Garden Wall II," Nevelson, 46
Moore, Honor, 226–27
Moral majority, 564
Morgan, Lewis Henry, 183, 185–86
Mormons, 334, 356
"Mother and Child," Cassatt, 229
"Mother and Child," Hoffman, 284
"Mother and Child," Mondersohn-Becker, 307
Mother-daughter relationship
and the family, 223–31, 239–40
female psychological development, 148–49
images, and sons, 306–8
Mother-infant relations, gender differences, 144–45
Motherhood, 281–317
choice and control, 301–6, 345
and ethnicity, 310–12
ideology and reality, 285–88
images, and who makes them, 33–36, 306–15, 439
and "mothering," 289
overthrow of "motherhood," 600–603
vs. parenthood, 282–90
and pregnancy, 290–92
as a "profession," 287
self-expression, literature, 314–15, 317
social roles, 196–97
support systems, 298–301
utopian communities, criticism, 338–39

and the welfare system, 198, 305, 552
and work, 304–6
Mott, Lucretia, 384–86
Ms. magazine, 84, 262, 562, 584
Multinational corporations, and cheap female labor, 508
Murasaki, Lady, eleventh century Japan, 205, 402
Murray, Pauli, 375, 559
Muslims
education, 399–400
marital laws, Egypt, 251–52
marital laws, Koran, 273, 370–71
religious leaders, 373
social control, clothing, 38–39, 201
Muted groups, theory of, 203–5
Mysticism, 381–82
Myths
and definition of women, 27–28, 439
mother-child relationship, 306–8
in religion, creation, 359–60
superwoman, 588–89

Naming
daughters, 221–23
after marriage, 261
National American Woman's Suffrage Association (NAWSA), 390, 556
National Black Feminist Organization (NBFO), 567
National Woman's party, 556–57, 562
National Women's Studies Association, 430
Native American women, 186, 209. See also Iroquois women
Natural childbirth, 293–95. See also Childbirth
Networking, women. See Women's networks
Nevelson, Louise, 45–47
Nietzsche, Friedrich, 73, 74
Nightengale, Florence, 441, 469, 597
Nineteenth Amendment to the Constitution, suffrage for women, 557, 559
NOW (National Organization for Women), 559–61
statement of purpose, 1966, 560
Noyes, John Humphrey, 335–36
Nuclear family
and capitalism, 511–12
household, 266–67
Nuns, 322–24, 350, 356, 377, 388–89, 404
Nursing profession, 468–70, 471
Nutrition, 448–49

Oberlin College, 415, 417–18
Obesity, 448–49
Occupations. See also Work
employment by gender, statistics, 502
nonsexist terms, 41
O'Connor, Sandra Day, 555
O'Keefe, Georgia, 44
Oedipal myth, 307–9

Oedipus complex. *See* Freudian theory; Psychoanalytic theory
Older women, 163–64. *See also* Aging; Mature women
Olsen, Tillie, 525, 530
Oneida community, 335
Orgasms, 114–15
Origin myths, religion, 359–60
"Other," women's nature, 60–63, 223

Paintings, and propaganda, 309
Pankhurst, Emmeline
 mother-daughter relations, 227
Parenthood
 fathering, 232, 282–83, 285, 298–300, 341, 584
 instinct and culture, 282–85
 vs. motherhood, 282–90
Parsons, Talcott, and family stereotype, 135
Patriarchal society
 evolutionary theories, 183–87
 feminine personality development, 239–40
 in political theory, 70
Patrilineal societies, 238
Paul, Alice, 556–57
Peace movements, 551–52
"Penis envy," 148, 162–63
"The personal is political," 536
Personality
 development in females, 143–60
 sex differences, 139
Philosophy, definitions of women, 63–66
Physical training in higher education, 419
Physicians
 career discrimination, 423–26
 women as, 471–72
Piercy, Marge, 51, 219, 275, 291, 333, 350, 551
Pink collar workers, 498–99, 503
Pizan, Christine de, 14, 403
Plato, 63
 ideas on equality, 77–78
 utopian ideas, 331
Political power, 531–70
 citizen role, 533, 548–54
 and control of property, 517
 definition of authority, 537–38
 definition of power, 537, 603–4
 equal rights, 554–68
 and feminist goals, 532–36
 future goals, 603–4
 and gender, what difference it makes, 546
 and "protective" work laws, 517–18
 stereotyped views
 of political behavior, 533–35
 women leaders, 535, 539–49
 in Communist countries, 545–48
 local level, United States, 542
 national legislative bodies, 549
 recent political gains, 543–45
 and stereotype of "politician," 542

Polyandry, 258
Polygyny, 258–59, 268–69
Pornography, imagery, 33
"Portrait of a Negress," Benoist, 578
Possession, religious, 382–83
Postpartum period, 118–20
Power. *See* Political power
Pregnancy
 attitudes toward, 290–92
 choice about, 301–3, 536
 ectopic, 117
 health aspects, 454–63
 medicalization, 455–56
 physiology, 116–17
 in teenagers, 456–57
Premenstrual syndrome, 111–12
Production
 capitalism, an alienated system, 489–510
 domestic mode, an integrated system, 485–88
Professional organizations, 515–16
Professions, and gender discrimination, 423–26, 503–7
"Protective" work legislation, 517–18
Protestantism, women leaders, 384
Psychoanalytic theory
 Deutsch, 160–61
 Freud and his critics, 146–151, 168
 Horney, 161–62
 psychosexual differences, 145
 sex differences, personality, 140–41
 adulthood, 160–63
 Thompson, 162–63
Psychodynamics, gender role development, 149–50
Psychotherapy
 American Psychological Association guidelines, 164–65
 goals for women, 163–65
 health care issues, 464

Quakers
 and Iroquois culture, 540
 women leaders, 384–86

Racism, and gender,
 analysis in women's studies, 11–13, 535–36
 and education, 421–22
 and work, 504–5, 507–9, 514
Radical feminism, 83–84, 579–80
Rape
 as a crime of violence, 467
 legal bias, 467–69, 553–54
 in marriage, 193–94
 mental health issues, 467–68
 and social control of women, 199–201, 541, 553–54
Reentry women, and college education, 428–29
Religion, 355–93

American women, 383–89, 583
beliefs, 356–67
definition of women, 66–67
gender of God, 363, 365, 367
ghosts and ancestor worship, 361
goddesses, 361–63
and immortality for women, 360–61
and individual fulfillment, 380–83
life-cycle rituals, 367–69
and origin myths, 359–60
"popular" sects, 372–73, 382–83
rebels, 378–80
and religious experiences of women, 358–59, 380–83
sexual controls, 369–70
women as leaders, 373–80, 583
women as mystics, 381–82
women as worshippers, 371–72, 380–81
Religious communities of women, 322–25
Renaissance, formal education, 402–6
Reproduction, marriage function, 247–48
Reproductive cycle, 107
Reproductive system, female, 103–5, 107–21
Reuther, Rosemary, 358–59, 394, 395
"Reverse discrimination," 518–19, 520
Revolution, and women, 595, 596. See also French Revolution
Rich, Adrienne, 191–93, 287, 306, 314, 318, 343, 352
Richards, Ellen Swallow, 421
Rites of passage, marriage, 261–64
Robusti, Marietta, 41–42
Role reversals, gender, 340–41
Roosevelt, Eleanor, 329, 538, 597
Rossi, Alice, 283, 338–39, 352
Rousseau, Jean Jacques
formal education ideas, 408–9
women's rights, inegalitarian views, 70–71
Rowbotham, Sheila, 82–83
Rushin, Donna Kate, 159
Russ, Joanna. See The Female Man

Saint-Phalle, Niki de, 32
Salaries, women and men, 504–5, 521–22
Salons, learned women, 404–6, 408
Sand, George (Amantine-Lucile-Aurore Dudevant), 9, 329
Sanday, Peggy, 359–60, 394, 395, 539, 540–41
Sanger, Margaret, 442–43, 470, 580
Sappho, women's communities, 45, 325–27, 401
Schneiderman, Rose, 495
Secondary education, achievement, 410–15
Secretaries, 498–99, 503
Self-concepts, and changing images, 37–41
Self-definition, imagery and symbolism, 23–55, 584
Self-employment, barriers, 509
Self-presentation, 26–27, 584

Seneca Falls, women's conventions, 386, 556, 562
Separate spheres theory, 26–27, 182–83
applied, 534–35, 536
and gender division of labor, 187–91
significance for social sciences, 183–87
Serfs, 491–92
Settlement house work, 419–20
Seventh-Day Adventism, 386
Sex and Temperament, Mead, 134–36
Sex differences, 138–43
biological explanations, 138, 174
and chromosomes, 98–103
physical, 97–98
and similarities, abilities and personality, 139
socialization theories, 141–43
"subjective experience," 140–41
Sex object role, imagery, 33
Sexism
definition of deviance, 553
and education texts, 427, 584
and language, 51–52, 133, 425
learned by women, 600
and unintentional power of men, 535
and work, 518–22
Sexual freedom, 346–48, 536
Sexual harassment, job, 512–13
Sexual organs, female-male, similarities, 103
Sexual response, females, 112–16, 461
Sexuality
health issues, 461–63
medical profession view, 442
"Shakespeare's sister," 236, 405
Shakers, 386
Shamans (curers), 373, 376–77
Sibling relationships, sisters, 230, 233–43
Silences, Olsen, 525, 530
Single parents, households, 343–45
Single women, 236–37, 343, 345–46, 348–50
Sisterhood of women, 239–41, 592–93
Sisters, sibling relationships, 233–43
Skilled labor, 492–93
Slavery, 491–92
Smith, Barbara, 567–68
Social change, 575–82
Social charter myths, 180–81
Social class, feminism, women's studies, 11–13
Social construction, gender, 176–78, 206–7
Social control and women's social roles, 197–203, 535–36
Social defintions, sex and gender, 174–76
Social learning theory, gender roles, 151
Social networks. See Women's networks
Social roles, 173–208
new interpretations, 205–6
origins of society, 180–87
sex and gender defined, 174–80
and social control, 197–203

and social invisibility, 203–5
and socialization, 187–97
Social science, gender role concepts, 179–80
Social support. See also Women's networks
 mothers, 298–301
 women's communities, 329–30
Socialism. See also Communism
 and feminism, 80–83, 536
 gender division of labor, impact on, 522–
 23
Socialization
 division of labor function, 187–91
 sex differences, personality, 141–43
Society
 contemporary picture, 583–84, 587
 gender role theories, 180–87, 534–35
 humane goals, 593–95
 mate selection, marriage, 251–53
 and social charter myths, 180–81
Sociobiology, 95
Sojourner Truth, 175, 387, 501
Song of Solomon (Song of Songs), 45, 48
Soviet Union, women leaders, 547–48
Sperm/egg relationship, 95
Stanton, Elizabeth Cady, 14, 17, 231, 347,
 386, 389–90, 396, 556–57
Starhawk, 365, 391, 392, 396
Stein, Gertrude, 347
Steinem, Gloria, 84, 86, 563
Stereotypes of "femininity," 133–43, 534–35
 consequences for politics, 542
Sterilization, 457, 460
Stone, Lucy, 329, 341, 417
"Stonerites," 342
Student Non-Violent Coordinating Commit-
 tee (SNCC), 561, 595
Students for a Democratic Society (SDS), 561
Subjective experience, gender differences,
 140–41
Substance dependence, 464, 466
Substance-of-we-feeling (SOWF), 16
Suffrage, 556–58, 559, 565
Suttee, 274
Superwoman myth, 588–89
Support systems, mothers, 298–301
Supreme Court decisions, and gender, 77,
 517, 521, 522, 534, 564–65, 587
Symbolism, and reality, 23–28. See also Ima-
 gery of women
Syphilis, 463

Taylor, Harriet. See Mill, Harriet Taylor
Teenage pregnancies, 456–57
Textbooks, and sexism, 426, 427
Television, mother images, 312–13
Thompson, Clara, 161–63. See also Psycho-
 analytic theory.
Tubman, Harriet, 491
Typewriter, and women office workers, 499,
 503

Unemployment, and gender discrimination, 510
Unions, labor, 494–95, 514–15
Unintentional power, 535
Universities, and affirmative action, 519, 521
Unmarried women, and choice, 345–46
Urbanization, and women's work, 489–90
Utopias, feminist, women's identity in, 50–
 52, 532
Utopian communities, experimental, 330–34,
 338–39

Valadon, Suzanne, 106
Venereal diseases, 461–63
"Venus" of Willendorf, 366
Verbal ability, sex differences, 124
Victorian "lady," 198–99. See also Separate
 spheres.
Victorian social theorists, 182–83
Virgin Mary, as an image of woman, 31
Visual-spatial ability, sex differences, 123
Vocational Counseling, and discrimination,
 427–28
Voting rights, 556–58, 565
 and power of the ballot, 603–4
Vulnerability, as social control, 199–202. See
 also Rape

Wages, men and women, 504–5, 521–22
War and women, 483, 548–51
Warner, Sylvia Townsend, 237
Wasbourne, Penelope, 369, 396
Washington, Mary Helen, 227
WEAL (Women's Equity Action League),
 425, 559–61
Wedding night, 264–65
Wedding rituals, 261, 263–64
Welfare and motherhood, 198
Wharton, Edith, 237
Widowhood, 196, 274–75
Willard, Emma, 411–12
Wilson, Woodrow, 538, 557, 558
Witches, 365, 378–80
Wives, 246–78
 as co-wives, 268–69
 and divorce, 271–74, 552–53
 feminist options, 275
 household arrangements, 265–71
 and linguistic taboos, 194, 267
 marriage, reasons, 247–51
 marriage types, 258–69
 president's wives, and power, 538
 selecting a mate, 251–58
 social roles, 196, 249–50, 401
 and widowhood, 274–75
 as working-class women, speak out, 279
Wollstonecraft, Mary, 576
 formal education ideas, 409, 410
 women's nature ideas, 71–73
Woman as "other," 60–63, 223
Woman on the Edge of Time, Piercy, 51,
 219, 275, 291, 333, 339, 350

The Woman's Bible, Stanton, 14, 17, 390
Woman's suffrage, 556–58, 565
The Woman Warrior, Kingston, 48, 253, 308, 317
Women and Economics, Gilman, 81, 580
"Women marriage," Igbo (Nigeria), 340
Women's Bureau, U.S. Department of Labor, 558, 562
Women's Christian Temperance Union (WCTU), 577
Women's Equity Action League (WEAL), 425, 559–61
"Women's houses," China, 327. *See also* Communities of women
Women's liberation movement. *See also* Equal rights movement; Feminism
 goals, 536, 594–95
 impact on work, 523–26
 origins, 558–65
Women's networks, 52–53
 childrearing support, 300
 and communities of women, 329–30
 and work, 516–17
The Women's Room, French, 49, 286, 330, 514
Women's Strike for Peace, 552
Women's studies, 3–17
 as an academic discipline, 13, 430–31
 and feminism, 4–7, 604–5
 history, 5–6, 430–31
 journals, 5, 430, 607
 issues and goals, 11–15, 431, 604–5
 methods, 6–7, 430–31
 need, 7–11, 429–30
Woolf, Virginia, 29, 45, 58, 243, 346, 405, 433, 550
Work, 479–528. *See also* Job discrimination
 and capitalism, 489–510, 511–12
 and cities, 489
 and college education, 419–26, 503, 506–7
 and communities of women, 326–29
 domestic made of production, 485–88
 and economic development, 401, 483–85
 flextime, 524
 gender division of labor, 187–91, 481–82, 491–507, 580
 gender socialization and goals, 188–91
 and labor of women in wartime, 483, 515, 580
 and the market place, 483
 and motherhood, 304–6
 new feminist directions, 523–26
 outside the home, as competition, 484, 511
 politics of, barriers and strategies, 510–23
 and role of technology, 488, 499
 in rural activities, comparison by gender, 486–87
 and social labor of women, 480, 482
 in utopian communities, 330–34
 and value of daughters, 220–21
 and the "working girl," 329, 528–29
Working-class women. *See also* "Lowell girls"; Work
 as clerical workers, 498–99, 503
 and craft skills, 327–28, 492–93
 as domestic servants, 493–94
 in the factory, 328–29, 494–98, 501, 514–15
 and heavy physical labor, 501, 507, 520
 and multinational corporations, 508–9
 speak out, self-portraits, 279

X chromosome, 99–101

Y chromosome, 99–101
Yörük women, Turkey, 195, 257

Zetkin, Clara, 551